Digital Media Revisited

Digital Media Revisited

Theoretical and Conceptual Innovation in Digital Domains

Edited by

Gunnar Liestøl, Andrew Morrison, and Terje Rasmussen

The MIT Press
Cambridge, Massachusetts
London, England

This book was set in Bell Gothic and Garamond 3 by Achorn Graphic Services, Inc. Printed and bound in the United States of America.

Library of Congress Cataloging-in-Publication Data

Digital media revisited : theoretical and conceptual innovation in digital domains / edited by Gunnar Liestøl, Andrew Morrison, and Terje Rasmussen.

 p. cm.

 Includes bibliographical references and index.

 ISBN 0-262-12256-1 (hc : alk. paper)

 1. Digital media—Social aspects. I. Liestøl, Gunnar. II. Morrison, Andrew. III. Rasmussen, Terje.

HM851 .D54 2003

302.23'4 — dc21

 2002035064

10 9 8 7 6 5 4 3 2 1

This publication was made possible by funding from The Norwegian Research Council (The SKIKT-program).

Contents

Contributors ix

Introduction 1
Gunnar Liestøl, Andrew Morrison, and Terje Rasmussen

I Education and Interdisciplinarity

1 Theory and Practice in New Media Studies 15
Jay David Bolter

**2 The Paradigm Is More Important Than the Purchase:
Educational Innovation and Hypertext Theory** 35
George P. Landow

**3 The Challenge of Digital Learning Environments in Higher
Education: The Need for a Merging of Perspectives on
Standardization** 65
Jon Lanestedt

4 **The Internet and Its Double: Voice in Electracy** 91
 Gregory L. Ulmer

5 **From Oracy to Electracies: Hypernarrative, Place, and**
 Multimodal Discourses in Learning 115
 Andrew Morrison

II **Design and Aesthetics**

6 **The Reading Senses: Designing Texts for Multisensory**
 Systems 157
 Maribeth Back

7 **Acting Machines** 183
 Peter Bøgh Andersen

8 **Performing the MUD Adventure** 215
 Ragnhild Tronstad

9 **Digital Art and Design Poetics: The Poetical Potentials of**
 Projection and Interaction 239
 Lars Qvortrup

10 **Low Tech–High Concept: Digital Media, Art, and the State**
 of the Arts 263
 Stian Grøgaard

III **Rhetoric and Interpretation**

11 **Rhetorical Convergence: Studying Web Media** 293
 Anders Fagerjord

12 **Computer Games and the Ludic Structure of**
 Interpretation 327
 Eva Liestøl

13 **"Next Level": Women's Digital Activism through Gaming** 359
 Mary Flanagan

14 **"Gameplay": From Synthesis to Analysis (and Vice Versa)**
 Topics of Conceptualization and Construction in Digital Media 389
 Gunnar Liestøl

15 **We All Want to Change the World: The Ideology of
 Innovation in Digital Media** 415
 Espen Aarseth

IV **Social Theory and Ethics**

16 **On Distributed Society: The Internet as a Guide to a
 Sociological Understanding of Communication** 443
 Terje Rasmussen

17 **Proper Distance: Toward an Ethics for Cyberspace** 469
 Roger Silverstone

18 **"Making Voices": New Media Technologies, Disabilities,
 and Articulation** 491
 Ingunn Moser and John Law

19 **The Good, the Bad, and the Virtual: Ethics in the Age of
 Information** 521
 Mark Poster

 Illustration Credits 547

 Index 549

Contents

Contributors

Espen Aarseth is an Associate Professor in Humanistic Informatics at the University of Bergen, Norway. His best-known book is *Cybertext: Perspectives on Ergodic Literature* (Johns Hopkins University Press, 1997). Among his interests are comparative media theory, digital aesthetics and culture, and the politics of humanities computing and digital studies. He is the founder of the Digital Arts and Culture annual series of international conferences (1998–), and directed the Lingo project at the University of Bergen (1997–2000), using and developing MOOs for language learning, in German and French. His current research is focused on computer games, which he has studied since 1984. ⟨http://cmc.uib.no⟩; ⟨espen.aarseth@hf.uib.no⟩

Peter Bøgh Andersen is a Professor in the Department of Computer Science, University of Aalborg, Denmark. He is also Codirector of the Danish Centre for Human Computer Interaction. He has a doctorate in Danish language (1971) and a second doctorate (1991); his dissertation was published as *A Theory of Computer Semiotics: Semiotic Approaches to Construction and Assessment of Computer Systems* (Cambridge University Press, 1991). His research interests include computer semiotics, maritime instrumentation, aesthetics of multimedia, organizational semiotics, task analysis, and human-machine interface. His recent

publications include "Genres as Self-Organising Systems," in P. Bøgh Anderson et al. (eds.), *Downward Causation: Minds, Bodies and Matter* (Aarhus University Press, 2000). "Agents and Actors" (with Jørgen Callesen), in L. Qvortrup et al. (eds.), *Virtual Interaction: Interaction in Virtual Inhabited 3D Worlds* (Springer Publishers, 2001); and "Tearing up Interfaces" (with Michael May), in K. Liu et al. (eds.), *Information, Organisation and Technology: Studies in Organisational Semiotics.* (Kluwer, 2001).

⟨pba@cs.auc.dk⟩

Maribeth Back is a senior member of the research staff at the Xerox Palo Alto Research Center (PARC). She designs, builds, and writes about multisensory objects and environments. Much of her work explores the functions of form and sensory syntax in emerging media genres, especially in new kinds of reading devices and electronic books. In 2001, her *Listen Reader* won the *I.D.* magazine Silver Medal for Interaction Design. Her background in dynamic media includes four years as resident sound designer at the American Repertory Theater, working with such artists as Robert Wilson, Andre Serban, and Phillip Glass. She was sound designer and a principal performer with the MIT Media Lab's Brain Opera. Back received her doctorate from the Harvard Graduate School of Design in 1996. At Xerox PARC, she works with the RED group on new media genres and design.

⟨http://www.parc.xerox.com/back/⟩; ⟨back@parc.xerox.com⟩

Jay David Bolter is director of the New Media Center and Wesley Chair of New Media in the School of Literature, Communication, and Culture at the Georgia Institute of Technology ⟨www.lcc.gatech.edu⟩. His works on digital technology and contemporary culture include *Turing's Man: Western Culture in the Computer Age, Writing Space: The Computer, Hypertext, and the History of Writing,* and *Remediation* (with Richard Grusin). With Michael Joyce, Bolter is the author of *Storyspace,* a program for creating hypertexts for individual use and World Wide Web publication. Bolter is currently collaborating with Blair Macintyre to build an augmented reality system for dramatic and narrative experiences ⟨http://www.sweetauburn.lcc.gatech.edu⟩.

⟨jay.bolter@lcc.gatech.edu⟩

Anders Fagerjord is a research fellow at the Department of Media and Communication, University of Oslo. He is currently finishing his doctoral dissertation

on World Wide Web versions of "old media" such as newspapers, magazines, and television, in particular their combination of spoken and written language and still and moving images. He is a *candidatus philologiae* in media and communication from the University of Oslo (1997). Outside of academia, he has worked as a radio host and as a Web designer.

⟨http://www.media.uio.no/personer/andersf/⟩; ⟨anders.fagerjord@media.uio.no⟩

Mary Flanagan is an interactive artist and software designer interested in the intersection of art, technology, and gender study. She wrote her chapter while living in Montreal; she is now an Associate Professor of Multimedia Design in the Art Department, University of Oregon. Recent creative works include the interactive VRML environment (*The Perpetual Bed*), the computer virus (*phage*), and (*rootings*), an Internet game. Before teaching, Flanagan was a producer of entertainment CD-ROMs and Web experiences in Austin, Texas. Her essays on digital art and games have appeared in *Convergence, Art Journal,* and *Wide Angle.* Flanagan's coedited volume entitled *Reload: Rethinking Women in Cyberculture* was published by the MIT Press in 2002.

⟨http://www.maryflanagan.com⟩; ⟨mary@maryflanagan.com⟩

Stian Grøgaard is an Associate Professor in Art Theory at The College of Fine Arts in Oslo. His university education is in philosophy, literature, and sociology from the University of Oslo. He studied art for five years and practiced as a painter before returning to philosophy in 1993. He is coeditor of *Agora,* a journal of philosophy. He has published essays on the aesthetics of German idealism, especially Kant's *Critique of Judgment,* French poststructuralism (Derrida, Bourdieu), and the art of Edvard Munch, Donald Judd, and Robert Smithson.

⟨stian.grogaard@khio.no⟩

George P. Landow is currently Dean, University Scholars Programme, University of Singapore. His books on hypertext and digital culture include *Hypermedia and Literary Studies* (MIT, 1991), and *The Digital Word: Text-Based Computing in the Humanities* (MIT, 1993), both of which he edited with Paul Delany, and *Hypertext: The Convergence of Contemporary Critical Theory and Technology* (Johns Hopkins University Press, 1992), which has appeared in various European and Asian languages and as *Hypertext in Hypertext* (Johns Hopkins University Press, 1994), a greatly expanded electronic version with original texts by Derrida,

reviews, student interventions, and works by other authors. In 1997, he published a much-expanded, completely revised version as *Hypertext 2.0*. He has also edited *Hyper/Text/Theory* (Johns Hopkins University Press, 1994).
⟨http://www.landow.com⟩; ⟨uspdean@nus.edu.sg⟩; ⟨george@landow.com⟩

Jon Lanestedt holds a position as senior engineer and head of the Digital Media in Learning Group, Center for Information Technology Services, University of Oslo. He has an M.A. in comparative literature on electronic fiction, as well as formal studies in French and informatics. Lanestedt has been involved in Web-based learning and digital media technology for a number of years, both as faculty, developer, and manager in academia as well as a multimedia editor in the publishing industry. He was central to the development of the Computers in the Humanities program at the University of Oslo, where he also taught hypermedia.
⟨jon.lanestedt@usit.uio.no⟩

John Law is Professor of Science, Technology, and Society at the Centre for Science Studies, and the Department of Sociology, at Lancaster University, U.K. He has written widely on actor network theory and subsequent theoretical developments in STS and cultural studies, focusing in particular on materiality, spatiality, subjectivity, and representation. He is currently working on technical systems, including aircraft projects and railway safety, and on medical practices, including diabetes self-management. His book *Aircraft Stories* was published by Duke University Press in 2002.
⟨http://www.comp.lancs.ac.uk/sociology/jlaw.html⟩; ⟨j.law@lancaster.ac.uk⟩

Eva Liestøl is a *candidatus philologiae* in the Department of History of Ideas at the University of Oslo. Research fellow (1989–1992). She has lectured in Gender and Culture Studies at the Department of Media and Communication. As an external researcher affiliated with the Department of Media and Communication, she has been project manager of "Computer Games and Learning," initiated and financed by Information Technology in Education (ITE/ITU). She has published articles on film, painting, computer games, and learning. Her work on hermeneutical approaches to computer games, entitled *Computer Games: Introduction and Analysis,* was published in autumn 2001 (Oslo: Universitets forlag).
⟨eva.liestol@media.uio.no⟩

Gunnar Liestøl is an Associate Professor, Department of Media and Communication, University of Oslo, Norway. He has a master's degree in literature and a doctorate in media studies, both from the University of Oslo. His research has been in the field of digital media and rhetorics and in developing pedagogies for teaching and learning about digital media. As director of the award-winning CD-ROM *Kon-Tiki Interactive,* he has considerable experience in digital media design and production. In addition to being a partner in several EU-funded projects, he is currently researching relationships between computer games, learning, and design methodologies.

⟨http://www.media.uio.no/⟩; ⟨gunnar.liestol@media.uio.no⟩

Andrew Morrison is an Associate Professor at Intermedia, the University of Oslo, where he teaches and researches digital media and learning in higher education in Norway and Zimbabwe, his country of origin. Trained in literary studies, applied linguistics, and media studies, he has published in print (e.g., literature and language in sub-Saharan Africa, English as a second language and academic communication, critical discourse and news, and HIV/AIDS education in Africa) and online (project-based learning in art education, the Internet in Zimbabwe, and net news). His doctoral dissertation (University of Oslo, November 2002) is entitled "Electracies: Investigating Transitions in Digital Discourses and Multimedia Pedagogies in Higher Education" and presents three case studies from Zimbabwe (including 2 CD-ROMs). His interests include electronic arts and design, e-narrative, and the rhetorics of research online. *Researching ICTs in Context* is his most recent edited anthology, containing a coauthored chapter on dance, media, and research.

⟨andrew.morrison@intermedia.uio.no⟩

Ingunn Moser is a Ph.D. student at the Center for Technology, Innovation and Culture at the University of Oslo. Her doctoral thesis deals with the reconfigurations of bodies and selves after traffic accidents, with the different modes of ordering through which people "become human" again in a rehabilitation process, and with the role of technology in these processes. Her field of interests comprises feminist science and technology studies, cultural studies, and disability studies. Her latest publications include "Against Normalisation: Subverting Norms of Ability and Disability" (*Science as Culture,* 2000) and "Managing, Subjectivities and Desires" (*Concepts and Transformation,* 1999).

⟨ingunn.moser@tmv.uio.no⟩

Lars Qvortrup is Professor of Multimedia in the Department of Communication, Aalborg University, Denmark. From 1998 to 2000 he was director of the multimedia research center at Aalborg University, InterMedia–Aalborg. Since 2000 he has been Professor of Multimedia in the Department of Interactive Media, University of Southern Denmark. Since 1999 he has been a Professor II (ICT and Learning) at Høgskolen in Lillehammer, Norway; he has also been associated with Urbino University, Italy, as a part-time guest professor. His research can be divided into the following main areas: IT sociology *(The Hypercomplex Society,* Peter Lang, forthcoming); IT aesthetics ("L'arte e la società dei multimedia interattivi: lo shaping socio-estetico die multimedia," in Danila Bertasio, ed., *Immagini sociali dell'arte,* Edizioni Dedalo, 1998); and virtual inhabited 3D worlds (editor of *Virtual Interaction: Interaction in Virtual Inhabited 3D Worlds,* Springer Verlag, 2001, and *Virtual Space: Spatiality of Virtual Inhabited 3D Worlds* (Springer Verlag, 2001).
⟨larsq@litcul.sdu.dk⟩

Mark Poster is Director of the Film Studies Program at University of California, Irvine and a member of the History Department. He also has a courtesy appointment in the Department of Information and Computer Science. He is a member of the Critical Theory Institute. His recent books are *What's the Matter with the Internet? A Critical Theory of Cyberspace* (University of Minnesota Press, 2001), the Information Subject in Critical Voices series (New York: Gordon and Breach Arts International, 2001), *Cultural History and Postmodernity* (Columbia University Press, 1997), *The Second Media Age* (London: Polity and New York: Blackwell, 1995), and *The Mode of Information* (Blackwell and University of Chicago Press, 1990).
⟨msposter@uci.edu⟩

Terje Rasmussen is a Professor of Media Studies in the Department of Media and Communication at the University of Oslo. Among his publications is *Social Theory and Communication Technology* (Ashgate, 2000). He has produced several books on media, social theory, and ethics. His current interests include sociological systems theory and the history and sociology of the Internet.
⟨terje.rasmussen@media.uio.no⟩

Roger Silverstone is a Professor of Media and Communications in the Department of Sociology at the London School of Economics. He joined the staff of

the LSE in May 1998 where he is creating a global program in media and communications research and teaching. He has done research in a number of areas of media and communications, with a recent focus on the relationship between media, technologies, and everyday life. Some recent books include *Television and Everyday Life* (Routledge, 1994); *Communication by Design* (with Robin Mansell, Oxford University Press, 1996); *Visions of Suburbia* (Routledge, 1997); *International Media Research* (with Philip Schlesinger and John Corner, Routledge, 1998); and *Die Internet-ökonomie* (with Axel Zerdick et al., Springer-Verlag, 1999). His most recent book, *Why Study the Media?* was published by Sage in 1999. He is currently a fellow of the European Communication Commission and the editor of *New Media & Society*.

⟨r.silverstone@lse.ac.uk⟩

Ragnhild Tronstad is a research fellow in the Department of Media and Communication, University of Oslo. She has previously published articles on the theater metaphor, performance and theatricality, and role-playing conventions in MUDs and on Usenet newsgroups. She has translated articles on theater, technology, and writing for the Norwegian theater theory journal *3t*. Currently she is writing her doctoral dissertation on performance and theatricality in adventure games like MUDs.

⟨ragnhitr@hedda.uio.no⟩

Gregory L. Ulmer is a Professor of English and Media Studies at the University of Florida. He is the author of *Applied Grammatology* (1985), *Teletheory* (1989), and *Heuretics: The Logic of Invention* (1994). His current project, *Miami Miautre: Mapping the Virtual City*, is a choreography of the Miami River, Florida, produced in collaboration with the Florida Research Ensemble. Some related projects are available at ⟨www.nwe.ufl.edu/~gulmer and www.elf.ufl.edu/⟩ (Electronic Learning Forum).

⟨gulmer@english.ufl.edu⟩

Digital Media Revisited

Introduction

Gunnar Liestøl, Andrew Morrison, and Terje Rasmussen

Second Encounters of the Close Kind

For more than a decade, digital media have been approached as a new and challenging subject matter from a variety of academic disciplines. We have seen a series of first encounters in which established theoretical traditions with their existing conceptual frameworks are applied, more or less directly, to the new digital artifacts, their uses and influences. These undertakings have been important and necessary. Despite their limitations in the long run, they have demonstrated the variety and complexity of digital domains and indicated the need to move beyond the immediacy and naiveté of such procedures.

In this book the "first-encounter approach" is taken as already having occurred and as being a matter of considerable critical inquiry. Our purpose, in contrast, may be described as a second-order approach to digital media—a revisiting—in which the first-encounter experience is included and reflected. Thus the underlying pattern that connects the chapters and the discussion within them is that of theoretical and conceptual reconfiguration and innovation in the wake of digital developments and communication changes. Our purpose, therefore, is to argue the need for such a revisiting and its importance in generating further discussion.

The contributors to this volume present a series of theoretical reflections on digital media, but, in addition, they question theory through interpretations of texts and communicative processes involved in the making, use, and analysis of these media. In recent years, it has become quite clear that, for the human sciences, digital media are not only objects of analysis, but also instruments for the development of innovative perspectives on both media and culture.

Considering Innovation

As the subtitle of the book suggests, "innovation" offers us a key concept through which we can address the two-way shuttle of insights between theorizing and experimenting. In discussing innovation and digital media, most of the contributors to the volume expressly detach themselves from the grand narrative of modernity. Today innovations are often seen as unintended effects of intentional change and unintentional effects of unintentional effects. Furthermore, it is often problematic to frame a bit of reality by calling it an innovation. For example, at what point did the Internet appear as an innovation? Was it in 1969, when the first bits were transmitted through ARPANET? Or was it in 1973, when the principles of the Internet protocol were publicized? Or in 1977, when the first bits were transmitted from one packet-switched network to another?

It could be argued that as a general term "innovation" encapsulates the essence of contemporary social change. This change appears not in the productive use of magical beliefs, tradition, or cultural values as much as from their rupture. Rather, we might say that innovation emerges from deconstructing; it implies taking things apart and putting them together again in new ways and in different combinations. Scientifically, the ethos as well as product of innovation is realized in various forms of "disciplined multidisciplinarity." At a general level, Kant observed this differentiation of reason, as did Weber the differentiation of value spheres, which motivated new forms of politics, nation building, secularization, bureaucratic organizations, etc. In other words, innovation implies increased flexibility and freedom, but also increased complexity. The name of the game is tearing apart and weaving together, decoupling and recoupling, analyzing and synthesizing, diverging and converging.

Revisiting Digital Media in Conceptualizing the New

To name an object is to conceptualize or to construct it. Here we need to recognize that innovators may be the ones who communicate about innovation, as is the case in this volume. As innovation in this way is a process of observing and critiquing, it refers as much to the position of the observer as to the nature of the object. Science has its double dependence on language and experience. To recombine elements into new objects—whether they be hardware, software, middleware, or meaningware—implies that we look differently, that we apply new concepts and models, and that we reflexively analyze how, why, and when to shift perspective. It may even mean we do the virtually impossible, that is, we observe from two or more positions at once. Multidisciplinarity, one could argue, is to look simultaneously from two or more angles to fix an object in a multidimensional space of double description (Bateson 1989: 69). Theoretically, this may seem to be an impossible endeavor, but one may learn much from an attempt at such an endeavor.

A Multiplicity of Views

The views and experiences of a diversity of digital media makers, teachers, critics, and scholars are gathered in the nineteen chapters offered here. This collection suggests the range of difficulties involved in trying to make sense of digital media and the claims surrounding them as novelty. The contributors typically recombine insights from different fields and disciplines, such as literary theory, aesthetics, sociology, ethics, philosophy, media studies, semiotics, and education, to construct new positions within which and from which digital media may be observed in meaningful and fresh ways.

The chapters are therefore involved in the double activity of understanding digital media as well as the very enterprise of their understanding. In connection with this double move, two central questions arise. What are the significances of social and cultural transformations related to digital media? What are the conditions in which such a question may be "answered" by the human sciences? Inevitably, the latter question opens up an ambitious project: the understanding of the status and functioning of

the human sciences today. This is an ongoing project from which we cannot escape.

A further question has to do with the extent to which we are prepared to engage critically within the processes and problematics of change where the shadows of uncertainty, risk, and modulation are always present. Many of the authors in this volume demonstrate how they have grappled with the lure and tensions involved in working with and analyzing digital media. In spite of our general wish to describe and interpret rather than to prescribe or preach, an underlying purpose of the chapters in this book is to address how to make the most and the best of the current wave of digital media as means of communication.

Repeatedly, the contributors to this volume pose questions about their own understanding and the influence of prior knowledge, training, and interests. They also often question the adequacy of earlier, less combinatorial approaches to knowledge in which practice and theory have been seen as unlikely partners. What is apparent is a common interest and investment in building a diversity of interlinked theories that are informed by and part of an expanded and reoriented practice in working with digital media and communication.

Outline of the Book

This book is presented according to four interrelated themes or parts. The chapters have also been ordered in a sequence, however, so that there is connectivity in their themes; many of the chapters may be linked with several others and on a variety of levels, concerns, and insights. We therefore invite readers to approach the collection as a lattice of related questions and perspectives arising out of the intersection of theory and practice as we continue to make and research digital media and communcation.

Part I: Education and Interdisciplinarity

Central to the academic discipline of digital media studies is the contradiction between the medium of theory and the media of practice. In the opening chapter, "Theory and Practice in New Media Studies," Jay David Bolter discusses how the media of theory and academic critique have continued to be those of traditional print. What happens when the medium

and the subject matter also become the medium of theory? Can theory continue to assert its customary critical distance? Bolter argues that these are questions most critical theorists are not yet prepared to consider, in part because they fear becoming implicated in the economic and social practices of our "late-capitalist, digital culture." Yet there are historically compelling reasons why we might at this moment seek to define a practical theory of new media.

The evolving relationship between digital media and pedagogics is also central to the critical understanding of digital media. George P. Landow illuminates in chapter 2, "The Paradigm Is More Important than the Purchase: Educational Innovation and Hypertext Theory," how hypertext theory and practice interact in the context of pedagogical applications in various institutional contexts. Landow draws his material from a cross-disciplinary program at the University of Singapore that emphasizes modes of thought, methodologies of various disciplines, multidisciplinarity, and a Singaporean synthesis of Eastern and Western cultures.

To be successful, institutional implementation of digital learning environments demands substantial rethinking of strategic options. A central problem is the lack of compatibility among various digital learning modules. In chapter 3, "The Challenge of Digital Learning Environments in Higher Education: The Need for a Merging of Perspectives on Standardization," Jon Lanestedt discusses problems of standardization in the development and implementation of learning management systems. His discussion, however, is not limited to hardware and software but includes a concept of standardization that also provides compatibility between various disciplines, theoretical traditions, and conceptual frameworks.

Developments of digital discourse so far have been oriented toward text and image but need to stress compatibility among all available information types and forms of representation. Sound and related topics such as "voice" have been marginalized. This is also the case with the evolution of digital literacy. Gregory Ulmer notes in chapter 4, "The Internet and Its Double: Voice in Electracy," that the basic rules of literacy include the admonition always to write in the active voice. Theorists have noted that a new modality of voice was being invented within twentieth-century experimental arts. Proposing that this new voice is to electracy what the active voice is to academic writing in literacy, this chapter uses the method

of the theoretical remake to present a new concept of voice from Artaud's *The Theater and Its Double* (1958).

Changing approaches to literacy and communication as "composition" are also the focus of chapter 5, by Andrew Morrison. In "From Oracy to Electracies: Hypernarrative, Place, and Multimodal Discourses in Learning," Morrison borrows the term "electracy" from Gregory Ulmer but argues that it too, like literacy, needs to be extended and rearticulated as a multiple of modes of discourses and literacies, namely, as electracies. In particular he claims that the emerging digital discourses of the academy and the flurry of new media marketing and networked pedagogies need to consider electracies as multimodal discourses. These are linked with emerging and multiply shaped electronic literacies in which processes of developing not only procedural skills, but also analytical and critical capacities, are considered. This claim is supported through a genre remake mixing hypernarrative and critical discourse both to create and to critique multimodal discourses in learning.

Part II: Design and Aesthetics

With digital media the act of reading extends beyond the visual field of perception toward multimodal and multisensory relationships between various textual artifacts and corresponding forms of reading. In chapter 6, "The Reading Sense: Designing Texts for Multisensory Systems," Maribeth Back describes and discusses experimental developments in digital reading devices and suggests an extended concept of authoring and design that stresses the inclusion of the physical contexts. Furthermore, she argues that critical theory needs to traverse traditional disciplinary boundaries for the successful exploitation and understanding of such multimodal and multisensory reading systems.

Peter Bøgh Andersen takes the question of boundaries as his starting point in chapter 7, "Acting Machines." Boundaries previously believed to be almost ontological now dissolve: the boundaries between leisure time and work, between the soft and hard sciences, between signs and their references, between humans and machines, and between truth and illusion are permeable, because digital media are a mixture of media, tools, and automata. By means of this permeability, habits and values originally evolved in one sphere of society are smuggled into the others. In addi-

tion, the development of shared interface standards means that the methods of operation are homogenized across diverse social domains. In his discussion, Andersen draws on specific examples from two apparently diverse domains, engineering (process control) and aesthetics (entertainment agents) and argues that, despite their differences, they require similar solutions for problems involving representation, description, and design.

In digital media people act through and with machines. In chapter 8, "Performing the MUD Adventure," Ragnhild Tronstad describes the implications and consequences of applying the notions of performance and theatricality to conceptualize multi-user dungeons (MUDs). She acknowledges that MUDs are game-like systems and thus require a conceptual framework beyond the traditional disciplines of theater studies. To provide such a framework, she draws on general game theorists such as Callois and Huizinga.

In chapter 9, "Digital Art and Design Poetics: The Poetical Potentials of Projection and Interaction," Lars Qvortrup draws a distinction between aesthetics (as artistic idea) and poetics (as artistic product) to develop a poetics of interactive form or a digital poetics. In his discussion of examples from Marcel Duchamp and various digital installations he uses perspectives from Immanuel Kant's aesthetics and Niklas Luhmann's systems theory.

Aesthetics and art theory are also the topic of chapter 10, "Low Tech–High Concept: Digital Media, Art, and the State of the Arts." Stian Grøgaard begins the chapter with a discussion of the argument that the modern relation between technology and art is one of deep dependence and a surprising irrelevance. The complexity of this relation is expressed in the invention of aesthetics, the modern philosophical discipline par excellence. This invention is based on the substitution, for traditional rhetoric and its seven liberal arts, of a new model, the natural sciences. Now aesthetics faces new and other demands on invention/innovation. What used to be the *art* of invention turns into a radicalized split between automation and experiment, between the clockwork of the mind (capacities) and the finally unjustifiable practice of judgment. For art, as it turns out, technological nostalgia was but one of several lines of flight. For a description of this changing definition of art, much is to be gained

through renegotiating modernism's concept of medium and remediation within media studies.

Part III: Rhetoric and Interpretation

"Convergence" has been a buzzword in popular and political conceptions of digital media. In chapter 11, "Rhetorical Convergence: Studying Web Media," Anders Fagerjord relates the metaphors of convergence and divergence to the level of rhetorical techniques and devices. Through a discussion of online journals, he is able to present both an innovative perspective on digital textuality and valuable critical comments on recent conceptualizations, for example, Bolter and Grusin's term "remediation" (1999).

Computer games remain the most successful and popular of digital artifacts and texts, but attention in academia to computer games is as yet inadequate. In chapter 12, "Computer Games and the Ludic Structure of Interpretation," Eva Liestøl treats the popular "shooter" game *Duke Nukem* on equal terms with art, literature, and film as a culturally constructed text worthy of critical attention and interpretation. By means of established methodologies in art history and hermeneutics, she points to the potential and characteristics of computer game analysis as a novel form of close reading.

Whereas earlier computer games were often considered a gender-specific activity of little artistic value, recent developments show that computer game genres and conventions are also being deployed in creative and critical ways, especially with attention to gender. In chapter 13, "Next Level: Women's Digital Activism through Gaming," Mary Flanagan shows, through a series of examples, how women artists are using tools of digital pop culture to express dissatisfaction with women's popular representation and gaming culture and thereby to set about redefining the relationships among theory, practice, and activism.

If digital forms of expression create a demand for different analytical categories and concepts, the question arises as to how we may invent or discover such categories or concepts. Or rather, we might ask, where are we to find them? In chapter 14, "From Synthetic to Analytic (and Vice Versa): Topics of Conceptualization and Construction in Digital Media," Gunnar Liestøl focuses on the language games of the developer's discourse in computer game production as a conceptual (re)source. Using a discus-

sion of the coined term "gameplay" as an example, he shows how a concept developed in the production environment can be transposed and tuned to serve analytical purposes.

A central question for understanding the consequences of technical innovation is its handling (subsumption) by social and commercial consciousness. In chapter 15, "We All Want to Change the World: The Ideology of Innovation in Digital Media," Espen Aarseth discusses the relationship between innovations in digital technology and ideology. He questions the role of hype in technological evolution and revolution. Through a broad discourse analysis of the three key terms "interactivity," "hypertext," and "virtuality," he explores the dialectic of rhetoric and research and development in the digital domain and shows that the relationship between ideology and technology is both problematic and symbiotic.

Part IV: Social Theory and Ethics

Terje Rasmussen argues in chapter 16, "On Distributed Society: The Internet as a Guide to a Sociological Understanding of Communication," that the evolving structure of the Internet may be applied as a sociological model of the world society, indicating what he calls a "distributed society." In a theoretical loop, this again may address the ways the Internet affects (interplay with) general social change. Drawing upon the sociological oeuvre of Niklas Luhmann, Rasmussen argues that the Internet both furthers and indicates a functionally differentiated world society.

In chapter 17, "Proper Distance: Toward an Ethics for Cyberspace," Roger Silverstone draws on the work of the philosopher Emmanuel Levinas, who has developed an ethics from the notion of "the other" and the appeal that stems from the other's face. Silverstone explores the new social relationships mediated by information and communication technologies on the basis of some central notions in Levinas's ethics. He argues that the possibility of a moral life is dependent on our capacity to establish what he calls a proper distance in the relationships that the digital media influence. He argues that the claim that the Internet is capable of providing extended forms of social experience needs to be addressed more critically.

In chapter 18, " 'Making Voices': New Media Technologies, Disabilities, and Articulation," Ingunn Moser and John Law discuss how

studies of digital media technologies for people with disabilities question traditional conceptions of both subjectivity and agency. They argue that theoretical and methodological resources and discussions within the interdisciplinary fields of feminist theory and gender studies, as well as studies of science and technology, allow us to reflect on how we can denaturalize taken-for-granted figures of subjectivity and agency.

In the closing chapter, "The Good, the Bad, and the Virtual: Ethics in the Age of Information," Mark Poster addresses how we are to make judgments about technologically mediated acts and in what ways they differ from face-to-face communication: "Do the standards deployed in real life serve us well in the virtual domains of cyberspace, film, radio, television, telephone, telegraph, and print—in short, in the media?" Poster examines the notion that an age of information may undermine established ethical principles. A key question is perhaps how to construct new theories and concepts of valuation that adhere more adequately to a technologically mediated world. Furthermore, new ethical rules for mediated culture suggest that established ethical theory may be dislodged as the familiar boundaries between relations among people and the media start to crumble.

Experimentation, Interpretation, and Theory

To conceptualize the new, to theorize the unknown, one might say, is to experiment with optics; to experiment in such a way is to transpose, to reconvene, and to rearticulate—to revisit. The continuing emergence of digital media in the twenty-first century presents precisely this complex state of affairs. It places an additional burden on the innovator: that of reflexivity. Knowing that what one discovers depends on where one stands may lead to knowing about oneself more than anything else. Critical engagement in innovation implies the immensely complex practice of locating oneself in relation to something the appearance of which changes according to position. In short, this is a highly paradoxical, indeed holographic, endeavor.

We encourage readers of this book, therefore, not only to see it as a set of separate sections, but also to read the chapters in relation to one another. By this we would like to suggest that readers revisit the chapters, conceptually, through cross-readings and by way of linking the chapters'

themes and perspectives, all the more so where these concern diverse sub-ject matter.

An underlying theme of this volume is that, within the context of the human sciences, the construction of adequate digital-media texts, uses, and analysis is perhaps only half the story. Each of the chapters in *Digital Media Revisited* attempts to present the other half of what is a complex discourse, one that is centered on an overall guiding question that is often ignored in how we present, analyze, and reflect critically on digital media in our times: to what extent can interpretation of and experimentation with digital media inform theory?

As both "new" and older media saturate modern societies, it seems plausible that our engagement with the media (as developers, consumers, analysts) contributes to the understanding not only of media, but also of culture and society. Although economic and political power should not be underestimated in the growth and scope of media development, "follow the media" might be our credo here for understanding social and cultural change. Innovative work together with analysis may lead to innovative theory, which again may inform development. The production of digital media, including our own productive, mediated communication, may also be enriched by such theories and their conceptual overlapping. We hope that the diversity of material presented in this collection will contribute to such a conceptual investment and an ongoing process of the revisiting of digital media.

References

Artaud, A. (1958) *The Theater and Its Double* (trans. M. C. Richards). New York: Grove.

Bateson, A. (1989) *Mind and Nature: A Necessary Unity.* New York: Bantam Books.

Bolter, J., and R. Grusin (1999) *Remediation: Understanding New Media.* Cambridge, MA: MIT Press.

I

Education and Interdisciplinarity

1

Theory and Practice in New Media Studies

Jay David Bolter

If there is already a field of new media studies, it is a combination of strategies established for understanding and working with earlier media. New digital media constitute a cultural and economic phenomenon; our society is willing to spend a great deal of money on the development of such forms as computer games, Web sites, and computer graphics for film and television. So it is not surprising that many academic disciplines are turning their attention to these forms, at least in part to claim a share in the resources that new media are generating. Computer science and computer engineering have a de facto claim, and at least some sociologists and economists as well as humanists in literature, art history, and musicology are seeking to show that their disciplinary perspectives are also relevant to this digital revolution. Some of these humanists want to use digital technology to further their traditional research and teaching; others may simply want to assert that their fields remain important to our culture's assimilation of new digital media forms.

Although academic humanists are attempting both to use and to theorize about new media, they tend to keep the two (use and theory) separate. There has been a great deal of theorizing. In a sense, we could say that the humanities in the second half of the twentieth century became

media theory, that is, the study of technologies of representation and communication, beginning with but no longer limited to printed books and the literary forms of print. The influential media theories, however, developed before the explosive popularity of digital media and media forms. Such theories were occasioned by earlier technologies (above all, the printed book, film, and television) and may be inadequate to the task of understanding new media, especially because these theories were not designed to improve the practice of these earlier technologies. Our culture's practical engagement with such digital forms as the World Wide Web may compel us to rethink the relationship of media theory and practice in the humanities.

To see why this rethinking may be necessary, let us begin by reminding ourselves about the different uses of the term "theory" in the sciences, the humanities, and the arts. Researchers in cultural studies know how subtle and varied are the uses of the term in empirical and theoretical sciences (and the public's perception of these sciences). Because I cannot do justice to the nuances here, let me limit myself to the notion of theory in computer science. Theoretical computer science includes the work of logicians (theory of automata) and mathematicians (computability theory and numerical analysis). In various subdisciplines of computer science (such as databases, operating systems, compilers, and programming languages) the formalism of mathematics and logic provides a foundation for the work of building effective systems and applications. Ultimately in computer science, theory always affirms practice, and practice justifies theory. Although the theory of computer science might be said to predate the computer itself (for example, in the 1930s work of the logician and mathematician A. M. Turing; see Hodges 1983), there would never have been a flourishing field of computer science without the existence of the machines themselves. The use of computers as corporate and now consumer products justifies the importance attached to computer theory. We might wonder how many mathematicians would be interested in the theory of automata without the cultural importance of the computer. And the theory of computing seeks to make computers work more efficiently or effectively.

If the abstract theories of computation are ultimately grounded in practice, then so are the fields of human-computer interaction (HCI) and software engineering. Drawing on cognitive psychology and using empiri-

cal techniques such as usability studies and surveys, HCI researchers critique existing and developing computer systems. Their critiques may be severe, but their purpose is to enable these systems to respond more effectively to the needs of those who use the systems. HCI aligns itself with the social sciences in using qualitative and quantitative methods to come up with principles of good design. In its practical intent, however, HCI more closely resembles the theoretical aspects of the industrial or fine arts, for example, graphic design.

Famous and accomplished graphic designers (such as Jan Tschichold, Herbert Bayer, and Paul Rand) have written books to explain their practice for other designers, and there are countless textbooks of design that codify practice into more or less formal principles (Meggs 1998). In *Designing Visual Interfaces* (1994), for example, Kevin Mulett and Darrell Sano offer a primer on graphic design explicitly for designers of computer interfaces. They present a vocabulary to describe values for which designers should strive (clarity, harmony, balance, and so on) and illustrate this vocabulary with examples drawn from modernist graphic design, principally the International Style of the 1940s and 1950s. Although Mulett and Sano's principles are abstract, or, as they claim, "timeless," in fact, their purpose is practical and immediate: to improve the visual attractiveness and effectiveness of user interfaces, to show how dialogue boxes can be improved by learning from the practice of Bayer or Müller-Brockman. All theories of graphic design have as their goal to produce better visual artifacts.

For the applied arts as for computer science (which is the paradigm of postindustrial engineering), the purpose of theory is to affirm and enhance practice. I make this obvious point because this emphasis on the practical is what separates theory in engineering and the applied arts from theory in the humanities. What we as humanists learned to call theory in the twentieth century, beginning with the poststructuralists or earlier with Marxist critics, does not seek to affirm practice, but rather to critique practice or to deconstruct it altogether. It is usually the case that critical theory is usually negative, especially when the objects of study are forms that elite Western culture has highly prized (the literary or artistic canon) or forms to which popular culture gives high economic value (popular films, music, and advertising). In recent decades the academic community

has come to prefer theories in part on the basis of the critical distance that they establish from the media that they examine, which is why "ideological" theories have gained ground at the expense of formal theories.

Formal Media Theory

The media theories of Walter Ong and Marshall McLuhan were formal theories. To claim as McLuhan (1964) did that media were "extensions of man" and that the medium was the message was to suggest that formal properties of media determined their use and significance. Ong occupied a similar position by suggesting that writing restructures consciousness (*Orality and Literacy*, 1982: 78–116). Because of this apparent technological determinism, many cultural critics have always regarded McLuhan and to some extent Ong with suspicion. Far more influential in the 1970s and 1980s, at least within the academy, were the poststructuralists. The poststructuralists were media theorists who confined themselves mainly to verbal media. Poststructuralist theories, including deconstruction, were also strategies of formal critique. Their goal was to examine the formal limits of language and writing, often through a close reading of the text or through a careful analysis of the practice of reading. It was not clear how to derive any precise ideological analysis from the deconstruction of philosophical and literary texts by Jacques Derrida or Paul de Man. The ideological implications of the work came from the fact that these theorists were calling into question the universal significance of traditional authors and their texts. On the other hand, it was clear that the poststructuralists did not frame their critique in such a way as to further practice. Unlike the formal critiques of graphic design, for example, poststructuralist criticism was not aimed at helping new fiction writers improve their work. The poststructuralists would have assured us that new works would be subject to the instability of meaning that they found in the classics. Finally, these critics did not address digital media, or even earlier audiovisual media, in any central way: they worked on texts as embodied and transmitted in print or, secondarily, handwriting. Gregory Ulmer's *Teletheory* (1989) was notable in its attempt to extend Derridean theory to television.

In the 1990s, however, a number of hypertext critics did apply poststructuralist theory to the new digital media. Ulmer himself wrote *Heu-*

retics (1994), in which he sought to apply poststructuralist theory specifically to hypermedia. George Landow made the definitive case in *Hypertext* (1992) and *Hypertext 2.0* (1997). Landow (1997) argued that "hypertext has much in common with some major points of contemporary literary and semiological theory, particular with Derrida's emphasis on decentering and with Barthes's conception of the readerly versus the writerly text. In fact, hypertext creates an almost embarrassingly literal embodiment of both concepts, one that in turn raises questions about them and their interesting combination of prescience and historical relations (or embeddedness)" (32). For Landow and others, hypertext became the electronic realization of poststructuralist theory. Many of the qualities that the poststructuralists had been claiming for print—the instability and the intertextuality of the text, the loss of authority of the author, and the changed relationship between author, text, and reader—were realized in a literal or operational way in the computer.

This linking of hypertext to poststructuralist theory, however, did not have the impact on the critical community that some had anticipated. It did not lead to widespread engagement with or acceptance of hypertext in humanities departments. For a number of reasons, the study of hypertext remained an esoteric activity of relatively few scholars. One was that interest in poststructuralist theory was waning at precisely this time in favor of various forms of postmodern theory, feminist theory, and cultural studies, which were overtly ideological, as poststructuralism was not. Hypertext theory was therefore identified with formalist theory at a time when formalism was particularly out of fashion. Hypertext fictions themselves certainly looked like formalist exercises, because of their emphasis on node-and-link structures and even structure diagrams (later known on the World Wide Web as image maps). Hypertext theory also seemed to be associated with technological determinism in the tradition of McLuhan. Like the claims of McLuhan for print and television and Ong for writing itself as technologies, the proponents of hypertext seemed to many to be claiming that computer technology itself could change the way we as writers communicate (Haas 1996; Grusin 1996). The idea that technologies could work as autonomous agents of social change has been explicitly rejected by cultural studies and by Marxist critics since Raymond Williams (1975). From the perspectives of such critics, it is society that

develops and molds new technologies to meet its cultural or economic needs.

Not only was hypertext associated with an obsolescent body of critical theory, but hypertext theory was also too closely associated with practice. The hypertext critics (Joyce, Landow, Moulthrop, Douglas, and others) were creative writers or teachers using hypertext with their students. Their theoretical writings explored and affirmed their Web sites, interactive environments, and stand-alone hypermedia. In other words, they were working not in the tradition of critics like Fish or Derrida, but rather in the tradition of graphic designers like Tschichold or Rand, generalizing from and justifying their own practice. Although they would certainly argue that this dual role was an advantage, their practical engagement made them guilty of special pleading as critics.

For these reasons hypertext as a practice has had only a limited influence on the method of the humanities. The potential influence still remains great, because of the ubiquity of the World Wide Web as global hypertext. Humanists are using the Web as well as other forms of hypermedia to make available teaching materials and research papers. These materials, however, have usually been composed for the medium of print and then repurposed for the Web. Written in the conventional style of linear argument, these research papers are sometimes dumped into a single Web page, sometimes broken into multiple pages corresponding to the various sections. In either case they are still meant to be read from beginning to end. Even the fully electronic journal *Postmodern Culture* ⟨www.jefferson.village.virginia.edu/pmc⟩ offers its readers more or less traditional, linear essays. Despite ten years of argument by critics such as Landow, the hypertextual essay hardly exists as a genre distinct from the printed essay, except in exercises assigned to students in courses on hypertext. Very few scholars have exploited the possibilities of multilinear rhetoric. On the other hand, there are many developing genres on the Web (the Webcam, the home page, the fan site, the marketing and sales site, the corporate public relations site, the Web radio station, and so on), but these are popular or business forms, not scholarly forms. Even the proponents of hypertext continue to describe their theories in linear essays destined for print (Landow 1997; Joyce 2000; Douglas 2000; Bolter

2001), because they know that the printed monograph is the media form through which they can reach their academic audience.

Ideological Critique

The dominant critical strategies in the humanities today are the many varieties of postmodernism, feminism, and cultural studies, all of which reject the formalist tendencies of poststructuralism. Applied for decades to magazines, newspapers, radio, film, and television, these strategies seek to expose and explore the ideological frameworks that control media—to show how the dominant (capitalist) ideology informs the purposes and messages of these media. The goal dates back at least to Theodor Adorno and Max Horkheimer's critique of the "culture industry" in the *Dialectic of Enlightenment,* published in the mid-1940s, with its vitriolic condemnation of contemporary mass media, such as Hollywood film and jazz music, as economically determined: "Interested parties explain the culture industry in technological terms. . . . No mention is made of the fact that the basis on which technology acquires power over society is the power of those whose economic hold over society is greatest. A technological rationale is the rationale of domination itself. It is the coercive nature of society alienated from itself. Automobiles, bombs and movies keep the whole thing together" (1993: 31). Times do change: contemporary cultural critics may now prefer to regard jazz as the creative expression of the marginalized African American minority. But the conviction remains that mass media are largely under the control of capitalist ideology and that the task of the media theorist is to expose the means of control that might otherwise lie hidden to popular consciousness.

One now classic example of this theoretical project was provided by film studies in the 1970s and 1980s, when critics argued that the very apparatus of film was hopelessly tainted by capitalist and sexist ideology. According to the psychoanalytic film theories of Metz, Baudry, and Mulvey, the very structure of film spectatorship affirmed the capitalist or male-sexist hegemony (Bordwell 1996). In this case critics carried the value of critique so far as to condemn the entire media form they were devoting their academic lives to studying. The purpose of their scholarship was to

free themselves from the ideological grip of the cinematic apparatus, from which they and other spectators could not hope to get free while actually in the theater. In this case to be a spectator was to make oneself complicit. To produce a film would presumably also make them complicit, because of the tenacious grip of the imaginary (in the Lacanian sense) or of the male gaze imposed by the camera (Mulvey 1986). Avant-garde or counterculture films could perhaps explore alternative "subject-positions," but such films are seldom made by film critics. It would be unlikely that anyone would give such critics the resources needed to produce a full-scale film. Even in its European form, less devoted to spectacle than the Hollywood variety, film is a capital-intensive mass medium that requires a great deal of money and a large, skilled crew.

The point is that film critics were and still are examining a mass medium to which they will not in general make a practical contribution. The same has been true for the critics of radio and television and to some extent even the mass print genres of magazines, newspapers, and trade fiction. Cultural critics of media—in this respect like the psychoanalytic critics of film, although in other ways very different—often assume that the audience, including themselves, will not have access to the means of production. They must expect that their critique will influence practice only indirectly. For this reason, they often concentrate on forms of what they call "resistance," the means by which apparently passive consumers of these cultural products can divert or distort them to meet their own cultural needs. As Bordwell (1996) puts it, "culturalists of all stripes promote reception studies, whereby audiences are often held to appropriate films for their cultural agendas. Indeed, within the Cultural Studies position, notions of subversive film have given way to conceptions of resistant readers" (10). When cultural studies critics now approach digital media, they often assume that these new media must follow the same pattern of hegemonic production and resistant reception. They look for examples of new media forms that can be characterized as mass media, because they are comfortable with the broadcast model in which the control of the media form is centralized.

For this reason, they focus on electronic commerce on the World Wide Web, which certainly exhibits excesses of late capitalism. American cultural studies critic Andrew Ross has published (on the Internet)

⟨www.ljudmila.org/nettime/zkp4/28.htm⟩ an essay on Silicon Alley, in which he applies the notions of alienation and exploitation to the new media entrepreneurs of New York City. Another good example is the two-part essay "Digital Diploma Mills" in which historian David Noble (1998a, 1998b) attacks the commercialization of universities moving into Web-based teaching. Arguing that the hegemony of new media is also an international phenomenon, cultural critics point to the ways in which the Western (primarily American) entertainment industry is exploiting new media (computer software, games) as well as old (film, television, audio CDs) to extend its control of entertainment and information in the less developed world.

Although often valuable and compelling, these arguments do not tell the whole story, because new media are not exclusively mass media. Although the Web sites of information companies like Yahoo! and amazon.com do share many qualities with the mass publication and retailing industries, it remains possible for individuals and small groups to create Web sites and CD-ROM or DVD applications and make them available to others in their community of interest. The open architecture of the Internet and the World Wide Web means that an individual's Web site is in principle just as accessible as amazon.com. One or two skilled programmers can work with a designer to create highly professional multimedia applications. Unlike broadcast television or film, then, "resistant reading" is not the only available strategy for digital media, because individual practitioners can produce their own alternative forms. And unlike the theorists of film and television, at least some new media theorists have the opportunity to become new media practitioners.

The combination of theory and practice is common among those who study online environments—chat rooms, multi-user dungeons (MUDs) and MUD-object-oriented (MOOs), and threaded discussion groups. They see these environments as places for the construction of postmodern identity and the testing of cultural notions of gender and race. Some cyberenthusiasts, such as John Perry Barlow in his 1999 "Declaration of Independence for Cyberspace" ⟨www.eff.org/pub/Publications/John_Perry_Barlow/barlow_0296.declaration⟩ claimed that the Internet offered a social and political environment free from the political and social limitations of the physical world; they implied that racial

and gender bias may be overcome on the Internet, which was, according to Barlow, the home of Mind. Cultural critics have descended on this claim, arguing that online environments both reflect and promote the sexual and racial stereotypes of the rest of our culture. Computer games, sometimes violent, sometimes pornographic, sometimes trivial, reflect cultural constructions and stereotypes as well. The critics (such as Allucquère Rosanne Stone [1991], Lisa Nakamura [1999], Beth Kolko [1998], Cynthia Haynes and Jan Rune Holmevik [1998], and many others) have argued that cyberspace is an extension of our culture, not a refuge from it.

Although these theorists can be extremely critical of the misreadings and misuses of new media, they do not necessarily maintain a critical distance from the forms they study. There is an anthropological strain in cultural studies, so that some critics immerse themselves through extensive interviews, as did Sherry Turkle for both her books *The Second Self* (1984) and *Life on the Screen* (1995). Some cultural critics, such as Stone and Kolko, study new media environments by making use of them, particularly for education or digital performance. Some, such as Kolko and Haynes, believe that electronic environments like MOOs can further educational goals. Like other academics, many cultural critics employ new media at least to the extent of creating Web pages for the classes they teach.

Yet even in these cases theorists may find it difficult to establish a connection between their critique and their own practice, because the ideological theories of media are simply not framed in such a way as to promote practice. It is much easier to relate formal critique to practice. In graphic design, what passes for theory can often be expressed as rules of thumb for beginners to follow. In computer science, HCI is a search for formal parameters that can be put into practice. Whether qualitative or quantitative, formal theories focus on aspects that are by definition under the control of the designer or producer. Cultural theories place their focus elsewhere. In showing how the weight of global capital defines new media production, a cultural theory seems to be taking control away from the individual designer or producer. In showing how sexual or racial stereotypes are reproduced in cyberspace, the critic seems to be suggesting that the individual producer or production team is reinscribing larger cultural values. It is not that cultural critics believe that individual artifacts

are determined by larger economic or social forces. In fact, they may also espouse forms of resistance, but the rhetoric of resistance seldom leads to concrete proposals for improving practice. And at least in some cases the most powerful critical voices are adamantly opposed to a practice that must seem to implicate them in capitalist ideology. The assumption of critical distance is deeply engrained in critical theory.

Theory and Practice in American Universities

Despite the so-called triumph of theory in the 1980s among academic researchers, the humanities as taught in the universities are not exclusively theoretical. In fact the tension between theory and practice arose long before the advent of new digital media. In European educational systems, at least in the past, this tension was perhaps mitigated by the traditional division between theoretical work in universities and practical or artistic work in technical high schools and conservatories. American universities, however, have for decades offered technical, preprofessional, and even business-oriented education along with the arts and sciences, so that the practical, theoretical, and historical dimensions of a subject have found themselves together on the same campus and even in the same department. These cohabitations have sometimes led to engaged debate, but perhaps more often simply a struggle for resources.

In American universities, the division between theory and practice becomes visible as academic fault lines within departments. In film schools or mass communication departments, there is a division between theorist-historians and practitioners. In the case of the best film schools, the practitioners may enjoy the potential for prestige and economic reward, which tends to enhance their status. Unlike in some European countries, the work of film scholars in the United States is considered quite separate from film production, and scholars are generally not held in high regard by filmmakers. In music departments, there may be a tripartite division between music theory, musicology, and performance. If the performers are not located in a separate department or conservatory, then the department as a whole may have a cast toward performance or toward theory and history. In foreign language departments, the teaching of the languages is usually accorded a lower status than the study of the literatures. The same

is true in English departments, in which theorists and historians of literature generally regard composition and technical writing as necessary evils, services that the department must deliver to the university. Those who make the teaching of expository or technical writing their research field seldom achieve the same renown as literary theorists. Where there are creative writers in English departments, they tend to enjoy a higher status than teachers of writing, but such writers are almost always a small minority.

Computer technology has improved the status of teachers of writing and rhetoric, who were in fact among the first faculty members in the humanities to embrace the new technology. It was clear to teachers of writing that word processors and then chat rooms and MOOs constituted a compelling new space for their pedagogy. It was (and remains) easier to see how the computer can change the practice of writing than to imagine how this technology could affect the work of literary and cultural theory. Although teachers of writing must still struggle with the prejudice against practice in English departments, the importance of computer technology in the university and the popularity of electronic projects with administrators and funding sources have meant that their influence is increasing. Scholars in literary theory may react in one of two opposite ways to the success of their colleagues. Some may simply resent the rising importance of practice within the university, whereas others may seek to garner resources by developing electronic pedagogical or research projects of their own.

New Media and Print

Teachers of writing have accepted new media as part of their field. They understand writing by computer as a new form whose continuity with and differences from writing for print are worth exploring. The success of teachers in defining new forms of writing suggests that cultural theorists may have been premature in lumping electronic media together with mass, audiovisual media such as television and film. The difference is that mass media necessarily cast us in the role of consumer, and mass audiovisual media make viewers into consumers of simulated perceptual experiences.

With traditional mass media, it is true that we must function largely as a consuming audience. We consume films and television and radio broadcasts, all of which are products that the entertainment industry prepares for us and over which we have only the most indirect forms of control—through audience ratings, for example. These products are perceptual experiences: film and television make very sparing use of textual representation, and radio of course can make none. As Martin Jay has meticulously documented in *Downcast Eyes* (1993), French critical theory has had a prejudice against the image throughout the twentieth century. Popular mass media forms have therefore been suspect on two counts: as promoters of both capitalist ideology and visual representation.

Although certain new media forms (the World Wide Web and computer games) do share some of the characteristics of mass media, they are not so relentlessly unidirectional, nor are they capital intensive to the same degree. The World Wide Web draws people into the production process on a much larger scale than television or film has ever done. Millions of people participate in the creating of Web pages and the planning and maintaining of Web sites. The popular Web browsers (*Netscape* and *Internet Explorer*) include simple editing modes, so consumers can also become producers. It is relatively easy and inexpensive to put a site on the Web, and it will remain easy so long as the current hypertext transfer protocol remains in place. Similarly, e-mail, newsgroups, MOOs, and chat rooms are open, participatory applications that encourage recipients to add to the stream of messages that circulates throughout the Internet. It is precisely these applications that the writing community has exploited to define computers as writing environments.

This shift from consumption to production should matter to cultural theorists, if only because the role of producer may allow resistance to the dominant ideology to take new forms. As a consumer, one can only redirect the intended effects of media artifacts, but as a producer one can change the artifacts themselves. In this respect new media forms resemble some forms of handwriting and print to a greater degree than they resemble film or television. We do not have to be utopian in our assessment of either print or new digital media. Handwritten or typed forms (the letter, the postcard) have always served our needs as media of

communication that were actively possessed and shaped by millions of literate writers. Only a relatively small group of writers could get their extended writing published as books and articles. But that small group, which of course includes academic humanists, remains much larger than the number who can produce a movie or television show.

Cultural theorists of media themselves have an ambiguous relationship to the medium of print. If many forms of print (magazines, trade books) are expressions of mass culture and global capitalism, it is nonetheless print that has enabled these theorists to frame and publish their critiques. Critical theory is indispensably linked to publication in the form of the scholarly essay and monograph. Cultural critics do address to some extent how their prose forms articulate with their theory. For example, they have considered whether the scholarly essay needs to be expanded in order to provide an appropriate vehicle for cultural critique. Cultural studies and feminist writers have experimented with first-person expression and the use of personal history as part of their work. But the theory community seems unwilling to extend its experimentation to electronic forms such as the linked hypertext or hypermedia document.

There is a greater willingness among academics in the humanities to experiment with hypertext and other forms of electronic writing for teaching purposes than for research. As we have remarked, teachers of writing have come to acknowledge electronic environments as part of the practice of writing, because of the acceptance of e-mail, Web pages, and other electronic forms on the part of the business and bureaucratic communities. Some humanists have also begun to experiment with hypermedia for the teaching of literature or humanities subjects. Since the 1980s, George Landow has pioneered multimedia applications and Web sites to provide supporting material for Victorian and postcolonial literature. Landow's sites combine visual and verbal materials: not only literary excerpts and descriptive and analytic essays, but also digitized images, including pre-Raphaelite paintings, book illustrations, and political cartoons. Such educational applications for new media do not subscribe to Jay's "anti-ocularist tradition" but instead openly explore the relationships between verbal and audiovisual forms of representation. A number of stand-alone multimedia applications for education refuse to follow the traditional hierarchy (still assumed by the theory community) in which

images are subordinate to text. Gunnar Liestøl's (1996) *Kon-Tiki Interactive* presents the expeditions of Thor Heyerdahl in images and sounds as well as words. Likewise, the multimedia application *Griffith in Context* by Gregory vanHoosier-Carey and Ellen Strain (2000) allows students to examine both the formal innovations and the cultural contexts of D. W. Griffith's film *Birth of a Nation*. Within the interface to *Griffith in Context,* the user moves easily among segments of film, still images, and units of text. The authors of this application understand that writing in the new digital environment can be a hybrid form of communication in which words instantiate and inform images as well as the reverse.

The Circle of Theory and Practice

If new media are becoming accepted in pedagogy, the question remains whether and when humanists will extend their notion of critical research beyond print to include new media forms. Will they be willing to redefine scholarship to include the multilinear structures of hypertext or (what may be even more radical) the multiplicity of representational modes afforded by digital multimedia? There are powerful institutional forces working against change: for example, the tenure system in the United States, which recognizes printed books and articles as the highest forms of scholarly production. But would anything lead us to expect change?

There is a precedent for such change in poststructuralism itself in the 1970s. The most radical and influential deconstructionists not only defined a method of inquiry, but also developed a new kind of writing— indeed, the writing was the method. The jargon-ridden and elliptical style of Derrida and others, so easy to parody, was nevertheless a remarkable achievement. Traditionalists at the time complained that deconstructionist prose was impenetrable, but the prose of deconstructionists had to be "difficult" in order to enact the breakdown of meaning that they were finding in traditional literature. In this sense theory and practice *did* merge for the poststructuralists. Their own writing was not just an exposition of their theory, but the very embodiment of theory. Derrida's *Glas* (1976), a book whose pages consisted of two parallel columns of two different texts, enacted the fragmentary and unstable character of linguistic reference. At their best, the poststructuralists closed the circle of theory and

practice: their theory grew out of practice and returned to inform practice. Closing the circle of theory and practice is what poststructuralism as an esoteric form of textual criticism has in common with graphic design as an eminently practical form of visual communication. Cultural studies researchers today write with greater clarity and accessibility than did the earlier poststructuralists, precisely because they are reasserting the conventional distance between the object of study (cultural artifacts) and the means of expression (the journal article, conference paper, or monograph).

The poststructuralists were able to close the circle of theory and practice because poststructuralism was in fact a critique of the assumptions of the medium of print from within that medium. Could the same strategy work for new digital media? Current cultural critics set out to explore the ideologies that inform new media from the critical distance assumed to be afforded to them by the medium of print. Although they themselves recognize that it is not possible to remain outside of the systemic work of ideology, nevertheless the history of the academic essay gives the work the appearance of scholarly distance. For this very reason, it might prove more compelling to fashion new media pieces that serve the goal of cultural critique. What is now recognized as digital performance art often serves this goal, but there is no analogous critical form for academics. Creating such a form would require the combination of formal and ideological criticism, a new form that would bridge the apparent gulf between academic theory and new media practice in the humanities. Do we need a new methodology to call forth this new media form? What we need is a hybrid, a fusion of the critical stance of cultural theory with the constructive attitude of the visual designer. This new media critic that we are imagining wants to make something, but what she wants to make will lead her viewers or readers to reevaluate their formal and cultural assumptions.

References

Adorno, T., and M. Horkheimer. (1993) "The Culture Industry." In S. During (ed.), *The Cultural Studies Reader*. London: Routledge, 30–43.

Bolter, J. D. (2001) *Writing Space: The Computer, Hypertext, and the Remediation of Print*. Mahwah, NJ: Lawrence Erlbaum.

Bordwell, D. (1996) "Contemporary Film Studies and the Vicissitudes of Grand Theory." In David Bordwell and Noël Carroll (eds.), *Post-Theory: Reconstructing Film Studies*. Madison: University of Wisconsin Press, 3–36.

Derrida, J. (1976) *Glas* (trans. J. P. Leavey Jr. and R. Rand). Lincoln: University of Nebraska Press.

Douglas, J. Y. (2000) *The End of Books—Or Books without End? Reading Interactive Narratives*. Ann Arbor: University of Michigan Press.

Grusin, R. (1996) "What Is an Electronic Author? Theory and the Technological Fallacy." In Robert Markley (ed.), *Virtual Realities and Their Discontents*. Baltimore: Johns Hopkins University Press, 39–53.

Haas, C. (1996) *Writing Technology: Studies on the Materiality of Literacy*. Mahwah, NJ: Lawrence Erlbaum.

Haynes, C., and J. R. Holmevik (eds.) (1998) *High Wired: On the Design, Use, and Theory of Educational MOOs*. Ann Arbor: University of Michigan Press.

Hodges, A. (1983) *Alan Turing: The Enigma*. New York: Simon & Schuster.

Jay, M. (1993) *Downcast Eyes: The Denigration of Vision in Twentieth-Century French Thought*. Berkeley: University of California Press.

Joyce, M. (2000) *OtherMindedness: The Emergence of Network Culture*. Ann Arbor: University of Michigan Press.

Kolko, B. (1998) "Bodies in Place: Real Politics, Real Pedagogy, and Virtual Space." In C. Haynes and J. R. Holmevik (eds.), *High Wired: On the Design, Use, and Theory of Educational MOOs*. Ann Arbor: University of Michigan Press, 253–265.

Landow, G. P. (1992) *Hypertext: The Convergence of Contemporary Critical Theory and Technology*. Baltimore: Johns Hopkins University Press.

Landow, G. P. (1997) *Hypertext 2.0: The Convergence of Contemporary Critical Theory and Technology.* Baltimore: Johns Hopkins University Press.

Liestøl, G. (1996) *Kon-Tiki Interactive* [CD-ROM]. New York: Voyager.

McLuhan, M. (1964) *Understanding Media: The Extensions of Man.* New York: McGraw-Hill.

Meggs, P. (1998) *A History of Graphic Design.* New York: Wiley.

Mulett, K., and D. Sano (1994) *Designing Visual Interfaces.* New York: Prentice Hall.

Mulvey, L. (1986) "Visual Pleasure and Narrative Cinema." In P. Rosen (ed.), *Narrative, Apparatus, Ideology: A Film Theory Reader.* New York: Columbia University Press, 198–209.

Nakamura, L. (1999) "Race in/for Cyberspace: Identity Tourism and Racial Passing on the Internet." In V. Vitanza (ed.), *Cyberreader* (2nd ed.). Needham Heights, MA: Allyn and Bacon, 442–452.

Noble, D. (1998a) "Digital Diploma Mills. Part 1: The Automation of Higher Education." *October* (Fall 1998), 107–117.

Noble, D. (1998b) "Digital Diploma Mills. Part 2: The Coming Battle over Online Instruction." *October* (Fall 1998), 118–129.

Ong, W. J. (1982) *Orality and Literacy: The Technologizing of the Word.* London: Methuen.

Stone, A. R. (1991) "Will the Real Body Please Stand Up?" In M. Benedikt (ed.), *Cyberspace: First Steps.* Cambridge: MIT Press, 81–118.

Turkle, S. (1984) *The Second Self: Computers and the Human Spirit.* New York: Simon & Schuster.

Turkle, S. (1995) *Life on the Screen: Identity in the Age of the Internet.* New York: Simon & Schuster.

Ulmer, G. (1989) *Teletheory: Grammatology in the Age of Video.* New York: Routledge.

Ulmer, G. (1994) *Heuretics: The Logic of Invention.* Baltimore: Johns Hopkins University Press.

vanHoosier-Carey, G., and E. Strain (2000) *Griffith in Context* [CD-ROM]. Available at ⟨http://griffith-in-context.gatech.edu/⟩.

Williams, R. (1975) *Television: Technology and Cultural Form.* New York: Schocken Books.

2

The Paradigm Is More Important
Than the Purchase

Educational Innovation and Hypertext Theory

George P. Landow

Why did it take so long? . . . Well, the first reason is the classical
inertia problem. New ideas take forever to be popularized. The sec-
ond reason is, of course, that there are technology problems. It takes
a long time to develop something as cheap and as user-friendly as
the Macintosh, for example. . . . Now the technology is definitely
here, and there is certainly no excuse for waiting any longer.
—Andries van Dam, Keynote Address, Hypertext '87

Theory and Innovation

A third reason for such resistance to computing by the humanities and
humanities educators is that digital media, hypertext, and networked com-
puting, like other innovations, at first tend to be (mis)understood in terms
of older technologies. We often approach an innovation, particularly an
innovative technology, in terms of an analogy or paradigm that at first
seems appropriate but later turns out to block much of the power of the
innovation. Thinking about two very different things only in terms of
their points of convergence promotes the assumption that they are in fact

more alike than they really are. Such assumptions bring much comfort, for they remove much that is most threatening about the new. But thus emphasizing continuity, however comforting, can blind us to the possibilities of beneficial innovation. Yes, it is easier to understand an automobile as a horseless carriage or a personal computer as a convenient form of typewriter. But our tendency to put new wine in old bottles, so common in early stages of technological innovation, can come at a high cost: it can render points of beneficial difference almost impossible to discern and encourage us to conceptualize new phenomena in inappropriate ways. Thus thinking of an automobile as a horseless carriage not only emphasizes what is missing (a horse) but also fails to take into account the way speed greatly changes the vehicle's relation to many aspects of self and society. Similarly, thinking of a computer, as so many users do, as a fancy typewriter that easily makes corrections prevents users from taking advantage of the labor-saving possibilities of the digital text, such as its configurability by styles, or the ways it permits seamless movement between paper documents and those moved about by e-mail.

Our understanding of the new is almost always mediated by our knowledge of the old and the familiar, but that mediation too often masks the new, making it invisible to most of us. When we confront hard-to-understand or even threatening innovation, critical theory comes to our aid. By forcing us to take a self-consciously distanced look at our assumptions, it renders the invisible visible. In the case of our encounter with new information technologies, theory plays a role similar to that of the graphite particles and ultraviolet light that make previously invisible fingerprints and other unexpected traces suddenly appear. Innovation creates new aspects of ourselves and theory reveals them.

Theorizing promotes innovative, effective use of digital informational technology by helping us understand those aspects of it that significantly differ from that with which we are already familiar. Equally significant, theorizing a technology, particularly an information technology, prevents us from suppressing its potential for innovation when we fail to see its cutting edges, its capacities for ways of doing something new. My claim has immediate practical importance, for one has only to look at most cultural and educational Web sites to see how much they fail to realize their potential. For an example, note how badly many muse-

ums' Web sites work because they were conceived primarily as nonbook books.

To see what I mean, let's first look at what features define the book (or print technology), then examine how very different ones characterize the Web, and finally see what has been lost by confusing the second with the first. Print technology as we have known it since the late Victorian age features

- a special combination of multiplicity and fixity produced by the existence of many copies of the same static text.
- a discrete text that is experienced as closed off or sharply separated from others, to the extent that following references to material not included requires considerable, nontrivial expenditures of time and effort.
- a sharp separation of the author or producer of the text from its community of readers.
- a set of assumptions about creativity, originality, and intellectual property that greatly overemphasize the importance of authorial contributions and suppress the importance of the community and of collaboration.

Finally, like all forms of writing before the electronic age, printed text takes the form of physical marks on physical surfaces.

Although text and reading on the Net still share many qualities of text and reading associated with the printed book, they also have fundamental differences. First of all, Web documents, like all computer-based (or digital) textuality, represents a major innovation: for the first time in human history, writing and the texts it produces are matters of codes. We often experience this form of writing in entirely new ways. It can be dynamic rather than static, and although a reader might not have the power to change the letters and words in someone else's text, he or she can change the size of font of that text for easier or more pleasant reading. Furthermore, certain forms of text presentation software use the coded, virtual nature of this form of writing to expand and contract the text itself, generate dynamic tables of contents, and otherwise produce text on demand.[1] Equally important, whereas the print book has fixed edges and borders, digital translations of the same text lose such territoriality: in a digital environment such as the Internet, the borders of one's text become

porous, and although one might want a reader to enter the text at a particular point, readers using Internet search tools enter one's text in many places—wherever, in fact, the search tool has found a word or phrase that seems to meet their interest.

Here are two examples, from the Web sites of small museums, of the high cost of failing to understand an innovative technology. A small historical museum in a region of the United States once dominated by the logging industry created a Web site as part of its mandate to play a greater role in the cultural life of its community. Featuring an exhibition of what life was like in the old logging days, it encouraged visitors to record their comments. Visitors responded by writing that their fathers had worked in the logging industry, or they remembered it as part of their own childhoods. What's wrong here? Having conceived its Web site as a printed book, the museum has blinded itself to the possibilities of the new technology. In particular, by assuming that a Web site is essentially a book, its creators suppressed various innovative capacities that would have well served their project and mission. Working with the flawed assumption that the Web site is fundamentally a particular kind of book—in this case a print exhibition catalogue placed in the gallery with a guest book next to it for handwritten comments—the museum developers made several unfortunate corollary assumptions. They took it for granted, for example, that the printed book's separation of author and audience is the right way to conceptualize the relationship between Web site and user. But is it? Since one of the purposes of this site involves building a sense of community and creating a community memory, why not take advantage of visitors' comments by adding them to the Web site, inviting people to expand upon them, provide family information, photographs, and the like? Why not use the fundamental characteristics of linked digital information resources (hypertext) to "grow the site"? Why not use a dynamic site to create or enhance a sense of community among its constituents? A dynamic, fluid textuality, such as that found on Web sites, can change and easily adapt to its users, taking advantage of the modularity and capacity for change of digital text. But it cannot do so if its developers and home institution only think of it as a book (wonderful as books are).

As another example, a small anthropological museum at a midwestern American university created a Web site with an elegant graphic design

obviously intended both to draw visitors and allow those who cannot come in person to enjoy some of its treasures. Individual screens present images of North American Indian artifacts together with basic information about them. So far so good. Unfortunately, that's all there is, for the entire site is nothing more than a direct electronic presentation of a museum catalogue. Putting print-derived text and images online, however, requires doing much more than formatting them in HTML, and a description of the site shows why. Since the designers began with the idea that a Web site is little more than an electronified book, they also assumed that readers would begin at the opening screen and make their way through one of several tightly limited paths. Making a common error, they failed to permit readers to return easily to the opening screen or site map, much less to provide similar access to site maps for subcategories (departments) in the museum. Such book-blindered design, all too common on Web sites, also shows that the designers never took into account that many Web readers will not arrive at the front entrance of the museum but, led there by Internet search tools, will arrive by falling through the roof and landing in the middle of a strange gallery: at a very minimum, they need to know where they are, and where they can go next.

The failings I've described thus far exemplify what happens when one assumes that a Web site, a nonphysical, electronic form, has the attributes of a book, which has a physical form. A related, though less obvious, set of mistakes has broader cultural, educational, and political implications. In the kind of mistake depicted in the first of the two examples above, one uses a potential innovation inefficiently; in the second, one suppresses it entirely: looking at the elegant graphic design of the site, one realizes the brief texts describing the represented objects in the collection contain no links. Conceptualized as old-fashioned catalogue entries, these passages fail to take advantage of the innovative capacity of links, which can provide basic glossary items that help younger users or those unfamiliar with the topic under discussion. Links can also lead interested readers to more advanced materials. Links, which can produce a kind of customizable text, have the power to turn such a site into a fully functioning educational resource. Used in this way, they serve to enrich and deepen the site as an introduction to the entire museum. Furthermore, linking to documents about materials outside the museum can also reconfigure

the site's relation to its intellectual community. Here, however, relying upon the book as thought-form or conceptual model prevented such innovation: although this anthropology museum site exists at a university that also has a department of anthropology, it makes no attempt to connect the two. The site contains no documents by members of that department, nor does it list relevant courses available at the university.

What could one do differently with such a resource if one understood that a Web site can be more than a booklike, static introduction to a museum collection? Since links cross borders and reconfigure our senses of relationships, why not use them to reconfigure the relations of museum and university? The site could include relevant departmental research, all or parts of previously published papers, bibliographies, research guides, exemplary work by undergraduate and graduate students, even material from other universities' collections, and so on. Once one conceives a Web site from the vantage point of innovation—asking what's different about this new information technology and what can we do with such differences—one can conceptualize it as a network within other networks, and not simply (and misleadingly) as a book.

The preceding criticisms of and suggestions for improving existing Web sites derive from two closely related bodies of experience: a decade and a half's work with hypertext resources and a longer period working with the theoretical writings of Roland Barthes, Jacques Derrida, and Mikhail Bakhtin that foreground our print-centered theories of textuality and thereby lead to better understanding of the potential of new media. Both the previous criticisms of these two Web sites and my suggestions for activating their potential for innovation derive from Derrida's deconstruction of textual borders, Bakhtin's emphasis on carnivalization and multivocality, and Barthes's theories of the writerly text traversed by a network of connections.

Hypertext and Education

In keeping with other contributors to this volume, I emphasize that this examination of the relationship between hypertext, an important form of digital information technology, and university education focuses chiefly upon hypertext as a paradigm, as a thought-form, rather than on the de-

tails of hardware and software. Having spent the past decade and a half working (and playing) with a wide range of hypertext environments, I have reported my conclusions about specific software features and the like elsewhere (Landow 1997, especially the chapters on reconfiguring writing and on the features of various hypertext software environments), and there is no need to repeat myself here.

Instead I wish to emphasize something quite different that I learned along the way, namely, that the paradigm is more important than the purchase. Thinking, working, teaching, and learning hypertextually have certain obvious advantages that benefit an educational institution in the early information age. Furthermore, critical theory provides a particularly helpful way to grasp the implications of innovation. To make my points, I propose to present the use of hypertext as an example of beneficial innovation in the context of the University Scholars Programme at the National University of Singapore (NUS). After looking at the extent to which hypertext-as-paradigm has affected this institution, I wish to examine the particular forms of applications of critical theory that illuminate various aspects of such innovation.

My proposition that hypertext-as-educational-paradigm ultimately has more importance to institutional innovation than do hardware and software means, I now realize, that I have come full circle: when I first began my decade-and-a-half-long work with hypertext, like most people, I had never seen a hypertext environment or system. I had never even heard the term. Here was the situation: after using the word processing software (*IBM Script*) available on the Brown University mainframe in collaborative student projects, I was invited to join the executive board of a newly founded, externally funded computer institute. One day the institute's associate director William Beeman asked me a simple question: "What would you do if you had a means of making connections?" That's all. Note, if you will, that Beeman did not mention computers or software or information technology. My answer was equally simple. I said, "I'd use it to help students learn to make connections." Some years before, the Carnegie Foundation had issued a report charging that the education of American secondary school students so emphasized learning facts that students did not develop critical thinking skills. In my teaching I had adopted an admittedly simple—and perhaps simple-minded or at least

overly simplifying—premise: critical thinking involves the ability to summon different kinds of information to solve a problem. From the point of view of Beeman's question, helping students develop their abilities to think critically by themselves and for themselves was a matter of helping them make connections.

Looking back, I now realize I was in search of workable paradigm. In fact, I was more attracted to the paradigm than to the technology. True, I was an experienced user of mainframe computing, having drawn upon it to help graduate students first in English and then in art history create large collaborative projects, each of which eventually appeared in the form of a published book. Although I had come to rely on the mainframe for my own writing, I saw computing only as a means of working with postgraduate students and those undergraduates, mostly honors students, working on long research and writing projects. I certainly did not think computing had a role in higher education, since the only computing experiments of which I knew took the form of vocabulary drills and similarly constrained tasks that embodied what I derisively used to call "the rat-maze theory of education." (Actually, I still do.)

Poststructuralist Theory, Hypertext, and Educational Innovation

Upon joining the Intermedia project at Brown University's Institute for Research in Information and Scholarship (IRIS), I first encountered hypertext theory in the form of the writings of Vannevar Bush, Ted Nelson, and Andries van Dam and his students. As the project team began to discuss the requirements of the planned new system, I came upon the following passage by van Dam and company describing the active reader that hypertext requires and creates: "Both an author's tool and a reader's medium, a hypertext document system allows authors or groups of authors to link information together, create paths through a corpus of related material, annotate existing texts, and create notes that point readers to either bibliographic data or the body of the referenced text. . . . Readers can browse through linked, cross-referenced, annotated texts in an orderly but nonsequential manner." Yankelovich et al. (1985: 17). Note the way this passage, which owes much to the writings of Bush and Nelson and actual work of van Dam and Douglas Englebart, emphasizes reconfiguring

the roles of author and reader. Note, too, how much this passage from *Reading and Writing the Electronic Book* resembles Barthes's description of the writerly text and its active reader.

After I had used the Intermedia system as a collaborative learning environment, I increasingly came to recognize the many ways in which this pioneering hypertext system converged with contemporary critical theory, and a few years later I wrote the first of several books on this subject. Having read French structuralist and poststructuralist theorists since 1965, I had found them occasionally interesting, often annoying, and almost never of much use in understanding either literary texts or cultural institutions. Once I'd experienced the theory and practice of hypertext, however, I discovered that the new digital information technology made critical theory much easier to understand, and equally important, the critical writings of Barthes, Bakhtin, Derrida, Baudrillard, and (later) Deleuze and Guattari provided the best explanation I have encountered of the way computer-based texts function.

Both hypertext theory and poststructuralist theory make us self-conscious about the paradigm one uses for educational and other forms of hypertext. The World Wide Web has not realized many of the visions of hypertext for three kinds of reasons—hardware, software, and mentalware—and at this stage of development, the third of these is the most important. In colleges and universities and other kinds of cultural institutions, such as art and other forms of museums, one encounters the effects of un-self-consciously remaining inside the culture of the book. Too many of us—and I include teachers, educational technologists, Web masters, and software developers—base our ideas about the nature of reading, the purpose of documents, and their relation to individuals and communities on the mistaken assumption that electronic documents are essentially the same as books. They're not.

Looking at the two kinds of theory I have shown converging, one may observe that the importance of hypertext theorists, such as Nelson and van Dam, is that they speak very precisely about the specific qualities of the book that they wish to change or surpass. They also conceive these innovations in terms of social and political roles in more direct and effective, if more limited, ways than do most poststructuralist cultural and literary theorists. The value of the poststructuralist theorists, who are

essentially more negative in their approach than hypertext theorists, is that they forcefully call attention to the book as a thought-form, though admittedly often in an obscure, even obscurantist, style. Part of this stylistic obscurity derives from the difficulty of writing about the book as a thought-form from within the physical form of the book itself. Nonetheless, despite the stylistic difficulty of Barthes, Bakhtin, Deleuze and Guatarri, and Derrida, their work proves more valuable than that of most writers on the new media because they foreground what is most needed to comprehend innovation at this point of transition and of competition among competing media forms: they offer a self-conscious awareness of the nature and limits of the book and of the literary and other cultural forms that it generates. Such awareness has great contemporary value because so many of us remain unaware of the way our information technologies permeate the way we think, the assumptions we make about business, and the way we conceptualize education. Even our technologists—and particularly our computer scientists—too frequently assume that we are still dealing with some sort of Essential Book.

Singapore and the Core Curriculum/University Scholars Programme

Rather than giving a blow-by-blow narrative account of how I came to realize that specific examples of critical theory led to innovative uses of computing and innovative educational practice, I propose to look at a single educational example, the University Scholars Programme at NUS, that embodies both central aspects of both hypertext and critical theory and thereby to show how some of its specific features relate to points of theory. Most obviously, the idea of multiple connections embodied in hypertext-as-technology and hypertext-as-paradigm lies at the heart of the University Scholars Programme. As one might expect, an elaborate Web site and other uses of digital information technology play key roles in an educational endeavor informed by a hypertext paradigm. Before describing the program, of which I am currently the dean, let me first explain why this innovation came into being.

NUS is already one of the top universities in Asia—certainly the top one for anybody wishing to study in English, the main official language of the country; Chinese (that is, Mandarin), Tamil, and Malay are also offi-

cial languages (Lee and Yong 1997). Leading American and European universities that recognize that Singapore is a gateway to Asia have been beating a path to NUS, which already has close relationships with MIT, Johns Hopkins, Harvard, and several other top institutions. NUS, which traces its origins to the founding of its medical school in 1905, took something like its present form in the 1970s, even before it moved to its present Kent Ridge campus.[2] Its primary role then was to help Singapore move from what amounted to being a third-world country without any resources (other than its people) to the first-world, globalized country it has been for the past decade. Its chief task, then, involved providing the technologically trained workforce that a modern nation requires. Not surprisingly, its faculties of engineering, business, medicine, and law—all immediately practical subjects—had especially high priority, and gaining entrance to them became the goal of the greater majority of the country's brightest secondary school students.[3]

Some years ago Singapore decided that both British-style early specialization and admission procedures could take Singapore only part of the way it needed to go in an era of globalization and knowledge-based economies. Deputy Prime Minister Tony Tan, a theoretical physicist who had briefly headed NUS, encouraged the university to create an interdisciplinary program that could nurture risk-taking, well-educated, creative students—essentially the same ideal actualized in Brown's top students (more on this later)—and thereby educate the future leaders of business, education, and government while helping forestall brain drain.

As it turns out, NUS has made two other quite successful attempts to broaden its undergraduate education before turning to the University Scholars Programme, and we have benefited from their example and experience. First, the Talent Development Programme (TDP) drew upon the top 3 percent of students in each of the university's nine faculties (Art and Social Sciences, Business, Computing, Dentistry, Design and Environment [including Architecture], Engineering, Law, Medicine, and Science). This innovation served to broaden and deepen the education of the top students within a single faculty. The Faculty of Science, which led the way with an earlier but still continuing Special Programme in the Study of Science (SPSS), has proved especially successful with courses like "Energy," taken by students in Biology, Chemistry, Mathematics, and

Physics. In contrast to the TDP, which emphasized interdisciplinary study within a single faculty, the SPSS's cross-faculty modules provide students with the opportunity to take very basic modules (that is, courses) in other faculties.

In the summer of 1997 an international advisory group including Jeremy Knowles, Harvard's Dean of Arts and Sciences, visited NUS and discussed reshaping the curriculum, thereby sowing the seeds of the present program.[4] Out of these discussions came the idea for what came to be known as the Core Curriculum, which then took over responsibility for the TDP, with these two programs joining in 2001 to become the University Scholars Programme. Permit me to describe the original curriculum, which now forms the first-tier or basic courses in the University Scholars Programme, and its relation to what I've been calling hypertext-as-paradigm. During their first three years, students take eight modules or courses from eleven areas,[5] including life sciences, moral reasoning, and science, technology, and society. Students planning to major in the sciences must do the majority of their coursework in these first three years in humanities and social sciences; those majoring in humanities and social sciences must take the majority in the sciences and technology. Two courses are mandatory for all students in the program: an intensive writing and critical thinking course and another in the history of Singapore and Southeast Asia.

This last course, one of the foundations of the program, was a test case, since many feared it would become either a kind of official history of the country, such as one receives in many American secondary schools, or else an occasion for memorizing facts, an approach all too common in Singaporean education. Instead, it turned out to embody an essentially Bakhtinian approach to education, one that emphasizes a multiplicity of voices, opinions, and viewpoints. Bakhtin, we recall, argued that nineteenth-century novels, particularly those of Dostoyevsky, perfectly suited modern culture, because multiple voices rather than a single point of view traversed and shaped them. Applied to analyses of novels, Bakhtin's notion of multivocality reveals the way different themes, techniques, and genres weave their way through the text. Thus, looking at George Eliot's *Middlemarch* through the lens of multivocality, for instance, reveals the presence of techniques and genres, such as the generalizations of wis-

dom literature and the sermon, epigrams, and descriptions of the word painter, as well as the narrative voice.

Applied to the teaching of literary analysis, Bakhtin's notion of multivocality encourages teacher and student to build readings upon close observation of the way individual texts work. Applied to educational practice as a whole, Bakhtin's notion of multivocality nurtures two particular approaches to student-centered teaching and learning. The first of these emphasizes approaching all issues from many points of view, attempting to have students find in them the principal voices and positions that led to a specific result: an individual text, historic event, and so on.

Under the leadership of Professors of History Ernest Chew and Albert Lau, the course in Singaporean and Southeast Asian history became an introduction to critical thinking about history, particularly local history. Like much cutting-edge scholarship, the course requires the students to ask, "What does it mean when you say, 'Sir Stamford Raffles founded Singapore'?" "What do you mean by 'founded'?" "Why did secondary school textbooks state that Singapore fell to the Japanese in World War II because the 'British guns pointed the wrong way' when this statement was long known to be false?" "How and why do nations develop such myths?" The course relies heavily on primary materials that offer different points of view and forces students "to think on their feet," making interpretations and defending them among their peers. This emphasis upon student participation—upon student voices—represents a second characteristic of a Bakhtinian approach to education.

This emphasis upon critical thinking, like the reliance on very active student participation, defines the program, differentiating it from most Singaporean (and American) tertiary education. In fact, the single defining feature of the entire University Scholars Programme is this emphasis upon helping students develop the ability to approach problems by summoning difficult kinds of argument, technique, and evidence. A key part of every course involves introducing students to the culture of each discipline. We want students to learn the ways in which one formulates questions and tries to answer them. How, for example, do physicists carry out research, and what constitutes evidence for them? How does their handling of evidence—or even accepting something as evidence—differ from what a chemist, a biologist, or a literary scholar does? And what are the moral

and societal implications of such questions? Similarly, how does narrative and metaphorical thought function in literature, painting, anthropology, history, and biology? These Bakhtinian approaches obviously have been around since the time of Plato, if not before, though too often they are forgotten in the economic or ideological need to rely upon the lecture, a form that embodies a top-down, hierarchical, unitary approach to education. Listening to another voice, encouraging other voices to make themselves heard, implies a very different relationship between teacher and student than does the lecture.

Speech as an information technology has very different implications for teaching and learning depending upon the contexts in which it appears. One crucial context, surely, is that provided by other information technologies. In a world without writing, the speech of the teacher must be pithy and memorable because it must be memorized; no record exists, and once the master stops speaking, nothing remains except scraps and patches in memory. With writing comes prosthetic memory, a way of capturing speech outside the self, but for so many centuries writing required so much time, effort, and financial resources that an important part of higher education took the form of simple dictation and copying. In the Middle Ages students wrote down the texts dictated in lectures, since that was generally the only way they could obtain a text. In such an information regime, skill at copying quickly, accurately, and legibly counted far more than did the student's ability to abstract and synthesize.

With the appearance of printing, the role of specific information technologies within educational institutions changed again: once print made texts relatively easy to obtain, the lecturer could do many more things than dictate a text with occasional comments. Now, the comments themselves became the focus of the verbal exchange. Although the lecturer conveying knowledge to students remains the chief mode of university education, formal and informal discussion among students—and occasionally between student and teacher—has always taken place.

What does the appearance of computing add to the mix? Networked computing, particularly that found in the World Wide Web, encourages yet other forms of Bahktinian multivocality. E-mail exchanges and discussion lists obviously present another means of activating student abilities to define ideas and convince others to accept their opinion. As many have

noted, such electronic exchanges often give voices to students too shy or deliberate to speak effectively in class. Course, subject, and institutional Web sites, such as those we have in the University Scholars Programme, offer yet another powerful means of applying multivocality as an educational policy. Putting reading questions, essays, and projects online, particularly when links interweave them with work by instructors and authorities outside the institution, immediately makes it clear to students that their opinions and ideas count for something important. Thus bootstrapping Web sites—building them with student work—has other valuable effects, including creating a course and an institutional memory and quickly and efficiently introducing each succeeding cohort of students to the standards and culture of the course.

The instructors in the program want University Scholars to make connections among various disciplines, and in fact a substantial portion of every one of our courses raises questions about such interdisciplinary connections—not necessarily offering satisfactory answers, but at least raising the questions. From the point of view of Bakhtinian theory, one could claim that such interconnections represent different voices throughout a student's entire education or throughout an institution. That's one way to conceptualize the program's multidisciplinary approach, but I'd prefer to think of it as applying Derrida's many reminders in *Dissemination* (1972) that print documents necessarily make misleading claims about the uniqueness and therefore separation of the materials "inside" a book and those in countless books "outside" them.

Derrida's deconstruction of the border, book, genre, and other categories provides a wonderfully effective means of thinking more clearly about crucial issues involving education and educational Web sites. For me as teacher, student, and worker with digital information technology, the most important aspect of Derrida's deconstructive method lies in what it tells us about our use of binary oppositions, such as East and West or student and teacher. According to my understanding of Derrida, he emphasizes again and again that binary oppositions are just thought-forms, simply ways of thinking that rely upon conceptualizing any two things as if they were diametrically opposed in order to achieve some end. Whether or not Claude Lévi-Strauss is correct that binary oppositions are a fundamental, even innate mode of thought, they remain just that: a

mode of thought, a technique of conceptualization that provisionally takes two items that may in fact lie close to one another on a continuum and presents them as opposites for the sake of some present purpose. According to Derrida, the individual halves of every binary opposition in fact share a great many qualities and thus have a great deal in common. Suppressing such commonality, however useful for political action and certain operations of thought, comes at a high cost, often blinding us to key issues. This deconstructive approach to divisions and borders has great value when one is conceptualizing the way authors and readers experience digital texts. It leads, I would argue, to a more effective use of linking, creation of navigational devices in Web documents, and organization of Web sites. It also offers a meaningful approach to issues involving multiculturalism that permeate the University Scholars Programme.

Many of our humanities, social science, and related courses in the program necessarily emphasize cross-cultural connections, for we try to offer an essentially Singaporean synthesis, drawing upon the cultures of India, China, and Southeast Asia in addition to the West. The cultural situation here—a blend of Chinese, Malay, Indian, and Western cultures—permits us to do comparatively effortlessly what many American universities have been stumbling around trying to do for a decade and a half. At my first meeting with Henry Rosovsky, Harvard's Dean Emeritus of Arts and Sciences, he urged the committee formulating the crucial first part of what was to become the University Scholars Programme not to imitate the Harvard Core Curriculum but to create its own. Take advantage of Harvard's successes and failures, he told us, but produce something particularly suited to the situation at NUS and Singapore. To many of us that means teaching multiculturally. A literature course studying the lyric, therefore, should include great works of Indian, Malay, and Chinese as well as Western literature. Similarly, a course in thinking sociologically should consider works by Islamic and Chinese thinkers as well as Thomas Hobbes and Karl Marx, whereas a course in issues of artistic representation should study works of the many rich traditions upon which Singapore draws.

Obviously, hypertext, an information technology based on connections, provides an efficient way to enhance such an enterprise, making it easier for students to connect materials from divergent cultures and

disciplines. The blend of deconstruction and hypertext theory, or hypertext illuminated by a deconstructive approach, provides a wonderfully appropriate way of designing curricula in a multicultural, and specifically a postcolonial, situation. A decade ago (1992) I argued in *Hypertext* that linked, networked digital text, which most of us know in the form of the World Wide Web, had converged with contemporary critical theory, particularly that of poststructuralism. In *Hypertext 2.0* (1997) I added that a similar convergence has occurred with scholarly editing, whose attitudes towards textuality and editions have become far more fundamentally radical than those of most poststructuralists. If there is ever a *Hypertext 3.0*, I would add to these convergences two more kinds of theory—those of film and postcolonialism—and I thank several people for this last recognition: Andrew Morrison, originally of the University of Zimbabwe and now of the University of Oslo, and Jaishree K. Odin, of the University of Hawaii at Manoa, have argued that theories of hypertextuality and postcoloniality may converge so much that one can usefully apply them to illuminate each other.[6] David Lichtenstein (1999) similarly used his idea of postcolonial Caribbean polyrhythm, and David Yun applied notions of a hypertext self to the Chinese diaspora.[7]

I have already told you that my first encounter with hypertext, or at least the idea of hypertext, took the form of a question about "a means of making connections." I was first attracted to it as a means of permitting students to make connections between a work of literature and its various historical contexts, whether they are biographical, literary, religious, or political. Out of this project developed first Intermedia's *Context32* and then the Victorian and other webs in a range of various hypertext environments, including the World Wide Web.[8] When I came to NUS in late December 1999 to head the new program, one of my first decisions was to create a Web site that would embody these fundamental educational assumptions and emphases.

The University Scholars Programme Web Site

Because NUS has a superb infrastructure for computing that almost all North American universities would envy, the program already had a basic Web site in place when it began. Having visited NUS while on sabbatical

from Brown from the summer of 1998 to the spring of 1999 as a consultant on, among other things, the use of hypertext in education and scholarship, I was somewhat chastened to discover that by most counts NUS far surpassed Brown in terms of both infrastructure and sophisticated general computer usage. NUS, for example, has a campus of 15,000 points of internet access, many of them in the open-sided, covered walkways that connect buildings throughout the campus, allowing people to make their way comfortably among buildings protected from the tropical sun and rain. Wherever one goes, one sees students seated at picnic tables, working away on their laptops while connected to the campus Intranet and the Internet beyond. (The university administration worries that perhaps the NUS infrastructure is becoming too outmoded and plans to make much of the campus wireless within the next few years; the University Scholars Programme has already begun to do so.)

At NUS students can check class and examination schedules online, register for courses, add and drop them, fill out confidential evaluations of their instructors, obtain their exam results, and check their accounts with the bursar. In addition to such prosaic if essential services, NUS uses its multigigabit high-speed intranet to enable students to access "live broadcasts of lectures and seminars [conference presentations] on any networked notebook or desktop computer in campus." Any lectures missed can easily be recalled, as all broadcast lectures are archived into a multimedia-on-demand server (National University of Singapore 2000: 9). This service forms a part of the NUS Computer Centre's Interactive Virtual Learning Environment (IVLE), created by a team led by its director, Lawrence Wong, and Ravi Chandran, acting director of the Centre of Instructional Technology. The suite of software packages that constitute IVLE also permits instructors to create discussion lists, chat rooms, online courses, digital library resources, desktop video conferencing, and basic Web materials.

The basic University Scholars Programme site, which at the time I am writing includes more than 5,000 documents, provides information for prospective students and faculty members as well as for scholars enrolled in the program. Its chief role, however, is educational, since it uses the World Wide Web to embody the multidisciplinary and interdisciplinary focus of the program. The site explains the fundamental emphases of

each of the program's eleven areas, linking different areas at the same time that it offers basic services to students in individual courses, such as course descriptions, introductions, reading lists, tutorial questions and schedules, essay assignments, and archives of interlinked student work. The University Scholars Programme server, which now draws 1.3 million hits per month in Singapore and 7.5 million hits per month on its U.S. mirror, contains not only materials created by the faculty and students of the program, but also three internationally known, prize-winning sites: The Victorian Web;[9] Postcolonial Literature and Culture,[10] which includes the Singapore Web; and the Cyberspace, Hypertext, and Critical Theory Web.[11]

When I first arrived at NUS, the Web site for the University Scholars Programme (at that time still called the Core Curriculum) chiefly acted, like those at most educational institutions, solely as an online depository for important information about its goals, faculty, staff, and admissions policies plus basic mission statements of each of the eleven areas and descriptions of the first few courses to be offered during the first semester of the Core's existence. Considered from the vantage point of our hypertext paradigm, the Web site was no more hypertextual than were the lists of online help files present on mainframe computers in the 1970s and before. In other words, the original Core site was organized as a top-down list of subjects rather than as a network: the connections were the connections of a one-way flow chart rather than of a multiply centered, nonhierarchical network. To put it another way, the Core Curriculum site all too precisely embodied the educational and organizational paradigm the program was supposed to replace.

The task, therefore, was to create a site—and particularly an opening screen—that would more accurately represent the program. First, drawing on the design first employed for the Postcolonial Web, I replaced the simple linear list with a home page, or overview screen, in the form of a square comprising twelve icons (one for each of the eleven subject areas plus another for information about the program).[12] Part of the reason behind this arrangement was to communicate to prospective students, current students, and our own faculty the overall organization of the program, emphasizing the equal importance of individual areas. At this first stage, however, each of the area icons simply linked to a single document

that contained the rationale for the area and a list of the few courses thus far planned or offered. The next stage involved area site maps.

These local site maps and the materials attached to them serve as an overview, introducing each area, listing the courses taught within it, and suggesting how it might relate to other areas in the University Scholars Programme. Thus, the overview screen contains sixteen icons. At top left, where almost all people first look, appears an icon for an introduction, followed by icons for area objectives, history of the discipline, and the first two subareas, information technology and the physical sciences. The second row of linked icons leads to information on four areas of the program (scientific practice and thinking, human behavior, social and economic analysis, and literature and the arts) and a fourth that explicitly serves as a bridge between the present main area and life sciences: biomedical technology. The third row contains icons for culture and contemporary societies, moral reasoning, modules (courses offered in the present area), student projects, and the icon for the program, which leads back to the main screen. The last row contains a single icon leading to the search tool.

Clicking on the icon for literature and the arts produces a representative document at this level of the site, offering material under five subheadings: (1) "The Reciprocal Relations of Science, Technology, Literature, and the Arts," (2) "The Effects of Information Technology upon Literature and the Arts," (3) "Literature as Information Technology," (4) "Science and Technology as Subject in Literature and the Arts," and (5) "Related Materials." This last thus far contains two links, the first to the literature and arts area and the second to a timeline of printing technology, which, since it is in the Victorian Web, opens in a new window. Each of these headings is followed by an introduction to relevant subjects interwoven with open-ended questions. Thus, the subheading entitled "The Reciprocal Relations of Science, Technology, Literature, and the Arts" begins by introducing and then questioning the attitudes and assumptions most students are likely to bring to this topic: "Although in ancient times scientific and technological knowledge was often presented in the form of poetry, modern scientists, engineers, and writers tend to think of their enterprises as fundamentally different and perhaps even diametrically opposed. Writers and literary scholars in particular of-

ten find questions involving possible relations between the fields annoying, irrelevant, and threatening. Can you explain why this might be the case?"

The two following paragraphs list authors of literary works who during the past two centuries have drawn on scientific ideas and examples of such scientists, like Darwin, who themselves have drawn on literature in their work. The second subheading, "The Effects of Information Technology upon Literature and the Arts," again offers information and then asks a series of questions, only the first of which contains a link to an answer:

- What effect does the cost of paper have on sales of poetry? Does poetry become more or less popular when paper becomes expensive?
- How did railways influence the popularity of novels?
- How does the printing press support standardized grammar and spelling? What does this have to do with nationalism?
- How does one define printing as an information technology? Is it the printing press, the press plus the methods used for typesetting, those plus systems of sale and distribution?

Again, the site provides information but then prompts the student to do something with it—a "something" that very often requires the resources found in another discipline and another area of the program.

This combination of introductory information, question, and occasional links either to materials that provide answers or to materials from which answers can be constructed obviously is intended to accustom students to making connections and to asking additional questions. It is also intended to introduce the approaches that characterize the University Scholars Programme to visitors, who may include potential Singaporean or regional applicants or potential foreign-exchange students from further afield. These methods have another important purpose: to encourage the instructors in the program (who write some of these crossroads or air lock documents) to think of their teaching in terms of both their own disciplines and the connections between those disciplines and others. Considering this method from the vantage point of hypertext theory or the writings of Derrida, the emphasis is the same: necessary as are disciplinary

(and departmental) boundaries, they have to be thought of as merely provisional. Using links, we can easily cross borders, profitably blur margins, and enable the students and faculty to see connections. Therefore, these brief documents suggest the kinds of materials that individual faculty members might create for use in their courses or those other faculty members could create for someone else's course as a means of suggesting connections between and among various areas of inquiry.

The University Scholars Progamme site has a section, "Related Web Resources," that contains links leading to two different kinds of information: first, there are the full texts of a number of classic works, ranging from Aristotle's *Poetics* and *Ethics* to *The Analects* of Confucius and Plato's *Republic*. Second, there are three large Web sites that I originally began while at Brown but that have grown considerably since I moved the main site to Singapore, largely because of the support I have enjoyed from NUS. These sites contain works by faculty and students, since in many cases certain resources fit more appropriately within these large subject sites than in the basic University Scholars Programme site. For example, with the assistance of student research assistants, Professor Mehda Malik Kudaisya has created a gallery of architecture and religion of the Indian subcontinent from photographs, mostly of buildings, she has taken herself. Student projects similarly appear both in the University Scholars Programme web and the larger subject ones. For example, when the program hosted a conference entitled "Moving Text into E-Space" in July 2000, students in my course on hypertext and narrative each wrote essays commenting on two of the presentations, and in some cases the speakers responded to the student comments. These essays formed a section of both the conference and course site on the program server. When, however, students in the same course created materials for the Victorian Web as a collaborative final project, their resultant interlinked essays on John Stuart Mill, Herbert Spencer, Victorian psychology, and the British in India (the common link was Mill, who worked in the Indian section of the Colonial Office), their essays obviously belonged on that portion of the site for which they intended them. Sometimes matters of design and format, rather than subject alone, determine the placement of student contributions. The program site uses a common set of icons, fonts, and colors to unify it, but when some students in my course on hypertext and narrative

elected to experiment with new ways of writing for e-space, their elaborate and sometimes quirky projects obviously belonged in the Cyberspace Web, which embraces all kinds of design and color, because it was created for such experimentation.

Where We Are, Where We Have to Go Next

Thus far, the Core Curriculum/University Scholars Programme has been in existence for less than two years. In fact, the University Scholars Programme officially began only in July 2001, although students admitted to the original Core Curriculum in good standing have the choice of becoming University Scholars. The original plan was to take in 250 to 300 of the 5,500 NUS undergraduates admitted each year, all of whom would come from the Faculty of Science, the Faculty of Arts and Social Sciences, and the School of Computing. Other faculties soon noticed what we were doing, and the Faculty of Business Administration and the Faculty of Engineering asked to join; it is also possible that Medicine and Dentistry will eventually become graduate schools drawing importantly upon our students. The morale among faculty and students is generally very high, as is often the case with new enterprises, and our hypertext paradigm has begun to affect the university as a whole as the barriers among faculties come down. Our students and faculty draw high marks from visitors, including our invaluable Harvard consultants, Rosovsky and Nancy Sommers, head of Harvard's brilliant Expository Writing program. It is clear that our writing program is one of the best in the world: unlike at most universities, our instructors (all of whom have doctorates and extensive teaching experience) teach only two sections of ten students each, and our hypertext paradigm gives our program a kind of intellectual structure generally missing from most core curricula. I have taught in the general education programs at Columbia, Chicago, and Brown. I have gone through the one at Princeton, and I have followed my children's experiences in them at Princeton and Yale. I can honestly say that the University Scholars Programme is building upon the best to do something new.

We're young—we are still toddlers as far as educational programs go—and we have a long way to go before coming close to realizing our

promise. We obviously need a far better student advising program, a strong student organization, and undergraduate peer tutors. We want to have more students from abroad in the program, and we want to send all our students abroad for one of their four years. Ideally, we would like to create a residential college somewhat on the order of those at Yale in which faculty advisors, writing teachers, and students live together.

Tentative Conclusions

The coming of digital information technology, as I have argued elsewhere, represents innovation in the form of a major paradigm shift. One needs theory—or more generally, philosophical or analytical approaches—to make the implications of new technologies visible. The problem of course is that any pervasive technology performs as a prosthesis, eventually becoming so naturalized as to become an invisible part of self and society. This becoming invisible—the process of naturalization by which a phenomenon or some of its implications appear to be "natural"—makes the technology invisible.

One effect of such naturalized invisibility is that we tend to see every new technology in two ways. First we see it as a technology, something foreign, mechanical, unnatural. This is why after millennia of information technologies, including speech, writing, print, telegraphy, film, and television, many of us nevertheless think of computing as if it were the only information technology. Second, we always necessarily think of the new in terms of the old. We either reduce the new technology to a simulacrum of the old, failing to note any differences between the two, thus suppressing new potentialities, or we see the new technology solely as one diametrically opposed to the old one when in fact the two may share many features. The benefit of theory, therefore, lies in its ability to enhance innovation by permitting us to recognize more easily and more clearly both the old and new, perceiving that any two such technologies or other cultural phenomena exist on a continuum or spectrum rather than in any fundamental opposition to one another. Fundamental oppositions are, as Derrida made us recognize, only thought-forms, provisional ways of thinking about something for a purpose and not a quality or truth about the relation between the two.

Notes

1. The dynamically produced Tables of Context in *DynaText* exemplify this kind of virtual, automatically generated text, as do various attempts to create Ted Nelson's notions of "stretch text."

2. Lee and Yong's *Beyond Degrees: The Making of the National University of Singapore* (1997), a booklet prepared by the Office of University Relations for prospective students, summarizes the history of NUS thus:

> It has its roots in Singapore's first centre of higher education—the Straits Settlement and Federated Malay States Government Medical School which was set up in 1905 and renamed King Edward VII College of Medicine in 1921.
>
> In 1949, the medical school merged with Raffles College, which was set up in 1929 to teach Arts and Science at the tertiary level, to become the University of Malaya until 1959, when two largely autonomous divisions of equal status were created—University of Malaya in Kuala Lumpur and the University of Malaya in Singapore. Steps to achieve the establishment of two separate universities were finalised in 1961, and the University of Singapore came into its own in January 1962.
>
> In 1974, a common admissions board was set up by the University of Singapore and Nanyang University to consolidate tertiary education in Singapore. Nanyang University was set up in 1956 as a privately funded Chinese-medium university, and its degrees were awarded official recognition by the government in 1968.
>
> Full commonality was achieved on 8 August 1980 when the two universities merged to form one strong and unified University serving the tertiary educational needs of the nation. The National University of Singapore was born.

3. NUS fulfilled its mission admirably, and during the 1980s, under the direction of Vice Chancellor Lim Pin, it transformed itself from a teaching institution into a research university. Despite its many changes it still followed important aspects of a British and British colonial model: NUS divided rather sharply into separate faculties with little interaction among them, and a student could take

courses only in his or her own faculty. In addition, professors and administrators remained essentially part of the civil service, following its rigid rules and workdays rather than those of most North American, British, and European academic institutions. At the same time the government and various funding agencies awarded scholarships for study abroad to Singaporean students who achieved high grades in the A-level examinations. Whereas all students chose at first to attend Oxford, Cambridge, and other leading British institutions, lately more than 80 percent have chosen North American universities, such as Harvard and Stanford. Some of these, it turns out, end up staying in the country in which they undertook their undergraduate degrees.

4. To quote the chronology provided on the University Scholars Programme Web site (⟨http://www.scholars.nus.edu.sg⟩), in August 1997 "the International Academic Advisory Panel (IAAP) visits NUS. Jeremy Knowles, Dean of Arts and Sciences, Harvard University, discusses curricular reform with the Faculties of Science, and Arts and Social Sciences, NUS." The following October, "DPM Dr. Tony Tan announces formation of Core Curriculum Committee, with Professor Shih Choon Fong as chairman." Then, in November two pioneers of Harvard's Core Curriculum visited for the first time: Henry Rosovsky, Dean of Arts and Sciences, and Phyllis Keller.

5. The eleven areas are culture and contemporary societies; history of Singapore and Southeast Asia; human behavior; literature and the arts; life sciences; moral reasoning; nature's laws; scientific practice and thinking; science, technology, and society; social and economic thought; and writing and critical thinking.

6. Morrison has discussed the convergences of postcolonial and hypertext theory in conversation several times over the past three or four years. See Odin's (n.d) essay on my *Postcolonial Literature and Culture Web.*

7. For Lichtenstein, see his Web essays beginning at ⟨www.postcolonialweb. org/caribbean/themes/rhythm.html⟩. Following is an extract from Yun's *Subway Story* (1997), an elegant Web project combining fiction, autobiography, and theory. (It appears in my *Cyberspace, Hypertext, and Critical Theory Web* at: ⟨http:// www.thecore.nus.edu.sg/landow/cpace/ht/dmyunfinal/frames.html⟩.)

(To find the relevant lexias, click on the *Subway Story* icon and when asked "Please choose which line you would like to ride," choose "R." This brings one to "Lexington Avenue"):

"My mind is like a hypertext. I am and always will be David and Dave and Ming-Cheng. But I am never David or Dave or Ming-Cheng all at once. What I mean is that Dave, the homosexual, can never be David, the facade, or Ming-Cheng, the first generation Asian-American, and vice versa. Each part of my identity has it's unique voice, it's own say its part of my whole. So I am a hypertext, a living, breathing example, complete with Bakhtin's multivocality, Derrida's decentering, and Barthes' lack of a coherent self. That's what I'm trying to express here, the frustration, the confusion, and joy that comes from being a gay, Asian male who is an English and computer science major."

8. On Intermedia, see Landow 1992; Yankelovich, Meyrowitz, and Drucker 1988; Haan et al. 1992. Paul Kahn, the last director of IRIS, created an hour-long archival video, *Intermedia: A Retrospective* (1992), which is available from the Association of Computing Machinery (ACM). On *Context32,* see Landow 1989 and the chapter on education in Landow 1992.

9. The 20,000 documents and images that make up the Victorian Web include a dozen books and several thousand articles by 500 scholars from four continents. These documents cover a wide range of Victorian subjects including literature, the arts and design, the history of science and technology, religion, gender matters, economics, and social and political history. It includes an online museum of nineteenth-century British art, architecture, sculpture, and design, has won more than forty awards and is recommended by the National Endowment for the Humanities (United States), the British Broadcasting Corporation, the *Encyclopædia Britannica,* the French and Swedish Ministries of Education, and organizations in Australia, Italy, New Zealand, Russia, and Singapore.

One of the most important sections of the site is that entitled "Victorian Web Books," which thus far contains the Web translations of a dozen important books on Victorian art, literature, religion, and social history. The purpose of this section is to answer with experimentation the question "What happens to the scholarly book, the scholarly or scientific paper in the age of the Internet?"

10. The Postcolonial Literature and Culture Web (Postcolonial Web for short), which has more than 15,000 documents, contains materials on the literature and culture of many countries formerly in the British Empire, including Australia, Canada, New Zealand, Nigeria, South Africa, Singapore, and Zimbabwe, created by faculty and student authors from the countries represented and from throughout Europe and Asia. Members of the University Scholars Programme faculty and student assistants are engaged in creating an online museum of Indian architecture, which will be used for program courses. Like the Victorian Web, the Postcolonial Web has won a substantial number of prizes and awards.

11. The Cyberspace, Hypertext, and Critical Theory Web (Cyberspace Web, for short) is formed primarily of elaborate projects by students from Brown University, NUS, and other institutions around the world as well as individuals from as far away as Russia. It represents the cutting edge of writing for e-space and the knowledge-based economy.

12. When I created the overview documents for Intermedia, I began with a kind of daisy wheel diagram that surrounded a single person (say, Charles Dickens or Elizabeth Barrett Browning), work (*Great Expectations, Aurora Leigh*), or subject (religion, the literary canon) with a range of topics, each represented by an icon, such as literary relations, visual arts, religion, history, and science and technology. The design effectively represented my pedagogical emphasis on having students realize that any one subject relates to many factors, only a few of which one might know or use. The design, in other words, incorporated the idea that students should move out from a central point and also realize that their inquiries, like hypertext, were recenterable, that is, that as they pursued their inquiries, a fact, a topic, or an idea that had been peripheral could well become the center of another inquiry. Thus, as one moved from one author to another during the class course, an author who has been a center of study would become a source or influence or usual tool for comparison with another author. Such a graphic design and the system of linking connected to it was intended to help students to keep in mind authors they had studied earlier in the term instead of assuming, as so many students do, that once the week for reading Jane Austen ends, they are supposed to turn attention away from her work until the final exam. The current version of the Victorian Web, some of whose contents go back to 1987 and Intermedia, retains much of this original centralized design,

though certain overviews or local site maps, such as that for history or arts and design, take the form of lists.

When I came to create a World Wide Web version of the Postcolonial Web, this centralized design seemed less obviously applicable, since I began with overviews for individual countries (Nigeria, Australia, India) that demanded a different approach. Because I wanted to emphasize the multiple factors ranging from literature to demography as much as the individual authors, I settled on a design that arranged a set of square icons in a rectangle. For the sake of consistency, I retained the same shape for each author's overview, though in the future I might experiment with using Victorian Web–style local site maps for each author.

References

Derrida, J. (1972) *Dissemination* (trans. B. Johnson). Chicago: University of Chicago Press, 1981.

Haan, B. J., P. Kahn, V. A. Riley, J. H. Coombs, and N. K. Meyrowitz (1992) "IRIS Hypermedia Services." *Communications of the ACM,* 35, 36–51.

Kahn, P. (1992) *Intermedia: A Retrospective,* a video available through the Association of Computing Machinery, New York.

Landow, G. P. (1989) "Hypertext in Literary Education, Criticism, and Scholarship." *Computers and the Humanities,* 23, 173–198.

Landow, G. P. (1992) *Hypertext: The Convergence of Contemporary Critical Theory and Technology.* Baltimore: Johns Hopkins University Press.

Landow, G. P. (1997) *Hypertext 2.0.* Baltimore: Johns Hopkins University Press.

Lee, E., and T. T. Yong (1997) *Beyond Degrees: The Making of the National University of Singapore.* Singapore: Singapore University Press.

Lichtenstein, D. (1999) ⟨http://www.scholars.nus.edu.sg/post/caribbean/themes/rhythm.html⟩.

National University of Singapore (2000) *Computer Centre* [information booklet]. Singapore.

Odin, J. C. (n.d.) "The Performative and Processual: A Study of Hypertext/ Postcolonial Aesthetic" Available at ⟨www.scholars.nus.edu.sg/landow/post/ poldiscourse/odin/odin1.html⟩.

Yankelovich, N., N. Meyrowitz, and A. Van Dam (1985) "Reading and Writing the Electronic Book," *IEEE Computer* 18, 15–30.

Yankelovich, N., N. Meyrowitz, and S. Drucker (1988) "Intermedia: The Concept and the Construction of a Seamless Information Environment." *IEEE Computer,* 21, 81–96.

Yun, D. (1997) *Subway Story.* Available at ⟨www.thecore.nus.edu.sg/landow/ cpace/ht/dmyunfinal/frames.html⟩.

3

The Challenge of Digital Learning Environments in Higher Education

The Need for a Merging of Perspectives on Standardization

Jon Lanestedt

During the past decade one of the recurrent arguments concerning digital media has been that our new objects of study—emerging digital media artifacts and forms of communication—may not be properly described and analyzed within the theoretical frameworks offered by current approaches to media objects, practices, and institutions. Consider, for instance, an ordinary Web page, which in most cases consists of several component subdocuments, perhaps originating from different sources (HTTP servers), retrieved on request and structured into a dynamic frame set presentation. *Where,* then, is the document at any particular time? And when a newspaper's Web page is generated on the fly based on database requests in a news database, *what* is the document? Is it what we see displayed in the browser? Does it somehow reside in the contents of the database? Is the document's true nature to be found in the database requests, in the algorithms that describe and carry out those requests, receive the results and transform them into the Web page we see on the screen, or in the document structure as defined in an Extensible Markup Language (XML) document type definition? In all of them? For that matter, *when* is the document? Does it come into being only at the brief moment of accidental display, or does it live its life on storage, as potential materials

for its realization by program logic? Is the very phenomenon of the document as a unified communicative entity with a certain permanence, a cornerstone of humanistic inquiry, now being replaced by communication *services* rather than communicative *objects?* This is just one example of reality trying to escape our analytic tools.

If the theories we have at our disposal do not help us account for empirical reality, actual behavior, and observed effects in terms of intersubjective and shared sets of rules, interpretive conventions, signifying systems, or structural, invariant, or formal properties, we need to develop new ones. The irrelevance or insufficiency of specific theories, however, is not the main issue here. Instead, the argument is that some of the theoretical constructions available to us are still highly durable, although we may certainly have to refine them and recombine them. We need to integrate more closely some of these bodies of theory, so that our efforts draw on expertise from a wider range of knowledge domains than is often currently the case.

In this chapter I point out some of the disciplinary challenges posed by developments in the field of digital media infrastructures in support of educational processes in higher education. Digital learning environments, their introduction at universities and colleges, and international efforts in technical standardization, on which any large-scale implementation of such environments depends, constitute an object of study and reflection that begs for interdisciplinarity. This object of digital learning environments may be approached from three perspectives: in such environments' capacity as signifying media, as support for learning and teaching, and in terms of computer systems. The relevant disciplines to inform our investigations are media studies, pedagogy, and informatics.[1]

Educational institutions worldwide currently integrate information technologies into the learning and teaching processes both as part of broader efforts to make pedagogy more relevant for campus and distance students alike, and as a means for addressing the challenges of lifelong learning. This involves infrastructures, collectively available suites of software tools, communication facilities, and administrative functionality as well as organizational reconfigurations and new methods in learning and teaching. These efforts call for coordinated approaches based on interdisciplinary expertise. The issue in this chapter, then, is processes of institu-

tional change in which digital media play a part; that is, the chapter is about media in real-life use and about the need for students of media, pedagogy, and informatics to join forces in reflecting and acting on these media. Among the critical questions in this context are: How can the discipline devoted to the study of media contribute to the development and critical understanding of digital learning environments? What is the role of educational theorists in the development of digital learning environments? That informatics is somehow involved is no big surprise, but how can informatics actually inform the work with pedagogy and the efforts of media scholars?

Digital Learning Environments

"Digital learning environments" is understood here as a common label for digital media solutions for, first, content production, management, and dissemination; second, teaching, team collaboration, and group support; and third, administration and management of learning processes. Digital learning environments include tools, various levels of infrastructure, media, and learning resources supporting teaching and learning processes in educational institutions. A possible usage scenario providing just a few examples might be as follows.

Life at Euphoria University

At Euphoria University the faculty of the History Department is getting ready for the first term of a new master's degree program in social history aimed at lifelong learning students (full and part-time campus students, distance students, continuing education, etc.). Faculty members recently started using one of the learning management systems, called Learning Groupware, *provided and maintained centrally by the university's Center for Information Technology Services. Professors in the department simply access the university web, press a few buttons, and a new set of virtual courses and activity rooms is generated for the various courses in the current semester. Seconds later, history department faculty find their course rooms ready for use, one for each seminar and educational event, and both their own user names and those of their students already in place with appropriate permissions (read, write, change, etc.). Also, their user names and passwords in* Learning Groupware *are*

identical to the ones they always use when accessing resources on campus servers, and there is no need to remember application-specific passwords. The system is automatically updated so that new students, groups, faculty, and course revisions entered into the university's administrative systems are mirrored daily into Learning Groupware. *Faculty members in the Euphoria University History Department are, as it were, euphoric, as they save much time on this procedure which they now spend as learning coaches and on content authoring. Staff and faculty members remember the changes taking place two years ago. Until then learning management systems were run and maintained as "black boxes" locally at the department level throughout the university without the communication with their surroundings that makes today's functionality happen. They remember creating rooms and populating them manually, including the act of inventing user names and passwords for use only in those local learning management systems. Since departments at this large university each have many hundreds of students, Euphoria faculty members and staff were earlier spending man-years' worth of effort in performing these routine tasks. No more of that. What is even better, the data used to achieve all this already exist, as part of the ordinary administrative systems and procedures that the university has to maintain anyway. Hence, there is no workload being moved from faculty to somewhere else in the university system, but the exploitation of the fruits of well-maintained administrative systems, made possible by standardized interfaces for information exchange.*

History Department faculty members have spent much of the summer online from their holiday residences creating digital content for the new program. A standardized and well-defined approach to content creation makes this a manageable task for faculty and a low-cost endeavor for Euphoria University as a whole. In creating learning resources for his course on living conditions in early-twentieth-century Northern Europe, Associate Professor Curt Branningan searches through repositories of media materials stored on campus servers. These materials are fine-granulated content "atoms" such as basic 3-D simulations, sound and animation resources, video items, and text boxes designed at a simple level of detail and focus so that they may be reused in many contexts and take part in many rhetorical constructs. Right now Curt is interested in the shipping industry along the Norwegian coastline, and he identifies and retrieves several photos of ships and shipyards, along with radio audio clips from 1924 and a 360-degree navigationable 3-D object on the

design of a dock. Curt assembles these materials, or content atoms, into his own new "molecules," or higher-level learning objects constituting a lesson or a limited theme to be adressed by the learner. He uses simple tools for this task. He obviously has to identify candidates for inclusion in his learning objects, and a simple search interface lets Curt search for a broad set of criteria associated with the content elements, related to both subject and form of presentation (e.g., "I need a 360-degrees rotatable Quicktime *presentation of a whaling vessel"). Curt retrieves some of the atoms from distributed repositories at the Universities of Oxford, Gothenburg, and Austin, as well as from several commercial content brokers. In the latter sources he discovers several items created by staff at Euphoria University's own Media Studies Department; there is a considerable market in corporate training, public administration, and the media industry for content originating in higher education. The process of creating learning resources basically consists in pointing and clicking, choosing among menu items and searching result lists of thumbnails, inspecting possible useful hits, and writing in text boxes. Curt finds the tools at his disposal very intuitive and assembles his object on the Norwegian shipping industry, along with another one that he put together last week on marriage patterns of Norwegian mariners in Great Britain at the beginning of the last century and several other ones, into a comprehensive "anthology" of subthemes: a course.*

Part of Curt's course touches upon demographic developments in coastal communities in the North Sea region in the 1920s. He finds a demographic simulation that illustrates the point he wants to make and builds it into one of his learning objects. Curt has used simulations before in his classes, with great success. In this particular simulation he has found, the students need to make decisions as to initial values of parameters, run the process based on these values, and adjust them eventually depending on the system's behavior. Curt has the students explain the process and the outcome. To be able to assess and respond to the students' interactions with the simulation, Curt wants the learning management system to document the process for each student and store it in its database. And it does. The learning object "tells" Learning Groupware *when the simulation starts and ends, which parameter values the student chooses, which decisions she makes in the course of events, and her responses to various questions and options. The log file documenting all of this information forms the basis for evaluation and relevant coaching of individual*

students and provides statistics concerning the simulation activities of the larger group of Curt's early-twentieth-century Northern Europe class.

One module of the master's degree program in social history, of which Curt's course forms part, has been run earlier in the context of another learning management system. There a vast resource of primary and secondary materials has been made available over the years. Links to additional materials are maintained, and long-time ongoing discussions in threaded conference forums represent knowledge development on key issues. Curt's colleague Professor Sue Smith, who is to teach the Learning Groupware *version of that particular nodule, easily activates a mechanism by which the entire virtual course room—documents, discussions, and all—is exported from that other system and imported into* Learning Groupware *and reconstructed there.*

Euphoria University wants to make Curt's and Sue's courses within the social history master's program available to brokers in continuing education, in the same manner as many institutions in higher education do. The major means available to Euphoria University for making its offerings visible to the public is to export data about them into a shared national database, which the brokers can in turn access and search and which provides content for various third-party catalog services. Administrative staff at Euphoria check Curt's and Sue's courses in their administrative systems for export to the broker database and send them off. Daily updates are now automatically sent to that database, as course information at Euphoria University is continuously edited and maintained.

What Is Involved in All This?

In preparing for the new semester, Curt, Sue, and the rest of the Euphoria University faculty and staff operate within the framework of the university's particular version of a digital learning environment. The overriding aim of introducing digital learning environments in higher education is to develop the educational processes and increase the *quality* of learning, to provide *relevant* learning environments in response to developments in working life, educational theory, and students' expectations, and, in the long term, to approach a better use of *resources* in terms of financial and human capital. In this perspective digital learning environments not only provide a means for dealing with continuing and distance education but

should also make information technology solutions, groupware, and digital resources an integral part of all educational arrangements and activities, including on-site educational programs.

Quality and relevance may translate into *flexibility* and better *pedagogy*. Flexibility concerning the temporal and physical location of students, faculty, and learning resources, respectively, is of prime importance when one is trying to meet the challenge of providing academically satisfactory, high-end educational offerings to a range of full-time as well as part-time students, campus as well as distance students, and various target groups along the path of lifelong learning. As for pedagogy, the introduction of digital learning environments needs to be part of broader institutional processes and institutional change to achieve greater emphasis on student-centered learning forms, on the student's own development and construction of knowledge, on the development of collaborative learning processes, and on various forms of evaluation relevant to such processes. When it comes to financial and human resources we observe that for the effort to be feasible and successful on a large scale, efficient routines must be established based on technical standardization and shared administrative solutions. Key concepts here are reusability of content and tools, well-defined interfaces and data exchange formats between component systems, interoperationality of functionality across server and client platforms, and mechanization of those operations that do not need human interference.

Three main areas of functionality, services, and tools may be said to constitute digital learning environments: those for (1) learning and teaching, (2) creating and managing content and learning resources, and (3) coordination on an institutional level. In all these areas, technical standardization of exchange formats and data models plays a crucial role in any large-scale deployment.

Digital learning environments as a concept encompass all digital support of the student's learning situation as well as the necessary functionality for online teaching. Digital learning environments provide functionality and tools for collaboration and communication in various modes between students and faculty and for information exchange, access to learning resources, etc. There are software products that integrate many of these tools into one single application, visually and logically organized

by means of common interface metaphors (e.g., buildings, desktops). Such systems, as illustrated in the Euphoria example, are commonly referred to as "learning management systems" (LMSs). LMSs are the most central category of applications within scalable digital learning environments.[2] Most LMSs include a basic set of functionalities covering most of the above and frequently some additional tools and functions. The *ways* these features are designed, however, often differ substantially among LMSs and may have strong pedagogical implications. (Hence, such systems may be said to emphasize particular world views and approaches to learning and teaching.) An institution's courses may be assigned virtual "rooms" in an LMS where students and teachers are allocated permissions to perform various tasks. Here the collaborative processes are conducted, and here learning and reference materials are organized and made available to the participants.

Digital learning environments encompass mechanisms and tools for production, management, and use of learning resources, multimedia documents, student writings, and educational materials of all kinds. This includes end-user applications for content production and editing and also deeper, so-called middleware tools and mechanisms that give programs, systems, and users access to networked services and resources in general. Middleware is a class of general services that are necessary for educational purposes but have little to do with the particular use in education as such. Key concepts in this context are identification and authentification of users and processes, authorization and access control, encryption/certificates, and client-server architectures for information retrieval in Internet-based repositories.

Digital learning environments involve management functionalities for the coordination of learning and teaching. The focus in this context is the authoritative administrative systems that universities and colleges use for representing and managing information on educational activities, courses, and programs in their organizational framework and faculty, students, and staff involved in these activities, along with the many relations and constraints that exist between these items. Such systems constitute a backbone for many potential educational services, including LMSs that can draw on their data when building educational support services and populated course "rooms" for all programs and courses.

Technical Standardization of Digital Learning Environments

The Euphoria example provides just a glimpse of the functionality in digital learning environments in which standardized "grammars" for the representation of reality and exchange of representational objects are introduced. Let us briefly review the potential results of some of the work in which international bodies of standardization invest substantial efforts. These results are of great importance to the large-scale inclusion of digital learning environments in educational programs in higher education. This work and its implications for LMS functionality is part of the empirical reality of media in use that practitioners of media studies should be addressing along with educationalists, informed by informatics.

The first issue addressed in the Euphoria example concerns drawing on administrative systems for building LMS support for courses and programs (course rooms, etc.). This is a precondition for any large-scale use of digital media in educational institutions. The LMS *Learning Groupware* in the Euphoria scenario is integrated with the university's central system for management of information on all educational offerings along with their registered students, faculty in charge, and teaching activities (seminars, group discussions, etc.). The functionality described presupposes, then, that the institutions actually use administrative systems that keep track of all data representing the educational institution, its organizational structure and units, its courses and educational activities, its students, staff, and faculty, the corresponding user identities and permissions, and the groupings of and relationships among all these items (which activities are part of which courses, which faculty member is responsible, and which students take part?). Such data collected in authoritative administrative sources form the basis for mechanizing the procedures for creating virtual course rooms ready for the use for each course and those for populating these virtual course rooms with students and faculty with correct levels of permissions. Furthermore, these kinds of administrative systems must comply with standardized data models representing the involved entities and be able to exchange their data with LMSs in a standardized syntax through a standardized interface. The LMSs must comply with common standards and be able to use imported data in a way conforming with common semantics or interpretation of them and must reconstruct

the representation derived from the administrative source system within their own structures. As long as they do comply in this way, LMSs are in many respects interchangeable; a pedagogically poor system can easily be changed for a richer one as long as it communicates in an identical manner with the surroundings according to the same interface syntax and semantics.

The second issue, which involves assembling new and more complex learning objects by combining simpler elements, implies a democratization of the process of creating learning resources. The modularization and reusability touched upon here is also the only viable road ahead when it comes to costs and resources. Content experts are likely to continue to be in scarce supply and an increasingly expensive resource. Content will therefore be a bottleneck in increasingly slimmer institutional budgets. Consequently, it is of great importance that as much content as possible should be used more than once, and when appropriate, in new contexts. Means are needed for building new structures on the basis of existing, simple structures. Standardized structure description "languages" must express sequence, relationships, and properties of content elements assembled in a greater whole. There must be agreement on methods of identifying and retrieving content elements. Hence, there must be descriptions associated with each element, so-called metadata, which include bibliographic, descriptive, and administrative information.[3] These descriptions are a precondition for retrievability and make it possible both to index and to search content repositories based on the metadata values. We need common "languages" for expressing metadata and thesauruses to define and constrain possible values of metadata attributes.[4] But the structure description "languages" also involve standard metadata that describe the individual elements and their relationships according to predefined principles and syntaxes.

The third issue, interaction between learning object and LMS, involves standardized interfaces between the two. Known to both "parties," these interfaces are the "window" through which both state information (e.g., function calls such as start and stop) and data streams (e.g., regarding the user's navigational whereabouts or behavior in a simulation) are exchanged. A dictionary of possible "utterances" in the dialogue between learning object and LMS must be established, as must a syntax for these

utterances. With such a standardized *application programming interface* (API), learning objects containing executable content elements are endowed with *interoperability* and can be reused in identical ways within many LMSs, provided that they all comply with the standard.

The fourth issue, moving about and reusing course rooms and exchanging such representations between different LMSs, is rather similar to the first one in that it involves the interchange of structured data representations between systems. Common object representations and interchange schemes must be defined and agreed on. Then courses may be copied and reused or just stored for later, possibly also for research purposes.

Finally, the fifth issue, making course information available to third parties, also resembles the first one, as it involves exchange of data from single authoritative sources in administrative systems via standardized export and transfer routines to common storage as objects based on standardized data models. It is crucial in this context that administrative data have only one authoritative source in which they are maintained and on which many applications draw.

None of the issues presented above is science fiction, and all are addressed by international standardization initiatives that pave the way for solutions to the real-life challenges of today.[5] In my view, such modularization and integration and the standardization that makes it all possible are prerequisites for scaling up digital learning environments to an institutional scope, given the number of users and offerings involved at many institutions.

Information Systems as Intentional Artifacts

We have seen how standards and descriptive mechanisms are crucial for systems' behavior. This implies that what actually appears for the user to see and interact with, and the overall behavior of digital media, is to a large degree defined and constrained by such standards and mechanisms. Therefore, disciplines that study digital media behavior should also turn their interests toward their defining properties as signifying machines. The reward for this is of course an understanding of the object under scrutiny, such as the Web document example at the beginning of this chapter.

Addressing symptoms without addressing causes is in general a rather limited approach.

Standards as Semiotic Codes

Digital media are not like other media. Digital media do not only carry or present signification as an end product, as do newspapers or analog radios. The very nature of digital media as data processors implies operations of signification on many levels. In its capacity as medium, digital information technology of the kind we are currently discussing constructs and expresses meaning along a "value chain" of signification, with (at least) three major levels.

The "highest" level of signification in this value chain is the semiotic messages that actually meet the user on the screen and with which the user interacts, expressed by using sign systems based on media types such as graphics, video, text, and audio. It includes the properties of such signs associated with their capacity of *initiating*—when clicked—or *standing for* actions and processes (e.g., the video progress indicator in Quicktime, the "micon" video link that visually points to the destination video segment), as well as their role as navigational cues, interface metaphors, among others. This is the traditional surface level of analysis in media studies. The "middle" level of signification is the computer's representations of those surface signs, the rules for their manipulation, and all the algorithmic processing needed for the action on the screen to take place. This level may be expressed in terms of data models, flowcharts, and logic diagrams and implemented as database tables and XML document type definitions with programming statements operating on these structures. The "lowest" level of signification is expressed in the overall architecture for coordination and data exchange between information systems such as user applications, server software, databases, administrative systems, services, search facilities, and resources of various kinds connected in a distributed environment. Again, we are moving toward middleware applications and services. This level includes defined protocols and interfaces among systems, syntaxes for exchange of data and semantics for their interpretation, and programming logic for making communication among systems happen.

It is the lowest and middle levels of signification that are of concern here. Let us for the purpose of this chapter refer to them in common as the "grammatical" level of digital media signification. It is on this level that standardization makes sense and on which support for exchange of data between systems and subsystems can be established, as demonstrated in the Euphoria University scenario; on this level, as well the security necessary for transactions and interplay between information systems can be ensured. This grammatical level may be regarded as a semiotic code, a sign system, a *semiotic* system.[6]

A code defines what are to count as signs in the system and what are not, that is, it defines a "vocabulary" for the sign system. The code also defines how the words, or whatever the elements are, may be combined syntactically into well-formed utterances, or texts. Furthermore, it defines how to relate elements and utterances through some defined interpretative scheme (semantics) to an external reality, or rather to some conception of it. Such a code is what Eco (1979a: 38) defines as an *s-code*. This relation between representing and represented must also be shared between the parties involved. Codes may be conventional or agreed upon.

Whereas natural languages are conventional, standards are clearly cases of agreement rather than of convention; they formulate rules rather than conventions. The point here is that in either case there must be some underlying code for something to represent and for making meaning happen. Such a code *defines what can be said and how* and is a grammar for meaningful communicative behavior. Standards of the kind I have discussed above are preconditions for making Web-based learning services, LMSs, and learning media of various sorts cooperate, exchange data, share resources, and in general "talk" to one another in a way that will support students and users, educational institutions and their employees, various kinds of course brokers, and other actors in the education sector. Standards as code or grammar define the behavior and functionality that will be possible and how it will be formulated. As codes standards give rise to and restrain various texts, or kinds of possible behavior.

Information systems are media systems for production, manipulation, communication, presentation, interchange, and collaboration related

to texts, as the term is used in its broad semiotic sense.[7] This implies that they are used to create and communicate signifying constructs with what Eco (1979b) refers to as a "model reader."[8] The model reader is a built-in, strategically motivated property of any media object; some assumptions simply have to be made in developing a media object in order for it to make sense at all, and most of them are not even made by the author but present themselves as "natural" in accordance with the surrounding cultural pressures. This implies that the media object clearly favors certain modes of interpretation and use and that it restrains and excludes yet others.

Furthermore, not only are information systems used to *generate and communicate* texts with these properties; information systems may *themselves* be considered texts with model readers. They are *intentional* artifacts, that is, their designs are informed by explicit and implicit assumptions about their potential users, the users' intentions, tasks, and challenges, their organizational settings, and other contextual matters.

Media Studies: From Grammar to Text

The field of media studies has so far tended to focus much of its interest in the new media on questions related to media objects, productions, and products *as they present themselves to end users, readers, viewers, players, and consumers*—that is, on media objects as *utterances,* as texts, the last step in the semiotic value chain, as opposed to a more holistic approach that also takes into account the properties of the grammars enabling and constraining these texts. Hence issues for research are multimedia interfaces, rhetorical conventions, usability, forms of interactivity, narrative structure, dramaturgy, and so forth. These are important issues indeed related to the machinations and interpretations of computers as representational media. What is called for here, however, is a stronger involvement on the part of media theorists with respect to the "inside," versus the surface, of the new media, that is, with respect to the logic and grammars built into them beneath the surface and which make them what they are.

As evident in the Web document example in the beginning of this chapter and in the Euphoria University example, the functionality and nature of digital media are crucially connected with their capacity as computer programs, as computer-processable applications and media objects.

They are fundamentally dependent on the means by which computer programs represent a world as data models and database tables, on communication protocols and interfaces among systems and processes, and on processing logic represented in programming languages—that is, on phenomena very much beneath what appears on the surface, on the screen, but to a large degree constitutive of the media objects consumed on the screen.

Consider, for example, two alternative approaches to handling access permissions. Euphoria uses an LMS to support the learning process. In an LMS we find participants organized according to roles such as student, teacher, and administrator. The roles are associated with particular sets of permissions. In one system, system A, the student role may have the right to create new documents and to update and delete its own documents but not those of other participants but not to update the calendar. The teacher's role, by contrast, may have the right to do all of the above and also to edit the students' documents and update the class calendar. In this system, system A, these permissions are properties of the student and teacher roles, respectively. In system A, a particular student who takes five courses and who consequently participates in the activities in five virtual course rooms has the same permissions in all of them, as the role is global. All changes in the student role have global effects. Let us consider another system, system B, in which permissions are differently distributed. Here rights are properties of the very objects to which the rights are regulating the access. A student may in system B give her document certain access permissions, which tell the system who may do what to it. A room may itself be defined to assign properties and permissions to its inhabitants to the effect that, say, in a particular room every object may be altered by all participants, whereas in another room this is not the case. Now, as different pedagogies assign different status to the learner, they also assign different nature, range, and scope of possible learner actions in the learning process and in the team of learners. A project-oriented course may have active students who comment on each other's drafts by writing in the text proper of those drafts and who do collaborative writing by turn taking and peer review. Students may manage their own schedule for producing a common deliverable by maintaining the common calendar and shared to-do lists. Another course may be more transmission-oriented,

with a reading list and materials, in which the students write individual assignments according to the teacher's list of deadlines.

In system A, with its global roles, the two types of courses cannot coexist, as students cannot have different rights in different rooms. In system B they can, and both courses can coexist. In what may seem a technical detail, the representation of rights in the underlying data model has direct consequences for the behavior and functionality of the user-media interface, with very clear implications for pedagogical flexibility or texts. Why, then, one may wonder, would the distribution of rights, the organization of roles and objects, and the data model in which it is all represented, that is, the syntax of systems behavior, not be a matter of interest in media studies, whereas the interactions in the interface are? Both levels are fundamental components in the signifying mechanisms that meet the user and define the framework within which the learning processes and group dynamics are conducted. The question as to whether access permissions are properties of actor roles or properties of objects or both is an issue of the kind about which standardization initiatives must make up their mind. Given the implications that possible answers will have for pedagogical practice and exchange of data among systems (again, cf. the Euphoria example), the question is by no means a technical question alone, but rather an interdisciplinary one.

With its repertoire of analytical tools, including linguistics, rhetorics, and semiotics, media studies should apply its apparatus to the grammars of digital media, including emerging technical standards, to critically assess and contribute to ongoing work while anticipating its implications for text production and bring the perspective of computer technology as *media* into this work.[9] This, can hardly be achieved, however, without substantial literacy in informatics.

Pedagogy: From Text to Grammar

The role of students of pedagogy and educational theory to the grammar of digital media may be opposite to that of the media studies approach. The surface behavior made possible by standardization involves the potentials of distributed, online learning in higher education. Interests and assumptions about how learning should be organized, about hierarchy and power in the learning situation, as well as institutional biases are built

into the standards' syntax as premises for and restraints on educational activities. To recapitulate: *a standard empowers certain approaches while constraining what can be expressed and which actions can be performed.* It is therefore of the greatest importance that educational theorists and pedagogues contribute to the process of designing those grammars in order to effect educationally sound system behavior and potentially supportive texts. Again, the rights distribution example above is most pertinent.

The educationalist approach is best played by formulating the practices that the standards are to support. In designing functionality and media support for, say, various kinds of computer-supported collaborative learning arrangements such as problem-based learning groups, project teams, and peer review groups, the pedagogue defines the mechanisms and behavior that the standards are to support. Different approaches to learning require widely different media functionality (Koschmann 1996; Jonassen and Land 2000). Translating from desired practice (text) to underlying generative grammars and assessing these grammars' consequences for actual systems behavior, must also be informed by an element of formal thinking, and here, too, informatics is a necessary component.

Informatics: From Grammar to Standards as Actor Networks

The international standardization initiatives directed toward digital learning environments are run by consortia of large actors in industry and public administration. It is a good thing indeed for higher education that such powerful players are involved in this work. The emerging standards cannot be expected to be pedagogically or hermeneutically neutral, however. Instead they reflect the interests, assumptions, and worldviews of participants—model readers, that is. There is nothing evil involved in this fact as such, but the positions and perspectives of these players need to be recognized. A serious situation arises, however, from the fact that educationalists do not contribute in any significant way to these model readers, and neither do media theorists.

Pedagogues' and media theorists' reluctance to get truly involved in digital information technology may stem from a certain widespread sense of technological determinism. Such a position would imply that the new media technologies develop by means of some inner dynamics and that there is little one can do to influence them. In Feenberg's (1999) words,

determinism is based on two premises, first, that "technical progress appears to follow a unilinear course, a fixed track, from less to more advanced configurations," and second, that "technological determinism also affirms that social institutions must adapt to the 'imperatives' of the technological base" (77). So why bother getting involved? Or the reluctance may be based on the directly opposite position of radical constructivism. In such a context technology is "just" about tools, and it is of limited actual importance, as it is people and organizations that really count; people may use technology in any which way they wish. Besides being theoretically dubious, both positions fail to grasp the complexity of the situation at hand regarding technical standardization, with potentially conflicting interests among actors both in the standardization committees and in the institutions in which digital learning environments are introduced.

Actor-network theory (ANT) constitutes one possible alternative position (see Law 1986; Latour 1987). Of semiotic origin, ANT postulates that technological artifacts, people, and organizational phenomena such as rules, routines, and standards may all be regarded as *actors,* as active nodes in *heterogeneous networks* (see chapter 18). Humans and physical and cultural artifacts are of the same explanatory order and share the property of having *interests.* Interests are *translated* into *inscriptions* in artifacts or social arrangements. Inscriptions are anticipations of potential patterns of use built into the artifacts (cf. model reader) with various *strength,* implying the degree to which the inscriptions must be followed or can be disregarded or circumvented. In ANT, networks of actors with varying interests are struggling toward a state of equilibrium. These processes involve *alignment,* in which the diverse interests are translated, understood, and accepted by the actors involved or simply enforced by building alliances or increasing the strength of inscriptions. This alignment eventually results in an *aligned network.*

One reason why students of information systems and digital infrastructure (e.g., Hanseth and Monteiro 1998) are interested in ANT is, first, that it does not focus on just one type of factor, which would easily be the case in approaches favoring either technology or humans. Second, ANT provides a "language" of description for the alignment process of negotiating, redefining, and appropriating interests with regard to interests in humans as well as inscriptions in artifacts and social arrangements. This

language makes it easier to describe, understand, and discuss the interests and alignment processes going on in international standardization initiatives, as well as in any particular academic institution in which the resulting technical standards are implemented. First, there must be a dialectic between work done by standardization committees, on the one hand, and practical experience, pilot projects, prototyping, and various dialogs with users, on the other. Second, to convince busy and sometimes outright conservative academics that the effort is worthwhile and to navigate institutional politics is itself a considerable task in which good tools for description, documentation, and reflection are needed.

The actors involved in the standardization of digital learning environments clearly represent differing interests. Governmental agencies and industry actors certainly have a rationality and views on cost-benefit ratios that differ somewhat from those in academia. Groupware for reflecting on Middle Ages aesthetics or the architectural principles of Gothic cathedrals in peer review teams at the master's level with extensive collaboration will necessarily be different from solutions for corporate training in which 60,000 employees worldwide are brought up to date on new *Microsoft Office* macros every third month.

Higher educational institutions need to take a more assertive stance in making their interests heard while contributing to the overall aims of the standardization initiatives. Again, educational theorists and practitioners are particularly called for. The body of ANT theory that originated in the social sciences but is frequently applied to studies in informatics may be regarded, on a macro level, as an extension of the semiotic approach in media studies.[10]

Concluding Remarks: A Lingua Franca of Perspectives

Reflection on/and Action

In this chapter I have sought to illustrate how new digital media in the educational arena are both a potential object of interdisciplinary study and reflection and an area of potential interdisciplinary action and development as well. I subscribe to the notion of a close relationship between research and development in academia also outside experimental disciplines such as medicine and many branches of science. As opposed to a

traditional approach in the humanities and much of social science, where research is always conducted *after* the fact (and in many cases, admittedly, for good reasons), the study of new digital media forms calls for a closer relationship of temporality and causality between research and object, between reflection and action. Media studies too should take part in inventing its own object, bringing theory to bear on active participation in media construction while developing and refining theory on the basis of this practice. By reflecting in public on phenomena emerging while we observe them, we already indirectly take part in their emergence. We can and should proceed one logical step further and also take part directly, by experimenting with, performing tests on, and exploring real media in use as an integral part of their development, guided by theory. We need to follow art and applied science, in which the very object of investigation is to a large degree created as an integral part of the process of reflection, of research, of exploration, and of experimentation.

A Merging of Perspectives

I have called for a closer relationship between media studies, pedagogy, and informatics. The perspectives in these theoretical and institutional constructs must overlap when we are reflecting and acting on the new digital media along their value chain of signification. I have emphasized that this entire value chain should be considered a matter of research and development in an expanded version of media studies, because studying just one end of it yields, as it were, only partial insights. The inner workings of digital media as computer applications and information systems may be regarded as grammars with implications for surface behavior. Consequently they should be addressable by media studies (including textual studies, semiotics, and rhetorics, among others) informed by informatics, and indeed by the intersection of the two. In the melting pot of humanistic approaches (such as rhetorics, semiotics, and textual studies as well as contributions from the social sciences), I would argue that media studies is indeed a potentially central disciplinary contributor. Media studies is a cluster of approaches to artifacts in their capacity of *media*. The discipline currently has limitations of scope, however, that may be supplemented by informatics: algorithmic processing, object orientation, structural description languages (e.g., XML), the overall workings of computer tech-

nology (digital media technology, that is). This is particularly clear in the case of industry standards for learning environments. The implications of such grammars for systems behavior in the case of educational applications of digital media call for the involvement of correspondingly informed educational theorists in their very development. I have briefly presented some of the significance of the ongoing international work of standardization related to data exchange formats and formal modeling of courses, learning resources, students, and more, which, I argue, is of great pedagogical and institutional relevance. Hence, we need more pedagogues who can analyze and participate in developing digital learning environments, who are familiar with the "technical stuff" and with the "inside" of computer media in general. The mutual fertilization of these three fields of inquiry may result in a reconfigured version of media studies, or of pedagogy, or of informatics—or of all of them. Perhaps most importantly, such a merging of perspectives will very likely result in more relevant standards.

Although semiotics represents one approach to the grammar of digital media, the political and institutional contexts of these very media (in the case of strategically important but also controversial issues of campus-wide infrastructures and distributed learning) must not be considered noise in the research design, but rather constituent properties of media in use, in which different actors advocate interests. These processes may be altered, developed, and influenced (by research, which also constitutes interests) as well as described and understood by means of ANT, an extension of the semiotic study of artifacts as texts invested with model readers and inscriptions. It is on this media-in-use level that much of the institutional struggle for integrating digital media in the learning processes in higher education is conducted. Again, this implies a demand for educational theorists and practitioners with insights into the potentials of digital media. It also implies a demand for pedagogues who are able to align digital technology with education and technologists with teachers and department administrators.

The merging of perspectives on digital learning environments as an object of reflection and action is relevant and needed because of properties of the object itself. To get a grip on and contribute to this phenomenon calls for an expansion of the portfolio of conceptual tools. But there will

evidently also be an impact on the disciplines sharing their tools in common effort. A conceptual and methodical common ground must and will be established, so that major terms and analytical language refer to the same phenomena. Here too the process is one of alignment, because disciplines tend to stick to their premises and worldviews. Many central terms have currently varying meanings. The term "standard" itself has variations of interpretation. Of twelfth-century Germanic origin with the sense of "rallying point" and "flagpole," something to use as a common point of reference and measurement, the term now refers in common language to a model or example established by consent or custom. The sense of the term in this chapter is clearly the one used in informatics and computer science, in the slightly metaphorical sense of "grammar." My observation is that both educationalists and media theorists often associate the term with uniform surface behavior, rather than more profound systemic premises. In general a core body of terms, concepts, and analytic procedures must to some degree together also become somehow standardized, in order to support coordinated efforts.

Lingua Franca

In the Middle Ages, when travelers, knights, and merchants from many countries met by water holes, by campfires, in marketplaces and other "rallying points," they obviously needed means of communication. The challenge was addressed by establishing the vocabulary and the grammar needed in a linguistic common denominator: a shared platform, a *standard*. Words and grammatical constructs were borrowed from existing languages and redeveloped, which in the eastern Mediterranean implied dialects of southern France and Italy, hence "lingua franca." Now goods could be traded, stories and curses could be exchanged, and social complexity and cooperation between participants from widely different languages and cultures could take place.

Today a set of standardized data models, common representational formalisms, interfaces among processes, exchange formats, and agreed-on middleware mechanisms in higher education at large may constitute a lingua franca for communication, cooperation, and coordinated complexity between component systems and media tools within and across institu-

tions. Likewise, a set of shared and, to some degree, standardized concepts and methodologies, as well as shared competencies, practices, theories, and research questions across media studies, pedagogy, and informatics, may make up a necessary academic lingua franca for reflection and action.

Acknowledgments

Thanks to my colleagues at the Center for Information Technology Services at the University of Oslo, Bjørn Ness, Hallgerd Benan, Jarle Ebeling, Kjartan Müller and Stefanie Jenssen for their critical reading of versions of this chapter, and to Andrew Morrison of InterMedia and Gunnar Liestøl of the Department of Media and Communication for even more critical reading and invaluable editorial input.

Notes

1. Informatics in its Scandinavian brand includes but exceeds computer science in that its domain of interest is information processes, whether in computers, in nature, in humans, or in organizations.

2. There are many vendors of such systems (cf. Atkinson 2001).

3. Bibliographic information: title, author, etc.; content description: genre, type of publication, theme, search terms, abstract, etc.; administrative information: property rights, organizational belonging, time of expiry, etc.

4. If authors can invent metadata values without constraints, it eventually becomes close to impossible to search them in any effective manner.

5. Some of the initiatives and consortia currently most important in the field of international standardization related to digital learning environments are the Airline Industry Computer Based Training (CBT) Committee (AICC 2001), the Instructional Management Systems Global Learning Consortium (IMS 2001), the Institute of Electrical and Electronic Engineers Learning Technology Standards Committee (IEEE 2001), the Advanced Distributed Learning Initiative

(ADL 2001), and eduPerson (EDUCAUSE 2001). Together these initiatives, which include major industy and governmental actors worldwide, such as the U.S. Department of Defense, the U.S. airline industry, large software companies, and the European Union, address all the crucial issues involving standards related to modeling, describing, and assembling content, student, faculty, and course objects and for exchanging such objects between systems for reasons illustrated above. I here merely refer the reader to one of the many excellent overviews with links to the primary sources, Hodgins and Connor 2000.

6. "Signifying codes are systems of signs. They have a number of units from which a selection is made. This is the paradigmatic dimension. These units may be combined by rules or conventions. This is the syntagmatic dimension. All codes convey meaning: their units are signs which refer, by various means, to something other than themselves" (Fiske 1990: 64–65).

7. Compare "The concept of text in its broadest sense refers to message of any code" (Nöth 1995: 331).

8. Eco explains that "to organize a text, its author has to rely upon a series of codes that assign given contents to the expression he uses. To make his text communicative, the author has to assume that the ensemble of codes he relies upon is the same as that shared by his possible reader. The author has thus to foresee a model of the possible reader (hereafter Model Reader) supposedly able to deal interpretatively with the expressions in the same way as the author deals generatively with them. At the minimal level, every text explicitly selects a very general model of possible reader through the choice of a specific linguistic code" (Eco 1979b: 7).

9. "The humanities may be defined as those disciplines primarily devoted to the study of texts . . . the humanities are connected by their common interest in communicative objects, or texts. Human beings are text-producing animals, and those disciplines called "humanities" are primarily engaged in the analysis, interpretation, evaluation, and production of texts. Where there are texts, of course, there are rules governing text production and interpretation" (Scholes 1982: 1).

10. The contribution on the part of informatics to the interdisciplinarity I am advocating obviously goes far beyond ANT and includes computer science.

References

ADL (2001) *ADL: Advanced Distributed Learning.* Available at ⟨http://www.adlnet.org/⟩.

AICC (2001) *AICC: Airline Industry CBT Committee.* Available at ⟨http://www.aicc.org/⟩

Atkinson, R. (2001) *Course Server Software for Online Teaching.* Perth, Australia: Murdoch University. Available at ⟨http://cleo.murdoch.edu.au/teach/guide/res/examples/course-servers.html⟩.

Ciborra, C. U., K. Braa, A. Cordella, B. Dahlbom, A. Failla, O. Hanseth, V. Hepsø, J. Ljungberg, E. Monteiro, and K. A. Simon (2000) *From Control to Drift: The Dynamics of Corporate Information Infrastructures.* Oxford: Oxford University Press.

Eco, U. (1979a) *A Theory of Semiotics.* Bloomington: Indiana University Press.

Eco, U. (1979b) *The Role of the Reader: Explorations in the Semiotics of Texts.* London: Hutchinson.

EDUCAUSE (2001) *eduPerson Object Class.* Available at ⟨http://www.educause.edu/eduperson/⟩.

Feenberg, A. (1999) *Questioning Technology.* London: Routledge.

Fiske, J. (1990) *Introduction to Communication Studies.* 2nd ed. London: Routledge.

Fronter (2000) Classfronter. URL: ⟨http://fronter.com⟩.

Hanseth, O., and E. Monteiro (1998) *Understanding Information Infrastructure.* Available at ⟨http://www.ifi.uio.no/~oleha/Publications/bok.html⟩.

Hodgins, W., and M. Connor (2000) "Everything You Ever Wanted to Know about Learning Standards but Were Afraid to Ask." *LiNE Zine* (Fall). Available at ⟨http://www.linezine.com/2.1/features/wheyewtkls.htm⟩.

IEEE (2001) *IEEE Learning Technology Standards Committee (LTSC).* Available at ⟨http://ltsc.ieee.org/⟩.

IMS (2001) *IMS Global Learning Consortium.* Available at ⟨http://www.imsproject.org/⟩.

Jonassen, D. H., and S. M. Land (eds.) (2000) *Theoretical Foundations of Learning Environments.* Mahwah, NJ: Lawrence Erlbaum.

Koschmann, T. (1996) "Paradigm Shifts and Instructional Technology." In *CSCL: Theory and Practice of an Emerging Paradigm.* Mahwah, NJ: Lawrence Erlbaum, 1–23.

Latour, B. (1987) *Science in Action.* London: Open University Press.

Law, J. (1986) "On the Methods of Long-Distance Control: Vessel, Navigation and the Portuguese Route to India." In J. Law (ed.) *Power, Action and Belief,* London: Routledge & Kegan Paul, 234–263.

Nöth, W. (1995) "3.1 Definitions of Text." In *Handbook of Semiotics.* Bloomington: Indiana University Press, 331–332.

Scholes, R. (1982) *Semiotics and Interpretation.* New Haven: Yale University Press.

4

The Internet and Its Double

Voice in Electracy

Gregory L. Ulmer

How to give a lesson online? In what voice? What mood or modality? What tone? The pedagogical tone of literacy will not do for electracy (which is to the digital apparatus what literacy is to print). The chief legacy of literacy is the insight that every practice institutionalized in our schools today had to be invented, just as the technology of alphabetic writing had to be invented. The challenge now is to do for electracy what Plato and Aristotle and their students and heirs did for literacy: to invent the categorical order of electracy.

The method I propose to use is that of the remake, applied to a specific modern performance practice. The success of the remake in other registers of arts and letters (from James Joyce to Hollywood) makes it worth trying as a way to move writing into electracy. Commentators explain that a film is remade when its themes resonate once again with the social or historical circumstances existing in the culture. The remake remains conceptual, in the sense of "conceptual art"—a practice for transforming concepts into performances. The new version is evoked by means of conjectures about it, and in this way the "performance" emerges within a text.

The Cough

The remake is a way to give and take lessons online. In this time of transition, I imagine myself giving a lesson to student-citizen-netizen-denizens. A feel for giving lessons online might be acquired by performing a remake of Antonin Artaud's notorious lecture at the Sorbonne (1933) in which he presented a chapter from what was to become his book, *The Theatre and Its Double.* Artaud used a metaphor to convey the nature of stage drama. He compared the experience and function of theater in the cultural and spiritual life of a society to the experience and role of plague. Such a theater he called a "theater of cruelty." The following excerpts from Artaud's (1958) manifesto show the analogy and its rationale:

> The state of the victim who dies without material destruction, with all the stigmata of an absolute and almost abstract disease upon him, is identical with the state of an actor entirely penetrated by feelings that do not benefit or even relate to his real condition. Everything in the physical aspect of the actor, as in that of the victim of the plague, shows that life has reacted to the paroxysm, and yet nothing has happened.
>
> Between the victim of the plague who runs in shrieking pursuit of his visions and the actor in pursuit of his feelings, between the man who invents for himself personages he could never have imagined without the plague, creating them in the midst of an audience of corpses and delirious lunatics and the poet who inopportunely invents characters, entrusting them to a public equally inert or delirious, there are other analogies which confirm the only truths that count and locate the action of the theater like that of the plague on the level of veritable epidemids. . . . Extending this spiritual image of the plague, we can comprehend the troubled body fluids of the victim as the material aspect of a disorder which, in other contexts, is equivalent to the conflicts, struggles, cataclysms and debacles our lives afford us. (24–25)

The event of Artaud's lecture survives in this description by Anaïs Nin: "But then, imperceptibly almost, he let go of the thread we were following

and began to act out dying by plague. No one quite knew when it began. To illustrate his conference, he was acting out an agony. . . . No word could describe what Artaud acted on the platform of the Sorbonne. . . . His face was contorted with anguish, one could see the perspiration dampening his hair. His eyes dilated, his muscles became cramped, his fingers struggled to retain their flexibility. He made one feel the parched and burning throat, the pains, the fever, the fire in the guts. He was in agony. He was screaming. He was delirious. He was enacting his own death, his own crucifixion" (Weiss 1990: 56).

In my remake the agony is not *La Peste* but something more modest, even abject—a café coronary, or choking to death on one's meal in a bar and grill—which is the double not of theater but of the Internet. Artaud's approach was literal. For me the action is transferred into the tone or mood of the scene. I look for something in keeping with Sylviane Agacinski's (1991) admonition to ask, "as a very serious question, why Kant tolerated neither coughing nor sneezing (and no doubt, in all likelihood any sort of spasm). Indeed, it seems that the autonomy of a subject that coughs is, if not gravely, at least distinctly weakened. A free subject must know how to prevent itself from coughing" (17). To cough or not to cough, however, is not always a matter of choice.

Mise-en-abyme

It is possible to state my purposes—the principles motivating instructions given online—in practical terms. The object of study appropriate for English language and literature is such things as voice and mood (linguistic concepts) to understand what happens to them and how to use them in an electronic apparatus. The material of the research, voice in this case, may be quickly identified in any handbook: "Direct kinds of sentences, active sentences place emphasis on the people and things responsible for actions and conditions. Passive sentences, on the other hand, are descriptive sentences that deemphasize the actors involved and instead focus on people or things that do not act. . . . Notice that the person completing the action can be totally absent from a passive sentence. . . . Because human choices and actions determine much of what goes on around us, give the credit or blame to the people responsible" (Perrin 1987: 268).

How is instruction in these and other grammatical categories affected by the theoretical debates surrounding such questions as "who comes after the subject," debates that make it difficult to ascertain who or what is responsible for anything? (Cadava and Nancy 1991). Another grammatical category extended into electracy is mood: "Mood, indicated by verb form, refers to the way writers present their ideas and information. Sometimes writers want to stress the factuality of information (indicative mood). Sometimes they want to give commands (imperative mood). Sometimes they want to stress that information is conditional or contrary to fact (subjunctive mood)" (Perrin 1987: 210–211).

"Voice" is sometimes used as a metonym for "style," as when writers are urged to "find their own voice." Theorists have been discussing for some time the emergence in experimental literature of a middle voice, expressing a condition in which the subject of the sentence is its own object. The question is not "attitude toward" but "state of mind" framing and shaping these intentions. The stand is neither active nor passive but "middle"—reflexive. This reflexivity is made collective (interlinked and amplified) by means of the Internet. The nature of the middle voice may be understood by means of an analogy with the Heimlich maneuver.

The Heimlich maneuver is for this inquiry what a scientist might call a model. In this remake the Heimlich maneuver is a miniaturization used to guide research into virtual voice. It is a found theory, selected first of all because of the accident, the contingent fact that the doctor who invented this procedure is named Heimlich (such is the method). It is difficult for anyone familiar with modern critical theory not to think of Freud's concept of the uncanny (*Unheimlich*) when they think of Dr. Heimlich's procedure. The exchange between proper names and common nouns (antonomasia) is a common linguistic and literary event. Only recently, however, have theorists begun to use this property of language heuretically, that is, not only hermeneutically but generatively in the invention and solution of disciplinary problems (heuretics).

In the logic of electracy everything to do with *Heim* is relevant to the design of the home page. For Heidegger, concerned with the fundamental problem of our time as the refusal to be (to be able to live with the proper mood of Being, which is anxiety before death), *Heimweh,* because of its association with boredom, provides access to the theme of the uncanny

(Krell 1992: 109). "The unhomelike home of Da-sein is of course what phenomenology calls world. Whether earnestly anxious or bored silly, Da-sein is not at home, is ill-at-ease" (110). It will do little good to inform students that the homesickness or boredom they feel are signals of a more fundamental mood, an anticipation of mortality, "an impossible mourning that is always and everywhere a Sehnsucht, a languor and a longing" (134). Indeed, that is the entire problem and possibility of the computer as the tool that supports tuning thought with feeling. Students will have to write this encounter themselves, testing the voice that exploits a slippage through the multiple meanings of "mood" and modality.

Even though I accept as a given skepticism toward philosophical arguments, we still need to review the immediate disciplinary materials of our uncanny analogy. The homonym or antonomasia linking Heimlich with *Unheimlich* across the registers of the pop cycle (the set of institution/discourses: Family, School, Entertainment, Career-Discipline) offers an immediate target for investigation. A heuristic (borrowed from structural linguist Roman Jakobson) is *whatever resembles, assembles.* What is the condition addressed by the *Unheimlich* maneuver? Both Freud and Heidegger were influenced in their choice of the term *Unheimlich* by their readings of Schelling (who defined the uncanny as something which ought to have been kept concealed but which has nevertheless come to light) and the other German Romantics who thought of life in terms of a circuitous Odyssean round-trip home. The anxiety that marked the fundamental mood of Being in Heidegger served rather for Freud as a symptom of repression. The feeling of dread he identified as the uncanny arises in our experience of encountering "something familiar and old—established in the mind that has been estranged only by the process of repression." The multitude of different experiences that produce in us the uncanny effect all turn out to be transformations of a more basic experience (he inscribes the Odyssean circuit into our biology): "This unheimlich place is the entrance to the former heim [home] of all human beings, to the place where everyone dwelt once upon a time and in the beginning. There is a humorous saying: 'Love is home-sickness'; and whenever a man dreams of a place or a country and says to himself, still in the dream, 'this place is familiar to me, I have been there before,' we may interpret the place as being his mother's genitals or her body. In this case, too, the unheimlich is what

was once heimisch, homelike, familiar; the prefix 'un' is the token of repression" (Freud 1958: 152–153). Fortunately, perhaps, in the scene we are examining, Freud's concept of "home" is but one more example in a series that it would be difficult to bring to a close. The relevance for electracy is the desublimation in Freud's comparison, the deflation of an idealized experience into an abject corporeal memory.

The Donor

The Heimlich maneuver has much to recommend it as a found theory, such as the fact that our society has been saturated with instructions for performing the maneuver, which are printed not only in first-aid manuals, but also in almanacs, pocket calendars, and any medium that might be handy in quotidian circumstances. The procedure is taught in the public schools as early as elementary school and may be by now the one piece of information that everyone in society knows, understands, and accepts. The nature of subjectivation in electracy is such that it gathers around these modest common denominators.

The first instructions for employing the model as a guide are that Internet writing is like giving (receiving) the Heimlich maneuver. How to read the first-aid instructions as an allegory of home page design? The home in question is virtual, for the virtual person that I am online. The entire scene surrounding the Heimlich maneuver is relevant for grasping this virtuality—not only the details of the technique itself (the repeated upward thrusts to the abdomen to eject a piece of food that has become lodged in the throat causing choking, suffocation, and death), but the theater of the café and its place in the life story, the need to eat, the kind of food desired, the choice of place to go, with whom, through to the rescue, the condition of the victim who may become unconscious during the episode, the delivery of first aid either by a companion or, as often happens, by a complete stranger, either another guest or the host of the establishment. If the relevance of this vernacular theory seems questionable, one need only refer for reassurance to a best-selling guide to online design, *Creating Killer Web Sites:* "I use a restaurant metaphor when thinking about sites. You hear about a restaurant from an advertisement or a friend, or discover it while passing by. Once through the door, you make

a quick stay-or-bail decision. In a popular restaurant, you might have to wait for a table. If you stay, someone shows you to a table and hands you the menu. You make your selection. When the food arrives, you have no urge to rearrange the various items on the plate. The food and presentation are the creations of the chef. You sample the various items, skipping among them, mixing flavors and textures. When you are finished, you have dessert, ask for the bill, and pay" (Siegel 1996: 28). This experience in the cafe is meant to illustrate a "third-generation" Web site design that "pulls visitors through using metaphor and well-known models of consumer psychology" (29). Despite the title of his book, Siegel obviously does not consider it relevant that a diner might choke to death before dessert is served, although in actual restaurants it happens all the time. In fact the most important feature of this interface metaphor for our purposes is the possibility of the café coronary.

To use interbody (beyond interface) metaphors, students need to manipulate language, to think figuratively. Therefore we begin modestly with a proportional analogy: the Heimlich maneuver is to the physical person what the *Unheimlich* maneuver is to the virtual person. The rhetorical maneuver involves mapping a relationship between first aid and the uncanny and applying the results as figurative instructions for online composition. In practice the construction of these instructions is not a step-by-step linear development but more the generation and selection of possibilities out of an intertextual combinatorial matrix. Perhaps the most immediate point of contact between the physical and virtual planes, besides the names covering the two concepts, is the recurrence on both sides of the analogy of the term "unconscious." Before considering the administration of treatment, however, I need to determine the setting in which the accident takes place. Where is the virtual scene of the café coronary?

The answer to this question, along with some guidance in the operations of dramatic scenes in general, comes from another discourse of the pop cycle: Entertainment. The students and I are as habituated to the economy of Entertainment as we are to that of Family. The narrative form that organizes much of the product that circulates in this economy is embodied in the ancient myth of the hero, which is to say that popular-culture cinema and television manifest the Odyssean circle of departure from and return to the self that organizes the canon of high culture, or

what was originally folk culture. A guide to mythic structure for story-tellers and screenwriters, authored by Christopher Vogler (described as having in his capacity as story analyst and consultant for Hollywood evaluated over 6,000 screenplays) is based on Joseph Campbell's *The Hero with a Thousand Faces*. Vogler's guide functions both hermeneutically and heuretically, as a way to analyze existing screenplays or to author new ones. Vogler's guide reflects the conventional wisdom of most such handbooks. This discourse, like the other ones in the pop cycle, operates around the creation, exploration, and solution of problems:

> Act I,1—the subject or protagonist begins in the ordinary world in which everything is normal and according to plan and expectation. 2—The call to adventure: the subject is presented with a problem or challenge that will change her destiny. 3—The reluctant hero: the subject experiences fear of the unknown or fear of outside forces. 4—The wise one: a mentor gives guidance and support to the subject.
> Act II, 5—Into the other world/the first threshold: having decided to accept the challenge, the subject enters into action (begins a journey). 6—Tests, allies, enemies: many times the subject is able to glean information pertinent to this other world and to the adventure ahead in out-of-the-way gathering places. 7—The inmost cave/the second threshold: the subject comes to a dangerous place (mythically the land of the dead). 8—The supreme ordeal: at this step the subject must seem to die so that he can be born anew. 9—Seizing the sword: the subject takes the prize (the object of the search). 10—The road back: the subject uses his new wisdom to deal with the consequences of his actions, and declares a desire to return to the ordinary world. Act 3, 11—Resurrection: the villains make one last unsuccessful attempt to defeat the subject. 12—Return with the elixir: the subject returns with a token of the journey. (Vogler, summarized in Kosberg 1991: 79–83).

The matrix coming into formation here might give rise to considerable discussion. Someone might notice that the café coronary allegorizes this myth of the circular journey to and from the land of the dead that

organizes so much entertainment. Thus the *Unheimlich* maneuver might be compared with the Zen pedagogy of nearly drowning the pupil and then telling her that she should desire truth as much as she desired air while her head was under water. The experience of suffocation—the blocking and clearing of the passage of breath—is a miniaturization of the experience of truth. I learned from this popular economy that the time and place of the screen (the virtual diegesis) may be found at the halfway point of Vogler's outline, at the early stages of the second act.

Part of the point for locating screen voice as just one site in the story, rather than as the setting for the entire narrative, is to clarify the goal, which is to learn how to write holistically, to tune together the economies (the voices) of the pop-cycle institutions. Digital technology can do more than support the specialized discourse of Discipline. It is capable, in fact, of bringing into correspondence all the discourses of the pop cycle. "Storytellers use this phase to test the hero, putting her through a series of trials and challenges that are meant to prepare her for greater ordeals ahead" (Vogler 1992: 158). The tests help the subject learn the new rules of the special world, rules that must be mastered quickly. "Why do so many heroes pass through bars and saloons at this point in the stories?" (162). In the myth, with its origins in a nomadic civilization of hunter-gatherers, this moment occurred at a watering hole rather than a bar. The bar can stand for a microworld through which we must all pass. Bars also provide spaces for music, gambling, and flirtation.

A more electrate name for a home page is "barscreen." It is helpful in trying to extract pedagogical instructions from this relay to refer to Vladimir Propp's description of the Wondertale (Propp 1984: 162). For Propp the basic unit of meaning in the narrative is the function (not the subject or the object, which may be filled with any number of different people and things). He also showed that the deep structure of narrative is a combinatorial supporting great surface flexibility of content. The bar scene that Vogler found in so many entertainment films is, in the Wondertale, the hut of Baba-Jaga, the Lady of the Forest. "Morphologically, the hut represents the abode of the donor (that is, the personage who gives the hero the magic tool)" (Propp 1984: 89). The donor function is central to online instruction. The online instructor is not the mentor that

she might sometimes be in the classroom. The assignments required in the classroom are the equivalents in the narrative of the tests and trials of the bar or hut. "The donor is a blend of hostile and hospitable qualities. Ivan is usually fed in the donor's abode" (Propp 1984: 89). If the subject passes the tests the donor supplies him with the magic tool, the talisman or device, that may be used in the supreme ordeal. Such too is the relationship of school to the other economies: the test of school is not the supreme ordeal in the students' life stories, but preparation for it. And what is the magic tool?

The virtual class accesses the teacher's barscreen on the Internet (MOO or Web). It is a bar with the functions of the hut of Baba-Jaga. As in a dream, each logger in the forest of symbols plays all the parts in the scene at one level, whereas at another level the position of each is determined by one's position in the other discourses of the pop cycle. This virtual bar belongs to all and to none of the four primary economies that converge here and whose tuning is now possible because of the computer. Or rather, the bar is the "see" of the Street institution, providing informal, unofficial settings for the outsiders and outlaws at odds with the primary discourses.

The topic may be researched at any level since the guiding thread is not a thesis, a content, an argument, but a series of signifiers: "voice," for example. Explaining Heidegger's point that astonishment is the fundamental condition of the philosopher, Ned Lukacher (1986) introduced an important sense of "voice" for electracy: "Heidegger chooses 'Stimmung' to translate pathos because 'Stimmung' derives from 'Stimme,' which means voice. Astonishment is thus a tuning in the sense of pitch or tone, and to step back is to be restrained or held by a certain tone. The retreat is a way of taking up a position, a dis-position, in relation to the voice of Being" (255). The difficulty for my design is that the astonishment results from the recognition that language relates to what-is in a mode of concealment (256). Nonetheless, this "astonishment," however temporary its effect, may hold the place for the state of mind to be discovered in the virtual bar (the experience of the uncanny).

I accept for now the lesson showing the scene of teaching and learning as that of the encounter of a secondary if powerful character who frequents the bar with a protagonist of a Wondertale. I understand that,

whatever our relationship might be in the pop cycle, online the parties inhabiting these functions are interchangeable, multiple. The assignment set in the economy of School has the force in popular or folk narrative of the task imposed by a magic troll. The drama is collective, interactive, engaging instructors as much as students. The temptation or intuitive preference on all sides is to avoid this encounter. I am ambivalent about responding to what the narrative model classifies as the call to adventure or the philosophical model names the call of Being. "At the origin of the subject is the voice (*Stimmung*). . . . We do not know what the voice is that we are concerned with here, nor what it says, if it says anything. We do not, moreover, know whether it calls and how it does so" (Courtine 1991: 79). *Dasein.* Conscience. Superego. The collective in me, the voice that speaks me.

Gift

If Entertainment provided a dramatization of my barscreen, the discourse of Discipline provides the theory. What is this hut of Baba-Jaga, this bar, in theoretical terms? "Mystory" is the superimposition of these discourses one upon the other, forming a database of whatever repeats. Using the Heimlich maneuver as a vehicle for an allegory allows me to thematize and thus pursue my design in a concrete way. The bar that this metaphorical investigation turned up, however, is theoretically the bar as such productive of figuration itself. The methodological principle derives from the arts (poetry, design). "Bar" as signifier and shape (*eidos*) gathers heterogeneous information into a set. In Jacques Lacan's structuralizing of Freud's discovery, his assimilation of the logic of dream work to the operations of rhetoric (condensation and displacement as metaphor and metonymy), Lacan made it possible to write a matheme or formula in which the unconscious could be represented as a bar in an algebraic formula. "The sign— placed between () represents the maintenance of the bar—which, in the original formula S/s marked the irreducibility in which, in the relations between signifier and signified, the resistance of signification is constituted" (Lemaire 1977: 194). The symptom is an unconscious metaphor (198). "Bar" as a verb names the operation of repression: "Foreclosure never conserves what it rejects; it purely and simply crosses it out or bars

it" (231). This bar marks the split in the subject: "The 'I' of discourse is radically separated from the Other of the subject, the unconscious. As a mediator, language distances the 'I' which speaks and believes itself to be telling the truth about its essence from the unconscious reality which founds it in its truth" (215). This gap between truth and knowledge may not be closed, a condition that constitutes the fundamental aporia of learning. At the same time, the gap of all gaps makes possible what it prevents: the inferential orientation directs me, albeit asymptotically, toward learning.

My design is motivated theoretically by the proposition that the computer is the prosthesis that makes it possible for groups meeting in a virtual bar to write the unconscious. I am using mystory (a passage through the pop cycle) to think electracy within the remake of Artaud's lecture. Entertainment supplied the function of donor. Discipline supplies theoretical instructions for how to give or how to make a gift, how to perform my function, in Jacques Derrida's *Donner le temps* (translated as "Given Time"). The lesson is to be "given" in this sense. The model shows me that my students and I are already underway in a complicated braid of narratives, all of which are organized as Odyssean circles, whose economies individually are the restricted ones of contract, exchange; but what is the economy of the braid as a whole? Theorizing how to interrupt this circle, break its rhythm, twist or wrench its line, Derrida sketched out an account of a certain conduct of narrative that is the key to giving the magic tool to my students (to myself in the middle voice). At the same time I am doing what I am saying; I give the magic tool by finding it.

Derrida's strategy is not to oppose the restricted economy: "One must in a certain way of course, inhabit the circle, turn around in it, live there a feat of thinking, and the gift, the gift of thinking, would be no stranger there" (Derrida 1992: 9). What is at steak (*sic*), here, if it is possible to generalize in this way, is that the students experience the "general economy" (to use Bataille's term for the other of "restricted economy"). The general economy, that is, puts the restricted economy of accumulation into the context of collective global energy expenditure. Although death is meaningless in the latter perspective, the individual might understand the juxtaposition of the two economies by means of the saying "You can't take it with you." Indeed, while speaking at this level of high abstrac-

tion, I could summarize the lesson of philosophy in one word: death; or in the relation between Being and Death, understood not in abstract but in personal terms. Wisdom is learning how to die (as Artaud is showing us all this time).

The problem for my design, which aims at tuning ideation and emotion, is that it is not possible to "live" one's own death (but it is possible to write it). Derrida works carefully through the paradoxes that proliferate in the neighborhood of thinking about death. It has to do with time, and the pun on the gift as "present" is prominent in the discussion, whose modality he says is "perhaps," which I am pushing into the virtual. The goal of the gift is to put the circle of *oikos* in contact with its exteriority, which puts it in motion (Derrida 1992: 30). How does the gift affect my pedagogy? Into the logic of my argumentation I insinuate the paradoxes of aporetics. "Everything seems to lead us back toward the paradox or the aporia of a nuclear proposition in the form of the 'if . . . then': if the gift appears or signifies itself, if it exists or if it is presented as gift, as what it is, then it is not, it annuls itself" (26). Such is the logic of the dilemma that organizes contact between language and its referent.

Aporia is defined as "the point at which the problematic task becomes impossible and where we are exposed, absolutely without protection, without problem, and without prosthesis, without possible substitution . . . in this place of aporia, there is no longer any problem" (Derrida 1992: 12). Some synonyms for what "aporia" names are "barred path"—the feeling of "I'm stuck, I cannot get out, I'm helpless" (13). Such is the movement required for the education of mood: a passage from homesickness to aporia, keeping in mind that I am talking about how to give a lesson on the Internet. The paradox of giving a gift is that for the gift to be a gift there must be no return whatsoever; the moment calculation enters into it, as in the instance of alms, for example, one is back in the circle of exchange. To apply the paradox to Discipline requires contrasting the qualities of the gift with the qualities of method. The tools of method, such as concept formation, gather and classify, create distinctions, whereas the gift disseminates and crosses all lines.

Gift is to electracy what communication is to literacy. The most difficult lesson for learning how to give a course in the modality of gift is the observation that "the death of the donor agency (and here we are

calling death the fatality that destines a gift not to return to the donor agency) is not a natural accident external to the donor agency; it is only thinkable on the basis of, setting out from the gift" (Derrida 1992: 102). For the lesson to be received I must not communicate it (its effect is unreceivable in the economy of exchange; it may not be defined). How to structure a narrative situation in the mode of gift? The answer is easy enough to state: "There must be event—and therefore appeal to narrative and event of narrative—for there to be gift, and there must be gift or phenomenon of gift for there to be narrative and history. And this event, event of condition and condition of event, must remain in a certain way unforeseeable. The gift, like the event, as event, must remain unforeseeable, but remain so without keeping itself. It must let itself be structured by the aleatory. . . apprehended as absolutely surprised by the encounter with what it perceives, beyond its horizon of anticipation" (122).

Mourning

The virtual bar is designed so that the tuning of discourses that it makes possible generates a surprise, an event, that figures the writing of the unconscious. Nor is it a question of preparing a surprise for someone else. Rather, taking into account the timing of differance and aporia, the subject—teacher or student or dean or citizen—addresses itself from across the bar (the split subject). The logic of this encounter is generated by the syntagm "my death," which helps clarify the logic of the expected surprise that constitutes the instructions for my design. I have a rendezvous at the bar, which is a meeting with the other and with myself (the self-relation of identity). "Both the one and the other never arrive together at this rendezvous, and the one who waits for the other there, at this border. . . . In order to wait for the other at this meeting place, one must, on the contrary, arrive there late, not early" (Derrida 1993: 66).

The method I am attempting to perform tells me where to look for at least a simulation (miniaturization) of the surprise. The combination of the key terms of the preceding discussion—"donor" and *donner* (to give)—create a pattern that evokes a third term: Donner (the proper name). The Donner Party was eighty-seven people in a wagon train trapped by winter snowfall trying to enter California through the passes

of the high Sierras in1846. Does this allusion only seem to be a feeble joke or choke: Derrida at the Donner Party (high concept)? The mnemonic skit would be: having a café coronary at the Donner party, while dining on one's own mother. This scene is not difficult to think theoretically (after Freud). It is a different matter to take responsibility for it— to sign it as mine, emotionally. But memorability is only one feature of this luck. The gift does not go outside the circle of *oikos,* but it inhabits the circle in this aleatory, interruptive way. The surprise redirects and displaces the movement of the circle, spinning it or resetting its heading, depending on how the aleatory becomes motivated in an oscillation between sense and non-sense. The surprise turns to learning by filling the gap with an associative sequence (secondary elaboration).

I was astonished to find the Donner Party. Knowing how the puncept works (conductive logic, dream work) does not ruin the surprise. The legend of this failed emigration, of this interrupted journey, supplies the discourse—history—that was missing from the pop cycle in this mystory. The students may be expected and required to find on their own (research) the three principal versions of their subject: mythological (learned in Entertainment), historical (learned in School), and personal (learned in Family). We learn history from textbooks, in those mandatory civics courses or reviews of state history offered in K–12. The Donner Party, however, is notorious enough to have migrated into popular culture (Entertainment). The key to the performance of voice, of course, concerns "responsibility": the students must recognize what they find as their "own" (the uncanny): the Donner Party "in me."

Having found the Donner Party, it remains to be seen if I may learn anything from the problem it recounts, to put its problem in tune with the ones driving the other circles using the conventions of literate research. Behind such problems and their solutions in the restricted economy remains the aporia and its impossibility in the general economy. The party begins as a story firmly within the circle of *oikos:* "All of us of the Donner Company had set out for California with the same ambitions and from the same motives. We had no thought of exploring unknown regions as Captains Lewis and Clark had done, of trading with the Indians like General Ashley and his men, of advancing the frontiers of our country. . . . We were self-seekers, hungry for new farming lands, considering only

ourselves and the material benefits to be gained by emigration to the far West. . . . We sought free acres and easy living in distant California, and that search had ended in stark tragedy. Why?" (Birney 1934: 239). It is a story of event and of the unforeseeable, bringing into focus the element of luck and chance, fate and necessity. The hindsight of history saturates the record with dramatic irony. The chief opponent of the group, says the historian, was "time." If they get to the Sierras by September, all should go well. "But let it come late October, or November, and the snow storms block the heights, then will come a story" (Stewart 1960: 5). Their late arrival at the pass, that is, created the narrative. The party thought it could save time by going to California by a more direct route, thus ignoring the wisdom of the trail couched in the saying "the longest way round is the shortest way home" (11).

The pedagogical challenge specific to the humanities is to understand what is impossible to think, whose relay is "my death." The goal is to braid or twist this spiritual strand into the practical exchanges of *oikos:* to braid the perspective of the general economy into the restricted economy. The magic tool for making this twist in understanding, the twist that creates reflection, reflexivity, is figuration, figurative language or discourse: image. The hut of Baba-Jaga, for example, is in this history thematized as the cabins and tents of the members of a fateful company. The meal consumed is the flesh taken from the dead, keeping in mind throughout the parallel processing of dinner table with truth table. The details form a strong image to mark and memorialize as a screen memory the trauma, the anxiety, of the not-at-home, as in the scene encountered by the relief parties. "Suddenly they stood upon the brink of a great cup, twenty-five feet deep, melted into the snow. At the bottom, the fire burned upon a space of bare ground as large as an ordinary room, and about it was a jumble of blankets and children and hideous things. . . . The body of Mrs. Graves lay there with flesh nearly all stripped from arms and legs. Her breasts were cut off and her heart and liver taken out, and all of these were boiling together in a pot upon the fire. Her year-old baby sat wailing, with one arm resting upon the mangled body of its mother. Little remained to be seen of the corpses of two children" (Stewart 1960: 244).

The Donner legend serves as a figure memorializing an emotion. The theory might associate it with one or the other fundamental dread,

embodied or abstract—of castration or *Dasein*. As such it participates in the larger interbody metaphor giving access to the question of the subject. The *Unheimlich* maneuver is first aid for the condition of subjectivity as such, governed by the syntagm "eating well." It performs what is happening to identity in electracy: "For everything that happens at the edge of the orifices (of orality, but also of the ear, the eye—and all the "senses" in general) the metonymy of 'eating well' would always be the rule. The question is no longer one of knowing if it is 'good' to eat the other or if the other is 'good' to eat, nor of knowing which other. One eats him regardless and lets oneself be eaten by him. The so-called nonanthropophagic cultures practice symbolic anthropophagy and even construct their most elevated socius, indeed the sublimity of their morality, their politics, and their right, on this anthropophagy" (Derrida 1991: 114). Eating is the metonym for the psychology of mourning, of the formation of identity and organization of the body by means of the introjection or incorporation of idealized others: "I am speaking here of metonymical eating as well as the very concept of experience, one must begin to identify with the other, who is to be assimilated, interiorized, understood ideally" (115). Such are the operations of the entry into language.

The Abject

The magic tool is somehow needed for the process of identification as it happens online, which may be assumed to be related to yet distinct from the support given to identification in the other media. The goal of electrate screen design is to create a virtual place capable of simulating or writing this event or ritual or sacrifice for which the subject is prepared by its knowledge of the *Unheimlich* maneuver. The bar has two sides (in several different registers)—"outside" and "inside" (the topology of borders). The difficulty of receiving/giving the gift is in the resistance to the connection between these abstract accounts and the materiality of our object of study: language. "For Derrida," Lukacher (1991) observed, "there is no idealization of the one who is departed that does not leave some inassimilable residue behind, some piece or fragment of the other or the other's speech secretly lodged or incorporated within the mourner's speech or behavior. This is also the case with language as such: we cannot take it in without

also coming upon the inassimilable remains of the Other" (12). In speaking "one eats a piece of the word's otherness," called the "bit" or *mors,* "the 'piece' of the dead that one eats in a cannibalistic mourning ritual that is enacted whenever one comes to the word" (12). Is it possible then to choke on such cinder words? And might this eventuality be sufficient explanation for why so many ignore the call with all their strength?

The convergence of discourses in the barscreen reveals the initiation ritual within the problems of Family, School, Entertainment, and Discipline. The site outside these institutions and the one "place" capable of receiving them all (where they all converge) is Street (the bar). To earn the magic tool the subject must complete the trials imposed by the donor encountered at the bar. The function of the humanities is to braid this process of subjectivation into the circular economy of practical life. What does our discipline and our mythology tell us about the trials associated with our assignments? It has to do with the problematic of Oedipus as prototype of the hero's journey. To become a subject requires a battle with and slaying of a "monster" whose imago is the "mother," according to Jean-Joseph Goux. The story of how Oedipus defeated the Sphinx is an exception and not the rule in the mythological representation of initiation into adulthood, for Oedipus took all into his intellect and denied the dimension of magic, of projective belief (Goux 1993: 120). The monster posed a riddle and the reply was a gesture of self-designation. Oedipus skipped the tests of caresses and blows and went directly to the trial by question (62). The supreme ordeal featured in our entertainment narratives figures this struggle to separate from the maternal body and achieve autonomy or identity. Are the representations too violent? "The one who does not kill the female monster in a bloody battle is the one whose destiny is to marry his mother [and murder his father]" (22). Goux also notes the role of the donor as the one who helps the novice complete this task.

Goux's reading—that the myth already knew what Lacan was able to glimpse only with the greatest difficulty (that the paternal castration threat actually protected the child from the more fundamental threat of being devoured by the mother) (Goux 1993: 35)—correlates with Julia Kristeva's theory of abjection. The key point of connection with the magic tool is that according to the myth the novice is swallowed by the monster

and kills (and is killed) from inside—devoured and regurgitated (Goux 1993: 45). The uncanny experience of virtual choking, then, is that it happens from or includes the point of view of the bit blocking the throat. Kristeva agrees with Goux that the trial involves releasing the hold of the maternal chora, and to this extent the encounter is uncanny in Freud's sense (even though she wants to distinguish the abject from the uncanny by saying that the former lacks the aspect of familiarity that is one feature of the latter) (Kristeva 1982: 5). The steak/stake in our context, asking what happens to subject formation in electracy, is that what must be abjected is the "self," understood as the subjectivation specific to the *literate* apparatus. At the same time, the terms of this question, the values and valences of the positions related in this situation, do not remain what they were in literacy.

What is the experience of abjection associated with the semiotic chora (the maternal place and stage in the formation of the subject)? "Kristeva uses the example of the repulsive skin of milk as an example. This skin makes the subject retch and choke because it also represents the subject's own skin, the boundary dividing itself from the world. In other words, the subject chokes on its own corporeal limits, its own mortality" (Gross 1990: 90). To survive and live—to be, to have an identity—the subject must expel from its border the abject. Abjection at the same time—"as an insistence on the subject's necessary relation to death, to animality, and to materiality, being the subject's recognition and refusal of its corporeality"—"demonstrates the impossibility of clear-cut borders, lines of demarcation, divisions between the clean and the unclean, the proper and the improper, order and disorder" (89). In short, abjection reflects the experience of metaphysical metamorphosis—a transformation of the very categories organizing reality, setting the line or border of inside/outside logically, psychologically, politically.

Abjection is a theoretical account of the learning and practice of language and design with special relevance for online production. To be "online" is to occupy this border and even to learn how to "write" with it (albeit no longer as a "self" or "individual"—the identity experiences of literacy). The theory suggests that when we speak and write we are chewing, devouring, choking on, and regurgitating the inassimilable pieces of our identity (our introjected others). Kristeva's special contribu-

tion to this problematic has been her demonstration that it is possible to research this dimension of language through the study and practice of the avant-garde and experimental arts. Her theory has been used to describe what is going on in the fringe counterculture of popular music as well, with such groups as Throbbing Gristle and Cabaret Voltaire. Abjection results when the introjected object (in mourning) "does not adequately fill the rim ['the erotogenic rim which locates the sexual drive in a particular bodily zone is a hole, a gap or lack seeking an object to satisfy it']. A gap reemerges, a hole which imperils the subject's identity, for it threatens to draw the subject rather than objects in it." (Gross 1990: 88). Such is the fringe experience of alienation, the Abjects being those condemned to life in the hole, which they attempt to fill each in their own way. "To each Abject his own abomination. Their condition being the result of their inability to accept society's norms, they find themselves in the realms of the taboo—that is, the unspeakable. They must invent their own language to name the state that so disturbs them" (Kopf 1987: 13). The online students take up this project as well, but virtually, their powers enhanced by the prosthetic unconscious: the Internet.

Imaging

The track of the gift: donor, *donner,* Donner. Voice in electracy is this practice of tuning the pop cycle, referring to the correspondence across the discourses created by such macaronic puns (puncept). With none of the security of correspondences that supported allegory at other historical moments, we are exploring a virtual singular category. The whole is structured by superimposition across the pop cycle. Theory shows me the hole in being and the aporetic condition of gift; School (history) shows me the powerful emotions of pioneers stuck in the passes of the High Sierras, who many times cursed their luck. The scene of this situation dramatizes the condition of "I'm stuck" (the feeling, the state of mind, of aporia). The insight (recognition) arises between the theory describing the principle of aporia and the historical event dramatizing it. The scene that inscribes me into the diegesis depicts two members of the Donner Party attempting to cross the mountain pass: "a mile beyond the pack-animals, the saddle horses failed, too. Refusing even yet to admit defeat with all that it im-

plied, the two fathers dismounted and plunged forward on foot through snow almost to their necks" (Stewart 1960: 101–102).

The relationships emerging around this image constitute the "magic tool." I recognize myself in this scene of the fathers who had gone ahead of the Donner Party wagon train on horseback and then tried unsuccessfully to return to their families, to secure a rescue. I countersign their desperate act, up to their necks in snow, immobilized within total straining, without any other rationale than that I experience this aporetic moment as uncanny (the unfamiliar familiar). I take responsibility for this scene as a found self-portrait of the human condition by signing it and saying "this is me; that is how I feel exactly." Nothing is communicated, but I recognize a feeling inside by means of these found documents that arrived in the mystory "by chance." The information is not addressed, or is only for the one who receives it as a message (like the door of the law in Kafka's story). Metaphor and metonymy, figuration (poetry and design) have the uncanny capacity to find and map the borders of the subject in relation to the collective. What does this attunement or cognitive map suggest about the temper of our times? There was a plague at Thebes when Oedipus submitted himself to the riddling Ker. Artaud performed this plague again to show the theater and its double. In my remake it is not the theater but the Internet; not the plague but a cafe coronary; not a mad actor but a mild academic; not a performance but a text. And yet, do we get the picture?

References

Agacinski, S. (1991) "Another Experience of the Questions, or Experiencing the Question Other-Wise." In E. P. C. Cadava and J.-L. Nancy (eds.), *Who Comes after the Subject?* New York: Routledge, 9–23.

Artaud, A. (1958) *The Theater and Its Double* (trans. M. C. Richards). New York: Grove.

Birney, H. (1934) *Grim Journey.* New York: Minton Balch.

Cadava, E. P. C., and J.-L. Nancy (eds.) (1991) *Who Comes After the Subject?* New York: Routledge.

Courtine, J.-F. (1991) "Voice of Conscience and Call of Being." In E. P. C. Cadava and J.-L. Nancy (eds.), *Who Comes After the Subject?* New York: Routledge, 79–93.

Derrida, J. (1991) " 'Eating Well,' or the Calculation of the Subject." In E. P. C. Cadava and J.-L. Nancy (eds.), *Who Comes After the Subject?* New York: Routledge, 96–119.

Derrida, J. (1992) *Given Time: I. Counterfeit Money* (trans. P. Kamuf). Chicago: University of Chicago Press.

Derrida, J. (1993) *Aporias* (trans. T. Dutoit). Stanford: Stanford University Press.

Freud, S. (1958) "The 'Uncanny.' " In *On Creativity and the Unconscious.* New York: Harper and Row, 123–159.

Goux, J.-J. (1993) *Oedipus, Philosopher* (trans. Catherine Porter). Stanford: Stanford University Press.

Gross, E. (1990) "The Body of Signification." In J. Fletcher and A. Benjamin (eds.), *Abjection, Melancholia, and Love: The Work of Julia Kristeva.* London: Routledge, 80–103.

Kopf, B. (1987) "Bacillus Culture." In C. Neal (ed.), *Tape Delay.* Harrow, UK: SAF, 10–15.

Kosberg, R. (1991) *How to Sell Your Idea to Hollywood.* New York: Harper.

Krell, D. F. (1992) *Daimon Life: Heidegger and Life Philosophy.* Bloomington: Indiana University Press.

Kristeva, J. (1982) *Powers of Horror: An Essay on Abjection* (trans. L. S. Roudiez). New York: Columbia University Press.

Lukacher, N. (1986) *Primal Scenes: Literature, Philosophy, Psychoanalysis.* Ithaca: Cornell University Press.

Lukacher, N. (1991) "Introduction: Mourning Becomes Telepathy." In J. Derrida, *Cinders* (trans. N. Lukacher). Lincoln: University of Nebraska Press, 1–18.

Perrin, R. (1987) *The Beacon Handbook.* Boston: Houghton Mifflin.

Propp, V. (1984) *The Theory and History of Folklore* (trans. A. Y. Martin and R. P. Martin) (ed. A. Liberman). Minneapolis: University of Minnesota Press.

Siegel, D. (1996) *Creating Killer Web Sites: The Art of Third-Generation Site Design.* Indianapolis: Hayden.

Stewart, G. R. (1960) *Ordeal by Hunger: The Story of the Donner Party.* New ed. Boston: Houghton Mifflin.

Vogler, C. (1992) *The Writer's Journey: Mythic Structure for Storytellers and Screenwriters.* Studio City, CA: Wiese.

Weiss, A. S. (1990) "K." *Art & Text,* no. 37 (September), 56–59.

5

From Oracy to Electracies

Hypernarrative, Place, and Multimodal Discourses in Learning

Andrew Morrison

> Please do not think that I am always this quick to speak to a stranger. Thank you for coming. And please do not think that I am always speaking this way to someone I do not know. We can leave out all the parts that waste time, I think that is best for I see that we may not have very long together.

These are the words of the main protagonist in a hypernarrative called *Just-Eating-the-Progressing*.[1] Never providing us with his name, the character is a male schoolteacher who has been dismissed from his job because of an inability to concentrate on his work and the students before him. His is a schizoid world: he lives on the streets of a modern African capital city; he shifts between urban and rural lifeworlds and landscapes. His home is a place of memory, his occupation one of struggling to remember and to locate himself.

Land, Literacy, and Learning

The experimental narrative discussed above was part of a project in learning about digital media and academic communication with new college and university students in the humanities and social sciences in Zim-

babwe. The project, called *HyperLand*,[2] was a collaborative and interdisciplinary inquiry into the ongoing transformation of academic literacy through the inclusion of multimodal, multimedia learning resources and their uses in situated cognition. The project took place in the English as a second language (ESL) setting of Zimbabwe.[3] Such settings and their explicity ESL and cultural discourses are rarely mentioned, however, in the literature on digital media (see Warschauer 1999). Further, attention has been given to the "what, why, and how" of multimodal multiliteracies (New London Group 2000), but less to the "where" (see fig. 5.1). In the *HyperLand* project, developing a hypernarrative as part of a hyperpedagogy was one approach used to investigate electronic literacy and *cyberplace*.

Figure 5.1

A digital window on a village scene from rural Zimbabwe. In the hypernarrative a picture from contemporary "development" discourse is a pastiche of colonial photography. Margaret Waller provided many of the black-and-white photographs that were modified for this hypernarrative, here apparent in figures 5.1, 5.4, 5.5, and 5.9. Her work as a photographer, trainer, and more recently as a researcher has been invaluable to the *HyperLand* project (see also Waller 2000).

"Not a Dry Eye in the Room"

It's 8 A.M. and lectures are beginning at the University of Zimbabwe. Students are running toward class from "Commuter omnibuses," as they are called. Today I have a double session with second-year students of literature in English. About forty students have turned up. It's an opportunity to introduce a whole class to the hypernarrative Just-Eating-the-Progressing. *I begin by explaining the general aims of the* HyperLand *project. I outline ways in which the project has been looking at issues of land and representation in a range of media. There is no computer projector in this or any other of the many tiered lecture halls. As a way in, I show overhead slides of the hypernarrative to try to introduce the story and to explain its workings. Then I begin to present aspects of hypertext theory.*

Suddenly, we hear people shouting and then the sound of gunshots. This is no longer fiction. It takes but a second for us all to imagine what's happening, but more than a few seconds to acknowledge that this is another battle between students and the riot police. Several times during the HyperLand *project in the second half of the 1990s the campus was closed, either briefly or at length. We all sit for a moment as we try to decide whether or not to remain in our lecture setting or to begin the messy business of departing the campus, showing ID cards, and determining the status and length of this latest action.*

The shouts and shots continue and then become louder, and the well-remembered smell of tear gas quickly enters our learning space. The class cannot go on. Yet we can't tell how dangerous the situation is without meeting the context of our learning, the now acrid avenues of the campus. How can digital media have any relevance in such a setting? Where in the body of work on digital media and narrative is there mention of such reading contexts?

Hybrid Discourses

In the past decade, the modes and means of reporting on poststructuralist-oriented research has been the focus of considerable attention in the humanities and the social sciences (e.g., Richardson 1994; van Maanen 1995). Although this has not been without fierce opposition from more positivistic sectors of the academy, academic writers have investigated what George Marcus (1994) calls "messy texts" as ways of mediating their research and as a mode of performing theory (Ulmer 1994: 147). Combinations of

Figure 5.2
Narrative as fabric: pixellated extract from printed textile.

fields and discourses as part of interdisciplinary research have also made it possible for researchers to investigate genres and styles of writing and presentation (see fig. 5.2). Often these take the form of hybrid, paralogical forms (see, e.g., Libby 1997) and accounts that are themselves transitional discourses;[4] they may include fictional persona through whom authors publish and develop pastiches of research paradigms and accountability (e.g., Curt 1994, Vielstimmig 1999); uses of nonlinear layout, typography, and images are also apparent in works such as a recent discussion of changing literacies by Wysocki and Johnson-Eilola (1999) (see also Johnson-Eilola 1998a, 1998b; Sosnoski 1999), there is growing interest too in visual-verbal discourse relations in digital text (Kress 1998). In a discussion of hypertext and hyperfiction as collage, Landow (1999) describes the "new kind of hypertext writing as a mode that both emphasizes and bridges gaps, and that hereby inevitably becomes an art of assemblage in which appropriation and catechresis rule. This a new writing that brings with it implications for our conceptions of text as well as of reader and author. It is a text in which new kinds of connections have become possible" (170).

Both the digital hypernarrative and this print chapter are interstitial texts. They are a kind of writing between the cracks, a mise-en-abyme. They push at the boundaries of their own construction and mediation. They are what Gregory Ulmer (1994) calls heuretic discourse: "As an

'experimental humanities,' heuretics appropriates the history of the avant-garde as a liberal arts mode of research and experimentation" (xii). Ulmer is concerned with generating a method out of theory, heuretics, and gives this method the name "chorography" (39).[5]

Gunnar Liestøl (1999, chapter 14 of this volume) has argued that both to develop and to critique digital media we need to adopt what he terms a "synthetic-analytic approach." He defines such an approach as the interplay involved between a developer's discourse and that of critical interpretation in building a rhetorics of digital media. This chapter is thus also an experience of hyperwriting and hyperreading from screen to page, from spoken discourse to the digitally mediated kinetics of reading, here transposed to paper and ink. Extracts from the hyperfiction *Just-eating-the-progressing* are included, with each extract being one screen or part thereof (screen frames are not shown). This is in keeping with the suggestion Landow (1997) makes about relations between theory and practice and the use of writing as a method of inquiry (Richardson 1994).

In short, this print chapter is an attempt to find what Michael Joyce (1995) calls "a middle voice," that is, to present, report on, and discuss a rhetorics of digital media research. Following Bakhtin (1981, 1986), this text ventriloquizes the hyperfiction; it re-presents and embodies in print form some of the shifts between verbal and pictorial narrative and between the "traditional village" and the "modern city," between changing political and cultural landscapes. In so doing, I have attempted to convey reflexively some of the problems of reporting on the making and reading of this electronic narrative in context, both in and about place. In a sense, this is a form of counter-narrative (Giroux et al. 1996), but an electronic one designed to test some of the claims made about "global" literacies (see, e.g., Hawisher and Selfe 2000) as well as criticism that electronic discourse is an extension of colonialism (Sardar 1996).

Changing Literacies

From Literacy to Electracies

Ilana Snyder (1998) has used the phrase "from page to screen" to signal the shift from print to digitally mediated literacies and communication. Just as the term "literacy" has been analyzed as social literacies (Street 1995) and as socially mediated discourse (Gee 1996), Ulmer (1989) has

argued that we need to view electronic media and literacies grammatalogically. He has introduced the term "electracy," claiming that electracy is to digital technologies as literacy is to print.

I suggest that we might usefully reconceptualize electracy in the plural, not just as electronic literacies, or multiliteracies, but as multimodal, mulitmediational digital discourses, or *electracies* (Morrison 2001; see also Ulmer 1998). In relation to place, and after Pierre Bourdieu, these electracies involve our existing cultural and symbolic resources and not merely learning sets of procedural computer skills. Such symbolic and cultural resources are increasingly shaped by the ways they are mediated electronically. Electracies also entail a range of modes of communication and pedagogies that may converge, overlap, diverge, or vary afresh in electronically mediated discourses (see, e.g., Kaplan 1995). Yet they are realized through and as performative discourses (see also Welch 1999).

Although with the spread of the Web there is growing interest in electronic literacies, especially in higher education (e.g., Hawisher and Selfe 1999), rarely is mention made of using digital media and hypernarrative in learning about digital media and discourse in relation to the "South." Rarer still are hypernarratives composed from the "South." In contrast to the volume of internationally marketed computer games concerned with violent conquest, how might an interdisciplinary inquiry into and pedagogy concerning building and investigating electronic literacies be conceptualized and realized so as to accentuate the local, the situated, and the proximal?[6] How might this be built into a larger framework of examining electracies through their making and critique in connection with the general theme of "land" in a "postcolonial" setting?

A Range of Voices

As is echoed in the extract with which the chapter opens, the teacher-wanderer speaks to us directly as readers, but perhaps as untrustworthy passersby. Here, not only is the author a fabricator, but the reader is positioned as a potential doubter. Most of the time, however, the man is happy enough to talk to us, and the hypernarrative has a distinctly oral tone. Of course, he also knows that his story is not quite ours. Fictionally, we participate in his "migrant world" on the other side of a screen, sepa-

rated from the actuality of his mental and material wandering and searching. He searches to find his voice, especially when it is seized by a roving, malevolent spirit. His words are conveyed in a range of type, point, and layout, especially when he addresses his former students. This, though, is a hypernarrative without sound, yet one that, invoking Bakhtin, draws attention to voice as utterance and via image.[7] Though much of the narrative is presented through the often disassociative perspectives of this former teacher, it is also polyvocal. A range of other voices exist (see Werbner 1996): sometimes imagined voices, the man's inner voice, arguments from unlikable strangers, the urgings of friends, suggestions from students, and the lament of a close family member.

In *Just-eating-the-progressing,* the former teacher imagines his students are still in front of him. Unlike the college-level readers who have used this hypernarrative as part of their learning about both multimedia and academic communication, his students are younger. The address by this teacher-narrator is overtly pedagogical and its rural setting also presents many higher education students with echoes of their own school days. In the following extract, as elsewhere in the hyperfiction, links are indicated in boldface.

Please, class,
do not think
that this is the kind of science which will bring clean water to your
village!

I have told you that I will make no hiss in the fire. But there is still
something in me that cannot let go of this car. It is a **magnet** and class
this too is not good science. Like objects attract. How can we say, then,
Jester, at the back there by the door, yes you, that there can be any
attraction between this shiny new car and this middle-aged man who
cannot remember what he did yesterday?

No, do not look down. Please do not be embarrassed. I am asking you
one of those questions you do not answer.

Who knows the answer to what we call those questions?

This chapter is not an exercise in rhetorical questions, though. Rather, it is concerned with ways of learning to learn about digital media in an African higher education setting.

Theory on the Move

Given the "development" context of the *HyperLand* project, how helpful would theories and criticism from postcolonial studies (e.g., Spivak 1993; Bhabha 1994; Moore-Gilbert 1997; Moore-Gilbert, Stanton, and Maley 1997) be in understanding a hypernarrative in context? How well might such theories and criticism travel across the equator from the predominantly North American campuses where they have challenged the curricular canon of works and criticism? How might the hypernarrative relate to the fierce debates surrounding the definition of the postcolonial (e.g., Dirlik 1997; Slemon 1994) and to critical readings of print narratives?

More than merely thinking of literacy in terms of the "empire writing back" (Ashcroft, Griffith, and Tiffin 1989), could we investigate ways in which learning about electronic literacies might draw on oral discourse (Hove 1997) and the picturing of the life worlds of our own "developing country"? And would existing postcolonial theories also travel well into a hypernarrative domain? How might this affect how we would approach introducing students to digital media and indeed to the place of electronic communication in postcolonial discourse, one rarely mentioned in the predominantly literary and historical writings in this field? What expectations might students have as readers of a narrative in a medium that they had never accessed? For Ulmer, what is important is to find ways to encourage learners to see *inventio*—to foster what Maxine Greene (1995) calls ingenuity and curiosity—as a key part of a digitally mediated pedagogy (see, e.g., fig. 5.3). The aim of *Just-Eating-the-Progressing* was to motivate student readers to traverse a digital landscape about their own context, but via a mediascape in which concepts and theories relating to digital media would be implied and "conducted" via reading processes and discussion.

Figure 5.3

The digitally altered image of a Zimbabwean decorative winnowing basket; suggestive of the reader's partial picture of the narrative's structural and discursive wheels within wheels; the filter.

Doing Chorography

Ulmer's experiments in heuretics—to invent a new poetics—are largely descriptive, analagous, and theoretical. Here I refer to an electronic text and its context and use, partly as taking up Ulmer's (1994: 41) invitation to *do* chorography, but also as an interplay between "composing" digital discourse and using a variety of theoretical approaches. The chorography I present is therefore also a multimodally rhizomatic one; it is at times oral, visual, digital, analog, kinetic, static, local, dispersed, merged, and diffuse. I employ the hypernarrative and its hyperreading as a component of building understanding about *electronic literacies in the making,* but in an African college setting. This too is to take up Ulmer's claim that we

deconstruct the frontier metaphor of research, one particularly problematic in postindependence Africa (see, e.g., Mudimbe 1994).[8]

Narrative and Learning Designs

Hypernarrative and the *HyperLand* Project

In keeping with the view of emerging electronic literacies as multimodal multiliteracies (New London Group 2000; Kress 1998, 1999), in this section I present theoretical connections that were involved in the composition of the hypernarrative and some of the problems linked with its use in teaching and learning. I briefly discuss some of the issues facing the researcher-practitioner, not only in generating theory from practice (e.g., Jarvis 1999), but also in reporting on digital media as rhetoric and its pedagogy as an interplay of theory and praxis.

What then might a locally authored and based hypernarrative look like? What place might there be for intuition, for using the apparatus of digital media for thinking and for inferring a local context as *cyberplace?* If, as Ulmer suggests, chora is only indirect and oblique, we would also need use indirection so as to draw attention to the apparatus of digital media *and* to our own chorographic or hyperreadings *as a means* of rethinking literacy, learning, and context.

Approached as electronic literacies in the making, *Just-eating-the-progressing* aimed to draw attention to relations between verbal and visual text and among navigation, negotiation, and memory. In addition, it highlighted the potential shifts in roles between teachers and students through this central narrator who implicates us in traversing a collage-like text in which "a collage of contingencies" is presented to the reader (Ulmer 1994: 221), as may be seen in figure 5.4. Rather than reifying choice, contingency, and the plasticity of text and reading paths, however, as is possible in the never-ending shape of hypernarratives (Douglas 2000), this was an experiment in learning about digital media and a local context, for students of academic communication, English literature, and art.

Digital Counternarrative

Poststructuralist theories have been at the center of much of the critical and analytical writing on digital media and especially hyperfictions already

Figure 5.4

The main narrative map in *Just-Eating-the-Progressing*.

prominent by the mid-1990s (e.g., Landow 1994; Douglas 1994, 1998; Murray 1998; Joyce 1998). Landow has gone so far as to argue for a strong match between hypertext and poststructuralist literary theory. Where the development and trial of a hypernarrative might help us investigate matters of literary and cultural theory centered on polyvocality and interpretation in context, in a place, at a locale, it might serve to raise new contextual problems concerning digital media, learning, and place.

Our Zimbabwean context is rather different from the U.S. Ivy League campuses where hypernarratives featured in English literature courses have been set (e.g., Landow 1994; Joyce 1995). The student users of *Just-eating-the-progressing* were general arts and social sciences first-year students taking obligatory courses in academic communication, together with largely volunteer undergraduate students studying literature and art. In formal classes and voluntary sessions, there would be little time for close theoretical discussion or reading of poststructuralist theory. Students

were therefore introduced to ways of hyperreading the text (Burbles 1998)[9] by peer tutors who had themselves been important commentators on draft versions of the story.[10] Most students who were interested in the work visited it at least twice, usually for not less than half an hour at a time.

Just-eating-the-progressing functioned as a "counternarrative" (Giroux et al. 1996) on four fronts. First, the hypernarrative questioned the reluctance of academic communication specialists to view media as part of academic literacies and extend our notions of ways to learn about digital media. One problem, then, was how to articulate a narrative as an example of "talking back," as bell hooks (1989) terms it, but in a different context and from a different speaking position with respect to established approaches to teaching about academic communication and digital media via expository discourse. Second, though, the experimental and user-driven hypernarrative challenged print-bound literary scholars perhaps worried that their students would have more interpretive freedom than provided within lecture- and seminar-based literature courses. Third, the postcolonial hypernarrative was a mesh of words and images, and, unlike all the commercially marketed hypernarratives, it was written from and about Africa. Fourth, a small group of students and contributors to the wider *HyperLand* project acted as readers for a work in progress and were an important resource in its making.

> What is happening? Do you know? Someone gives me an apple from her groceries before she is getting on the bus. I find some scraps behind the Half-Hearted Cafe. I will remain here in the city where there are taps and water still flows from them. That's what I was saying last week when I was living life like a dry land lizard. Now, I should be an amphibian.

> It has rained for almost a week and I will have to change my life on the street. Every single thing I own is wet. My hair, my hat, these useless old boots and even my new **notebook.**

In the above extract, the man's obsession with change and with movement and his documentation of events are presented within an urban

African setting. The hypernarrative encompassed many of the questions of local context and situated cognition in scenarios such as this one. Discussions between students about his life and its parallels with other characters in Zimbabwean fiction contributed to the overall goal of the project of building a community or communities of practice (Wenger 1998), but also in our case a practice of a small experimental community of users of digital media in learning.

Writing and Reading "the Local"

Inside an Emergency Taxi I see you overtake us — a quick flash of gold in the bright sunlight — and I am shouting at the driver to move it and the passengers are all shouting back at me and the car is empty but for its oily driver and the ET is squashed and a woman is tearing at the driver's sleeve to let her out. The car veers to a halt and there is the popping of doors and again people swear at me and put name to the fears they carry in their pockets tight with their metal I.D. cards and folded banknotes now smaller than a box of matches.

The car has gone and I am standing in a part of the city I do not know. I turn my feet to face the **direction** I have come from. I stand and look at them and they are still, together in their worn shoes. My own feet are **still the same.**

Theoretically, the hypernarrative *Just-eating-the-progressing* may be contrasted with Marxist-influenced interpretative approaches often applied to African literature. This situates Landow's important question "What's a critic to do?" (Landow 1994) in the midst of debates on postcolonial literary theory and criticism. These debates have rarely been linked with hypernarratives themselves (see Odin 2000).

Some critics of digital media, such as Sardar (1996), have argued that the rapid and global spread of digital media is merely a reinscription of colonialism. Yet in media studies recent attention has been given to "de-Westernizing" what is already an interdisciplinary field (e.g., Curran and Park 2000). More specifically, Escobar (1999) has argued for a more ecological approach to digital media in a "development" context (see also Nardi and O'Day 1999), suggesting that "from the corridors of cyberspace

can thus be launched a defence of place and place-based ecological and cultural practices which might, in turn, transform the worlds that dominant networks help to create" (33).

Many of the leading authors of hyperfictions are also teachers of literature, digital media, and communication (see Joyce 1995; Douglas 2000). In contast to their reporting on their works, as authors and then as teachers, *Just-eating-the-progressing* was read and commented on by young black Zimbabwean college students as part of hyperreading of a work in progress. Many fiction writers value the criticism of a close corps of readers, and this is an invaluable part of many expository and creative writing workshops and classrooms. When hypernarrative is included as a part of a hyperpedagogy about academic communication, learners may see works in the making. This may help them relate interpretation and critique to process and not only to a canon of prevalued print. In addition, in a multimodal hypernarrative in which a narrative and pictorial realism are not the goal, such a "developmental" approach may offer a counterweight to the potential technoromanticism (Coyne 1999) involved either in creating photo-realistic digital narrative or in conceptualizing readers' choices as fetishes.

Studying Literature in English

The movement between the city and the communal lands of the country-side has been a prominent feature in Zimbabwean literature in English, such as in the published print works of Charles Mungoshi, Stanley Nyamfukudza, and Chenjerai Hove.[11] Such fiction is studied in school and university literature classes. It is part of body of narrative that has flourished since Zimbabwe's political independence in 1980 and that has been important in reshaping a formerly colonial educational system. Such fictional works, including those of women writers such as Tsitsi Dangarembgwa and Yvonne Vera, have presented counternarratives to the earlier models and content of literacy and learning. Indeed, writers such as Hove and Vera have posed a new allegorical stylistics. Accompanying this fictional work is a growing body of literary criticism, although issues of postmodernist and postcolonial theory have only more recently become widely discussed by Zimbabwean literary scholars, much of which has had a strongly Marxist character since independence (e.g., Ngara 1985).

In contrast to the acclaimed print narratives from Zimbabwe, *Just-eating-the-progressing* is an unpublished hypernarrative. And in contrast to almost all such works by contemporary black Zimbabwean writers, it is a digitally mediated fiction I have written as a privileged, white, tenured, Zimbabwean man. In further contrast, the readers of this experimental work have almost all been young black Zimbabwean undergraduates.

Earlier research into language-based literature teaching and stylistics (e.g., Carter and McRae 1996) from within applied linguistics and from literary studies have provided an important crossover between theory and practice, especially for ESL students. In the case of *Just-eating-the-progressing,* the protagonist is obsessed with language; he has a dictionary he keeps under his hat; he makes copious records in notebooks that he then cannot find; his diction switches among description of scenery, arguments with friends and strangers, and the mutterings of a homeless person trying to navigate a vanishing horizon. At times his syntax is muddled; occasionally he provides florid descriptions only to discover his less harmonious physical location.

Bill Louw, a Zimbabwean literary and linguistics scholar, commented that the hypernarrative indirectly reworked approaches to both language-based literature teaching and literature-based language teaching via the mutability of digital media. This was one of the major "connections" of this experimental composition; another, the intersection of development studies, postcolonial theory and criticism, and contemporary writings on hypernarrative, was perhaps more complex and difficult.

Border Crossing: Development Studies and Postcolonial Studies

We are all thirsty. But we cannot say a word. The drum is silent. There next to us the well is dry. The well is dry. Ants are all walking away from this village. Across our feet. Leaving the shells of beetles they have tasted.

It is hot and we are all looking at the thin **woman.** I can see her face now. Watching us with big open eyes, trying to find the light in our spirits. Flies tickle at the corners of her eyes but she does not move. Her hands together in her lap. **Waiting.** Her eyes open. Legs together, stretched straight out. But it is her nurse's cap. That is what she is

wearing. Creamy with the dust. People are looking at it. The years of her pens and papers learning to care for the sick. Two clips keep her cap in place. But there is no wind. There is no wind to tug at it. Her white starched cap we all see on her head as her brothers remember her graduation and mothers recall her soft voice for lost children. The one who made us well. She has gone before us into the cracks of the earth beside the well where the mud has dried harder than bricks. She has let her spirit trickle away from us.

In attempting to "revisit" digital media by translocating its contemporary theories and practices to an African higher educational setting where they are yet to be widely implemented, I would also need to move beyond literary studies and the North American setting of most of this work to "development studies" and an African context.

The notion of border crossing is prominent in the literature on critical pedagogy and that of postcolonial studies. In these fields, but also in "development" settings, border crossing may be understood as part of the necessary negotiation of a variety of concepts, demands, situations, and tactics in shaping identity and its articulation. Debates concerning postcolonial studies are characterized by important contests over definition and praxis.[12] In postcolonial literary studies this debate has centered on issues of "nation and narration" in building and understanding the "location of culture" (Bhabha 1994). Here and in "development" contexts, the voice of the subaltern (Spivak 1988)—those without the power of their own public articulation—is overwhelmed and contained by the economically and institutionally privileged. Concerning history and the postcolonial, the unmasking of colonial discourse (as only partial, selective, and self-constructing of the imperial subject) may be contrasted with a more complex and multi-faceted approach to historiography in which the "other" of colonial discourse is countered by inquiry in which polyvocality and reflexivity are present.

Christine Sylvester (1999) has argued that two bodies of work referring to the "third world," namely, development studies and postcolonial studies, typically do not intersect but that their selective convergence may be fruitful. Having also conducted research in Zimbabwe, she argues that the more recent approaches of postdevelopment, such as that of Escobar,

Figure 5.5

Digital imaging of cracked earth: an allusion to narrative's context, to its hyperstructure, and to the fragmented simulacrum of the narrator's and reader's memory.

function in a "globalised, mutually implicating and interrogating postcolonial time. Facing it, development studies stands on the millenium stoop, pants around the ankles but shirt pockets bulging conditions, deficits and participatory creeds" (711).

The subaltern of postcolonial studies, the essentialized villager or recipient of development in context, is rarely asked to speak and less often heard as part of development projects. The force of the international expert and remote policies all too often bleach away local knowledge and articulation.

As a Zimbabwean teacher and multimedia developer I wanted to make the local context part of the problematic of introducing digital media to students (see fig. 5.5). New tools and means of communication do not necessarily mean better understanding and expression of local needs and interests. The central character of *Just-eating-the-progressing* would thus need to be not a digital artist or self-conscious poststructuralist critic in search of a postcolonial collage, but one for whom the medium might allow the mediation of a fragmented, troubling, and varied experience. Would students want to "hear" this teacher-traveler? Would they reject the digital and their active roles as readers? Or, inside a digital domain, would they demand computer games and access to remotely authored material rather than a bricolage of their own world?

Hypernarrative and Setting

In *Just-eating-the-progressing* I was particularly motivated to draw students' attention to the intersection of verbal and pictorial discourses and

to hypernarrative as a potential medley of media. Although writers have discussed questions of visual literacy (e.g., Bolter 1998), through the narrative my intention was to draw on collage as a means of presenting relations between parts and whole and between realist and nonrealist images. Given the potential replacement of one screen by another, and through the possibility of juxtaposing several screens, readers would have the possibility of learning about hyperreading (Burbles 1998) as performative discourse.

The example in figure 5.6 indicates one of the ways in which shifts in point of view were realized in *Just-eating-the-progressing* through a series of successive screens (start top right). Here the questions and comments by the former teacher point to issues of location and identity discussed in postcolonial theoretical writing on print narratives. In this example, the man moves from wondering where he is to deciphering that he is back home, or *kumusha* in Shona, a place where family land and the spirit world converge. This is a place that is recognized through the digital imaging of a realist photograph that is revealed in full frame at the end of this sequence. The man's dispersed sense of self and his arrival are undercut, however, when the image of home is clicked on, for the reader is returned to the main narrative screen of the story.

Familiar and Unfamiliar Readers and Readings

As strangers, we the readers may not take enough time to follow the protagonist of *Just-eating-the-progressing* through his mazelike narrative of written description, heard conversations, notebook entries, obsession with vocabulary, and monologues of inner search for understanding. We may not be sufficiently patient to try to understand how such a mind works and how its narrative is patterned. Perhaps we will shy away from the man's unruly appearance and the ways he shifts between description and direct address.

The work also interweaves grayscale images, occasionally photorealistic like the ones in figure 5.6, but more often more abstract ones, such as parts from a larger picture linked in a series of questions, the repeated pattern of a hand-dyed fabric, or the cross-woven base of a basket (see figure 5.7). Through images adapted from print texts on basketry

Oh, oh, my students, I am frightened, where am I and why am I here?

Who is this?

he does not know I am here

Yes, the place seems familiar, I think I know it. You have seen similar places?

Yes, that's better. I am home.

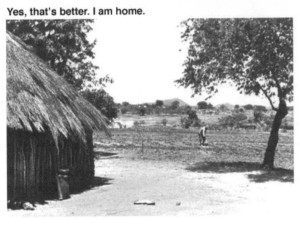

Figure 5.6

Investigating place and recognition.

Figure 5.7
Handwoven basket with tree pattern.

in Zimbabwe, familiar cultural resources are re-presented. Their structural elements are accentuated. Their handcrafted qualities as visibly reworked by a digital hand. They are woven into a narrative, thereby forming part of its hypersymbolic patterning. We are invited to become fellow travelers in a narrative of the man's own memory mapping and the appearance of images in this rhizomatic, digitally mediated tale. This too becomes a process of our own piecing together of story and discourse and of our own recollections of this interplay, verbal and visual.

Through our actions as dynamic, digital readers, we build the narrative: we follow explicit links and attempt to build coherence over time. But then we are confronted with sudden "dismemberings." Time and space do not match: points of departure from specific points in the narrative (screens, links) result in displaced arrivals. The former teacher's own expectations—and those he and the hypertextual markings set up for us—are rerouted. He "lands" in uncomfortable situations, ones he cannot immediately fathom, just as by our acts of reading we too begin to question where we are in this cybernarrative and how we are drawing on our own conceptual resources to give shape and meaning to it.

In our role in tracing the movements of the main character we make selections. Through our actions as hyperreaders, we follow seemingly explicit links only to discover that these are tangential allusions that in turn are disrupted, as the title of the work suggests. This forms a deconstructed syntax and semantics of linking. Indirectly, as hyperreaders, we are implicated in his search for his "voice" but also for the physical and associative places where he has recorded his memories. More than once, speaking to us as readers or having described his actual and imagined urban surroundings, the former teacher wakes up to find himself on a bus to his ancestral home in the countryside:

> Puff. I step down from the bus and the earth splashes powder back at me. A teacher stands in the field beside his school in a dark suit. Tie askew. Singing hymns. Slow hymns are all he has left between his empty classrooms and neatly ordered college notebooks. I know they are hymns even though I cannot hear them much. He is calling to his god of blood to **bless** the land with water.

As the image of a rural setting shown at the start of the chapter indicates, the story is played out far from a computer desktop. Yet we are reminded that it is a digitally mediated and manipulated image by the application of an elliptical tool in Photoshop. The image is at once present on our screens, precoded in digital space, and resonant of earlier photographs of "Africa" and the problems of representation and reception surrounding them.

Like the "earth" that "splashes powder back" at the traveler, this is a narrative that, like many other well-known hyperfictions, also toys with significations and with transpositions. It plays on synesthesia, it shifts between verbal and visual text and their intersection and suspension. As the former teacher observes another teacher, so too are we implicated in our own reflexive reading and interpretation.

Wandering, Searching, Remembering: A Simulacrum of Memory

While distracted and often confused about the schisms between his physical location and understanding of "reality" and the meanderings of his

mental self and universe, the central character is nevertheless also lucid and watchful. His movements are those of both a wanderer and a detective (Rosello 1994). He documents the workings of a corrupt politican. The protagonist meticulously records his observations, the evidence of a murder and its connection to a gold Mercedes Benz with which he becomes obsessed. This obsession with the gleaming imported automobile—alternately that of idolatory, a link in a narrative, and the emblem of corrupt politicians in contemporary Africa—cannot be maintained or fully understood through logical linking. Of this he is no longer capable, yet his spoken voice is processed by readers in the form of a digitally mediated narrative. Flickering between the schoolroom and the screen, a documentary photographic trace and metonymic visual elements, the text-based narrative entices readers to piece together another person's perspectives and purposes.

Following Bakhtin's notions of discourse, utterance and polyvocality in text, the reader is thus encouraged to assume a number of reading positions: to identify with the first-person protagonist, to respond to his address to the "you" as a student, to distance herself from the narrative and assume an omniscient reader's role, or to toggle between the screens as they run or as they may be juxtaposed. As the words above indicate, the narrative is presented largely from the main character's point of view. Yet as we follow him across the screen, his utterances are also addressed to the general reader:

What is your greatest fear?
Do you not like me mentioning the bats that sing our names?
Do not worry, I will not spend the rest of the year with my back to the mirror and quickly turning to it to see the shape of the memories of the future.

I am **not in one place,** you know that. But that moment of seeing is with me in strange places and yes it is true that sometimes it frightens me. But let us think of our memories. You see, most of them have their **roots** here, with us and it is for us to tend to the tree, to find there the worries that haunt us and will fall silently from the branches in the night and in the hours when the sun is hardest in the afternoon. Our worries

that will fall thick and ripe with the time of our worrying and the secrets and hopes that have fed them, like the fruit from the sausage tree which is as heavy as a grey brick. A fruit but thick with danger. So let us take care where we rest for in the **shade of the tree** there may be a nasty shock! But I should **go on.**

Just-eating-the-progressing is thus a hypernarrative about disjuncture, disappearance, and disassociative motion. By our actions in selecting links, by juxtaposing screens, and through "replacing" texts and images, as digital readers we are implicated in these movements and memory making. Bakhtin's polyvocality is built through the coarticulation of hyperwriting and hyperreading. The spoken words[13] of the teacher and their realization through our actions as multimedia readers are part of an authorial, and specifically pedagogical, design. This, then, is a story that investigates the interplay of oracy and electronic text—verbal and visual—in which the reader's kinetic also embodies processes of patterning, memory making, and proximal understanding of character.

Topographical Composing

Jay Bolter (1991) has repeatedly drawn our attention to hypertext and topographical writing. Scenes in *Just-eating-the-progressing* such as the one above from the capital city contrast with those from the drought-ravaged countryside. It is as if in his physical wanderings the protagonist literally falls through the cracks of his own memory making. This is symbolized in the narrative through the interplay of verbal and visual text as topographical composition.

As readers we find ourselves in unexpected places, translocated from our actions as users building coherence. We realize that this must be built inferentially and in the mind. One day the man *Just-eating-the-progressing* awakens to find himself on a bus traveling deep into the countryside. The drought has not lifted and—bringing the campus-based student back to the country—the teacher-narrator observes:

Another woman, nearby, is stacking stones, grey white, all hot from the sun. Piling the stones into a wall. The field beside her is empty. She

places the stones one on top of another. Three weeks of work so far she tells me. I can see her earlier in the day. Each morning. She decided to work away her strength and have done with it, have done with the waiting and the acidity in her throat. It is drier now, these three weeks later, and she sits for a while and rests from her labor, feeling the stones point and stab at her, their inanimate warmth, and is pleased with her power **to fill the dry landscape with a sign.**

The ants have begun to move again, crawling more furiously, before their supply of food leaves them too weak to search for more. A long thin line, the community, setting off for a place they cannot see, across the dried pool, lifting themselves across the cracks, finally clambering around the sun dried fish. I am **home** to my village.

This description is one of many that serve to draw attention to looking at the world that surrounds us. Indirectly, it links to the ways in which realist and nonrealist images are used in the narrative in a play of connotation and denotation.

At one point the teacher-traveler says, "It took me months to save for the deposit for the bed. And now, concrete is my **mattress,**" with the link leading to the image (in figure 5.8). We do not know who this is asleep on this traffic island. Is it the former teacher, now motionless, his racing after the car reduced to a publicly observable death, a stage lit by steetlights? As a way of suggesting that the reader observe this image critically, three altered versions of the image are presented. The accompanying link on the word "concrete" leads to an embossed, cropped close-up from this image. The street sign in this image also appears in other screens (e.g., figure 5.4). It is possibly a stop or yield sign; we may use it as a link to a place, only to discover that it is decontextualized from this photo-realistic imaging of place and of photographic punctum. The narrative builds on such part-whole relationships, suggesting that we too think about the mapping of the world not only through verbal associations and jumps but from the perspective of a "migrant" person typically marginalized in many contemporary African societies, but nonetheless here our digital guide.

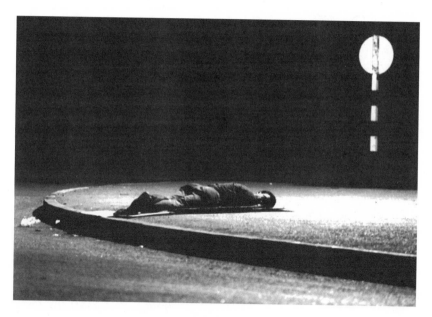

Figure 5.8

Just-eating-the-progressing asks that we engage with questions of observation, representation and experience; our screen reading position is accentuated by our distance from this image.

Electracies in Place?

Hyperreading and Context

Below, I continue the scenario I introduced near the start of the chapter. The scenario presents a reading context, one that is rarely reported in the rhetorics of the new, digital media (see chapter 15) and perhaps even less so in 'development' discourse. It reminds us that, as Ulmer (1994: 224) says, chorography is a site of risk.

> *The sound of shooting near our university classroom. Is this what all the teaching about informed debate and critical argument has amounted to? A project about critical discourse and digital media with land as its focus. Students are alarmed. They grab at their books and bags. I am concerned for our safety. In seconds, we stream out of the class. But it's not clear whether*

this is another "localized" run-in between some students and the riot police or a more serious dispute that will result in the closure of the campus. We are not jaded about such violence, just weary of this repetition of a breakdown in civic communication. Will another semester be interrupted? Curriculum theory as interruption? Interruptive hypernarrative?

The ground is strewn with rocks. Barricades have been placed across the upper gates of the campus, branches have been torn from trees and lie motionless. People are running past us. Is it safe to try to leave the campus or to quietly move to another room and wait to see if calm returns? It is still early in the day. Some students say they want to continue. They are tired of these antics. We come across a student having a debate with a riot policeman. Another student rushes past and says "it" is all moving down to the front gates and toward the main road to the city center. "Let's go on," suggest several members of the class. Not with the run-in, that is, but with the digital demo. I am not certain that this is what we should do. I suggest, then, that those students who do wish to carry on might move down to the HyperLand room, in the basement of the Faculty of Arts Language Center. We hurry off to continue learning about hypernarrative in a small, air-conditioned room half below the earth while outside tear gas fills the air.

It's now less than five minutes later, and, to my surprise, half the class has reconvened in the project room, formerly a sound recording studio. I mention that one of the aims of the HyperLand project was to create space, content, and a means of building civic discourse. I say no more. Hypercontext.

What will happen now? We have two machines: a PowerMac with a seventeen-inch monitor and a PowerBook. Two of the peer tutors from the project introduce the students to the story. And then something strange happens. Amidst all the clamor, students begin to read the hyperfiction out loud. These are echoes of reading out loud in classrooms where not everyone has a book. Here not everyone can read the words on the screen. Students take turns in reading without discussing this. Sometimes there is ironic laughter, sometimes quiet.

Then people start to comment on the story. They liken it to the well-known works of Dambudzo Marechera. Students change places around the screen. I wonder what Bakhtin would have made of this? The story is shared through many voices. "Go there." "No wait." Then, a little later, "Who is the author?" one student asks. One of the tutors points to me and turns back to the story. There is laughter. "It's not possible," says the student. I laugh,

nervously, watching a lesson take its own shape, following a completely differ-
ent track from the one I had rehearsed.

I invite the students to read the work in their own time and to discuss
it with the tutors. I leave the room and walk upstairs to see if I can find out
if the riot police are moving people off the campus and whether our hyperread-
ing will be interrupted again. Downstairs, perhaps a student is reading the
following screen from a section called "Telescope:"

> I have climbed the hill **to look out** over the city. To sit above the smoke
> from buses and the hard light from the tall **mirror** buildings. Why do
> they make us want to look back at ourselves in all those windows so far
> up above the earth which we cannot reach? It is just as hot at the top
> of this hill. There is a tap beside the office of the water department. It
> must be so dark inside that tank of concrete which sits here like a heavy
> **hat.** There's that burning feeling in my heart again as soon as I think
> of water. It is a cold and thin feeling which is cutting into my chest in
> one place only. The sky has dried up all our hopes. The water comes
> all this way from the shrunken lake and it rests beneath the cool lid of
> the concrete. I will lie beside the wall of the tank and wait for some
> sleep to find me. But first the water. Small cupped hands are all I have
> today. Lower my head and take the **water** slowly into my mouth. The
> pink cups of my palms with their brown edges.

Emerging Digital Media

A variety of Internet-based services, mobile telephony, and satellite broad-
casting are part of, and are contributing to, changing communication en-
vironments in much of southern Africa. Indeed, recent contests over
physical land and resources may also be seen in various representations
of the "land question" and "land reform" in online news. These changes
in the global spread and local uptake of digital media take place within
a "development" context, as is suggested by the village and city scenes
presented in *Just-eating-the-progressing.* Unlike most of the environments
in which the innovative uses of digital media are reported, the Zimbab-
wean one is in which most citizens live in the countryside, where there
is still limited access to clean water or electricity, let alone digital networks.
As leading hyperfiction author, literary critic and educator Michael Joyce

(1995) comments: "Whether such networks can bridge widening gulfs between developed and less developed countries and economic and social classes will assume paramount importance in browsing through continents of knowledge and mapping the topographical multiverse" (28–29).

It is important that we see these networks not only as infrastructural ones but also as interrelated symbolic sets. This is especially the case if we are to diminish the distinction between an electronically linked world composed of people who are "interacting" and those who are "interacted" (Castells 1996: 371). One link in the story leads to a large advertisement, which may be read against the dusty fields of the drought-ridden country-side (symbolically or via juxtaposed windows):

TrickleDown

the new electronic sprinkler

system for your

lawn.

"Browsing through continents of knowledge" is still a painfully slow activity available to very few undergraduates in higher education in Zimbabwe. When students are able to access the Web, the continents of knowledge they encounter are largely remote from their own gigantic one. Metaphorically, connectivity and "access" are therefore at the center of this *Just-eating-the-progressing.*

Although I am skeptical of the liberatory determinism of much of the writing on critical pedagogy,[14] I would argue that for higher education students in Africa, digital media may indeed offer tools and strategies for a reflexive analysis of their changing literacy, that is, for studying their own emerging electronic rhetorics and literacies. Without attention to content, modes of address and their mediation and analysis, young African students may indeed be linked to remote servers with account of their life-worlds written from afar, as the recent Microsoft CD-ROM encyclopedia *Encarta Africana* might be interpreted.

In pedagogical terms, accessing postcolonial studies in an African higher education setting may provide ways of engaging theoretically with the legacy of colonialism but also the often contradictory character of the monoparty postindependence state and its nation-building project,

alongside troubling neocolonial economics and the delicate negotiations around development aid. When campuses are often closed and examination success drives instrumentalist learning, digital media may be used as a means of generating open rather than closed readings and debate connected to place, both proximal and remote.

Revisiting Digital Media

Through authorship of a locally oriented digital fiction, I attempted to offer students a narrative of migrancy involving movement between town and country, between the electronic cityscape and the unelectrified countryside, and also to point to questions about oracy, literacy, and electracy and their representations in digital media. Perhaps in the future students might revisit their early hyperreading of *Just-eating-the-progressing* and find ways to transpose its implied critical local voice to other more digitally complex texts and environments.

In a section of the story called "This is My Time" (which can be arrived at through different routes), the teacher-traveler wakens to discover that he is in the country, wedged between his home, the crime he has observed and cannot remember, the assembled villagers, a corrupt politician and his gold Mercedes Benz, and the security police:

> I stand up and tell the village what he has done with their other daughter. Where to find her **bones.** Not a sound when I have said this. There is no snapping of pods and the entire sky is staring down at us all.
>
> I talk softly and I am again a teacher and people listen to me. This is my time. Here is my dictionary.
>
> They all look up.
>
> I wonder if I have lost myself again. So I turn to the **map.**
>
> And then there is a silence that has gathered the grief of these people I have known all my days.
>
> I know now that I will lose the sight of the car. It must be.
>
> But I did not know this is where I would stand in the skin of my own life and in my loneliness speak that which cannot be buried with the dead. I did not know. One of the Suits nods his head once.
>
> And then I am **forgotten.**

Acknowledgments

My thanks go to the students of literature at the University of Zimbabwe and of art at Harare Polytechnic who read and commented on the hypernarrative. Jacob Ngandu, Nyasha Tsikayi, Garikai Mupango, George Mubayiwa, and Stewart Ngandu offered valuable comments on the story and also introduced it to other students in the *HyperLand* project. Bill Louw of the University of Zimbabwe's English department suggested ways in which the work might be used with his students. Margaret Waller provided many photographs and the permission to modify them for the narrative. Baobab Books gave permission to use reworked images of baskets (Locke 1994), and the Department of Fine Art and Graphics at Harare Polytechnic allowed the use of extracts of student works. My thanks go to Terrence Kawadza, Hilde Arntsen and Synne Skjulstad for critical comments on this chapter.

Notes

1. Like many of the hyperfictions not on the Web, this one was authored in *Storyspace* from Eastgate Systems ⟨www.eastgate.com⟩.

2. The *HyperLand* project was therefore an attempt to investigate multimodal, multimedia digital discourses in learning and importantly, in the making, in a southern African context. In short, it was concerned with local contexts of learning, culture, collaboration, use, and interpretation. The overall *HyperLand* project was collaboratively designed innovation with staff and students from the University of Zimbabwe and the Harare Polytechnic. It had three main parts: a focus on "college communication," the study of genre and gender in legal discourse, and collaborative design and representation in art education.

3. On ESL and English as a foreign language, see Nayar 1997; on electronic literacies and ESL and culture see Knobel et al. 1998; Spack 1998a; Warschauer 1999.

4. I am reminded of Bruno Latour's (1996) innovative account of the demise of a planned metro system for Paris, which he ventriloquizes through the voice

of an engineering student and through the inclusion of official documents, interviews, and diagrams. Like Latour's narration on research, the hypernarrative also has a pedagogical twist, but one centred in southern Africa. This chapter is a similar hybrid account. It is much shorter, however, than Latour's lengthy book study. Whereas his account is presented through a student researcher reflecting on his research methods and the status of plans and of empirical evidence, this is a short print text that refers to a fictional and digitally mediated narrative.

5. As a chorography—what Ulmer calls a method for studying electronic rhetoric—this chapter is an assemblage of perspectives from the hypernarrative, from theories and from teaching and learning about digital media in context. Ulmer (1994) argues that "the chorographer . . . writes with paradigms (sets), not arguments" (38). Here, the sets on which I draw are digital media and especially visual communication from media studies, narrative theory from postcolonial studies and from hyperfiction studies, literacy theory and its relations to academic communication, and experimental rhetorics from academic communication studies and the reporting of social science discourse. These sets are themselves related to the learning context of a development-oriented university and the problematics of "development" projects, digital media, and literacies.

6. Ulmer (1994: 31) presents his heuretics as an undoing of research as colonial exploration—as topics (topos)—by turning frontier into chora or *place*. Here "chora" refers to the way in which we may approach place as making, generating, and critiquing (he presents this with reference to the celebrations and contests over Columbus Day in the United States in 1992).

7. Spivak's (1988) "Can the Subaltern Speak?" is a central text in asking whether "voice" is compromised: the Western intellectual adopts the speaking position of the subaltern. See also Colin Wright's (n.d.) "Can the Subaltern Hear? The Rhetoric of Place and the Place of Rhetoric in Postcolonial Theory."

8. This is now also discussed in terms of "the internet as middle landscape on the electronic frontier" (Healy 1997), traversing the Web as a tourist (Nakamura 2000), modes of representing and translating people and their landscape in anthropological discourse, and debates about the "third world," Africa, and digital technologies (e.g., Cubitt 1999). The mediating computer screen may be

seen as chora; in the hypernarrative digitally altered baskets attest to the medium as a technology, that is, as "figure of spacing," and to its relation to our altering *sense* of imprinting (Ulmer 1994: 73; 71 on Derrida and chora). Chora also becomes the search itself, just as the narrative is itself about a search for the absent, the slippery, the different as postcolonial space, a "work around the margins" (118).

9. Here the term "hyperreading" is used to describe the various ways in which readers may read the text: through a range of tools in the software, and especially by juxtaposing screens within the narrative, but also with reference to other digital discourses, such as the other three webs in the *HyperLand* project, as well as print narratives.

10. *Just-eating-the-progressing* was examined by a range of readers, some on request, others as a result of the suggestion of the peer tutors in *HyperLand,* and others out of their own curiosity. Eastgate-published hyperfictions were shown to some of the students who were interested. In addition, for future reference, readers were referred to Landow's Web site for further theoretical materials and also to his specific section on Zimbabwean fiction. Students of visual arts were also readers of the story; one student described it as a wheel that keeps turning, as symbolized earlier by the basket, with the story never following the same pattern (Douglas 1994).

11. See, for example, on Zimbabwean literature, the work of Rino Zhuwarara and other links at ⟨http://www.scholars.nus.edu.sg/landow/post/zimbabwe/zlitov.html⟩.

12. Moore-Gilbert (1997) and Dirlik (1997), for example, present comprehensive, if differing, overviews.

13. In her novel *Nehanda,* Yvonne Vera (1993: 39–40) indicates the importance of words in the meeting of spoken and written communication; see ⟨http://www.scholars.nus.edu.sg/landow/cv/firstscreens/casablanca/vera1.html⟩.

14. Green (1998) argues that we need to deconstruct the critical literacies approach and escape its determinism; in its place what is needed is a postcritical

pedagogy in which risk, heterogeneity, otherness, exploration and incompleteness are seen as resources for learning in digital domains (Green 1998: 189ff). Such a pedagogy will pay greater attention not only to learning theories, but also to reworking semiosis and text beyond their print borders, so as to learn "how to teach *for* difference, and also *with* difference" (Green 1998: 194).

References

Ashcroft, G., G. Griffith, and H. Tiffin (eds.) (1989) *The Empire Writes Back: Theory and Practice in Post-Colonial Literatures.* London: Routledge.

Bakhtin, M. (1981) *The Dialogic Imagination.* Austin: University of Texas Press.

Bakhtin, M. (1986) *Speech Genres and Other Late Essays.* Austin: University of Texas Press.

Bhabha, H. (1994) *The Location of Culture.* London: Routledge.

Bolter, J. (1991) "Topographic Writing: Hypertext and the Electronic Writing Space." In P. Delaney and J. Landow (eds.), *Hypermedia and Literary Studies.* Cambridge: MIT Press, 105–118.

Bolter, J. (1998) "Hypertext and the Question of Visual Literacy." In D. Reinking, M. McKenna, L. Labbo, and R. Kieffer (eds.), *Handbook of Literacy and Technology: Transformations in a Post-typographic World.* Mahwah, NJ: Lawrence Erlbaum, 3–13.

Burbles, N. (1998) "Rhetorics of the Web: Hyperreading and Critical Literacy." In I. Snyder (ed.), *Page to Screen: Taking Literacy into the Electronic Era.* New York: Routledge, 102–122.

Carter, R., and J. McRae (eds.) (1996) *Language, Literature and the Learner: Creative Classroom Practice.* London: Longman.

Castells, M. (1996) *The Rise of the Network Society.* Vol. 1 of The Information Age. Oxford: Blackwell.

Coyne, R. (1999) *Technoromanticism: Digital Narrative, Holism, and the Romance of the Real.* Cambridge: MIT Press.

Cubitt, S. (1999) "Orbis tertius." *Third Text,* 47, 3–10.

Curran, J. and M. Park (2000) "Beyond Globalization Theory." In J. Curran and M. Park (eds.), *De-Westernizing Media Studies.* London: Routledge, 3–18.

Curt, B. (1994) *Textuality and Textonics: Troubling Social and Psychological Science.* Buckingham, UK: The Open University Press.

Dirlik, A. (1997) *The Postcolonial Aura.* Boulder, CO: Westview Press.

Douglas, J. (1994) "'How Do I Stop This Thing?' Closure and Indeterminacy in Interactive Narratives." In G. Landow (ed.), *Hyper/Text/Theory.* Baltimore: Johns Hopkins University Press, 159–188.

Douglas, J. (1998) "Will the Most Reflexive Relativist Please Stand Up: Hypertext, Argument and Relativism." In I. Snyder (ed.), *Page to Screen: Taking Literature into the Electronic Era.* London: Routledge, 144–162.

Douglas, J. (2000) *The End of Books—Or Books without End? Reading Interactive Narratives.* Ann Arbor: University of Michigan Press.

Escobar, A. (1999) "Gender, Place and Networks." In W. Harcourt (ed.), *Women@Internet.* London: Zed Books, 31–54.

Gee, J. (1996) *Social Linguistics and Literacies: Ideology in Discourses.* London: Taylor and Francis.

Giroux, H., C. Lankshear, P. McLaren, and M. Peters (1996) *Counternarratives: Cultural Studies and Critical Pedagogies in Postmodern Space.* London: Routledge.

Giroux, H., and P. McLaren (1994) *Between Borders: Pedagogy and the Politics of Cultural Studies.* London: Routledge.

Green, B. (1998) "Teaching for Difference: Learning Theory and Post-critical Pedagogy." In D. Buckingham (ed.), *Teaching Popular Culture: Beyond Radical Pedagogy.* London: UCL Press, 177–197.

Greene, M. (1995) *Releasing the Imagination: Essays on Education, the Arts and Social Change.* San Francisco: Jossey-Bass.

Hall, S. (1996) "When Was the 'Post-colonial'? Thinking at the Limit." In I. Chambers and L. Curti (eds.), *Common Skies, Divided Horizons.* London: Routledge, 242–260.

Hawisher, G., and C. Selfe (1999) "The Passions That Mark Us: Teaching, Texts, and Technologies." In G. Hawisher and C. Selfe (eds.), *Passions, Pedagogies and 21st Century Technologies.* Logan: Utah State University Press, 1–12.

Hawisher, G., and C. Selfe (2000) "Introduction: Testing the Claims." In G. Hawisher and C. Selfe (eds.), *Global Literacies and the World Wide Web.* London: Routledge, 1–18.

Healy, D. (1997) "Cyberspace and Place: The Internet as Middle Landscape on the Electronic Frontier." In D. Porter (ed.), *Internet Culture.* New York: Routledge, 55–68.

Hooks, B. (1989) *Talking Back: Thinking Feminist, Thinking Black.* London: Sheba Feminist.

Hove, C. (1997) "Oral Traditions Claim a Place in Modern Mass Media." *Media Development,* 3, 13–14.

Jarvis, P. (1999) *The Practitioner-Researcher: Developing Theory from Practice.* San Francisco: Jossey Bass.

Johnson-Eilola, J. (1998a) "Living on the Surface: Learning in the Age of Global Communication Networks." In I. Snyder (ed.), *Page to Screen: Taking Literature into the Electronic Era.* London: Routledge, 185–210.

Johnson-Eilola, J. (1998b) "Negative Space: From Production to Connection in Composition." In R. Taylor and E. Ward (eds.), *Literacy Theory in the Age of the Internet*. New York: Columbia University Press, 17–33.

Joyce, M. (1995) *Of Two Minds: Hypertext Pedagogy and Poetics*. Ann Arbor: University of Michigan Press.

Joyce, M. (1998) "New Stories for our Readers: Contour, Coherence and Constructive Hypertext." In I. Snyder (ed.), *Page to Screen: Taking Literature into the Electronic Era*. London: Routledge, 163–182.

Kaplan, N. (1995) "E-Literacies: Politexts, Hypertexts and other Cultural Formations in the Late Age of Print." *Computer-Mediated Communication*, 2(3). Available at ⟨http://www.ibiblio.org/cmc/mag/1995/mar/kaplan.html⟩.

Knobel, M., C. Lankshear, E. Honan, and J. Crawford (1998) "The Wired World of Second-Language Education." In I. Snyder (ed.), *Page to Screen: Taking Literacy into the Electronic Era*. London: Routledge, 20–50.

Kress, G. (1998) "Visual and Verbal Modes of Representation in Electronically Mediated Communication: The Potentials of New Forms of Text." In I. Snyder (ed.), *Page to Screen: Taking Literacy into the Electronic Era*. New York: Routledge.

Kress, G. (1999) " 'English' at the Crossroads: Rethinking Curricula of Communication in the Context of the Turn to the Visual." In G. Hawisher and C. Selfe (eds.), *Passions, Pedagogies and 21st Century Technologies*. Logan: Utah State University Press, 66–88.

Landow, G. (1994) "What's a Critic to Do? Critical Theory in the Age of Hypertext." In G. Landow (ed.), *Hyper/Text/Theory*. Baltimore: Johns Hopkins University Press, 1–48.

Landow, G. (1997) *Hypertext 2.0: The Convergence of Contemporary Critical Theory and Technology*. Baltimore: Johns Hopkins University Press.

Landow, G. (1999) "Hypertext as Collage-Like Writing." In P. Lunenfeld (ed.), *The Digital Dialectic: New Essays on New Media.* Cambridge: MIT Press, 150–170.

Latour, B. (1996) *Aramis or the Love of Technology.* Cambridge: Harvard University Press.

Libby, L. (1997) "Passing Theory in Action: The Discourse between Hypertext and Paralogic Hermeneutics." *Kairos* 2, no. 2. Available at ⟨http://english.ttu.edu/kairos/2.2/features/paralogic/bridge.html⟩.

Liestøl, G. (1999) *Essays in Rhetorics of Hypermedia Design.* Oslo: Department of Media and Communication, University of Oslo.

Locke, M. (1994) *The Dove's Footprints: Basketry Patterns in Matabeleland.* Harare, Zimbabwe: Baobab Books.

Marcus, G. (1994) "What Comes (Just) After 'Post'? The Case of Ethnography." In N. Denzin and Y. Lincoln (eds.), *Handbook of Qualitative Research.* Thousand Oaks CA: Sage, 563–574.

Moore-Gilbert, B. (1997) *Postcolonial Theory.* London: Verso.

Moore-Gilbert, B., G. Stanton, and W. Maley (1997) "Introduction." In B. Moore-Gilbert, G. Stanton, and W. Maley (eds.), *Postcolonial Criticism.* Harlow UK: Addison Wesley Longman, 1–72.

Morrison, A. (2001) "Electracies: Investigating Transitions in Digital Discourses and Multimedia Pedagogies in Higher Education. Case Studies in Academic Communication from Zimbabwe." Ph.D. diss., Department of Media and Communication, University of Oslo. Partly available at ⟨www.media.uio.no/personer/morrison.electracies/selchs.html⟩.

Mudimbe, V. (1994) *The Idea of Africa.* Bloomington: Indiana University Press.

Murray, J. (1998) *Hamlet on the Holodeck: The Future of Narrative in Cyberspace.* New York: Free Press.

Nakamura, L. (2000) "'Where Do You Want to Go Today?' Cybernetic Tourism, the Internet, and Transnationality." In B. Kolko, L. Nakamura and G. Rodman (eds.), *Race in Cyberspace.* London: Routledge, 15–26.

Nardi, B. and O'Day, V. (1999) *Information Ecologies: Using Technology with Heart.* Cambridge, MA: The MIT Press.

Nayar, P. (1997) "EFL/ESL Dichotomy Today: Language Politics or Pragmatics." *TESOL Quarterly,* 31, (1), 9–38.

New London Group (2000) "A Pedagogy of Multiliteracies: Designing Social Futures." In B. Cope and M. Kalantzis (eds.), *Multiliteracies: Literacy Learning and the Design of Social Futures.* London: Routledge, 9–37.

Ngara, E. (ed.) (1985) *Art and Ideology in the African Novel: A Study of the Influence of Marxism on African Writing.* London: Heinemann Educational.

Odin, J. (2000) *The Performative and Processual: A Study of Hypertext/Postcolonial Aesthetic.* Available at ⟨http://www.scholars.nus.edu.sg/landow/post/poldiscourse/odin/odin14.html⟩.

Ranger, T. (1996) "Colonial and Postcolonial Identities." In R. Werbner and T. Ranger (eds.), *Postcolonial Identities in Africa.* London: ZED Books, 271–281.

Richardson, L. (1994) "Writing: A Method of Inquiry." In N. Denzin and Y. Lincoln (eds.), *Handbook of Qualitative Research.* Thousand Oaks, CA: Sage, 516–529.

Rosello, M. (1994) "The Screener's Maps: Michel de Certeau's 'Wandersmänner' and Paul Auster's Hypertextual Detective." In G. Landow (ed.), *Hyper/Text/Theory.* Baltimore: Johns Hopkins University Press, 120–158.

Sardar, Z. (1996) "alt.civilisations.faq: Cyberspace and the Darker Side of the West." In Z. Sardar and R. Ravetz (eds.), *Cyberfutures.* London: Pluto, 14–41.

Slemon, S. (1994) "The Scramble for Post-Colonialism." In C. Tiffin and A. Lawson, (eds.), *De-scribing Empire: Post-Colonialism and Textuality.* London: Routledge, 15–32.

Snyder, I. (1998) "Page to Screen." In I. Snyder (ed.), *Page to Screen: Taking Literacy into the Electronic Era.* New York: Routledge, xx–xxxvi.

Sosnoski, J. (1999) "Hyper-readers and Their Reading Engines." In G. Hawisher and C. Selfe (eds.), *Passions, Pedagogies and 21st Century Technologies.* Logan: Utah State University Press, 161–177.

Spack, R. (1988) "Initiating Students into the Academic Discourse Community: How Far Should We Go?" *TESOL Quarterly,* 22(1), 29–51.

Spivak, G. (1993) *Outside in the Teaching Machine.* New York: Routledge.

Spivak, G. (1988) "Can the Subaltern Speak?" In C. Nelson and L. Grossberg (eds.), *Marxism and the Interpretation of Culture.* Basingstoke, UK: Macmillan, 271–313.

Street, B. (1995) *Social Literacies: Critical Approaches to Literacy in Development, Ethnography and Education.* Harlow, UK: Longman.

Sylvester, C. (1999) "Development Studies and Postcolonial Studies: Disparate Tales of the 'Third World'" *Third World Quarterly,* 20(4), 703–721.

Ulmer, G. (1989) *Teletheory: Grammatology in the Age of Video.* Baltimore: Johns Hopkins University Press.

Ulmer, G. (1994) *Heuretics.* Baltimore: Johns Hopkins University Press.

Ulmer, G. (1997) "The Grammatology of Distance Learning." *TEXT Technology,* 7(3), 5–20.

Ulmer, G. (1998) "Foreword/Forward (into Electracy)." In T. Taylor and E. Ward (eds.), *Literacy Theory in the Age of the Internet*. New York: Columbia University Press, ix–xiii.

van Maanen, J. (1995) "An End to Innocence: The Ethnography of Ethnography." In J. van Maanen (ed.), *Representation in Ethnography*. Thousand Oaks, CA: Sage, 1–35.

Vera, Y. (1993) *Nehanda*. Harare, Zimbabwe: Baobab Books.

Vielstimmig, M. (1999) "*Petals on a Wet Black Bough:* Textuality, Collaboration, and the New Essay." In G. Hawisher and C. Selfe (eds.), *Passions, Pedagogies and 21st Century Technologies*. Logan: Utah State University Press, 89–114.

Waller, M. (2000) *A Bigger Picture: A Manual of Photojournalism in Southern Africa*. Kenwyn, South Africa: Juta.

Warschauer, M. (1999) *Electronic Literacies: Language, Culture, and Power in Online Education*. Mahwah, NJ: Lawrence Erlbaum.

Welch, K. (1999) *Electric Rhetoric: Classical Rhetoric, Oralism, and New Literacy*. Cambridge: MIT Press.

Wenger, E. (1998) *Communities of Practice: Learning, Meaning, and Identity*. Cambridge: Cambridge University Press.

Werbner, R. (1996) "Introduction: Multiple Identities, Plural Arenas." In R. Werbner and T. Ranger (eds.), *Postcolonial Identities in Africa*. London: ZED Books, 1–25.

Wright, C. (n.d.) "Can the Subaltern Hear? The Rhetoric of Place and the Place of Rhetoric in Postcolonial Theory." Available at ⟨http:www.scholars.nus.edu.sg/landow/post/poldiscourse/casablanca.wright.html⟩.

Wysocki, A., and J. Johnson-Eilola (1999) "Blinded by the Letter: Why Are We Using Literacy as a Metaphor for Everything Else?" In G. Hawisher and C. Selfe (eds.), *Passions, Pedagogies and 21st Century Technologies*. Logan: Utah State University Press, 349–368.

II

Design and Aesthetics

6

The Reading Senses

Designing Texts for Multisensory Systems

Maribeth Back

I had always used the word "read" in a different, broader context. One "reads" the weather patterns from the drifting clouds . . .

Then I remembered certain professionals practiced the art of reading. . . . I supposed that one could read words as well as say them. But how inefficient it all seemed! I pitied the ancients who did not know how to encode information into ideoplasts and directly superscribe the various sense and cognitive centers of the brain. . . . To read with the eyes, it's so . . . clumsy.
—David Zindell, *Neverness*

Reading is one of our oldest technologies, and continually we remake it into one of our newest. We invent new typefaces, new book forms, new reading devices. We create ways for reading to migrate into new sections of the world; these days we read from clothing, buses, carpeting, even fruit. For our children, we cut animal books in the form of animals; we use alphabet blocks to encourage the idea of text as an object to be manipulated. The ubiquitous computer itself is a reading machine, its most powerful computational functions accessible only through text.

The ways we read continually adapt to whatever technological or social changes come along. Currently, the book as a primary form of reading seems to be challenged by e-books, the Web, and other media, yet more books are being printed—and read—now than ever before. Due to the pervasiveness of digital technologies, the creation of written language—its content, its genre, and even its physical embodiment—has changed utterly, and so has the act of reading. What chance would Mark Twain have of correctly interpreting the text (menus, ads, buttons) on an average Web page?

Now, the reading experience extends beyond the book, beyond the computer screen, and into the world around us. Text is accompanied by—or perhaps more accurately, includes—image, sound, and physical form, any or all of which might be dynamic or interactive. In such a world multisensory reading can allow greater bandwidth into the human mind, providing meaning on multiple levels and through several sensory pathways at once. The compact between author and reader gains new dimensions, deepening the reading experience. Rather than competing with or replacing written text, carefully authored multisensory texts enrich reading by complementing written text with effective semantic support in multiple modalities.

Innovations in the way we now read include the use of reading devices designed for new behaviors and interactions as well as multiple sensory modalities. These interactive capacities are not simply an added pathway to understanding a text; they change the basic way the text is understood (Schilit et al. 1999). Physical form and interactive behaviors affect our interpretation of the things we read. Digital technologies enable the form of the reading device to be authored along with content, allowing ever more specific contextual interpretations of text and genre.

Conscientious authors have always been aware of the implications of form for their work. Form shapes the space, both physical and mental, in which reading occurs. Such mental space creation allows us to "place" what we're reading appropriately. The form of a piece can literally be one of the things that helps to define its genre. With the advent of desktop publishing and even more complex digital authoring systems for multimedia, such context-aware authoring can incorporate tasks we might have called sculpting or composition a decade or two ago. Physical forms can

be specifically designed via computer-controlled laser cutters or CNC[1] machines (precision computer-controlled sculpting and cutting machines widely used in manufacturing). Programming languages control not only software but robotics, lighting, and environments; thus behaviors and dynamic form yield to authorship. Embedded systems, smart objects, and augmented realities become themselves readable texts.

The ease of authoring physical form is echoed in the increasing ability to author for sensory modalities that were difficult to modulate before now, including hearing, touch and its submodalities (such as tactile sensation, haptic feedback, thermal perception, and kinesthetic and proprioceptic knowledge), and even, to some degree, smell and taste. We know more about manipulating sound than we do about haptics and its kin; we know more about haptics than olfactory systems. Each new modality carries its own set of affordances and its own most effective kind of information.

The more sophisticated our manipulation/authoring systems for a particular modality become, the better we understand the applications of that modality and the more frequent its use becomes in innovative devices and artifacts. Common usages develop, to the point of becoming iconized. Once a modality carries a set of recognizable icons, increasingly sophisticated usage of these icons may encourage a cognitive leap to abstract representations based on them, much as the alphabet developed from pictographs. These representations are built in the modality itself and begin to develop into a lexicon for that modality. Thus, the sound of thunder denotes a deteriorating weather pattern, but it carries emotional valence as well and is often used as an expressive abstraction.

Grammars for dynamic media such as film and video are described as formalizations of the methods developed over many years of production. Such elements as camera angle, focus, shot width, and camera motion are combined in known ways to produce certain effects. Such grammars in dynamic media are not prescriptive; that is, they do not exclude new possibilities. Rather, these lexical structures add to possible creative combinations by allowing the artist to consider as single units scenes with internal complexities, much as a writer might use a favorite phrase that is made out of individual words.

This is how the complex visual vocabulary of film developed, one that we have learned to read with ease and can discuss critically. The

several symbol sets of sound design (discussed in more detail below) are all approaching similar levels of representational and relational complexity. As complex representations develop for more sensory modalities, the authoring task for new media becomes richer and harder. This increased depth in authorship is matched by the change in the task of reading: how can we track changes in reading in these new modalities?

Reading Multisensory Lexical Structures

Let's postulate reading as the primary activity that takes place with new media. That clearly means reading beyond text: reading in the sense of interpretation of complex symbol sets embedded in meaningful structures, within a combination of sensory modalities. The act of reading text today seems primarily a visual act: a structured interpretation of a standard set of symbolic images. These images, whether alphabetic, pictographic, or hieroglyphic, grew from the original invention (or inventions) of writing: that innovative intuition that connected marks made by the hands with sounds produced in spoken language. But text itself is inherently multisensory: it is a visual representation of oral/auditory language. Some written languages (the phonetic languages) are more closely bound to sound than others; nonetheless nearly all written languages reproduce words and structures from spoken tongues (Coulmas 1989).

In fact the act of reading includes an entire complex of cultural and cognitive filters through which the symbols of whatever is being read are interpreted. These filters bear various labels: for example, in literary studies, genre, media type; in the social or cultural sciences, class, culture, and gender; or in the cognitive sciences, image schema, sensorimotor loops, mental models. The dynamic text flying across a television screen is valued and interpreted differently than the calligraphy of a poet's broadsheet, both culturally and cognitively. The form offers context to the reader, indicating the amount of care and attention appropriate to the particular reading task as well as commenting on its relative value.

Consider as an example the complex formal structure of sound design, which includes the vocabularies and grammars of Foley sound artists, sound designers, musical composers, and vocal acting techniques, all of which combine to produce a fictional auditory reality for the audiences

of films and theatrical productions (Chion 1994). In order to be properly "read" at all, a sound design must not only be rooted within its own strict set of behaviors and symbologies but considered in relation to the content and the context of the larger piece it serves. It is a symbol set nested within another in a symbiotic relationship that enriches both. Audiences parse the sound of a film along with its visuals, as a natural adjunct. But those who choose to read a film more closely often find deeper layers to appreciate, and in fact, sound often provides the key to correct interpretation of a visual event. In radio drama or on the stage, a series of sound effects can sometimes create and carry an entire story.

In similar fashion, innovative computational artifacts often use a stack of sensory modalities: for example, sound plus visuals plus haptics. Each of these sensory modalities has submodalities: visuals include text, images still and moving, and graphic elements, and sound incorporates music, sound, and voice. These modalities in their turn each possess structures with symbolic meaning; their use is an act of authorship, embedded in genre and intended to be read. They may carry semantic support, affect, or metadata (data about data, like navigation cues). This is true whether the multisensory artifact is a virtual world, an onscreen game or other software, or a physical device or real environment. Even in the most innovative of these artifacts, conventions drawn from genre type and cultural context drive the design. Such layering of complex symbol sets means the development of a new kind of reading, inclusive of text: multisensory reading.

Multisensory reading relies on people's ability to collate and decipher multiple sensory streams simultaneously, much as we interpret the world around us through the use of multiple senses. This is more than a simple struggle between perceptual sensitivities, however; we use cultural cues and personal perceptual history as criteria to interpret sensory data. Fortunately, such complex patterning tasks are just what the human brain excels at: we do possess what Manguel (1996) calls a "reading sense."

In this argument, use of the term "multisensory" rather than "multimodal" or "multimedia" is deliberate: an attempt to pull critical analysis in new media toward consideration of the human body's interface systems as well as cultural systems. Herbert Simon (1994) is among those scholars attempting to induce the domains of cognitive science and literary

criticism to become more aware of their parallel concerns. Still, critical analysis has historically been weighted toward the cultural symptoms embodied in visual submodalities (text, 2-D and 3-D image, moving image). Most early multimedia pieces were primarily visual, with some relatively crude uses of sound.[2] As an attempt to balance this inequity, this chapter deals primarily with the nonvisual modalities of sound and touch, which have historically been less amenable to the critical process, just as until recently they have been less amenable to authoring. The ideas about the development of sensory reading systems presented here may represent one methodological approach for critical analysis of sound and touch, both separately and in combination with other modalities.

Before we can legitimately critique multisensory media, we must teach ourselves to read them accurately. The "language of the senses," that poetic phrase, may no longer be hyperbole in the age of multisensory semiotics. Increasing fineness of control in new arenas like sound or the several modalities of touch creates the opportunity for complex creative expression unachievable without digital tools. Such work soon moves beyond attempts at replication of the real world into iconic representations of it, and from there into more abstract representations. The alphabets of touch and smell are in their infancy; that of sound is a toddler. We have manipulated visual symbols for many thousands of years, in many forms and with great detail and sophistication. Only in the past century have we begun to approach a similar level of control with sound and moving image; with touch modalities, only in the past few years.

The complementary tasks of reading, authoring, and critiquing multisensory media must share an understanding of the basic relationships between the sensory modalities themselves as well as the culturally and perceptually influenced symbol sets that have grown up in those modalities. Such issues as sensory resolution, time granularity, available level of abstraction, intersensory affordances, and probable sensory priority take their place alongside more traditional literary considerations.

The sophistication of representation in each of the sensory modes, as well as the interaction among them, offers matter for critical analysis. If we recognize that interaction design deals with symbolic systems in sensory realms beyond the visual, we can attempt to define those symbol sets and their unique behavioral structures. As with any critical task, such

interpretations will shift with time and cultural changes, as well as with our understanding of our cognitive abilities. We are only beginning to understand the levels of manipulation—and therefore representation—possible in multisensory design.

Replication to Representation to Abstraction: The Genesis of Multisensory Language Tools

As our degree of control over communication in a variety of sensory modalities grows, we develop new symbol sets associated with them. As with the visual symbols we read, these symbols begin by imitating the real world but rapidly take on first representational, then meaningful abstract characteristics through the same kind of development process that alphabets or other forms of written language underwent. Common usage becomes common language.

As an example, consider the development of Western alphabets. There is well-documented motion from protowriting—pictorial representations of simple ideas—to the strictly representational (drawing of house = house) to the iconic (sketch of roof line = house) to the abstract symbol (letter B, *beth*) which no longer has anything at all to do with the concept "house." Rather it is associated with a particular set of verbal sounds, what Coulmas (1989) calls the movement from word to syllable. The letters of the alphabet have become completely disassociated from their replication/iconic representation origins; they are now arbitrary symbols. We are now in a position to watch this process of development in other sensory modalities and perhaps to help it along, if in fact such development can occur. How shall we begin to understand the parameters whereby such arbitrary symbol sets can develop?

Visually, we interact with the world through pattern analysis. But reading a landscape is a different sort of task than the act of reading the written word. In reading a landscape one traces the contours of the real world, assigning meanings based on experience or learning: the fault line lies there, a ridge of limestone runs along over there. But the natural landscape is neither representational nor abstract; it is the thing itself, not a signifier standing in place of some other thing. There is no alphabet in the natural lay of the land.

Similarly there is no alphabet in music; though composers do use sets of culturally oriented musical metaphors as well as physically based perceptual signifiers to represent meaning, the meaning is not fixed and is open to widely variant interpretations. The step from abstraction to abstract representation has not yet fully occurred in music. Every few years a claim is made that this step has in fact been made: that the key of G major "means" happiness, for example. In fact, G major is commonly used by European composers (notably Mozart and Schumann) to represent a happy mood. These emotion-to-key mappings can be tracked primarily in Western music or other musics that have been influenced by Western compositions; they are culturally induced. (Unlike rhythmic structures, which do echo and affect body rhythms, there is little evidence that these tone-based key mappings are perceptually based.) Tonal mappings create a "cloud" of emotional impression, a sonic landscape against which the composer creates figures. Such figures do not carry overt, generalizable meaning outside general cultural stereotypes, though an imaginative listener will often assign images and ideas to musical figures. Each composer creates a unique set of musical figures within new compositions, but so far a general representative structure (in the sense of an abstract language with assignable symbols) has not evolved in music.

Much has been written about the texts embodied in various virtual realities (VRs): the entire replication or representation of a world or environment, with as many sensory modalities as can be managed. Most VR worlds choose to remain in the realm of representation, aiming to allow the visitor to use his or her own customary patterns of sensory input. Arbitrary symbols in VR, if they exist, can have no (or only local) meaning, because there is no common agreement on what such symbols might consist of or represent. The multiple texts of VR share with other multisensory systems the lack of abstract symbolic representations for nonvisual modalities.

Simple progressions from replication to representation to abstract representation can be tracked in sound design for film. Consider this example: a tiger growl, a threatening sound, is easily interpreted as such in association with the image of a large feline (MGM's signature image of a lion roaring actually features a tiger roar). Hollywood sound designers often assign tiger growls and roars to other images as well, however, di-

vorcing the sound from its apparent source. So tigers may be found enriching the overwhelming growl of tornadoes, lending a peculiarly personal, organic feel to the threat of the deadly wind funnels in the Hollywood blockbuster *Twister* (1996). Even human actions may be so enhanced: sound designer Mark Mangini (1997) tells of a scene from *Raiders of the Lost Ark* (1981) wherein Harrison Ford must rid his vehicle of clinging bad guys by yanking the steering wheel back and forth, attempting to fling them off the outside of the truck. No matter how vicious the yank, however, Ford's actions at the steering wheel simply did not "read" as aggressive acts. Mangini fixed the scene by adding a tiger growl each time the steering wheel got yanked. As Ford hauled the wheel first one way, then the other, evocative layers of growls and roars were added in on top of the rest of the soundtrack. In these cases the tiger roar itself has attained abstract status; it is a symbol, meant not to evoke the actual presence of a large threatening wildcat, but rather a sense of active, personal menace. Still, though the symbol is present and serves its function well, it is not yet fully abstract; it is not yet part of a generalizable arbitrary symbol set.

Image Schema and Sensory Representations: Cognition as Narrative

How do sensory representations develop? We can "read" such representations because we understand the story embedded in them; they make sense to us because of our own physical or cultural experience. Perceptual and cognitive psychologists have been speculating about the place of story in the construction of knowledge and memory in the human brain. It's generally agreed that narrative is a powerful cognitive mechanism in memory, in knowledge construction and retention, and in sensory perception (Bregman 1994; Minsky 1988).

Many perceptual psychologists argue that our cognitive modeling is schema-based, that is, built in small, storylike segments. Using multiple sensory modalities to "tell a story"—that is, to build a set of schemas in the mind—is a powerful way to deliver information. Albert Bregman, a psychologist specializing in auditory perception, distinguishes between "primitive" perceptual processes (those found in infants, for example, or those employed when one hears an unfamiliar sound) and "schema-based"

perceptual processes, in which attention focus, prior experience, and gestalt mechanisms combine to create a mental model about a sound that is integral to the understanding of the perception. Bregman showed that in fact, if the schema for a particular sound is strongly developed, significant portions of that sound can be completely masked or missing, yet still be perceived as present, because of the listener's schema-based perceptual processing. The listener is "reading" the sound for the story it tells and interpreting it as a tiny narrative.

Bregman (1994) defines his own use of the term "schema" thus:

> This word is used by cognitive psychologists to refer to some control system in the human brain that is sensitive to some frequently occurring pattern, either in the environment, in ourselves, or in how the two interact. When we perceptually analyze our auditory input, we can make use of schemas about recurring patterns in the world of sound. These patterns vary enormously in their degree of complexity and abstraction. . . .
>
> Often the sound we are listening to contains more than one pattern. If each pattern activates a schema, there will be a combination or pattern of schemas active at that time. Sometimes the pattern of activated schemas will form a larger pattern that the perceiver has experienced in the past. In this case the pattern of activity can evoke a higher-order schema. (402)

Bregman's description of a higher-order schema built from smaller auditory patterns offers a parallel to the designer's conceptual process: imagine a sound, then an accompanying sound, and then the environment within which the two sounds must occur; then other sounds will suggest themselves, as an extension of the pattern. All of this process itself exists within the larger design scope of an entire multisensory artifact; the pattern can extend into other sensory channels.

Schank and Abelson (1995) take the idea of the schema-based perceptual process even further:

> We argue that stories about one's experiences and the experiences of others are the fundamental constituents of human memory, knowl-

edge, and social communication. This argument includes three propositions:

1. Virtually all human knowledge is based on stories constructed around past experiences,
2. New experiences are interpreted in terms of old stories,
3. The content of story memories depends on whether and how they are told to others, and these reconstituted memories form the basis of the individual's remembered self. (1)

Story as the human system for understanding experience resonates with the idea of the creative reader, often described as a collaborator in the authoring experience. Schank and Abelson would claim that in fact the experience is created entirely by the user, from schematic cues provided by the designer. The user is reading the provided schema set by filtering it through his or her own experience.

Narrative Projection: Stacking Schemas

Innovators who design multimodal artifacts often combine two dissimilar but familiar media, wrapping one genre around or into another: they combine a book with a video driving game or put an orchestra into a storybook. Providing such conceptual "handles" allows a familiar object or idea to take on new properties. In essence, designers are stacking schemas, using two or more existing mental templates to allow people to understand what they encounter in innovative objects or processes. Mark Turner (1996) calls this "projection," the placing of one well-understood narrative into a new situation. Recontextualizing familiar behavior, for example, allows the use of known body actions in novel situations. A critical reader can recognize the different schema in the projected stack and read them both separately and in combination. Thus, we may hear what is recognizably music, which we can judge critically according to our heritage of centuries of musical analysis and cultural custom, but we may find it inextricably linked with an interactive graphical display, for which critical analysis must draw from known techniques in visual display as well as knowledge about effectiveness in interactive artifacts, rooted in the fields

of human-computer interaction, perceptual psychology, and cognitive science.

In analysis of a particular multimodal artifact or environment, the critic must first identify the various applicable disciplines that contributed to the device's design and address the canonical issues in each field as they appear embodied in the artifact as well as in their interaction with each other. For example, *Speeder Reader,* an artifact that will be discussed later in this chapter, draws from pedagogy about reading, video gaming systems, visual and perceptual systems research, typography, and museum design. Upon this data field one can build a modified type of context-based narrative analysis by examining the coherence of the library of symbol sets (representing schemas) used in multimodal artifacts. In effect, we "read" the artifact for both perceptual and cultural literacy, for its effective use of ever-developing new media symbol sets that designers use to stack schemas.

Reading Sound

Consider as an example the critical reading of sound in interactive artifacts. Each of the fields that inform sound design for multimodal artifacts—computer music, sound art, game design, auditory display, auditory perception, and virtual environment design, among others—contributes a set of critical stances, some artistic or designerly, others scientific or technical. The question is how to tell which disciplines (and therefore which critical viewpoints) are applicable for a particular artifact. To a large degree, this depends on the positioning of the artifact by its designer. To the extent that a new artifact inherits elements from a recognized genre, it is responsible to that genre's historical contract with the community of users. If a game paradigm is used, then a user will expect that the rules be clear and the goals and obstacles well-defined. If the designer's choice is to use some game structures, but to use them in such a way that the artifact now becomes an instrument, then in combining the two genres the designer must be clear exactly where the differentiation begins and what form it takes and try to let the user know that the use contract has been altered and in what way.

An example of this can be found in Tod Machover's (1996) *Brain Opera*, which featured a number of interactive musical experiences. One of the instruments, called "Singing Tree," allowed the visitor to explore the graphically beautiful images on a screen, causing a ballerina to dance or a rose to bloom. But in order for the dancer or the rose to reach its most sublime beauty, the visitor had to sing a pure note into a microphone and sustain it for several seconds with no vibrato or wavering. In this case, a musical action (singing a clear note) is mapped to a gamelike reward (the discovery of a beautiful image). The action is remapped into the musical realm a few minutes later when the sung notes are sampled and used as part of the *Brain Opera*'s live performance.

In interactive systems, sound often provides feedback for user actions or directives to new functions. In such cases, sound serves a new kind of narrative function: it creates a set of expectations—an auditory context—that helps people understand more easily what their next choices are. For example, one of the major pitfalls in the use of sound is "local" design, that is, using a sound that works well enough in the immediate context but that doesn't support (or may even actively work against) an overall design structure. Arbitrary use of sound may confuse the listener and create a mistrust of the auditory modality in general (e.g., "I hate computer sound"). Just as artists and writers labor to construct cohesive works, each with its own internal logic, sound designers must work within the affordances of their materials to create coherent structures. A coherent and internally logical sonic reality supports the listener's engagement with the story of an interactive environment.

Sonic Templates: Telling the Story

The most vital realization in sound design is that real sound doesn't work. To tell a specific story in sound, one cannot simply run out and "record the sound." People don't always interpret sound correctly when it stands alone. In real life, we use confirmatory evidence from other senses and our knowledge of context and history to help decode auditory information. People interpret what they hear in recordings according to the story they tell themselves about what they're hearing. Thus, film sound designers

can use "fake" Foley effects; the sound is authored to tell a believable story in context.

Effective storytelling in sound differs from accuracy in sound. A sound designer's task is not accurate sonic replication of sound as it exists in the world; rather it is the building of a schema, a sonic template. The sound designer must represent the ideal instance of a sound as it exists in the listener's mind. Therefore, a recording must match that ideal, in spite of the fact that the real sound may be wildly different. Seals make hundreds of sounds, many of them highly un-seal-like, but what a listener expects to hear is a "characteristic" seal sound. Of course, a designer can stretch and train a listener's expectations through manipulation of sonic context; that too is a literary task. The sound designer imagines and creates these ideal sounds, or schemas, first by telling the story of each sound effectively, given the likely audience, the media and genre within which the sound appears, and the immediate context of the scene or the interaction, and secondly by taking full advantage of perceptual features of the auditory system in support of this sonic storytelling.

Close Readings in Audio

Designers and psychologists alike distinguish between naive and expert users of computational systems and artifacts. We may think of this distinction in terms of learning to read multisensory devices, a skill area in which a similar continuum between naive readers and expert readers emerges.

For example, a maxim in the recording industry has it that for an audio engineer, it takes five years to "learn to hear" (Back 1996). Of course audio engineers can hear to begin with, but something else is meant by the phrase. An audio engineer must parse the intricate layering of sounds in a multitrack mix, diagnosing tiny conflicts and finding minute errors in the midst of dense, complex audio environments. If a mix is "muddy" or "bottom-heavy" (two common terms in music production), the audio engineer must be able to hear the combination of factors that make it so. Without this developed ability to "read" the soundscape, the engineer's audio and electronics skills, typically gained through years of hands-on studio apprenticeship, are useless.

How do audio engineers learn to read sound? Most begin with immersion in the same sonic symbol sets that an eventual audience will employ: a combination of musical, cognitive, and cultural interpretations of the sound striking the ear. Beyond that, however, "learning to hear" in the recording studio means employing an effective method that resembles traditional signal-processing schemes. First, all sound that enters the ear is accepted as a vast, undifferentiated field. Then this field is listened to in a very particular way in which one's ear acts rather like a graphic equalizer (or perhaps a piano keyboard in reverse). The sound field is analyzed by frequency (pitch), broken into as many different adjoining bandwidths as the person can recognize. These gain specificity over time; one might start out thinking of a sound as "in the mid-highs" and a year later be able to very specifically note the same sound "right at 4 KHz." (This is similar to the training of a musician's ear to recognize pitch.) Activity within each range is then listened to very specifically: what should be there (harmonics on the guitar's pluck), what shouldn't (hiss from the guitar amp). The rest of the sound field is tuned out while each sound within the selected range is analyzed for relative volume, effectiveness of effects processing (such as reverberation), and possible system weaknesses (an unexplained pop in the recording or a generally high level of background noise).

Sound is intrinsically time-based; it doesn't exist in a static "object" form. The engineer is really listening to sonic behaviors in a sound field and interpreting these behaviors—the changes over time—through a complex set of symbols that completely describe them. By learning to hear a sound field in this analytical way—to read it—audio engineers give themselves another set of sonic symbols that allows them to read, author, and revise sound fields just as intricately as a writer does text.

The Story around the Story: Schema Maps to Metadata and Subtext

One type of multilevel reading involves the simultaneous ingestion of metadata along with content. Metadata, or data about data, take many forms and are of many types: descriptions, categories, locations, ages (Marshall 1998). A library card holds metadata about a library book, for

example: its author, location, an abstract, press, and date of publication. In complex systems, using a particular modality as a metadata map can be useful. For example, differing audio textures might be used to indicate location in a virtual world, with sonic "hot spots" identifying places of special interest. Data sonification or auditory display systems are often used in conjunction with visual or tactile systems to track changes in dimensions too numerous to map in one single modality (Kramer 1994).

Metadata can also be mapped onto the real world, as in *Audio Aura,* an experimental audio-augmented reality system that mapped sound to various workplace data such as amount and type of e-mail, meeting notifications, and individual or group presence. Motion through the workplace triggered appropriate audio symbols: passing the mailboxes caused the rippling bell sound signifying an e-mail update; pausing at a conference room door caused one to hear the sound of a group of people chatting, if a meeting is scheduled there soon (Mynatt et al. 1998). Note that the system did not deliver the data themselves; one heard representations of metadata: status or update information about e-mail, but not the e-mail itself.

In the case of the *Audio Aura* system, the data sets were deliberately mapped into various symbolic landscapes, so that the user could listen to a set of related sounds and construct a story around them with which to understand ("read") his or her personal datascape. For example, in one soundscape, there were four sounds that together represented the datascape as beach: ocean waves, seagulls crying, a bell buoy ringing, and the sound of children playing. Each sound represented a particular kind of data, and the character of the sound changed as the data content changed. The "group presence" information was mapped to the sound of waves; if many people from the workgroup were at work right then, the waves would be louder and faster than if only one or two people were present. E-mail was mapped to seagull cries; if you had only one or two messages waiting, passing an e-mail trigger point you might hear a single, far-off seagull calling. If you had numerous messages, or if one of the messages was from someone ranked by you as important (your boss, your spouse), then the e-mail notification sound was more urgent: an entire flock of seagulls squabbling, quite close by. Bell buoy sounds indicated office occupation history: if a coworker was present but not in the office, one ring;

if out of the office for the day, two rings. The sound of children playing was mapped to meeting notifications. Thus, the user of an *Audio Aura* system could listen to a pleasant ocean atmosphere while still reading it to gain some notion of the state of his or her datascape.

Audio Aura's representational system used overt mappings that the user learned to read: a particular sound to a particular data type. It also used less overt means to communicate, such as schema stacking (four sounds equal a virtual beachscape) and experience-based logic (more = more, as in, more seagulls equals more e-mail).

An approach to a critical reading of *Audio Aura* might address the effectiveness of the sounds in creating the beachscape as well as the skill of the designers in leveraging people's experience-based logic. In other words, how easy is it to read this interactive system? And beyond the question of simple ease of use, how effective or evocative is it? Critical questions extend beyond whether the system is readable into whether it is worth reading. "User studies" in the form offered by the human-computer interaction community seldom address the latter question except in terms of business sense or efficiency.

By recognizing that a system has deliberately made the jump to representation, a critic can examine it for consistency or note where the internal logic of the representational system breaks down. It can also be critiqued with regard to the interactions between modalities: in this case, there were two time-based modalities (motion through space, sound) but for technical reasons they could not quite be matched in time, so that the sound lagged behind the motion. (This in fact was the biggest issue with the *Audio Aura* system.) A critical reading of such innovative artifacts should look for such intersensory qualities and consider the effectiveness of their intersection.

Reading with the Body: Haptic, Tactile, and Kinesthetic/Proprioceptive Representations

The several submodalities of touch that are often found in innovative media include tactile sensation, temperature sensing, haptic sensation, kinesthetics, and proprioceptics. This is not an exhaustive list (some authors list up to seventeen touch submodalities), but it does encompass

most of those that are computationally addressable in 2002. For the purposes of this discussion, here are some quickly sketched definitions of these terms.

Tactile sensation occurs on the surface of the skin: sensations such as graininess, slickness, wetness, wind. It is an analysis of surface texture through slight pressure and/or vibration (for example, judging the degree of roughness of something by the vibrations felt from rubbing across it). Temperature sensing is often linked with tactile sensation: a simple judgment of relative temperature. Kinesthetics is the sense of one's own motion, gained from internal clues. Proprioception is the perception of relative motion between one's body and the external world, which is aided by the vestibular sense, that is, a sense of balance partially cued from the eyes and inner ear. Haptics, often called force feedback, involves a combination of skin sensation, pressure sensing, and kinesthetics. All touch modalities are strongly influenced by one another and by other senses, especially visual.

Familiar behaviors involving interaction with physical objects can be thought of as stories the body understands largely through some combination of the touch modalities. Riding a horse, dancing, or driving a car involve bodily skills in sync with intellectual knowledge. In essence, these skills invoke sensorimotor stories to which the body responds. Recontextualizing this kind of familiar behavior allows the use of these sensorimotor stories in novel situations (Ishii and Ullmer 1997). The appropriate use of physical metaphors in control and feedback systems can help create fail-safe systems. The inappropriate use of them can lead to disaster, as Norman's studies of the control room at Three Mile Island point out (Norman 1995; Hutchins 1995). In that case, the design of the controls and the associated systems governing the nuclear power plant led the technicians to "read" them incorrectly; the result was a near meltdown of the nuclear core in the reactor.

A Haptic Schema for Dynamic Text Metadata: *Speeder Reader*

Let's look at an example of a novel reading device that uses touch modality schema projections to help interpret the text as well as metadata about

both the text and the device. *Speeder Reader* uses the familiar physical tasks associated with driving to enable readers to control it; in essence, they are "driving through a book." In this unusual reading device, the traditional rectangular layout of words on a page, read from left to right, is replaced by dynamic text (RSVP, or rapid serial visual presentation), so that the words flash one after another in the same position. In this case, the real-time metadata of dynamic text navigation—Where am I in the text? How do I get elsewhere? How do I control the speed of what I'm reading here?—are mapped to the familiar physical schema involved in driving.

First, a more complete description: *Speeder Reader*[3] is a reading machine that looks like a car-driving video game. On the floor is a foot pedal; on the console are a steering wheel and a stick shift. A view plate shows a speedometer and above that, where a car's windshield would normally be, words flash rapidly, one word at a time. The rate of word flash is controlled with a foot pedal ("gas" pedal), and the text stream is selected with a steering wheel. The speedometer shows how many words per minute are being presented.

Speeder Reader changes the way the human eye takes in text. Printed words on a page are read in "saccadic jumps," a series of short eye motions around a page. RSVP is a kind of dynamic typography wherein words or short phrases appear in sequence in one spot on a screen. As the words continually flash in one spot, the reader does not have to move his or her eyes, thus avoiding the saccadic jumps and eliminating the time used in moving and refocusing the eyes (Potter 1984; Ishizaki 1997; Wong 1995). With RSVP people can increase their reading speed to up to 2,000 words per minute (an average reader can read about 300 to 400 words per minute). With *Speeder Reader,* most first-time users double their reading speed.

Metadata Mapping: Stories about Navigation and Control

One problem with RSVP text is navigation: how to browse it. How does one find different sections of content, play them at an appropriate speed, and replay them at will? In *Speeder Reader,* as in the real world, this

problem is solved with known types of navigation and speed controls: a steering wheel, a gas pedal. Because it uses a familiar haptic story (driving) to control a new visual treatment of text, naive users can simply walk up to *Speeder Reader* and start using it with some confidence. Readers project the ideas of personal control and personal navigation that they understand from automobiles onto the use of this unique artifact.

How closely should a designer cleave to the original physical story? As with sonic material, complete and accurate replication of the physical experience is likely to be less desirable than a somewhat looser representation that allows some play in the design. For example, *Speeder Reader* really needed three or four forms of "reverse," none of them an exact replication of what happens when a car reverses. (Trying to read words in a backward stream does not work.) Instead, a reader might want to skip back to the beginning of a sentence, the beginning of a paragraph, or the beginning of the chapter, or even to start over completely. Rather than a reverse mode on the gearshift, *Speeder Reader* incorporates reverse buttons that allow the reader to jump backward through the text stream at a chosen granularity: sentence, paragraph, or chapter. When a button is pushed, the text stream jumps to that point and then begins running forward again. Not only that, but there is no brake pedal; speed simply lessens as the reader lets up on the gas. In this case, *Speeder Reader* is really borrowing a physical control schema from video driving games rather than from real automobile driving.

Still, the simple physical facts of the steering wheel and gas pedal give people the idea that they can control this device themselves. That schema works very effectively; people approach and assume a "driving" position without having to ask how to use *Speeder Reader*. Simple experimentation assures them that in fact the mappings are familiar to them: pedal controls speed, steering wheel controls location. The controls themselves tell the right story; bodily habits people have developed in driving cars (or video driving games) translate to physical control of *Speeder Reader*. This haptic storytelling works, even though it is not an exact replication of driving; in fact it works better than an exact replication would have. We can see in this example how the haptic story embodied in the interface design moves from replication to representation.

Achieving Abstraction . . . or Choosing to Forego It

The respective sonic and haptic representations of metadata in the *Audio Aura* and *Speeder Reader* systems offer a point of departure for exploration. Designing *Audio Aura* required the creation of a soundscape (several, actually) to be parsed for embedded data; developing *Speeder Reader* meant building a device for exploiting known physical skills for navigation. Much of the design process for each was a lexical task: What meaning is vital? What is privileged? How is it best represented? If this piece of data is represented by this sound, what does that imply for another similar, but slightly different, piece of data? How does sonic context or a change in sonic behavior (such as fading out more quickly) change the meaning of a sound? How detailed a representation is it reasonable to expect the user of these systems to be able to read, considering that these protogrammars are not taught in schools (unless of course one wishes to classify television programming as a form of media schooling, which may be valid)?

Whether it is possible, or even desirable, to attempt meaningful abstraction in nonvisual modalities that is as detailed and arbitrary as alphabetic text remains to be tested. To date, reading in multisensory systems divides itself between detailed information streams (like text or the spoken word) and simpler, less arbitrary representations that reside in the accompanying modalities. Experiments with abstraction in nonvisual modalities raise some obvious questions, granularity in particular. It seems unlikely, for example, that smell can carry complex ideas as efficiently as visual alphabetic text (Kaye 2001). It may be possible, however, to say things in scent that are unsayable any other way: consider the oenophile's vocabulary.

This chapter has been an attempt to draw useful connections between the development of symbolic languages in nonvisual sensory modalities and our understanding of the operations of image schema in the way we parse the world. These increasingly complex structures we author for nonvisual modalities are being read, for the most part successfully, by their intended audience. Conceiving of and respecting these structures as a developing language allows us to take a more complex and challenging, but more rewarding, authoring stance.

Critical Reading of Multisensory Texts

Reading in the sense of critical interpretation, that is, "close reading" of texts, buildings, art, and now new media—incorporates sets of metasymbols and the intertwining of cultural structures into the act of reading. In parallel with the development of multisensory reading systems, critical reading pulls from a variety of sources to create a cohesive—if temporary—fabric for understanding authored works. Arguably, those trained in close reading are uniquely qualified to engage in multisensory reading: it is an extension of the work of critical interpretation which they are already trained.

The proposals in this chapter for approaching and reading multisensory works are meant to be provocative. Certainly we cannot read languages that do not yet exist, and as we have noted, we are only beginning to develop structures that can carry complex, abstract meaning in nonvisual modalities. Nor did this chapter address the complexities of combinatory schema systems, in which the schema built in one sensory modality might undercut or cancel the effects of the schema built in another. Still, we can profit from awareness of the development of these inchoate sensory languages. If nothing else, the work presented in this chapter may be able to provoke the critical eye into becoming the critical body, aware of the many sensory pathways used in authoring and reading innovative media.

Whether we can move this specialized activity closer to the mainstream of symbolic understanding is one of the questions facing the authors of multisensory texts. Traditionally, multisensory media have been authored by teams: collaborative works like film, theater, and many if not most Web sites and CD-ROMs all employ specialists in each modality to participate in authoring the whole. A strong central vision—the film director, the Web producer—is needed to pull together the streams of media, mediating intersensory contradictions. As multisensory reading and authoring become better understood, these multiple tasks may become addressable by a single author. Many interactive works are now made by a single person and do reflect a single person's vision; the act of multisensory authoring is not necessarily a large-scale production effort. The increasing ease of use and accessibility of multisensory authoring tools offers the certainty of many more multisensory texts in the next few years.

Maribeth Back

Learning to read the developing sensory symbols sets in innovative new media will be a primary challenge for the critical community. The application of informed critical theory may well speed the development of these systems. Critical theory is well rooted in historical and cultural development, but understanding of basics in the perceptual and cognitive sciences is still only beginning to become part of the necessary critical vocabulary. Once again, reading has changed: the text of the future is text for all of the senses.

Acknowledgments

Many of this chapter's reflections on the current state of reading and the cultural and technological implications thereof are a product of lively discussions with Rich Gold and my colleagues in the RED (Research in Experimental Documents) group at Xerox PARC. RED's work in new media genres has informed and helped iterate these speculations on multi-sensory texts, symbol sets, and design. The RED group has since left PARC to form theREDshift, a high-tech research and design company. Special thanks go to Matt Gorbet and Jonathan Cohen for contributing their insight to the design of *Speeder Reader*.

Notes

1. Computer Numerical Control (CNC) is computerized machining: special tools that machine intricate parts according to a control program.

2. These early pieces were crude by necessity; until the late 1990s multimedia authoring tools had minimal sound manipulation capabilities. Most did not permit graceful cross-fades or individual treatment of tracks and had very bad effects processing, when they had any at all. Many did not even permit the use of high-quality sound files. Early multimedia were plagued with harsh, often jerky audio. Although studies show that high-quality audio can improve the apparent quality of a visual experience, the inverse is not true. Recent work shows that high-resolution graphics make low-quality audio seem even worse than it is (Storms 2000).

3. *Speeder Reader* was designed as one of eleven interactive experiences in "XFR: Experiments in the Future of Reading," a museum exhibition from Xerox PARC about the effect of digital technologies on reading. More than 250,000 people visited the exhibition at the San Jose Tech Museum of Innovation between March and September 2000 (Back et al. 2001).

References

Back, M. (1996) "Reconceiving the Computer Game as an Instrument for Expression: Narrative Techniques for Nonspeech Audio in the Design of Multimodal Systems." Ph.D. diss., Harvard Graduate School of Design.

Back, M., M. Chow, R. Gold, A. Balsamo, M. Gorbet, S. Harrison, D. MacDonald, and S. Minneman (2001) "Designing Interactive Reading Experiences for a Museum Exhibition." *IEEE Computer Magazine,* 34 (1), 1–8.

Bregman, A. (1994) *Auditory Scene Analysis.* Cambridge: MIT Press.

Chion, M. (1994) *Audio-Vision: Sound on Screen.* New York: Columbia University Press.

Coulmas, F. (1989) *The Writing Systems of the World.* Cambridge: Blackwell.

Hutchins, E. (1995) *Cognition in the Wild.* Cambridge: MIT Press.

Ishii, H., and B. Ullmer (1997) "Tangible Bits: Towards Seamless Interfaces between People, Bits and Atoms." In *Proceedings of Conference on Human Factors in Computing Systems (CHI '97).* New York: ACM Press, 234–24.

Ishizaki, S. (1997) Kinetic Typography: Expressive Writing beyond the Smileys :-). At the Vision Plus 3 Conference Monographs. Vienna: International Institute for Information Design (IIID).

Kaye, J. (2001) "Symbolic Olfactory Display." Master's thesis, Media Lab, Massachusetts Institute of Technology.

Kramer, G. (ed.) (1994) *Auditory Display: Sonification, Audification, and Auditory Interfaces.* Reading, MA: Addison-Wesley, 8–15.

Machover, T. (1996) "Brain Opera." In *Memesis: The Future of Evolution.* Linz, Austria: Ars Electronica Editions, 300–309.

Mangini, M. (1997) Plenary speech delivered at ICAD (International Community for Auditory Display) conference, Xerox PARC, Palo Alto, CA, November 2–5, 1997.

Manguel, A. (1996) *A History of Reading.* New York: Penguin Putnam, 6–7.

Marshall, C. (1998) "Making Metadata: A Study of Metadata Creation for a Mixed Physical-Digital Collection." In *Proceedings of the ACM Digital Libraries '98* (Pittsburgh, June 23–26). New York: ACM, 162–171.

Minsky, M. (1988) *The Society of Mind.* New York: Simon and Schuster.

Mynatt, E., M. Back, R. Want, J. Ellis, and M. Baer (1998) "Designing Audio Aura." In C. Karat et al. (eds.), *Proceedings of CHI '98.* New York: ACM Press, 566–573.

Norman, D. (1988/1995) *The Design of Everyday Things.* New York: Doubleday.

Potter, M. (1984) "Rapid Serial Visual Presentation (RSVP): A Method for Studying Language Processing." In D. E. Kieras and M. Just (eds.), *New methods in reading comprehension research.* Hillsboro, NJ: Lawrence Erlbaum, 91–118.

Raiders of the Lost Ark. (1981) San Rafael, CA: Lucasfilm Ltd.

Schank, R., and R. Abelson (1995) "Knowledge and Memory: The Real Story." In R. S. Wyer, Jr. (ed.), *Advances in Social Cognition,* vol. 8. Hillsdale, NJ: Lawrence Erlbaum, 1–85.

Schilit, B., M. Price, G. Golovchinsky, K. Tanaka, and C. Marshall (1999) "As We May Read: The Reading Appliance Revolution." *IEEE Computer,* 32 (1), 65–73.

Simon, H. (1994) "Literary Criticism: A Cognitive Approach." *Stanford Humanities Review,* 4(1) suppl., 1–25.

Storms, R. (2000) "Auditory-Visual Cross-Modal Perception." Paper presented at ICAD conference, April 2–5, 2000. Atlanta, GA: International Community for Auditory Display (ICAD).

Turner, M. (1996) *The Literary Mind.* New York: Oxford University Press, 17–18. *Twister.* (1996) Burbank, CA: Warner Brothers.

Wong, Y. (1995) *Temporal Typography: Characterization of Time-Varying Typographic Forms.* Master's thesis, Media Lab, Massachusetts Institute of Technology.

Zindell, D. (1989) *Neverness.* New York: Bantam Books.

7

Acting Machines

Peter Bøgh Andersen

The digital media are in the process of dissolving many boundaries that were previously believed to be almost ontological: the boundary between leisure time and work, between the soft and hard sciences, between signs and their references, between humans and machines, between truth and illusion. The reason for this is that digital media are a mixture of media, tools, and automata. When one buys one part, one simultaneously buys the other two as well. In addition, the development of shared interface standards means that the methods of operation are homogenized across diverse social domains. Playing with a flight simulator at home is similar to flying a real airplane.

This chapter shows that knowledge from seemingly separate domains of knowledge is needed to design good computer systems. I discuss a specific example, namely, a project on design of computerized maritime instruments, and I argue that knowledge from film theory and linguistics is helpful in formulating such a design. Although the fields seem different, the former being an engineering domain, the latter two belonging to the humanities, they address a similar problem, namely, how to present the inner states and processes of a complex system in a clear and understandable way. Before I point out the practical benefits of shifting the

boundaries between the technical and the humanistic disciplines, however, I shall give a short sketch of the historical background for this boundary and present the general reasons why we have to rethink it.

Computers Are a Mixture of Media, Tools, and Automata

The computer is unique in its versatility. It replaces or enhances nearly all artifacts of modern life and plays three roles that were previously enacted by three different types of objects: media, tools, and automata. By an *automaton* I understand an artifact that can perform some reasonably complicated process that ends in a desired state (e.g., having produced a certain product) without human interference, although humans may need to provide its material, set its controls, and start it. By a *tool* I understand an artifact that is under full manual control of its operator and is designed for producing or changing some physical object. Finally, by a *medium* I understand an artifact that is shaped with the explicit purpose of affecting other minds by offering information, issuing requests, posing questions, or yielding emotional experiences. Before the computer, these three kinds of artifacts were implemented by different technologies (an automatic weaving machine did not share properties with hammers or movies) and their contexts of use were disjunct (film cameras seldom entered the workplace, and combine harvesters only in accidents intruded into people's living rooms). Media belonged to the private and public sphere of society, whereas tools and automata were characteristic of the working sphere. Each type was produced by a distinct profession: media professionals came from the journalistic, the humanistic, or pedagogical educations, whereas engineering and the natural sciences were responsible for producing tools and automata.

These corresponding divisions of artifacts, professions, educations, and spheres of life goes back to at least the seventeenth century, in which the emerging natural science defined nature as a subject matter separate from the human mind. From that time onward, accelerating from mid-nineteenth century, we have a process of repeated differentiations within the domain of knowledge, all of them reproducing the basic gulf between humans and nature.

In the middle of the twentieth century, however, this nice and orderly picture began to be undermined gradually by a new artifact, the computer, that turned out to be able to play all three roles at the same time: automaton, tool, and medium. In the period up until 1980, most computers worked as *automata,* number crunchers that were fed with punched cards or paper tapes, processed the data those cards or tapes contained, and produced a result in the shape of endless fanfold paper. The 1980s saw the advent of interactive systems that allowed the user to continually influence the data processing and in this way could act as *tools.* We got word processors, spreadsheets, and drawing programs, and the computers moved from specialized computer departments into offices and later into homes. Finally, in the 1990s the Internet with the World Wide Web began to explode with copies of old *media* functions (e.g., mail) and brand new ones (e.g., chatrooms), and new hardware enabled multimedia technology; instead of being a textual medium, computers came to include digitized versions of all old media: pictures, sound, and movies.

Thus, at the dawn of the twenty-first century, we are faced with a technology that can pose as automaton, tool, and medium at the same time. Often the same hardware can change function, just by the replacement of one piece of software with another.

In addition, a set of nontrivial underlying concepts is common to all three domains: concepts of analysis, design, and programming. This shared set of concepts is enforced by the technology, since, for the first time in history, we have tools that come with a predefined semantics, namely, the formal semantics of the selected programming language. One may certainly say that the movie camera has an immanent semantics that can be discovered (e.g., movies invite narrative genres), but the semantics is not planned and explicitly represented in the camera. It is, however, planned and explicitly represented with programming tools. In this way, a shared mode of thinking is enforced across domains.

These shared formal concepts and skills are not sufficient, however, for building good computer systems: domain knowledge is required too. To make a good bank system, professional knowledge of banking must be represented among the designers. Similarly, a team aiming at designing good media applications must include general computing skills, as well

as traditional competencies from the media: journalistic, artistic, graphic, and editorial competencies. In short, the century-old division of skills and knowledge must be changed, influenced by an artifact that is inherently disrespectful of the traditional borderlines, and new ways of organizing knowledge must be developed.

In Denmark, such reorganizations of knowledge began in the early 1980s. The humanistic faculties of several Danish universities created programs of study for professionals in the digital media, and a decade later, the natural science faculties began doing the same, namely, defining educations or specializations that involve knowledge from the humanities and social sciences. I know of similar types of programs in the other Scandinavian countries, in Germany, and in France. Thus, the century-old division between natural science and the humanities has begun to bifurcate into more variants: classical media studies, digital media studies, informatics based on the humanities, digital art educations, "soft" computer science (concerned with organizational and human aspects of technology), and "hard" computer science (based on mathematics).

Summing up we can say that in the last two decades we have witnessed renegotiation of the boundaries between the soft and hard sciences and between media and machines. In addition, we can claim with some kind of certainty that a nontrivial set of shared knowledge, conventions, and values has begun to develop across the traditional social spheres. To give a very concrete example: a captain may find the same joystick on his ship's bridge as his son is using at home for his Playstation, and *NT Windows* may be the operating system of his conning display on the bridge, as well as of his personal computer at home.

Besides changes of curricula, we can observe similar changes in the call for papers of international conferences. Here is a particularly clear example:

IFAC Human-Machine Systems 2001
Human-Machine Systems (HMS) are influencing human life everywhere—at work, on the move or at home. . . . Cross-disciplinary experience, e.g., from the entertainment sectors such as the performing arts and music, should be exploited for the industrial, transportation, home, and service domains.

In the following sections, I shall give a concrete example of the reconfiguration of skills and knowledge. The example comes from a research project I conduct at the moment, namely design of maritime instrumentation. The project, part of the Danish Center for Human-Machine Interaction, started in 1998 and involves engineers, psychologists, computer scientists, and semioticians. Its purpose is to produce ethnographic descriptions of maritime work and communication, control analyses of typical tasks at sea, and computer prototypes that illustrate ways of designing flexible and interpretable instruments supporting the information needs discovered in empirical and analytical activities. At the time of writing, video data and logs have been collected during more than three months' field work on board various types of vessels; the data are used in analyses of tasks, communication, and control situations, and we have begun to design experimental prototypes (Andersen 2001). Theoretically, the project has mainly drawn upon semiotics and control theory, so to a large extent, it practices the renegotiation of knowledge boundaries discussed above.

The examples in the following sections are inspired by the project, but my emphasis will mainly be constructive, not analytical: I shall try to demonstrate that the cross-disciplinary focus of the International Federation of Automatic Control (IFAC) call for papers is in fact well justified and that designers of tools and automation may learn useful things from the aesthetic professions. In the next sections I show how to use concepts from film analysis and linguistics for designing maritime instruments.

Multimodality and Multimedia: The Bridges on Modern Ships

Like many other places of work, a modern ship bridge is a multimedia system (Petersen and Vittrup 1998). Figures 7.1–7.4 present a collection of instruments from a fast ferry.

Besides the view through the bridge's window, visual sources of information available to those on the bridge include VMS (Voyage Management System, allowing the ship to be guided by a map), ARPA (computer-enhanced radar), ECDIS (electronic sea map), conning displays (information relevant for maneuvering, the forces working on the ship), echo sounders (keeping track of the ground), the Doppler log (yielding speed), video screens (displaying images from remote-controlled

Figure 7.1

Closeup from ECDIS.

Figure 7.2

Video picture (left) and ECDIS (right).

Figure 7.3

Conning display.

Figure 7.4

ARPA.

Acting Machines

189

cameras), and old-fashioned stand-alone instruments, such as wind and temperature indicators. Apart from the information that such instrumentation provides, which is directly relevant for maneuvering and navigating, officers on the bridge may have access to engine information too. Auditory signals include communication gear (VHF radio, walkie-talkies, and intercom) and various alarms from the instruments.

Problems

There are two major reasons for introducing computer technology on the bridge: to enhance safety, and to save manpower (Lee and Sanquist 1996). Those operating on the bridge do in fact seem to be well supported by the new gear. When we left one ship with a modern integrated bridge, however, the two officers took us aside. They were quite satisfied with the bridge, but they asked, "How do we know what is left when a component stops working?"

This is in fact a very good question. The old bridges on ships contained only isolated stand-alone instruments, such as a GPS (global positioning sysem) receiver, a wind indicator, a radar, or a compass. If one component, such as the GPS receiver, malfunctioned or stopped functioning altogether, it had no effect whatsoever on the other instruments. The captain knew "what was left" when the GPS malfunctioned.

The situation is different on the new integrated ship's bridge. Here sensors deliver measurements to a shared database that is communicated through a local area network. The individual displays and instruments pick up a selection of signals and transform them in various ways. For example, the ARPA not only receives signals from the radar receivers, it also uses signals from the GPS receiver and the gyro. These signals enable the ARPA to calculate the position of the targets acquired on the radar and to superimpose map elements ("navlines" showing, e.g., traffic separations) on the radar plot and not only to display head-up displays, but to rotate them to north-up. Figure 7.5 shows only a small part of the signal exploitation one can encounter on an integrated bridge. (Head-up means that the course line of the radar points in the same direction as the ship is sailing, and north-up means that the line points to the north. It is important that the radar can be rotated in this way, as the officer sometimes

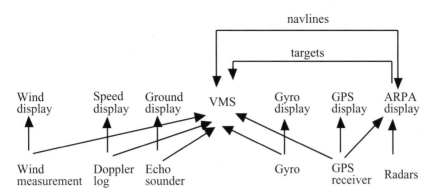

Figure 7.5

Simplified diagram of integrated bridge.

needs to compare the radar to the paper map, which has "north up," and to the view out the window.) Since an officer can no longer assume that a particular measurement is used in only one display, but must take into account that it may be used to calculate many pieces of information in different displays, it becomes really hard to estimate the damage done by a single faulty information source. To tell the users of such equipment "what goes on" is therefore much more difficult now than previously.

Steering

Let us illustrate this interconnectedness and interdependency of the equipment on the modern bridge by means of the steering equipment. Modern steering involves many levels of automation, as shown in table 7.1. The VMS sends course commands to the autopilot, which compares these commands to the ship's actual course (from the gyro compass) and calculates a course correction. The correction must be converted into a rudder order that is sent to the servo system that controls the hydraulic rudder engine that ultimately rotates the rudder.

The table also shows what the operator can do manually at each level. For example, she can enter waypoints into the VMS (figure 7.6), she can enter course commands into the autopilot (figure 7.7), and she can turn the wheel at the helm stand. If the automation breaks down,

Table 7.1

Levels of automation on modern ship

Level	User operations	
VMS (figure 7.6)	Make new plan	Draw waypoints
	Remove plan	Execute plan
	Get old plan	Stop plan
Autopilot (figure 7.7)	Enter course commands	
Helm	Turn the wheel	
Non-followup (NFU)	Press buttons	
Hydraulic pump (figure 7.8)	Pull rod	
Rudder	Pull rudder by means of wires	

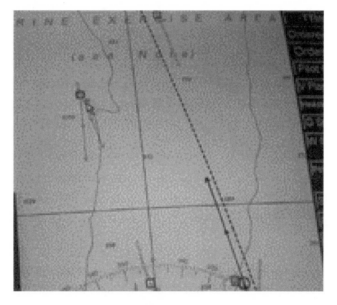

Figure 7.6

VMS on bridge.

Figure 7.7
Autopilot on bridge.

she can go down to the rudder engine and manually control the hydraulic pump by pulling a rod (figure 7.8)—and if everything breaks down, she can fasten a wire to the rudder and pull it.

This arrangement is not easy to understand, and one definitely needs diagrams to do so. In the old days, remote steering was also possible, but at that time, no diagrams were needed to understand causes and effects. One just started at the stern where the rudder is placed (figure 7.9), and followed the cordage through the officers' cabins (figure 7.10) until it disappears through the ceiling (figure 7.11). If one moved up on the deck, one could continue tracing its path to the helm stand.

Officers operating a modern ship need to develop a similar understanding of modern maritime systems in the following cases, which are all part of a normal routine:

• when errors occur (the conning display cannot contact the LAN)
• when the system is reconfigured (switch from 10 cm radar to 3 cm as a part of a normal harbor approach)

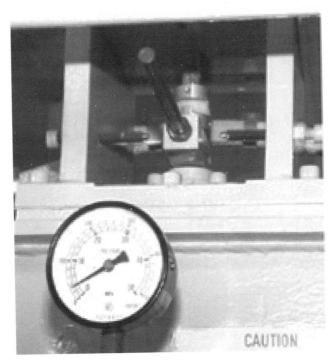

Figure 7.8
Manual steering in engine room.

- when automation level changes (change from autopilot to hand steering)
- when equipment is checked (make the bridge ready for departure from and entry into harbor)

It is well-known that complicated machinery does not create such understanding by itself. Many systems are "strong, silent, clumsy, and difficult to direct" (Woods 1996: 6) and too often give rise to the following questions: "What is it doing? Why is it doing that? What will it do next? How in the world did we get into that mode?" (7).

Before computers came aboard, it was possible for the well-educated engineers operating the ship to see through the automation, understand

Figure 7.9

Steering in the frigate *Jylland* (from 1860). Rudder stem with tiller.

Figure 7.10

Cordage runs through several cabins.

Figure 7.11

Cordage is led out through the ceiling to the deck above where the wheel is placed.

causes and effects, diagnose errors, and find a way out of any trouble that occurred. As we saw in the steering example, the governing architectural principle is that if higher-level automation breaks down, there must always be a handle underneath the engineer can grasp. This kind of self-reliance is necessary out on the open sea, far from any repair shop. "Graceful degradation" is a proud old tradition at sea.

Computers, however, are not made in this way. There is nothing graceful about a computer error: it says "poof," the system dies, and nobody aboard can repair anything. The only remedy when this happens is to shut it down and restart it. Therefore, introduction of computers onto ships puts the following question on the agenda: How can we communicate the inner states and processes of a complex system to its operators? As the organizers of the IFAC conference saw, a good place to look for an answer is in the performing arts and music, which have addressed this question for millennia. In addition to pursuing the traditional engineering virtues of stability, efficiency, and robustness, we also need to view our activity as a staging process. We are staging a complex machinery for the same reason as a director is staging a play: to communicate the inner states and processes of a complex system to a human audience in a clear way. I shall give two examples from film theory (Bordwell and

Figure 7.12

Patch-up of failed sound design.

Thompson 1997; Monaco 1977; Raskin, Forsberg, and Boysen 1988) to illustrate the idea.

Sound

On a ship we were visiting we saw the display shown in figure 7.12. It turned out that the display was added to the bridge to help the officers discriminate among the different kinds of audio alarms. Some innocent alarms (e.g., lack of paper in a printer) sounded as if the ship was about to sink, whereas other, more serious ones (collision warnings) were very discreet; finally, some of the alarms were so similar that they could not be distinguished from one another.

The problem here is twofold in that

- The alarms were not designed as a total "sound carpet" in which each component is balanced in relation to the others, because the sounds were delivered by different companies.
- The alarms were not designed as signs that should carry a meaning.

A good method for solving this problem is simply to buy a ticket for a good movie! Moviemakers are certainly conscious of both issues: for example, sound types in movies have standard priorities, so that music is turned

down when dialogue begins, and there are fixed conventions as to what kinds of music evoke what kind of emotional response in the movie's viewers (idyllic, ominous, merry, etc.).

Another area in which much can be learned from film art is the relation between the visual and auditory. Maritime work is very visual; the eye is constantly occupied in reading instruments and looking out the window. One way to alleviate the visual burden is to enable some kinds of information to have an alternative auditory shape. For example, one could use speech synthesis to inform operators of course changes, and 3-D sound could supplement inspection of the radar image.

Bordwell and Thompson (1997) report a revealing example of using sound instead of pictures for presenting information from John Ford's *The Stagecoach:*

> In John Ford's *Stagecoach,* the stagecoach is desperately fleeing from a band of Indians. The ammunition is running out, and all seems lost until a troop of cavalry suddenly arrives. Yet Ford does not present the situation this baldly. He shows a medium close-up of one of the passengers, Hatfield, who has just discovered that he is down to his last bullet. He glances off right and raises his gun. The camera pans right to a woman, Lucy, praying. During all this, orchestral music, including bugles, plays nondiegetically. Unseen by Lucy, the gun comes into the frame from the left as Hatfield prepares to shoot her to prevent her from being captured by the Indians. But before he shoots, an offscreen gunshot is heard, and Hatfield's hand and gun drop down out of the frame. Then the bugle music becomes somewhat more prominent. Lucy's expression changes as she says, "Can you hear it. Can you hear it? It's a bugle. They're blowing the charge." Only then does Ford cut to the cavalry itself racing toward the coach.

Focus

Some information sources run the risk of causing information overload. This can easily happen with electronic sea maps (an example is shown in

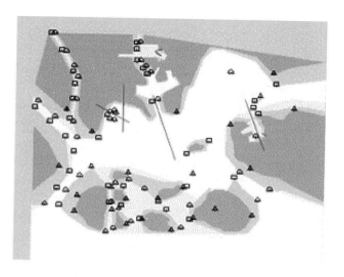

Figure 7.13

Simple electronic sea map.

figure 7.13), which can display a host of features: contours of the sea bed, buoys, lights, signals, danger areas, coastal features, check points, currents, depths, navlines, track of own ship, and so on. Each of these features can be turned on and off, since leaving them all on would create an overflow of information. The problem is that one might want to have some indication of, say, depth contours, even if they are not the most relevant information at the moment. That is, one might want more than two levels, on and off, to be available for each of the features of the map, and available in a form that does not contribute to information overload.

Again a visit to the movies might be a good idea. In particular, one should look for the director's use of shallow or deep focus (Bordwell and Thompson 1997: 221). In deep focus, all elements on the scene are sharp, whereas in shallow focus, only a certain depth is sharp, and the rest is blurred. Focus is used to gently guide the attention of the viewer: the sharp parts catch the eye, the blurred parts provide background and context. Change of focus, referred to as "pulling focus," is used to draw attention to objects. For example, a shot may start with focus on an

Figure 7.14

Electronic sea map focusing nearby lines and buoys.

object nearby and then refocus so that something in the distance springs into crisp focus. Examples of pulling focus abound in any movie, and it is a standard when a conversation is filmed: the one talking comes into focus.

If we replace the on-off facility in the electronic map with a focus property that allows us to focus more or less on the individual information types, then displays like those in figures 7.14 and 7.15 could result. (The black-and-white reproduction here unfortunately does not do justice to the power of focus; if color were available, we would decrease hue and saturation in the background and increase it in the focused parts. In this way, the focus would stand very clearly out from the background.)

The examples from moviemaking presented above came from the areas of editing and camerawork, but a glance at the actors themselves may be useful too. Good actors know how to express a state of mind by means of bodily posture, gestures, and facial mimic. As shown in figure 7.16, computer games have already learned the lesson (Andersen and Callesen 2001), so why not nonfiction applications?

Figure 7.15
Electronic sea map focusing radar.

Figure 7.16
Final Fantasy VII. Emotional gestures: shaking hands in anger.

Self-Reference and Self-Similarity

In this section I shall discuss the general architecture of transparent systems, and in doing so, I shall draw upon yet another medium, namely, language. In its development, language has had to cope with the reality that language users must repair any failures of communication themselves. If misunderstandings have jeopardized communication, the interlocutors cannot send for a repairman to have it fixed. In this respect, they are in the same

Figure 7.17

The first version of the prototype bridge. Courtesy Henrik Garde.

situation as the ship's officers in the middle of the Atlantic Ocean: they have to be self-reliant. But if one needs to repair or change something, one also needs to be able to talk about it: "On a very abstract level one could say, an adaptable application has to include a representation of aspects of itself. This self-representation needs to be manipulable and causally connected to the represented aspects, i.e. if the representation changes, the application changes as well" (Stiemerling and Cremers 1998: 303).

This is true of our prototypes too. Figure 7.17 shows our first attempt to design instruments for the ship's bridge that the users can them-

selves adapt to their needs. The upper part of the figure shows a simulation of a very simple bridge; the lower part is an editing area where users can themselves compose new instruments according to their needs. Like most editing tools, the lower part contains iconic representations that refer to the real instruments in the upper part of the panel by means of similarity.

Language too has developed mechanisms for referring to itself (Andersen 1998). So, for example, if I say to my students that language is a self-similar system, the students can interrupt: "I did not understand the term 'self-similar'; could you please explain?" In this sentence the phrase "the term 'self-similar'" refers to the conversation itself, namely, to a word I used a few seconds ago. I could answer the student by saying, "Well, 'self-similar' means that parts of the system have the same structure as the system as a whole. If we enlarge a part, we recognize the same structure as we saw in the whole." Incidentally, in saying so, I have proved my own point, since my answer demonstrates self-similarity syntactically as well as semantically.

Let us first look at syntax and analyze the first sentence of my response. As figure 7.18 shows, the sentence consists of a main clause containing a subordinate clause that functions as the object of the main clause,

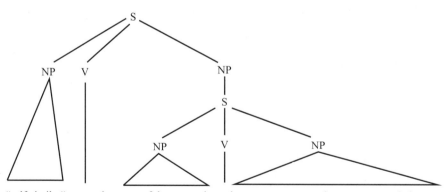

"self-similar" means that parts of the system have the same structure as the system as a whole

Figure 7.18

The subordinate clauses has (nearly) the same structure as the main clause to which it is subordinate.

and the two clauses have the same syntactic structure, NP + V + NP (subject + verb + object). The main clause thus contains a part with the same structure as it has itself.

As for semantic self-similarity, notice that the sentence provides a definition of the word "self-similar," and it does so by means of a new sentence consisting of words: "parts of the system have the same structure as the system as a whole." A part of the whole, the word "self-similar," is "opened," its internal structure is inspected, and it turns out that this structure is describable in the same way as the whole. Thus, the fact that lexicons and lexical definitions exist is an indication that language is semantically self-similar.

I believe that self-similarity is an effect of the fact that language must be self-referential. The argument runs as follows: language must refer to something that is not language—the social, psychic and physical world we live in—and it has developed methods for doing this. In addition, it must also refer to itself, because speakers not only must deal with nonlinguistic problems but must also take care of the linguistic ones themselves. The easiest solution to this problem is to use the same semantic categories for both domains, and that is in fact what we do. We can say, "He got off the track of the railroad," as well as, "He got off the track of the argument." Some researchers (Johnson 1992) describe this by saying that we use the physical domain as a metaphor for the communicative; I prefer saying that we use similar categories to structure both domains.

Suppose now we want to elucidate a detail of these descriptions. If semantics were not self-similar, we would have to shift categories and structures as we described the parts of the events in more detail. If each level of detail required its own semantic structures, then either there would be a finite number of levels of detail, after which discussion would be disabled, or we would have to remember infinitely many types of semantic structures. Both consequences would be detrimental to communication, and luckily this is not what we observe in practice.

A much better solution is to structure each level of detail according to the same schema. We would need to remember only one way of structuring, and there would be no limit as to the granularity of our discussion. Thus, self-similarity is the most rational solution to the problem.

The gist of this argument is that there is a causal relation between three phenomena relating to language (cf. similar ideas in Luhmann 1984, 1990):

• Language users must be able to repair (and renew) their means of communication themselves.
• Language is self-referential.
• Language is self-similar.

From this line of argument we can infer that if users of computer systems are responsible for maintaining, repairing, and adapting the system to new circumstances, then it is an advantage for the system to be self-referential and self-similar. The next question is then: what does it mean for a computer system to be self-referential and self-similar?

We can start to answer this question by noticing that computer systems are *syntactically* self-similar in much the same way as language. Clauses in a programming language can normally contain other clauses, and the meaning of a procedure call—a "word"—is given in a declaration that follows the same structure as the rest of the language. We can also note that the formal semantics of programming language is the same at all levels. A problem therefore lies in the realm of domain semantics, that is, what the system does in terms of its function and denotation. Here we very often have a very layered structure, with each layer having its own semantics that requires very different skills to understand. Parts of a program can be interpreted as a description of objects and events in the program's domain. Other parts have an internal interpretation in terms of data structures, and still other parts refer to the physical parts of the machine. This means that the user of a system is normally totally unable to apply his concepts for using the system to understand its internal working. As any computer user knows, this is most unfortunate if you have to take care of malfunctions yourself.

There are examples, however, in which a kind of self-similarity has been used as a design principle. In recent years, most systems have been able to be tailored to a limited degree, allowing the user not only to manipulate his work objects, but also his tools. In *Word 98*, for example, the user can add and delete items from the tool bar. As shown in figure 7.19,

Figure 7.19

Tailoring the tool bar in *Word 98*.

the tool bar is manipulated in a way very similar to the text manipulation
the user already knows how to do. For example, if you want to add the
Show All button to the tool bar, either you cut and paste it, or you simply
drag it to the bar, just as you would do to a chunk of text you want to
move in your document.

Another example comes from Bill Atkinson's *HyperCard*, a pioneer-
ing tool for end-user programming. *HyperCard* tried to adhere to the prin-
ciple that everything the program can do, the user should be able to do
by means of mouse and keyboard. What goes on inside the machine
should be able to be done by the user via the interface.

Figure 7.20 shows two buttons, Save and Close. The Close button
closes the system, but before that, it calls the Save button to save data.
This last operation can also be done by the user herself by pressing the
Save button.

Figure 7.20 shows clearly that what the system (the Close button)
does can be understood in terms of what the user herself can do, namely,
in both cases sending a "MouseUp" event to the Save button.

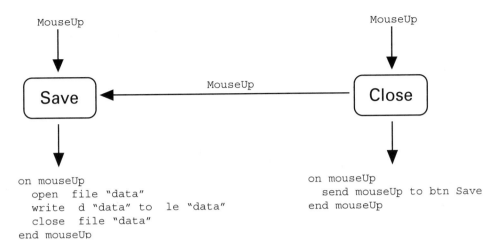

```
MouseUp                                         MouseUp
   |                                               |
   v                                               v
+--------+      MouseUp              +--------+
|  Save  | <------------------------ |  Close |
+--------+                           +--------+
   |                                               |
   v                                               v
on mouseUp                          on mouseUp
  open  file "data"                   send mouseUp to btn Save
  write  d "data" to  le "data"     end mouseUp
  close  file "data"
end mouseUp
```

Figure 7.20

HyperCard. Everything you can do I can do (better?).

The examples from *Word 98* and *HyperCard* motivate the following two principles:

• *The principle of tailorability.* Changing any object of the system is like changing the work objects of the system.
• *The principle of transparency.* What goes on between two internal objects of the system is similar to what goes on between the user and the interface objects.

Word 98 illustrates the principle of tailorability, since modifying the menu is like manipulating the text. *Hypercard* illustrates the principle of transparency, since the system's interaction with the Save operation is identical to the user's interaction with this process. The principle of tailorability is not my own invention but has been formulated in, for example, Malone, Lai, and Fry 1995: "More specifically, by tailorable we mean that end users (not skilled programmers) can progressively modify a working system (such as a spreadsheet) without ever having to leave the application domain to work in a separate underlying 'programming' domain" (178).

How could these two principles help in alleviating the problems of our two officers (Andersen and May 2001; Andersen 2001)? If we apply

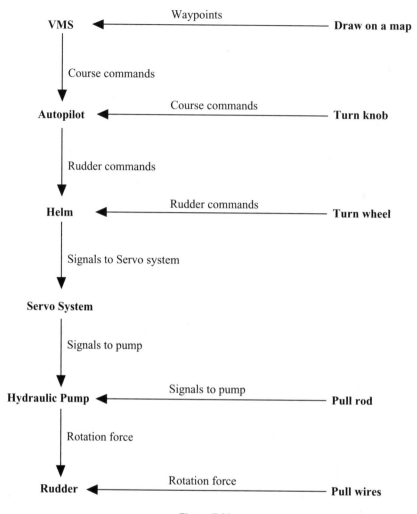

VMS ◀——— Waypoints ——— **Draw on a map**

| Course commands

Autopilot ◀——— Course commands ——— **Turn knob**

| Rudder commands

Helm ◀——— Rudder commands ——— **Turn wheel**

| Signals to Servo system

Servo System

| Signals to pump

Hydraulic Pump ◀——— Signals to pump ——— **Pull rod**

| Rotation force

Rudder ◀——— Rotation force ——— **Pull wires**

Figure 7.21

The principle of transparency applied to the steering system.

the principle of transparency to table 7.1 we get the diagram in figure 7.21, which incorporates the principle that everything a higher-level component does to a lower-level component, the officer can do herself to the lower-level component.

It is very encouraging that this is to some degree what happens on a real ship! For example, the officer can himself enter course orders into

the autopilot and also observe how the VMS does it. What I have done in constructing the system in this way is merely to apply the principle of transparency systematically. This is certainly not what normally happens, however, in computer systems. A possible guideline for designers, especially of maritime systems, could be to learn from existing noncomputerized automation and use the transparency and tailorability principles when they design the new software for the new system.

A consequence of the transparency principle is that there is more than one interface to a system. Normally one thinks of a system in terms of three components: a hidden model of the domain, hidden functionality that makes the model useful to the user, and the interface that presents the functionality to the user (figure 7.22). The principle of transparency requires us to assign an interface to all components, so that the user can inspect the working of the system at all levels. As illustrated in figure 7.23, this yields another self-similar structure in which the opposition Hidden Part + Interface forms a self-similar structure. It allows the user to open the hidden part, which will contain a set of objects with the same structure, Hidden Part + Interface. This opening-up process can go on through as many levels of the system as needed.

We plan to use a similar architecture in our prototype, because to modify old instruments and create new ones, the user has to understand how they work. Otherwise he would work in the dark. Applying the prin-

Insides (invisible) Interface (visible)

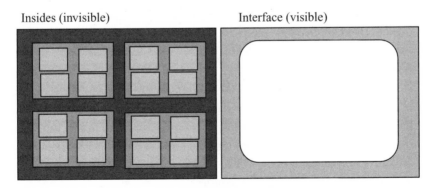

Figure 7.22
The interface as an independent component.

Figure 7.23
The interface as a recursive component.

ciple of transparency would mean that the individual instrument can be "opened" and that its interior must look like a collection of (simpler) instruments.

Discussion

In the preceding sections I have tried to show that it does indeed make sense to learn from older media, such as film and language, when we develop the new computer medium. Such knowledge cannot, however, be transferred to the new medium wholesale. Computer systems are not movies, since computer systems are machines. Nor are they a natural language, since the rules of a computer system are explicit and have a physical existence, which is not the case with the rules of our language. Therefore, our skills and techniques from older media must be modified and adapted to the new medium if they are to be productive.

As indicated at the beginning of this chapter, however, the issues in developing an adequate understanding of information technology go deeper than simply adapting old skills and techniques to a new domain. Qua mixture of automaton, tool, and medium, the computer challenges a centuries-old division of knowledge in Western society, the gulf between the natural sciences and the humanities.

In many countries, this challenge has been met by establishing new programs of study that incorporate elements from both sides of this gulf.

I have myself been involved in initiating three curricula of this type. As anyone that has attempted developing such curricula can attest, the task is not an easy one: organizational structures reflecting the old division of knowledge and historical cultural differences between the two communities exert very powerful conservative powers—and rightfully so! Valuable traditional ways of working and thinking do indeed run the risk of being thrown out in the process of change.

To avoid this, we must realize the magnitude of the task: to build a new scientific field that cuts across the old borderlines but retains the same theoretical standards we are used to. This objective is often neglected in the development of such programs, since the new curricula tend to be market-driven; that is, the contents are a reflection of the demand for labor power and not a natural consequence of a long-term scientific development. In establishing such a new field of knowledge we must disregard our old prejudices and try to select the skills and theories demanded by the new subject matter. Humanists may need to get rid of their math phobia, and natural scientists must recognize that subjective interpretations exist in the world along with the traditional "hard facts."

A very good example of this in our project is the opposition between *causal* and *intentional* explanations. Process control is traditionally concerned with the causal relations among the various processes in a plant and uses differential equations to describe these relations. Film theory and linguistics, on the other hand, assume that the filmmaker or the speaker has specific communicative intentions, and the two fields refer to these communicative intentions in the analysis of a movie or a speech act. But how should we view a display that is the result of the automatic processing of many different signals? On the one hand, there is clearly a causal chain from the individual sensors, via the computer system, to the visible display. But on the other hand, the display is clearly a sign that is designed with a purpose in mind.

Does this mean that intentional processes are really causal in nature, or conversely, that the causal processes are inherently intentional too? Or is there a third solution to the problem, for example, that the intention expressed belongs to the designers, who merely harness causal processes to accomplish their purpose? Whatever the solution may be, the questions are clearly disquieting for both natural science and the humanities.

Natural science will balk at the prospect of explaining natural processes by means of intention, and the humanities will fervently oppose the reductionism inherent in the view that intentional processes can be fully causally explained. Thus, the questions involved are certainly hard to solve, but we have to take the bull by the horns; otherwise the theoretical foundations of the new field will forever remain wobbly.

References

Andersen, P. B. (1998) "The Mass and the Individual In A. Jürgensen (ed.), *The Mass Ornament*. Odense: Kunsthallen Brandts Klædefabrik.

Andersen, P. B. (2001) "Elastic Systems." In M. Hirose (ed.), *Human-Computer Interaction. Interact '01. IFIP TC.13 International Conference on Human-Computer Interaction,* (July 9–13, Tokyo). Amsterdam; IOS Press, 367–374

Andersen, P. B., and J. Callesen (2001) "Agents and Actors." In L. Qvortrup (ed.), *Virtual Interaction: Interaction in Virtual Inhabited 3D Worlds.* London: Springer, 132–165.

Andersen, P. B., and M. May (2001) "Tearing up Interfaces." In K. Liu, R.J. Clarke, P. B. Andersen, and R. K. Stamper (eds.), *Information, Organisation and Technology: Studies in Organisational Semiotics.* Boston: Kluwer, 299–338.

Bordwell, D., and K. Thompson (1997) *Film Art.* New York: McGraw-Hill.

Johnson, M. (1992) *The Body in the Mind.* Chicago and London: University of Chicago Press.

Lee, J. D., and T. F. Sanquist (1996) "Maritime Automation." In R. Paraduramen and M. Mouloua (eds.), *Automation and Human Performance: Theory and Applications.* Mahwah, N.J.: Lawrence Erlbaum, 365–384.

Luhmann, N. (1984) *Soziale Systeme* [Social System]. Frankfurt am Main: Suhrkamp.

Luhmann, N. (1990) *Essays on Self-Reference*. New York: Columbia University Press.

Malone, T. W., K.-Y. Lai, and C. Fry (1995) "Experiments with Oval: A Radically Tailorable Tool for Cooperative Work." *ACM Transactions on Information Systems,* 13(2), 177–205.

Monaco, J. (1977) *How to Read a Film*. New York: Oxford University Press.

Petersen, V. A., and J. Vittrup (1998) *Navigation 2-3*. Copenhagen: Weilbach.

Raskin, R., F. Forsberg, and G. Boysen (1988) *La Dentillière—en filmbog. [La Dentillière—A Filmbook]* Viborg, Denmark: Systime.

Stiemerling, O., and A. B. Cremers (1998) "Tailorable Component Architectures for CSCW-Systems." In *PDP '98 (6th Euromicro Workshop on Parallel and Distributed Processing)* (Madrid). IEEE Press, 302–308.

Woods, D. D. (1996) "Decomposing Automation: Apparent Simplicity, Real Complexity. In R. Paraduramen & M. Mouloua (eds.), *Automation and Human Performance: Theory and Applications,* Mahwah, N.J.: Lawrence Erlbaum, 1–17.

8

Performing the MUD Adventure

Ragnhild Tronstad

MUDs as Theatrical Games

Conceptualizing multi-user dungeons (MUDs)[1] in terms of performance
and theatricality, this chapter deals with how the different possibilities of
acting and interacting within a MUD environment affect the games that
are being played there. Potentially MUDs can be conceptualized in a great
number of ways, both according to variations in structure and content
and dependent on the perspective researchers lay upon them. So far, it
is the social and educational aspects that seem to have caught the attention
of most of the researchers who study MUDs, which is probably why
MUDs are so often defined as "text-based multi-user virtual environ-
ments" and hardly ever as "text-based multi-user adventure games."[2] The
latter definition is, however, a much more precise description of the
MUDs I study.

Conceptualizing MUDs as games means entering a field that is not
yet properly established, namely, the field of game studies. Still in its initial
phase, game studies is currently searching to define its *ludology*[3] of appro-
priate methods, models, and concepts. At this stage, special emphasis is
being placed on defining what distinguishes games from literature, film,
theater, and drama, as these are the fields suspected to be most likely to

"colonize" the study of games.[4] Somewhat ironically, this stage is similar to that of theater studies about a hundred years ago, when it was trying to gain autonomy and independence from literary studies by defining its object of research to be the theatrical performance and not the dramatic text. The term "theatricality," as it will be used here to describe MUDs, was coined in this process as a description of what is essentially theater-like.

In this chapter I will identify or establish a connection between theatricality, performance, and gaming. I am not attempting, though, to colonize the field of game studies through theatricality, as neither am I going to claim that all games are theatrical, nor will I try to reach a general definition of what games are. I won't even claim that all MUDs should, or could, be conceptualized as games. Being hybrid game environments, different MUDs are serving very different purposes. Dependent on our conceptions of games and theater, certain MUDs will appear more gamelike or more theatrical than others. I am therefore taking a specific rather than general approach, using theatrical metaphors to describe certain gamelike aspects of adventure-oriented MUDding. Thus, my approach will result in but one of many possible definitions of what the MUD adventure is all about.

In theater studies today, theatricality and performance are concepts used mostly in the interdisciplinary study of theater-like phenomena outside institutional theater. Neither performance nor theatricality is therefore a clearly defined term, but instead both tend to change meaning according to how and in what context they are used. This makes them, of course, highly usable, but also potentially confusing. Instead of keeping them both floating freely, signifying some diffuse, theater-like quality in the MUD, I'll do my best to define my use of them as clearly as possible and in relation to each other as both opposite and complementary terms. They do often start floating again as soon as they are "released" into context, probably because of the wide range of different metaphorical usages connected with them. Considering that they are after all rather complex phenomena, I don't really find this behavior inappropriate at all.

Performance versus Interpretation

Whereas the first part of this chapter is about the different ways characters act and interact within a MUD environment, the second focuses on the

quest. Taking the hermeneutics of Paul Ricoeur and his concept of a "world of the text" as my point of departure, I'd like to point to some rhetorical differences between the MUD puzzle quest and traditional "stories." At first sight hermeneutics would seem to be the perfect theory to apply to an activity so fundamentally interpretative as puzzle solving. But it soon turns out to be an impossible enterprise to apply hermeneutics to questing without making severe changes to the theory. Will it still be hermeneutics, after all these changes are made? Most of these problems are due to hermeneutics's being developed according to a different medium than that in questing: traditional print texts, defined as "works." Not only is it difficult to define certain cybertexts as "works," it may also be pointless even to try to do so, that is, unless we want the new medium only to reproduce the possibilities and restrictions of the old. Another, perhaps even more severe problem of applying hermeneutics to questing is that in focusing on the interpretation part, we are conceptualizing the MUD adventure as a story-to-be-interpreted rather than as a quest-to-be-accomplished. This may be entirely to miss the point of questing.[5]

In conceptualizing questing in terms of performance rather than as storytelling, I hope to show why and how traditional hermeneutics fails to grasp the more gamelike aspects of puzzle-solving quests. Now, I'd like to start out by introducing my main theoretical framework—theatricality, performance, and performatives—and explain how I apply them to MUDding.

Theatricality, Performance, and Performatives

Theatrical Games

In his 1958 book, *Man, Play, and Games,* Roger Caillois divides games into four different categories. There are games of *competition,* dependent upon skills, like football and chess; there are games of *chance,* like betting; games of *simulation,* like theater, exist; and, finally, we have the category called *vertigo,* including games like mountain climbing, skiing, and tightrope walking (Caillois 1958/1979: 36).

It is possible to find examples of all four of Caillois's categories within adventure-oriented MUDs. The acquisition of skills to beat monsters or other players in combat is an obvious example of the *competition*

category. Certain mazes or simply virtual lotteries are games of *chance,* and *vertigo* is realized when one's character enters a trap door or when the slaying of a monster triggers some unexpected consequences. With MUDs, however, the most obvious category must be said to be *simulation,* without which none of the examples mentioned above could ever take place.

Both Caillois and Johan Huizinga, author of the other play theory classic *Homo ludens* (1950), include theater and pretending in their definition of games and play.[6] The earliest and most detailed theoretical treatment of this *simulation* category is, however, carried out by Russian playwright, actor, theater director, and theorist Nicolas Evreinoff. His term for it is "theatricality," and he is credited as the first to use this term (in Russian, *teatralnost*) as a description of what is specifically "theatre-like," both in and outside the theater.

My approach is to present Evreinoff's concept of theatricality first as a universal phenomenon, to be found everywhere, and second as an aesthetic category, describing how Evreinoff defines the specifics of theater as an art form. I am then going to connect his theory to MUDding. I believe MUDs and theater share some of the same limitations: both media are restricted when it comes to presenting what we perceive as "realistic" representations. Connecting MUDding to an aesthetics that is explicitly antirealistic in its scope, I want to present a more general definition of MUD conventions in which the "closing of gaps" isn't automatically understood as a means to obtain narrative coherence.

The Theater-for-Oneself

In 1927, some of Evreinoff's essays were published in English in a volume titled *The Theatre in Life.* The main part of these essays treats theatricality as a universal phenomenon, inherent in human beings' (and animals') nature as a "will to theatre." Theatricality is here understood as the deliberate transforming of everyday life. According to Evreinoff, theatricality is present when we pretend (or dream about) being someone else or when we imagine the world to be different. A variety of other phenomena that owe their existence to the "theatrical instinct" are playing: all sorts of progress, shaving, religion, and, of course, theater.

As we are here talking about a theatrical instinct, Evreinoff prefers to define theatricality as a pre-aesthetic phenomenon. After all, he argues, theatricality is about *transformation,* which is a much more primitive operation than aesthetic *formation.* Still, he believes that the theatrical framing and transformation of otherwise boring everyday life is the best, if not the only, way of producing first-class theater today—a theater-for-oneself, capable of satisfying the needs of modern people who have learned to despise everything "common." Not only is the theater-for-oneself a purely individual experience, it is also possible to stage for anyone at any time and place by using one's imagination.

Evreinoff's Theater Aesthetics

A contemporary of Konstantin Stanislavski and his highly naturalistic Moscow Art Theater, Evreinoff feels personally offended by the new trend of naturalism in the theater. As Evreinoff is doing his very best to escape the boredom of everyday life by theatricalizing the world, he notices his colleagues being busy doing the exact opposite: moving everyday life into the theater. What could otherwise be the purpose of bringing in real chairs, real food, and actors who act like real people? Evreinoff (1927) sees this as a fundamental misunderstanding of the theater as a medium, in which *theatrical illusions* appear as a result of theatrical conventions rather than as a result of realism:

> Everything in the theater is, and must be, conventional. There exists at the moment of theatrical perception a sort of silent agreement . . . between the spectator and the player whereby the former undertakes to assume a certain attitude, and no other, towards the "make-believe" acting, while the latter undertakes to live up to this assumed attitude as best he can. The spectator as it were, says to himself: "This is a piece of canvas, but I willingly take it for the sky." If he cannot do so, it is either the fault of the artist who painted the decorations, or the fault of the player who betrays by his apathetic gaze his sceptical attitude towards this "sky," or else of the spectator himself, who is so dull-minded as to be utterly unable to mistake a makeshift for the real sky. (141–142)

Evreinoff's Definition of the "Monodrama"

As a dramatist, Evreinoff invents a genre he names, for lack of a better term, the monodrama.[7] Monodrama, in Evreinoff's definition, is when everything on stage is seen from the viewpoint of one main character only. There might well be other characters involved in the play, but these will appear to the spectator as the main character sees them. So when the main character dislikes one of the other characters, this other character will appear unsympathetic to the spectator too. The reason for advocating the staging of monodramas over the staging of ordinary dramas is that Evreinoff believes it is easier for the spectator to concentrate upon one mind at a time. Thus, by his or her identifying with one character only, the spectator's opportunity to be immersed in the play is enhanced. Furthermore, the monodrama facilitates the staging of complex psychological processes, of what is going on in people's minds.

The MUD Adventure as a Theater-for-Oneself

MUDs are fictional spaces. They are very far from what we call "reality" or "the real world." If we define "reality" as an opposite to "theatricality," MUDs are more theatrical than real. Following Evreinoff's definition, theatricality is the process that makes it possible to transform a situation into some sort of fiction: either in the theater, done by actors, or in the bus, street, or home, by me or you, as either actor or spectator. Theatricality can be to show things in a different setting other than the one in which they are normally perceived, and it can be just to see things differently. A misreading can thus produce theatricality, as it creates a breach in the perception of (intended) "meaning."

MUDs provide numerous possibilities for such "misreadings," as written descriptions of objects provide little information compared to objects we see in the real world. As MUDs are textual representations of spaces, places, objects, and beings, nothing is really seen in a MUD. All representations are—more or less vividly—imagined, and they are imagined differently by each player, according to his or her previous experiences inside and outside the MUD. We could refer to the experiences called upon while interpreting inside the MUD "context" or "frame." Thus, spaces, places, objects, and beings are framed differently by each and every player of the MUD.

This is why I prefer to look at the MUD as some fictional world I imagine by interacting with room, object, and character descriptions. I know that there are real persons behind the characters, but I also know that unless I have met these people in real life, my interaction with them is more theatrical than real. I imagine them.

MUD Conventions

You only give a start to my fantasy, set it working, and it will offer me in the most obliging manner all I want to see.
—N. Evreinoff, *The Theatre in Life*

The short descriptions defining each MUD room contain very limited information. They provide the spectator with key words conventionally describing a more or less "known" scenery, such as "the mansion of the evil sorcerer" or "the medieval village square." The details lacking in the descriptions need to be filled in by the spectator's imagination, according to his or her personal (p)references. Object and nonplayer character (NPC)[8] descriptions are also highly conventional. More than psychologically defined characters, NPCs are representative of types, and one can be sure one will never find a real chair in a MUD (if only because of the textual character of the medium).

The player in a MUD is both character and spectator in one person: a combination of the monodramatic main character and the autonomous spectator from the theater-for-oneself. He or she is watching the spectacle unfolding in his or her imagination, triggered by the words on the screen representing a world of its own. Automatically all other characters are seen through the main character's mind. If my character doesn't like one of them, I (as spectator) will certainly have no difficulties detecting that.

Performance

Performance is an even more complex concept than theatricality. Since the term is used to describe phenomena within many different disciplines, there are at least as many definitions of the term as there are different disciplines utilizing it. Thus, in a sociological context performance can be connected to the representations of the self, whereas in an anthropological setting it could refer to the dramatic structure of rituals. In linguistics

words perform, for instance, when someone makes a promise. In theater studies, performance can refer either generally to the staging of something or specifically to the form "performance art." When used in relation to performance art, performance means "real," not "theatrical." In general terms, and specifically in the social sciences, the term seems to be closer to "theatrical."

Although there are many more differences between the several performance definitions,[9] the way performance relates to theatricality is of fundamental importance in this study of MUDs. Whereas some theorists insist that performance is about representation, others equally strongly insist on its nonrepresentational qualities. Theorists insisting on the nonrepresentational aspects of performance will describe performance in terms of "physical presence," "nonrepresentation," or "nonreferentiality." Thus in performance art theory, performance is viewed as the nonrepresentational counterpart to representational theater (see Féral 1992, 1982/1997).[10]

Austin and MUDding

A nonreferential understanding of performance is also reflected in J. L. Austin's description of "performatives" in his book *How to Do Things with Words.* Austin distinguishes between normal statements (which he calls "constatives") and performatives by saying that whereas constatives are used to say something about the world, performatives act directly in the world. Promises are one example of such performatives.[11] By uttering a promise, the promise is made and not merely described. Because of this difference, Austin argues, performatives must be judged according to different criteria than constatives. Most important, we cannot ask whether a performative is true or false. As it is not referring to anything other than itself, it simply cannot be true or false. It can, however, be "happy" or "unhappy," dependent on the circumstances under which it is being uttered, affecting the "effect" it has on the world.

In MUDs we have a similar type of self- or nonreferential "speech acts." My typing "n" in a room will, if happily performed, effect the moving north of my character. Commands like "kill guard," "sit on chair," and "buy beer" function in the same way. Such commands, like Austin's performatives, are never true or false, but they can be happily or unhappily

performed. For instance, the absence of a guard in the room would make the performative "kill guard" infelicitous: the intended effect would not happen, there would be no fight. "Kill guard" is thus essentially performative and not representational. But of course it can also be used theatrically, if, for instance, I want to show off my fighting skills to an audience of other players.

Another way of showing off that is representational rather than performative is to use the "emote" command. With the emote command I am able to describe any possible action for the other players to see without my character's actually performing it. Emotes have a stylistic advantage over performatives, as using them allows players to decide exactly how they want their actions performed. The disadvantage is that these actions are not "really" performed, as they are not causing any "real" changes to the MUD environment. The example shown in figure 8.1 of an emoted kill succeeded by a real one will illustrate this difference.[12]

Being a description of an act, the emote command is closer to a constative than to a performative. We should be able, however, to define whether it, as a constative, is true or false. Logically, these constatives will always be false, as they are describing actions that do not really take place. On the other hand, they may also always be true, if we take the rules of the medium into consideration. According to the conventions of MUD communication, describing an action is equivalent to performing it. This could be our reason for regarding emote commands too as performatives and for judging them not according to whether they are true or false, but rather according to whether they are happily or unhappily performed.

We could then call emotes "theatrical performatives,"[13] as they do not really produce any effect "in reality," that is, within the "reality" in which they occur: the MUD world. Here, happy or unhappy will be a question of the effect they are producing in the spectator(s). A commands like "kill guard," on the other hand, will still be a nonreferential performative in the sense that typing it affects the "reality" of the MUD: if happily performed, it triggers a fight.

Different types of MUDs provide players with different ways of acting and communicating. Although all MUDs will allow their players to go north performatively, by typing "n" or "north," not all MUDs allow the players to attack guards or anyone else using performative commands.

The entrance hall of this castle is really impressive. A marble
staircase leads up and is covered with expensive rugs. The tapestry
decorates the walls. From the ceiling hangs a large candelabra which
illuminates the room.
There are four obvious exits: east, west, north and up.
A stone with a sword in it.
A large silver mirror.
One of the Leader's famous Elite Guards.

1) theatrical performative (emote)

> emote chops off the guard's head! Dead!
Edvard chops off the guard's head! Dead!

2) "real" performative

> kill guard
You tickle the guard in the stomach.
> The guard hits you very hard.
You miss the guard.
You can see a dark hooded man standing beside your corpse. He is wiping the
bloody blade of a wicked looking scythe with slow measured motions. Suddenly he
stops and seems to look straight at you with his empty... no, not empty but...
orbs...

Death says: COME WITH ME, MORTAL ONE!

He reaches for you and suddenly you find yourself in another place.

You die.
You have a strange feeling.
You can see your own dead body from above.

Figure 8.1

Examples of theoretical and "real" performatives in TubMud.

Instead, the players have to role play their attacks, using emotes, or what we called theatrical performatives. As these commands do not affect the physical reality of the MUD, the felicity of such performances depends on how the other players in the room react to them. In the earlier example, although I claimed to be chopping off the guard's head, the guard would still be visibly standing and alive to anyone curious enough to examine him. To challenge my performance, another player could simply start interacting with the guard. Alternatively, he or she could follow up on my performance by picking up the pieces or burying the guard.

In her article "Building a World with Words," Beth Kolko (1995) ascribes the happy performing of such theatrical performatives to the other players' wish to maintain coherence in the fictional world. Playing with theatrical performatives is thus described as a game of collaboratively creating coherent stories.[14]

Our theatrical perspective luckily allows us to forget about coherence, as we are putting more faith in the playful imagination of the participants than in the abilities of the medium to present anything at all "realistically." Generally, happy or unhappy performances depend on the player's learning and abiding by the rules, or conventions, of the game and do not have anything to do with coherence or realism unless these are the preferred modes of simulation in the particular MUD in question.

Playing with "theatrical" performatives and playing with "real" performatives thus are two ways of simulating MUDs. Both ways will occasionally produce games of competition, chance, and vertigo, though first and foremost MUDs are games of simulation. The basic formal difference between "theatrical" and "real" performatives is that whereas "theatrical performatives" are played against the other players in the MUD, "real performatives" are played against the machine.

The World of the Text: Questing and Hermeneutics

When the MUDs discussed in this study are defined as adventure games, it is because they provide quests for players to solve. In this part of the chapter I will look at the quest from two different perspectives: first from a hermeneutical point of view, applying Paul Ricoeur's notion of a "world

of the text" that can be reached through interpretation, and second as performance. As questing is a highly interpretative activity, a hermeneutical perspective seems relevant. Conceptualizing quests within Ricoeur's vocabulary will prove to be difficult, however, for two reasons: first because his hermeneutics is developed according to a different medium, and second because interpretation serves a different purpose when applied in quests. The performative perspective will be used to identify and resolve some of the problems connected to this.

Ricoeur's Definition of a "Work"

According to Ricoeur (1981), what must be interpreted in the reading of a text is "a *proposed world* which I could inhabit and wherein I could project one of my ownmost possibilities" (142).[15] To project a world, the text in question must succeed in establishing (and to a certain extent, limit) its own context, according to which it is being interpreted. Such texts are "works." If we want to apply the "world of the text" to MUDs, we will therefore first need to decide whether and in what way MUDs can be said to be "works." We have two possibilities here: either the MUD as a whole can be considered the "work," or we can choose to divide the MUD into quests and quest areas, which are then to be considered "works" too, or "works-within-the-work." Ricoeur's (1981) definition of a "work" goes as follows: "First, a work is a sequence longer than the sentence; it raises a new problem of understanding, relative to the finite and closed totality which constitutes the work as such. Second, the work is submitted to a form of codification which is applied to the composition itself, and which transforms discourse into a story, a poem, an essay, etc. . . . Finally, a work is given a unique configuration which likens it to an individual and which may be called its style" (136).

I shall start with defining the quest as the "work." Quests consist of a certain number of rooms normally defining, or at least being situated within, a limited area of the MUD. The limited text space demarcating this area thus also defines the narrative unit that needs to be interpreted in order to solve the quest. As such, quests could possibly fit Ricoeur's first criterion of a work, that is, a finite and closed totality. They are submitted to the form of codification that applies to quests: the special composition needed to transform a number of room descriptions into a

possible adventure. Finally, quests are often written by one single wizard-author, which should account for their individual style.

The Problem of Multilinearity

How does the notion of multilinearity apply to this? Multilinearity, if defined as multiple ways of solving the quest, would imply that the quest realm too consists of several "works" and of multiple potential "worlds of the text."[16]

As the MUD consists of several quest works connected and combined to represent a world, there is also always the possibility of a player's creating his own personal adventure by radically misinterpreting the limits of the quest work. When a misreading includes rooms from areas outside the quest realm in the interpretation of the quest, this will affect the "world of the text." What happens then to the quest as a "work"?

Problems such as these could be avoided by defining the MUD as a whole, and not the single quest, as the "work." The MUD as a whole is easily defined as a finite and closed totality, thus fitting Ricoeur's first criterion much better than the quest does. If we see the quest as a MUD subgenre, we can describe the primary "form of codification" of MUDs as to connect rooms to each other in a way that simulates a virtual world. This way Ricoeur's second criterion is also easily fulfilled by the MUD as a whole. His third criterion, the question of style, could prove more tricky, since MUDs are normally written by several different authors. There are often "rules," however, as to what kind of rooms, areas, and fictions are allowed within the MUD environment to ensure a certain coherence and also a certain style.[17]

Viewing the MUD as a whole as the work to be interpreted solves the problem of multilinearity connected to defining the limits of each quest work. Still, there are reasons for also regarding quests as works, or works-within-the-work, to be interpreted according to their own context and limits.

The Problem of Exhaustion

Questing is in many ways a fundamentally hermeneutic activity in which the hints function as parts that need to be understood in relation to the whole. The whole, in turn, becomes richer and more understandable by the addition of each part (unless of course the part is a false hint, leading

to confusion, but still at least extending the interpretative experience.) Even if a hermeneutical approach is necessary to solve the quest, however, what interpretation aims at is quite different in quests and the texts with which traditional hermeneutics is concerned. According to hermeneutics, the goal of interpretation is a more or less complete understanding of the text, a "fusion of horizons" in which the (previously alien) horizon of the text meets with my horizon of understanding (which has been educated through my gradual interpretation of the text). This is supposed to be an endless process in which the text's horizon always to some extent seems to escape complete understanding: there will always be more to explore. In questing, this is not the case. After the puzzles are solved, the text is, more often than not, experienced as exhausted. Mysterious hints that seemed to lead nowhere in the questing process are generally ignored after the quest is completed (that is, if they are experienced as belonging to the current quest and not to be leading somewhere else), even though there is a possibility that examining them further would reveal information that could broaden one's "understanding" of the quest. Why aren't these hints interesting? I believe that the reason for this is to be found in a functional difference between quests and narratives, similar in some ways to Austin's distinction between "performatives" and "constatives."

Solving a puzzle changes the function of it: from behaving like a performative when the solution is unknown, it turns into a constative when the solution is found. Or in hermeneutical terms, in realizing a quest, language is still event. First, when the quest is finished, it turns into meaning.[18] This might explain why the text is experienced as exhausted after the quest is completed. The only (hermeneutical) reason now for going back and continuing to explore would be to add to the narrative. This would require a different kind of interest. Some quests will of course "survive" this transformation from quest to story and be fascinating also after they are complete. This, however, is a different kind of fascination. You cannot really *do* a quest more than once, unless there are different ways of doing it.

The Performative Function of Quests

It was Shoshana Felman who gave me the idea of a possible performative function active in quests. In her book *The Literary Speech Act: Don Juan*

with J. L. Austin, or Seduction in Two Languages (1983), she describes the dialogues in Molière's play between Don Juan and the others as "a dialogue between two orders that, in reality, do not communicate: the order of the act and the order of meaning, the register of pleasure and the register of knowledge. . . . The trap of seduction . . . consists in producing a *referential illusion* through an utterance that is by its very nature *self-referential:* the illusion of a real or extralinguistic act of commitment created by an utterance that refers only to itself" (31). By referential illusions, Felman is referring to Don Juan's promises. Don Juan makes promise after promise, with no intention whatsoever of keeping them. This is what keeps Don Juan going. What keeps the MUD adventurer going is the promise of finding the solution to the puzzle, a promise that is renewed every time the participant finds a new object. When Don Juan finally keeps his promise, he dies. When the adventurer solves the quest, her adventure is over too.

The performative function of the quest requires a certain number of objects that the adventurer can interact with. As the examining of objects is fundamental, nothing is more annoying than objects that do not really exist, that is, that are in the room description but impossible to look at. Furthermore, they should serve some performative purpose. It should be possible to climb the trees, throw the stones, and search the bushes, mostly because the "happy" searching of a bush motivates the player to keep going, even when she does not find anything (this time): "If promising consists in the production of an expectation . . .—of meaning?—, the very disappointment of this expectation only perpetuates it, by bringing the acts of commitment back into play" (Felman 1983: 50).

Remembering that the ultimate promise of a quest is its solution, the excerpt from a TubMud quest shown in figure 8.2 serves as an example of how this expectation is created in the questing process. *The Realm of Witches Is in Danger* differs, however, from most other quests in that it can be carried out in three different ways: as a white, a grey, or a black witch. It can hardly be done in all three ways by one character, though, because the evil actions one performs as a black witch are not forgotten by the nice NPCs whose help you may need to do it the white way. Yet refraining from performing evil actions will prevent one from gaining the knowledge the nasty witch has to offer. This, combined with a couple of

```
            You walk along a long and dark corridor leading slightly
    @--?    downwards into the scary depths underneath the Grey Witch's
            castle. To the west, stairs lead up into the Entryhall.
            There are two obvious exits: up and east.
> examine stairs
The stairs lead upwards to brighter parts of Ardanna's castle.
> examine corridor
It is long and dark and might contain a hidden hint.
> examine walls
They are made of black stone. Maybe you should search
the corridor, there might be something to find...
> search corridor
After a short glace around, you make out a tiny inscription on the
east wall.
> read inscription
The inscription says: WIKKA PICCA MALEFIZ
A picture of no mean artistic value is drawn underneath.
It shows a broom, a witchhat, a black witchcloak and a black cat
arranged in a circle.
...
> east

            Five white candles illuminate this chamber with a flickering
    ?--@    light. They stand on the corners of a silver pentagram, which is
            inlaid into the floor.
            There is one obvious exit: west.
> examine pentagram
Fine lines of a silver metal form a pentagram on
the floor of this chamber. You could step into the pentagram
and try out a conjuration....
> enter pentagram
Sadly you can't initiate the ceremony!
You don't wear the right attire or don't wield the right weapon!
The demon doesn't heed your call!
But you have become part of the magic ritual now...
```

Figure 8.2

Excerpt from *The Realm of Witches Is in Danger,* by Ardanna.

extremely difficult puzzles (possibly bugs) in the neighboring areas, makes it virtually impossible to find and resolve all the potential hints. In this way, this particular quest succeeds in keeping the performative alive. By continuing to promise also after it is done, it never really ends.

Theatrical Metaphors and Gaming

In the first part of the chapter the use of theatrical metaphors to describe gamelike aspects of MUDding was based on and justified by the similarities between Evreinoff's conception of theatricality, Caillois's simulation category, and Huizinga's definition of play. This is a relevant approach for understanding the simulation part of MUDding. But theatricality is not sufficient to describe the other types of games that are taking place within the MUD environments.

In the second part, I used the category of "performatives" to point to a difference between quests and narratives, arguing for the advantage of conceptualizing quests as performance rather than as stories. This is because storytelling metaphors prevent us from focusing on the quest as it is happening, and thus they obscure the game play aspects of questing.

Although both theatricality and performance are concepts traditionally applied to theater studies, the "performatives" discussed in the second part of the chapter are not essentially "theatrical," but rather the opposite. Other established interdisciplinary conceptions of "performance" do, however, define it as a fundamentally representational activity, thus closer to our definition of the "theatrical." This floating of terms is apt to cause confusion, especially when the terminology and methodological framework of the "discipline" we are trying to establish them within are vaguely defined too.

Establishing game studies as a discipline on its own terms would certainly facilitate future interdisciplinary approaches to gaming, as we could then hope to have at least game-specific concepts and references as part of a common inquiry. The attempts of the ludologists (Aarseth 1997, 1999; Eskelinen 2001; Frasca 1999; Juul 1998) to reach the "bare essentials of gaming" by avoiding the trend of uncritically conceptualizing computer games in terms of theater, film, or literature and instead focus on

identifying features and dynamics characteristic for games in general are important steps in this direction.

If I was to define what characterizes games in general, the theater would perhaps not be my primary source for comparison. Still, the overlapping areas between games and play, play and theater, theater and performance, and performance and games indicate that a clear-cut distinction between these phenomena is difficult to make. Some games are more theatrical than others. The adventure-oriented MUD is but one example of a game that can hardly be conceptualized within a strict formal scheme of "gaming essentials" alone.

Acknowledgments

My thanks to Markku Eskelinen for reading and commenting on several versions of this chapter. Many thanks also to Janne Falch Irgens and Eli Leland for proofreading and to the editors, Andrew Morrison, Gunnar Liestøl, and Terje Rasmussen, for inviting me to contribute to the volume and for valuable comments and suggestions during the writing process. My research is funded by the SKIKT program of the Norwegian Research Council and the University of Oslo.

Notes

1. A brief introduction to MUDs can be found at ⟨http://www.mud connector.com⟩. From this site it is also possible to connect to a number of MUDs, including TubMud, the one from which the examples in this chapter are taken.

2. "Text-based" here means that all representations are written, as opposed to graphical or partly graphical MUDs.

3. The term is proposed to signify "the yet non-existent 'discipline that studies game and play activities'" (Frasca 1999).

4. Cf. Eskelinen 2001: "If and when games and especially computer games are studied and theorized they are almost without exception colonised from the

fields of literary, theatre, drama and film studies. Games are seen as interactive narratives, procedural stories or remediated cinema."

5. Cf. Eskelinen 2001: "A quick look at Espen Aarseth's typology of cybertexts (Aarseth 1997, 62–65) should make us see that the dominant user function in literature, theatre and film is interpretative, but in games it is the configurative (and sometimes the textonic) one. To generalize: in art we might have to configure in order to be able to interpret whereas in games we have to interpret in order to be able to configure, and proceed from the beginning to the winning or some other situation."

6. Huizinga's (1950) definition of play goes as follows: "a voluntary activity or occupation executed within certain fixed limits of time and place, according to rules freely accepted but absolutely binding, having its aim in itself and accompanied by a feeling of tension, joy and the consciousness that it is 'different' from 'ordinary life'" (28).

7. Note that "monodrama" normally signifies something completely different than what is implied by Evreinoff. It is therefore necessary to point out that we are here dealing solely with Evreinoff's personal invention/definition.

8. NPCs are robots representing living beings in the MUD. These are often referred to as monsters, although they can represent anything from trolls and dragons to shopkeepers and princesses.

9. See Carlson 1996 for a more detailed introduction to the different uses of this term. States (1996: 3) provides a quite useful illustration of the term's metaphorical diffusion.

10. Féral shares much of Evreinoff's view on theatricality. According to Féral, theatricality is a process that needs a room and a spectator to frame the room theatrically. Also, an actor can produce theatricality, but he or she will need a spectator to recognize it. If the spectator does not recognize the theatrical framing, there might have been theater, but no theatricality; Féral's example of this is "invisible theater." (Féral 1988/1997). The spectator can also identify theatricality where there is no intentional theatricality produced. Because the theatrical

framing is most explicit in the theater, or in a staged situation, it can be difficult to escape the theatrical gaze of the spectators under such circumstances. Still, this was what the performance artists in the 1960s and 1970s were trying to do. Trying to produce some kind of unmediated presence—by hurting themselves on stage, attacking the audience, etc.—they tried to escape theatricality and enter some kind of exaggerated "reality." In this context, performance thus means "lack of theatricality."

11. Other examples are marrying, naming, betting. In short, these are all acts that are performed by the uttering of words.

12. All examples in this chapter are from TubMud ⟨telnet morgen.cs.tu-berlin.de 7680⟩. They are performed and edited by me for the sake of illustration.

13. Austin (1955/1997) of course refused to talk about representational performatives, as in cases in which a performative is being uttered by an actor. He writes: "Language in such circumstances is in special ways—intelligibly—used not seriously, but in ways *parasitic* upon its normal use—ways in which fall under the doctrine of the *etiolations* of language. All this we are *excluding* from consideration. Our performative utterances, felicitous or not, are to be understood as issued in ordinary circumstances" (22).

14. Kolko (1995) would perhaps have disapproved of this definition, as according to her, "the construction of the world of MOO via narrative *is about more than mere word games* to its participants. Participants come to care, deeply, about the shape of narrative in MOO, and they will invest significant effort to ensure that those narratives proceed in a manner that ascribes to specific (not static or universal) conventions" (emphasis added). She does, however, describe MOOing in terms of gaming shortly after: "When the competing narrative threads that characterize each of these examples begin to unravel, the action in the room will center around whose story 'wins.' Who will control the direction in which the narrative moves? Who, if anyone, will accede to the other choices made? In the vast majority of circumstances, there will be an attempt to close the gap, to resolve that narrative split." Conceptualizing MOO interaction as "narratives" and "more than mere word games," Kolko wants to show the pedagogical possibilities of using MOOs in teaching students rhetorics: "From a peda-

gogical perspective, understanding the need to close narrative gaps, to reweave divergent threads, and to continue a story's development . . . MOO can provide a place for students to learn that their language has material effects."

15. As Ricoeur's hermeneutics is based on the interpretation of more traditional literary works, "inhabiting the proposed world" does not imply being able to "physically" enter the text space, as is possible in MUDs. Rather the proposed world must be understood as the mental conception of a "world," projected by and in front of the text during the interpretation of it.

16. Certainly, according to my experience, most quests are not really multilinear but structured to provide one main story that unfolds as the player interprets certain rooms and their relations in the "right" order. Although the clues given by the text can often be false and thus seduce the player only into wasting time trying to include them in the big scheme, such clues do not really provide alternative stories, as they normally lead to dead ends. During the "right" interpretation leading to the quest's solution, false clues will be forgotten or disregarded, as they are insignificant in the context of the "real story." So "false hints" are not necessarily representative of the problems of deciding the limits of a quest, although they may be. This does not make the question of multilinearity irrelevant. After all some quests do provide different solutions dependent on the choices made by the player during the questing process. Knowing and expecting some quests to have a multilinear structure, I argue that multilinearity should be included as one of the genre conventions of quests even if it is not always carried out in practice.

17. Cf. TubMud's wizrule 8: "The game is supposed to be in the 'long distant past,' and thus no modern things should exist. If you want some kind of airplane, use a flying horse instead etc." ⟨http://autos.cs.tu-berlin.de/~tubmud/help/ ?keyword=w/i/z/r/u/l/e/s⟩.

18. In his article on temporality in ergodic art, Espen Aarseth (1999) identifies a similar difference between the ergodic process of playing and the narrative produced after this process is completed: "Once realized, the ergodically produced sequence may be regarded and narratively reproduced as a story, but not one told for the player's benefit at the time of playing" (35).

References

Aarseth, E. (1997) *Cybertext: Perspectives on Ergodic Literature.* Baltimore and London: Johns Hopkins University Press.

Aarseth, E. (1999) "Aporia and Epiphany in *Doom* and *The Speaking Clock:* Temporality in Ergodic Art." In M.-L. Ryan (ed.), *Cyberspace Textuality.* Bloomington and Indianapolis: University of Indiana Press, 31–41.

Austin, J. L. (1995/1997) *How to Do Things with Words.* Cambridge: Harvard University Press.

Caillois, R. (1958/1979) *Man, Play, and Games* (trans. M. Barash). New York: Schocken Books.

Carlson, M. (1996) *Performance: A Critical Introduction.* London: Routledge.

Eskelinen, M. (2001) "The Gaming Situation." Paper presented at the 4th Digital Arts and Culture conference, Providence, April 26–28. Published in *Game Studies: The International Journal of Computer Game Research,* 1. Available at ⟨http://www.gamestudies.org⟩.

Evreinoff, N. (1927) *The Theatre in Life* (ed. and trans. A. I. Nazaroff). London: George G. Harrap.

Evreinoff, N. (1908/1978) "Introduktion til monodramaet" [Introduction to the monodrama] (trans. E. Bondo). In K. Kvam (ed.), *Europæisk Avant-Garde Teater 1896–1930 (Ungarn, Polen, Sovjet)* [European Avant-Garde Theater 1896–1930 (Hungary, Poland, Soviet Union)]. Odense, Denmark: Odense Universitetsforlag, 149–170.

Felman, S. (1983) *The Literary Speech Act: Don Juan with J. L. Austin, or Seduction in Two Languages* (trans. C. Porter). Ithaca: Cornell University Press.

Féral, J. (1992) "What Is Left of Performance Art? Autopsy of a Function, Birth of a Genre" (trans. C. Tennessen). *Discourse,* 14(2), 142–162.

Féral, J. (1982/1997) "Performance and Theatricality: The Subject Demystified" (trans. T. Lyons). In T. Murray (ed.), *Mimesis, Masochism, and Mime: The Politics of Theatricality in Contemporary French Thought*. Ann Arbor: University of Michigan Press, 289–300.

Féral, J. (1988/1997) "Teatralitet" [Theatricality] (trans. E. Falck and Å. Redtrøen. *3t*, 2, 8–20.

Frasca, G. (1999) "Ludology Meets Narratology: Similitude and Differences between (Video)Games and Narrative." Available at ⟨http://www.jacaranda.org/frasca/ludology.htm⟩.

Huizinga, J. (1950) *Homo ludens: A Study of the Play Element in Culture*. Boston: Beacon Press.

Juul, J. (1998) "A Clash between Game and Narrative." Paper presented at the 1st Digital Arts and Culture conference, Bergen, November 26–28. Available at ⟨http://www.jesperjuul.dk/text/DAC%20Paper%201998.html⟩.

Kolko, B. E. (1995) "Building a World with Words: The Narrative Reality of Virtual Communities." *Works and Days* 25/26, Vol. 13. Available at ⟨http://www2.iup.edu/en/workdays/KOLKO.HTML⟩.

Ricoeur, P. (1981) *Hermeneutics and the Human Sciences* (ed. and trans. John B. Thompson). Cambridge: Cambridge University Press and Paris: Editions de la Maison des Sciences de l'Homme.

States, B. O. (1996) "Performance as Metaphor." *Theatre Journal*, 48(1). Available at ⟨http://control.press.jhu.edu/demo/tj/48.1states.html⟩.

9

Digital Poetics

The Poetical Potentials of Projection and Interaction

Lars Qvortrup

In 1993, Brenda Laurel published *Computers as Theatre,* which revolution-ized the understanding of designing interfaces in interactive digital media. The message was that one should think of the interface not as a "transfer link" between the user and the computer, but as a stage populated by human and computer-generated agents in a digital context with objects, settings, effects, lighting, and so on. Consequently, the aim of the interface designer is to stage a play, and Laurel labeled the analytical description of this activity a "poetics of interactive form" 35).

In this chapter I will take a closer look at the concept of "digital poetics."[1] For me, "poetics" is an analytical, not necessarily prescriptive description (and here I totally agree with Brenda Laurel) of the way in which artists articulate an artistic idea or aim in their specific matter: letters, clay, stone, oil and canvas, stage elements—or digits. This does not mean that the artistic idea or aim exists in advance. On the contrary, typically is it realized only through the intense molding of matter. Thus, one should not confuse poetics and aesthetics. Aesthetics is about the artistic idea: what is in a certain era considered "beautiful," artistically desirable, and so on. Poetics is about the artistic work: how does the artist shape his or her material to give form to the artistic idea? How can the

process of poetical composition be described? Thus, poetics studies and conceptualizes the meeting between aesthetics and matter.

In this chapter I look at two important issues within the "poetics of interactive form" or "digital poetics": projection and interaction. Although we think that we know what projection and interaction mean, we haven't fully realized their implications for digital art and design poetics, that is, their potentials for articulating artistically desirable aims. Thus, my aim is to identify the poetic potentials of projection and interaction.

Marcel Duchamp

One of the most important and well-known art and design events in the twentieth century was the event staged by Marcel Duchamp in 1917. He bought a white porcelain urinal from R. L. Mott Iron Works in New York, signed it "R. Mutt, 1917" (which is pronounced the same way as the German *Armut,* meaning both material and spiritual poverty), gave it the name *The Fountain,* and submitted it to what was at that time the biggest art exhibition in North America. Although the art exhibition was uncensored, the exhibition committee refused to display the work. This developed into a press event, thus becoming a *succès de scandale* that expanded into an art historical episode with mythological dimensions. In 1964 a large number of replicas of *The Fountain* were made, authorized by Duchamp. Today these replicas are displayed at many leading modern art museums all over the world.

This series of events symbolizes the changing notion of art and a parallel changing relationship between art and design. The notion of art changed between Duchamp's original rejection and the acceptance of the 1964 copies because acceptance of the Kantian and the romantic idea that aesthetics is concerned with universal human beauty came to an end. Similarly, the relationship between art and design changed over the same period, because the hierarchical idea of art as the primary activity, placed very close to the holy halls of divine beauty, followed only at a lower step of the ladder by design, was replaced with an idea of "interference" between art and design in which design objects could become artworks simply through renaming.

Many contemporary digital artworks remind us of Duchamp's readymades. One example is the Danish digital installation *Recoil,* which I will analyze later in this chapter. It consists of a number of readymades: a microphone, a projector, a computer, and a screen. When the user enters the installation space and uses the microphone, however, things happen. Thus, in one sense it builds on the ideas developed by Duchamp and twentieth-century avant-garde aesthetics that art is not the realization of transcendental beauty but emerges from the interference of objects in or for use. In another sense, however, it adds to the potentials of Duchamp. We know that Duchamp and his colleagues loved action and kinetics in art, such as sculptures that moved when the audience pressed a button or images that changed as they were being viewed. It is my assumption, however, that only digital materials have realized the intentions of the avant-garde, or to turn the argument upside down, that Duchamp and his fellows were digital avant-gardists before the existence of the digital computer. Therefore, in order to understand contemporary digital art, those two sources that together constitute digital poetics must be identified: the aesthetics of the twentieth century and the computer as a digital art medium.

The Changing of Aesthetics

When Duchamp staged his porcelain urinal event, he introduced a new era of art. Going back in history, for Aristotle and for classical, premodern art theory, the basic aim of art was to articulate the divine secrets of life, that is, beauty. Being divine, these secrets were universal and metaphysical, and they existed in God-created matter. The task of the artist was to call these secrets forward by giving matter form. "By 'form' I mean the essentials of each single object, the 'thing' in itself in its primary meaning," Aristotle said (quoted in Bernsen (2000: 41). In doing so, the artist became a medium for God, and God sort of "guided" the hand or tongue of the "inspired" artist. The implicit argument is that as beauty is a universal phenomenon, equal from person to person, and from one art form to another, some external spirit must inform the artist. This spirit is God, and in the most successful ("inspired") artworks God's spirit is manifested and visible as "catharsis."

Since the European renaissance, art theory has reacted against this argument. For instance, art theoretician Leone Battista Alberti, in his epoch-making 1435 book *De pictura,* emphasizes that the traditional principle of "verisimilitude," that is, the highest possible similarity between the object and the artistic work of art, must be replaced by the principle of "convenienza" or "concinnitas," in other words, by an artistic criterion based on internal correspondences in the work of art. Artists must, as Alberti says, "do their best in order to establish a mutual correspondence of all parts of the work of art; and this they will be if they in quantity, in function, in colour and in all other matters correspond in one beauty" (quoted in Panofsky 1969: 29). Here, the art theoretician does not derive the criteria of aesthetic form from anything outside the work of art, be it from religious norms or from political instructions, but finds these criteria in art itself. That "one beauty" in which all parts of the work of art must correspond is the beauty of universal humanity.

This beauty of universal humanity is expressed by the linear perspective of the visual arts, the implicit utterance being that art speaks on behalf of the human, that is, that the world is seen within the perspective of the universal human observer. As Alberti said, all parts of the artwork should be arranged in mutual correspondence. The principle guaranteeing this correspondence is linear perspective. But in the organization of the components of the painting according to the linear perspective a latent observer—the artist—is implied, in whose position the audience can place itself, thus representing the absent artist. This latent observer represents the universal human being. This principle is also seen in more general considerations concerning the judgment of taste, which implies that beauty does not exist in the thing in itself, but in the observer of the thing.

The classical argument for this position can be found in Immanuel Kant's *Kritik der Urteilskraft* (1790), for example, in his definition and discussion of aesthetic judgment. Aesthetic judgment has the form "X is beautiful." But what is the semantic structure of this judgment or, rather, the structure of the optical form of the aesthetic observation? The starting point for aesthetic observation is that a specific object awakes what Kant calls a "Wohlgefallen"—a delight—in the observer. But where is the source of delight? Kant begins with the observation that the form of de-

light, that is, of aesthetic judgment, is common to all humans. We often pronounce identical aesthetic judgments: what is considered beautiful for one person is often beautiful for another person as well. Even though we sometimes disagree about our aesthetic judgment, according to the argument of Kant, at least we share aesthetic criteria. Otherwise, we could not discuss aesthetic experiences. Art observation would have been a private matter that could not be communicated.

Following the argument of Kant, based on the fact that the form of beauty is not a private, but a shared, experience, one might think that the pleasure of observing beauty could be derived from qualities in the observed object. Not only I, but also you and others, experience a similar delight. Thus, one should think that beauty is a quality of the thing. But Kant refutes this as a delusion of objectivity. Although beautiful things have common qualities, they have these only according to a specific observational form. Consequently, beauty is not a quality of the thing being observed, but it exists as aesthetic judgments based on the existence of a common sense—the sense of beauty—in the observers. Kant states this as follows:

> Hence he must regard it as resting on what he may also presuppose in every other person; and therefore he must believe that he has reason for demanding a similar delight from every one. Accordingly he will speak of the beautiful as if beauty were a quality of the object and the judgement logical (forming a cognition of the Object by concepts of it); although it is only aesthetic, and contains merely a reference of the representation of the object to the Subject. . . . The result is that the judgement of taste, with its attendant consciousness of detachment from all interest, must involve a claim to validity for all men, and must do so apart from universality attached to Objects, i.e. there must be coupled with it a claim to subjective universality. (Kant 1971: 80f; English translation 1991: 51)

The judgment of taste, however, is different from other judgments (the pure and the practical) as it cannot be derived from universal concepts but must instead be derived from "subjective universality." But where does this subjective universality originate? The answer is summarized by Kant in the headline of paragraph 20 of *Kritik der Urteilskraft:* "The condition of the

necessity advanced by a judgement of taste is the idea of a common sense" (Kant 1971: 123f; English translation 1991: 82). According to Kant one should immediately think that beauty as supposed by Alberti exists in the work of art or in the object as internal correspondences. In reality, however, the category of universal delight is motivated by subjective universality, that is, by the judgment of taste performed by the transcendental subject. Accordingly, in Kant's argument in *Kritik der Urteilskraft,* we find an explicit anthropocentric paradigm. Beauty or delight is not a quality of the thing, but a quality of the optical form through which the transcendental subject observes the object.

During the early years of the twentieth century the anthropocentric paradigm began to be challenged. There is considerable distance between this anthropocentric judgment of taste and the notion of aesthetics implied by Duchamp's readymade strategy. The alternative to the anthropocentric position, an alternative that has been explicated by, for example, Niklas Luhmann (1990, 1994, 1995), is that the form of the judgment of taste is a social evolutionary outcome. In other words, it is always a provisional outcome of the development of the self-referential art system. Sometimes this position has been mistakenly interpreted as an "institutional" position, implying that single institutions (museums, galleries, etc.) can freely define what should be considered aesthetically good or bad. This is far from Luhmann's position. Of course society's aesthetic-meaning horizon is an outcome of complex communications between different institutions and between past and present ideals, but it is exactly the aesthetic-meaning horizon that constitutes the basis of aesthetic judgments. This aesthetic-meaning horizon cannot be replaced by local judgments of one or the other institution. This latter, rather simplistic, postmodern idea that "anything goes" has nothing in common with Luhmann's conceptualization of aesthetic judgments in a polycentric society.

Within this aesthetic context the traditional notion of "beauty" is challenged. Here, the artistic utterance has the character of a form decision. The artistic observation cannot, however, be identified through the difference between beautiful and nonbeautiful. Art is not defined through reference to universal divine or to universal human characteristics, but through self-reference. Artistic observation occurs as a copying of form into form. It is a form decision referring to artistic form. This implies that art func-

tions as the unfolding of a universe from a form principle. Art becomes world art, with the artist as a kind of motor of universe creation.

This view of art represents a fundamental break with prior conceptions, as artistic form creation is not observed in reference to an ontological or transcendental standard. Consequently, art is "de-orthodoxified." It is liberated from its obligation to be part of a religious project or to be devotional or just informative on behalf of the universally human. Instead of assuming a normative responsibility, the artistic form creation takes its starting point in difference. The dictum of the English mathematician George Spencer Brown (1971: 3) that form is taken out of form by drawing a distinction reflects this observation.[2]

The starting point of artistic form creation is to make a difference. Substance is cloven into form and ground, and the resulting form is reentered into itself to produce creations of complex form. This approach may be called the principle of differentiation. A decision is made that radically changes an object from being a design object into becoming an art object.

For art that celebrates the "aesthetics of interference," beauty does not arise in spite of the banality of the world, but on the contrary, by starting a game of banalities and clichés and letting them form new patterns. Here, that we do not understand each other is not seen as a tragic barrier: the greater the differences among us, the sharper the curiosity with which we observe each other from each of our own worlds. In such games technological artifacts may participate in the social play as coacting agents on equal footing with human actors, who according to tradition have had the monopoly of creating form. In the words of Bruno Latour (1996), patterns of networks stabilize in which small actors, both artificial and human, establish provisional couplings that because of their complexity create a certain stability: "Strength (order) does not come from concentration, purity and unity, but from extension, heterogeneity and by carefully weaving weak patterns" (49). Among other things, this explains why the relationship between art and design has changed. By recontextualizing or recombining design objects, the artist can transform such objects into artworks, whether as part of an ironic, a critical, or simply a passion-based project.

This new direction for art seems to represent an artistic reflection of the social fact that the world during the twentieth century became so

complex that it could not be observed in its totality from a single grand position or through a single principle. The world could only be grasped by letting it grasp itself, from below, so to speak. Consequently, order was not created from above, whether the principle was divine or human, religious or rational. On the contrary, order was created through self-organization. The hypercomplex system created order through its own self-generated principles of making patterns.

This transformation may be called a transformation from an art practice motivated by metaphysics to an art practice motivated by the principle of interference. Metaphysics represented an order that seemed to exist prior to the world. This was an order, such as that in the old European ideal of beauty, that art was supposed to reconstruct. The artist looked back or up or into himself to find the authentically or universally beautiful. Compared with this, the aesthetics of interference constitutes an order that exists as a *result* of the dynamics of the world. Here order emerges as an outcome of the development of the world, for example, in the form of patterns created by fluctuations; compare Ilya Prigogine's idea of dissipative structures that do not develop as chaos out of natural order, but that constitute order (or rather: complex criticality) out of complexity (Prigogine and Stengers 1979; see also Bak 1996). Order, understood as pattern creation, is created in art by starting aesthetic games and by discovering those unexpected and unforeseeable patterns that emerge when already known elements are invested in new games. The aesthetic project is no longer based on principles of inspection or looking back, but is based on the principle of letting things happen: the above-mentioned principle of autology, of reentering form into itself, and in particular by reentering design objects into art contexts. This reentering of form into form, or this recontextualizing design into art, constitutes the creative process of art production.

Duchamp made this absolutely explicit when he commented on the so-called Richard Mutt Case:

What were the grounds for refusing Mr Mutt's fountain:

1. Some contended it was immoral, vulgar.
2. Others, it was plagiarism, a plain piece of plumbing.

Now Mr Mutt's fountain is not immoral, that is absurd, no more than a bathtub is immoral. It is a fixture that you see every day in the plumbers' show windows.

Whether Mr Mutt with his own hands made the fountain or not has no importance. He CHOSE it. He took an ordinary article of life, placed it so that its useful significance disappeared under the new title and point of view—created a new thought for that object.

As for plumbing, that is absurd. The only works of art America has given are her plumbing and her bridges. (quoted in Blazwick and Wilson 2000: 70).

Already here, in 1917, the decontextualization strategy is totally clear, implying that the relationship between design and art must be reconsidered. Also, this suggests that the classical hermeneutic understanding of the role of the audience as somebody adding significance to the artwork was challenged. Consequently, Duchamp must have been amused when he heard the well-intentioned and in their own opinion progressive reactions to his *Fountain*, according to which the urinal has "a lovely form," resembles the image of "a seated Buddha" or even—highly sophisticated—is compared to a vagina, "a ready receptacle for male fluids." (Blazwick and Wilson 2000: 148). This was exactly the kind of old-fashioned, hermeneutic tastefulness that Duchamp fought against.

A Poetics of Digital Art

One consequence of the art historical development summarized above is that the relationship between art and design has changed. Design is no longer a secondary art form—"art with a purpose"—but on a level with art. This also implies that design need not be so busy legitimizing itself as "almost art." On the contrary, art and design are both concerned with forming matter according to intention, whether this intention is artistic or design-oriented, and they can mutually learn and steal from each other: artists take design objects and recontextualize them or just give them signatures, and designers take artworks and art strategies and recombine them in cities, infrastructures, world designs, and supermarkets. Their meeting point is poetics.

What differences remain between art and design? The basic difference remaining between the two is that whereas for art the final aim is, through creation of significant forms, to make that which we take for artistically significant available for communication, for design the final aim is to make externally defined purposes accessible for communication. More importantly, the communality of art and design is that they both experiment with the manipulation of tools and materials for realizing a certain aim. This is so whether this aim is artistic (and is called aesthetics) or external, coming from functional domains of human-centered usability, business, politics, ecology, ethics, and so on. Thus design poetics may be defined as ways in which purpose can be translated into material, or, more precisely, strategies for making an external purpose visible in objects through tool-based forming of these materials.

In a digital domain, however, both art and design must reflect the reality that to some extent physical matter has been replaced by digits and mechanical tools by computers. Thus, a poetics of digital art and design must reflect both that aesthetics has changed from anthropocentrism to polycentrism and that matter has changed from matter to digits. A basic task for a poetics of digital art and design is to conceptualize digital materials and to identify the basic topics or strategies of digital poetics. Consequently, in the following sections I will first suggest a conceptualization of the "matter" of digital art and design. Second, I will identify two strategic issues for digital poetics: projection and interaction. It should be noted that my argument refers only to the representational or interface level, not to the structural level, of the computer.

From Matter to Digital Signs

What is the raw material of digital design? It is not physical matter, but digits. At the representational level, however, digits exist for us as signs, something standing for something else according to a convention. Consequently, to understand what constitutes the "matter" that digital artists and designers have to mold, a classification of signs can be helpful. It should be remembered, however, that this concerns the matter or the medium of digital design, not its references. Consequently, there is no implicit or explicit reference to the discussion concerning the relationship

between the visual and verbal relevance of contemporary design, for example, Gunther Kress and Theo van Leuwen's (1996) position that regarding modern design, visual competence is as legitimate as verbal competence. In this section I am referring to the medium of digital art and design, not to their references.

According to American semiotician Charles Sanders Peirce, signs can be classified into three basic groups: indexical signs, iconic signs, and symbolic signs. An index is a sign, says Peirce, that refers to the object that it denotes by virtue of being affected by that object (cf. Peirce 1955: 102). The sign is "reactive" in the same way that a tree leaning towards the east is a sign of westerly winds. An icon is a sign that refers to the object it denotes by virtue of its similarity with the object (Peirce 1955: 105). Simple as it sounds, one should, however, add that "similarity" is a tricky concept and should be used only in relation to implicit or explicit criteria of similarity. For instance, a photo is an icon. Finally, a symbol is a sign that refers to the object that it denotes by virtue of a law (cf. Peirce 1955: 102), for example, a social convention or agreement. Language is the most well-known system of symbolic signs. Finally, signs can be put together in sign systems, the system of road signs providing one such example.

This theory can be applied directly to digital signs on the computer screen, thus providing an overview of the basic design matters of digital design. On the Web, buttons, links, and animations are indexes. They belong to the class of digital signs that change upon being affected by something or somebody. A button turns blue when the user clicks on it, thus indicating that it functions as a tool for the user. A digital agent moves according to my moving of the joystick, thus indicating that it is my avatar. Images, video clips, sounds, and the like are icons. They belong to the class of digital signs that function because of their similarity to something or somebody. For instance, the digital wastebasket on the desktop interface functions as it does because of its similarity to a "real" wastebasket. (As a matter of fact it is both an icon and an index, because it opens when we trash a file and closes when it is deleted.) Letters, words and texts are symbols. They belong to the class of digital signs that function because of their reference to something or somebody according to social conventions. Finally, most well-functioning interfaces are systems

of mutually related signs, signs that constitute systems according to a common idea. The desktop metaphor system is one such example, and in cyberspace large numbers of metaphor-based digital worlds and universes exist (cf. Johnson 1997).

I will not go into these basic elements of digital art and design but just mention that whereas in design normally the aim is to make the effects and functions of digital signs immediately accessible and understandable—for instance, by establishing a shared interface culture (Johnson 1997)—in digital art the aim may be the opposite (i.e., to hide the functional buttons, icons, and conventional signs, or rather to question their naturalness by making them problematic and thus making them a case for observation). One doesn't just use these tools unobserved, but one is forced to reobserve them. Here, the aim seems to be related to the strategy of Marcel Duchamp to create a new and critical view on what has already become culturally obvious. The aim is to take that which has already become an all too natural design object (the computer screen designed to look like a desktop or the urinal) and make it a material for artwork. This represents the classical "installation" strategy: to recontextualize well-known objects and thus to change their meanings.

From Being to Projection

Traditionally, artworks have been conceptualized as matter with a form: oil painted on the canvas, letters combined into texts in a book, persons acting on the stage. Within this tradition one can talk about the artwork in "being" categories. The painting "is" in front of the viewer, the play "happens" on the stage. Of course, in many cases projection techniques are used: front projection in the cinema, back projection in television sets, virtual reality systems, and so on. In most cases, however, projection is treated as a simple tool that should be kept out of vision. One focuses on the projection aspect only in cases of accident, as when a roll of film breaks or the television set does not work properly.

With digital art and design the configuration is often different. Here, the work of art includes the relationship implied by the projection. Some source, a projector, throws images onto a surface, and the resulting artwork depends as much on the projecting source and the quality and shape

of the surface as on the internal relationships between objects in the text or visual and auditory image. Thus, the artwork object to be observed by the audience is not just the resulting image or projection, but the relationship between the projection source and the material base of the projection, not as a simple cause-and-effect relationship, but as a complex system of material interferences and of textual interreferences. We know this in its most simple form from shadow plays, and we know it from the effect of sunlight cast through colored glasses in baroque churches, where the dust in the church plays an important role in seeing the colored column of light in the interior of the church, often interpreted as a manifestation of the auratic force of God. In the shadow play the source of fascination is not simply the moving shadows, but the fact that a person with simple finger and hand gestures can create very convincing moving images.

In digital art, one is presented with an increasing number of similar experiments. Let me just mention Japanese artist Makoto Sei Watanabe's *Fiber Wave II,* which in autumn 1999 was installed in the InterCommunication Center in the Opera City Tower in Tokyo. The heart of the installation was a computer that continuously registered wind speeds and wind direction in cities that included Paris, Buffalo, and Moscow and on planets such as Jupiter and Mars. While different wind conditions were depicted on huge displays in the installation hall depending on which location the public selected on the computer screen, the computer also transmitted wind data to two great jet engines, each mounted on a wall in the hall. From these, a Mars storm or Moscow breeze was then sent over a field of three-meter-high fiber-optic tubes, which glowed fluorescent green as they shifted. The public was thus walking around in a field of fiber optics rippled by a "universal" wind.

What is challenged in *Fiber Wave II* is the medium, or rather, our preconceived ideas of what an interface consists of. An interface is not necessarily a computer terminal putting out text, images, and sound; it might easily be plastic media: rippling fiber-optic fields, physical installations that dance, walls that seem to breathe as they contract and expand. The contribution of the artist is primarily to establish fascinating relations between different sources that in toto constitute the art installation. Projectors (projecting not only light but also wind) are directed by real-world phenomena, and the shape and quality of projection materials influence

the resulting dynamics. And the audience can influence the connectedness of the projectors with the real world and must observe the interplay between the different art installation elements and sources.

Consider another installation, also from the InterCommunication Center in Tokyo, in which one puts sensors on one's body and sits in a chair in a soundproof room. The sensors transmit the sounds of the body (the heartbeat, the pulse of the blood, the workings of the lungs) in amplified, distorted, and retransmitted form into the room, exposing the user to a wonderful, not out-of-body, but into-body experience—literally, an introvertive experience. Here, the initial projection source is not the external world but, in a very literal sense, the internal bodyworld, and in similar artworks the body may as well act as the projection surface, such as it is known from body art.

Although this installation represents an innovation of digital art, the basic mechanisms through which it operates are well known from art history. In all art there is a double relationship: the internal narrative relationship in the story being told or the painting being shown and the external relationship between the agents or actors in the story or the painting and the storyteller. With the initial "Once upon a time . . ." the storyteller directs himself explicitly to the audience, but soon he disappears behind the story. This double relationship is repeated within projection art installations, with the projector as a technical representative of the narrator. Sometimes actors in the play can break the narrative illusion and direct themselves to the audience, as has been well known since Bertold Brecht's "*Verfremdung* technique," which again is rooted in traditional Greek theater.

In projection-based digital art and design, however, particularly subtle ways of using such multiplications of relations can be found. One extraordinarily refined and complex example of the use of projection techniques is provided by Jeffrey Shaw's *The Golden Calf*, which was created for and first exhibited at Ars Electronica in Linz, Austria, in 1994.[3] In *The Golden Calf* the viewer holds a color monitor screen in his or her hands, and by moving it around a bare pedestal one can see a virtual golden calf standing on the pedestal. The monitor is a large, flat liquid crystal display (LCD) screen with a spatial tracking system attached to it so that the graphics computer system displays the appro-

priate view of the golden calf depending on the actual position, in relation to the pedestal, of the viewer holding the screen. Not only is a relationship constituted between the physical exhibition room, the viewer, and the projection image, but references are also established between the room and the image. The virtual golden calf has a very shiny mirroring skin in which the viewer can see the actual room of the exhibition reflected. Technically speaking this is achieved by first having photographed the exhibition hall with a fish-eye camera, then using the photographs to create a virtual panorama around the golden calf. This panorama has then been reflection-mapped into the calf so that the installation room is real-time reflection-mapped onto the calf depending on the position of the screen.

This digital installation has been analyzed by Anne-Marie Duguet, who calls it a "virtual site-specific art-work." Duguet (1997) notes that *The Golden Calf* "weaves a set of subtle paradoxes into a web of virtualization and actualization" (46). She describes it as a kind of interaction space in which the user, in order to observe the calf in the virtual/real room, has to dance around the pedestal on which the golden calf is perched. The viewer is forced to enter the narrative world of the artwork, and simultaneously the artwork exists in and refers to the exhibition world of the viewer.

Actually, this constitutes an examination of simulacra in which Shaw, as noted by Duguet (1997), draws on the notion of the "inframince" (i.e. "infra-thin") separation developed by Marcel Duchamp in forty-six notes made between 1912 and 1968. Although in some of the notes Duchamp focuses on the relationship between "identicality" and separateness, that is, the "infra-thin separative difference," in his final note he emphasizes that the "infra-thin" separation acts not only as a separator, but also as a conductor, a passage between different dimensions: "Infrathin. Reflections of light on diff. surfaces more or less polished—Matt reflections giving an effect or reflection—mirror in depth could serve as an optical illustration of the idea of the infra-thin as 'conductor' from the 2nd to the 3rd dimension" (Duchamp, quoted in Duguet 1997: 46).

Duguet has identified a number of other aspects of the projection image: the "link-image," referring to the fact that images are interlinked within webs of images; the "sizeable image," referring to the fact that

through projection the scaling relationship between image and reality is being challenged, as has already been experimented with in land art installations; and the "interface image," in which an important aspect is the combination of being separated and being in contact. The viewer is of course separated from the narrative worlds in front of him or her, but simultaneously he or she can observe a subtle contact: if one raises a hand, the person in the image does something similar. If one moves close to the image, the fictive person in the image moves back in what looks like fear. Such relations have been exploited, for instance, in the works of Gary Hill (in, for example, his *Tall Ships*).

From Interpretation to Interaction

By tradition, the relationship between audience and artwork has been analyzed as an active one characterized by "interpretation." According to traditional notions, interpretation changes the artwork (e.g., the reader "acquires" the text, thus changing its meaning into something different). This understanding of the relationship between artwork and audience is rooted in the analysis from the late eighteenth century by German philosopher Friedrich Schleiermacher of the difference between science and arts. According to Schleiermacher, natural science registers that which is the case, whereas art performs "sign interpretation." Whereas the relationship between the scientific observer and natural objects, according to Shleiermacher's concepts, is "dialectic," the relationship between the audience and artwork is "hermeneutic." Thus, "hermeneutics" was Schleiermacher's designation of the theory concerning this particular form of observational relationship between an audience and the sign object in which the interpretative observation changes the meaning of the sign object. From here stems the notion of a circular process constituted by artwork and observer, the so-called hermeneutic circle.

Computer art has taken this spiritual and idealistic notion of the audience-art relationship and made it concrete. The artwork does something to the audience, or, more appropriately, to the user, who does something to the artwork. This is reminiscent of the old Marxist slogan: So far we have interpreted the artwork, from now on we want to change it. In computer art, interpretation is being replaced by interaction. Further-

Figure 9.1
An image from *Recoil*.

more, this mutual process of change propagates into its environment, which is being included in the interaction. A complex network of communication and observation is being established.

An illustrative example of this mechanism is provided by the Danish artists Morten Schjødt, Theis Barenkopf Dinesen, Anne Dorte Christiansen, and Peter Thillemann in the digital art group Oncotype's interactive installation *Rekyl* (in English, *Recoil*) (see figure 9.1). That this work is interactive is signified already in its title, for when the artwork is modified by the actions of the user, it recoils back into his or her mind.

Recoil is an interactive installation consisting of a computer, a projector, a screen, and a microphone, which are installed in a room of approximately 3 × 3 × 8 meters. The user enters the room from one end. The other end is covered by the screen, on which text-based statistical information is rolling (concerning living conditions, consumption of alcohol, health conditions, traffic accidents, etc.). In the middle of the room is a

microphone. As a user, one starts by observing the elements of the installation: one reads the rolling text (and of course tries to interpret it, as we have learned to apply meaning to everything that we see in an art museum), looks at the computer and the projector and tries to understand the sophisticated significance of the microphone standing in the middle of the room. Sooner or later, however, one has to experiment with the microphone. And then something happens. If the user shouts into the microphone, for example, the rolling statistical text is replaced by a bluish video film showing the face of a person who presents his or her personal history. In total approximately fourteen stories can be activated, each one taking between 30 seconds and 2–3 minutes. The person on the video relates an episode from his or her life with indirect references to the statistical text. As soon as one stops shouting, the video film disappears and the statistical information starts again.

Many points of general significance for interactive artworks can be made using this installation. The first and most obvious point is that the veneration for untouchable artwork is replaced by an active and playful relationship with the work. "Don't touch" is being replaced by a command to interact. In this respect the interactive digital works are related to the kinetic artworks of the twentieth century: Tinguely's mechanical figures, Calder's mobiles, Moholy-Nagy's modulators, Takis's magnetic ballets, Duchamp's perpetual installations.

Following from this, the traditional thoughtful interpretation—the attribution of meaning activated in art environments—is being replaced by practical action. One important question is how to keep on making sound to prevent the image from disappearing and the story from being interrupted. This again implies that the user's attention is being moved from the artwork as such to the relationship between oneself as observe and the work of art. For instance one obviously notices the dilemma between shouting and listening. To keep contact, one has to shout. But simultaneously one's shouting prevents one from hearing what is being told by the person on the screen.

Finally, this implies that the environment is involved. What happens when an unknown member of the audience enters the room while one is yelling at an artwork? The answer is that many different things may happen. When *Recoil* was exhibited in Denmark in late 2000, often the

result was a sense of embarrassment. The user lowered his voice in order not to exhibit himself, that is, not to become part of the art installation. The situation was totally different when *Recoil* was exhibited in Paris two months later. There, the actual user normally began to play with the installation, whisper, shout, and sing in rhythmic phrases, creating interferential patterns of text information and video clips. There he or she clearly performed, made him- or herself an active part of the dynamic installation, the other part being the computer. But whatever the reaction, the reach of the installation expands, so that everybody in the installation hall becomes being involved in artistic observations and actions. Here the performance art tradition is obvious: whether or not by choice, we are involved in the realization of the artwork.

In recent years we have begun to see many digital artworks like *Recoil.* In computer games we interact with autonomous agents or we are being represented in the fiction world by avatars. In advanced 3-D artworks such as Shaw's *Configuring the Cave,* one enters the virtual world through digital interfaces or motion-capturing devices, thus being able to move around, investigate, and manipulate the virtual world. In another of Shaw's digital installations, *The Legible City* (ZKM, Karlsruhe, 1989–1991) one moves around on a motion bike in a virtual city constructed by letters and words. In one Italian digital artwork, one is forced to walk on a transparent floor under which one can see naked bodies of people moving in pain when one tramples on them.

It is an important consequence of the way in which interactive artworks function that one has to reinterpret the interpretation process. We are used to observing the relationship between artwork and audience as a transmission relationship: the aura from God or from the art genius is transmitted to the viewer. Yet in front of the digital and interactive artwork, no such auratic transmission occurs. It simply does not work to present a spiritual and receptive attitude; the spirit stays away. Here, as an audience one must contribute to the artistic form creation, almost on a level with the artist. The difference is primarily related to the order of succession. The artist makes the first form creation, building a dynamic world of potentialities, an art world. But only the second form decision realizes the artwork as work, and this form realization occurs only when the audience goes into interaction with the artwork.

What, though, are the aspects of such an audience-based form of realization? In digital interactive artworks, it is not enough just to push a button, making a mechanical figure move, or gently to touch a mobile, which begins to move. On the contrary, the relationship between audience and artwork is potentially much more sophisticated. Through the interface one enters a digital world of signs that are mutually interrelated. This is the sign universe with which and in which one acts.

As argued by Wibroe, Nygaard, and Andersen (2001) one can interact at several levels. The first level is the kinetic level: using the mouse, a joystick, or a motion-capturing device, one can make digital signs (images, icons, text elements, etc.) move. The second level is the plot level: here one can control which information is presented at what time so that the narrative sequence is being modified. This is well known from computer games in which one can decide about the sequence of places to visit or tasks to solve. The third, and highest, level is the story or artwork level. Here, the user can influence the meaning or morality of the artwork, the intentions of the main figure and, thus, the basic structure of the narrative (see, for example, Eva Liestøl, this volume).

This argument implies that the very concept of artwork is being modified. An artwork is not an autonomous object that can be observed from the outside according to the tradition of thoughtful interpretation. Rather, the artwork appears to be a world of potentialities that must be realized by the user. What seems to be a leveling of artist and audience, however, may in reality become the opposite: that the artist acts as a producer of art worlds, that is, as a world creator. These are the worlds that we as users can enter and make into realities, whether hells or paradises.

Conclusion

In this chapter I have argued that contemporary digital art is influenced by two major sources: partly it is influenced by the avant-garde movement of the twentieth century, here represented by Marcel Duchamp's ready-mades, and partly it is influenced by the particular potentials of the computer as a digital art medium (projection and interaction). The creative melting pot of these two trends is reflected by a new poetics: digital poetics.

Looking back from our current position one may say that the avant-garde artists worked as if they were in search of a nonexistent art medium: the computer. They invented digital aesthetics before the realization of the digital medium. Positioning oneself in the twentieth century, looking at history as an evolutionary process, one observes that the computer has become a medium for the articulation of the latent digital aesthetics of the avant-garde. Thus it has been a medium for the realization of digital poetics.

Notes

1. The definitions of aesthetics and poetics have been inspired by conversations with my colleague Bo Kampmann Walther at the University of Southern Denmark in relation to his manuscript *Laterna magica* (forthcoming).

2. In addition to Luhmann, in aesthetic theory this idea is unfolded by, for example, Gilles Deleuze (e.g., Deleuze 1968), and Jean-François Lyotard (e.g., Lyotard 1983).

3. The following discussion is inspired by personal conversation with Anne-Marie Duguet.

References

Alberti, L. B. (1972) *On Painting and On Sculpture* (ed. and trans. Cecil Grayson). London: Phaidon.

Ammundsen, K. (ed.) (1995) *Design Is an Artistic Expression with a Purpose*. Copenhagen: Danish Design School.

Bak, P. (1996) *How Nature Works: The Science of Self-Organized Criticality*. New York: Springer Verlag.

Bernsen, J. (1986) *Design: The Problem Comes First*. Copenhagen: Danish Design Council.

Bernsen, J. (2000) *Every New Idea*. Copenhagen: Danish Design Centre.

Blazwick, I., and S. Wilson (eds.) (2000) *Tate Modern: The Handbook*. London: Tate.

Brown, G. S. (1971) *Laws of Form*. London: George Allen and Unwin.

Deleuze, G. (1968) *Difference et Repetition*. Paris: Presses Universitaires de France.

Duguet, A.-M. (1997) "Jeffrey Shaw: From Expanded Cinema to Virtual Reality." In J. Shaw, H. Koltz and A.-M. Duguet, (eds.) *Jeffrey Shaw: A User's Manual*. Bonn: Edition Cantz.

Johnson, S. (1997) *Interface Culture*. San Francisco: HarperEdge.

Kant, I. (1971) *Kritik der Urteilskraft* (trans. J.C. Meredith) Stuttgart: Philipp Reclam Jun. Cf. Immanuel Kant, *The Critique of Judgement*. Oxford: Clarendon Press, 1952, 13th impression 1991.

Kress, G., and T. van Leuwen. (1996) *Reading Images: The Grammar of Visual Design*. London and New York: Routledge.

Latour, B. (1996) "Om aktørnetværksteori" [On Actor-Network Theory]. *Philosophia*, 25, 3–4.

Laurel, B. (1993) *Computers as Theatre*. Reading: Addison-Wesley.

Luhman, N. (1990) "Weltkunst" [World Art]. In N. Luhmann, F. D. Bunsen, and D. Baecker (eds.), *Unbeobachtbare Welt. Uber Kunst und Architektur* [unobservable world: on Art and Architecture]. Bielefeld, Germany: Verlag Cordula Haux.

Luhmann, N. (1994) *Die Ausdifferenzierung des Kunstsystems* [The outdifferentiation of the Art System] Bern, Switzerland: Benteli Verlag.

Luhmann, N. (1995) *Die Kunst der Gesellschaft* [The Art of Society]. Frankfurt am Main: Suhrkamp Verlag.

Lyotard, J.-F. (1983) *Le Différend.* Paris: Les Editions de Minuit.

Panofsky, E. (1969) *Renaissance and Renascences in Western Art.* New York: Harper & Row.

Peirce, C. S. (1955) *Philosophical Writings of Peirce* (sel. and ed. Justus Buchler). New York: Dover.

Prigogine, I., and I. Stengers. (1979) *La Nouvelle Alliance: Metamorphose de la Science.* Paris: Editions Gallimard.

Simon, H. A. (1982) *The Sciences of the Artificial.* 2nd ed. Cambridge: MIT Press.

Walther, B. K. (forthcoming) *Laterna magica: På sporet af en digital æstetik* [Magic Lantern: In search of a digital aesthetic]. Odense, Denmark: University of Odense Press.

Wibroe, M., K. K. Nygaard, and P. B. Andersen (2001) "Games and Stories." In L. Qvortrup (ed.), *Virtual Interaction: Interaction in Virtual Inhabited 3D Worlds.* London: Springer, 166–181.

Low Tech–High Concept

Digital Media, Art, and the State of the Arts

Stian Grøgaard

Painting as Theory

On a Web page for Momentum International Art Conference, art theorist Annette W. Balkema (2000) foresees the day when "familiar philosophical concepts will no longer be able to understand and clarify what visual art in the 21st century is about" (4). The reason Balkema gives for this rather radical change in circumstances should come as no surprise: the impact of media technology on all forms of practice, including art. "There is an enormous shift in today's artistic attitude, which may be traced back to the world of the Internet" (2), says Balkema. Art, too, is advancing into the present century, pulling theoreticians along with it: "we will have to imitate artists and shift our (theoretical) attitudes" (4). Art theory usually arrives late, but it shouldn't have to *imitate* artists unless there is something about to happen that will completely redefine its relation to practice.

How then can we account for such a shift in attitude when the conceptual tools at our disposal are known in advance to be inadequate, and how do we go about inventing adequate ones? Since not every shift in attitude demands new concepts, perhaps our preparing ourselves for

the unfamiliar is a question of methodology. No dialectical squeeze or other deprecatory gestures on our part will, however, stop the unfamiliar from taking place. If there is a problem with such attempts to ward off the future, the point being not to be proven wrong, then the problem with an open-minded attitude is truism, the point being that one is always proven right. Apart from a general preparedness for the unfamiliar, then, we will have to make the most out of possibilities lost in a well-known, earlier account.

In fact, the account given by the Balkema quotes alone is familiar enough. Though drastic in tone, the optimism still shines through while the continuum of history remains unoffended. The call for the invention of unfamiliar concepts follows a one-way street toward a future that is present everywhere outside art. And maybe the account is too narrow in its focus on rapidly shifting attitudes in a contemporary art under the influence of the Internet. There is, for that matter, a more speculative consequence, surfacing time and again in the history of modern art, that is left out. If art theory imitates artists, this may simply mean that practice itself creates better theory. Since so much that was outside of art and previously unaccounted for is now drawn inside, thus "exploding aesthetics" (as Balkema's paper is titled), what if the theory to be drawn from this turns out to have consequences for a lot more than art, extending to the humanities in general? Such speculative consequences cannot simply be drawn from the future. They are discontinuous to art history and need to expose yet another of its premises.

An art imitated by theory as the best way to practice theory stands out as an exception in the history of art, but not only because it has been modernized by technology, regardless of the latter's capacity for changing the forms of our social life. Rather, such an art imitation meets a demand for an art with the aspiration to be modern, however plausible this familiar concept might be. No technological innovation would make art theory imitate artists if artists didn't practice theory in a manner immanent to their art practice. This happened for the first time with modernist painting. Whatever it achieved, beyond breaking up the face of art, modernist painting went full circle with a familiar concept. In regard to aesthetics it was a second explosion: when modernist painting "deskilled" an old craft,[1] thereby exposing the logic of the medium, it fulfilled romanticism's

wish to include the agency of criticism in its practice. Modernism was a shift not only in attitude but also in the aspects of painting. Instead of the rabbit we saw the duck's head. Modernism opened another direction for the reading of pictures, a reading with an enhanced consistency received from the objectified medium itself.

There are causes for shifting attitudes, and there are reasons, but not even poor reasons will reappear as a plausible cause. If it is the Internet that is causing art theory to imitate artists and "exploding" not only aesthetics, but the humanities on a broad scale, by the same token it once may have taken a simple technical apparatus called photography to change the practice of painting. This gives Balkema all the more reason to expect the unfamiliar from the Internet, but it was the change known as modernism that initially focused on the medium as an account for such "shifting attitudes." Balkema's account is in fact modernist, and when history returns to rake it in, the familiar has already turned uncanny. An example at the far end of modernism's redefinition of art practice is Mel Bochner's *Theory of Painting* (1969). Bochner's painting installation consists of four sets of painted newspaper arranged on the floor that exhibit the four possible relations of cohere/disperse spelled out on the wall behind. One medium is mirrored in another, resulting in a hybrid and, in fact, a reductivist thesis: the rock bottom of painting preceding even the monochrome. It is still painting but mirrors itself in a loose definition of sculpture called installation: painting not only made but presented on the floor, erecting a general taxonomy of possible relations between form and *informe*, between a gestalt and its backdrop. Rosalind Krauss (1978) would name such a practice "sculpture in the expanded field." That is, art after the breakdown of Greenbergian, media-specific modernism, which she prefers to expand via the more elastic medium of sculpture (if a medium and not a discipline) to avoid what years later she would on a more resigned note see as "Art in the Age of the Post-Medium Condition" (from the title of her 2000 work).

The point of our speculation, however, is that *Theory of Painting* is still painting, because theory, whatever the generality of its thesis, is always specific, the demonstration of which in this case contextualizes the general. Bochner's installation may be said to ground the medium of a general thesis, thereby turning against a phonocentric understanding of discourse.

The inclusion of different media or sign types reflects the hybridity inherent in media-specific formalism to begin with, that is, its pretensions of also being theoretical. This aspect of modernist painting, which Bochner's piece makes explicit, is the beginning of understanding media. It suggests by way of the familiar what Balkema demands of concepts: to "understand and clarify" visual art in the twenty-first century. Media specificity may not be useful any longer to art in its present state, but it now serves a purpose in media studies as a common ground for the humanities, modernizing them under the umbrella of digital media.

The Covert Modernization of a Printmaking Department

In Norway, there are three academies of fine arts. These are interconnected through *Norgesnettet,* a national program for the rationalization of efforts among institutions of higher education. Under this program the academy in Bergen was assigned special responsibility for art theory, the one in Trondheim for new media—certainly the two most challenging topics in art education today. The academy in Oslo, the only city in Norway large enough to enjoy a vital art scene, was given responsibility for traditional art techniques: painting, sculpture, and printmaking.

What a pity, then, that traditional printmaking had long since been dead. There was a boom in the 1970s that led to the founding of a print department and professorship in Oslo. The 1980s, however, saw the most emphatic return to painting in decades, another neo-expressionism, but with a German twist this time around, now even bigger, more pastose, and before long completely inflated. To meet this challenge from the ever-returning success of painting, printmaking abandoned its tradition of the intimate, book-sized format and expanded beyond the capacity of the presses to accept woodcuts requiring the weight of steam rollers. Ideal focus lay on the monotype: the fewer copies printed, the more dignified as art—this was printmaking as close as it gets to painting. The only thing retained was the typical graphic contrast (not gradation) of light and shade, and of course, the print's mirror inversion. To no avail, the old printing presses remained a cold reminder of their capacity to define graphics, and monotype did not promise any way out. It was nothing but an awkward way to practice painting.

The academy in Oslo knew it could succeed in somehow side-stepping the official division of labor between the academies and justifying an interest in the aesthetic potential of digital media only through a reframing of the traditional. As part of the process of appointing a new professor, the definition of graphics was changed. Emphasis went from monotype to reproduction, and every attempt to compete with painting was abandoned. Printmaking now meant anything graphic that could be reproduced regardless of technique, from woodcut to photography to digital media, that is, a move toward the complete desacralization of the original, including everything that inflated the value of the pictorial object and its authenticity, admitting to the object's dependency on an external code that made the object's presence somewhat pathetic and uncalled for.

In short, traditional printmaking had an old antiplatonist dream of perfection for each new multiplication technique. Each technique, stimulated by each new printed letter device, was to attain the ultimate indifference between original and copy—what postmodernism called the simulacrum, expecting from it a rather gloomy outlook on the possibility of invention and historical change. The print department took this to be good news, or rather the fulfilled promise of traditional printmaking, something it had coming ever since Gutenberg's invention relaunched the old woodcut technique as a medium. If the machine means, as Gilles Deleuze reminds us, something that always is "social before being technical" (Deleuze and Parnet 1987: 70), then the establishment of a medium may be an instance of a social machine, producing explanations on its own—a new medium, that is, not only embedded in conditions of possibility wider and more complex than the pure instrumental "how," but in fact channeling the social itself, which once dreamt up the medium.

An awareness of Deleuze's "social" account may help to contextualize the determinism of media studies and the fondness for monocausality wherever media is concerned. From Marshall McLuhan to Friederich Kittler, one continually encounters this rhetorical device for profaning or externalizing anything by the instatement of a medium, or in Kittler's case, shifts between media. Here, analogical media like photography or the gramophone proved to be unsurpassable. What was a ghost became a machine and more convincing. The ghost Kittler is out to externalize, of course, is the unconscious, the real human double, not as a talking

analysand curing herself on the couch, but as the voice stunningly doubled on the phonographic role of wax: Mary had a little lamb. Rather than applying psychoanalysis to media, Kittler uses media history on psychoanalysis, and the reason for the success of the latter is, according to *Gramophone–Film–Typewriter* (1999), its reformulation of a longstanding fantasy in the old storage monopoly of literature, a fantasy that resurfaces a few years before Freud's time in gothic romanticism: the motive of the doppelgänger. According to Kittler, this fantasy proved to be nothing but literature's idealist or imaginary way of storing bodies. With the gramophone, the doubling became an aesthetic fact for the first time and entered the order of the real. Freud stuck to the old symbolic storage. He referred to modern media, such as the gramophone or his "photographic memory," by way of metaphoric *compensation*. The beauty of his conception of the unconscious is in fact due to the insufficiency of his medium, not the insufficiency of the voice, this time, but the imaginary manner in which he insisted on storing it. He made the unconscious as external as writing would possibly allow.

As a rhetorical device, Kittler's account is less reductionistic than it is a tongue-in-cheek version of providence. Monocausality makes a better story, of course. It automatically gives media studies a direction, or an unconscious, from the outset. This deal with the unconscious, which offered psychoanalysis an analogical medium like the gramophone in return for a machine to propel the story, that is, the unconscious drive of media theory, reveals the accelerated expansion of the storage medium in a field desolate and cruel enough to count as a modern narrative. The question to be asked of Kittler's account, however, is whether the modern resides less in an effect of contemporary (analogical) media than in a complex compensation for sticking with old media. There are certainly consequences to be had from the ability of such narratives to order facts, but the crucial question is whether the consequences of this narratological efficiency meet the demands of a given or yet to be invented scientific discipline or whether the narrative implies a whole new way of delimiting disciplinarity itself.

The Oslo academy's redefinition of printmaking was, if anything, a coup, but it was presented as the concept of printmaking finally coming into its own. The strategy succeeded. The new professor turned out to be a video artist specializing in digital media. In regard to the justification

for the coup—the woodcut enmeshed in a dream of perfect reproducibility or simulacrum from the time of Gutenberg—such a justification is given as if by compensation. In fact we wanted only to be allowed better opportunities. But also in regard to its consequences, such as the vast amount of money put into this dream to make it come true, the coup's eventual success might have been too much to handle for an academy of fine arts. Not least of all this was because the artistic profits from these investments seemed only to confirm the popular suspicion that video art is film for amateurs and that its aesthetic value is nothing but a lack of technique. All this may say something about changes and how changes may be accounted for when media propel the narrative.

The printmaking department certainly changed beyond recognition. The irony is, however, that the coup necessary to modernize this department and to adapt it to the possibilities of digital media seems to run counter to what makes art modern, that is, the way we manage to discern art from everything else, including media. For we may be slightly uneasy about terms like "Web art." We never say "paint art," just "painting" or "art," since to most people painting still means art, and even more surprisingly, modern art. The identification of painting with art serves as a socially advantageous guarantee of autonomy from the outside, counterbalancing the inside agenda of an art that, since the time of the historical avant-garde, moved beyond painting and medium altogether in its attempt to be socially relevant.

Commonplaces on Invention

Invention was once an art, and art was a plurality of techniques as defined by rhetoric. In this definition invention stood first in a series of necessary preparations for speech: *inventio,* followed by *dispositio, eloqutio, memoria,* and finally *actio.* The Romans understood invention as something found, something already there for the taking, and as an element of rhetoric named "topics." It equipped one with a general means of how and where to search in each particular case of invention. The case is the same for innovation. *Innovare* was a verb in ancient Latin with the explicit meaning of repeating the new: to renew. If there was a given to be found by invention, there is an imitation inherent in innovation.

As the first one-fifth of a rhetoric belonging to the central trivium of the seven liberal arts, in most accounts all the way up to the Renaissance,[2] invention did not lose its privilege until this hierarchy was overturned by the model of natural science. Some of the arts, such as logic and geometry, were of immediate use and promoted to science, whereas others, music, for instance, changed from a liberal to a fine art in the new regime for the nonscientific leftovers (cf. Kristeller 1996). "Fine" belongs to the first contender to rhetoric under the classic regime, a modern invention necessary to secure the invention of the modern. It was called *aesthetics,* the only new philosophical discipline, although it was unable to defend its novelty for long. Here the technical externalism of rhetoric disappeared in a clockwork of faculties of the mind, which at the same time launched a more general approach to media extending beyond the rules of speech. These rules became destabilized the moment "normative poetics" was shown to rule out aesthetic experience in advance. Such experience turned out to be resistant to the generalities rhetoric seemed to handle with such ease. The conceptual became both a promise and a problem, creating a barrier between aesthetics and its object, aesthetic experience.

Perhaps that is the only thing the new discipline managed to establish as common sense. Its most radical contention, namely, its defense of the claims of taste or aesthetic judgment as being simultaneously unfounded and universal, did not stir enthusiasm for long, not least of all because the instances in which taste really mattered were passed off as too private to be worthy of critical reflection. Within the fine arts taste was outmaneuvered by a faculty that was also given autonomy, since this faculty occupied the more prestigious topos of creativity denied to even the purest and most impartial aesthetic judgment. With the breakthrough of romanticism, not only the *sensus communis* of taste but also the representative taste *for* the common turned philistine and had to be silenced in the presence of the individual genius of *imagination.* The emphasis on sensibility—what Deleuze calls "the passive syntheses" of cognition—couldn't outlive the first naïve perspective of bourgeois politics, which aspired to unite the refined and the common, that is, to justify the aesthetic by merits of moral character rather than by ascribed traditional privilege.

So when the liberal arts finally received their autonomy as fine, this meant a liberation from rhetoric (which was both one of the liberal arts and the organizing principle for them all, including the mechanical arts; rhetoric, in fact, qualified as an impossible member of its own set). In the common account of this modern distribution into spheres of validity, with science estranged from art and both from morality, aesthetics was tied to an optical model that stayed uncontested within philosophy from German idealism all the way up to Edmund Husserl's phenomenology. Aesthetics, a waste product from epistemology but the only philosophically modern discipline, fulfilled the need for surveillance of the divide between art and science. No wonder it soon turned its waste into philosophy of art and let the border guard itself.

Such harsh conditions put a price on rigor, and no version of aesthetics would ever be able to pay it. The philosophy of art was the only credible way out on aesthetics' way down. The status of imagination in romanticism, though unlimited, is a resigned gesture compared to the skills and mastery of character presupposed by rhetoric. Imagination automates invention (an automation impossible in aesthetic judgment) and thereby spins it out of control. The withering away of the given to be found in invention meant that nothing could turn the art of invention into science, and even less into a science of innovation. The general theory of invention was either a normative manual of how to go about inventing, precluding it in advance, or a critical reflection *post festum,* a stranger to its object never to obtain self-transparency to its own potential for invention. So it seems the liberal arts, being liberal, contain invention as immanent to their techniques, whereas science cannot move other than by logical displacement, as if every paradigmatic change occurs with the immediate rupture of an earthquake, a suitable threat to the fragile correspondence occupying the concept of truth in epistemology. Invention has to appear traumatic to be sufficiently forgotten.

Invention was an art, as art of any worth is inventive. An art of invention, then, would give a privileged perspective on art production: the art of the arts. But it is as if this possibility was lost when art turned reflective and modern.[3] The smooth transition from poem to poetics, from speech to rhetoric, opened up an abyss underneath the intermediary of

aesthetics. It meant that innovation somehow had to disconnect from mastery in order to convince.

As it appears in the repetition of *innovare,* or the given to be found in *inventio,* a stability ruled the regime of the liberal arts that restricted the new to part of a continuum and allowed for a formalized method of innovation. Whatever the historical reasons, this stability belonged to craft and its metaphors, the shortest possible step from intention to realized work. It was this regime that became destabilized with the advent of aesthetics and the divide between rigorous science and fine arts.

The possible interface between regulative reason and aesthetic reflection through the functioning of judgment, or in short, between art and science, is left by Immanuel Kant to speculation outside the critical domain, perilous as this is to the stability of the modern correspondence of faculties to autonomous fields of inquiry. Although his position may be atypical for the century of aesthetics, it nonetheless became decisive for the philosophy of art, which made speculative profits from his suggestions in order to surpass him. For Kant, the intermediary remains an "imaginary focus" for the unrealizable ideal of unified science, and when speculation threatens to take over, he resorts to restating the self-evidence of the divide. The problem surfaces one last time in regard to the question of formalizing a method of aesthetic judgment in section 60 of the Third Critique (Kant 1952: B261). Method is the final chapter of any discipline, but this time the space remains empty. Kant made epistemology the ordering principle of his aesthetics and modeled the Third Critique on the formula of the First. Instead of a *Metodenlehre,* he thus concludes with a summary of his earlier justification for a faculty of aesthetic judgment (the "aesthetic" or subjective instance of teleology). For the fine arts, he says, there exists just a *Manier* or *modus,* no *Lehrart* or *methodus.* Romanticism read this distinction as an opening for the genius of art, as if its ways were better suited to this side of the divide. This is the modern abyss exposed by aesthetics. In section 34 of the *Critique of Judgement* there is the more prosaic question of two forms of critique. The critic of taste in the ordinary sense is not out to subsume cases of beauty under a general rule but tries to extract empirical rules from experience through reflection on pleasure felt from different objects. This is criticism as an art form. As a form of science, on the other hand, the critic "deduces [*ableiten*] the possibility

of judgments from the nature of a faculty of judgement" (B144). Such a criticism is transcendental, and this is what Kant is up to in his *Critique of Judgement*. But why is there no method for *this* deduction? Maybe it is because such a method will reveal itself as a speculative excess of reason itself and thereby lose its claim to science, or maybe Kant, on the contrary, thinks such a method is already delivered in the *Methodenlehre* of pure reason. In both cases the consequence is a blurred distinction between the two kinds of critics, and the *Critique* loses control over the interface between them.

One tenor in the philosophy of art since German romanticism seems to be the call for a new poetics that would compensate for the lag within critical reflection and catch up with the art process itself, not least of all because even reflection has its decisive moment of presentation. Walter Benjamin's emphatic sense of experience is connected to this modern abyss in epistemology, demanding a change in focus from philosophical depth to the surface of its presentation. A philosophy unaware of its outside neither approaches the level of traditional rhetoric nor is sufficiently modernized. It is an invention within a genre belonging to another regime, losing the prerogatives of both. So the turn toward presentation, the blind spot in the camera obscura of epistemology, is recognizable as a renewed moment of rhetoric. Epistemology managed to modernize each element but left the genre of philosophy intact. When the genre breaks up in an extended reflection on its interface, jumping from analytic rigor to the synthesis of presentation, science loses its prerogative to art. In the interface between science and its presentation, rhetoric returns.

Rhetoric occupied the place of the interface, securing convertibility between speech and topic, and, according to Gregory Ulmer, now deserves to win it back, if only through a modified name. "Another name for 'rhetoric' in a computer context is 'interface,'" he states in his *Heuretics* (1994: 28). There are reasons for this return of art as analogical to the mastering of speech, once more to open the humanities to techological innovation. With reference to Benjamin, Ulmer observes by way of analogy: "hypermedia does for scholarship what photography did for portrait painting" (29). Whatever photography achieved, the principle of *Reprodusierbarkeit* had immediate consequences for other media. And when it reaches scholarship, the consequence concerns the question of a

methodology for the study of these effects. With Ulmer's *Heuretics,* the steps Benjamin took to overcome neo-Kantianism appear to be taken a step further toward a formalization of method. The subtitle of Ulmer's book is *The Logic of Invention,* and the logic in question abandons "discursiveness" for an explicit cinematic handling of scenes. It is tempting to see discourse replaced by the automation (Ulmer's expression) to which hypertext exposes scholarship. It then seems justified to imitate in an old medium, like the scholarly essay, the open form of presentation and plural reading of hypertext. The automation of scholarship reinscribes the presentation itself in a new, nondiscursive way of presenting findings. "Heuretical" indicates an admittance of uncertainty connected to their processing, but also a logic that will meet the demands for a method specific enough to secure media studies a proper inclusion in academia.[4] "*Heuretics* is not written as a complete example of its own poetics" (41), says Ulmer. For obvious reasons, a complete heuretics would no longer be heuretics. Ulmer makes a further distinction to circumscribe (the changed conditions for) media studies: "to collect what I find into a set, unified by a pattern of repetitions, rather than by a concept. Electronic learning is more like discovery than proof" (56). Here he can fall back on the insight of rhetoric that was lost when science became rigorous: the knowledge that finding and presenting the findings will be at the expense of the discursive certainty science obtained when it left such considerations to the fine arts and withdrew into representation in order to secure the *adequatio* of epistemology.

A discourse on method has to appear analogical to the practice of invention, adapted to the occasion of digital media by the renaming of "topics" as "chorology." Still, as a new practice it seems familiar enough, at least when resorting to poiesis/making as the only way to avoid traditional idealist alternatives: "How to practice choral writing then? It must be in the order neither of the sensible nor the intelligible but in the order of making, of generating. And it must be transferable, without generalization, conducted from one particular to another," (67) says Ulmer. Choral writing, this twisted name for topics, experienced its failure in the pseudoscience of aesthetics. There is a surprising imbalance in Ulmer's presentation between his conviction of the radicality of digital media and his chosen examples, but such is the way of metaphoric appropriation, when

approaching the unknown by way of the familiar. Only now is the route from one created particular to another applied outside art. At least on the methodological level, the making of particulars is given back to rhetoric and the state of the arts.

Painting As Emblematically Modern

Ulmer offers a complicated analogy between painting and scholarship, in accordance with Benjamin, and it proceeds roughly like this: digital media's impact on scholarship equals the impact photography once had on painting. The complexity lies in the difference between art and the human sciences being smoothed over with a "making," that is, in moving from one particular to the other. Of course, there is another analogy to be had: digital media equals photography in its impact on contemporary art. Following Benjamin's (1978) essay on art in the age of its "reproducibility," thirty years after it entered common awareness and as if his point had to be repeated to enter memory, there is no question. If the genre of painting was portraiture, which had its finality completely reformulated by photography, we will have to ask what digital media will do to an art that is not only postgenre, but what Krauss labels "post-medium." The label serves as a short expression for our common understanding of neo-avant-garde art practice, emphasizing interactivity, art's interface with the social, at the expense of the more self-indulgent media-specific art object.

Expectations run high for an art settling into new networks in which new social forms are produced like artworks without the incentives of utopia. The art of digital media will not just be producing aesthetic objects to be acted upon. These objects will, so to speak, objectify interaction. Although the social is a concept without limits (as opposed to the political, according to Hannah Arendt; see Arendt 1996: chap. 2), not even a screen-based communications prothesis may be capable of stretching it. And so we easily get carried away by the metaphors produced by this new technology as we continue to place our hopes in the interactive possibilities of the Net, as though the drama were social and not gothic in origin, that is, an interface between doubles that remains somewhat uncanny.

The impact of more familiar metaphors, however, may be what it is all about anyway. According to Balkema, Web site designers are the

new heroes of the art scene, and responses to their innovations can be seen everywhere, whether in exhibitions or in the restyling of art in print (cf. Balkema 2000: 2). Web site–induced design has become sufficient to signal art in its own right, as if art once more was but a question of style, given the adequate technology. Whatever the impact, one must question how design confers the innovation principles necessary to form it, whether it is a familiar conviction operating under technological disguise, or, on the contrary, a rather unfamiliar strategy for keeping technology at arm's length through the enthusiasm for digital media. On the one hand, we have another instance of social mimesis, the interface of digital media meeting the expectations for change already idealized, and, on the other hand, the design keeps us from recognizing the decisive difference to media in the traditional sense.

Still, the more complex analogy of digital media's "automation" of scientific scholarship needs to be reminded of a twist in Benjamin's model case, a twist necessary to account for the reinvention of painting, or rather, its medial dignity. Why did the emblem of modern art turn out to be painting rather than modern media like photography at the time of Manet or cinema at the time of Picasso? Painting had been obsolete for more than a century; it was, to use a Freudian expression, decathected even before being distorted or made opaque as a medium in modernist art, a medium marginalized twice over, first by the bourgeois literary public at the middle of the eighteenth century, and finally defeated on its home ground with the invention of photography around 1850. And the answer is: if it were the modernity of the medium that makes art modern, we would still have had art in the classic sense, that is, familiar themes and ceremonial acts in the most effective communication media available. But we would not have had modern art.

The story of how painting became a modern emblem is meant neither as a general case for innovation in art or even modern art, nor for art as exemplary for a theory of innovation in human sciences. In a scientific perspective art and its theories are often found to be technophobic, gazing back and immobilized, as if it had a Sodom to lose, the outcome of a nostalgia that makes art the salt pillar of media. I will turn to a story of painting that has become boring even within art theory, now that art has reached the "post-medium condition," not in order to address contempo-

rary art, but rather to address the need for a possible modernism within humanist scholarship.[5]

There are reasons for this repetition. And painting may be of provisional help, for in the end we have to drop it for communication in general, just as art dropped painting (as explanation) and the criteria of medium specificity altogether. It is a story of why art theory is not media theory and why painting was the last heuristic device to glue the two together, a device once called modernist art. The point is that media became the intermediary for modernism's *deskilling,* when understanding the medium became the substitute for craft and the production of art changed its rationale. For if deskilling still means a practice, it is discontinuous, or, as Jean-François Lyotard would say of modern art, mortal. It represents a crisis, but not necessarily a decrease in art production. This deskilling has implications that reach far beyond art history. As a continuous practice of painting, deskilling implies an alienation from mastery with consequences for the traditional rhetorical account of this practice. Deskilling breaks with the premodern form of mastery that rhetoric presupposes. So Ulmer is in his full right to revise it, even if a chorology far from promises an automation of scholarship. For in fact, besides aesthetic judgment, even the scholarly need for a capacity for or rather practice of judgment admits of little automation.

Perhaps this retreat from mastery, in which the medium appears as if for the first time, has an analogy in scholarship itself when, in the name of relevance and complexity, it has to deskill or disarm its strongest asset: explanation. Modernism in science occurs when explanation becomes deautomated into a narrative device not originating in a fission between art and science. Ulmer says he prefers "discovery" to "proof," and as a consequence, the singular to the general. A speculative point may be that this divide and the modern understanding of media may use modernism to put restrictions on explanation. If the example of painting is a genuine expression of new media's impact on art, of how art turned modern through a recycling of a traditional medium, it still does not present media as an explanation. One may think of Ludwig Wittgenstein's warning against explanation, for instance, as used by Sigmund Freud, and his insistence on keeping to the surface of description (cf. Wittgenstein 1989: 13–28). Another familiar case of scholarly modernism might be Michel

Foucault, who in *The Order of Things* (1973) consistently abstains from connecting invention to historical events, as if this would be too crude, even in connection with an event as consequential as the French Revolution. It is of little help and would be to miss the point to qualify invention with a weakened sociological probability. Foucault describes each new episteme as a coherent epic, and when the coherence is broken, he puts a work of art as a substitute for an explanation of the historical crack between epistemes. As if to offer us something in return, we at least get a picture or a novel to pause over to cover up any discernible historic reason for why, for example, the intrahistoric organism of Georges Cuvier succeeded Carl von Linné's timeless family structure of plants. When scientific narrative reaches a historical state in which explanation feels obsolete, it may in fact mean that scholarship has reached the state of modernism.[6]

Modernist painting is the beginning and the end of the medium, which means it turns opaque and thereby visible, able to communicate itself consistently as a specific medium. This opacity is a necessary condition for reflection, for the mirror effect returning the image to understanding. As Clement Greenberg (1992) states in a famous passage: "The essence of Modernism lies, as I see it, in the use of the characteristic methods of a discipline to criticize the discipline itself—not in order to subvert it, but to entrench it more firmly in its area of competence" (755). Deskilling involves competence in a medium. Specificity means this competence has to curb any wish or potential for a general aesthetics. Media specificity also openly admits a dependency compensated for by a surplus of reflection. The basic flaw in Greenberg's argument is this resulting nondifferentiation in a self-relation that hovers over every medium. Still, the relation is always displaced. Not even within modernist painting is the medium the message. It is everything else while entrenched in its relation to itself. Greenberg wouldn't mind. After all, he was a critic. Someone had to entrench the discipline or medium more firmly, and a modernist painting firmly entrenched in its area of competence did not shut him out.

Such a competence, or deskilling, for the sake of self-reflexivity, might be described as an innovation by compensation, parallel to the logic of Kittler's description of the double in romantic literature, the reason

this time being photography's unprecedented capacity for a real storing of the body. To motivate a plain technological answer to the question of why painting became an emblem of modernity, we may say that modernist painting meets this challenge from the real by storing the medium as object. The restricted focus on medium shows a form of painting with ambitions beyond purely symbolic storage. This is also the point Greenberg (1995) dared to arrive at in his "After Abstract Expressionism," in which he simplified his view and was dumbfounding in his reflection of an obvious fact: "Under the testing of modernism more and more of the conventions of the art of painting have shown themselves to be dispensable, unessential. By now it has been established, it would seem, that the irreducible essence of pictorial art consists in but two constitutive conventions or norms: flatness and the delimitation of flatness" (131).

Obsolescence

Greenberg may have been too happy for criteria as irresistible as these, which he thought could ward off the subsequent conclusions drawn by minimal art, such as Donald Judd's post-medial concept of "specific objects." These are neither painting nor sculpture, but are, as Judd admits, related to the debate over painting. Greenberg had already stepped over the line himself. He had given in to a positivist demand for proof and was displaced by minimalism's objects. The constitutive norm for medium specificity will never amount to a medium. It splits in two.

Greenberg traded in specificity for a general self-reflection and a flat object. For Krauss, it has been a point to stretch or extend the medium, rather than reduce it to whatever basic conventions it might have. Specificity need not be pure or keep within the bounds of one particular medium to stay medium immanent. On the contrary, in Krauss's presentation, medium seems to live up to its own concept all the more when it extends to become a go-between between media. And this immanence has to be preserved in any circumstance, if one is not to spoil both medial coherence and specificity in the name of general conditions situated on another level than the medial itself. Krauss (2000) names this desired immanence "differential specificity" and equates it with "the medium as such," something that she emphasizes it is important to "reinvent or

rearticulate" (56). Her proposal for a reinvention of "medium as such" seems to build on some kind of time-consuming narrative, such as *A Voyage on the North Sea* by Marcel Broodthaers, the protagonist of her recent book.

Despite the literary impurity of the intermedial as a natural state of the medium, certain aesthetic reservations still apply for the medium "as such." On the one hand Krauss sticks to the coherence of medium as a real in-between, to avoid giving in to a post-medial "leeching of the aesthetic out into the social field in general" (56). This seems like a concern for aesthetic autonomy, but Krauss is basically out to secure an identity for art, something that explains why she is on the other hand anxious to avoid any confusion with digital media. Krauss prefers to apply the plural form "mediums" to keep art apart, the justification for such a resort to the ungrammatical being the split between art and media in the first place. But the plural form "mediums" may be a too weak a reservation to meet the threat of media in general. Krauss's point is to avoid a positivist concept of medium that could either be summoned as critical police in formalism or simply abandoned for the aesthetic anarchy of post-medium art. Krauss holds that the ideology if not the practice of post-medium, for all its freedom, entails a loss of the consistency that formalist critics like Greenberg proposed as medium specificity and lost when taking medium for an object. Krauss would correct this fallacy by recycling a typical representative of the post-medium condition, Marcel Broodthaers, as the reinforcement of an extended concept of medium. For all that this pays off in terms of criteria for aesthetic judgment, it certainly implies the imperative of sticking to the work itself. In contrast to making an idle contextual reading, Krauss is really out to save interpretation.

The reservation against media in general that art put on "mediums" is expressed in a nontransparent time structure specific to art called *obsolescence.* Once again, Benjamin is the chosen reference. For the medium to lose its transparence, art has to wait for the leftovers of media. Its inventiveness is secondary, a change in the aspects of what is already there. Art conserves possibilities in media technologies not needed when used for communication proper. Such technologies never stop communicating something, if nothing other than a promise unrealized in their own history. Medial nontransparency is not nostalgia; that would be to cling to the medium as transparent, as communicating everything but itself.

The unburdening of reference is a relief from function. In his unfinished *Passagen Werk* Benjamin speaks of liberating "things from the burden of utility" (Krauss 2000: 38). The look of obsolescence is in fact, an experience of utopia. "As Benjamin had predicted, nothing brings the promise encoded at the birth of a technological form to light as effectively as the fall into obsolescence of its final stages of development" (45). Obsolescence, then, is not just compensation demanding a changed perspective on media, but an asset beyond utility, a nontransparency necessary for a view of lost historical possibilities, relevant because they are lost.

Remediation

Medial obsolescence turns out to mean the opposite. In fact, it signals the possibility of an alternative use that for the first time may delimit and "objectify" the medium in question, that is, lift the medium from the illusion of *immediacy:* all the things the medium communicates, which is everything but the medium itself. This possibility for a once functional medium to reappear as art also suggests why media theory is not art theory when it comes to the central concept of "medium" and why Krauss chose to resort to the plural form "mediums" to stop short of the interdisciplinary discussion of media in general, that is, art subsumed under digital media. This may also account for why the old theory of communication, namely rhetoric, had to be replaced by aesthetics at the opening of the modern era. Still, this conclusion seems all too familiar and gets close to media theoreticians' own widespread skepticism concerning high art, whether it is modern or not.

A relevant alternative to Krauss's defense of the communicatively obsolete is Jay David Bolter and Richard Grusin's concept of "remediation" in a book bearing that title (1999). The motivating force behind the innovation of new media is always, according to Bolter and Grusin, "the desire for immediacy" (35), or medial transparence. But even in productions that feed on fullfilling this desire (such as action films), there exists an oscillation between immediacy and "hypermediacy," the latter describing indulgence in the playfulness and opacity of the medium. The methodological feat of Bolter and Grusin's *Remediation* lies in the fundamental status it gives to this oscillation. Prior to immediacy there is the

oscillation itself. Immediacy, the denial of mediation, is nothing but the basic desire for remediation on the level of representation, and hypermediacy, which comes second in relation to the desire for immediacy, exceeds representation to ground it in mediation. This is why Bolter and Grusin, with a deconstructive gesture, can claim that "transparency needs hypermediacy" (84). The beginning is a return; mediation is a remediation. With the term "hypermediacy," space is opened up for a vast range of procedures, including modernist art. Modernism, in other words, is part of a returning interest in the medium and its possibilities beyond representation, on a par with the illustrated manuscripts of the Middle Ages and the exposure of the pleasure taken in the opacity of the decorated letters.[7] The threshold of modern art is then both originary and remediated, and its radical irreversibility is thus eroded.

Remediation is a methodological tool for a media-saturated age in which every medium is bound to interconnect; in another coinage of Fredric Jameson's, it is an age of "mediatization." This is the historical picture hovering over remediation. Despite an open-ended, contextualized concept of medium, what matters is the juxtaposition of medium, whether obsolete or just hypermediated, *and* its social context. On the level of the opaque letter, media has colonized "mediation" in general, since it must be tacitly understood that there is a medium for every mediation. This gives Bolter and Grusin's presentation a bias toward immediacy, no matter how opaque or "hyper" the medium is portrayed to be.

Whether Krauss will succeed in redefining medium at the long end of obsolescence remains to be seen. For now, this redefinition seems too restricted to a somewhat melancholy expression of social utopia. The same restriction weighs on the false plural "mediums." This will hardly be open and speculative enough. Negotiations with general media theory are unavoidable and have just begun, even if the right to the concept "medium" seems a lost case for art, and for good reasons. This is in itself a suggestive starting point for negotiating a common ground in the divide between art theory and media theory.

Perhaps a tentative alignment of art theory to media theory can be suggested through a borrowed expression from yet another area. In the days following the terror of September 11, a specialist on military strategy who appeared on BBC World labeled the terror act as "low tech, high

concept." Inappropriate as it may sound in this context, this description may still have transferential value for modern art. A first indication would be to gauge the effect when the adjectives change places: "high tech, low concept" has no such value, since this is what modern art had to avoid if it was to justify its remediation of the obsolete. "Low tech," on the other hand, includes functionality on its way to obsolescence, in this case, an unexpected functionality. It is unexpected since "low" used in connection with technology is secondary and derivative of "high," whereas "high" applied to concept is simply the wrong adjective, motivated or, rather, contaminated by the former opposition and its measure of technology. In military jargon, I imagine "high concept" means strategic compensation for what in "high-tech" terminology is allowed to be called "smart."

So "low tech, high concept," though being a derivate of "high tech" twice over, addresses an art condition where "high tech" may become, and for the first time, a general topic on the level of practice itself, that is, the making of a medium an immediate object without resorting to immediacy or media transparency. This is no argument for obsolescence, but quite the contrary. If there is a lesson to be drawn, however, from modern art's double dependence on high tech, it must be such an argument in order to displace the immediacy of the blue screen, that is, the screen's automation of social context.

Model Art

The classic distinction between praxis and poiesis, or between phronesis (practical wisdom or judgment) and *techne,* reappears in theories of modernity as an opposition between communicative and instrumental reason. No media theory will ever feel at ease with this opposition, and media theory has invested pride in questioning it.

In an interview, Kittler (2000) points out that the clear-cut Habermasian version of this opposition denies the fact that technology constantly redefines communication and thereby makes the opposition everything but stable. Of course he is right; in modern society instrumental reason eats its way into the traditional potlatch, turning the accumulation of honor everywhere into the accumulation of goods. Modern art seems strangely enough to move in the opposite direction. Once, it was

defined as *techne,* a mastery idealized for being scarce. Art was instrumental by definition, except that what it was about was not, and its content was about anything else than art. With the concept of medium something happened to mastery. A process of deskilling or continuous displacement and reinvention of skill began that has not ended yet, and certainly not in art's post-medium condition. Still, as commonly understood, art is considered from the perspective of mastery. There must be more to this than a cultural lag, since this perspective is shared both by futurists and nostalgists of art theory. Despite the honorable role Martin Heidegger bestows on art in the Greek polis, namely, to contain a whole world surrounding its public, his account of art is surprisingly instrumentalist. No wonder he saw technology as the end of art. What he was not aware of was that technology was less about the end of classic art than the classic end of art.

Modern aesthetics launched another definition of worldliness. In fact, its original ambition as a science gives ample evidence of Krauss's description of the post-medium condition. Scientific means general, but a general aesthetics poses the threat of leaching "out into the social field." Contrary to formalist readings of Kant, and of course to his own intentions, Kant may in fact be seen to put forward the premises for an interactive avant-gardist sensibility. The taste for scandal is nothing but a redefined taste for the common. Displaced by aesthetic judgment, art became the fetish of bourgeois publicness, and the latter a thing of acute scarcity idealized in art. Aesthetic judgment shares its groundlessness with politics; the condition of modern art is eminently political, not as *engagé,* but, as Kant would say, as its condition of possibility. The shared condition for both is the condition of community, the *sensus communis* (Kant 1952: B155) or social telos of sense running through all the diversities of taste, as if only aesthetic disagreement exposes this condition and deserves to be public. This sliding from *techne/* production to judgment as exemplified by aesthetics is decisive for a modern concept of art. And in the unstable opposition between poetic skills and social practice, in the medial in-between, modernist painting appeared as a compromise.

Modernism invented the concept of medium to ward off the consequences of a general aesthetics. This invention found another aspect in painting, since however distorted, paintings will never be ordinary de-

limited objects. They will always be seen as something or something else. This invention of medium turned the traditional vector of reading pictures from one "through the window" of a transparent medium to a reading along the picture plane. It has been contended that this invention led to the disappearance of medium altogether. The result was rather, so the criticism of modern art goes, a kind of symbolism, not a given manual, but every modern work in need of a commentary, open to dispute and to a deferred value. This also implies a new role for theory, less a grammar than some heuristic device. Instead of measuring conformity to the norm, its task is to substantiate innovation as a thing of the past, to justify an event through description rather than to preclude it through prescription. Art theory, then, becomes part of the problem, not a key to the solution.

This change implies a displacement of the traditional rhetorical formalism of the trope or decorum. Adornment is no longer external and secondary, as in the classical style (versus the more expressive or untempered "Asian" style), where the aim was to minimize adornment to permit the message to come through more clearly. If the old formalism was marginal to the function of the medium, the modern formalism was constitutive. It made medium the message through a sequence of steps whose logic appeared in the end—in Greenberg's criticism—to have been doing its work from the beginning of modern art in a successive reduction to "flatness and the delimitation of flatness." At this point it appears as medium in general, where specificity is exposed to the monotheism of media. Now, after media's dethronement, we walk through the twilight of idols that Krauss labels post-medium, as though there was nothing like medium to regulate the vicissitudes of interpretation, even as a frame for possible readings discernible in any reading. It became visible as a cliché and couldn't stand this exposure for long.

The shift of attitude has already taken place. Digital media, which have yet to become an art form, have turned everything in art around. The pull is felt everywhere, and for this expanding ontology no substitution seems radical enough. This concerns not only practice but the object form, the reason for being a museum, for presentation, even in its most modest forms of souvenirs or documents of art practice. The state of the arts sweeps the floor of art. In line with the 1960s' dematerialization of the art object, today's Web design amplifies the aesthetics of earlier

conceptual art with the much mentioned "disappearance of the object," as though the social utopia of the historical avant-garde needed a corresponding technique, a state of the arts. This is not like Krauss's recommendation to stretch the medium into the post-medium condition to render it consistent. On the contrary, it would seem to restore a formalism by a step from post-medium to digital media. The influence of Web site design points to a final restoration of rhetoric mastery, but it may be too narrow a solution to stop the old aesthetics from leaching "out into the social field."

As the avant-garde has become normalized within the art institution, its aesthetic radicalism lost but not its possibilities for repeated innovation, the only possible place to reinvent avant-gardism seems to be inside digital media. Not even medium-specific art obscured the need for art to mirror a medium in another medium, but this time around the analogy of modernist painting is scientific scholarship, that is, the technique of the human sciences. The social may be exempt from medium, and this exemption explains the strategy behind the leaching of aesthetics into the social, mentioned above. For scholarship, however, there is no such escape beyond medium; there is no metaposition from which the medium will lose its specificity. Notwithstanding the look of modernism, or its criticism, it is time for the human sciences to turn modern, not just as an art form, but in the form of modern art. In fact, this already has taken place under a somewhat mistaken identity. What remains is just a plea for the legitimacy of this change, not the least since it cannot be automated. So the question is whether media theory will stay modern, when it has no obsolete technology to modernize, just modern technology. As a final prospect, media theory may reflect its search for an unfamiliar method in the medium of painting.

Notes

1. Cézanne was mocked in public for his lack of skill, or "gaucherie," but deskilling is in fact used as a neutral description of modern art in general. Just as there are constructs in deconstruction, not only simple destruction, there are skills in deskilling. The point is, however, to define modern art as a displacement of skill, meaning both an enhanced reflection and some sort of delay, or distanc-

ing, of art production. This must not be taken to mean a slowed-down pace of output. On the contrary, deskilling involves a change on a par with new demands on mechanical reproduction. It refers to an art under quite unprecedented pressure of rationalization.

2. See the chapter on Hugo St. Victor's *Didascalion* in Grabmann 1911: 235–249.

3. The dream of romantic poets like Novalis or Friederich Schlegel was to see art "sublated" by the intermediary of art criticism into "the medium of art," that is, art as a generalized medium. See Benjamin 1978 (63).

4. The influence of digital media is both a guarantee of and an obstacle to this inclusion. According to common understanding the discipline should appear first, as though every academic discipline did not "forget" its pragmatic genealogy and become scientific at the moment the *pragma* coagulates into an essential difference in relation to other disciplines, such as the one taken for granted between sociology, the study of "our" society, and anthropology, the study of "theirs." When anthropology returns to study "our" society, this genealogy explains a methodological adaptation. The former "strange" object of study is promoted to an alienation technique. Modernity is seen from the outside, the accumulation of capital from the point of view of potlatch.

5. There is ample evidence of this change taking place in critical discourse, but not within modernist criticism itself. In fact, it seems the academic legitimation of a "modernist" discourse had to wait for modernism to pass out as an event of pure art immanence.

6. The famous analysis of Velazquez's painting *Las Meninas* occurs in chapter 1, pp. 3 ff.; that of Cervantes' novel *Don Quixote,* in chapter 3, pp. 46 ff.

7. Bolter and Grusin's portrayal of modern art may appear somewhat disappointing in its reversible ease. For them modernism has become the simple opposite of obsolescence, without any feeling of loss or of compensation. Their chosen examples of computer art seem rather to exemplify a familiar and older repurposing of pictures, hypermediatized or not, here on the side of immediacy, of what

the computer mediates. Art is picture making, and digital art a new way of making, rather than simply taking pictures for photodocumentation. The functionality of modern art must be understood as going deeper than this. Production of hardware and software programming may be both too ambitious an analogy for art and a framework that reduces art to the classic *techne*. If we are to approach the issue of modern art in digital media, we might instead look at things like the dissemination of data viruses. In this case function goes to the heart of the medium: virus as something that exposes the social immanence of the medium, its plane of immanence laid out (real hypermediacy, in Bolter's terms) and with a negative motive indiscernable from creativity. Still, this analogy has some undesired consequences beyond the obvious ethical ones. The virus disturbs immediacy for sure, but surely not when it is obsolete.

References

Arendt, H. (1996) *Vita activa* (*The Human Condition*). Oslo: Pax Forlag.

Balkema, A. (2000) "Exploding Aesthetics." Web pages for Momentum International Art Conference: Questioning the Social—Ethics and Aesthetics in Contemporary Art, Moss, Norway. Available at www.kunst.no/questioning/new.html.

Benjamin, W. (1978) *Der Begriff Kunstkritik in der deutschen Romantik* [The concept of Art Critique in German Romanticism]. Frankfurt am Main: Suhrkamp Verlag.

Bolter, J. D., and R. Grusin (1999) *Remediation: Understanding New Media*. Cambridge: MIT Press.

Deleuze, G., and C. Parnet (1987) *Dialogues*. London: Athlone Press.

Foucault, M. (1973) *The Order of Things*. New York: Random House Vintage Books.

Grabmann, M. (1911) *Die Geschichte der scholastischen Methode* (The History of Scholastic Method), vol. 2. Freiburg, Germany: Herdersche Verlag.

Greenberg, C. (1992) "Modernist Painting." In *Art in Theory 1900–1990.* Oxford: Blackwell.

Greenberg, C. (1995) *The Collected Essays and Criticism,* vol. 4 (ed. J. O'Brian). Chicago: University of Chicago Press, pp. 121–134.

Kant, I. (1952) *The Critique of Judgement.* Oxford: Clarendon Press.

Kittler, F. (1999) *Gramophone–Film–Typewriter.* Stanford: Stanford University Press.

Kittler, F. (2000) "Conversation with Friederich Kittler." *Mediert,* no. 1, 15–17.

Krauss, R. (1978) *Passages in Modern Sculpture.* London: Thames and Hudson.

Krauss, R. (2000) *"A Voyage on the North Sea"—Art in the Age of the Post-Medium Condition.* London: Thames and Hudson.

Kristeller, P. O. (1996) *Konstarternas moderna system* (The modern System of the Arts). Stockholm: Raster Förlag.

Ulmer, G. (1994) *Heuretics: The Logic of Invention.* Baltimore: Johns Hopkins University Press.

Wittgenstein, L. (1989) *Lectures and Conversations on Aesthetics, Psychology and Religious Belief.* Oxford: Blackwell.

III

Rhetoric and Interpretation

11

Rhetorical Convergence

Studying Web Media

Anders Fagerjord

In the late 1990s, major news sites on the World Wide Web started to incorporate streaming audio and video alongside text and pictures. The result has been a new news medium to which tens (if not hundreds) of millions of people turn every day. Although text has been shown in movies and television programs since their very beginnings, it has always been the preference to use "printed words" sparingly, a few sentences at a time at most. Letters and moving images have not been considered to work together that well. With a Web browser, however, things are a little different. Video is frequently combined with long pages of text, as moving images can be put inside bodies of text, not just text into moving images. Video playback, including up-to-the-minute newscasts, can be paused and restarted, fast-forwarded, or started over from the beginning by the user. Added to this is the power of linking that enables the user to call other pages, illustrations, or video clips to the front of his screen, a device added to both text and images, still or moving.

Reading these complex Web pages is not like reading a print newspaper or watching broadcast television. How should we understand these complex texts? The loosely defined field of media studies has provided theoretical understanding of how the popular media existing before the

Web are written and read, that is how they communicate. We have yet to develop such a theory, however, for Web media. It might be built on theories of older media, but most studies of media texts are confined to one medium, be it film, television, news writing, or photography. Each of the earlier media has its own recognized rhetoric (or poetic) that is studied by media scholars. With the increasing use of streaming media on the World Wide Web, we need to study the combination of these rhetorics if we are to understand how Web media communicate. Existing media theories can serve only as inspiration for this work.

Combinations of letters, sound, and still and moving images in the computer are often described as *convergence*. We lack a thorough understanding of convergence as a process of invention of new symbolic practices and not just computer protocols. Convergence also seems to be a bad description of the actual development we see at our turn of the century. The same words, sounds, and images can be fed into an increasing number of software applications, running on large and small machines, grounded or mobile. By way of an example, I will in this chapter try to view the concepts of *convergence* and its counterpart *divergence* from the perspective of Web "content": stories made for people, told on computers. I will do this with close reference to online news from Norway.

The Triple Murder Trial

In the early days of May 2001, VG Nett, the Web site of Norway's largest newspaper *VG*, contained a special section titled *Trippeldrapet* (literally, The Triple Murder) devoted to an ongoing murder trial. The trial was the culmination of a murder case that had dominated Norwegian news media for two years. In May 1999, a couple in their eighties and their forty-seven-year-old daughter were brutally executed in the middle of the night. In May 2001, four members of their family went on trial for the three murders. This was an extremely tangled and difficult case in which there was little evidence.

VG Nett's coverage of the case was extensive. Inside the courtroom, reporters tried to transcribe every word, publishing the proceedings on-

line, literally a line at a time. When important facts were uncovered, other reporters wrote regular news stories that were published both in the special section on the murder case and on the regular first page of the Web edition of the newspaper. The special section also contained pictures and biographies of the victims and the accused, interactive maps of the scene of the crime and the courtroom, and an archive of all of *VG* and VG Nett's stories related to the crime since 1999. Photographers were not allowed into the courtroom during the trial, but video from the courtroom before and after each day's proceedings and videotaped interviews with commentators were published daily (see figure 11.1).

VG Nett's special section combined written transcripts, written news stories, photographs, *Flash* animations and video, news archive, front page editions, and live updates. This kind of mix is seldom described in the heterogeneous body of theory we call media studies. General semiotic and poststructuralist theories of meaning should be expected to have bearing on new, or digital, media too. Theories within sociology and political science of news media and their relation to news and to society should be applied and tested with Web news. But detailed studies of form, aesthetics, and rhetoric tend to be focused on one medium, and often even just one aspect of the medium's appearance.[1] I can think of no theory of newspaper journalism, photography, visual design, or television form that can fully account for the media mix of VG Nett. Similarly, the growing body of theory written about scholarly hypertexts, computer games, and hypertext fiction tends to concentrate either on text or visuals or on structures that can be represented with different sign systems, such as narrative. It is telling that Jay David Bolter, a leading theorist of computer media, has put forward two books on the theory of remediation, one with Richard Grusin on visual media (Bolter and Grusin 1999) and one on text (Bolter 1991). VG Nett's special section *Trippeldrapet* is a prime example of the kind of digital authoring and publication of news on the Web that is frequently referred to as convergence. I see this term as an example of the undertheorized development of a critical vocabulary and concepts for analyzing digital media. My aim here is to further examine the term "convergence" so as to suggest how it might be conceptualized in the analysis and understanding of Web media.

Figure 11.1

The *Trippeldrapet* section of VG Nett. Columns of the section's first page (center) from left to right: first column: logo and links to other sections of VG Nett; second column: leads and links to breaking news stories from the trial; third column: "Today in Court," with link to live transcripts (top right), and "Background," with links to interactive maps (middle right), select archive stories about the murder (not shown), and video from the trial (bottom right); fourth column: links to articles about the suspects, victims, crime scene, evidence, and witnesses (not shown).

Anders Fagerjord

Convergence

The term "convergence" has the general sense of a coming together. It is a word widely used to describe the effect of digitization. The fact that alphabetic text, still and moving images, and sound can be coded as digital numbers so they all can be displayed and manipulated by computers and distributed through computer networks has led to what many call the "digital revolution," whatever we may make of this troublesome term. Van Cuilenburg and Slaa (1993) have summed up the many effects of digitization as three kinds of convergence: network convergence, service convergence, and corporate convergence. We can illustrate this with the convergence of three Web media, CNN, Yahoo! and *VG*. First, originating as cable television network, Web directory, and newspaper, respectively, all three now publish through the Internet (network convergence). Second, they offer three similar news services (service convergence). Third, the owners of CNN have merged with the Internet access and software company America Online, and the owners of *VG* own Scandinavia's largest Internet provider and have interests in a number of television and radio stations (corporate convergence).

What is missing in van Cuilenburg and Slaa's overview is the combination of media forms. Service convergence, according to these authors, occurs in two forms: "at the level of *service provision,* convergence refers to the development of both hybrid services (datacasting, videotex) and to the use of existing services in new broadcasting-oriented forms, such as audiotex" (158). Both new hybrid services and repurposed services, however, need to combine communication in language and images—*rhetorics,* in short—from different media in new ways. The service convergence in the example of the three providers of Web media (with all three providing up-to-the-minute news on the Web in text and video) clearly shows another convergence: the coming together of different kinds of storytelling through means such as text, spoken language, photographs, drawings, video, live coverage, and continuous updates. I see this as related to, but not the same as, service convergence. Service convergence might have taken place if all three Web sites had published only text. The combination of text, video, interactive graphics, linking, and frequent updates can be seen at work in Web sites providing different services, such as news

sites (e.g., VG Nett), educational sites (e.g., BBC Online Education), and commercial sites (e.g., Apple.com).

Remediation

Most theoretical work on new media is about art, fiction, scholarly work, or education. Outside of departments of human-computer interaction, theoretical writing on popular Web sites is hard to find. A notable exception is Bolter and Grusin's 1999 book *Remediation: Understanding New Media.* In this book, Bolter and Grusin launch a theory of *remediation,* a theory that sets out to explain the relations between old and new media as well as convergence. As they put it: "Convergence is remediation under another name" (Bolter and Grusin 1999: 224). Bolter and Grusin "call the representation of one medium in another *remediation,*" and argue that "remediation is a defining characteristic of the new digital media" (45). Echoing Marshall McLuhan's claim that the content of each medium is another medium, Bolter and Grusin state that "it would seem then, that *all* mediation is remediation. We are not claiming this is an a priori truth, but rather arguing that at this extended historical moment, all current media function as remediators and that remediation offers us a means of interpreting the work of earlier media as well. Our culture conceives of each medium or constellation of media as it responds to, redeploys, competes with, and reforms other media" (55). This competition and reform is the main focus of their book. The theory of remediation is a theory of how different media achieve and contest their different statuses within contemporary North American culture. Bolter and Grusin suggest that we can identify "a spectrum of different ways in which digital media remediate their predecessors, a spectrum depending on the degree of perceived competition or rivalry between the new media and the old" (45).

To achieve higher status within a culture, media remediate each other according to what Bolter and Grusin label the double logic of *immediacy* and *hypermediacy.* The logic of immediacy, or transparency as it is also called throughout the book, "dictates that the medium itself should disappear and leave us in the presence of the thing represented" (5–6). This is the logic behind perspective painting, photography, photorealistic painting, digital imaging, and virtual reality. Hypermediacy is described

as the multiple, the diversified, and as a style calling attention to the medium itself: "The logic of hypermediacy multiplies the signs of mediation and in this way tries to reproduce the rich sensorium of human experience. . . . In every manifestation, hypermediacy makes us aware of the medium or media" (34). Immediacy and hypermediacy are linked to two human desires, the "desire for transparent immediacy" (31) and a "fascination with media or mediations" (34).

Bolter and Grusin's book appears to present a relevant theory for helping us understand VG Nett's combination of forms from earlier media. However, the focus of *Remediation* is not communication with combined media, but the status different media have within a culture and how this status is achieved, challenged, and defended. In investigating these processes, the authors follow the "double logic of remediation" through history, sketching a twin "genealogy" of immediacy and hypermediacy back to the renaissance. A broad range of electronic media—the Web being only one of them—is analyzed as examples of the principles of remediation. Although the book seeks to answer a different set of questions, might the analyses presented of media such as CNN.com and USAToday.com offer some understanding of VG Nett? Bolter and Grusin observe that "the Web today is eclectic and inclusive and continues to borrow from and remediate almost any visual and verbal medium we can name. What is constantly changing is the ratio among the media that the Web favors for its remediations; what remains the same is the promise of immediacy through the flexibility and liveness of the Web's networked communication. The liveness of the Web is a refashioned version of the liveness of broadcast television" (197). Bolter and Grusin try to understand the whole of the Web in one large sweep. In this chapter, I will try to show that this large sweep results in internal contradictions in their text, thereby limiting its value for the understanding of Web media such as VG Nett. To be able to do that with such a tightly woven theory as this, one has to go into the details of *Remediation,* and I therefore need to quote from it extensively. I would urge readers to consult this interesting text themselves.

Let us first consider the claim that what remains the same throughout the Web is its remediation of television. Do Bolter and Grusin see an online store like Amazon.com or reading e-mail at Microsoft's HotMail as remediations of television? It is also worth pointing out that much

Figure 11.2

Front pages of CNN.com (left) and VG Nett (right). Note similarities in design: links to main sections in left column, first-page leads and links to news stories broken into columns, links to video marked with small icons.

television (drama, for instance) is not live. Furthermore, I will argue later that even broadcast television news is not as live as Bolter and Grusin appear to believe. The insistence of television as content of the Web (content, since remediation is the presence of one medium in another) seems to rise out of Bolter and Grusin's fascination with Web cameras. Web cameras are of course interesting, and the analysis of them in *Remediation* is significant. To extend the understanding of Webcams to the whole of the Web, however, obscures far more than it brings to light.

In their analysis of CNN.com, Bolter and Grusin's motivation to discuss the relation to television is more obvious: "The CNN site is hypermediated—arranging text, graphics, and video in multiple panes and windows and joining them with numerous hyperlinks; yet the Web site borrows its sense of immediacy from the televised CNN newscasts" (9). Following this argument, CNN.com's video would qualify as being more immediate than VG Nett's, as the latter does not have a television station to fall back on. This may be true. My point is that the uses of text, graphics, video, and the linking of the two different sites are so similar that obviously they can be treated equally in textual analysis (see figure 11.2). At the other end of the book, however, CNN's coverage of the 1996

election in the United States is described. On CNN's TV broadcast, results were presented state by state; on the Web, users were able to focus on just one state, with online connection to the TV station's numbers. "The assumed immediacy of broadcast television was exposed as faulty, in that television could not be interactive and respond to the needs of each viewer" (268), comment Bolter and Grusin. Again, it is the ongoing relation to television that is the focus. During the 1996 election, Bolter and Grusin read advertising of the Web site to place the site in opposition to television. In 1998, the Web site is back to its normal state of dependency on television. Writing of text, editing of video, and layout of text and images, however, are similar in the two cases. Bolter and Grusin do not seem to offer an analysis of the actual writing, editing, and layout of CNN.com.

In their discussion of *USA Today,* Bolter and Grusin again focus on the relation between the parent and its Web offspring: "Although the paper has been criticized for lowering print journalism to the level of television news, visually, the *USA Today* . . . attempts to emulate in print the graphical user interface of a Web site" (40). The illustrations given to drive this point home are the *USA Today* Web site (founded years later than the newspaper) and a front page of the print newspaper. They are quite similar, but they are both also similar to what Kevin G. Barnhurst in a book on newspaper design calls "the archetypal newspaper." Barnhurst's example, the front page of *New York World Telegram* of February 18, 1932, also has columns of differing height and width, some with pictures, and headlines of different size and weight spanning one or more columns (Barnhurst 1994: 9). I do believe Bolter and Grusin confuse original and copy, but of more theoretical value to our present discussion is the similarity between the home pages of *USA Today* on the Web and CNN.com. I am quite willing to agree that CNN.com borrows immediacy from the television network (whatever that may imply), but at the same time, it borrows its looks from Web newspapers and news magazines and ultimately from print newspapers. When Bolter and Grusin analyze Web media, the focus on the all-embracing double logic of remediation and its consequences for the status of new and old media obscures the vision of remediations occurring in several directions at once.

Hypermediacy and Immediacy

The key to Bolter and Grusin's theory of remediation is the double logic of hypermediacy and immediacy. To subscribe to this theory, we must be convinced that there are no more logics than these two, that the two are really different, and that they are connected. *Immediacy* is defined in the book's glossary as "a style of visual representation whose goal is to make the viewer forget the presence of the medium" (272). It is achieved in painting through perspective and effacement, in photography by the physical process of light and film, in film by movement, and in interactive media through interactivity (24–30). But immediacy is more than "a style of visual representation." There are routes to immediacy other than "perfect transparency," such as television's characteristic presentation of "live events" (81). Neither is "forgetting the presence of the medium" really a prerequisite for immediacy: "Although the real and the representational are separated in modern art, modern art is not therefore less immediate. Modern painting achieves immediacy not by denying its mediation but by acknowledging it" (58).

The other logic, *hypermediacy,* is defined as "a style of visual representation whose goal is to remind the viewer of the medium" (272). It is a visual style incorporating several systems of significations, different viewpoints, text, and images, thus opposing the unified style of immediacy. For Bolter and Grusin, however, "hypermediacy can operate even in a single and apparently unified medium, particularly when the illusion of realistic representation is somehow stretched or altogether ruptured. For example, perspective paintings or computer graphics are often hypermediated, particularly when they offer fantastic scenes that the viewer is not expected to accept as real or even possible. . . . In every manifestation, hypermediacy makes us aware of the medium or media and . . . reminds us of our desire for immediacy" (34).

Not only are there apparently different kinds of both hypermediacy and immediacy, but the two can also be so close to each other that they are indistinguishable. The authors argue that through hypermediacy, immediacy also occurs, when we glance at the medium itself or at the variety of media that may be presented (81).

If we are to use the theory of remediation to analyze VG Nett's special section on the triple murder, how are we to distinguish between the parts that "hide the medium" and the parts that "acknowledge" the medium, when hiding it can make us acknowledge it, and acknowledging the medium can make it go away? Before attempting to answer the question, let us ask a few others.

Reality and Mediation

Remediation is a theory of the status of media, of media's different claims to *immediacy* or *reality,* and of how media respond to, redeploy, compete with, and reform other media. What is the locus, the arena for this process? Who are the actors? The place of the contestation must be "in culture," more precisely, in North American culture. The actors are presumably "media." But culture is of, by, for, and through the people, and media technologies and visual styles do not really have voices that can form responses and make claims against other media. Consider the definitions of immediacy and hypermediacy cited above. Do visual styles really have their own goals? So if competition among media and claims toward a "reality" exist (and I agree that they do), these are realized in the opinions of media shared by people in a culture. Both the reasons for and the effects of remediation are found in culture, not in the media themselves.

Now we can return to the paradoxical descriptions of the double logic of remediation. The key to the understanding of the theory is in Bolter and Grusin's concept of "reality": "Hypermedia and transparent media are opposite manifestations of the same desire: the desire to get past the limits of representation and to achieve the real. They are not striving for the real in any metaphysical sense. Instead, the real is defined in terms of the viewer's experience; it is that which would evoke an immediate (and therefore authentic) emotional response" (53). The core difference between hypermediacy and immediacy in all their different and confusing guises is their different strategies for achieving an unmediated authentic experience in ourselves. It is our experience that is the locus of remediation. Furthermore, if "reality" is located in the individual, then it is not a stable concept. It differs from text to text, from reader to reader. It is different from immediate media to hypermediated media. In im-

mediate media, the real is the mediated diegesis (whether real or fictional); in hypermediated media, the real is the medium itself. The real even oscillates in one reading between the represented and the medium. This of course means that outside of the mediations studied in *Remediation,* the real is perfectly stable to each reader. What is real is the reader herself.

This has two consequences for analysis. First, to undertake serious analysis of any medium text, a researcher must develop a strategy to find the cultural understanding of a medium's relationship to the "real." Bolter and Grusin are at their very best when they criticize an article in *Wired* about future "push media" exactly because they can pinpoint the voices of the arguments and the locus of the debate. Second, a researcher must realize that real human beings may have other concerns than media's relationships to "reality" from time to time. When I drive my car in the rush hour, the radio is my medium of choice because I can listen while I drive, not because it is closer to any "reality" than wide-screen THX cinema. Indeed, it allows me to pay close attention to real traffic!

Immediacy and hypermediacy are different strategies employed to "seek the real." What gets in their way of finding the real is mediation. In all their effort to show that media remediate other media, Bolter and Grusin find no place to talk about media as communication. Media are defined as "that which remediates" (66). As remediation is "the representation of one medium in another," the definition is circular. A medium is that which represents one medium in another medium. Alternately, a medium is seen as a hybrid, "a network of formal, material and social practices" (67). But later, when discussing replacement as the essence of hypermedia, a medium seems to be reduced to a signifying system: "Replacement is at its most radical when the new space is of a different medium—for example, when the user clicks on an underlined phrase and a graphic appears. Hypermedia . . . replace one medium with another all the time" (44). There is never an assertion of the fact that new, digital media communicate *meaning,* as old media also do. They use signs from different systems of signification that can invoke in readers an understanding of events in the world or in a fictional world. As the theory of remediation does not address this, it cannot help us in understanding the signifying practices or the rhetoric of VG Nett.

Mens **gjerningspersonene** står inne på kjøkke-
net, kommer den hardt sårede Marie Orderud
vaklende fra soverommet, gjennom gangen og
ut i stuen mot den knuste verandadøren.
 Inne i stuen blir hun skutt to ganger i ryggen
og segner om på gulvet, for gjerningspersone-
ne avfyrer et siste skudd i halsen på 84-årin-
gen, og forsvinner ut gjennom den oppbrutte
verandadøren. Rettsmedisinerne er ikke sikker
på hvor lenge 84-åringen ligger på stuegulvet
før hun dør av skader og blodtap.

Grafikk: Kenneth Lauveng/ Ivar Gaaso

Figure 11.3

Interactive maps from VG Nett. When the mouse is rolled over a body or a piece of
evidence, a description of the events that took place in the room is shown.

Rhetorical Convergence

When VG Nett remediates, it remediates many media. In the *Trippeldra-
pet* section, we find layout conventions from newspapers and magazines
and a traditional newspaper writing style. Photographs and illustrative
graphics are included as they would be in a newspaper or news magazine,
although some of them have rollover functionality of a kind made popu-
lar in CD-ROMs in the early 1990s (see figure 11.3). There is live cover-
age from the courtroom, as radio might provide, but it is written and
can thus be skimmed or read slowly several times by the reader (see

Grafikk: Kenneth Lauveng/ Ivar Gaaso

figure 11.4). Video interviews made in a traditional television style can be watched at any time, unbound from any television schedule (see figure 11.5). The links provided for navigating the massive text draw on conventions from newspapers ("continues on page *n*"), tables of contents and indices from books, and navigation tools from hypertexts, such as the links on top and in the left column (see figure 11.6). The resulting text is a tangle of remediations, and merely to label it "hypermediacy" or to relate it to television does not give a deep understanding of how such a text communicates. I propose to understand such hybrid Web texts as VG Nett as results of *rhetorical convergence,* emphasizing how different styles and sign systems are combined into complex texts and thus also complex significations and reader selections and processes of semiosis.

| April 2001 |
| Man Tir Ons Tor Fre Lør Søn |

Man	Tir	Ons	Tor	Fre	Lør	Søn
						01
02	03	04	05	06	07	08
09	10	11	12	13	14	15
16	17	**18**	**19**	**20**	**21**	**22**
23	**24**	**25**	**26**	**27**	**28**	**29**
30						

Mai 2001

Man Tir Ons Tor Fre Lør Søn

Man	Tir	Ons	Tor	Fre	Lør	Søn
	01	**02**	**03**	**04**	05	06
07	08	09	10	11	12	13
14	15	16	17	18	19	20
21	22	23	24	25	26	27
28	29	30	31			

4. mai 2001

08:00 - 09:00
09:00 - 10:00
10:00 - 11:00
11:00 - 12:00
12:00 - 13:00
13:00 - 14:00
14:00 - 15:00
15:00 - 16:00

Hansen: Nei.

Olav Helge Thue: Ok, da kan vi gå videre.

Hansen: Det var de her som det gjorde det på. Men det var utallige varianter av det mønsteret.[...]

Olav Helge Thue: Er dette tilstrekkelig i forhold til det vitnet dere har?

Heidi Ysen: Hovedsakelig i forhold til sokken.

Hansen forklarer litt mer om de tekniske detaljene rundt fotavtrykk-undersøkelsene. (4/05 - 15:18)

Olav Helge Thue: Og dette er helt ute?

Hansen: Dette er rett på innsiden av verandadøren. De to foliene vi ser her som jeg har lagt tilbake, er de to foliene her. Avtrykket er i retning inn i huset. Dette passer med at - hvis man skal vurdere hvor man finner de beste avtrykkene - så er det de første avtrykkene vi har sikret. Jo lengre inn i huset vi har sikret avtrykk, jo svakere er avtrykkene.

Olav Helge Thue: Er det en naturlig utvikling?

Hansen: Det er en naturlig utvikling, for hvis man kommer utenfra så er det en del smuss under sålen og jo lenger det går, jo mer faller det av.
[...]
Hansen: Det avtrykket her går over to folier og det er det avtrykket her som danner grunnlaget for Eriksens konklusjon om at vi snakker om en sko av størrelse 40-41. Og når det gjelder denne skoen her, så er det bare deler av en sko vi har her.

Olav Helge Thue: Kan du si noe om [...]

Hansen: Ja, vi mener at det er en høyre sko.

Olav Helge Thue: Og den her da?

Hansen: Det er en venstre. Den er noe uklar, men det er den som danner utgangspunktet. Nå har vi tatt et fotografi i området her, på kjøkkenet, som vi peker på nå, og vi ser her omriss av føttene hvor Anne Orderud Paust lå. På den folien, og den, har vi også deler av avtrykk som passer med at skoene har stått i den posisjonen.

Olav Helge Thue: Venstre, høyre osv. (4/05 - 15:22)

Figure 11.4

Transcripts from the trial are updated on VG Nett every few minutes. Earlier transcripts are available from the links in the left column.

Figure 11.5

Streaming video in VG Nett. When a link to a video on the first page is clicked, a new window opens with the clip.

Let us take a short closer look at this complexity. A link in the video column (red links in the bottom third of figure 11.5) reads "Se videoen fra Orderud-saken" ("See the video from the Orderud trial"). Activating the link brings a new window to the front of the user's screen (see figure 11.5) with an advertisement and a video player. The video player first shows an animated VG Nett logo, then a five-second advertisement, and then the video from the courtroom is played. The clip runs for eighty seconds, and consists of eight shots showing the four suspects entering the courtroom one by one. Apart from a couple of sentences spoken by

Figure 11.6

The first page of the *Trippeldrapet* section of VG Nett.

one of the suspects and her lawyer, the only sound is the constant clicking of press camera shutters. We recognize the shots as the kind of footage that regularly illustrate TV news reports. What is different from television is the lack of explanatory voice-over. The images are just presented as they are, rather roughly edited together. On television, these images could have illustrated any news story about the trial (especially since cameras were prohibited in the courtroom during the proceedings). Thus, shots from the video clip could have been used to illustrate any or all the news stories found on the first page of *Trippeldrapet*.

There seems to be a common conclusion that such video material is used in newscasts as pieces of reality, as proofs. Bolter and Grusin (1999: 25 ff.) point to how the "automation of linear perspective" has been a strategy to achieve immediacy. They are far from the first to notice this; the indexicality of the documentary image, its status as a chemical imprint of reality, is a common theme in much of documentary theory (Renov 1993 provides a good overview of this view). The courtroom video shows us all four suspects together at the same time, how their movemens reveal their nervousness, how ordinary the courtroom looks. The (written) news stories in *Trippeldrapet* are all accompanied by a photo, but the photo is either from the newspaper's archive or a recent one from a break in the court proceedings. These photos are tightly cropped to a close-up of one or two persons with few other visible details. They are much more detached from time and place and do not give the impression of reality of the video. By adding video as a complement to the written articles, VG Nett achieves some of the perceived reality of television without having to reuse the same shots over and over again, as television often has to do.

The next video in the list in figure 11.5 is an interview with *VG* and VG Nett's senior journalist Olav Versto, who has followed the trial. It is shot as a regular TV news interview, in close-up, with Versto facing the interviewer, a little left of the camera. The "colleague interview"— interviewing another journalist—is quite a common practice in radio and television as a faster way of getting information on the air, since the interviewer structures the interview, and the interviewee provides the information (Jacobsen 1993). This is not normal practice, however, in Norwegian newspapers, in which the journalist instead would be expected to write

a well-phrased news analysis. Print journalists also normally leave the questions out. In the video interview, although the interview is visibly edited, the questions are heard. The video is shot outside of the courthouse, showing how the Web newspaper is on the spot where the action takes place, faithfully covering the case for its readers. This second video is a clear example of television rhetoric entering a Web newspaper.

The placement of the video clips within the whole, however, is very different from television. News on television is a carefully scripted ceremony in which the news anchor leads the audience through the chosen reports of the day and gives the floor to a succession of reporters for the main stories, reading the lesser ones him- or herself. *Trippeldrapet* is laid out much more like a newspaper, with a list of stories competing for the reader/viewer's interest. Depending on the size of the user's screen, the two video segments I have discussed are located at least two full screens down the page in small print. There, they are offered with no introduction, nor with the ceremony of the television newscast. Thus, although having imported television rhetoric, the clips adopt a very different part in the whole, the television rhetoric being subsumed into a larger, newspaper-like rhetorical whole.

The layout of *Trippeldrapet*'s first page (see figure 11.6) is newspaper-like, but only to a certain point. In the main column, stories are presented chronologically, the most recent at the top. There is little of the sense of hierarchy found on the front page of a print newspaper, on which the stories considered most important by the editors are given the most prominent placement. On the Web, news items are printed as they arrive, and readers may leave and return at any time. For the returning reader, then, this chronological layout is practical: it is easy to locate the stories she has not already read. For more casual readers, the links to archived background material in the two columns to the right are an aid to getting the gist of the complex case. The Web's possibility of immediate publishing lends it a freshness even more profound than that in radio or round-the-clock TV news channels like CNN. Instead of encapsulating stories in an "edition," they are frozen on the page in the sequence in which they are placed online.

Reading *Trippeldrapet* in VG Nett is reading a hybrid of rhetorics from print, television, Web, and even radio. Rhetorical convergence has

resulted in a kind of text not quite like any media "content" we have previously seen.

I use the word rhetoric to describe the products of an author's choice of topic, arguments, sequence and words. Further, as I take the word "text" also to cover media other than writing, I will expand "rhetoric" to cover more than written words. Here, it also embraces still and moving images, visual aspects of typography (typefaces, sizes, colors, layout, etc.), and programmed procedures in computer texts. In the wide sense, then, I use rhetoric to describe how media messages are made to appear. I am aware that quite a few scholars will find this to be a peculiar use of the term "rhetoric,"[2] but I believe there also are those that will find it natural.

In borrowing the term "rhetoric," I also want to imply a wish to start the collection of a catalogue of techniques and figures of rhetorical convergence. The rhetoric tradition has always made catalogues of rhetorical figures and techniques (although sometimes blown up to a ridiculous scale). As a well-known, centuries-old tradition, these studies form the backbone of a diversity of literary studies today. In beginning to single out and classify new ways of conveying meaning in interactive media, we may hope to extend rhetorical understanding to digital literary and journalistic formats as well.

Web Media

Earlier, I criticized Bolter and Grusin for trying to embrace the whole World Wide Web within one theory. To be able to place the rhetoric of VG Nett in relation to that of other media, we should acknowledge that the Web functions as a medium on (at least) two different levels. For simplicity's sake, I will not use the term "medium" for the first level (although I could), but instead call the Web as a whole a publishing channel, a set of technology protocols working on the Internet (which itself can be subdivided in a similar matter). The flexible character of this publishing channel, allowing anyone to publish globally and to receive responses through the same line, has of course resulted in a myriad of uses. I will suggest that these various uses are so different from each other, and at the same time so similar to what we call media outside the Web, that the term "medium" is applicable at this level too (and this time I will use it).

In the following discussion, then, I will speak of the "Web channel" enabling many "Web media": news media (of which VG Nett is one instance), entertainment media, media of personal expression, "shopping media," surveillance media, and so on. But are these not mere different uses of a technology? Indeed they are, but I will argue that these uses create patterns of writing, of distribution, of consumption, and of economy that make them different media, just as we speak of newspapers, women's magazines, and books as different media, although they are just different uses of the printing press. We may not be able to establish clear-cut borders between Web media, but we might at least distinguish between different gravitational centers around which many Web sites cluster, some close to the center, some in the fringes, all influenced by more than one gravitational field.

This moves the concept of medium very close to the concept of genre. Arguably, what I call Web media could equally well be called Web genres. In time, then, the convergence of digital media may force us to rewrite both concepts, medium and genre, or at least to reconsider their relationship.

The differentiation between Web channel and Web media made here is crude and should probably be worked out in more refinement and detail at a later time. I hope it will suffice for now.

Rhetoric and Technology

At this point, describing VG Nett as rhetorical convergence might seem to be just substituting another word for "multimedia," a combination of text, sound, still images, and video. I believe the argument needs to be taken a step further, however.

Any medium is more than a technology for communication with a certain kind of signifiers (written language, moving photographic images, etc.). The different rhetorics used in VG Nett are as much conventions of practice as products of technology. The rhetoric of VG Nett is a composite of (or compromise among) form, technology, economy, and social practices. As Raymond Williams has shown in the case of television (1992), the technology for television was invented without any specific uses in mind. Many forms of programming arose out of the broadcasting

of events already taking place, such as sports or theatrical and musical productions. This development coincided with a development of domestic commodities, and the varied television menu suited a system of television receivers in private homes. Broadcasting from a center to private homes made it difficult to collect revenue, and because much TV production is expensive, systems for financing TV programming such as public service license fees and commercial television arose as a result. These different systems of financing led to different forms of programming and to different rhetorical practices.

Williams criticizes technological determinists for believing that media technology is the cause of both media content and societal change. Technology is only one of several important factors. Still, we can see that a change of technology is likely to change a medium's rhetoric as well. We can suggest that a medium's rhetoric—any author's choice of means—may be viewed as an equation, somewhat like this:

$$\text{Topic} + \text{Intended Effect} + \text{Audience's Social Setting}$$
$$+ \text{Audience's Use of Media} + \text{Economy} + \text{Technology}$$
$$+ \text{Traditions and Conventions} = \text{Rhetoric.}$$

If we change one variable, the rest of the equation changes with it.

The movement from the print newspaper *VG* to the Web news site VG Nett has changed at least the technological part of the equation, and we can see the other variables change as well. VG Nett, unlike *VG,* is no longer bound by technology to stick to either text and images or video and sound.[3] The publishing cycle for a Web site is limited neither by printing and distribution time, nor by the audience's viewing habits. It can be written and published any time, and it is immediately available and for as long a time as is desired by the user. The social setting of the Web audience is also different from that of the print newspaper. VG Nett reaches users' computer screens, most of which are not on the breakfast table nor yet available on the morning commuter train. Whereas readers fold a regular newspaper and carry it with them, most computers with Internet access in 2001 cannot be carried very far. Also the economy is different. People do not want to pay for Web news, and neither advertising nor subscription has become a secure source of revenue for most sites.

Schibsted (2001), the owners of VG Nett, discloses on its Web site that it did not make a profit from its Web newspapers in either 1999 or 2000.

Thus, when a certain text written for print or a video clip edited for television is also published on the Web, it becomes part of a different rhetoric. This is just a modern variety of ancient rhetorical knowledge. The same words and the same argument have different effects in different settings and also for different speakers and with different audiences.

Incompatible Rhetorics

I have argued that a rhetorical device changes when lifted to a new medium. We have also seen that new media tend to lift rhetorical techniques from several media. Bolter and Grusin call this hypermediacy, but I here call it rhetorical convergence. In Web media, rhetorical convergence occurs when rhetorical techniques inherited from different media coexist within the same Web text. Why call this "convergence" and not "collage" or "coexistence"? Coexistence itself may bring about new effects. In the section *Trippeldrapet* in VG Nett, regular news writing is placed alongside video interviews. Stories are written in ways similar to print journalism; videos are edited as television news clips. The resulting Web pages behave differently from both newspaper and television. As Gunnar Liestøl has shown, text and moving images are read differently, as the eye moves over the former, whereas the latter is played in front of our eyes (Liestøl 1999). To read a page combining the two will force a reader to shift between these two modes of acquisition. Liestøl's argument goes much further, but I will merely note here that this simple combination of video and text, to be found every day in VG Nett, results in new effects that do not lend themselves easily to descriptions from analyses of newspapers or television or even hypertext studies.

So if we just place a text and a video clip next to each other, each is read differently. But is the authoring of the two different? Is it just a case of juxtaposing text and video? My hypothesis is that the shift from text to video clip involves a change in authoring as well. Above, the opposition between moving images and text was deduced from their different kinds of signification. Furthermore, rhetorical convergence can also de-

scribe a coming together of conventions of rhetorical practice. Some of these are mutually exclusive, and an author must make a choice among them. Space here does not allow an extensive analysis of the convergent rhetoric in *Trippeldrapet.* I hope, however, that the following three simple examples can demonstrate the point that the rhetorical practices of television and writing do not necessarily fit together:

1. There is nothing in the technology of film or video that dictates the use of "continuity editing" of shots and reverse shots, but the majority of moving images are edited in this fashion. The video clips in VG Nett are no exception. The effects of this kind of editing are widely studied within film theory, for example in the French "suture" theory school. Within an interactive medium as the Web, however, this kind of streamlined editing, with its effect relying on the alternating camera angles, is in opposition to an ideal of letting the user control everything with her mouse, as strongly endorsed by, for example, Janet Murray (1997) or George P. Landow (1992), or to the continuous first-person perspective of many popular computer games.

2. Raymond Williams (1992) and John Ellis (1982) have described television as "a flow" in which the main feature is to keep the audience glued to the screen with an endless stream of pictures. This kind of programming effect cannot be achieved on VG Nett, where readers are encouraged to jump from one story, video, or headline to the next, actively choosing what to read when.

3. I earlier mentioned how Bolter and Grusin (1999) find live television news to be the core of television. Stig Hjarvard (1992) has discussed this phenomenon and pointed out how this "liveness" is an effect achieved through a special style of reporting: reports are given in real time from the scene where an event took place earlier (or will take place in the future). Such live reports, however, have meaning only when placed within a TV schedule. The schedule ensures an audience, inasmuch as the audience knows when the news begins and may want to turn the television on and to a particular channel at that time. At the time of the news broadcast, a reporter is ready on the remote spot when (in most cases) something happened several hours ago and can give his or her report "live." Most news sites on the Web, on the other hand, are continuously updated, as

readers may log on at any time. The "live" retrospective report does not make sense within this paradigm. Live coverage would seem worthwhile only if an event takes place that is known about beforehand, such as a press conference, a speech or a ceremony. VG Nett exemplifies this. In *Trippeldrapet,* the proceedings in court are covered live as they proceed. In all other cases, such as commentary, news leaks from the prosecution or the police, or gossip about the suspects, what we see is that in practice live coverage and on-demand access exclude one another.

These three examples show, I hope, that when rhetorics converge in *Trippeldrapet,* different practices need to be weighed against each other. Some conventions and practices from old media will be used, whereas others will not. I suggest that the first part of the study of rhetorical convergence is to chart this process.

Computer Rhetoric

It should be remembered that computer technology may offer more new possibilities and limitations than the ability to incorporate text, images, audio, and video. Computers can be programmed and networked, they have large memory, and they work fast. These abilities can also form new rhetorical techniques. Relational databases are very different texts from feature films, although they may cover the same topic, for example, the U.S. Civil War. The computer's rhetoric is not yet greatly studied, although Aarseth, Bolter, Murray, and Manovich have provided insightful foundations. These writers have pointed to important aspects of computer (or digital) rhetorics, such as the flexibility of digital text (Bolter 1991) and the ergodic nature of cybertexts (Aarseth 1997). Murray (1997) has advanced four essential properties of computers: the procedural, the participatory, the spatial, and the encyclopedic. Manovich (2001) has suggested the key trends of modularity, variability, automation, and transcoding. In these theories, and in others, we can find starting points for an understanding of the computer technology's influence on Web media authoring.

This does not mean that it is sufficient to point to computer aesthetics alone to understand current Web media. For example, one of the most

widely discussed traits of hypertext (and the Web is a form of hypertext, according to most definitions) is its so-called nonlinearity or multicursality: the user chooses what to read next from a set of links instead of following a sequence set by an author or director. Multicursality is certainly at work in VG Nett, but much of it does not operate in a radically different way from a similar property inherent in the print version of the newspaper, where stories also continue from the first page and several stories are placed next to each other on a page, leaving the reader to decide which to read first. The navigation links on top and at the left of each page of VG Nett, on the other hand, are part of a hypertext rhetoric that has risen out of computer text (see, e.g., Landow 1991). As Aarseth (1997) has pointed out, some Web texts are even more linear than print. Although there is not one in the *Trippeldrapet* section, VG Nett regularly features "photo specials," series of photographs presented one by one, in a linear series of pages. In print, the photos would have been laid out next to each other on a spread, thereby enabling the reader to scan them in totality.

Conceptual Convergence

To gain an understanding of the textual mechanisms at work in Web sites such as VG Nett, we need to carry out close readings of them, a task as yet taken on by very few scholars. At a conference in 2000, Matt Kirschenbaum commented that "if it is true that the devil's in the details, then most of what has been written in new media studies is truly angelic." It is exactly through detailed, close readings that studies such as Gérard Genette's (1980) study of Proust's *A la récherche du temps perdu* and Roland Barthes's (1993) reading of Balzac's *Sarrasine* were made. By reading VG Nett with the concept of rhetorical convergence in mind, we become aware of the constant mingle of rhetorical forms inherited from earlier media and acknowledge as well the emergence of new communicative ways enabled by computer technology. Further, we might study the interrelations of these rhetorical forms and communicative ways in a new text and indeed in multimedia format.

The study of rhetorical convergence will necessarily be an interdisciplinary task. We will need to be informed by the insights from studies of earlier media and computer texts to single out the influences from

prior media and to study their interplay. Earlier theories and insights from studies often use very different vocabulary and have conflicting concepts or different names for related concepts. In the study of rhetorical convergence, then, there will be a need to establish a fitted set of useful concepts. For a large part, these concepts will probably be found in earlier theories. They must, however, be adjusted and weighed against each other in order to work together. We might call this *conceptual convergence*. Investigating the grounds for such conceptual convergence is one of the aims of this book.

Another source of conceptual understanding will be the detailed study itself. Barthes's (1993, 1994a, 1994b, 1994c) method of textual analysis is a good example of this. His method was to "star the text" by cutting it up in random reading bits, *lexia*, according to his own reading of signs in the text. These lexia were coded into a large number of codes, in turn grouped into five main codes. The number and names of the subcodes was varied to suit the different texts in the different analyses he conducted. Much of Aarseth's *Cybertext* (1997) is also critiques of studies of digital media in which he instead forwards new theoretical concepts based in analyses of certain texts. Barthes and Aarseth are put forward here not as models for ideal research, but as examples of concepts and understanding built on empirical analysis. I believe such a bottom-up approach would be a good strategy to adapt in the study of rhetorical convergence.

Many of the studies of various digital media, such as computer games, hypertext, and MUDs, have tried to stretch the vocabulary of narrative theories, poststructuralist literary theory, and film theory very far in order to describe digital media. An increasing number of scholars are now beginning to treat computer games and other digital media as fundamentally different from earlier media (e.g., Aarseth 1997; Juul 2000), and calls for a new theory are frequently heard (see also chapter 14).

Developing a method of thorough reading of a text is difficult for multicursal texts such as Web sites. As Landow (1994) has problematized in "What's a Critic to Do?" two users will not encounter a hypertext in the same way, as there is no fixed pattern of reading. This is even more true with modern commercial Web sites such as VG Nett. When a user accesses the first page of *Trippeldrapet*, the text "content" is pulled from a database and instantly coded in code tailor-made for the user's browser

make and version, with banner ads chosen for her geographical area or even demographic or interest. Thus, the elements that make the page the user encounters are not stored in one place and may never show their face again. Even when the page is recalled from an archive, much of it will have changed.

This is a challenge to the researcher, but the many different articles about Michael Joyce's (1992) hypertext novel *afternoon*, perhaps the world's most studied hypertext, show that it indeed can be done. Studies of *afternoon* follow mainly two strategies or a combination of the two: the researcher may take care to note exactly what happens in one or more reading(s) and base the analysis on this metatext. Both J. Yellowlees Douglas (1994) and Jill Walker (1999) offer detailed stories of their reading sessions in their analyses of *afternoon*. The researcher may also map the spectrum of different possible readings, by analyzing the linking or programmed routines of the text. Aarseth (1997) takes this approach to *afternoon* and the computer game *Deadline*.

Convergence or Divergence?

A colleague recently asked me: "If there is so much convergence going on, why do I have to buy more and more digital gadgets?" Bolter and Grusin (1999) have the answer: "Convergence means greater diversity for digital technologies in our culture" (225). Convergence is a symbolic phenomenon; it is the effect of our being able to code all kinds of signs into numbers and back again with the aid of the computer. This basic convergence enables a diversity of technical platforms that share the same basic principles of digital formats and programming algorithms. We might say that symbolic convergence leads to technical divergence. Or we might view technology as we have already done, with medium and rhetoric as consisting of different parts, some shared or converging and some unique and diverging, some purely technical, some deeply economical and social. In all these cases, the symbolic part of convergence seems to be the most fundamental, and at the same time the least studied. In studying rhetorical convergence in Web sites, I suggest we direct attention to the rhetorical consequences of the basic convergence of sign systems: the convergence of symbols, of rhetoric.

Acknowledgments

I would like to express my gratitude to the people who have discussed these ideas with me and helped me shape them: Espen Aarseth, Gunnar Liestøl, Andrew Morrison, and Tanja Storsul. This research was supported by the U.S.-Norway Fulbright Foundation and the Norwegian Research Council.

Notes

1. Arnt Maasø (1995) has for example criticized how studies of film and television tend to focus solely on the visual and forget the sound, as has Andrew Goodwin (1993) in the case of music video.

2. Classicists may stress that rhetoric should be understood as it was in antiquity: the art of persuasion through public speech, as opposed to poetic. George A. Kennedy (1995), however, who has written extensively on the history of rhetoric, shows that the opposition between rhetoric and poetic weakens through Roman and medieval times. The rhetorical techniques become internalized in all educated men and also are found to be of use for writers of poetry and fiction. Poetic is seen to be a special case of rhetoric, and as new genres of text emerge, rhetoric is seen to have bearing on those as well. At the same time, the persuasive aspect of rhetoric is toned down. The techniques of argumentation are still a part of rhetoric, but rhetoric can just as well be used for texts aiming to please, divert, or inform. It is no longer confined to speeches on the practice of law or governing of the state (and certainly already in antiquity the epideictic speeches, the speeches of praise, were part of teaching of rhetoric).

3. In reality, Web technology does put limits on the use of images, video, and sound, as they move more slowly through the Net than text does. Within these limits, however, many Web sites make effective use of, for example, video. It is *impossible*, on the other hand, to have video in a printed book.

Web Sites Analyzed

Apple.com. Apple Computer, Inc. ⟨http://apple.com/⟩, February 22, 2001.

BBC Online Education. British Broadcasting Corporation. ⟨http://www.bbc.co.uk/education/home/⟩, February 23, 2001.

CNN.com. Cable News Network. ⟨http://cnn.com⟩, January 24, 2001.

Trippeldrapet. VG Nett. ⟨http://www.vg.no/nyheter/spesial/trippeldrapet/⟩, May 10, 2001.

USAToday.com. USA Today. ⟨http://www.usatoday.com⟩, January 24, 2001.

Yahoo! Yahoo Inc. ⟨http://www.yahoo.com/⟩, May 10, 2001.

References

Aarseth, E. J. (1997) *Cybertext: Perspectives on Ergodic Literature.* Baltimore: Johns Hopkins University Press.

Barnhurst, K. G. (1994) *Seeing the Newspaper.* New York: St. Martin's Press.

Barthes, R. (1993) *S/Z* (translated by R. Miller). Oxford: Blackwell.

Barthes, R. (1994a) "The Sequence of Actions." In *The Semiotic Challenge.* Berkeley: University of California Press, pp. 136–148.

Barthes, R. (1994b) "Textual Analysis of a Tale by Edgar Allan Poe." In *The Semiotic Challenge.* Berkeley and Los Angeles: University of California Press, pp. 261–293.

Barthes, R. (1994c) "Wrestling with the Angel: Textual Analysis of Genesis 32: 23–33." In *The Semiotic Challenge.* Berkeley and Los Angeles: University of California Press, pp. 246–260.

Bolter, J. D. (1991) *Writing Space: The Computer, Hypertext, and the History of Writing.* Hillsdale, NJ: Erlbaum.

Bolter, J. D., and R. Grusin (1999) *Remediation: Understanding New Media.* Cambridge: MIT Press.

Cuilenburg, J. van, and P. Slaa (1993) "From Media Policy towards a National Communications Policy: Broadening the Scope." *European Journal of Communication,* 8, 149–176.

Douglas, J. Y. (1994) " 'How Do I Stop This Thing?' Closure and Indeterminacy in Interactive Narratives." In G. P. Landow (ed.), *Hyper/Text/Theory.* Baltimore: Johns Hopkins University Press.

Genette, G. (1980) *Narrative Discourse* (trans. J. E. Lewin). Ithaca: Cornell University Press.

Goodwin, A. (1993) *Dancing in the Distraction Factory: Music Television and Popular Culture.* London: Routledge.

Hjarvard, S. (1992) "Live: om tid og rum i TV-nyheder" [Live: On Time and Space in TV News]. *Mediekultur,* 19.

Jacobsen, J. K. (1993) *Interview: Kunsten at lytte og spørge* [*Interview: The Art of Listening and Asking*]. Copenhagen: Reitzel.

Joyce, M. (1992) *afternoon, a story.* 3rd ed. Watertown, MA: Eastgate Systems.

Juul, J. (2000) "What Computer Games Can and Can't Do." Paper presented at Digital Arts and Culture conference, August 4, University of Bergen.

Kennedy, G. A. (1995) "Retorikk og poetikk" (Rhetorics and Poetics). In Ø. Andersen (ed.), *I Retorikkens hage* (*In the Garden of Rhetorics*). Oslo: Universitetsforlaget.

Kirschenbaum, M. (2000) "New Media, New Historicisms." *Digital Arts and Culture.* University of Bergen, Bergen.

Landow, G. P. (1991) "The Rhetoric of Hypermedia: Some Rules for Authors. In P. Delaney and G. P. Landow (eds.), *Hypermedia and Literary Studies.* Cambridge: MIT Press, pp. 81–103.

Landow, G. P. (1992) *Hypertext: The Convergence of Contemporary Critical Theory and Technology.* Baltimore: Johns Hopkins University Press.

Landow, G. P. (1994) "What's a Critic to Do? Critical Theory in the Age of Hypertext." In G. P. Landow (ed.), *Hyper/Text/Theory.* Baltimore: Johns Hopkins University Press, pp. 1–50.

Liestøl, G. (1999) "Essays in Rhetorics of Hypermedia Design." Ph.D. diss., Department of Media and Communication, University of Oslo.

Maasø, A. (1995) *Lyden av Levende Bilder (The Sound of Moving Images). IMK-report no. 14.* Oslo: Department of Media and Communication, University of Oslo.

Manovich, L. (2001) *The Language of New Media.* Cambridge: MIT Press.

Murray, J. (1997) *Hamlet on the Holodeck: The Future of Narrative in Cyberspace.* Cambridge: MIT Press.

Renov, M. (1993) "Toward a Poetics of Documentary." In M. Renov (ed.), *Theorizing Documentary.* New York: Routledge, pp. 12–36.

Schibsted. (2001) "Resultat Schibsted Nettaviser (Results of Schibsted's News Web sites). Available at ⟨http://www.schibsted.no/⟩.

Walker, J. (1999) "Piecing Together and Tearing Apart: Finding the Story in *afternoon.*" In *Proceedings of the Tenth ACM Conference on Hypertext and Hypermedia, Darmstadt, Germany.* New York: ACM, pp. 111–117.

Williams, R. (1992) *Television: Technology and Cultural Form.* Wesleyan ed. Hanover, NH: Wesleyan University Press.

Computer Games and the Ludic Structure of Interpretation

Eva Liestøl

When Ted Nelson published his high-spirited textbook *Computer Lib* in 1974, with its manifold perspectives on the computer, the main title bore the following encouraging request: "You can and must understand computers NOW."

Over the last two decades many people have simply been entertained by playing with/on the computer. There are various genres to choose from, and the action game is by far the most popular. Transferring Nelson's appeal to "understand" to the action gamer's discourse would seem to reduce the potentially wide concept of understanding into the mere skill of coordinating perception with physical (re)action (eye-hand coordination). Considering that the computer game industry has emerged as a major player in popular culture and has even moved beyond the economic power of Hollywood filmmaking, we might feel that we must or should "understand." But can we? Or more precisely, moving the understanding of the action game beyond the gamer's discourse into a scholarly discourse of understanding as an act of hermeneutic interpretation questions not only whether the game has a meaning to be understood, but also whether these relatively new artifacts of popular culture can be "read" as we have been accustomed to "reading texts" from literature and painting to film

and televison. Will the implicit and obvious conceptual imperialism of this lingocentric metaphor, originating in studies of literature and linguistics, also work when critically engaged with computer games? How may we, as academic interpreters of popular culture, relate to this new kid on the block? Are computer games just another textual variant ready to be subsumed under the ever-developing and -expanding vocabulary of textual analysis?

Since the playing of a computer game is different from the reading of a novel or the viewing of a fiction film, we should attempt to look beyond established methods and theories of literature and cinema for conceptual frameworks as means for sounder strategies for computer game decoding and interpretation. Still, art historian Erwin Panofsky (1955) pinpoints a situation that might seem too obvious to be worth mentioning but articulates both a general insight and the particular situation when one wants to analyze the computer game: "Since we cannot analyze what we do not understand, our examination turns out to presuppose decoding and interpretation" (9).

My approach to understanding the speechless action game I discuss in this chapter is indebted to and applies heuristically Panofsky's concept of the different levels of interpretation of visual arts as he explains it in "Iconography and Iconology: An Introduction to the Study of Renaissance Art" (in Panofsky 1955). Panofsky indicates different spheres of meaning corresponding to three distinct but related acts of interpretation: first, the preiconographical description (primary, natural meaning); second, iconographical analysis (secondary, conventional meaning); and third, iconological interpretation (intrinsic meaning).

This chapter therefore has three strands. Rather than mobilizing established and specialized arsenals of interpretative criteria and concepts, I will start by getting better acquainted with the subject matter itself, as it were, by playing the game. This description of my immediate encounter with the game constitutes the preiconographical level of understanding. Through the descriptive narrative and the inclusion of screenshots from this popular, ludic text, however, I am able only to suggest the dynamic and kinetic qualities of my actual real-time gameplay. Second, I also attempt to interpret this game by referring to traces of themes in earlier cultural works and formations, what Panofsky refers to as iconographical

analysis. Third, the recognition and identification of themes, motives, and stories is tentatively put into play, thereby suggesting an iconological interpretation. But the question remains: does this procedure capture and acknowledge the distinctive characteristics of the gaming experience? To answer this I close the chapter with a discussion of the unrealized potential in Hans-Georg Gadamer's notion of interpretation as play.

The Game

Let's venture together into the action game *Duke Nukem 3D Atomic Edition* (1996), a successor to *Duke Nukem* and a clone of the computer game *Doom*. Duke, the main character of the game, became quite a popular figure. For those unfamiliar with the title, details on the package suggest some of its main features, as can be seen in figure 12.1. Partly

Figure 12.1
"Packaging" Duke.

from below, we see a male bodybuilder in a sleeveless undershirt, clean-shaven and with crewcut and sunglasses. Around his waist and below his right and left chest he wears a full ammunition belt, and we can make out a weapon in his right hand. The illustration is rendered in shades of red, brown, and orange, whereas Duke's body emerges in brilliant yellow, as though illuminated by a powerful explosion. Duke's physical characteristics signal a "he-man" type. Associations may be made with the hero of John McTiernan's *Die Hard* (1988), although even Bruce Willis's character in that movie seems wimpy in comparison to this fellow. Duke's body is a caricatured version of the giant male fighting machines we recognize from action films such as James Cameron's *The Terminator* (1984). Duke, however, is merely a potential he-man, as it is the player who empowers him and gives the role life; game figure Duke has no weak spots other than those displayed by the player's lack of skill.

We leave our world and venture into the game's realm. A brief video in the opening shows Duke engaged in heavy gunfire with opponents in different environments. The animation informs us that we will be faced with attacking adversaries and that our role is to annihilate them at a rapid pace.

In the introduction to the game, Duke's mission instructor shows us a video that has been confiscated by a previous agent. We are shown a young woman giving birth to a "thing" while strange creatures encircle her in a dance. The instructor believes that this newborn thing is an "Alien Queen" whose intention is to take over Los Angeles. Her efforts must be thwarted! More than a dozen agents have attempted to meet with her but none have ever reported back. Conquering this creature seems to be a "mission impossible"! The player's mission in the role of Duke is to complete this difficult task. The aim is to battle all of the aliens who have infiltrated Los Angeles, and if we are successful in realizing Duke's potential then perhaps we will have attained the same caliber on the same par—at least in the game's fictional world. It is dangerous and demanding, but the need to experience firsthand, to master, motivates us more than warnings inhibit, and the mission becomes perceived as a personal challenge.

A Different Kind of Night on the Town

We begin in the game's first episode, "L.A. Meltdown/Hollywood Holocaust," and find ourselves on the roof of a building. Game character Duke has left us in the lurch. His muscular body is not in front of us, and we must tackle this unknown world without any buffer. In front of us we see a hand holding out the weapon we have chosen and the world in which we are supposed to use it. We have no idea of what lies in wait and do not want to take the chance of exploring unarmed. But what should we do? There are no opponents in sight! There is neither visual nor textual information. We see only the flat roof surrounded by a fence made of wire, some uninteresting boxes, and a ventilation fan. The desire to get out of this boring situation leads us to search for a way out, but there are no doors to be seen. As the weapon is our only tool, we shoot at the boxes in the hope that something will happen. Nothing! Perhaps there is some detail we have overlooked. We examine the setting closely but can find no clues. Irritated at being stuck, we shoot at the ventilation fan. Yes! An opening and we swish through narrow ducts and land on street level. We recognize elements in the urban scene from the U.S. city of Los Angeles (see figure 12.2). We see the entrance to a movie theater, part of Hollywood Boulevard's "Walk of Fame," and a fire burning nearby in a container. The streets are empty of people and cars. It is night.

In the grayness of the street scene, the movie theater's neon and flash of yellow draws our attention (see figure 12.2). It seems safer to head in that direction instead of toward the dark end of the street. We have barely started to move toward the movie house when a disgusting creature (resembling those that danced around the woman giving birth in the introduction) jumps out of the container and approaches us threateningly. We do what we can: shoot, hit our mark, and get to the theater. "The Attack of the Bleached Blonde Biker Bimboes" is the feature film, and we are led by curiosity toward the entrance. Closed! There must be a way in. As we move further along the building another howling creature jumps out and we shoot, miss, and shoot again. Got it! We are on our guard, but it seems to be safe, and we move along an alley where we spot a back

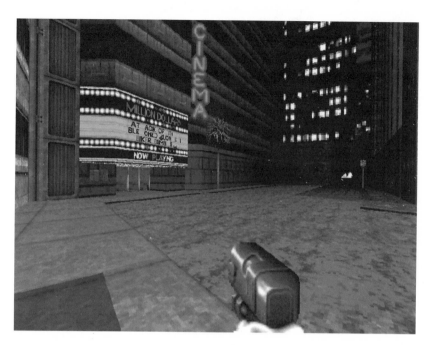

Figure 12.2

The player's elongated arm in the visual space, with hand visible.

door into the movie theater. We move in. In the hallway we see a bikini-clad blonde woman on posters with the text "Beat the Blonde Bimbo." We find a stairway to the second floor and walk up. We make our way to the projectionist's room only to find that two aliens have taken control. We fire. When both creatures are down we take a look through one of the two openings and down to the screen. Nothing. We take over the controls and the film begins. On the screen we see a blonde woman seemingly masturbating with a feather boa! Someone begins to shoot from the theater below, which is otherwise empty.

We make our way down the same stairs and over to some closed doors, open them, and move in. It is not the theater, as we had believed, but a bathroom! Best to check all corners and crevices. In one of the bowls we find an alien and exterminate it. We feel in control and take a look in the mirror (see figure 12.3). Duke, our alter ego, comes into view.

Figure 12.3

As we stand before a mirror, Duke appears and says, "Damn I'm looking good!"

Without prompting he comments on his own image: "Damn, I'm looking good!"

Not wanting to remain here, we search further until we enter the theater, eliminating some more aliens between seat rows as we move along. During the exchange of gunfire a hole is torn in the screen, allowing us a chance to get rid of the disgusting monsters strutting around in the back room.

Moving through the many narrow corridors we have the creepy sensation of danger lurking behind us, and we move forward at a fast pace. After wandering around, retrieving first aid kits and ammunition and firing at anything that moves, we approach a large round target, the goal of this episode. We let out a sigh of relief. So far so good. We check the score, keeping in mind that we have liberated but a small part of Los

Angeles from these aliens. There is much to be done, and we enter into a new area of town strengthened by the belief that we can make it, we can win this battle.

Business or Pleasure?

We're on the move again: new roads, passages, ventilation ducts, stairs, closed doors, storerooms, and cellars are explored while we are on a constant lookout for aliens. Occasionally we find first aid kits that we pick up. Hesitate or linger and we hear Duke's sarcastic remark: "What are you waiting for, Christmas?" Then it happens! While on our way up the stairs to a club in the "Red Light District," we are too slow to react and fall to enemy fire. The image tilts and as from below we see triumphant aliens swarm around us. We must start again, but now we have the advantage of knowing where they will come from the next time we play. This allows us to concentrate on one thing: to get them before they get us. We sneak our way through passageways and see colonies of large oval pulsating eggs in dark corners! Repulsive. Should we bother using our ammunition on them? We shoot at some of them and take off but are suddenly lost in a bar that is crawling with aliens while women clad in G-strings and bikini tops incessantly wriggle and writhe in a mechanical dance.

How can they stomach dancing among these creatures? Is there an alliance between the women and the unearthly monsters? We seek out one of the women and can do one of two things: either shoot or attempt a click on the space bar that has worked before to open doors. We opt for the latter and the elongated hand that has served as a guide is replaced by a hand that gives the woman money. "Shake it, baby!" says Duke, and by pressing the space bar what was hidden and concealed under her bra is revealed. "Oops, I did it again!" We go down for the count.

We took a sex break in the endless sequence of gunfire and the result was fatal. Try again! This time we do not allow ourselves to be distracted by the women but get the job done first. We concentrate on the horrific creatures, and in the heat of the battle we hit one of the women. She is immediately transformed into several more aliens to fight! A pre-

Figure 12.4

Alien monsters in *Duke Nukem*.

programmed reprimand? No time to wonder about what and why. We must move on. The music, the desire to get out alive, the countless passages to be explored and the closed doors to be opened are all part of the process that leads us to yet another episodic goal.

Not only are there aliens (see figure 12.4) occupying *Duke Nukem*'s realistic urban universe (the streets, the movie theater, the public bathrooms, and even the bars); they look like grotesque devilish creatures (see figure 12.5) from another place and time. More disturbingly, some of the rooms, passages, and areas resemble body cavities!

Ladies in Distress

In the next episode, we leave the city's adult entertainment district for the business center of Los Angeles. The wide, empty streets are lined with solemn buildings with dignified entrances. We head for the bank, fighting off unfamiliar alien creatures to make our way in. Several more creatures lurk inside, and we barrel them down and take what we need most of all, ammunition.

Figure 12.5
Devils from the fourteenth century.

Once more we examine all the nooks and crannies to avoid any sneak attacks and finally reach what appears to be the bank's vault. Prepared to do battle on the other side of the door we change weapons, fiddle with the vault mechanism, and enter. Before opening the bank's vault we had expected to find a tidy chamber for bonds, money, and gold. Instead we find ourselves in what almost appears as an inner organ. Beautiful, naked women are tied and bound by plants resembling seaweed. On our hasty journey through the other episodes we have noticed a few similar figures here and there in small strange cavities, standing in corners, coiled within green growth, immobilized. Are these, then, the most valuable objects to be found in Los Angeles? In pose and figure some recall romantic "ladies in distress" (see figure 12.6) and seem to belong to times long past. Some of the women, however, might seem less otherworldly (see figure 12.7) and bring us back to earth.

Figure 12.6

Jean Auguste Dominique Ingres, *Roger and Angelique* (1819), a valuable art piece located in the Louvre.

In a subsequent episode we find several women in a similar dilemma, apparently being pulled into the muddy ground. We approach them and hear them whispering a plea: "Kill me! Kill me!" Although these imprisoned women may evoke sympathy or a desire to rescue them, there is nothing that can be done. The alternatives are to perform euthanasia or to abandon them. We experience distress at being as helpless and paralyzed as the women are. Perhaps this experience of frustration is intentional, to spur us on in our mission to reach and destroy the ultimate enemy. Who actually controls this universe? Who has made this world into an incessant battle? The answer is not found until hours of gameplaying and countless exchanges of fire.

Figure 12.7

A less sophisticated version of "Ladies in distress," located in the Los Angeles of *Duke Nukem.*

Alien Queen

We eventually reach the last episode, in which we are finally going to meet the Alien Queen. Our expectations have been built up, and our impression is that she will be invincible. Our self-confidence, however, makes us feel pretty invincible as well. A peek at the game's introductory brochure, which presents all of the alien types with their characteristics, provides no information about the Queen other than that she likely has an "aquatic nature." We make our way into this final labyrinth's last corner and again experience being in an organic space. The walls are covered with networks of veins and arteries. It is uncomfortably claustrophobic. What seems to be an opening into the next room almost appears as an orifice. Aliens once again attempt to block our path, however, and must be fought. No sooner have we beaten one than another appears. Does it

never end? Finally we are able to move unhindered into the next space and when the opening closes behind us there is a sense of having crossed a point of no return.

Finally we see her: the Alien Queen. She struts about on a raised platform and as the mother of all aliens she is continually giving birth to new creatures: her blob of excrement is immediately transformed into a monstrous entity that storms toward us and attacks. We alternate between aiming our shots at her and at the offspring. After several bitter defeats we finally manage to kill both her and her issue.

A video clip takes over and we see Duke place a bomb in the crotch of the Alien Queen. Before it explodes Duke drives away saying: "It's time to abort your freakin' species!"

We have fought a hard battle, not only against the enemy, but against ourselves as well. At times we wandered aimlessly, but mainly we actively sought out new challenges with excitement and a curiosity as to whether we would succeed. We took wrong turns, ended up in dead ends, and had to start again. The task was presented as a "mission impossible," but we succeeded in liberating Los Angeles and in emerging heroically from the game.

The Labyrinth

We journeyed into a game world that was easier to enter than leave. We found objects along the way, made connections between different situations, had some experiences—foremost with ourselves—but we also uncovered strange phenomena that we were not quite able to comprehend. And strangely, this lack of understanding and inability to interpret did not seem to prevent us from performing the basic actions necessary to win the game. How can we account for this detachment of (hidden) meaning and our actions as the player?

Being a woman and a scholar I am twice detached from this action game. As a woman I feel as if I am being trapped inside a world scattered with elements of masculine myths, fantasies, fears, and desires. As a scholar I am also enticed to reenter the world of the game in search of meaning. As I search my memory for related experiences I am unable to relate or

contextualize what I have been through by drawing on personal experiences. As a consequence, I have to turn elsewhere for possible references that might help me interpret what I have been through.

Recapitulating what we made happen without taking into account any of the details, we could say that we have played a macho hero, anno 1996, and fought our way through a labyrinth before finally slaying a monster. This feat, however, is not a unique theme in our culture. Our slaying of a dragon-like monster situates us alongside the many other male heroes who have succeeded in doing the same in myths, folk tales, and legends.

From Minotaur to Alien Queen

The labyrinthine passages in *Duke Nukem* lead us back to another era, a mythical world in which a young man once fought a monster in a labyrinth and attained the status of perpetual hero. The myth is about King Minos of Crete, whose wife gave birth to a Minotaur as a result of an "unnatural yearning" for an ox. King Minos had the Minotaur (half person, half ox) imprisoned in a labyrinth (see figure 12.8), where it demanded seven young men and seven young women as sacrificial victims each year, not unlike the trolls in several Norwegian fairy tales. Theseus arrives, bravely enters the labyrinth, and defeats the Minotaur, just as in *Duke Nukem* we entered the computer's 3-D labyrinth, fought, and finally conquered the Alien Queen. In the action game, a woman gives birth to the Alien Queen as did the Minotaur in the myth. In contemporary times we have encountered women mating with strange entities and bearing their alien and dangerous offspring mainly through film narratives, among them the devil (Roman Polanski's *Rosemary's Baby,* 1968), the computer Proteus IV (Donald Cammell's *Demon Seed,* 1977) and an alien (John Hough's *The Incubus,* 1982). In the Greek myth, however, the Minotaur's half-sister Ariadne gave Theseus a red thread that would enable him to leave a trail and find his way out of the labyrinth. Is there a thread in the action game's mire of passages and cavities that enables us to emerge with more than a score? An alien, dragon-like creature has occupied a city, and its liberation is our mission. This is a battle fought numerous times before in legends.

Figure 12.8
Illustration of Theseus's labyrinth from fifteenth-century Florence.

One of the most well-known legends is that of St. George's battle with the dragon, which has been rendered in countless ages and scenes (see figure 12.9).[1] England's national hero fought a dragon that resided in a grotto surrounded by a swampy area near the city of Sylene. To appease the dragon at first the residents of the town had to sacrifice sheep, then later people, including the king's daughter. In *Duke Nukem,* the dragon-like creatures have frightening swamplike cavities, and only after we have fought through the entire maternal body are we finally able to enter the grotto, where we find the Alien Queen squatting and giving birth to monsters in countless numbers. Squatting when giving birth might be associated with animal behavior, but the Great Mother of the Aztecs (see figure 12.10) was represented giving birth in the same manner.

Entering a labyrinth creates an experience of angst (Dahl 1984: 52), and the further we tread into the game's labyrinth, the more aware we become that the angst emanates from the secret cavity in the female body

Figure 12.9

Paolo Uccello, *St. George and the Dragon* (1460), National Gallery, London. The dragon is often depicted as a female in representations of this scene and has been interpreted as the repressed feminine side of the hero.

where the births occur. The night on the town in *Duke Nukem* ended in a maternal cave (Skirrow 1986: 123), and we find ourselves in a fantasy in which the frightening and the seductive, angst and desire, are one and the same. There is general acceptance among researchers of myths and folklore that the dragon represents the maternal body or the mother complex from which the hero must liberate himself to find his masculine identity (Hoffmann 1997: 16).

The final scene in *Duke Nukem* is a return to a maternal recess, but not to the uterus (*regressus ad uterum*). The space we enter is the anus (*regressus ad rectum*), and since we know that "kicking alien ass" is one

Figure 12.10

The Great Mother squatting and giving birth was once worshipped.

of Duke's strongest assets, it is natural that he conquer the ultimate "asshole," the Alien Queen, who is constantly breeding new "alien assholes."

There is no possibility of retreat in the final episode. This episode entails battle without an opportunity for negotiation, for this alien is literally an obstacle to one's life and freedom to act, move, and desire. The battle will determine who is to rule and to control this large space (the city). We are denied the experience of freedom and autonomy until the revolt against the omnipotent mother monster and her offspring is successfully completed.

Duke and St. George: Brothers in Arms

The legendary dragon slayer St. George and the action game character Duke share a common crusade: to annihilate a female monster that is terrorizing a city. St. George liberated the town of Sylene; Duke liberates

the city of Los Angeles. St. George demanded that the town's residents convert to Christianity before he killed the dragon, for he served as God's tool in the battle of good and evil. The legend of St. George's heroic deeds continues to cultivate the notion of the revered hero. His canonization in 1222 secured him the role of patron saint for numerous congregations. The image of St. George as a knight from the Middle Ages also endowed him with a following outside the church. Knights appeal to young boys, and when Sir Robert Baden-Powell, a knighted military officer in the English army, founded the Boy Scouts, St. George was a natural archetype to adopt.

The purpose of the Boy Scouts was to contribute to building the character of the nation's boys, and their fascination with St. George was beneficial to scouting. In addition, Baden-Powell was able to associate the dragon slayer (see figure 12.11) with the underlying moral code upon which the fundamental principles of the movement were based. Self-discipline, courage, duty, and a willingness to serve others are ideals associated with quite a few male monster-slaying heroes who have battled evil, but in contrast to the heathen Theseus, St. George had the advantage of representing a devout man who served as a national protector.

In a sense, our battle with the Alien Queen almost represents a heathen version of the legend of St. George. St. George's victory is ascribed

Figure 12.11

Two illustrations of scouts as St. George from Baden-Powell's *Scouting for Boys* (1908).

to his relationship with God, in which he serves as God's tool and realizes His will. Although as modern day gamers we must always act with courage, exercise self-discipline, and be on guard in accordance with the Boy Scout motto "Be prepared,"[2] our experience of the game is that it requires faith mainly in our own abilities. It is as though we are on our own and must take fate into our own hands without the benefit of higher powers.

St. George's battle also involves an element of knighthood in that he rescues a princess, whereas there are no princesses waiting in the wings in *Duke Nukem*. The beautiful but bemired damsels trapped in slimy caves are beyond rescue, and we are thus denied the role of knight in shining armor. Our hero role also has a "die-hard" aspect that is revered and ritually cultivated through mass-produced portrayals developed by arms of the culture industry, such as Hollywood. In playing the game, we reenact characteristic qualities of popular culture's masculine hero myths. Not only does Duke's physical likeness (on the packaging) with *Rambo* (1985, 1988)[3] and *Terminator* (1984, 1991) figures relate this hero to the male stereotype of action films, but as action he-man hero[4] we exclude all feminine attributes, as we alone can get the job done in rugged solitude and by sparing no ammo.

Women are not part of the reward in this action game; rather, they are part of the landscape (Skirrow 1986: 129) that we endeavor to conquer. The Boy Scouts also offer boys the chance to master dangerous landscapes, but for Baden-Powell the modern city lacked the necessary challenges that would make boys into strong, independent, and brave men.

Escape from Home Sweet Home?

Under Baden-Powell's direction, the Boy Scout organization aimed to save boys and young men from the unfortunate consequences of progress. Cars, bicycles, elevators, and an educational system that emphasized writing and reading makes our sons "grow brains instead of brawn," according to the founder (Baden-Powell 1933). Boys lack "initiative and the guts for adventure," he complained. As an antidote, Baden-Powell advocated character building through physical training away from city, home, mother, father, and "the fetish of safety first." Several generations later,

Norwegian writer and game enthusiast Tor Edvin Dahl writes: "In the 20th century we have seen a move away from the possibilities of the open toward a regulated, controlled, safe—but also tame existence. The days of the adventurer are long gone; work became increasingly monotonous. Leisure time is used for passive activities such as media entertainment, or controlled activities: such as skiing on prearranged trails, swimming laps in pools and near beaches with lifeguards and working out in gyms" (Dahl 1984: 146). The safety and regulation of everyday life creates a desire and need to participate in an activity that involves adventure and dangerous challenges. Dahl maintains that excitement and uncertainty may be experienced by a trip into the virtual world of game and computer. The respective worlds of the Boy Scouts and the computer adventure game offer two different means of casting safety aside and seeking new adventurous journeys, the first by getting out, the other by taking a dangerous journey into an illusory, labyrinthine world.

Baden-Powell (1933) wrote that the fundamental concept for Boy Scout activities was "planned on the principle of being an educative game; recreation in which the boy would be insensibly led to educate himself." These were games in which boys, without really being aware of it, assume responsibility for their own education through active participation. *Duke Nukem* has no explicit intention of building character or of being an educational game. Although one must take responsibility for one's own learning, what do we learn about developing the male character by playing the macho hero? Jensen (1993) views the action game's "powerplay" as a natural extension of Western culture's masculine character in which social power, dominance, and control also include control of technology.

Some maintain that there is no aspect of character building to the game (Skirrow 1986: 130). It is obvious that Duke does not undergo any personal changes, and to the extent that we as players develop in any way, it must be primarily in terms of practical and reaction skills. The game poses the question "Where am I?" rather than "Who am I?" and we never arrive at any kind of consciousness about who we are (130).

We have fought our way through *Duke Nukem,* and I have posed questions about where we have been (city, labyrinth, swampy cavity) and what we have encountered in the different places (aliens, imprisoned

women, the propagating she-dragon Alien Queen). The answer to the question "Where am I?" becomes one not of topology but of psychology. The battle we have fought may be transferred to an "inner stage," and it is tempting to ask whether the world and angst-filled experience we seek in *Duke Nukem* are merely a virtual escape from home sweet home.

We are allowed into Duke Nukem's world to tackle desires and fears by ourselves. We are equipped with a first-person point-of-view but also with weapons. Every move becomes a constant fight and struggle to stay "alive." Although the masculine body of Duke is absent, his voice reminds us of his masculinity and of his role as combatant. If we hesitate to realize this role, our inactivity is responded to by Duke's ironic remark that tells us that questioning our role is ridiculous. In the aftermath of the focus on the male identity crisis in the 1990s, Brøgger (1995) writes that "the consequences of father's absence and mother's oversized presence are what is truly interesting" (189). In *Duke Nukem* the situation is turned into a game.

Identity's Crisis and Masculinity's Replacement

In *Duke Nukem,* we get the chance to fight against a female monster's oversized presence. Not only do the she-dragon's offspring assume all the important positions in Los Angeles (finance, space travel, politics, entertainment) traditionally secured by men through different means, but there is nothing to indicate that she needs a man's participation in the procreation process. The entity is a nightmarish vision of an "independent woman" whose self-propagating omnipotence breeds new monsters, replicants of those already threatening the autonomous masculine hero role. On our journey through the city, the monstrous creatures create a mix of fear and aggression, and when what we feel the need to do is the only thing we can do in the game world—kill them—the violence seems justified. This is a "natural" reaction to the mental situation we experience in the game, and we perform the "necessary matricide" as a symbolic murder (Badinter 1995: 33).

At the end of the twentieth century it was asserted that one in five children in America is raised in a home without a father, and one in four grows up with only one parent present. As many as 89 percent of these

have a woman as single head of household (Brøgger 1995), meaning that many children are raised by single mothers. One Norwegian colonel went as far, in the Norwegian newspaper *Dagbladet* (February 8, 2000), as declaring that boys who are raised by their mothers become weaklings. In contrast, Badinter (1995: 33) warns that when mothers prevent boys from becoming men, grown sons need to break away in the most gruesome manner. One consequence of this seems to be that boys may seek father replacements in macho heroes of the likes of Duke.

It appears as though the mission and the activity in which boys are invited to join in the game *Duke Nukem* are based on life itself, but outside experiential borders and unbound by the reasonable or the possible. Perhaps the image of Duke on the cover of the package deludes us into believing that we are faced with a superficial he-man stereotype, whereas the game actually has a kind of hidden therapeutic function. The game's illusory world serves as a means for boys to experience a sense of freedom and masculine autonomy. In the real world they struggle with mother separation, father absence, and the impression that women occupy positions and arenas once considered exclusively male turf.

Alien Queen and the Demon Machine

Ultimately there is an essential difference between our opponents and us: as gamers, we are relating to and fighting machine entities. The dancing women in the red-light district of *Duke Nukem* are machine-operated creatures that pique our curiosity and satisfy it, not unlike automated peepshow strippers who come to life when (mostly) men signal their need for attention. The ultimate machine monster in the form of Alien Queen is different. Her endless breeding of new machine monsters hinders both our movement and our insight into the game. She is a machine that has run amok and mass-produces opponents whom we must stop.

Duke Nukem portrays the breeding machine of the Alien Queen as the computer game's innermost essence. This is not the first time in history that the notion of the uncontrollable machine is represented by an image of a monstrous woman. At one point in time it was industry's mechanized machines (Huyssen 1986: 79)[5] that gave people (man!) a sense of losing control, of being faced with a machine that mercilessly rolled

Figure 12.12

Jean Veber, *Allegory of the Man-Eating Machine*.

and walked. Jean Veber's painting *Allégorie sur la machine dévoreuse des hommes* (Allegory of the Man-Eating Machine) from around 1900 is an example (see figure 12.12). In this male rendering of the world, woman and machine are the respective bearers of that which is alien, frightening, and merciless, and man's encounter ends with annihilation in both instances. A contemporary analysis of the painting (Huyssen 1986) has linked the cold and gruesome machine, which incessantly sacrificed men as though they were utterly worthless, with the "man-strangling Minotaur-like nature of woman" (70).

The concern for industry's mechanical machines created a century ago is not unlike the fear and worry provoked by the computer's presence in different everyday contexts. In the section "Myth of the Machine" in his book *Computer Lib/Dream Machine*, Ted Nelson describes this perception as he viewed it in 1974. The myth of the machine, according to Nelson, is based mainly on the fear that machines will take over the world. The machine is inflexible, unchanging, monotonous, merciless, inconsiderate,

inhuman, and dehumanizing, an impersonal juggernaut[6] that performs mindlessly repetitive and often violent acts.

As the demonic machine has assumed female form in both past and present times, we seem faced with a status quo in emotional terms. However, in *Duke Nukem,* young men are motivated to battle for control over this Minotaur-like, woman-machine monster by means of a kind of explosive exorcism! When the game requires us to drive the monster out of the machine, it is as though an independent masculine hero is replacing the female demon that had lived in symbiosis with the machine. In *Duke Nukem* we develop an experience of independence and mastery through the practical control exercised. Our sense of pleasure and pride in having won the battle also provides a sense of having won autonomy or a control of technology, but as player, we have nonetheless subjugated ourselves to a juggernaut.

Mirror, Mirror on the Wall . . .

Our hero role resembles that of St. George: we are tools for a creator whose power lies beyond us. When we succeed it is more than a relationship between technology and us. Although it seems as though we are accomplishing our goals, the premises have nonetheless been determined by the computer game's hidden dungeon master. We control neither role, nor theme, nor alternative actions, and we react and perform according to a specific program. The setting, position, mission, and situation create a need to respond to the game's instructions. We experience an optimal communication flow that reduces the split between real playing-self and the character that we play. The subjective perspective encourages us to invest our own frustration, desire, fear, and aggression, but, as in fairy tales, the mirror is able both to spot and to reveal whoever stands before it.

When we stand before the mirror in *Duke Nukem,* a WASM (white Anglo-Saxon male) is revealed. Thrown into the aggressive behavior we have toward the aliens in general and an alien woman in particular, the male hero role we are offered is that of a fascist macho man peppered with sexism. As players we drive out a machine monster and lend our practical skills to someone else. When the action game allows us to drive

the monster out of the machine, we do so with a repetitive series of hardened and monotonous violent acts. As with assembly line workers in the service of mass production, we have been presented with parts of a final product that must be dealt with at a fast pace,[7] but we feel alienated and without ownership rights to the final product.

3D Realms Entertainment has the ownership rights to *Duke Nukem,* and the real assembly line workers are the production group Team Duke Nukem. They are the game's dungeon masters, presenting the player with a world in which problems must be solved at quick speed using tools that have been supplied beforehand. As players, we do what must be done, and we adapt to the tempo required of us. Yet by combining the computer's playing techniques (subjective perspective, navigational 3-D, large number of opponents) with content from viable cultural concepts (hero/labyrinth/female machine monster/demonic machine), Team Duke Nukem has created a game that challenges not only our practical skills, but also our ability to reflect on the meaning of where we have been and what we have done and seen. It is by means of our ability to reflect and contextualize beyond the immediate that we preserve our characteristic human resources.

A new labyrinth, one from which there is not one but many ways out, may be seen to exist when we consider such an attempt to uncover the game's possible meanings. Our project and our experiences as player-woman-interpreter link the action game's program to a wealth of themes and cultural conventions expressed in myths, legends, paintings, fairy tales, and films but may also be related to understandings of the computer's role in society and the sociologist's focus on the male identity crisis. In *Man, Play and Games* (1961) Roger Caillois pinpoints what may serve as a general conclusion: "It is not absurd to try diagonizing a civilization in terms of the games that are especially popular there. In fact, if games are cultural factor and images, it follows to a certain degree that civilization and its content may be characterized by its games" (55).

Because of the cultural symptoms or symbols that are to be found in this computer game, it is impossible to maintain that the enemy we fight in *Duke Nukem* represents anything new. An age-old battle is played and brought into the present via other means and techniques. To venture into this game's labyrinth becomes a question of testing angst in an

encounter with culturally determined concepts that are as tenacious as the many-headed trolls in fairy tales.

Retrospect

As I argued in the opening of this chapter, understanding of the computer game needs to be moved beyond the gamer's discourse and into the scholarly field of hermeneutic interpretation. Panofsky's interpretive procedure or system of making sense of Renaissance art is embedded in his concept of the humanities. The humanities, he wrote, are faced by the task not of arresting what otherwise would slip away, but of enlivening what otherwise would remain dead (Panofsky 1955: 24). Applying Panofsky's methodological framework to understand computer games seems to enliven an interpretive method that on first glance, and because of new technology, would seem dead and powerless. Yet we might argue that Panofsky's three levels of interpretation function as conjecture. We might even argue not only that the interpreter's quest for understanding this computer game, with its scattered cultural images, implies the knowledge of themes, images, and stories, but also that the multifaceted frames of reference demand what Panofsky calls "synthetic intuition" (38). Still, there are elements of the game experience that seem to slip away.

This exegesis of the game's cultural context actually differs from other more traditional "readings" and, indeed, those that are practiced with respect to other types of media. The spectator/interpreter of paintings enjoys a contemplative position, whereas a gamer/interpreter of an action computer game must struggle to get a steady point of view, whether literal, figurative, or transferred (Chatman 1983: 151). Likewise, the reader of novels or spectator of feature films seldom dies or gets kicked out of their respective fictional universes. In my performance as Duke I died frequently and was repeatedly shut out. In fact, I had to continue to die (and be reinstalled) to finally fullfill the mission. As main performer or actor and as interpreter, I was thrown out of the game when my skills were insufficient, but I was allowed reentrance immediately, for additional attempts at the ultimate conquest. Playing action and adventure games requires and presupposes this physical and brutal oscillation between being inside and outside the game, a process of progress and

resistance, trial and error. This to-and-fro, back-and-forth movement is a basic relationship between the player and the game. In fact it is a basic characteristic of playing computer games and a part of both the play and the game as well.

On the basis of one best-selling computer action game we have seen how the iconography of the computer game interior plays with an external and established cultural context. But from where may we draw theoretical or methodological perspectives that could interact with and make sense of our real and symbolic engagement with the various levels of a computer game such as *Duke Nukem?* The following quote from Hans-Georg Gadamer (1997) may serve as a relevant starting point: "In order for there to be a game, there always has to be, not necessarily literally another player, but something else with which the player plays and which automatically responds to his movement with a countermove" (105–106). As a backdrop and introduction to his philosophical hermeneutics, Gadamer discusses the concept of "play" in aesthetics. He argues that the play of the imagination and the understanding in the experience of the beautiful, in a revised form, offers a perspective on the involved and intimate relationship between reader and text in interpretation and understanding. Gadamer develops this conception through a particularly playful chapter on play and gaming in general, from which the quote above is taken.

Gadamer applies play as a metaphor to characterize the structure and process of interpretation and understanding and to found a general hermeneutics further as "a universal aspect of philosophy" (476). With this general ambition, which includes establishing hermeneutics as the methodological basis of the human sciences, he simultaneously provides us with a conceptual framework that might even include computer games. Game and play may be thoughtful and provoking analogies for the characterization of the interpretative relationship between a reader and a traditional text, whether fictional or factional, visual or verbal, but the description is definitely directly relevant to the relationship between the player of a computer game and the computer game itself.

In our case, then, we may ask the following question: when the object of understanding is no longer a static text but a game itself, and when play no longer serves as a defining metaphor, but instead as the subject matter of our interpretative engagement, what happens to the

pursuit of meaning? In such a hermeneutical interpretation concerning computer gaming, we are in fact faced with a game of doubling, that is, a play between two levels of play. Interestingly, Gadamer makes a distinction that may actually account for this doubling when play becomes both object and relationship, suggesting that "it becomes apparent that the play bears within itself a meaning to be understood and that can therefore be detached from the behaviour of the player" (110).

In *Duke Nukem* this distinction between play and player is evident. As a player I am not required to understand the bizarre iconography of the game's symbolic inventory, for instance, the representation of women. I just play and act accordingly as the game draws me in and as the game demands, because "the attraction of a game, the fascination it exerts, consists precisely in the fact that the game masters the players" (Gadamer 1997: 106).

When playing I am "transformed" into the player. The task demands my attention and requires active participation. To stay in the game, reach the goal of each and every episode, get into the next, and finally win, I must do what must be done. I have to keep up the speed of my immediate actions in order to "stay alive." I perform in a goal-oriented, competitive simulated world where I win or lose, stay in or get kicked out. But as Gadamer suggests, I can also detach myself from the immediate and "physical" behavior of the player and engage in interpretative actions. At this level, and as I reenter the fictional universe of the game, or rather reflect on the temporal and sequential trail my playing produced, I need no longer to overcome the immediate obstacles of my mission but to decode the enigmatic representations of this universe.

This interpretation, however, must also take into account its relationship to the playing at the first level and become a play of plays. As a consequence, Gadamer's concept of hermeneutics as an interpretive act related to the to-and-fro movement of play seems to be prepared for and to be able to mimic these relationships. As such, it may be a theoretical and methodological tradition that offers useful perspectives on computer games as a serious subject matter for critical attention, despite the fact that such an approach to hermeneutics was not originally conceptualized for such "ludic interpretation," as I call it. A metaphorical transposition has thus turned out to be the schema for a real relationship.

Notes

1. Uccello's painting represents a condensed version of the act in the legend. The princess depicted holding the dragon by leash led the dragon into town after St. George had tamed it.

2. "Be prepared" was initialized by Baden-Powell.

3. On Georges P. Cosmatos's film *Rambo: First Blood Part II* (1985), Leonard Maltin writes that "it remains firmly footed in the genre of Idiot Action Movies" (1995: 1066).

4. In David and Brannon 1976, these traditional American he-man qualities are characterized as No Sissy Stuff, The Big Wheel, The Sturdy Oak, and Giv'em Hell.

5. Huyssen depicts the machine as having been considered demonic in the late 1800s, bearing with it chaos and destruction, whereas contemporaneous literature and visual expressions fantasize about a *Maschinenmensch* that resembles and is joined with a woman.

6. *Jaggernautvogn* is Sanskrit and describes a wagon of God under which faithful Hindus would cast themselves in a fit of ecstacy in order to be crushed by the wheels.

7. In Charlie Chaplin's silent movie *Modern Times* (1936), the "man devoured by machine" motif was based on Chaplin's related experience with a printing press in London at the turn of the century. See Nash and Ross 1986.

References

Baden-Powell, R. S. S. (1993) Lessons from the Varsity of Life. Available at http://www.pinetreeweb.com/bp-varsity01.

Badinter, E. (1995) *XY, Hva er en mann?* XY European Perspectives: A Series in Social Thought and Cultural Criticisms. Oslo: Tiden Norsk Forlag.

Brøgger, J. (1995) *Forsvarstale for mannen* (*In Defense of the Male*). Oslo; NW Damm.

Caillois, R. (1961) *Man, Play and Games.* New York: Free Press of Glencoe.

Cameron, J. (1984) *The Terminator.* Pacific Western.

Cammell, D. (1977) *Demon Seed.* Metro-Goldwyn Mayer.

Chaplin, C. (1936) *Modern Times.* United Artists.

Chatman, S. (1983) *Story and Discourse: Narrative Structure in Fiction and Film.* Ithaca: Cornell University Press.

Cronenberg, D. (1979) *The Brood.* New World.

Dahl, T. E. (1984) *Spillenes verden* (*The World of Games*). Oslo: Grøndahl.

David, D. S., and R. Brannon. (1976) *The Forty-Nine Percent Majority: The Male Sex Role.* New York: Addison-Wesley.

Gadamer, Hans-Georg (1997) *Truth and Method.* New York: Continuum.

Hoffmann, R. (1997) *Gjennom ild og luft: om kvinner, eventyr og drager* (*Through Fire and Air: On Women, Fairy Tales, and Dragons*). Oslo: Pax.

Høgh, C. (1996) *Eventyrleksikon.* Copenhagen: Munksgaard Rosinante.

Hough, J. (1982) *The Incubus.* Film Ventures International.

Huyssen, A. (1986) *After the Great Divide: Modernism, Mass Culture and Postmodernism.* London: Macmillian Press.

Jensen, J. F. (1993) "Powerplay—Masculinity, Power and Violence in Computer Games." In C. von Felitzen, M. Forsman, and K. Roe (eds.), *Violence from All Holds: An Anthology on Violence in Moving Images.* Stockholm: Stehag, 69–83.

MacCabe, C. (1986) *High Theory/Low Culture: Analysing Popular Television and Film.* Manchester, UK: Manchester University Press.

Maltin, L. (1995) *Movie and Video Guide 1996.* New York: Penguin.

McTiernan, J. (1988) *Die Hard.* 20th Century Fox.

Nash, J. R., and S. R. Ross (1986) *The Motion Picture Guide,* vol. 5, Chicago: Cinebooks.

Nelson, T. (1974) *Computer Lib/Dream Machine* (ninth printing, 1983). South Bend, IN: Author.

Panofsky, E. (1955) *Meaning in the Visual Arts.* New York: Doubleday Anchor Books.

Polanski, R. (1968) *Rosemary's Baby.* Paramount.

Skirrow, (1986) "Hellivision: An Analysis of Video Games." In C. McCabe (ed.), *High Theory/Low Culture: Analysis of Popular Television and Film.* Manchester, UK: Manchester University Press, 115–142.

13

"Next Level"

Women's Digital Activism through Gaming

Mary Flanagan

The growth of the computer gaming industry is at the forefront of defining cyberculture. Game makers possess both the most interesting technology and the distribution channels to truly lead the direction of the future of popular media. Games themselves have evolved as well: the ability to create AIs or random operations, true chance, simulation, 3-D action, and strategy have become relatively common, and the genre leads the movement toward interactive narrative. Because of their central role in both the economy and technology-obsessed culture, we need to contextualize computer games critically, a particularly difficult task when we are engulfed in rhetoric of a cybersociety that looks to technology as an engine for liberation. In an age filled with attractive rhetoric promoting the dissolution of spatial, temporal, and bodily boundaries, it is easy to believe that such permeability signals the end to concerns about race, class, and gender issues in our high-tech era. Yet as participants in Western culture, we know these possibilities are not inherent in any media form; in many ways, the current technology gap reinforces the divides of class hierarchy, gender imbalance, and ethnic discrimination. In response to this predicament, a number of women artists (such as Victoria Vesna, Tina LaPorta, Nancy Patterson, Orlan, and I) are utilizing images of the body, space,

the physical, and the organic and are using the tools of pop culture to express dissatisfaction with women's popular representation, and more deeply, with social categories and cultural constructions related to techno-society as a whole and within it, gaming culture.

In this chapter, I will explore noncommercial computer games created by women. Previously established languages and conventions of gaming culture change in the hands of women artist activists. These feminist artists conceptually remap political, aesthetic, and epistemological aspects of culture by using the tropes and conventions of computer games in unique ways. The bulk of electronic media tools, however, as we know, have their roots in military applications. How can we study this field made possible by technological innovation, a field that is very clearly a part of our future, yet at the same time stay aware of its problematic context (beginning with its origin in the military-industrial complex, for example, and being carried through the obsessive teen male audience for new computer games)? New ways of thinking about these works are necessary, first, because there are few if any serious cultural studies of gaming, and second, because these games present themselves in opposition to the larger commercially based gaming culture narrative. We must look to hypermedia practices at the intersection of women's art and gaming culture, for it is at this location that the boundaries of both commercial gaming practices and stereotypically gendered technoculture are being effectively studied, critiqued, and reworked—reworked in opposition to the dominant ideologies of our time both in popular culture and in the field of multimedia art. A look to women's games and their relationship to cyberfeminist practices will be useful, because at the very least these approaches are engaged in similar political arenas and often feed from each other. Where is the location of this type of alternative production, and what kinds of social change can we hope for? Using work by women artists Natalie Bookchin, Pamela Jennings, and Lucia Grossberger-Morales, this chapter examines women-made games in a cyberfeminist light to understand the motivations, themes, and impact of feminist gaming practices in culture and in cyberfeminism.

The Context of Cyberfeminism

Women's games are produced at the margins of the largest entertainment industry in history. Gaming is now a bigger and more profitable

enterprise than the film and television industries combined ($6.3 billion in video games was sold worldwide in 1999, and online gaming is a $250 million industry) and presents us with special challenges (Taylor 1999). As Thom Gillespie (2000) notes, "this $9 billion market is art and is significant in today's culture in the same way that books, film, radio, television, and rock-and-roll were the significant media of the past" (17). For feminists and others studying the intersection of technology and culture, hegemonic gaming culture is problematic. Although gaming does have some good aspects, such as the community-building power of online games such as *Everquest,* stereotypical human forms and female pleasure machines with hyperreal bodies performing violent acts populate game culture. The image and virtual body of "woman" within this culture is primarily created and represented by men, leaving "real" women less and less interested in engaging with this massive system of interaction and representation.

A look at game making and its relationship to cyberfeminist practices is useful, for as a critical movement cyberfeminism specifically addresses the question of women within technological culture. Cyberfeminists are actively studying technoculture to find ways to place women back both into the history of technological development and within (or at least alongside) the current cybercultural traditions and institutions. Perhaps the most effective investigation in cyberfeminist research works from an analysis of empiricism and of objective knowledge begun by women in the fields of the sciences and philosophy. This basis, the study of science, traces the way new technologies might offer hope for women to invert traditional power struggles and hierarchies embedded in Western culture in regard to the body, work, and the use of technology. Donna Haraway (1991: 175), perhaps the first and certainly one of the most influential cyberfeminists, suggests that women should seize the tools and technologies that have already marked them as "other." Her claim to be a cyborg rather than the more commonly invoked second-wave feminist/New Age "goddess" proclaims her hope in the emancipating possibilities for women offered—both spiritually and materially—through technology. Sadie Plant furthers this argument by noting that women have in fact been a part of the history of both the use and development of technologies and goes further to envision that women's increasing use of technology, coupled with their "innate" skills with weaving, as described in

Plant's (2000) overview of history, means that once and for all "cyberspace is out of man's control" (273).

The writings of cyberfeminist critics and theorists have become important components of technology and cultural studies in academic circles and have had a dramatic impact on discourses about innovation, science fiction, political activism, and the historical position of women and technology. The rise of cyberfeminist writings has focused increased attention on women's computer-based artistic practices as a result; women's interactive games, however, remain somewhat obscure to both popular and scholarly attention. Of course, there is a lack of scholarly attention given to gaming altogether. Our most popular pastime (in the form of electronic games, sports, etc.) receives very little scrutiny. Critics, either not involved in the culture or afraid to make overly obvious critiques of what seems to "an outsider" like frivolous content lying under gratuitous, violent imagery, shy away from gaming in general. Yet the cultural stakes are quite important and necessitate thoughtful evaluation. In the competition for consumers' attention and dollars, gaming companies' interactive worlds and marketing material become more and more embellished and problematic through time, not less, and are getting more and more complicated in form, content, and the integration of gaming into everyday life. Still, cultural stakes are high, and stereotypes abound. For instance, censure by the Advertising Standards Authority has not stopped companies such as SEGA from creating games based on ethnic stereotypes ("SEGA Dreamcast" 2000).[1] In addition, those who study or speak out on issues like violence in gaming are targets for derision by proponents of computer gaming's representational "innocence."[2]

Women's games propose an investigation of contemporary issues in electronic media and culture and offer commentary on social experiences such as discrimination, violence, and aging that traditional gaming culture stereotypically uses unquestioningly. Games produced by women will be explored in a close textual reading to take a look at exactly how they rework these issues.

Social Critique

In her "low-tech" game projects, California artist Natalie Bookchin uses humor, pixelation, and juxtaposition to enact disturbing stories. Her

3,912,567

2,674,190

839,230

492,426

364,434

19,927

14,994

666

165

Figure 13.1

Natalie Bookchin, *Truth* (1999).

ironic number/word play *Truth* (1999) (figure 13.1), for example, begins
with a list of numbers. Clicking on the numbers brings up thwarted
searches in search engines or sites pertaining to "truth." Of course, as any
user of a search engine expects, a great deal of irrelevant "truths" appear
before the user. Bookchin's play on our expectation of fact or true story,
however, is not important; her use of both political- and personal-style
stories emphasizes ideas about the outside and interior worlds that "truth"
inhabits.

 Truth 2 (1999) (figure 13.2) is a sliding block puzzle composed of
pieces of e-mail. It contains the broken narrative of a relationship, with
references to "our house" and "when I first met you" and "when your
flight arrived"; we get the sense of a present-day couple, perhaps even a
long-distance romance, falling apart, or perhaps this is a commentary on
the way we construct our contemporary communications, in fragments.
The image is a narrative jumble of layers of e-mail, window upon window,
with snippets of intimacy chopped off by operating system windows. Play-
ers piece together this history in a voyeuristic fashion, trying to see the
sentences' form in the sliding block-style game.

 The most well known of Bookchin's gaming material is *The Intruder*
(1998–1999) (figure 13.3). Working from a Jorge Luis Borges short story,
"The Intruder" takes the participant through ten arcade-style games as
the means of conveying the short story. Participants must play the simple
arcade-style games to advance the narrative.

Click here to scramble

To play: click on puzzle parts
to slide them to their proper position.

Figure 13.2

Natalie Bookchin, *Truth 2* (1999).

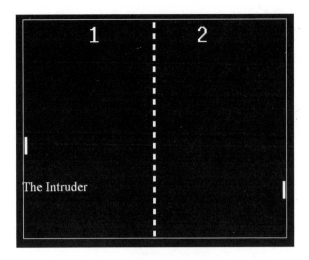

Figure 13.3

Natalie Bookchin, *the Intruder* (1998–1999): opening scene.

In the story, two close brothers decide to share their relationship with a woman named Juliana between themselves. Different games enable the narrative to move forward. With each game move, the player earns a sentence or phrase and thus advances the narrative. We learn about the brothers' relationship, their history, and their fight over Juliana. For example, when the brothers decide that Juliana is getting in the way of their close relationship, they have her pack up her meager belongings and sell her to a whorehouse.

The game participants play during this sequence commences with a start, presenting us immediately with the image of a woman's bare underside and a meager bucket (figure 13.4). The body produces little trinkets; the objects begin pouring out of the woman's torso. This loaded image represents several narrative layers: Juliana's meager possessions, the wretchedness of Juliana herself as a possession, or even the trinkets that could be purchased as an exchange from Juliana's sale price to the whorehouse. In the end, they fall from her body like loose children, and we collect these bits to know more about her fate.

When a silent, pixelated, blocky figure of a woman appears onscreen in yet another game (figure 13.5), we immediately know this is Juliana,

Figure 13.4

Natalie Bookchin, *The Intruder* (1998–1999): trinkets collection game.

Figure 13.5

Natalie Bookchin, *The Intruder* (1998–1999): woman-running game.

Mary Flanagan

yet she is never given dialogue or a voice in Borges's story. While the story unfolds around her she becomes, more and more, a shadow produced by men's desire. The game's aesthetic further supports this narrative evolution. Whereas the background graphic (a small town) is somewhat detailed, the closer human figure is obliterated in chunky pixels. As game players we maneuver Juliana, causing her to run or jump, eventually advancing the narrative when she falls into a hole.

Looking at the content of the work and the interaction style, we immediately notice the gap between these two areas, a gap cyberfeminists might note is a site for irony. To cyberfeminists, irony is celebrated as a strategy of resistance. Rosi Braidotti (1996) notes that irony must be performed, not simply presented. "Postmodern feminist knowledge claims are grounded in life-experiences and consequently mark radical forms of re-embodiment," she notes. But they also need to be dynamic—or nomadic—and allow for shifts of location and multiplicity" (para. 19). Thus, whereas women's lived experiences culminate in a variety of complex physical, social, and philosophical realities, commercial games' women characters act as static agents of pleasure. Bookchin's seemingly stiff graphic style and the narrator's solemn reading ironically play off the arcade game concept. Although the story itself is written by a Latino author, the pieces excerpted into the games are narrated (when there is voice at all) by a Latina. Because the narrative is about the control of a Latina woman character, having a Latina both participate in the narrative and refute, or at least cause us to reflect upon, the issue of voice by reading it aloud is an important aspect of the artwork.

The story becomes particularly effective and poignant because of the technological approach used; we, the once perhaps "innocent" interactors/readers/listeners of a short story, find ourselves, within a game format, actually participating in the further abuse of Juliana. What is striking about the work as a whole is not the assembly of cute, fun games but rather how those cute, fun games implicate the participant within the dark narrative. The political position of the game interaction against the narrative becomes stronger when one takes into account the user: we instinctively know that as users we are in a precarious and uncomfortable place, not the typical "rewarded" command post most computer gaming

products offer. The implication of the male user becomes particularly marked because of the narrative's focus.

The final tense game seals this implication into an indictment. The player takes part in a "fugitive"-style game in which we guide crosshairs over a pixelated "brush" landscape. The point of view and the sound of a helicopter let us know we are hunters and thus, there is indeed a victim. To complete the narrative, we must aim and "shoot at" a fugitive figure below (metaphorically, at least, this is Juliana) to earn the "reward": the story's end.

While the debate about violence and gaming rages on, the use or at least the suggestion of violence is invoked in Bookchin's work. Mary K. Jones, a producer for Edmark Software, notes that although it is too simple to blame video games for cultural violence, games do offer a unique platform for violence over other media: "I think the trouble with computer-game violence is that you actually cause it to happen . . . you make choices in computer games" (Gillespie 2000: 17). At first, Bookchin's work looks like pure arcade fun; while playing *The Intruder,* however, we unsuspectingly cause Juliana's destruction. Perhaps this is a stronger indictment about violence in computer games than any critic's words could offer, or we could read this activity of "hunting the fugitive" in its larger technocultural context, in which, it seems, woman just does not belong.

Questioning "Woman"

Many women's gaming projects delve into the meaning of "woman in technoculture." This investigation works at odds with stereotypical game images of women and against larger assumptions about the body. The perpetually problematic issues brought forth by the body-mind duality are now inflated by the incorporation of technology artifacts; the relationship of the body to the mind to, now, new technologies and networks must be better articulated and mapped. As architect Karen Franck (1999) notes, "We construct what we know, and these constructions are deeply influenced by our early experiences and by the nature of our underlying relationship to the world" (295). And these experiences have been lived through the body, though Western traditions (including disciplines rang-

ing from classic philosophy to, more recently, design) have sought to deny that fact. Because the body itself not only is a matter of material existence but is also constructed through common practices and discourses, the question of women in computer culture takes on additional meaning as game bodies such as avatars and virtual characters are literally and consciously constructed.

Gaming culture's production of woman is problematic. In fact, while computer games offer a seeming variety of characters as women, from random monsters in *Resident Evil* to *Tomb Raider*'s Lara Croft, the games' relationship to women is an exploitative one. For every seemingly liberatory image of a female heroine or monster in these games, the problematic side of these characters—through dress, unreal body design, and the relationship of the body to the user—dominates. Braidotti (1996), among other writers, is struck by the repetitive "pornographic, violent and humiliating images of women" (para. 46) that are circulated and produced in new technology artifacts. Proponents of computer games argue that characters are simply fictional constructions; many say that games, as a form of popular culture, cannot be taken seriously. Yet the problem lies not only in the representation of the image of woman in gaming culture, but in the relationship we have to that image through game-style interaction and the subjectivities offered through games. The centrality of women characters and bodies in computer games is disturbing because of the control of the virtual body; users cause these virtual women to respond to their actions at all times, complicitly assuming a command-and-control relationship with virtual bodies. This is problematic because such total control over the body, any body, makes the body itself quantifiable. Further, because women have been historically "tied to the body" in a range of ways, from the writings of classic epistemology to current-day health realities (such as higher health premiums due to women's birthing capacity) to marketing efforts that encourage us to "fix" the body (with cosmetics and other products), this association has had a particularly negative effect upon women. Since women are at a disadvantage by being historically "tied" to the body, the controlling relationship to our virtual avatar bodies reduces women's autonomy and value. As Dianne Butterworth (1996) cautions, high-tech "propaganda reinforces men's [and via them, women's] conceptions of the 'inherent' dominance and subordination

in sexual and other relations between the sexes. . . . Just as the personal is political, she notes, "so is the technological" (320). Gaming culture has historically been defined by men; therefore women's alternative practices in electronic media can be read against both popular-culture creations and the history of electronic art as well, bringing with them a different definition of "woman" into technoculture practices.

Exploring Memory and Space

Like many works of art by women that delve into recollection or ideas of memory, loss, and retrieval, women's games have a peculiar fascination with memory, land, and the past as sites for the formation of identity.[3] Women's games are preoccupied with notions about the body, homeland, loss, landscapes, identity, and social constructions. Is this because of women's lived experiences, or is it for more deeply rooted reasons explained by psychoanalysis? Perhaps like Sigmund Freud's description of the "Fort–Da" game children play or Jacques Lacan's rereading of this interpretation, in which Lacan notes that loss is rooted in desire: an inability to master personal loss is the very cause of desire, and these game experiences are in touch with loss and desire in complex ways (Fer 1999). In any event, these subject areas are not usual subjects for commercial-style gaming, and thus women's independent games set a very different tone.

Creating work that reshapes or creates new enactments of memory and history is a way to explore productively ideas about identity, the body, and loss through an alternate and politically loaded means. Like much of feminist artwork, popular computer games are almost exclusively composed of bodies and environments. But unlike the feminists who play with concepts of disassembly, dissolving or displaced landscapes, and memberment/dismemberment, popular commercial games work to construct the contrary: cohesive, "realistic" rooms, containable lands, whole and hyper- (or oppositely, "dead" or broken) bodies, and rigid boundaries. Landscapes in games have believable rules and a rational order, though the effects of the rules in the game worlds may be detrimental to the bodies contained within. But as bell hooks (1999) importantly tells us, "Spaces can be real and imagined. Spaces can tell stories and unfold histories. Spaces can be

Figure 13.6

Lucia Grossberger-Morales, *Sangre Boliviana* (2001): "Cholera 92" game.

interrupted, appropriated, and transformed through artistic and literary practices" (209). Women's games thus counter traditional gaming spaces.

Lucia Grossberger-Morales, an artist who has been creating interactive art since 1982, created the installation *Sangre Boliviana* (*Bolivian Blood*) in 1995 (figure 13.6). Her practice is encapsulated into a personal mythology: she recounts that she was inspired to purchase a computer while working as a reading teacher and watching students become more enthralled with video games and arcades than her courses (Arts Wire 1995). The installation was turned into an interactive CD-ROM in 2001.

Sangre Boliviana focuses on Grossberger-Morale's bicultural experience of being both from Bolivia and from the United States. The project consists of nine interactive pieces, each of which concentrates on a segment of her visit to her homeland and comments on the politics of home and place. Grossberger-Morales uses different media—photography, video, fractal art, and various traditional designs—to reflect upon and re-create the fragmentary and layered nature of memory and of cultural hybridity.

The section of *Sangre Boliviana* entitled "The Dream" leaves the user with Grossberger-Morales first driving with friends in a Jeep Cherokee. She then recounts being lost in a mysterious landscape until she

begins a narration about computers, which sends her on an adventure with her mother and her younger self. Another area, "Emigrating," layers reminiscence with family photographs to show the relationship between personal and national history by focusing on the town in which Grossberger-Morales was born. The arcade game experience entitled "Cholera 92" explores the Bolivian cholera outbreak in 1992 in which 500 people perished. Users "shoot at" cartoon images of water, toilets, dirt, and other sketches drawn from the artist's dialogue. As a "reward" for shooting the image, we learn more about cholera, the history of the Andes, and the simple cure for cholera shown in short *Quicktime* movies and text. The play between such text and image is ironic and disturbing; as players we begin to realize how simple education and resources could have changed the trajectory of a whole town's history. Then, after the informative moment, on to the next level, which displays a different cartoon image to shoot. Here, a hybrid of game and interactive art techniques is used to subvert computer gaming tropes with political messages.

Grossberger-Morales (2001) notes in her "Artist's Statement" accompanying the CD-ROM version of *Sangre Boliviana* that she can represent her bilingual and bicultural experiences best through multimedia and that her work creates a "post-modern collage." Like *Sangre Boliviana, Endangered and Imagined Animals* (1995) (figure 13.7) is an interactive CD containing seven interactive experiences; some use fractal-generated images to create animals inspired by the weaving of inhabitants of the Andes and the extinction of species in the Amazon. Inspired by ancient murals and patterns from traditional artwork, Grossberger-Morales explores the real and mythic animal shapes ingrained in Bolivian and South American culture. "These are images from ancient civilizations," she notes in the "Artist's Statement" accompanying Endangered and Imagined Animals. Again, exploring nature and memory through the work, Grossberger-Morales examines the complex cycle of history and of life—in fact, one of her games is entitled "Web of Life."

Grossberger-Morales pushes the links between her creative computer work, history and memory by contextualizing her work culturally, pushing the link between her own cultural hybridity and heritages in both the work and the creative process. Between 1988 and 1995, she incorporated a "fun flow" process into her computer art practice in which animals and

Figure 13.7

Lucia Grossberger-Morales, *Endangered and Imaginary Animals* (1995): screen capture.

other shapes and patterns from her cultural heritage would emerge from fractals and designs. Memory, landscapes, and bodies are key areas for women artists' exploration because they provide the context of women's lived experiences and are often incorporated into creative practice. As feminist philosopher Sandra Harding (1996) notes, "one's social situation enables and sets limits on what one can know" (240); women's games thus help articulate these boundaries, providing a fundamental map between the unknown and the known.

Grossberger-Morales (1995) strongly connects her art practice with her lived experiences. "One day," she notes, "I understood what the animals meant." The artist recounts her process of reconciling her connection to native cultures with computers. She presents each set of images in *Endangered and Imaginary Animals* in a unique way. In one game, maneuvering the mouse causes the player to begin "painting" with the animal

shape; in another, we find ourselves stretching and squashing the images of these unusual creatures. As in a children's paint program, interaction here is simple, but the theme, the loss of the "endangered" position of Grossberger-Morales's cultural memory, is especially poignant because of the simplicity of interaction. The real and imagined animals, along with the bicultural dream spaces in *Sangre Boliviana,* work to strongly counter seamless, cohesive commercial-style game spaces and complicate identities offered by popular gaming practices and also work to personalize the gaming arena into an intimate individual space.

Self-Discovery

Of all the complex facets present in women's games, perhaps the most interesting is the way in which they bring exploration, chance, and connections to the forefront. These games function to celebrate the act of playing as a means for self-discovery—not world discovery, not conquest, not high score. Perhaps this discovery is even more important than the product produced by play. Certainly women artists' games place play and content over outcome (winning), especially since artists' games as a product are themselves an awkward commodity, as they have no standardized system of distribution or mode of reception.[4]

Why has interactivity almost inherently and inescapably produced games as a form of artistic expression? The concept of games as art is not a new idea; historically, the surrealists were among the first artist groups to incorporate the game as a complement to creative thinking (Brotchie and Gooding 1995). Drawing heavily on theories adapted from Freud, André Breton and other surrealist participants sought to unite the worlds of fantasy and dream with that of everyday existence. As the seat of imagination, the unconscious could be accessed through concerted effort—for example, in consciously performing "unconscious acts." The fascination with art games has continued ever since, from movements like Fluxus to the digital art games presented in this chapter. We must, however, consider the computer in light of socioeconomic and political conditions. Computer games, like games from team sports to board games like chess, often reenact the logic of war play. Computer games have a particularly violent historical context; not only were computers developed for warfare,

but Celia Pearce (1998) notes that "the earliest virtual reality systems were developed for training military personnel" (222). Artists using the computer for games must come to terms with this history and with, more recently, the Western cultural imperialism of the American software industry.

Like Grossberger-Morales, whose computer play produced the *Endangered and Imaginary Animals* game, other women computer artists use the computer for creation and discovery. Does this reject the militaristic use of the computer, or does it replace an older mythology with a new one, one that is constructive rather than destructive? The work of artist Pamela Jennings, a professional software developer and designer, uses the technology in its purely exploratory form, trying to define the interactive computer medium as neither a tool for training nor for data storage but as a tool that recreates the organic.

Jennings's work has explored issues of identity and otherness in contemporary Western society. Her projects include the CD-ROM *Solitaire: Dream Journal* as well as installation projects. Like the popular card game of the same name, *Solitaire* is played alone; in fact, Jennings asks at the beginning of the CD whether participants are viewing the CD in a public or private space. It aims to be an intimate experience, immediately reflecting one's relationship to the computer.

According to Jennings, *Solitaire* is a "journey of self-discovery" divided into three thematic areas: "The Book of Balance," "The Book of Melancholy," and "The Book of Flight." Participants choose a corner of a triangle interface to journey to one of the "books." Each book begins with a pyramid game interaction (figure 13.8). The user must "jump" one piece in the pyramid with another piece to cause a piece to vanish; it seems the goal of the game is to eliminate, or at least work through, each of the pieces in the pyramid. In installation form, Jennings has utilized a three-dimensional version of the card game Solitaire as the basis for the interface.

By making a move on the board, the user is "rewarded" with an interactive scene of some sort somehow related to the theme of the section (balance, etc.) (figure 13.9). Each move exposes many layers of media bits, memory snippets, and other material: we see miniature video sequences embedded in collage-type doorways; the areas are graphically crisp but

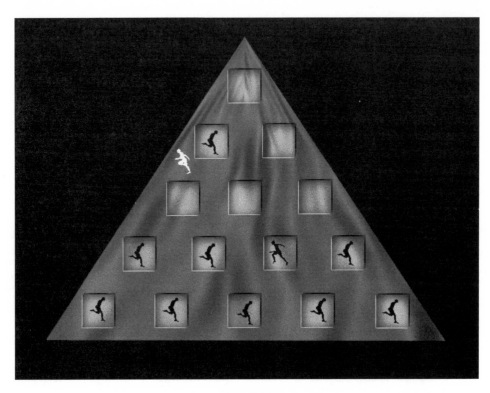

Figure 13.8

Pamela Jennings, "The Book of Melancholy," from *Solitaire: Dream Journal* (1995): game interface.

abstract, reflecting a strong personal aesthetic. Thus by playing, each user forges his or her own path by the choices made on each game board, finding minigames and interactive experiences within.

A game in "The Book of Flight" offers users a chance to construct a fairy tale figure (figure 13.10). As we add feathers to a skeletally winged creature, we receive bits of text and poetry. The interactive exercises Jennings offers seem more like meditation than "action"-packed or arcade-style games, but in the end users do finish and "win." The worlds and interactive episodes Jennings produces are rich, and unlike many technological products, have a perennial, collage-like texture rather than the look of a game rendered in 3-D. Even more important than the compelling

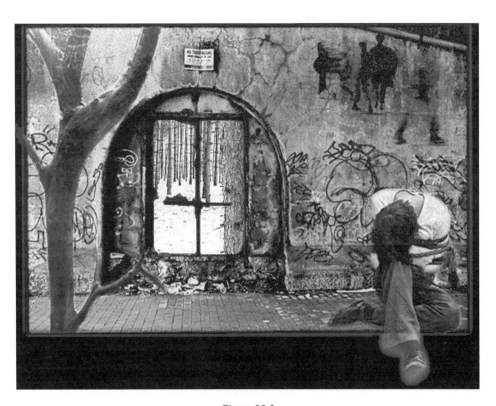

Figure 13.9

Pamela Jennings, "The Book of Melancholy," from *Solitaire: Dream Journal* (1995): game.

images is the rich soundtrack; nicely captured, haunting sounds and brief retellings of dreams offer narrative suspense and mystery to keep participants motivated to explore.

Each screen and environment in *Solitaire: Dream Journal* is abstract and unique and keeps its own rules and secrets. The journal's focus on personal themes of balance, flight, and melancholy creates a completely different thematic journey than that which is typical of games that feature conquest, levels, advancement, score, and skill. As Jennings (1995) notes, the journey she offers is a "quest for desire of peace with oneself and connection with another."

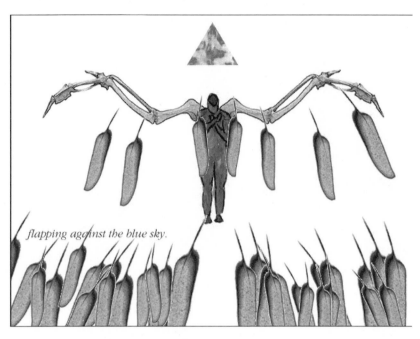

flapping against the blue sky.

Figure 13.10

Pamela Jennings, "The Book of Flight," from *Solitaire: Dream Journal* (1995): game.

Time for Player no. 2?

Computer games represent a "continued present" that, although full of potential and positive elements, offers problematic representations and limited thematic exploration. Women's games question the cohesive narratives and speed rushes offered by commercial game culture, and the examples of work by Bookchin, Grossberger-Morales, and Jennings presented in this chapter demonstrate the significance of their approach to reworking elements of popular culture. Their games represent a new way of thinking about gaming, technoculture, and digital art. They are essential to opening up not only what we consider a "game" to be, but what is appropriate for interactive exploration; they arrive, however, in a strange context, first, because there are few serious cultural studies of gam-

ing, and second, because the games present themselves in total opposition (technically, formally, and aesthetically) to the larger gaming culture narrative.

Méret Oppenheim, a major contributor to the surrealist movement,[5] noted in 1955 that surrealist works, based on the psyche and automatism, "will always remain alive and will always be revolutionary" (Rosemont 1998: LI) because they are in alignment with the organic and with nature, and that explicit to Surrealism is a reliance on theory and practice. This chapter argues that revolutionary activism within art practice is prospering in the rather novel form of women's computer art games. First, women's games counter the hegemonic representation offered by commercial computer games and popular technoculture; secondly, they explore the construction of "woman" in such a setting; third, they are fascinated with land, memory, and history; and finally, they introduce tactics to celebrate notions of movement, chance, and play for self-discovery. The approach that women digital artists are employing in their work offers an essential counterpoint to digital culture; artists are making cyberculture, a distant and masculine terrain, into an area for more personal exploration. The "anxious digital artifacts" produced by these artists help us to understand not only the contemporary context that women game artists work within, but also our own cultural situations, for women artists' games differ both from commercial games and from independent male artists' games in their incorporation of personal stakes within conceptual and formalistic play.

Why do computer games play a particular role in memory and dream space? The connection between the two has been evidenced by a recent study by Robert Stickgold (2000) that focused on computer games' significant impact upon players' dreams while asleep.[6] Stickgold's controversial work reflects a new scientific examination of the abstract and romantic concepts long purported by the surrealists and other artists interested in dream space. We take our games seriously for several reasons: they allow us to react to cultural and social rules, traverse boundaries and enter new environments, and sample new ideas without fear of injury or punishment (Sandler 1993). Games offer us a chance to explore what social scientist Sherry Turkle (1997) calls our "second self." Further, they allow us to explore our social realities, our environments, our bodies, and

allow us fantasy, freedom, and a chance to use our imaginations in abstract, fantastic ways.

Artworks which involve interactivity almost inherently produce activities that involve play and exploration as a form of artistic expression.[7] And some of the most compelling game activities—those from *Asteroids, Pong, Tetris,* or the other types of arcade game archetypes employed by Bookchin—do not themselves reflect specific narratives but in fact structurally reflect specific cultural narratives or issues of race, gender, or politics in that they are designed to detect collision, they are designed to shoot, and are programmed to keep a score. Women artists, however, are using these games to do precisely what they are not designed to do: through appropriation of gaming conventions, feminist game makers are able to make popular their insightful critiques of contemporary practices (see also Flanagan 2001).

It is essential to be aware that many women taking up gaming as a discourse and as a practice are women of color or are focused on the experiences of women of color. Jennings offers the user a chance to explore the dreams and ideas of an African American digital artist, a focus that within current commercial gaming culture would find little support. Grossberger-Morales takes us on a journey of biculturality and bilingualism between North and South America, and Bookchin sets the stage for a Latina rereading of Borges. There are few women of color in gaming in any capacity (as producers, characters, or consumers), and there are even fewer African American or Latina women lead characters of any computer games.[8]

I do wish to emphasize that I do not believe that there is yet an intentional, political, progressive "women's gaming movement." There is a large group of women online who refer to themselves this way— gamegrrls and womengamers.com among them—but they are not seeking to create new gaming paradigms. Rather, they work to get women "accepted" by male gaming communities playing male games and offer camp-like readings of popular, existing games.[9] This is not the approach I look to in this chapter. Rather, I am interested in women making games for themselves using the tools of this system, countering them, and making new meaning with them. The works presented in this chapter represent a collection of pieces I find to have commonalities with other examples

of women's art and among themselves as electronic works. This "movement" should not to be seen as monolithic, united, or creating a counterhegemony en masse. Rather, as with Luce Irigaray and other feminists who offer ideas about women's liberation and feminism, if women's gaming did become a "movement," it would be one consisting of pluralities; as Irigaray notes, "Indeed, in the women's struggle today there is a great number of groups and tendencies; thus to speak of them as a Movement runs the risk of introducing hierarchies amongst them, or of leading to claims of orthodoxy" (Venn 1990: 86).

What kinds of social change can we hope for through women's gaming practices? Women game artists are in some ways the embodiment of the cyborg "weaver" imagined by cyberfeminists such as Haraway and Plant, though in an unpredictable and unromantic way. Rather than expound upon their natural affinity to technology and networks, these game makers are technically proficient women who have chosen to incorporate cyberfeminist and political ideas into their work while remaining conscious of the limitations imposed by their male-constructed and -dominated artistic platform. With their clear evaluation of social experiences such as discrimination, violence, the representation of women, and aging that traditional gaming culture stereotypes, as well as their unique notions about the body, homeland, landscapes, and social constructions as they relate to the body and to identity, women's games celebrate the act of playing as a means of self-discovery. Through their privileging of spontaneity and combination of ironic and impossible opposites, feminist artists' games expose an arena in contemporary artistic practice that reflects approaches for political ends.

Next Level Discourse

To close this chapter I would like to look to possible ways of realizing in the critical and theoretical sphere the methodology women game makers are creating and using in their practice. The movement from critique to action means a shift in practices. This of course means reshaping academic discourse and even popular language. For as Irigaray notes, "So long as one does not question the overall functioning of . . . all theoretical discourse—even unconsciously—one only guarantees the continuation of

the existing system" (Venn 1990: 81). The same can be said directly about the day-to-day discourse of technoculture and gaming specifically.

Political implications arise when we look to interactive art forms such as multimedia works and even computer-generated art itself. Only recently have women begun producing interactive electronic artwork in large numbers. Early practitioners in the field of electronic art, such as Peter Weibel, David Rokeby, Simon Penny, and George Legrady, established practices, and international venues such as ISEA and SIGGRAPH helped establish a forum for this emerging form of art during the 1980s. But rarely do the myriad interactive electronic works venture into critiques of popular culture; rather, they tend to stand as conceptual works in their own right. Take, for example, the *ArtIntact* book and CD-ROM series created by ZKM throughout the 1990s. The works collected in this series provide a representative cross-section of the interests of interactive artists: interactive narrative, conceptual architecture, nature versus culture, the nature of media and memory, the beauty of virtual space. But although these works certainly are positioned in a very distinct and alternative creative space than that of commercial media, they have not inherently addressed the forms of computer games or other pop culture media.

Indeed, just as forms of electronic media (commercial games and the very distant interactive artworks) are produced almost in denial of the existence of the other, writing about interactive work falls into two distinct categories: writing about commercial work from an "insider's" view and writing about them from an academic point of view. Moving back and forth between these two categories of practice, however, is perhaps a powerful, hybrid way to approach them. The gap between commercial, popular work and alternative artistic praxis must be breached in critical discourse surrounding interactive media. Indeed, whether artists like it or not, their work will be read in the media context created by Hollywood cinema, advertising, and U.S.-dominated global commercial interests; likewise, commercial production will be read from the standpoint of a cultural studies, conceptual, or other sociopolitical critique. Women's praxis traverses these two sets of seemingly opposite arenas of discourse smoothly. Women's computer games have worked to challenge both their location alongside the generic arena of electronic media as well as the commercial world of pop culture gaming. Yet what are the conceptual

and theoretical frames within which to analyze this relatively new kind of work? And how could these particular approaches inform the field of new media in general?

Three broad perspectives are helpful here for proposing an overall disciplinary revolution inspired by the women game makers' example: the purposeful use of hybrid spaces can be an effective strategy for change. First, the writings of feminist studies of science and technology offer a larger context within which to rethink inherent power structures in technologies themselves. The interdisciplinary space created by such research encourages cross-disciplinary fertilization and inquiry that investigates authorship, representation, and philosophies perhaps not fully investigated in earlier approaches. In multimedia discourse in particular, we need to locate our approaches in between many types of dichotomies: amidst commercial work and conceptual or independent work, in between feminist studies and queer studies, and in between the ideologies of team production and solitary production. In these in-between spaces we should find better languages and methodologies for quality media making.

A second approach to creating a framework for new media innovation is the exploration of the interplay between fiction and theory, and in the case of women in cyberculture, between cyberfeminist studies and cyberfiction. In the collection *Reload: Rethinking Women + Cyberculture* (2002), H. Austin Booth and I set out to create a site for such cross-disciplinary investigation, believing it to be a fertile area for scholars and makers alike. The writings of cyberfeminist critics provide a detailed challenge to both commercial and personal media artists, beginning a useful critique of new media practice; the writings of cyberfiction authors provide alternate visions to those produced by contemporary cyberculture and offer a much needed voice in envisioning the future.

Finally, real-world social commentary and the investment in and investigation of political themes are the key to innovation in both reading and rethinking new media theory and practice. Theory and practice must come together, and the science behind technology creation must understand the political implications inherent in the tools. Media makers must take responsibility for the images they create and creatively break the stereotypes so commonly offered by popular genres. Only recently have women begun producing interactive electronic artwork in large numbers;

there are even fewer people of color in the field. Opening up opportunities for new business models and new content models will enable change and encourage a variety of voices to create media.

Although I am a U.S. citizen living outside the United States, I am struck by the U.S. tendency to make monolithic and singular each narrative, story, election, or slice of culture. This is true for electronic culture and space as well, a site dominated by U.S. interests. Whereas the early-twentieth-century film industry took over twenty years to develop fixed standards, formats, conventions, and even genres, it took only about two years for the same "fixing" to occur with respect to commercial Web sites. We do not seem to allow for fragments, gaps, or contradictions. Indeed, "cyberculture" seems predefined to be constructed as "U.S. technoculture" in academic and pop culture representation. The detriment of this quick conventionalizing is again the tendency toward singularity; it has been difficult to bring into discussion experimental practices such as Web art, artists' CD-ROMs, and non-Western and noncommercial or alternative uses for technology. Thus, artists' voices, non-Western voices, the voices of people of color, gay and lesbian voices, differently abled voices, and economically disadvantaged voices—these are not present. This absence allows for further assumption of virtual space for the consumption of mainstream stories that continue the cycle of oppression. In one way or another, the games discussed in this chapter poke holes in this seamless ribbon, for which I for one am grateful. Now it is time for fresh theorizing about the way interactive media are created and thought about utilizing a hybrid approach of theory, practice, and activism.

Notes

1. The Advertising Standards Authority upheld a complaint against a poster for SEGA's *Dreamcast,* headlined "Spank Johnny Foreigner Online," saying it could be seen to condone violence against foreigners.

2. See, for example, the July 2000 statement by *Computer Gaming World*'s editor, Jeff Green, in which he notes that a document by the American Psychological Association's *Journal of Personality and Social Psychology* "claims to have found a link between video game violence and an increase in aggressive thoughts

and behavior. My initial thought, upon reading this, was to find the scrawny, know-it-all eggheads responsible for this gibberish and kick their freakin' asses" (136).

3. Examples of works that involve memory are numerous (and an exhaustive list of them nearly impossible to produce) but include Mona Hatoum's 1995 installation *Recollection,* in which the artist uses her own hairs, collected over the years, within a gallery space, and Ana Mendieta's *Silueta Works* in Mexico (1973), a photograph in which the body and the earth become one, covered with flowers and vegetation. Memory, the body, and landscapes are also topics of artwork by surrealist women; for instance, Meret Oppenheim's *Fur Breakfast* (1936) and *My Governess* (1936) deal with memory and fetishized, unexpected objects in a psychoanalytic fashion, Eve Andrée Laramée's *The Eroded Terrain of Memory* (1990) explores geological history and civilization's relationship to geographic faultlines, and Rosie Leventon's *Souterrain* (1986) refers to the earth and ground through broken floorboards.

4. Compared to artists' distribution systems within galleries, publications, or festivals, digital art is still defining its mode of distribution and reception.

5. Oppenheim (1913–1985) is probably best known for her fur teacup and spoon (*Fur Breakfast,* 1936), one of the most recognized of surrealist objects. Many of her objects and paintings created during the same period have since been lost.

6. Stickgold and his colleagues researched the dreams that people experience while learning the computer game *Tetris.* The aim of *Tetris* is to rotate differently shaped blocks as they fall down the screen so that they drop into the spaces left by shapes stacking up below, leaving as few gaps as possible. Many of the trainees said that they saw images of the *Tetris* blocks as they fell asleep, most vividly on the second night of the study. The images seemed to represent some salient feature of the game. For example, one trainee said she frequently saw the piece she had the most trouble placing. Another said he saw the piece he needed most often to fill gaps. And the trainees who reported the most imagery were also the ones who were worst at the game when they started—the ones who seemed to have the most to learn.

7. Surrealists and those involved in Fluxus are two examples of this, along with digital interactive media (see Breton 1978).

8. One exception is the African American character D'Arci Stern of *Urban Chaos*. *Urban Chaos* was released by Eidos (the makers of *Tomb Raider*) in late 1999. Representation of women of color in technoculture is still unfortunately rare, and of course since the portrayals of women characters in games are already rife with problems, perhaps adding women of color to this milieu would not be a progressive act; some exceptions are works by artists Pamela Jennings, Leah Gilliam, Betye Saar, and Carmin Karasic; in addition, the author's own online game for girls features girls and women of color only. See at ⟨http://www.josietrue.com⟩.

9. Typical of my interviews with women in online gaming communities is this response from Nanogirl: "I admittedly don't like the 'girl' games and I would rather thrust myself out in the 'guy' community trying to get girls more accepted."

References

Arts Wire. (1995) "Interview with Lucia Grossberger-Morales." From the Interactive Art Conference, Item 64. Available at ⟨http://www.artswire.org/Artswire/interactive/www/lucia/lucia.html#sangre⟩.

Brookchin, N. (1999) *Truth* and *Truth 2*. Available at ⟨http://www.calarts.edu/~bookchin/Truth 2/⟩.

Bookchin, N. (1998–1999) *The Intruder*. Available at ⟨http://www.calarts.edu/~bookchin⟩.

Braidotti, R. (1996) "Cyberfeminism with a difference." Available at ⟨http://www.let.uu.nl/womens_studies/rosi/cyberfem.htm⟩.

Breton, A. (1978) *What Is Surrealism? Selected Writings* (ed. F. Rosemont). London: Pluto Press.

Brotchie, A., and M. Gooding (1995) *A Book of Surrealist Games*. Boston and London: Shambala Press.

Butterworth, D. (1996) "Wanking in Cyberspace: The Development of Computer Porn." In S. Jackson and S. Scott (eds.), *Feminism and Sexuality—A Reader*. New York: Columbia University Press, 314–320.

Fer, B. (1999) "The Work of Art, The Work of Psychoanalysis." In G. Perry (ed.), *Gender and Art*. New Haven and London: Yale University Press, 240–251.

Flanagan, M. (2001) [rootings]. Available at ⟨http://www.turbulence.org⟩ and at ⟨http://www.maryflanagan.com⟩.

Flanagan, M., and A. Booth (2002) *Reload: Rethinking Women + Cyberculture*. Cambridge, MA: MIT Press.

Franck, K. A. (1999) "A Feminist Approach to Architecture: Acknowledging Women's Ways of Knowing." In J. Rendell, B. Penner, and I. Borden (eds.), *Gender, Space, and Architecture*. London and New York: Routledge, 295–305.

Gillespie, T. (2000) "Violence, Games & Art (Part 1)". *Technos: Quarterly* 9, no. 1 (Spring). Available at ⟨http://www.technos.net/tq_09/1gillespie.htm⟩.

Green, J. (2000) "The Violence Problem—And My Humble Solution: Kill the Academics" [Editorial]. *Computer Gaming World* (July 2000), 136.

Grossberger-Morales, L. (1995) "Artist's Statement." On *Endangered and Imaginary Animals* [Hybrid CD-ROM]. Distributed by the author (lllucia@well.com).

Grossberger-Morales, L. (2001) "Artist's Statement." On *Sangre Boliviana* [Macintosh CD-ROM]. Distributed by the author (lllucia@well.com).

Haraway, D. (1991) *Simians, Cyborgs, and Women: The Reinvention of Nature*. New York: Routledge.

Harding, S. (1996) "Rethinking Standpoint Epistemology." In E. F. Keller and H. E. Longino (eds.), *Feminism and Science*. New York: Oxford University Press, 235–248.

hooks, b. (1999) "Choosing the Margin as a Space of Radical Openness." In J. Rendell, B. Penner, and I. Borden (eds.), *Gender, Space, and Architecture*. London and New York: Routledge, 203–209.

Jennings, P. (1995) "Read Me." On *Solitaire: Dream Journal*. [Macintosh CD-ROM]. Distributed by the author (pamelaj@cs.cmu.edu; http://digital-bauhaus. com/).

Pearce, C. (1998) "Beyond Shoot Your Friends: A Call to Arms in the Battle against Violence." In Clark Dodsworth (ed.), *Digital Illusion: Entertaining the Future with High Technology*. New York: ACM Press, 209–228.

Plant, S. (2000) "On the Matrix: Cyberfeminist Simulations." In G. Kirkup, L. James, K. Woodward, and F. Hovenden (eds.), *The Gendered Cyborg: A Reader*. New York: Routledge, 265–275.

Rosemont, P. (1998) "Introduction: All My Names Know Your Leap: Surrealist Women and Their Challenge." In P. Rosemont (ed.), *Surrealist Women: An International Anthology*. Austin: University of Texas Press, xxix–lix.

Sandler, C. (1993) "The Game of Life: Why We Play Games and the Impacts of Computer Games." *PC World*, 11(8), M89.

"Sega Dreamcast Ads Censured by ASA for 'Racism.'" (2000) *Marketing*, December 7, 3.

Stickgold, R. J., A. Malia, D. Maguire, D. Roddenberry, and M. O'Connor (2000) "Replaying the Game: Hypnagogic Images in Normals and Amnesics." *Science*, 290, 350.

Taylor, C. (1999) "Games Enter the Mainstream." *Time* 154(22), 107.

Turkle, S. (1997) *Life on the Screen: Identity in the Age of the Internet*. Cambridge: MIT Press.

Venn, C. (trans.) (1990) "Women's Exile: Interview with Luce Irigaray." In D. Cameron (ed.), *The Feminist Critique of Language*. London and New York: Routledge, 80–96.

"Gameplay": From Synthesis to Analysis (and Vice Versa)

Topics of Conceptualization and Construction in Digital Media

Gunnar Liestøl

For decades developments in digitization were limited to various subfields of computer science and were perceived as predominantly irrelevant to most humanistic disciplines. In recent years things have changed. No longer is it only the evolution of hardware and software that is viewed as influencing people's lives. The computer, in its various manifestations, has become a dominant tool for communication and the exchange of *meaning*. In addition to the traditional levels of hardware and software, we are now experiencing the emergence of *meaningware*. The production, dissemination, and consumption of meaningware, in all its genres and shades, from Web pages to computer games, now extends beyond the traditional catchment area of computer science and related disciplines and constitutes key subject matter for humanistic approaches to digital media.

The interplay of technical, textual, and theoretical inventions and innovations in digital media has become both intricate and complex. By their mere establishment over the years, however, humanistic approaches (to media in general) have reduced the existence and emergence of such relationships to a temporal sequence in which a technology is invented and established as a platform for encoding, distribution, and

decoding of textual artifacts. This again is eventually institutionalized as a subject matter of academic study. Such is the story for most humanistic disciplines directed toward media, communication, and exchange, from literature and theater to press, film, television, and digital media. This post-Renaissance tradition of the human sciences—reducing the inter-relationships among the technical, textual, and theoretical levels to a one-directional sequence of after-the-event reflection and hindsight—is, I believe, challenged by the ongoing digitization of old media and the continued emergence of innovative digital media forms. Current changes and reconfigurations are fast and far-reaching, a fact that by itself questions the traditional one-directional relationship of analysis (and interpretation) in most humanistic inquiry.

This limitation of traditional humanistic analysis also affects analytical and interpretative practices themselves. When differentiation, complexity, and speed of change increase at the same rate as subject matter, the existing repertoire of analytical means is in danger of becoming inadequate and obsolete. How may we solve this problem? What strategies might we adopt to prevent such a situation of misrepresentation in the relationship between object and concept?

To answer these questions I will focus on the connection between production (*synthesis*) on the one hand and interpretation (*analysis*) on the other. By examining the concepts and practices at play in the relationship between synthesis and analysis, I believe it is possible to inform and refresh our current analytical vocabulary. An exchange of conceptual means between the positions in the synthetic-analytic relationship not only may improve our analytical capabilities, but may also shed some light on how humanistic scholars might escape the isolating wash of after-the-event inquiry only.

Synthesis → Analysis: From Developer's Discourse to Descriptive Tool

As ingenious, digitally coded texts of various kinds have emerged over the past few decades, the need for more suitable vocabularies of analysis has become increasingly evident. This problem is neither new nor limited to our understanding of digital media. In Goethe's *Faust,* Mephistopheles

states that "where concepts are absent, there a word will present itself in due course" (Denn eben wo Begriffe fehlen, da stellt ein Wort zur rechten Zeit sich ein) (Goethe 1927: 57).

One might not have the patience, however, to wait for concepts to present themselves. Thus, for the eager but impatient critic, the question becomes: *how* or from *where* might the relevant concepts, for tools in textual analysis and interpretation, be obtained? In my own work such absence has been particularly notable in respect to textual artifacts in the most successful branch of digital media, that is, computer games. Computer games represent relatively young, innovative, and different textual structures when compared to those of literature, film, and television. As a consequence, the academic vocabulary of critical analysis appropriate for interpretation is still mainly lacking, or at best, in its early infancy (interesting appoaches, however, can be found, for example, in Manovich 2000; Aarseth 2001).

In textual analysis one exploits a vast repertoire of methodologies, models, analytical strategies, theories, terminologies, and concepts. My use of the term "concept" is here both basic and general and needs some elaboration. The purpose is not to answer the frequently asked philosophical question "What *is* a concept?" but rather to explore how we might *find* or *produce* conceptual means when required. This notion of concept is thus a general one: as an appropriate tool for analysis and understanding. Hence, the word concept is synonymous with "term," "tool," or "word," as in the Goethe quote above.

Merriam-Webster's Dictionary ⟨www.m-w.com⟩ defines "concept" simply as "an abstract or generic idea generalized from particular instances." As such, a concept is formed by combining characteristics and particular qualities from one or more objects; concepts are constituted by acts of selection and combination and form rules for these actions. A notion of "editing style" in film, for example, combines the particular instances and properties of different editing techniques, forming a pattern that again could be characterized in a specific concept of a certain style. A concept and its application upon textual material highlight and relate to certain aspects of the text, thereby viewing the whole in parts. Consequently, for the purpose of analysis (taking the object apart) we also

combine selected qualities of the object (synthesis). In this process, as elsewhere, we experience the close reciprocal relationship between synthesis and analysis, how they coexist as two sides of the same operation. Synthesis at the concept level creates analysis at the object level.

In everyday academic work contact with concepts, whether for production, interpretation, or theory, consists of a more or less procedural process of acquisition and application rather than creative and innovative use. In the humanities tradition one predominantly learns how to use terminology that is already central to the tradition of a discipline or a methodology. In the humanities this procedure of order and sequence in the acquistion of theory is dominant. The theoretical and conceptual apparatus is relatively stable, whereas the subject matter of our research differs; new novels, new objects of art, new films, that is, new texts are continually created and subjected to analysis and interpretation. In disciplines predominantly defined by subject matter, such as literature, art, language, and media, the object of study is continually governed by patterns of conventions, such as, for example, genre characteristics.

Sometimes the transformations in media and communication technologies and practices, however, do not form a flexible and stable continuum. Changes in key conditions cause more radical breaks. Digitalization seems to form such a basic break with tradition, causing textual production to emerge on new and different technological platforms shaped by redefined and constantly changing economic, institutional, and cultural conditions.

In such a situation of transition two options immediately present themselves to critics in need of conceptual resources (these options often appear and are applicable in combination). The first option is that we might borrow approaches from *neighboring disciplines*. This involves selecting and transposing concepts from established domains to new environments and then testing and adjusting them to function in a different role in new (but perhaps related) contexts. This has occurred in both film and television studies (see, for example, Andrew 1976 and Allen 1987). Literary theories have informed and provided emerging media forms with theoretical and methodological solutions. Narratology is one example. It developed as the structural analysis of oral storytelling and evolved into

a successful literary method before eventually moving on to be applied to the study of film and television.

A second option is to look to theoretical projects and fields with more general ambitions. Semiotics and its concept of signs and signification provides such a *general approach*. As a project of scientific ambition and claim for general applicability, semiotics is not easily overtaken by the emergence of qualitatively new representational forms or textual structures. Whatever signifying structure or system might materialize, semiotics typically asserts that its conceptual framework is directly or indirectly applicable for description and analysis of the new structure or system. If a new medium generates new sign types, these are only reconstellations of already existing and well-known elements.

Here one might counter with several challenging questions. Why do we need to find or construct other theoretical and methodological approximations? Isn't it sufficient to adjust the ones already available? Why this obsession with rejection and innovation? These may indeed be legitimate questions, but, as indicated, in the case of computer games there are key features that cannot be adequately accounted for from within traditional, established humanistic perspectives: textual analysis has not, prior to the emergence of digital media, occupied itself with readers or viewers who actively manipulate the material existence of the textual object. Manipulation and feedback, however, are central features of the relationship between digital media texts and users. I shall briefly illustrate this with three examples of computer games selected from different genres.

Three Games

Tetris, conceived by Alexey Pajitnov in 1985 (Herman 1997: 139), is one of the most simple and successful digitally based games ever made. The basic elements of *Tetris* are adapted from traditional jigsaw puzzles, but a time constraint has been added, turning the traditional jigsaw into a *dynamic* puzzle game. In *Tetris* pieces of a puzzle are thrown at us in sequence, and with increasing speed. By means of manipulating the pieces—rotate, drop, slide left, slide right—the player's project is to place

the various pieces together as compactly as possible to advance to more challenging levels as skills improve. In playing the game the player is under constant pressure to perform necessary actions fast enough to keep up with the constant but changing stream of new pieces in the puzzle. The central aspect of playing this game is apparently the *relationship* between the player's manipulation of the pieces and the performance of the game software itself in continually presenting new pieces to be placed. Although at first glance this may appear to be a rather elementary computer game, it presents us with an interesting problem. How may we account for this experience of reciprocal interrelationship between game and player in terms of established theories and concepts of textual analysis? To my knowledge there is no obvious candidate for the task.

Some models of general narratology could be applied, such as A. J. Greimas's (1973) mythic actant model, which relates the basic operations, functions, and actants in any narrative project. Playing *Tetris* could be percieved as a project in which the objective is to master the game and produce the highest score, which always can be improved. But when this game is played, the acting subject is not only an internal actant in the game structure itself but an external player with access to the game's programmed functionality. If, as an external subject, the player is allowed to take the position of an internal subject actant, the model is turned into a general description of action and thus applicable to any conceivable situation in which human or other actions and goals are involved. As a consequence, Greimas's model seems to lose its precision and descriptive value.

PaRappa The Rapper, published by Sony for the Playstation console in 1996, is described on the cover as a "music and rhythm game." It is a novel production that mixes music and rhythm with the player's actions in a flexible and involving manner. Again, in order to function as a player in this game—in fact, for the game to be played at all—the user must enter into a similar relationship with the game as was the case with *Tetris.* A time-dependent stream of instructive events, accompanied by music, rhythm, and song, invites the player to master the basic techniques of dance and rap. The state of playing the game is obtained when the player achieves approximate equilibrium in the relationship between this stream of events generated by the game itself and her own actions. Despite a

familiar framing narrative (the male hero's quest to impress and conquer a woman), it is again difficult to see how established analytical strategies can account for the relationship between text and subject, in which the subject actively intervenes and manipulates the materiality of the text.

Caesar III is a resource and management (strategy) game set in the Roman Republic. The player's task is to build, manage, and expand a Roman settlement in one of the empire's provinces. *Caesar III* is a complex game. Like the two titles mentioned above it has a time constraint that here, however, simulates the unfolding chronology of history. Significantly, this history is a historical sequence cocreated by the player. In the virtual world of Caesar III the stream of life also goes on partly independent of the user's engagement: people arrive or leave the settlement, buildings burn, the river keeps flowing, and so on. But as the manager in charge, the player can play along with this continuum of events and improve the quality of the city and its population. The content of the game is potentially much richer than that of *Tetris* and *PaRappa The Rapper*. It is also obvious that the played game, namely, the sequence of events that has been produced, constitutes in retrospect a narrative that more easily could be subjected to traditional critical analysis, as in textual analysis of film and television, than those of *Tetris* or *PaRappa the Rapper*. Such a solution, however, would be reductionistic, in that it would transform the subject matter into something it is not (the narrative thus generated would always be synchronous and one-dimensional). Such a transformation would cause the game's dominant, double feature to be lost: the strangely balanced and evolving oscillation between the performances of the game and the counterperformances of the player, and vice versa.

A Third Option

What, then, is an academic critic to do? From where might we draw our conceptual and analytical tools? How are we to proceed in building a vocabulary that can guide us in accounting for the significant features of relationships and activities that seem to dominate the character of our engagement with these digital artifacts?

In reply, a *third option* beyond the two presented in the previous section may be possible. The way an object is created necessarily conditions

its identity and how it is used. Similarily, the way an object is described in the process of production is related to the way it is described when used. Concepts and words deployed in the language game of construction are equally related to the vocabulary found in the language games of reception and use. In fact, a term may be presented in both contexts of the object, production and consumption. Critique, evaluation, and analysis are specialized versions of consumption and use. When one is producing objects, particularly in groups, discourse embodied in and coexisting with this production often includes a vocabulary that describes key qualities of the object itself. In fact, these might be necessary conditions for the design of the object and thus also be relevant to the description and understanding of the nature of the object, including academic analysis. Consequently, according to this argument, the *developer's discourse* is a relevant place to (re)search (for) conceptual sources.

The Language Game of Computer Game Development

In environments of creation and production, especially those in which teamwork is predominant, people involved in the making discuss what they do as they do it. They plan, design, name, describe, command, argue, try out, solve problems, and so on as they propagate their products. This is the case in numerous fields of human creation and production, from architecture to engineering and industrial design. As praxis fields of varying complexity they constitute language games in the Wittgensteinian sense.

Computer game development is such a production environment, and a complex vocabulary has evolved in this context. Game development is a fully institutionalized community, an industry that today competes shoulder to shoulder, and sometimes collaborates, with the moviemaking industry. As a community, computer gaming has its own organizations, journals, and conferences, all of which contribute to the reinforcement of particular uses of language, both verbal and pictorial.

The computer game development process is basically divided into creative development and the production process (Godager 2000). This can be seen as a four-step movement toward the finished game product. First, a proposal for a game, a game idea, is put forward by a "lead game

designer" who seeks approval for the idea from a group of developers. In describing the idea the game designer identifies the genre, hardware/software platform, target audience, length of time required for the playing of the game, and business model and offers a synopsis describing the game's plot. Further, some of the game features are described, such as competition in the market and graphics style. Second, the idea for the game is approved by the group of developers, a "design council," and developed into a design materialized in a more detailed descriptive document and a prototype that implements the game's core features. Third, a technical specification is then developed based on collaboration between the idea and design developers and technical implementers. Fourth and finally, the product is implemented through an iterative process akin to that employed in other kinds of software development.

Throughout this process a specific vocabulary is in use and under constant adjustment because of, among other things, the changing technological conditions in the field as a whole. The detail of the computer game design and production process might differ from company to company, and the developer's discourse might have local and national dialects, but in general, procedures and concepts are shared by the international game developer community. They also emerge as part of a creative articulation, of making and playing with concepts, models, and demos. The discourses by which I have been informed possess a rich repertoire of concepts, and they tend to be genre specific. Among the mostly used terms one in particular distinguishes itself from the others and seems to have general validity and genre independence: *gameplay*. Any computer game has gameplay, of some quality and quantity. In the following discussion, "gameplay" will be used as an example of a concept that might be deliberately moved from the language game of computer game production (synthesis) to the language game of critical interpretation and understanding (analysis).

Toward an Analytical Concept: The Case of Gameplay

"Game" and particularly "play" have been the object of extensive investigation and theoretical application in modern history, starting with Friedrich von Schiller's (1794) work on play and education, informed by Immanuel Kant's critique of aesthetic judgment (1790/1974), and

moving on to the more recent theories of Johan Huizinga (1970), Roger Caillois (1961), and Hans-Georg Gadamer (1997).

The term "gameplay" is used to define the quality of playing the game, akin to the concepts of usability and readability. Gameplay is central in the production process as a whole and consequently has several meanings. It is the most fundamental quality a game can possess, and as such it is constituted by a multitude of underlying aspects and properties. Toward the end of the computer game production process, gameplay becomes crucial and is particularly obtained in the final stages of development when the game is balanced and tweaked into its final shape.

So what exactly is gameplay and how might we take advantage of the term in a context of interpretation and analysis? The game industry in part answers this question through its product marketing. On computer game packaging one finds phrasings like "length of gameplay," indicating that gameplay is a merely quantitative and descriptive term. Computer game reviews often use gameplay alongside a set of other categories for evaluation, such as plot, graphics, characters, sound, innovation, replayability, and fun factor, often rated on a scale from zero to ten.

"Gameplay" is used in various ways, depending on where in the circulation of computer games its user is situated: production, marketing, reviewing, or consumption. It originated, however, in the design and development practices. Gameplay is a concept coined relatively recently, most probably in the late 1970s. It is not traceable to any origin outside the computer game industry. It is not listed in any of the major dictionaries, either in printed or electronic form. Neither is it to be found in the indices of various computer game studies that have so far surfaced (Herman 1998, Herz 1997), which obviously shows that it is not yet critically or academically established.

In contrast, a search on the Web for a definition of gameplay gives us easily more than a thousand listings. Most of the definitions and uses found here add to the general and quantitative description applied in marketing. A typical example from a discussion list on the Web reads as follows: "Gameplay, by definition, is a play system that challenges the gamer, is easy to learn, with some effort, yet hard to truly master; and involving experience that allows for high interactivity, yet gives the player a believable world to accomplish goals in. Without gameplay, a game is just something pretty to look at: an uninteractive romp through a fantasy

world that feels more detached from the player than the player feels drawn into it" (Cosner 1999).

There is one interesting exception, however. In 1982 game designer Chris Crawford wrote *The Art of Computer Game Design,* a small thesis reflecting upon the nature of computer games. Here he provides the first serious definition: "Game play is a crucial element in any skill-and-action game. This term has been used for some years, but no clear consensus has arisen as to its meaning. Everyone agrees that good game play is essential to the success of a game, and that game play has something to do with the quality of the player's *interaction* with the game. Beyond that, nuances of meaning are as numerous as users of the phrase. The term is losing descriptive value because of its ambiguity. I therefore present here a more precise, more limited, and (I hope) more useful meaning for the term 'game play.' I suggest that this elusive trait is derived from the combination of pace and cognitive effort required by the game" (21). After discussing two games with different uses of "pace and cognitive demands," Crawford concludes that "both games have roughly equivalent game play even though they have very different paces. Pace and cognitive effort combine to yield game play" (22). I will return to the ingredients in Crawford's definition below. It is interesting to note, though, that at the time of Crawford's discussion "gameplay" was not written as a single word; instead, the more descriptive "game play" was used. What actually happened when the signifier changed from "game play" to "gameplay," from two words to one word, from description to "concept"?

At first "gameplay" sounds odd, a pleonasm, a way of combining words that produces redundance. In English "game" and "play" are often used to mean or signify the same thing. In dictionary definitions (for example, that of Merriam-Webster) they are also applied to define one another; in other words, they are used as synonyms: "game" is defined as "1. sport, *play,* amusement," whereas "play" is defined as "1. sport, *game,* amusement," but also "to act, perform, *to play*" (italics added). There is one significant difference here. Whereas "game" is exclusively a noun, "play" is both a noun and a verb. One may play a game, or even play a play, but may not game a play or game a game.

The immediate and obvious meaning of the term "gameplay" is as an abbreviation of "the playing of a game," which is consistent with at

least the marketing use of "gameplay." But if "the playing of a game" or "the gameplaying" is the obvious origin of the elliptical form "gameplay," why was the term not in use prior to the emergence of computer games? And why too has it not been reduced to the word "play," which is the situation in similar language games: for example, "to sail a boat" becomes, not "boat*sailing*," but simply "sailing"? The fact that this seemingly superfluous nominalization emerged with the new game type indicates that the playing of computer games requires a specific expression. What then is new or different in computer gameplaying that demands this double, non-elliptic articulation? When "game" and "play" are conjoined and turned into a noun, "gameplay" seems to mean the process that takes place when a game is played, the activity that is produced over time as a result of the subject's engagement with the rules, objects, and activities of the game.

Between Activities

Interestingly, Crawford relates gameplay to the player's *interaction* with the game. Over the past 20 years "interaction" or "interactivity" has become one of the most (mis)used as well as one of the most criticized and rejected concepts in the whole field of digital media (Jensen 1998). Interactivity has been rejected as useless in attempts to describe the relationship between user and computer (see chapter 15). There is little doubt that interactivity is an overused and thus almost barren concept in many contexts, however, this does not prevent this juxtaposition from being useful and meaningful. "Interactivity/interaction" is a combination of "inter" and "activity/action" and as such has been through phases of constitution similar to that of gameplay. If for a moment we disregard all the contradictory confusion surrounding this term and think of it as a fresh combination of two otherwise straightforward terms, it might help us to clarify the term "gameplay."

One of the fundamental critiques of "interaction" is that it is limited to relationships and engagements between human beings; thus, the argument goes, it is misapplied when describing human-machine relationships. One might question, however, why (inter)actions should be limited to the social life of human beings. One of the most frequently used examples, when defining the many meanings and uses of "action" in the English

language, is the sentence, "The wind *acted* upon the sail" (*Webster's* 1994: 15). In this and in similar language games, natural events are actions. The captain of a sailing boat also acts, not primarily upon the sail, but he uses it as one of many available means (the boat and its attributes) in controlling the boat for the purpose of sailing. This activity of sailing is made possible because the captain *reacts* to the *wind's actions* upon the sail. When sailing occurs there exists a relationship between the actions of the wind and the actions of the person in charge of the boat, with the canvas and other navigational devices (helm, keel etc.) as interface. This is a relationship *between* actions (or activities). As such, it does give meaning to the term "interaction" as inter-actions. Based on the common usage of the words "action" and "activity," as demonstrated in the discussion above, it is perfectly plausible to state that if persons can interact with the wind, so too can they interact with machines made and programmed by human beings.

In this relationship *between activities* we might make a distinction between *object-activity,* activity performed and conditioned by the computer, and *subject-activity,* activity performed and conditioned by the user (Liestøl 1999a). The relationship between activities, as presented here, indicates that "gameplay" is a concept analogous to "interaction." As a concept it relates to how these relationships between activities manifest themselves in the phenomenon we know as playing computer games.

Crawford suggests that gameplay remains the defining quality of computer games and that its constituent components vary among genres depending on their different constellations of pace and cognitive effort. Pace is then the object-activity of the system, whereas cognitive effort may be seen as related to the subject-activity of the user. The pace of a game, according to Crawford, may be "demonic" or "deliberate," and under cognitive effort the amount of "planning and conceptualization" may vary depending on game and genre. "Gameplay" expresses the relationship between the two: one game may have demonic pace but limited cognitive effort, whereas another game might have deliberate pace and equally more planning and conceptualization. This approach to a differentiation of gameplay is limited to its quantitative aspects and turns out to be of relatively little value as a tool for detailed computer game analysis and

interpretation. A similar approach was proposed by Laurel (1986) in which interactivity in computer games was described as characterized by three variables: frequency (how often can one interact), range (how many choices are available), and signification (how much the choices really affect matters). Different games (and genres) provided different mixes of these variables. Again the perspective is strictly quantitative. Laurel (1991: 21) later stated that this approach was too simplistic and that a more rudimentary measure is the feeling of participating in the ongoing action of the representation. "Feeling of participation," however, does not provide much more analytical precision than "cognitive effort." The mentalism of these approximations, I believe, represents a blind alley in the attempt to draft a strategy for the differentiation of "gameplay" as an analytical term, although they point in the right direction when it comes to variations in the relationship between system and user, between object-activity and subject-activity.

Different kinds of object-activity and subject-activity and their internal relationship in gameplay could be further analyzed, not only as pace and cognitive effort, but as relationships between *real, imaginary,* and *symbolic actions* and *manifestations* (Wilden 1987) in the play between object-activity and subject-activity. If the oscillating and balanced relationships between various forms and levels of object-activity and subject-activity are central to the explication and detailing of the concept "gameplay," some defining principles need to be explored and named.

I briefly mentioned above the general applicability of Greimas's mythic actant model. In traditional linear narratives, delivered by means of stable document structures, such as literature and film, the project axis and its progressive movement from subject to object position frames and defines the main objective of the narrative. In computer games the dominion of this axis is reduced. There is customarily a framing story in computer games, either implicit or explicitly articulated (and predominantly to provide motivation through a task or an instruction for the user to start with). Referring to the three examples of games examined above, such framing (or initiating) narratives are to advance levels and improve the high score in *Tetris,* the hip-hop hero's aim to impress and conquer Sunny in *PaRappa the Rapper,* and the quest to make a career as a politician in the Roman Republic in *Caesar III.*

When the significance of the project axis is reduced, the axis of conflict comes into dominance. What is basically a means to an end in traditional stories has been raised to supremacy, whereas the framing project and its objective are reduced to mere ornamentation. A project that continually evolves and progress remains, but the purpose is no longer primarily to reach the end, to close the book, but to stay in the ever-changing process of play, of gameplay, as an oscillation between player and other, between subject-activity and object-activity.

I also mentioned above that Schiller, as one of the first modern theoreticians of children's play, was informed and influenced by Kant's aesthetics. Fundamental to Kant's notion of aesthetic judgment is the principle of *purposiveness without purpose* in the free play between imagination and understanding as a ground for aesthetic judgment and the predicate "beautiful." Schiller applies this principle also to physical play. In computer games the closed narrative structure of the project axis gives way to the continual, but changing and balanced, relationship between the opposing sides of the conflict axis. This oscillation between object-activity and subject-activity is *purposive* in the continued maintenance of the gameplay, of staying in the equilibrial relationship between opposing forces, but it is *without purpose* in relation to a final closure or a defined goal for this process. In computer game structures the framing narrative might have an end, however, this is not the dominant purpose of the game activity, but rather a residual element of the computer game tradition's exploitation of narratives as a means of efficient introduction to the initial setting of the game.

We may well ask, then, whether there is no real difference between play and gameplay. Gameplay is a particular kind of play closely related to, but not identical with, every or any other form of play. Gameplay is the kind of play practiced in the playing of computer games, and its characteristics can be properly described and detailed only in close analysis of actual gameplay through the playing of individual games (see chapter 12, this volume). As mentioned above, an obvious starting point for gameplay analysis is the classification and understanding of the various real, imaginary, and symbolic forms the two kinds of activity take in different games and genres, and further, how these manifestations interrelate and interinfluence each other.

The purpose of the discussion so far in this chapter has been to highlight and contemplate an alternative route to the analysis of digital media texts. It has been argued that the practices and discourses constituting the creation and production of a textual artifact are a relevant potential source for analytical tools, particularly when the textual field is new and we are in need of a critical nomenclature. The case of gameplay offers a suggestion as to how such a vocabulary might be found and established.

The quest for such an approach in digital media production and analysis is by no means an isolated suggestion. A similar strategy has evolved in hypertext authoring and editing, drawing together technical, developer, and academic discourses. Hypertext pioneer Mark Bernstein (1998) describes how he and his authors were forced to develop a vocabulary of hypertext structures to communicate about and improve hypertext designs as part of editorial processes. In this effort he came up with an impressive taxonomy of hypertextual patterns. It is obvious that such patterns and structures, despite the fact that they have originally been generated within the developer's discourse of hypertexts, are significant and that they are applicable to individual hypertexts as objects of textual analysis.

Between Concepts

By propagating the developer's discourse as a conceptual resource for digital media understanding, I am not rejecting the two alternative options mentioned earlier. Established and traditional theories and concepts are crucial to the understanding of digital media. They are not, however, necessarily directly applicable when new kinds of textual objects are mechanically subsumed under existing knowledge without recognition of the unfamiliar and unknown characteristics of the artifacts. It is in combining the concepts of the developer's discourse with the theories and methodologies of established fields that we obtain substantial means for analytical understanding of digital media texts.

The discussions above require some further comment and reflection. We see that by applying the "neighboring-discipline approach," that is, by elongating Greimas's model beyond literary and narrative objects, it is possible to detect an affinity to a central feature of Kant's reconception of aesthetics in his critique of reflexive judgment. Such an appli-

cation, and by implication the combinations of perspectives, are constructive and show that established theories and concepts are indeed relevant to the understanding of new phenomena. But to what extent and why?

When establishing new disciplines and defining new subject matter there is a tendency to stress difference rather than connection and continuity (see discussions of narrative and gaming in chapter 8). Notions of distinctly bounded disciplines and subject matters are paralleled in the idea of clearly defined concepts, a way of thinking well established in logic and analytical philosophy. Gottlob Frege, for instance, compared a concept to an area and concluded that areas with vague boundaries cannot be called areas at all. This demand for exactness and map-territory thinking about the relationship between concepts and their applications is strongly refuted by Ludwig Wittgenstein. Discussing the concept of "game," which is central to the status of his own methodology, Wittgenstein (1978) writes, "One might say that the concept 'game' is a concept with blurred edges.—"But is a blurred concept a concept at all?"— Is an indistinct photograph a picture at all? Is it even always an advantage to replace an indistinct picture by a sharp one? Isn't the indistinct one often exactly what we need?" (34).

I believe that indistinction and blurred edges are exactly what we need when we invent and develop innovative uses of concepts in new and different contexts. Blurred edges and fringe areas are inherent and important aspects of most concepts and their application. When we are moving beyond the well known and on to the new and not yet known, these "areas" become useful and creative exactly because of their vagueness. Their blurriness makes them open, that is, open to diversity, creation, and combination. Thus, the blurred edges of concepts are places (topics) where invention and innovation take place.

When applied on the outskirts of their conventional domain, concepts reveal qualities, both of themselves and their object, which were neither intended nor explicated in the traditional setting. With Sigmund Freud one might say that concepts (as well as models and theories) in analytical disciplines, like other utterances (dreams, jokes, slips of the tongue, etc.) are *overdetermined.* This conceptual overdetermination is possible because most concepts (particularly in the humanities) have fuzzy

borders. The coining and emergence of "'gameplay," as the combination of the established concepts "game" and "play," exploits exactly this feature.

Following Goethe, we might say that "gameplay" presented itself when it was needed. That is, it appeared as a necessary means in the language game of the developer's discourse during the creation of certain key features in the history of computer game evolution. It is up to academic discourse, however, to develop and differentiate the concept further for the purpose of interpretation and analysis.

Analysis → Synthesis: From Analytical Category to Constructive Schema—A Possible Procedure?

In the sections above, I have tried to show that, as far as new, digital media are concerned, a conceptual transition from construction to interpretation is indeed plausible. This movement opens a gateway between the two (often separated) fields of synthesis and analysis. If it is possible to inform interpretation by means of the constructive domain, the reverse should also be possible: to inform construction by means of interpretation. The task remains, then, to examine briefly whether the relationship between interpretation and construction could evolve into a two-way channel. In such a bidirectional channel, the analytical and interpretative knowledge domains of the humanities could be converted to and made available to the developer's discourses and their processes of synthesis on a more permanent basis, thus establishing a two-way exchange relationship between the domains of authoring and interpretation.

The various humanistic disciplines of art, literature, language, film, and media possess a unique knowledge base concerning communication, rhetorics, narratives, genres, meaning, and signification. Competencies in these areas are of a different kind from the ones found in the respective production positions and developer communities. Such humanistic competencies might in some cases exceed the depth and detail of the insights operationalized by developers. This is not intended as a disparagement of producers, whether authors of novels or designers of computer games, but in general it seems reasonable to anticipate that various production environments could benefit creatively from being more directly supplied by insights and perspectives originating within these knowledge domains.

To establish a reverse channel, with movement from analytic to synthetic, that is, from interpretation to construction, we need efficient and reliable procedures, some kind of *method*. In the humanities, however, constructive methods for making cultural artifacts are not often encountered. From *where* then, might we obtain such methodologies? As with our search for conceptual means for the purpose of analysis above, there might be several options in this context as well: adaptation of procedures in neighboring disciplines or general approaches. The natural and technical sciences are rich in such approaches and methodologies, from the hypothetical-deductive method itself to industrial experimentation and testing.

To illuminate and prepare answers to these questions, however, at least as a starting point, it might not be necessary to search outside the central traditions of the humanities. Revisiting and reflecting upon the duration of validity concerning some of these disciplines is always useful. The ancient tradition of rhetoric is in its most elaborate and influential version a method for construction, a method for the making of oral presentations. Rhetoric has on numerous occasions been suggested as a useful resource and been applied constructively in humanistic approaches to hypermedia development and implementation (Landow 1991; Ulmer 1994; Liestøl 1999b). Throughout the ages and culminating in the Renaissance, the material of rhetoric extended beyond the oral to include any representational form, be it written, figurative, or plastic, and the rhetorical method proved itself as a general system for communication and construction (Vickers 1997).

Rhetoric in its prescriptive, constructive mode is basically constituted by a set of procedures to find the available means for efficient communication in a certain context. The basic rhetorical operation of *finding*, the Romans refer to as *inventio* and the Greeks *heuresis*. Under *inventio* the explicit exertion for finding is the *topics*. In his overview of ancient rhetoric Roland Barthes (1988: 65–69) distinguishes three executions of the topics: (1) as a *reservoir* in which one can find ready-made shapes for reuse; (2) as a *grid* that provides a network of empty forms to be filled by elementary operations; and (3) as a *method* by means of which, through standardized procedures, to find the substance of a discourse, even when the subject matter is unknown to the speaker. The last variant (as method)

has understandably caused a great deal of concern because of its superficiality and arrogance to truthful conduct and knowledge of subject matter. It is exactly the topics as a standardized method for relating to the *unknown,* however, that is relevant here, and not the topics as a method in ignorance of the factual, but rather because the *fact does not yet exist!* The topics is needed here as a method for making the unknown the not-yet-known; it is a method for realizing what only exists as a possibility. "The topics is the midwife of latency," Barthes states (66). Might this discredited method be rehabilitated as a constructive channel for existing and predominantly analytical humanistic knowledge?

I will draw on the concept "genre" to exemplify this remaking of method. Across a number of fields, for example, in literary and linguistic studies, genre is already a concept used for both synthesis and analysis, but only in a limited sense. There are established topical uses of genre in the grid mode of rhetoric referred to above, in which empty forms need to be filled. Popular literature, film, and television make extensive use of this topical mode. In pronounced genres, like, for instance, mystery in literature and western in film, we find the coexistence of both prodution and consumption. In genre theory various grids or categories as aggregates of qualities are central in the analytical procedure, such as setting, character, story, iconography, style, and stars (Lacey 2000: 136–141). These categories are used to structure the analytical process directed toward individual texts to explicate their qualities and their relations to other texts and genres. Approximately the same categories, however, the same or similar grids, are used (more or less consciously) by producers for construction of literary and cinematic texts (which again become subject of analysis). In both instances the procedure is topical. The categories might be performed as instructive questions that when answered generate material for the product under construction. Several of the criteria according to which texts are constructed (the applications of the grid) are shared by both analytical and synthetical actions, by both users and producers.

This symmetry between production and consumption and between construction and interpretation requires that the genres be well established and relatively stable. Both construction and interpretation take place within a paradigm, a common set of interests, understanding, knowledge, and competencies, shared by both encoder and decoder. Construction

also takes place, however, on the blurred borders between genres. Genre constraints are continually exceeded by innovative texts that both do and do not belong to existing genres. The relevant question, then, is whether the topics as *method* (according to Barthes) can be applied to the construction of the unknown, including as yet unknown genres (Ulmer 1989). Our heuretic approach is that this might be done by inverting the analytical concept, here the concept of genre, and applying it in the act of prototyping in digital media development by means of the topic as method.

This inversion is carried out by projecting the abstract knowledge and qualities of genre onto the concrete application in development of prototypes. "Prototype" here refers to the individual artifact exemplifying a potential genre. The prototype is then manipulated and developed by means of the genre concept and its attributes as topical grid (or schema). The prototype is the elementary implementation of a concrete example, and by using the topics as method, one continually projects contexts and features onto the prototype *as if* the prototype constituted a (potential) genre. Thus, concepts of genre are used constructively to demand specific requirements from the prototype; individual genre qualities are projected onto the prototype. Central to prototyping in software design (Vienneau and Senn 1995) is scalability, both quantitative and qualitative. In our context of searching for a method of construction, the prototype is textual and scaled according to its potential as a genre. It is the projection of this perspective that places the prototype in a context in which fresh, new, and latent qualities are continually invented, found, or constructed. Thus the topic is applied as a humanistically informed method for innovation and invention in the development of expressive forms and genres in digital media.

This strategic and tactical approach is an *inversion of analytical concepts for constructive purposes,* that is, a reversion of the traditional sequence between object and concept in the humanities. As argued in the introduction to this chapter, key humanistic disciplines generate theories and concepts after the events (a posteriori), that is, presupposed by the experience and existence of the object. By an inversion of analytical concepts we reverse this sequence. Such a reversal derives guidance for its construction by exploiting concepts that exists prior to the object (a priori). The concepts of genre are predominantly analytical. But it is precisely

with the inversion of analytical concepts that we find the opening, the channel, that provides the humanities with access to and a more direct influence upon the meaningware layer of digital development. Such a strategy might not be restricted to the concept of genre. In theory, any analytical concept could be inverted for synthetic purposes. Only a few, however, might be applicable for constructive exploration of latent features in digital media.

Closing Remarks

In this chapter I have indicated that traditional humanistic approaches to digital media may benefit from a closer connection between development and interpretation for purely analytical purposes. Further, the humanities are dominated by a posteriori, after-the-event connection, temporally and spatially detached from the discourses and actions guiding and constituting the object of study. This post/external relationship is opposed to the pre/internal practice of digital media development and innovation. To properly handle these changes, humanist scholars must rethink their relationship to ongoing developments, at least if they intend to transcend the traditional position of being mere onlookers, without direct influence, and to move toward closer encounters and collaborations with other condition providers. Humanists who want to make this leap need to make their knowledge base available to such development, not just for free exploitation, but also to provide conditions for and to inform innovative production. What is called for, then, is a more intimate and dynamic relationship between how digital media texts are *both constructed and interpreted*. I refer to this as a *synthetic-analytic* approach in digital media research and development (Liestøl 1999a). Such a synthetic-analytic approach is conceived not only to influence construction by means of a humanistic knowledge base, but also as a means to enrich interpretation by way of knowledge from the constructive domain.

Jay David Bolter suggests in chapter 1 that we might close the circle of theory and practice in humanistic studies of digital media and asks if we need a new methodology to call forth this new media form. His answer suggests that we need a hybrid, "a fusion of the critical stance of cultural theory with the constructive attitude of the visual designer"

(Bolter, this volume: 30). The connections between theory and practice are complex. Their relationship is not that of *either* the one *or* the other, but rather that *both* theory *and* practice include practical and theoretical elements. In this chapter I have explored this circle of theory and practice in digital media research and development and tried to show that hybrid methodological explorations (of the kind Bolter suggests) should take into consideration the implicit concepts (and theories) of practical construction as well as the latent constructive potential of theory. After all, both practice and theory simultaneously contain the basic operations of synthesis and analysis.

References

Aarseth, E. (2001) "Editorial." Available at ⟨www.gamestudies.org⟩.

Allen, R. C. (ed.) (1987) *Discourse: Contemporary Criticism.* London: Methuen.

Andrew, D. (1976) *The Major Film Theories: An Introduction.* New York: Oxford University Press.

Barthes, R. (1988) "The Old Rhetoric: An aidé-mémoire." In *The Semiotic Challenge.* Oxford: Basil Blackwell.

Bernstein, M. (1998) "Patterns of Hypertext." In *Proceedings of the Ninth ACM Conference on Hypertext and Hypermedia* (June 20–24, 1998, Pittsburgh, PA). 21–29. Available at ⟨http://www.acm.org/pubs/contents/proceedings/hypertext/276627/⟩.

Caillois, R. (1961) *Man, Play and Games* (trans. M. Barash). New York: Free Trade Press.

Cosner, D. (1999) *Double Agent.* Available at ⟨www.thegia.com/letters/l0799/12.html⟩.

Crawford, C. (1982) *The Art of Computer Game Design.* Available at ⟨http://members.nbci.com/kalid/art/art.html⟩.

Gadamer, H.-G. (1997) *Truth and Method.* (trans. J. Weinsheimer and D. G. Marshall) 2nd rev. ed. New York: Continuum.

Godager, G. (2000) *Begrepsdannelse i FunCom/dataspill-bransjen (Concept-Construction in FunCom/computer Game Industry).* Lecture delivered at Department of Media and Communication, University of Oslo, April 2000. Available at ⟨www.uio.no/~gautego/funcom/begrep_files/frame.htm⟩.

Goethe, J. W. von (1927) *Goethes Werke: Auswahl in zehn Teilen (Goethe's Work: Selected in Ten Parts. Part 3). Dritter Teil.* Berlin: Bong.

Greimas, J. A. (1973) *Strukturel Semantik (Structural Semantics).* Copenhagen: Gyldendal.

Herman, L. (1997) *Phoenix: The Rise and Fall of Videogames.* 2nd ed. Union: Roleta Press.

Herz, J. C. (1997) *Joystick Nation: How Videogames Ate Our Quarters, Won Our Hearts, and Rewired Our Minds* Boston: Little, Brown.

Huizinga, J. (1970) *Homo ludens: A Study of the Play Element in Culture.* Rev. ed. London: Temple.

Jensen, J. F. (1998) "Interactivity: Tracking a New Concept in Media and Communication Studies." *Nordicom Review,* 12(1). Available at ⟨www.nordicom.gu.se/reviewcontents/ncomreview198/jensen.pdf⟩.

Kant, I. (1790/1974) *Kritik der Urteilskraft (Critique of Judgment).* Hamburg: Felix Meiner Verlag.

Landow, G. P. (1991) "The Rhetoric of Hypermedia: Some Rules for Authors." In G. P. Landow and P. Delany (eds.), *Hypermedia and Literary Studies.* Cambridge: MIT Press, pp. 82–103.

Laurel, B. (1986) "Toward the Design of a Computer-Based Interactive Fantasy System." Ph.D. diss., Ohio State University.

Laurel, B. (1991) *Computers as Theatre.* Reading, MA: Addison-Wesley.

Lacey, N. (2000) *Narrative and Genre: Key Concepts in Media Studies.* London: Macmillian Press.

Liestøl, G. (1999a) "Video on the Web: Continuity Linking and Narrative Flow." In *Proceedings of the AACE WebNet '99.* 666–671.

Liestøl, G. (1999b) *Essays in Rhetorics of Hypermedia Design.* Oslo: Department of Media and Communication, University of Oslo. (Partly available at ⟨http://www.media.uio.no/personer/gunnarl/essays/rhetorics.html⟩.)

Manovich, L. (2000) *The Language of New Media.* Cambridge: MIT Press.

Schiller, F. (1794) *Über die Ästhetische Erziehung des Menschen in einer Reihe von Briefen* (*On the Aesthetic Upbringing of Human Beings in a Series of Letters*) Jena.

Ulmer, G. (1989) *Teletheory: Grammatology in the Age of Video.* New York: Routledge.

Ulmer, G. (1994) *Heuretics: The Logic of Invention.* Baltimore: Johns Hopkins University Press.

Vickers, B. (1997) *In Defence of Rhetoric.* Oxford: Clarendon Press.

Vienneau, L., and R. Senn (1995) *A State of the Art Report: Software Design Methods.* Rome: ITT Systems Corporation. Available at ⟨http://www.dacs.dtic.mil/techs/design/Design.Title.html⟩.

Webster's Encyclopedic Unabridged Dictionary (1994) New York: Gramercy Books.

Wilden, A. (1987) *The Rules Are No Game: The Strategy of Communication.* New York: Routledge and Kegan Paul.

Wittgenstein, L. (1978) *Philosophical Investigations.* Cambridge: Basil Blackwell.

15

We All Want to Change the World

The Ideology of Innovation in Digital Media

Espen Aarseth

The struggle against ideology has become a new ideology.
—*Bertolt Brecht*

In much of the critical discourse on science and technology, the role of ideology in the evolution of technology is usually portrayed as negative and one-dimensional. Technologists are portrayed as trying to imbue their innovations with ultimately false claims of revolutionary and liberatory effects, and the sheer seductive effect of new technology is seen as one to be profoundly distrusted. Even the previous sentence shows this predicament: how can we talk about new technology in neutral terms when the very word "new" works to seduce us with its connoted promise of improvement and innovation? Although there may be good cause to be suspicious, we should not let our distrust of techno-rhetoric blind us to other aspects of the relationship between technology and ideology. In the following, I will focus on three "phenomena" in digital media: *interactivity, hypertext,* and *virtuality*—all three words with persuasive, if unclear, technological references, imbued with great promise, and with their full potential somehow still unrealized. How do these words function in the

discourse of technological innovation, and is it possible to disentangle their ideological and their technical meanings? All three terms are in use by technologists and media theorists, but does that mean that their uses are purely analytical and technical?

In this chapter I use the phrase "digital media" rather than "new media," since the latter is *even more* problematic than the former. What is the newness of the new media? How many are they, anyway? Are they all new in the same way? At least it seems safe to assume that they all are digital. Then this must be their novelty? But what else is new?

Sometimes, there seems to be only one medium: "the new digital medium." The phrase implies instant familiarity, but do we really know what it means? Are all digital media the same medium? Are a Furby, a Palm Pilot, and an automated teller machine (ATM) the same medium, since they are all "being digital"? Are *Tetris* and *Quake*? Surely not, no more than telegrams, lecture notes, and restaurant menus are the same medium, and probably much less so. Niels Ole Finnemann (1999) has argued that when the "typewriter, calculator, book, telephone, musical instrument, radio, fax, video, television" are being simulated (maybe emulated is a better term) by the computer, "they *cease to be media and become genres* within the new digital medium" (13). Finnemann's examples clearly support his case, and his terminology is useful for describing things like "the same genre in different media," but if we include the full range of computerized, digital media, or even just different computers with different output/input devices (same thing), the argument becomes problematic.

The celebrated teleological myth of "media convergence," in which all the old media come together in the dawn of the high-tech era and are subsumed by the new digital supermedium, is so far thoroughly refuted, perhaps even ridiculed, by all the wildly different, completely idiosyncratic computer-based media gadgets (e.g., Gameboys, smartcards, DVD players, e-book readers, spreadsheets, beepers, pet ID chips, global positioning systems) that make up the fauna of the current digital media ecology. The digital medium (singular) never existed, and chances are overwhelming that it never will. Or perhaps it did exist once, with that first digital computer in the 1940s and the others just like it, but then diverged the minute a second computer type, with a different interface, was turned on.

So digital media are legion. But what about them is new? According to Nicholas Negroponte's *Being Digital* (1995), the answer is simple: it is the bits. In Negroponte's fascinating grand narrative, the atoms of communication have given way to bits, and according to him, the digital revolution in communication is to be understood primarily by this replacement. But Negroponte's elliptic history of media puts too much weight on the role of atoms and their transportation. Only some of the old media use the transportation of atoms as their main technology. From the start, communication involving sight and sound over distance (drums, whistling, smoke, semaphor, even, in a sense, theater) did not involve atom transport. Neither did many of the newer old media (radio, telephone, television). Indeed, analog technologies, such as broadcasting, share many of the "digital" qualities of the new media, such as effortless reproduction and copying, instant access, and "global" reach. The atoms/bits dichotomy is an unreliable, if charmingly simple, guide to the digital future. And as Tom Standage has shown in his highly entertaining *The Victorian Internet* (1999), the *telegraph* preproduced not only many of the technical and logistic effects and possibilities of digital communication networks, but most of the social phenomena as well.

Other media historians, notably Carolyn Marvin (1988) and James W. Carey (1988), have pointed out that the current media rhetoric closely follows its historical precedents, the discourse of the telegraph, telephone, and electricity, to the point that the "revolution" seems to be a permanent trend of the last two hundred years. In Marvin's book, *When Old Technologies Were New,* the emerging terminology and popular rhetoric of the old new technologies is shown to be a great cause for concern, in magazines such as *Electrician* or *Electrical World.* "New words permitted those who were richer in awareness and imagination than in educational or technical resources to have their own special entry into electrical culture" (49).

Bits, of course, a metonym for computer technology, are new in the strict technological sense that they afford (almost) equal opportunities to more kinds of sign systems than any earlier media technology. If a sign type (touch, smell) can be coded and reproduced, bits are there to transfer the message. Unlike paper, or analog radio, the bit does not favor certain sign systems or exclude any others a priori. But for the same reason, bits

are not media, they are only part of a technological foundation for several types of complex media machines. A 3-D space war simulator game with a force feedback joystick and surround sound cannot be understood purely as a transfer of bits. The complexities of look, feel, sound, and play in such systems stand to the bit as a twelve-cylinder Ferrari 456M GT stands to gasoline. Both depend on technological foundations, true, but they are hardly defined or understood by it.

The question of what the newness of digital media actually is cannot be answered in a singular way, except, perhaps, by a simple tautology: the digital media are different and new because they are computerized, mediated by a computer/processor/chip. But mediated in what way? Here we must distinguish between digital sign distribution and digital sign production as two quite different, unrelated types of *new*. An analog movie, shot and edited on chemical film and then digitized and distributed digitally, is digital in a totally different way than a digitally generated animation movie, transferred to film and shown with an analog projector. Clearly, they are both being digital in only the most superficial sense. The mere fact of their "digitality" does not really identify them and therefore does not really matter. Something else is making the difference. But what?

The keywords of this chapter—interactivity, hypertext, virtuality—all offer partial, inconsistent, ideological answers to the question of newness, as we shall see. The media themselves, if studied closely and empirically, all have different answers too. In my book *Cybertext* (1997) I tried to show that the functional differences between old and new media, paper and digitality, could not be drawn clearly; that some paper media had more in common with some digital media than certain digital media had with each other; and that the rich variety in both material forms show that the analog/digital distinction in media is overrated and uninformative and breaks down under scrutiny. Perhaps the most important reason for using these distinctive terms is to create an enthusiasm ("hype") that will make a difference eventually where no difference of importance yet exists. Maybe this is the only way to innovate, to bring about something new.

Before we continue, a brief note on ideology. The concept is used here in its Althusserian sense, not as a set of explicit dogmata, but as a subconscious, tacit, collective worldview, transparent to its holders. As James Kavanagh (1995) explains that an ideology structures the per-

ceptions of seeing and feeling before that of thinking and thus seems to be an ahistorical, non-social, and natural means to the perception of reality.

Also, the concept of medium needs clarification. Recent discussions of "new media," such as Bolter and Grusin 1999, seem to avoid[1] a formal definition of the problematic term "medium," or, like Murray (1997), tend to construct an ideal, all-embracing "computer medium" that seems to need no further identification. Of course, given the scholarly genealogy of "medium" as a term usually linked to mass audiences, filtered content, and broadcast-like situations, it may not be possible to construct a viable definition that encompasses both most kinds of computer-based communication *and* the traditional mass media (or even only the entire range of precomputer communicative forms). In addition, the border between communication devices and "gadgets" such as the computerized toy Furby seems less than clear. We should allow for the possibility that the attempt to find a definition for medium that spans all these phenomena will not yield fruitful results.

At least we must take into account the very obvious difference between the analog mass media and computer-based communication: the latter involves machinery and/or manipulation that is intrinsic to the signification process. This is not new, and it also places computer-based sign processes closer to phenomena such as tool use, rituals, performance, and games than to the analog mass media. The difference can be summed up in the models depicted in figure 15.1. If the "old" media model consists of a social discourse (say, news) carried out in a physical channel (printed paper, radio, television), then the digital media model must include something more: the active application that manipulates the signs at the time

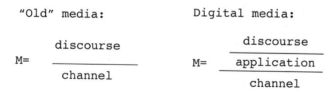

Figure 15.1

Differences between "old" and "new" media.

of use. This level is neither part of the discourse nor the channel but constitutes a third, rule-based level in between the other two. For instance, with respect to a chatroom, where the Internet and the users' hardware is the physical channel, the discourse would be anything that goes on in the channel, but the actual chat software (of which there are many different types, with significant differences in functionality) is described accurately by the latter model but not by the former. The application layer (typically a computer program, but also the rules of any rule-based game or complex communicative situation) cannot be reduced to the physical channel, since that would mean a different channel for every unique application (which is simply not useful, since the physical channels, e.g., Internet hardware, are unchanged by the applications that use them). Neither can it be reduced to the discourse level in any useful way, since the programming of a communication system and the use of it are clearly different processes socially, spatially, and temporally.

One could argue that "there is no software" (to borrow a phrase from Friedrich Kittler), that the application, logically, is part of the channel, as nothing more than the current states of the logic gates of the physical hardware, but this would then subsume the discourse level under the channel as well. And more importantly, given a multi-user context, say, a chatroom with more than two participants, only the discourse level might be "real," that is, the same for all participants. This became clear to me, rather dramatically, many years ago in a Usenet newsgroup discussion, when one of the posters was flamed for using the wrong international character code set. "Oh, I am sorry," he replied, "but I couldn't see it, because I am blind." We should never assume that computer media have to be visual! Or even if they are, that the visual aspect is always the most significant (cf. television news). Of course, in multiuser contexts, there are many ways to individualize output as well as input: the use of automatic responses, "gagging" (filtering out troublesome participants), voice recognition and/or synthesis, "personalized" (tailored) preferences, and so on.

In light of these techniques, which allow innumerable "personal" modes of perception and exclusion of the same "raw" chat stream, it could be argued that a given chatroom could host several concurrent and mutually exclusive conversations, using different applications and even variable physical channels: a user on a wirelessly connected Personal Digital Assis-

tant (PDA) could use her stylus to communicate with a blind person using voice recognition and synthesis, whereas another pair in the same chatroom could type messages to each other on standard terminals, and both these pairs could filter out the messages from the other pair in such a way that only a possible fifth participant, using an old-fashioned tele-printer, would read it all, and on paper. (The example is contrived, but perfectly realistic.) Then we would have, on the discourse level, three different text streams, on the application level, from three to five different pieces of software, and on the channel level four different output technologies and three different input technologies, as well as a number of different transmission technologies (wireless and any combination of twisted pair, coaxial, and fiber-optic cable). Maybe some of the participants are unable to "personalize"/configure their end. Are all these using the same medium, or is the term "medium" obsolete? Clearly, the chatroom itself is not the medium, since every user can be mediated differently, by choice or circumstance. Rather, it is a communication nexus, an *intermedium,* in which different or similar media interface with each other.

To extend Kittler's maxim, we could say that in the world of open standards and interface protocols, "there is no medium," since, as we have seen, the end-users' equipment and means of connection could be very different from one another's and still communicate. A clearer conclusion would be that in multi-user contexts, all levels (discourse, application, and channel) are in principle replaceable and that messages are always intermediated. Like the term "Internet," "medium" is hardly more than a convention, a term hiding a plethora of social and technical meanings and levels.

It is extremely important to emphasize that the present "discourse/application/channel" model is not exclusive to digital communication but would have to include any practice or technology, new or old, with a manipulative component. Oracular systems, like the ancient Chinese text *I Ching,* are prime examples of this. Also, consider an analog pinball machine or a regular baseball game, which contains a set of procedural rules that makes it similar to a digital game in the sense that the user's/player's engagement with the rule level determines the sign process. Hence, there is no point in appealing to the digital or "new" media as uniquely different from other phenomena; many digital media are different, but they are

certainly not all different in the same way, and for some, the difference from other nondigital media is trivial. "The digital medium" (singular), in other words, is a vague and confused phrase that completely lacks analytical value and should be abandoned.

Can "New Media" Be Invented?

How does one go about inventing media? Is it even possible? For instance, despite decades of research and numerous trials, "interactive television" (a possible injection of computer technology into the television medium) never caught on. Maybe it still could happen, but so far it seems that the evolution has moved in the opposite direction, in which television has become integrated into computer-based communication such as the World Wide Web and not the other way around, as the powerful television industry hoped. Instead of accommodating "set-top" computer boxes, television itself is now reduced to a "box" on the "desktop" computer screen.

And yet new communication technologies are invented all the time, or at least they appear all the time: for instance, e-mail, Usenet news, multi-user dungeons, Internet Relay Chat, the World Wide Web, and ICQ. The interesting fact about all of these successful Internet applications is that they were not the result of a focused research program, planned, implemented, and funded by government, academia, or the military. Instead, they were the result of individual or small groups of programmers who simply wanted new communicative tools. E-mail was at first simply various means of leaving messages for people who used the same mainframe computer in the 1960s. Then, unpredictably, it took over as the most used and useful service on the ARPANET, Internet's predecessor in 1971, when Ray Tomlinson at Bolt, Beranek, and Newman wrote a simple program called SNDMSG, using the @ in the now familiar way for the first time. "There was no directive to 'go forth and invent e-mail,'" Tomlinson later explained. He did it "because it seemed like a neat idea" (Campbell 1998). Similarly, Usenet news, with its thousands of newsgroups, was developed by students at two different American campuses, Duke and North Carolina, in 1979, and started out using Unix (uucp—unix to unix copy) over telephone lines rather than

the Internet. The first multi-user dungeon, programmed the same year by Roy Trubshaw and Richard Bartle, two students at the University of Essex, also relied on modem connections and was later transplanted to the Internet. Internet Relay Chat was also a single-student project, and the World Wide Web, as is well known, started as a small practical project at CERN, without prestige or great expectations. Even Unix, arguably the most important operating system in computer history, was "invented in 1969 by Ken Thompson after Bell Labs left the Multics project, *originally so he could play games on his scavenged PDP-7*" ("Unix" (2001), italics added).

A final example, from mobile telephony: WAP (wireless application protocol) was among the most hyped and invested-in technologies at the turn of the century. What could be better and more useful than a union of the two most important new innovations, cellular phones and the World Wide Web, in one box? Despite the enormous buzz and the investments, WAP has not caught on, at least not yet. In extreme contrast, another mobile telephone technology has become a huge hit all over the world, at the same time that WAP didn't happen: SMS (short message service) is a completely unexpected success, an alternative e-mail/chat system that has several advantages over voice telephony: it's cheaper, more discreet in public places, and, of course, eminently mobile. The true measure of its success is that users have invented a large set of new language codes: " 'Where are you?' becomes 'WRU,' and 'See you tonight' becomes 'CU 2NYT' " (Arnold 2000). In the Philippines, SMS even ended up at the front of the government/guerrilla war, with messages being sent across enemy lines, as well as being used to spread jokes and rumors about the president (Arnold 2000). Even in the most oral of technologies, text communication is alive and thriving.

As these examples show, the successful invention of new communication technologies seems to happen independent of, and seemingly in opposition to, large, concerted industrial or research efforts and predictions. Large-effort commercial products and technologies certainly play a part in these evolutions, but the key element is the playful, sometimes anonymous, individual or collective effort. "The Street," as author William Gibson (1991) says, "finds its own uses for things—uses the manufacturers never imagined" (29).

Interactivity Then and Now

Ask anyone to identify the distinguishing features of digital media, and chances are they will answer "interactivity." But what is interactivity, and are only digital media interactive? Remember when Web pages used to be interactive? Around 1995 or so, before Java and Javascript, Web pages were generally described as "interactive," whatever that meant. But later, after the proliferation of cgi (common gateway interface), Java, and Javascript, the good old link was no longer enough. Only Web pages with some sort of program or "applet" on them were considered interactive. Will that be enough in the future?

The genealogy of the word "interactive" is simple enough. Four decades ago, when computers slowly changed from punchcard operated to keyboard and screen operated, there was need of a terminology to describe these two modes of operation. The old machines, in which a stack of punch cards was handed over to the operator and the results could be collected the next day, was termed "batch," and the new machines, which were operated by the users directly and with much quicker feedback, were termed "interactive." The difference between batch and interactive, clearly, was one of speed and interface (direct contact with the machine). Following this semantic, both pure html Web pages and enhanced Web pages must be classified as interactive, yet they are not. So what does interactive really mean?

An even stranger use of the word can be found in the oft-used phrase "interactive games."[2] Does that mean that there are games that are not interactive? If so, is it still possible to play them? Perhaps they are "batch" games, or Web-based games that use links but no Java or Javascript?

The ease with which such ridiculing questions can be asked indicates that the word "interactive" contains no clear, analytical concept. To quote the character Inigo Montoya from *The Princess Bride:* "You keep using that word? I do not think it means what you think it means."

Rather than hiding some obscure theoretical meaning beneath the computer salesman rhetoric, "interactive" has two relatively clear connotations. First, it means computerized, digital, online, etc. Replace any occurrence of "interactive" with "digital," and the meaning of the sentence changes very little, if at all. The other connotation, following the

batch/interactive evolution, is "better." Implicitly in most uses of the word is the idea that the "interactive" object is simply better than its "noninteractive" counterpart.

Of course, definitions of interactivity do exist, and they are usually in one of three categories: (1) A phenomenon involving the exchange of information between two equal partners, typically human; (2) a situation involving a feedback loop and response; and (3) composite definitions that talk of either degrees or components of interactivity.

Of these, only (1) makes sense from a semantic point of view. The word "interact" entails a form of reciprocal relationship, which would exclude relationships between humans and things, such as computer programs. To imply that there is functional or cognitive equality between human and machine is ludicrous, yet that is the implied logic of the sales rhetoric that tries to promote "interactive teaching," etc. Definitions of type (1), such as Andy Lippman's "[m]utual and simultaneous activity on the part of both participants, usually working towards some goal, but not necessarily" (in Brand 1988: 46) or Chris Crawford's "a cyclic process in which two actors alternately listen, think, and speak" (Crawford 2000) try to take the etymology of interactivity seriously and consequently produce a definition that excludes all current human-machine communication systems.

Definitions of type (2), typically something like "reacting to input and producing output to which a user can respond," are too broad to be of use. In this definition, even a light switch would be interactive, not to mention a pinball machine. Type (3), composite definitions, usually entail breaking interactivity down into several independent aspects, such as procedural and participatory (Murray 1997: 71) or into degrees, with terms like "reactive," "proactive," "higher," and "fuller." In both cases, the term itself is disintegrated and made superfluous by the use of modifiers and replacements.

In spite of the obvious analytical problems with the term "interactivity" and its unfortunate tendency to equate and confuse human qualities with machine capabilities, there are considerable academic efforts still being made to rescue the term and fill it with conceptual meaning. Why? What is the motivation for making "interactivity" into a legitimate, scientific concept? Who gains by this?

There is obviously quite a large amount of cultural capital connected to "interactivity." Thus, it is tempting for a scholar to try to catch the slippery term once and for all and put one's mark on it. As with the electrical discourse in the nineteenth century, those who can define and explain a technological concept successfully have power, and the quest for this power may, unintentionally, supplant the quest for knowledge. But even when they are not analytically successful, these attempts have the unfortunate effect of bestowing an aura of validity and legitimacy on a marketing term with no analytical value and several negative ideological aspects. Perhaps future attempts to clarify what "interactivity" means should start by acknowledging that the term's meaning is constantly shifting and probably without descriptive power and then try to argue why we need it, in spite of this.

There is no doubt that "interactivity" has meant much as a rallying point in the funding and spreading of digital media and digital media research and that most researchers in the field have personal reasons to be grateful for this, but the rhetorical and political merit of a term should not be enough to grant it a pseudoscientific status. Or perhaps it is time to bestow an "honorary concepthood" and leave it at that.

Does Hypertext Exist?

In Ted Nelson's (1990) famous definition of the term he coined, *hypertext* is "nonsequential writing—text that branches and allows choice to the reader, best read at an interactive screen" (1990: 0/2–0/3). Clearly Nelson allows for noncomputerized forms but identifies the computer screen as the most efficient channel. Later discussions, however, have been less inclusive, and as Johan Svedjedal (2000) has pointed out, citing George Landow and Ilana Snyder, "For some scholars, "hypertext" seems to be entirely linked to the Internet or other digital environments" (56). The controversy over whether or not hypertext can be found on paper indicates the concept's ideological nature and, as we shall see in this section, is also indicative of whether hypertext is anything *other* than an ideology.

But surely hypertext is a technology? The field of technological hypertext research is well-established, with practitioners in respected institutions all over the world. Well, if it were a technology, wouldn't it have

to be clearly defined, in unambiguous technological terms? There might be many varieties, but they should have certain concrete aspects in common for the concept to remain useful. Yet there seems to be a lingering confusion as to what hypertext is and isn't (though most seem to have a better understanding than my hometown newspaper, which defined hypertext simply as "information marked in blue").

Many such attempts at concrete definitions have been made since Nelson's definition. Perhaps the most prominent is the so-called Dexter model, named after a hotel in New Hampshire where several leading hypertext researchers met in 1988. The Dexter model defined what is known as the node/link paradigm of hypertext, as well as general directions for how to implement it. The node/link paradigm, in which a hypertext is a set of text fragments, connected by active pointers in each fragment that lead to other fragments, is quite consistent with Nelson's initial vision, but in the meantime, several other ideas about what hypertext could be had been developed, as Jim Rosenberg (1998) points out: "Various alternative hypertext models have been proposed, e.g., relations, piles, sets, Petri Nets, simultaneities." The most common alternative to the node/link model is known as spatial hypertext, and within the hypertext research community, links are clearly not the only way to do things. But with all these different approaches, is hypertext still one thing (see fig. 15.2)? Many forms of digital textual communication have been called hypertext, such as adventure games and MUDs, in which the user types commands and watches the system's response, and digital poetry generators, which produce text by themselves. These expansive claims beg the question: where does hypertext end and other modes of textuality/computer communication begin? What would be a nonhypertext digital text? Is a computer game with buttons hypertext? Is a graphical user interface?

Because of its unclear borders and many influential followers, "hypertext" has come to be synonymous with "electronic textuality." So perhaps hypertext is just a word, one (dominant) name for the highly contested and diverse field of digital textual communication? A rhetorical strategy for a group of researchers to take control of a field? Rather than a technology or even a theoretical object, it seems to be a hyped, enthusiastic vision intended to produce or inspire a technology that will make a "better" tool for writing and reading.

Figure 15.2

Is this hypertext?

What is believed by many to be a concrete technology is really an ideological perspective on the larger sector of text technology in general, a vision that blinds us to the fact that it is both unclear and unlimited, not specific or material. Hypertext ideology tries to make us believe that the link will solve many of our textual and cognitive problems while at the same time holding the door open to both advanced textual automanipulation and to "spatialization," features that in no way are required by the initial vision but must be included in the paradigm, lest "hypertext" be left behind by technological progress. Like that of "interactivity," the meaning of "hypertext" seems to be fluid and changing, always focused on, or hinting at, the next, better solution.

In *Cybertext* I tried to replace the vague textual model implied by the hypertext paradigm with a more functional typology of textual/media differences. How *do* text modes differ from each other, regardless of their material base (paper or digital)? In my model, a cybertext is a general-

purpose textual machine that, among more complex things, can emulate simpler textual modes, such as node/link texts (hypertexts) and sequential texts. Thus, a node/link text is not a cybertext, just as a sequential text is not a cybertext. A node/link text is static, like a multicursal labyrinth. And like a sequential text, it does not require a machine. However, a cybertext does not have to be computerized, as my favorite example, the *I Ching,* shows.

In hindsight, it is easy (as always) for me to see that I should have been more explicit in defining the relationship between hyper- and cyber-text, since this in particular seems to have caused substantial confusion among my readers. In the book I tried to show that the perceived and acclaimed differences in hypertext theory between digital and paper-based literatures were to a large extent ideological and that paper literatures were capable of a number of "feats" that were falsely ascribed to the digital. I also rejected the widespread notion that electronic documents somehow "incorporated" poststructuralist ideas about textuality (Aarseth 1997: 82–84). Even so, one critic has put me at the "heart of hypertext theory" (Jenkins 1999: 247), among those who "build on poststructuralist literary theory to imagine digital media as reconfiguring the relations between readers, writers, and texts" (246), and another has placed me among those "who are too infatuated with technology to consider what print texts can do" (Herman 2000). Both these strange misreadings can probably be ascribed to the fact that even thoughtful critics of the "new"/digital/hypertext ideology expect other critics to obey it. Or perhaps one can just never be careful and explicit enough in critiquing ideology. It is all too easy to forget that Norbert Wiener himself subtitled his 1948 book on cybernetics *Control and Communication in the* Animal *and the Machine* (emphasis added), thus including organic as well as mechanic systems.

The Meaning of Virtual Words

"Virtual" is a dangerous word, a word full of promise but maybe not so full of clarity. It stems from the Middle Latin *virtualis* (effective), which comes from the Latin *virtus* (strength or power). In modern times it has come to mean a substitute that contains some but not all of the original's features, something that pretends to be, but isn't, something else. The

word is often used in phrases that only superficially reflect this semantic. Virtual reality, for instance, only makes sense if you do not stop to think about what it really must mean. The strong meaning of the term is simply self-contradictory (a reality that is what isn't), but in reality the term is used synonymously with "digital" or computerized. A "virtual bank," for instance, simply means a bank on the Internet, not a bank that provides you with fake money. This is the weak meaning of the term, as Michael Heim (1998: 5) has pointed out. For Heim, virtual reality is chiefly a type of presentational technology, an advanced form of interface, involving visual feedback derived from body movement and 3-D graphics that simulate realistic surroundings of some kind.

But even if we give up on extracting an analytic meaning from "virtual reality" (and many researchers have, and instead use terms like "synthetic environments" or "virtual worlds"), there might still be some use for the concept of virtuality, if we can manage to define it in a way that is useful and not too hair-splitting.

What is the "virtual"? What kinds of phenomena does the term illuminate? Can just anything be virtualized? Let me first try to answer by pointing to a class of objects that cannot have virtual counterparts. These are phenomena that exist primarily on a metaphysical level. For instance, take friendship. There is no such thing as a virtual friendship. You are either a friend, or not a friend. There are of course many degrees and kinds of friendship. In addition, false friends do exist, but they are not virtual. They fall into the category of "not friends." So "virtual" is not the same as "fake" (or there would be no need for "virtual").

Another problematic phrase is "virtual community." This term is much used, but what does it mean? Perhaps a social structure that displays many of the symptoms of a community, but isn't quite a community after all? The term is not used, as one might imagine, about artificial communities in a computer simulation (e.g., *SimCity*), but about online meeting places where long conversations, romances, and friendships are developed and maintained. It is almost a paradox that people, such as author Howard Rheingold (1994), who most strongly advocate the benefits of these "virtual communities," which they often describe as better than old-fashioned, local communities, should use this term. For although the differences between the online and the local communities are mainly

geographical distance and the medium of socialization, these properties are not what communities are based on. It seems to me that to use the term "virtual community" privileges the physical (distance and medium) above the spiritual and therefore in effect belittles the communities one tries to promote. An online community, judging by the glowing acclaims by Rheingold et al., is just as valuable to its members as any other type of community, and therefore there can be nothing virtual about it. The word "virtual" is used in this context, I suspect, as in many others (and like "interactive"), simply because it is a more fashionable synonym for "computerized" and not because the activities in the online communities are only virtually social.

This list of unfruitful uses of "virtual" could go on and on, but that is not very fruitful either. So let us examine what virtuality can offer as a descriptive term for something that cannot just as well or better be described by the more concrete terms "computerized," "digital," "on-line," etc.

Toward a Hermeneutics of Virtuality

What types of phenomena are meaningfully described as virtual? This is a big question not suited to an exhaustive answer here. I will instead point to a central group: those systems that are dynamic representations of an artificial world. There may be other meaningful uses of the concept of virtuality, but in the rest of this chapter I will confine my arguments to this group. They could also be called (computer) simulations, but sometimes (e.g., a fantasy world) there exists no real counterpart that is being simulated, and so it cannot be called a simulation, although simulation techniques are indeed used. Let us call these systems "virtual worlds."

A world is not the same as reality. There are fictional worlds, dream worlds, and imaginary worlds of many kinds. The distinguishing quality of the virtual world is that the system lets the participant-observer play an active role in which he or she can experiment and test the system and discover the rules and structural qualities in the process. This is not true for a fictional world, where the reader/viewer can only experience what the author/designer explicitly permits. In Ibsen's *Peer Gynt* I cannot ask Peer for a cigar, and I cannot go elsewhere when Mother Åse is dying.

There are no rules to *Peer Gynt,* only the words in the text. The virtual world holds a quality that makes it potentially richer than the fictional world. (This is of course a dangerous claim, but as long as we do not confuse potential richness with achieved greatness, we are in the clear.)

Current virtual worlds are still nowhere near as rich as the highest achievements of film or fiction, but since new media take time (50 years?) to mature, it shouldn't be long before virtual worlds may be counted among the most serious and influential art forms. In the popular sector, the change has already taken place: in Norway in 1999, people spent twice as much on computer games as on cinema.[3] Simulators of all sorts are used in research, teaching, and planning and for military purposes to an ever-increasing degree. In sum, this represents a fundamental shift in our culture, one that is not nearly as prominent and visible as that represented by the Internet and the World Wide Web, but with far greater potential for altering the way we learn and think.

Claims of how new technologies are altering our way of thinking should always be viewed with suspicion. Usually a new mode of communication will strengthen our habits and methods, not change them. Again, a good example is hypertext, heralded as a mode of writing that would free us from the tyranny of linear discourse and produce a more natural way of writing and reading. Isn't it strange that, when we look at the proceedings from hypertext conferences, all the papers are in linear form? One could almost suspect that the researchers didn't believe in their own invention. And as many have pointed out, hypertext, in the form of the World Wide Web, has turned out to be not a challenge to sequential writing and thinking, but a superior distribution mechanism for traditional, sequentially written texts: a continuation of print publication by more efficient means.

In light of this, it is hard to claim that new and revolutionary modes of communication based on digital technology do exist. If hypertext couldn't generate a revolution in the way we communicate, what can? It all depends on what "it" is. What can a virtual world do that could not be done before?

To explicate this crucial development, I must first discuss something else. The dominant mode of communication in our culture, since long before the modern media, is the story. Everywhere we encounter stories,

we tell each other stories, we teach and learn using stories. Storytelling is our dominant, preeminently ideological way of transmitting information and transferring experience. It is, furthermore, not a bad mechanism. But even good systems may have better alternatives. For instance, when we learn to drive a car, we are already bombarded with car stories. But that is not enough. We need to take lessons in the form of a hands-on experience. No one would teach driving simply by telling stories about it. ("When you come to the red light, you wait for it to turn green, then you push the gas pedal. Good luck!") But a useful alternative to real-road driving lessons may be a car simulator, in which the only thing missing is the real road and the real traffic, not to mention real accidents.

My claim is that storytelling, as a hegemonic means of communication, has got some serious competition at last. In the natural sciences, before we build expensive lab machines and buy costly materials, we can simulate the effects of our experiments using accurate, dynamic models. Earlier, scientists might tell themselves a story about what was most likely to happen given a certain setup, but they had no easy way of testing the hypothesis without completing the experiment. These days, the speculation takes place in a computer model, not just in the scientists' heads. A possible course of possible events becomes a real course of virtual events, and problematic details that previously might have been ignored or taken for granted can now be identified and taken into account.

When we simulate a phenomenon, our ignorance can't be hidden or controlled but must be faced directly, or the simulation will produce tell-tale results about our false assumptions. *This principle holds for all computer-related work,* from BASIC programming to making errors in a game of *Quake.* It is perhaps the most defining quality of computer technology. In the following, I will use computer games to illustrate the difference between these two discursive modes, between game/simulation and story.

But first, what is a story, and why can a game not be a story? Games and stories are often confused, partly because the study of computer games is conducted largely by literary theorists or film scholars, and they have a tendency to find the object of their theory in whatever empirical field it is employed. Also, stories and games contain many of the same elements—events and existents—but then again, so does life itself, and we

do not call life a story. There are many stories about life, but life itself is something else. Games are also more fundamental (primitive?) than stories; they give rise to stories of many different kinds. A game of football can be narrated in many different ways, depending on the position and the knowledge of the narrator. But the football game itself is something other than a story and unfolds according to different rules. Games are closer to life, since they demand that we act to the best of our abilities, rather than passively observe the events.

In *X—Beyond the Frontier,* a German science fiction game from 1999, the player is dropped into an open, unknown world. There he may pursue many different destinies and careers: as a trader, a factory owner, a pirate, a bounty hunter, an explorer. He may wage war against the various races in the world, and the only real goal in the simulation is to increase his knowledge and discover as much as possible about the world. In doing so, the player learns spaceship flying and combat (and that can be useful someday), commodities pricing and trading, planning ahead in a complex market economy, and so on. The game is very open, and there are few obvious clues and cues about what to do. This is well illustrated in the online discussion forum for the game, in which players tell each other about the outcomes of performing various experiments in the game ("I bought 300 fighters, destroyed all the jump gates but one from the enemy sector, and sat back and watched the ensuing battle"). In this game, it is not important what the designers may have wanted players to do, but to find out for yourself what you can do. With luck and imagination, it may be something that no one has done before.

Hermeneutics is the theory and practice of interpretation. It is as old as the humanities and started out in the studies of classical and biblical literature. It is oriented toward texts, but any type of sign provides a legitimate object of study. The basic tenet of hermeneutics is that understanding is gradual, a circle alternating between the parts and the whole and thus closing in on a better view of the world, but with the realization that there can never be a final, closed interpretation. New aspects will always come into play, and the process never stops. The hermeneutic circle is a suspiciously good model for the computer-based work process, from programming (coding, compiling, running, debugging, coding, compiling, etc.) to gameplay (problem, solution, new problem, new solution, etc.).

In the construction of virtual worlds, hermeneutic principles are clearly at play in both the construction and the exploration of these systems. Simulation is a technically advanced form of interpretation in which the results of the model at an early stage are used to fine-tune and modify it, thus producing a gradually better, but never complete, model. Following this insight, we can postulate that virtual-worlds technology is not about creating alternatives to reality, but about interpreting and understanding our own reality. Until now, narrative has been the privileged object of hermeneutics, but now we should see virtuality as a strong contender for the attention of the hermeneuts. In a way, narrative is a type of interface, a way of transporting the subject matter to the recipient. But now there is a newer, perhaps better interface, especially useful for conveying complex, spatial, and temporal relationships. In short, virtuality, seemingly the least concrete of our three words, may have the most to offer as analytical concept. The virtual, as a communicative mode parallel to stories, represents something truly new: an innovation not only of technology but of how we interpret and represent the world.

Conclusion: The Politics of "New Media" Studies

How do ideology and innovation relate? The common conception seems to be that there is a fundamental dichotomy, that important new media and new technology are created despite the hype from the industry. One such example may be Linux, a free operating system developed collectively through the Internet since 1991, without funding, marketing, or a formal organization. Anyone can participate in, and will be allowed to contribute to, the development of Linux, if their effort is good enough. Linux is better than the commercial alternatives, notably Microsoft Windows NT—or so the story goes. In reality, Linux is driven by as much hype as Microsoft, and with strict hierarchical channels in which power over the kernel (the core of the system) is no less prestigious than at Microsoft and handled by a small clique. Linux is driven by a different ideology, the open-source/free software movement, but is of course no less ideologically determined than the commercial software industry. Ironically, the buzz surrounding Linux has largely coincided with the largest stock bubble in recent history, so even as the Linux movement presents itself as an alternative to industrial

capitalism, it is also a recipient of the wealth from the system it is seen as a critique of. Rather than denying each other, Linux and the system of industrial capitalism have appropriated each other, and as with the equally ambiguous war between the music copyright holders and the "free-sharing" movements, for a while led by Napster, it is hard to say which, if either, will come out on top.

In any case, the relationship between innovation and ideology should not be seen as dichotomy but as symbiosis, in which the "hype" (the overdone rhetorical product of an ideology) is an essential (but not sufficient) element in building new technologies and media. Words, even and perhaps especially *unclear* words, are among the necessary building blocks of technology, which they prefigure, inspire, and sell. As long as we don't mistake these entrepreneurial terms for scientific ones, there is nothing wrong with them, not even ideologically.

The three terms criticized in this chapter—interactivity, hypertext, and virtuality—all display different ideological patterns and uses. All three are linked to the vision of how the computer will make our lives better, and all three are tainted by their proponents' lack of analytical rigor. The first two were promoted from being relatively clear technical terms to become vague, totalist notions of the improved nature of future technologies. In my diagnosis of their analytical and academic value, these two are terminally (or at least terminologically) ill, whereas I think the third term, virtuality, can be saved for a very important descriptive task: to help us understand how computer technology is indeed and *already* offering something *new* to human discourse.

For an academic like myself, the real problem with ideology is of course academic, not industrial. Academic research and innovation is nothing if not also entrepreneurial, ideological, and the like, and so we get rhetoric, hype, and buzz that is disguised as scholarship. Take, for instance, the budding field of "new media." How did such a vague ideological term end up as the name of a would-be discipline, in competition with strong contenders such as multimedia, hypermedia, digital media, interactive media, and computer media? (Or why not just skip "media" for the more general "communication"?) As the saying goes, that is a good question. But what implications does it have? As already noted, the literal focus on the *new* will almost certainly carry the ideology of novelty inside.

Espen Aarseth

Equally problematic is the second part of the phrase, *media*. Is the *mediation* of the new digital communication technologies their most important aspect? In that case, why could not the old media studies take care of those aspects? (In a wise move, the Humanities Department at MIT has named its graduate program in the field "comparative media studies," to keep the historical perspective and not privilege any one material technology.) I fear that "new media studies" will come to privilege the visual aspects of computer-based communication, in homage to the field it merely *seems* to grow out of, media studies. From the flat surfaces of the mass media (newspapers, cinema, television) to the flat screen of the computer there exists a dangerous semiotic shortcut. The more important aspects of "new media," its virtual and discursive aspects, needed to understand the workings of the *new* in the new media, may well be marginalized by the current ideological focus on images, just as the visual was neglected by the first wave of media theorists trained in textual theory and semiotics. The coming years will be interesting times.

Notes

1. Bolter and Grusin (1999) offer two definitions of *medium:* "that which remediates" (65) and "the formal, social and material network of practices that generates a logic by which additional instances are repeated or remediated, such as photography, film or television" (273). The first definition, like the point of their book, does describe an interesting and quite important aspect of some media but is too circular and particular to work on its own. The second does not address the communicational aspects of media and seems to describe material, artifact-producing processes (e.g., the car industry) better than signifying ones (e.g., telephony).

2. According to google.com this phrase occurs 133,000 times on the World Wide Web.

3. The computer game business in Norway had a turnover of almost 1 billion NOK in 1999 (*Dagens Næringsliv,* February 21, 2000); Norwegian cinemas grossed only 487 million NOK in 1997 (State Statistics Bureau).

References

Aarseth, E. (1997) *Cybertext: Perspectives on Ergodic Literature.* Baltimore: Johns Hopkins University Press.

Arnold, W. (2000) "Manila's Talk of the Town Is Text Messaging." *New York Times,* July 5. Available at ⟨http://www.nytimes.com/library/tech/00/07/biztech/articles/05talk.html⟩.

Bolter, J. D., and R. Grusin (1999) *Remediation: Understanding New Media.* Cambridge: MIT Press.

Brand, S. (1988) *The Media Lab: Inventing the Future at M.I.T.* Harmondsworth, UK: Penguin Books.

Campbell, T. (1998) "The First Email Message." *Pretext.* Available at ⟨http://www.pretext.com/mar98/features/story2.htm⟩.

Carey, J. W. (1988). *Communication as Culture: Essays on Media and Society.* Boston: Unwin Hyman.

Crawford, C. (2000) *Understanding Interactivity.* Available at ⟨http://www.erasmatazz.com/Book/Chapter%201.html⟩.

Finnemann, N. O. (1999) "Hypertext and the Representational Capacities of the Binary Alphabet." Aarhus, Denmark: Aarhus University. Available at ⟨http://www.hum.au.dk/ckulturf/pages/publications/nof/hypertext.htm⟩.

Gibson, W. (1991) "Academy Leader." In M. Benedikt (ed.), *Cyberspace: First Steps.* Cambridge: MIT Press, 27–29.

Heim, M. (1998) *Virtual Realism.* Oxford: Oxford University Press.

Herman, L. (2000) "Digital vs. Traditional?" Review of Marie-Laure Ryan (ed.), *Cyberspace Textuality: Computer Technology and Literary Theory. Electronic Book Review 10.* Available at ⟨http://www.altx.com/ebr/reviews/rev10/r10her.htm⟩.

Jenkins, H. (1999) "The Work of Theory in the Age of Digital Transformation: In T. Miller and R. Stam (eds.), *A Companion to Film Theory*. London: Blackwell, 234–261.

Kavanagh, J. (1995) "Ideology." In F. Lentricchia and T. McLaughlin (ed.), *Critical Terms for Literary Study*. Chicago: University of Chicago Press, 306–320.

Marvin, C. (1988) *When Old Technologies Were New: Thinking about Electric Communication in the Late Nineteenth Century*. Oxford: Oxford University Press.

Murray, J. H. (1997) *Hamlet on the Holodeck: The Future of Narrative in Cyberspace*. New York: Free Press.

Negroponte, N. (1995) *Being Digital*. New York: Knopf.

Nelson, T. H. (1990) *Literary Machines*. Edition 90.1. Available from the author, P.O. Box 128, Swarthmore, PA 19091.

Rheingold, H. (1994) *The Virtual Community: Homesteading on the Electronic Frontier*. New York: Harper.

Rosenberg, J. (1998) "Locus Looks at the Turing Play: Hypertextuality vs. Full Programmability." Available at ⟨http://www.well.com/user/jer/LLTP_out. html⟩.

Standage, T. (1999) *The Victorian Internet: The Remarkable Story of the Telegraph and the Nineteenth Century's On-Line Pioneers*. London: Orion.

Svedjedal, J. (2000) *The Literary Web: Literature and Publishing in the Age of Digital Production*. Stockholm: Kungliga Bibiloteket.

Wiener, N. (1948) *Cybernetics*. New York: The Technology Press.

Williams, R., and S. Cummings (1993) *Jargon: An Informal Dictionary of Computer Terms*. Berkeley: Peachpit Press.

IV

Social Theory and Ethics

16

On Distributed Society

The Internet as a Guide to a Sociological Understanding of
Communication

Terje Rasmussen

As early as 1960, the Internet pioneer J. C. R. Licklider stated, "In due
course [the computer] will be part of the formulation of problems: part
of real-time thinking, problem-solving, doing of research, conducting of
experiments, getting into the literature and finding references. . . . And
it will mediate and facilitate communication among human beings" in
Hauben and Hauben 1998: chap. 6). Licklider expressed the hope that
the computer "through its contribution to formulative thinking . . . will
help us understand the structure of ideas, the nature of intellectual pro-
cesses" (chap. 6). The "most important present function of the digital
computer in the university should be to catalyse the development of com-
puter science" (chap. 6), he said.

And so it did. As the ARPANET and other network experiments
unfolded in the 1960s and 1970s, the computer as a medium inspired
the transition of computer science toward information science. I think it
is possible and potentially constructive to go even further. In due course,
to paraphrase Licklider, one important function of the Internet may be
to inform our "formulative thinking" about society itself. The Internet
may help to catalyze not only the development of computer and informa-
tion science, but sociology and social theory as well. In what follows,

"innovation" will refer precisely to applying the Internet as a design or as an inspiration for the understanding of what society is.

This may appear to be a strange and perhaps somewhat awkward approach. Yet I think that if such a theory exists (or ideas that lead to such a theory in the future), it may be worthwhile to address the ways such a perspective may enlighten our understanding of the Internet and its social significance, at least on a general level. If central features of the Internet do in fact provide insights into the understanding of society, we may have at our disposal a more focused optics for observing structural changes as the Internet penetrates social activities.

I am in no way suggesting that the Internet has turned society into a global technological system carrying with it utopian or dystopian futures, as in the tradition of Jacques Ellul and, in part, Herbert Marcuse. On the contrary, only if we keep society and the Internet conceptually distinct from each other may we heuristically play with the Internet structure as a theoretical idea or model of society. I propose to go one step back and to look for sociological insights that seem most compatible (commensurable) with the logic of the Internet. I will simply suggest, as a heuristic idea or thought experiment (in an attempt at being innovative), that central features of the history and anatomy of the Internet may transcend the technological and then may point toward central aspects of society as well. Or so as to avoid mechanistic or naturalistic fallacies, central features of the Net may direct us toward basic ideas that are addressed in the discourse of sociology. I would like to suggest that the Internet, by its technical development and structure, hints at what I like to call a "distributed society."

But why should the technical solutions that make up the Internet lead us to more sophisticated knowledge about communication and society in general? One answer is that the explosive success of the Internet indicates some sort of "compatibility" between the development of the Net and the transformation of the societies in which it operates. After all, ARPANET and later the Internet and other information-technological changes are as much social as technical innovations. In other words, the general evolutionary forces that lie under the innovation and development of computer technology and the Net also affect social change. If we want to approach the Internet's rapidly growing significance for general social

change, it seems logical to begin with the success of the Net. It is also worth noting that both society and sociology seem to converge in an increasing focus on communication. First, society is turning more and more toward information and communication as vital aspects of the economy. Notions such as the postindustrial society, the information society, and the network society illustrate this new turn. Second, sociology, as well as human thought in general, has gradually turned toward language (the linguistic turn) as a focal point of research. The next step, I believe, is the contextualizing of language in a more general concept of communication. This is latent in the social theory of Jürgen Habermas and explicit in the sociology of Niklas Luhmann (1928–1998). Consequently, studies of the Internet may inform a concept of communication that is highly relevant for the information sciences as well as the social sciences. And in the next instance (as is my underlying purpose of addressing this) such insights about the nature of modern communication may help us to understand the social significance of the Internet in contemporary society.

In this chapter, then, I shall draw upon some elements of the history of the Internet to approach sociological insights. I shall do this by briefly recapitulating selected stages or episodes in the social history of the Internet to draw some parallels to sociological theory. I shall discuss a communication perspective on society, the relationship between communication and its environment, the relationship between communication systems, and the nature of "human-society interface." I address phenomena in the history of networking, such as packet switching, layering, and the controversy over standardization.

Particularly, I would like to argue that technical features in the history of ARPANET and later on the Internet indicate a *systems-theoretical perspective* on society, and of course, on the Internet in that society. Luhmann modifies structural-functional sociology, general systems theory and cybernetics to show that communication always produces social *systems* of various kinds (interactions, organizations, function systems), which produce and reproduce themselves through sequences of communication. Since it is impossible to fully articulate his general theory here, I can only briefly indicate the importance of communication in the self-production of societal function systems, such as art, politics, economics, and science. The self-steering nature of the system (autopoiesis) implies that the system

is autonomous; it produces itself through its communicative elements, in contrast to what that communication observes as environment. For example, political communication (through the symbolic medium of power) distinguishes itself from the sciences, which communicate through the symbolic medium of truth. Communication concludes preceding communication and enables connecting ones. In this way, communication always reproduces the difference between the system and its environment and reproduces itself as autopoietically and operatively closed. Through this autopoiesis, the system is deemed to increase complexity as it expands and more relationships develop or become possible. But the system also develops abilities for handling this complexity, by introducing representations of the difference to the environment into the communication of the system (reentry). Function systems relate by observing each other, communicating about each other internally, and linking structurally to each other, but not by communicating. Together, all social systems and protest movements make up society.

Communication, Nothing but Communication

Partly because of the popularizing of the theory by Warren Weaver, Claude Shannon's *Mathematical Theory of Communication* (1949) received considerable attention in a number of academic disciplines. At the time, there was a general feeling that Shannon's theory finally made communication theory into something that could be applied scientifically and that it transformed communication theory from guesswork into science through the quantitative measure of the effectiveness of communication (Hauben 2000). As John Durham Peters (1999: 23) notes, the new theory brought forth a host of concepts and understandings in a number of sciences like psychology, psychiatry, biology, and therapy. Concepts like feedback, information, coding, storing, signaling, and control became part of the vocabulary in management science, economics, computer science, and communication studies. In fact, this tendency seemed to express a quest for a unifying science, latent since Descartes, as a compensation for the unstoppable differentiation of academic thought.

The enthusiasm about communication research sparked by Shannon's theory paved the way for new ideas about the relationship between

humans and computers in the 1950s, especially at MIT. Licklider, the visionary head of the Information Processing Techniques Office in ARPA in the mid-1960s, turned ARPA's attention in the area of computers away from control and command research and toward communications. The focus on the computer as a machine was transformed into a focus on computer networks. As the ARPA completion report states, "the ARPA theme is that the promise offered by the computer as a communications medium between people, dwarfs into relative insignificance the historical beginnings of the computer as an arithmetic engine" (in Hauben 2000: chap. 7).

Shannon's communication model stresses that what is of importance in terms of communication is whether or not a message that has been transmitted reaches its destination. To calculate the probability of this, Shannon distinguished among signals (which are transmitted), noise (which reduces the signals), channel (which transmits the signals), and messages (which are sent and received). What is critical in this model is the nature of the signaling. If, in relation to the other variables, the signaling or coding is well adjusted, the messages are most likely to reach their destination. But Shannon's model is a model of analog communication. The problem of noise, which analog line switching attempted to solve through introducing ever more efficient exchanges, was approached differently by the ARPA project. Neither perfect transmission of signals nor transmission without noise was imagined. In fact, only by assuming noise could communication and its contingency be understood. Transmission was more realistically handled through redundancy of routing alternatives and the retransmission of packets (perhaps through different routers) until all were received and reassembled into messages. This was possible only through a feedback or error mechanisms that continually informed the sender of the fate of each packet. If transmission was successful, more signals were transmitted. If transmission was less successful, fewer signals were transmitted. In fact, the ARPANET project toned down the aim of perfect transmission as a challenge for computer communication research in favor of tackling problems related to detecting errors and retransmission.

Similarly, from the point of view of social communication, Luhmann argues that communication is not about transmission through the

means of a medium, since the sender does not give up anything that the receiver acquires. Furthermore, communication is not about the ability of the sender to get his message across, but about the understanding of the receiver. What is received may be quite different from that which was sent. The identity of a message lies in the *reception* of the message. For Luhmann, communication is not about transmission but a result of three selections: information, utterance (*mitteilung*), and understanding (*verstehen*). Communication emerges only if all three selections are made. Information is the selection of something in the world that can be uttered in some way. Information is the meaning construction of something that potentially can serve as a message. It actualizes something from the infinite latency of human existence. Next, an utterance or message must be selected, which refers to the expression of the information in some distinct fashion, through some language or image, through the telephone or television, etc. An utterance is interpretable as a selection. Only when an utterance is produced does the third selection, understanding, come into play. Understanding refers to the change in the state of the one who receives the utterance. Understanding is a selection based upon a distinction between information and utterance. For more communication to follow, however, the receiver must confirm or manifest herself through some reaction to the information or utterance of the sender. Therefore, there is always something in communication that works to enable new communication (through questions, friendliness, provocations, appeals, etc.). Social systems can reproduce themselves only if communication follows preceding communication. This is precisely the constant challenge for modern communication. It cannot rely fully on moral and normative support, as did communication in traditional society.

Communication is therefore notoriously unreliable and contingent. Luhmann's term "double contingency" refers to the idea that the communication process is open to interruption in at least two places: if the sender ignores selecting information or an utterance and if the receiver fails to select or act on the understanding. Communication may always break down, and in fact, it often does. Contrary to Habermas, Luhmann argues that there is no rationality embedded in communication, only vulnerability. Support for communication is supplied from the environment in the shape of media, culture, and a number of other social phenomena that

society invents to keep itself going. In such a perspective, sociology should not hide in idealized versions of communication but should assume noise. Only with such a realistic approach can sociology be truly critical. In this way, sociology may uncover how communication takes place in spite of its improbability. From a technical point of view, this was the challenge of packet switching and distributed routing. If sociology follows the ideas of the early ARPANET days, I would argue, the sociological emphasis moves away from the intention of the sender and the normative and pragmatic reason of the message toward communication as flow or process, emphasizing the medium that keeps communication going.

Communication and Survivability

More scientifically speaking, what *is* the problem of communication? In an early ARPA memo, Licklider writes: "Consider the situation in which several different centers are netted together, each center being highly individualistic and having its own special language and its own special way of doing things. . . . Is it not desirable or even necessary for all the centers to agree upon some language or, at least, upon some conventions for asking such questions as 'What language do you speak?' At this extreme, the problem is essentially the one discussed by science-fiction writers: How do you get communications started among totally uncorrelated sapient beings?" (in Hafner and Lyon 1996: 38).

Not only is the problem formulated by Licklider essential in science fiction, but it is important for sociology as well. The sociologist might have reformulated it as follows: "How does society enable communication in a world of complexity and contingency, in a world that no longer is morally integrated through the taken for granted−ness of the authority of ancestors, God, or the nobility?" Communication no longer has anything to fall back on but itself. So how is risky and improbable communication made less improbable? Licklider's way of posing the problem (communication as something complex, contingent, and even improbable) stems from multiple sources like Norbert Wiener's cybernetics, various responses to the communication theory of Claude Shannon, and subsequent basic systems research in the 1950s. For example, the notion of feedback suggests not only that sociability implies the constant interplay of viewpoints and

arguments, that is, as communication, but also that such a communication-oriented society is an unstable society. As Wiener pointed out in several contexts, the more information, the more *misinformation* and risk of breakdown. Let me illustrate some aspects of this understanding of communication with the case of Paul Baran's well-known research on distributed networks, published in a collection of papers in 1964.

In the early 1960s, and as part of the flexible response strategy of the United States during the Cold War, robust and survivable communications networks were a widely recognized ideal. The flexible-response strategy required that political leaders be able to continue to communicate during nuclear crisis. At the Rand Corporation, Baran worked on the problem of combining survivability and high capacity for three years. A central principle in Baran's theory was "distributed communications," the technique of which differed from those of traditional telecommunications systems, which relied on hierarchical layers of exchanges. In the traditional system, each user (phone) was connected to only one local switching node, and each local switching node served a large number of users (Abbate 1999). As opposed to this, distributed communications (or distributed networks) signified many switching nodes and many links attached to each node. The system built in a high degree of network redundancy to make it more difficult to isolate users. Knocking out some nodes could not paralyze the whole network. The improbability of communication through long-distance networks was thereby made less improbable.

The principle of store-and-forward switching, which Baran adapted, made it possible for information to follow different routes to its destination. Each "message block" was labeled with information about addressee and address, and this was passed on from one switching node to another. Baran developed this further into what was to be called *packet switching*. Messages were transmitted in digital form and could be recognized as voice, text, or computer data. They were all binary digits, or bits. These bits were sent in fixed-size message blocks. Each block carried its address as well as other control information. Each block that made up a message was routed independently, and the message could be reconstructed at the local switching node so as to be comprehensible to the receiver.

Baran's point was that this method of packet switching increased the survivability of the network, in that routes could be changed locally

at any moment. There was no central command center, nor were there preset routes of communication. This increased potential survivability, which according to Baran is "a function of switching flexibility" (Abbate 1999: 13). In fact, Baran replaced the well-established principle of reliability with that of "link redundancy," which again would better serve the aim of survivability. Whereas AT&T worked on increasing the reliability of the telephone network (diminishing error rates) by making each switching node as reliable as possible, Baran provided redundancy of lower-quality nodes to compensate for errors.

The principle of packet switching and distributive routing resulted in a design that could work under less than perfect conditions. It did not aspire to perfection, as did line switching. In other words, where communication is vulnerable and often fails, one cannot work for or presuppose ideal conditions. Rather, the role of the system is to make improbable communication possible.

Distributed routing and packet switching signified an entirely new way of thinking about telecommunications. The number-one priority was no longer to reach perfectibility in the switching by working to reduce noise and error rates. Communication was now viewed as something that always was, and always would be, risky and improbable. The ideological climate of the Cold War probably contributed to this idea of communication as something risky. Communication needed a plan B, that is, alternative ways and routes to reach its destination. From a *traditional* telecommunications point of view, communication was something that worked more or less perfectly, and the challenge was to improve all the switches so as to reach a noise-free system. From a *computer* communication point of view, communication was something that would always break down now and again. According to this view, ways should be available to ensure communication under risky conditions. The approach stressed realism rather than idealism, robustness rather than elegance, with emphasis on the workable rather than the perfect.

Like Luhmann's communication theory, this was *not* a view that in any way saw communication as of less importance or value than in other perspectives. On the contrary, this approach implied that in times of crisis as well as in modern civil life, communication is even more important than computing. In times of trouble, the primary purpose for computers

would be to support data transmission. Large, high-capacity computer nodes were not imperative, but many computers were. Communication was seen to be too important to be perfect. What was important was that communication work, meaning that in most cases communication is succeeded by more communication.

Baran's *On Distributed Communication* was published in 1964 but did not receive wide attention until the late 1960s. It is interesting that this work was carried out within a military framework and justified by defense-strategic considerations. Military concerns and priorities were the driving forces behind ARPANET throughout the 1960s and far into the 1970s. "The use of new communication media was meant to make it easier to tailor command and control systems to specific military environments. . . . The idea that network protocols should be simple and adaptable derived in part from the military's continued concern with survivability" (Abbate 1999: 144). It is correctly observed that the Internet was not built in response to a market or popular demand, but that "the project reflected the command economy of military procurement, where specialized performance is everything and money no object, and the research ethos of the university, where experimental interest and technical elegance take the precedence over commercial application" (Abbate 1999: 145).

Baran's scenario of a possible nuclear disaster should *not* be seen as an exception to normal conditions of communication, but rather as an extrapolation of the risk that is *always* at play in social communication. This is in accord with Luhmann's sociological perspective, stressing communicative vulnerability, which, so that communication may be sustained, leads to technological and symbolic media, along with culture. Technical media make it possible to maintain communication in a large-scale and globalized world; symbolic media supply communication with language or language games that make understanding a less improbable task. Culture supplies communication with themes, that is, something to communicate about. Also, in contrast to line switching, the structure of packet switching proposed communication as nonhierarchical, symmetrical, and functional.

By linking Baran's ideas to Luhmann's, we may see that the military view of communication (as in constant danger of breakdown) can be re-

garded as applicable to *all* communication. Imagining communication during times of crisis and disaster crystallizes what applies to communication in general but is hidden behind the seeming naturalness of daily life. Communication is constantly subject to "disaster." From this constant threat, two theoretical positions may be identified. The first is the one that hopes and works for a world of perfect communication (socialism, perfect democracy, unrealized modernity). The second considers risk and contingency to be embedded in communication itself and thus seeks to modify damage by backup measures.

Most theories of communication, notably the Chicago school, but basically all humanistic versions of communication, seem to be compatible with premodern features of society (social integration, society as action, norms, values, as a moral whole). Luhmann's theory is one important exception. If we now switch to the technical world, predominant perspectives on communication seem to parallel the traditional telecommunication model of analog line switching (as opposed to digital packet switching), which did not operate with a basic distinction between content and communication. In this view, content (electromagnetic pulses) were to be transported from user to user through a switched network of sufficient quality to keep the noise below a certain level. In spite of the heavy critique that has been directed toward linear models of communication (from Shannon's model onward), from the tradition of human communication, transmission is still what is stressed.

In the ARPANET project, communication was seen as contingent and risky. What mattered was that the packets transmitted reached their destination and formed a comprehensive message. ARPANET did not view communication as following preestablished transmission hierarchies. This enabled the project to come up with ideas on packet switching and distributed network communication among servers, rather than focusing on perfect end-to-end transmission.

Communication in a World of Diversity

Another example of the "letting go" approach of the Internet is the controversies over standardization in the 1980s. The transmission control protocol/Internet protocol (TCP/IP) was the official standard for

communication at the beginning of the 1980s, but only one among many others. Its principle on internetworking was new and expressed a quite different view on computer communication from that developed through more authoritative channels, notably the CCITT, which produced the X25 standard in 1976. By the early 1980s, the freely available TCP/IP had been in use for several years, and an international Internet community was already vibrating.

CCITT, a branch of the UN International Telecommunication Union, was dominated by the public telecoms and expressed a tradition of analog line switching. Representatives from the British, French, and Canadian telecoms headed the group that developed the X25 recommendation. Consequently, X25 assumed that one central body would be responsible for the maintenance of the computer networks that the Internet would connect. Whereas TCP/IP assumed that each node in a network would be responsible for its own transmission and that control and error recovering would be functions of the servers, X25 assumed that such a central function would lie in the network, thus within the telecom's operational responsibility. As public agencies, they could not simply delegate important functions to private servers beyond their reach. As a telecommunications recommendation, X25 assumed that the transmitting network could maintain the quality necessary for the transmission. The public telecoms did not want users to operate some of the protocols in the X25. Also, X25 operated with simple gateway solutions, since it assumed that the networks that would be connected were homogenous and would use X25. The existing differences between networks were seen as a problem that would be eliminated by the official standard.

TCP/IP had different preferences. As it was a standard only for those explicitly interested in decentered networking, it did not need to take on public obligations. It simply assumed that the hosts could perform the signaling and control functions, independent of the network itself. It did not assume transmission without errors; on the contrary, it assumed problems to be normal. TCP/IP derived from the computer-based world of risky communication, which emphasized mobility, flexibility, and relatively low investment.

The differences between the two standards were later to be resolved through the OSI model. But the Internet has long since confirmed itself as

drawing on a new and different perspective of computer communication. Communication needs support, rather than impossible dreams of perfection. The Internet has left the old world of homogeneity and, along with it, the notion that standards mean central standards for all steps in the transmission process. Certainly, the controversy over standards can also be seen as a conflict between private initiative and government responsibility and between American and European interests in dominating the telecommunications field. In a more general sense, this illustrates that telecommunications no longer means what some control body defines it as, but that it has become something much closer to communication itself and thus a question of how to independently communicate effectively about everything. The Internet suggests that communication between computers will increasingly be as diverse and changeable as human language itself. One does not regulate oral language: it is up to each one of us to make ourselves understood through the medium of language.

Communication and Agency

If the packet switching of the ARPANET was an answer to the vulnerability and complexity of communication, it also added to these problems. The decision to use packet switching for ARPANET transmissions was a risky one. The technique would increase the uncertainty and complexity of the system design. Communications professionals reacted with hostility to this decision. Packet switching seemed too difficult to be performed reliably and automatically. Another factor that added to the complexity was the great variety of computers that the network was expected to connect. Machines from IBM, DEC, G.E., and UNIVAC were involved, as were unique experimental computers like the ILLIAC supercomputer. Since they were all incompatible, complex programming for accessing data from other computers was required. From a conventional telecommunications perspective, this looked like a severe weakness of the ARPANET design. The heads of the project, however, regarded this as a strength and as a research challenge that would have to be met. The future of networking would be heterogeneous. An architecture designed to accommodate a variety of computer models enabled the Internet design to adapt to an unpredictable future of digital technologies.

The solution to this problem of diversity was to find a way to ignore it! The first step was to decide that all host computers should implement a standard set of rules, called message protocols, for handling network connection. This would help to overcome the problem of incompatibility among different types of computers. But it also created a big complexity problem for the local sites, which had to add these protocols to the various computers. New technical solutions were required.

As Abbate (1999) notes, "the ARPANET's approach to routing reflected its designers' commitment to exploring new techniques and building a high-performance network, even at the price of creating a system that was, at times, difficult to understand and control" (62). Still, the idea of distinguishing between host and communication layers served to reduce complexity. Each of the host computers was attached to a subnet of minicomputers that acted as the host computer's interfaces to the network. It was no longer the hosts but the minicomputers, or interface message processors (IMPs), that would be the nodes of the network and would handle the packet-switched networking. The subnet design created a functional division of labor between switching nodes and the communication (IMPs), on the one hand, and the hosts, which were responsible for the content of the communication, on the other. Communication could now be processed by a single type (or some few types) of minicomputers, which allowed many different hosts to be connected. The ARPANET team began to see the system as being divided into two layers: there was a *communications* layer, consisting of packet-switching IMPs connected by leased telephone lines, and a *host* layer, which would coordinate interactions between host processes and provide user services.

This two-layer model was later to be extended to three and then to more layers. The host layer was later separated into a host layer, which was designed only to set up communications between hosts, and an application layer, which provided specific services like remote log-in and file transfer. This further served to eliminate the need for each specific application to set up host connections, which made it easier to produce applications. It also increased the usability of the network and the resources available. The distinction between host and application layers was later to be abandoned, when the TCP/IP protocol was introduced. But it was the beginning of the idea of differentiating functionally among layers in

digital telecommunications, as in the later ISO model. The success of ARPANET's version of layering made layering a widely used principle in construction of other networks (Abbate 1999: 80), and to a large extent, it is precisely this principle that enables everyone to go on- and offline, to select among a wide variety of applications, and to use a wide variety of terminals. User-friendliness and availability, in other words, rests on the distinction between applications and networking. This distinction allows for the two elements to be linked more flexibly. The system moved from ambitious integration (as in the case of the analog line switching of the PTTs) to flexible compatibility. The point here is that this model was viewed as a way to reduce complexity by making distinctions between content or services and communication (switching and distributed routing). This proved to be the functionally best way to resolve the problems of diversity and complexity to which the choice of packet switching had led.[1]

The novel thinking in the ARPA project with regard to handling computer diversity points to an interesting way of looking at social communication in general, again departing from most humanistic approaches. An exception here is sociological systems theory. One radical conclusion from Luhmann's communication perspective is that humans (psychic systems) belong to the environment of society. Human beings (consciousness, bodies) are not *in* society. As Luhmann often puts it, consciousness can be reproduced only by consciousness (thoughts), and society can be reproduced only by communication. Thoughts enable communication but are not in it. This allows Luhmann to construct a theory of communication systems and to concentrate on communication problems. He does this by asking Licklider's question: how is contingent communication among different people, strangers and over distance, possible in a complex world? What in communication triggers further communication? What error mechanisms are operative? As I have indicated, these are the questions that were asked in the ARPANET project and led to a number of innovative resolutions. The focus was on protocols and mechanisms that enabled repeated messages in case of breakdown. The terminals and their human operators enabled communication, but as we have seen, they were not part of the network as such.

Another approach to this is epistemological: what society is can only be described or observed by someone. At the most general level what

society is can only be observed by society itself. Consequently, self-descriptions are always involved. Sociology, for instance (as a discipline dedicated to observe society and located among the disciplines of the sciences), produces descriptions (analysis, research) of society in society. Naturally, this lack of ontological grounding in an understanding of society leaves us with formidable epistemological challenges. If society is a product of descriptions, then the only meaningful element of society we are left with is these descriptions themselves, hence, communication. Society, then, is the product of all previous and possible communication.

One single human being cannot communicate. Two or more human beings can communicate, or rather, they *enable communication* through their selections of information, utterances, and understandings. As mentioned, Luhmann views communication as a synthesis of the selections of information, utterance, and understanding. It is important to note that Luhmann moves away not only from a transmission perspective, but also from the sender and, in part, the receiver. The three selections made in communication are produced by the communication itself. Decisions by human beings (utterances, replies, etc.) are executed on the basis of communication. Communication is always an effect of preceding communication.

From this it appears that society is communication and that what is not communication belongs to the environment of society. After all, it makes little sense to say that society consists of human bodies, trees, or computer terminals. Society never catches a cold, never needs insulin, and never thinks. Luhmann asks: Does the society consist of arms, legs of thoughts or enzymes? Does the barber cut the hair of society? Similarly, we may add: Does society work or not work? Does it need to be upgraded? We may be tempted to suggest that it certainly does, but only metaphorically. Society cannot but upgrade (differentiate, restabilize) itself through communication.

This view does not indicate a downgrading of the individual, since the environment of society is as important for society as society itself. This means that society is not—is no longer—something of which each individual is a part or of which computers and transmission networks are part. Today, the individual can say yes or no to what the modern society offers if the structural conditions allow it. Modernity signifies the emanci-

pation of the individual from society. The individual may act as if collectively involved, but his or her mind may go its own ways. Individuals think, technologies function, and society communicates. Without sustainable communication, there can be no defense, no commercial activity, no scientific possibilities, and no society. What does not communicate belongs to the environment of society.

Second-Order Communication

The Internet is a network of networks, and a network of networks of networks consisting of an enormous quantity of terminals and hosts. How many, no one knows. Not even the Internet knows, and it does not need to know. What the Internet is concerned about, so to speak, is that bits reach their addressee. To see this, we need to distinguish between an operative and a monitoring level. As we have seen, the routing of bits in the Internet follows the principle of distributed control. Communication does not simply take place, however; it also monitors itself in that communication. Lost communication is observed, and new communication is retransmitted. But the Internet cannot see threats (spam, viruses) that cannot be seen through its inherent monitoring mechanisms.

These points can be traced in Luhmann's theory as well. For Luhmann, communication always appears as operations and observations. In operations, there are elements in communication processes that produce the system communicatively. But in modern society, communication is also observation. Communication always observes (comments upon, refers to, reacts to, etc.) other communication, as it is always itself observed. Communication always observes other communication, that is, reflection. Society then is communication about communication: second-order communication. The human sciences, journalism, politics, and so on contribute to the self-observation and self-descriptions of society. This is intended to add transparency and a clearer view of the horizon of possibilities and alternatives. But this again, of course, furthers new complexity. Through second-order communication, social systems observe themselves. This enables some degree of flexibility and control of the increasing complexity in their environments. But social systems cannot see themselves outside their own communication. The system never gets access to its "true

nature." In Luhmann's terms, social systems can never see what they cannot see that they cannot see.

World Society from Integration to Couplings

In early 1973, a project on internetworking developed that suggested how the networks initiated or supported by ARPA could be interlinked into what was to appear as one network. The project and the then-established International Network Working Group worked to reach an informal and international agreement on Internet standards. The crucial premise in the project was that digital technology and various networks needed to interconnect if they were to have a central role in the future. Other projects in France, Britain, and the United States worked on similar problems. At a seminar at Stanford University in 1973, Vint Cerf and Robert Kahn introduced what they called the transmission control protocol (TCP), which subsequently became the standard host protocol on every network built by ARPA. The protocol deviated from the ARPANET solution in that more advanced error recovery mechanisms were introduced. It also revised the two-level model involving a host layer and a communication layer. The new solution was motivated by the fact that if the number of networks in the ARPANET were to increase substantially, the internetworking would break down without a common protocol. The TCP would also create the illusion of one network, which would facilitate the network's use. As British Internet researcher Donald Davies noted in the 1960s, user-friendliness is all about simulation. To this we may add that a user interface simulates communication as easier than it is.

As a solution to what was called the multiple-network problem, the Internet ended up embodying the idea of open-architecture networks. The architecture of the Internet does not dictate the choice of individual networks but enables internetworking with other networks through a meta-level (Leiner et al. 1997). This move to open architecture signified the beginning of the end of ARPANET and the beginning of an Internet that allowed for other networks to link up.

The innovation of TCP marks another step toward loosening up elements of the network to rely on a more flexible and independent system. The choice of packet switching and distributed networking was the

first such step. The host-IMP distinction was the second, and the interconnection of dissimilar packet networks was another. At the time, the world of networks was already becoming rather diverse; there were different solutions operating in France and Britain. The question was no longer how to integrate several networks into one, but how to transmit computer data on heterogenous networks without requiring substantial changes in the networks. This was a formidable challenge. As Ronda Hauben (2000) comments: "Different networks mean that there can be different packet sizes to accommodate, different network parameters such as different communication media rates, different buffering and signalling strategies, different ways of routing packets, and different propagation relays. Also dissimilar networks can have different error control techniques and different ways of determining the status of network components" (note 16). The question was: how could network architecture allow such diversity?

This was the "Hobbesian" question posed within the world of information science, and the answer was not to give all power to a Leviathan in the shape of telecommunication giants. Nor was it to impose impossible demands about normative order and homogeneity of terminals or common-user-interface regulations. Rather the answer was autonomy and coupling in the shape of a common network communication protocol created by the Network Working Group. The open-architecture environment meant that each distinct network was independent of the others. There was no global operations control (Leiner et al. 1997). Second, if a packet did not make it to its destination, it would not be reconstituted by the network, but simply retransmitted from the source. Third, black boxes (gateways, routers) connected the networks, without interfering with the particular flows of bits that they transmitted. Gateways connected two or more networks and allowed packets to pass from one network to another. They relied on local networks to handle information about the overall network and about changes in other networks. Gateways were another mechanism that emphasized the distributive character of the Net by localizing particular functions to particular elements of the network, and so reducing, or rather controlling, the complexity that emerged from the growth and diversity of technology.

Host addresses were introduced. These specified the name of a particular network and the host in that network. This enabled packets to be

directed to a particular host. The address system facilitated the division between the networks and the gateways (Abbate 1999: 129). Later, in 1978, the TCP protocol was further differentiated into two separate parts, one host protocol (TCP), and one Internet protocol (IP), which made the system more robust and simplified the connection of new networks. The successful connection of ARPANET with the two other packet-switched networks PRNET and SATNET in 1977 represented the beginning of the Internet as an operating internetwork.

Today, the Internet can be seen as a global distributed system of interconnected networks allowing a wide range of communication sequences to occur and at the same time supervising, controlling, or monitoring this communication to maximize the success of transmissions. Read sociologically, the Net seems to suggest a society consisting of mutually autonomous, operatively closed systems—social systems that reproduce themselves—that are not morally integrated as in premodern times, but simply coupled through structural couplings. The Internet suggests a global society of societies without global control. It suggests a world communication system of outdifferentiated systems (networks) and a system of systems of systems that are no longer normatively integrated into one overarching structure but interlinked through gateways.

Conclusion

I have, by means of brief, historical illustrations, suggested in this chapter that the Internet, if read sociologically, can be viewed as a guide to *a distributed society,* to draw upon Baran's term. I have argued that sociological systems theory may be what the Net itself "recommends" if read as a sociological model. This may not be very surprising, as Luhmann explicitly develops his work from general systems theory (von Bertalanffy) cybernetics (von Foerster) and also theory of living systems (Varela, Maturana). Historically, general systems theory and cybernetics in particular constitute a common ground for sociological systems theory and for understanding the ingenuity of the pioneers of ARPANET and the Internet. This again may suggest that systems theory is a promising way to go for a sociological understanding of the Internet and society. To put this somewhat boldly, the creation of the ARPANET can be seen as a way of resolv-

ing the incompatibility between the traditional line switching of the telephone network and the then-emerging world of circuit technology in computers. Similarly, sociological systems theory may serve as a body of sociological thought resolving the incompatibility between humanistic, agency-oriented sociology and the modern, complex world society of self-referential communication.

In spite of this metaphorical thinking, interplaying autopoietic systems and the Internet, it is essential not to confuse technical and social realms. We should not compromise with regard to technological concepts that in themselves have no place in descriptions of human communication (homeostasis, feedback, control), forcing upon us an image of society as a technological system. Conversely, I do *not* consider the Internet to be a social system. Whether the Internet should be regarded as a technical system, I shall leave to others to debate more fully. I have simply argued that the Internet suggests that society should be observed as a social system of social systems. Internet design indicates a sociological systems perspective, which stresses communication rather than action, differentiation rather than unity, structural couplings and compatibility rather than normative integration. It suggests that society is a world society.

I have limited my discussion to the symbolic side of the Internet and considered only its plausibility as a map or design for a sociological theory of society, this in order to reach at a constructive platform for understanding of the actual role of the Internet in society. As all sectors of society increasingly put information and communication on the Internet, the role of the Net needs to be studied both in terms of general theory and with empirical specificity. Both the Internet and society are consequences of historical contingencies, as well as of evolution. Both the Internet and society could have been different under different historical conditions. Yet neither technical media nor society could avoid being faced with ever more complexity, communication, difference, and instability that in one way or another needed to be handled. One of the reasons that the Internet may serve as an adequate model of society is precisely that it has developed in response to the general, functional differentiation of society.

The background for the widespread adoption and diffusion of the Net can be understood in terms of its compatibility with modern society.

The Internet developed through processes of functional differentiation in its technical world in ways that are reminiscent of the turn to functional differentiation in the social world and that made the world modern. As a technical system, telecommunications had from the start a social and human environment that it developed in relation to. This cannot be truly understood, however, unless we think of the modernization process as an evolution of communication. It seems to me that we need to reconsider some controversial ideas in sociology associated with concepts like evolution, society as a system of communication systems, autopoiesis or self-reference, and second-order cybernetics. Sociology needs to overcome its system phobia to understand what transforms society today.

In the context of Luhmann's sociology, I think the Internet can be viewed as a category of technical dissemination media that *mediates* system communication (organizations, personal interaction, or function systems like science, politics, or art). It mediates all kinds of communication, from children's games, financial markets, journalism, and artistic experimentation to scientific publication. From here I think sociology should begin its observations of the Internet. Similar to what Luhmann calls generalizable symbolic communication media (truth, power, money, love, trust, etc.), the Internet is a set of media that manipulate system communication in time and space. An important question, then, is how the Internet influences the various kinds of communication in its temporal, social, and topical dimensions of meaning. Through its speed, multimediality, hypertextuality, interactivity, and so on, the Internet favors certain communication patterns and discourages others.

We live in a world society with tremendous capacities for both personal and impersonal relationships, because it has become possible to communicate with people around the world about all kinds of topics, through a wide variety of media. As Luhmann (1998c) writes, society "affords more opportunities both for impersonal and for more intensive personal relationships. This double adaptive capacity can be further expanded because present society is, as a whole, more complex, can more effectively regulate interdependencies between different forms of social relations and is better able to filter out potential disturbances" (13). Technical and symbolic media of communication have developed that allow for innumerable networks, independent of knowledge of the individuals involved, their

social status, their social context, morality, integrity, and so on. Luhmann continues: "Never before has a society exhibited such improbable, contingent dependencies, which can neither be held to be natural, nor interpreted solely on the basis of one's knowledge of other people" (13). Right here, the world society engages the Internet in the transformation of itself.

Note

1. It is also interesting to note that the technique of layering became a way to manage social relations in addition to its function of reducing technical complexity. Abbate (1999) notes that "designing a subnet to operate independent of the hosts made the network more robust, eased the technical task of the BBN [Bolt, Beranek, and Newman] team and allowed the team to maintain control over the design and operation of IMPs" (63). Thus this indicates another form of compatibility, that between the technical and the organizational aspects of the project. A model that stressed function distinctions in the network also became a way to sort out organizational matters.

References

Abbate, J. (1999) *Inventing the Internet.* Cambridge, MA: MIT Press.

Baran, P. (1964) *On Distributed Communications.* Memorandum RM-3420-PR. Available at ⟨http://www.rand.org/publications/RM/RM3420/⟩.

Durham Peters, J. (1999) *Speaking into the Air: A History of the Idea of Communication.* Chicago: University of Chicago Press.

Foerster, H. von (1980) "Epistemology and Communication." In K. Woodward (ed.), *The Myths of Information: Technology and Postindustrial Culture.* Madison, WI: Coda Press, pp. 18–28.

Fuchs, P. (1997) "Adresseabilität als Grundbegriff der soziologischen Systemtheorie" ("Addressability as Basic Concept in Sociological Systems Theory"). *Soziale Systeme* 1, 57–81.

Habermas, J. (1984) *The Theory of Communicative Action*. Vol. 1. London: Beacon Press.

Habermas, J. (1987) *Theory of Communicative Action*. Vol. 2. Cambridge: Polity Press.

Hafner, H., and M. Lyon (1996) *Where Wizards Stay up Late: Origins of the Internet*. New York: Simon & Schuster.

Hauben, R. (2000) "The Birth of the Internet: An Architectural Conception for Solving the Multiple Network Problem." Available at ⟨www.columbia.edu/rh120/other/birth_internet.txt⟩.

Hauben, R., and H. M. Hauben (1998) "A Brief History of the Internet." Available at ⟨www.columbia.edu/rh120/other/birth_internet.txt⟩.

Hobart, M. E., and Z. S. Schiffman (1998) *Information Ages: Literacy, Numeracy, and the Computer Revolution*. Baltimore: Johns Hopkins University Press.

Leiner, B. M., V. G. Cerf, D. D. Clark, R. E. Kahn, L. Kleinrock, D. C. Lynch, J. Postel, L. G. Roberts, and S. Wolff (1997) *A Brief History of the Internet*. Available at ⟨www.isoc.org/internet-history⟩.

Luhmann, N. (1990) *Essays on Self-Reference*. New York: Columbia University Press.

Luhmann, N. (1995) *Social Systems*. Stanford: Stanford University Press.

Luhmann, N. (1996) *Die Realität der Massenmedien*. Opladen, Germany: Westdeutscher Verlag.

Luhmann, N. (1997a) "Globalization or World Society: How to Conceive of Modern Society?" *International Review of Sociology*, 7(1).

Luhmann, N. (1997b) *Die Gesellschaft der Gesellschaft*. Opladen, Germany: Westdeutscher Verlag.

Luhmann, N. (1998a) *Observations on Modernity.* Stanford: Stanford University Press.

Luhmann, N. (1998b) "Politics and Economy." *Thesis Eleven,* 53, 1–9.

Luhmann, N. (1998c) *Love as Passion.* Stanford: Stanford University Press.

Moschovitis, C. J. P., H. Poole, T. Schuyler, and T. M. Senft (1999) *The History of the Internet: A Chronology, 1843 to the Present.* Santa Barbara, CA: ABC-CLIO.

Peters, J. D. (1999) *Speaking into the Air.* Chicago: University of Chicago Press.

Rasmussen, T. (2000) *Social Theory and Communication Technologies.* Aldershot, UK: Ashgate.

Reid, R. H. (1997) *Architects of the Web.* New York: Wiley.

Segaller, S. (1998) *Nerds 2.1: A Brief History of the Internet.* New York: TV Books.

Shannon, C. (1949) *The Mathematical Theory of Communication* (with W. Weaver). Urbana: University of Illinois Press.

Watzlawik, P., J. H. Beavin, and D. D. Jackson (1967) *Pragmatics of Human Communication.* New York: W.W. Norton.

17

Proper Distance

Toward an Ethics for Cyberspace

Roger Silverstone

> It is only in approaching the Other that I attend to myself. . . . In
> discourse I expose myself to the questioning of the Other, and this
> urgency of the response—acuteness of the present—engenders me
> for responsibility; as responsible I am brought to my final reality.
> —Emmanuel Levinas, *Totality and Infinity*

This is a chapter on media ethics. And as such it is neither easy nor fashionable. It attempts a critical engagement with a range of theories and positions that touch on community and identity, on reciprocity and responsibility, and above all on the way in which media, and especially the new medium of the Internet, might be seen to enable or disable what I will call the moral life. The ethics I intend are not specific. I will not be arguing about particular individual, institutional, or professional ethics in defined circumstances. I will not be making recommendations on how people should behave either online or offline. I will not be drafting an ethical code. I will not be discussing netiquette.

In this sense maybe the word "ethical" should be substituted for "ethics," and in this sense too the ethical elides with the moral, with what

I have already called the moral life. It is this, the moral life, and the conditions of its possibility in electronic space, that provides my focus in what follows.

This is also a chapter on metaphysics, since it draws on what I have understood from the work of French philosopher Emmanuel Levinas, who resolutely refuses a singular ontology as a basis for understanding the human condition in favor of an (admittedly often somewhat equally unhistorical and unsociological) approach grounded in transcendence and critique. I would contend, however, that metaphysics, in my case as in Levinas's, provides a basis for measuring history, society, and technology—and for calling all of them to account.

My own concern, therefore, is also critique: to interrogate both the claims for, and the consequences of, the increasingly intense and interactive mediation of social relations by information and communication technologies. I will argue that the possibility of a moral life is dependent upon our capacity to define and sustain a proper distance in the relationships we have between ourselves and others and that our media technologies can be seen to affect that. I will suggest that claims that the Internet is capable of providing new, more intense, more genuine forms of social relationships are based on unexamined notions of what social relationships are or could be.

In one obvious sense it would be perfectly reasonable to suggest that this is not a new argument, that we know already that electronic mediation is no substitute for the face to face and that whatever value we ascribe to the latter, it is not transferable once distances are mediated. But although the basic argument that I attempt to outline in what follows is recognizable and familiar, I hope I will be able to throw some new light upon it as I try to define the elements of a position that at least offers the terms for a debate on the moral consequences of electronic mediation.

Infinity

I will begin with me. As a child I would, from time to time, write my name and address as follows:

Roger Saul Silverstone

21 Brancote Road

Oxton

Birkenhead

Cheshire, England, UK, Europe, the World, the Solar System, the
Universe, Infinity

And in so doing I would move, progressively, from the known to the
unknown, though with me always, and of course, at the center. But in this
projection of myself from the apparent security of home to the increasing
distance and incomprehensibility of what was beyond reach and actually
beyond imagination, I was at the same time displacing myself from the
center, and in that displacement acknowledging, albeit unconsciously,
that I was just a speck, that movement through the ether was both an
extension of my power and the force of my identity into global space and
simultaneously an expression of the insignificance of that power and the
weakness and vulnerability of that identity. There was, in my childhood
fantasy, somewhere else, something else, something that I could not com-
prehend but that I knew existed and that, arguably, by virtue of my knowl-
edge of its existence gave a certain reality to my own.

René Descartes (1940) had a similar—but a rather more radical—
thought. Toward the end of his Third Meditation he had this to say:
"And I must not imagine that I do not apprehend the infinite by a true
idea, but only by the negation of the finite, in the same way that I compre-
hend repose and darkness by the negation of motion and light: since, on
the contrary, I clearly perceive that there is more reality in the infinite
substance than in the finite, and therefore that in some way I possess the
perception . . . of the infinite before that of the finite, that is, the percep-
tion of God before that of myself, for how could I know that I doubt,
desire, or that something is wanting in me, and that I am not wholly
perfect, if I possessed no idea of a being more perfect than myself, by
comparison of which I knew the deficiencies of nature" (78). The key
idea here lies in the second half of this. It is the argument that there is
something that we know, or have a sense of, that precedes our capacity
to be: there is something before being, something that limits our being

and is irreducible to our being. There is something out there that in no way can be held or contained or even understood fully. It is this recognition that makes us human, because through it we see our limits and we gain a measure of our strengths and weaknesses. In such acknowledgment we can come to terms with the reality of our doubts and desires, and in recognizing this reality, we can claim our humanity: the painful acceptance of our vulnerability.

Emmanuel Levinas takes this idea as the foundation of his moral philosophy and uses it as the stick with which to beat much of modern Western thinking, particularly the phenomenology of Martin Heidegger, for its reductive insistence on the singularity of the self as the locus of experience and as the foundation of being. Levinas takes issue with modernism's dreams of omnipotence, drawing a fundamental ethical lesson, negatively, from this reduction. It is because there will always be something that we know we cannot know and because there will always be something, someone, some aspect of someone, beyond our reach and beyond our comprehension—something, perhaps only metaphorically, that precedes us—that we can discover who we are. But, most crucially (and I will come back to this shortly) we learn through this recognition of the irreducible otherness of the world to accept our responsibility for our place in the world and for the other who occupies that world alongside us, whom we will never, ever, know quite entirely.

It is this argument that I want briefly to trace, for it opens up, as it has also for Zygmunt Bauman, an agenda for understanding the limits of moral sensibility as it has emerged through modernity that in both Bauman's arguments and my own finds its way into a critique of technology and mediation. Bauman's ambition lies in the exploration of what he calls a postmodern ethics; mine, more modestly, is to explore the idea of what I am calling *proper distance.*

Proper Distance

What do I mean by proper distance? There are a number of different ways of answering the question.

Let me begin etymologically and say something about the word "proper." The word "proper" (Latin *proprius,* one's own, special, particu-

lar, peculiar) has, in English, a number of related but quite distinct meanings that make it both useful and suggestive in the context of what I want to say. "Proper" has both descriptive and evaluative senses. Its first meaning refers to the sense of belonging: it is a property or a quality of a thing—the stars, for example, have their proper motion. It also refers to that quality of ownership as being distinctive: a proper name as opposed to a common name.

The second meaning emerges when the term is applied to a situation of conformity with a rule: when something is accurate, exact, or correct or when something is strictly the case, genuine, true, or real, we use the word "proper." So when something or someone is excellent, admirable, commendable, fine, goodly, or of high quality, we can say of it or them, perhaps slightly archaically, that they are proper: a proper person.

Third, we use the word "proper" to refer to something that is adapted to some purpose or requirement, that it is fit, apt, suitable, fitting or befitting, or when it is especially appropriate to the circumstances or conditions at hand. In this sense "proper" is what something should be or what is required: what one ought to do or have or use. It is a synonym, almost, for right; for example, one might say, "This is a proper time" to do something. Such a sense, finally, leads to a use of the word "proper" to describe and adjudge something or someone that conforms with social ethics or with the demands or usages of society, polite or otherwise. We talk about behaving properly or improperly.

"Proper" is not a word we use much in media or new media research. It is a modern rather than a postmodern term. It speaks of value: of the normative, as well as of the descriptive. But in its principal manifestations—as distinctive, correct, and ethically or socially appropriate—it commends itself to me, properly, as a way of approaching the question of distance and of providing an opening into a critical inquiry into the ethics of the media, both old and new.

And so to distance. There is often quite a fundamental confusion in much of the writing on the new geography of the Internet. Time-space distanciation, or compression, or what Frances Cairncross (1997) has called the death of distance, suggests a profound and illegitimate elision between two kinds of distance: the spatial and the social. The presumption in these discussions is that the electronic mediation of physical or material

connection provides at the same time social or psychic connection. The technologically enabled transformation of time and space that marked the entry into the modern world certainly provided new conditions and possibilities for communication, communication that provided connection despite physical separation. Yet the paradoxes at the heart of such communication, although noted, as Ithiel de Sola Pool (1977), for example, famously noted them, have been insufficiently investigated, above all for their consequences for our relationships to each other. My point is that distance is not just a material, a geographical, or even a social category, but it is, by virtue of both and as a product of their interrelation, a moral category. The overcoming of distance requires more than technology and indeed more than the creation of a public sphere. It requires proximity.

Zygmunt Bauman (1993) makes the following assertion:

> Modern society specialised in the refurbishment of the social space: it aimed at the creation of a public space in which there was to be *no moral proximity*. Proximity is the realm of intimacy and morality; distance is the realm of estrangement and the Law. . . . (83) If postmodernity is a retreat from the blind alleys into which radically pursued ambitions of modernity have led, a postmodern ethics would be one that readmits the Other as a neighbour, as the close-to-hand-*and*-mind, into the hard core of the moral self, back from the wasteland of calculated interests to which it had been exiled; an ethics that restores the autonomous moral significance of proximity; an ethics that recasts the Other as the crucial character in the process through which the moral self comes into its own (83–84).

"Proximity" is close here to what I have called "proper distance." Proper distance involves contact: the close at hand but also close to mind (Levinas 1981/1998: 86). Bauman, in his analysis of the proximal and of the ethics of distance, traces modernity's progressive refusal of the intimate and the individually responsible, a refusal that the activities of law and the state paradoxically impose on social life. Technology is a crucial component of this process, and horrendously so in his analysis of the Holocaust. Proximity involves also, as we shall see, responsibility. And responsibility, individual responsibility, has also been progressively denied by modernity and its technological handmaidens.

Where Bauman sees proximity as a synonym for closeness, however, and sees in technology an ethical juggernaut, I want to pose proper distance as a firmer basis for enquiring into the possibilities of a moral life, and I want to push back somewhat from the technologically determinant. In the relation to the first, it should be pointed out (Silverstone 1999) that we can be blinded morally by the too close at hand just as easily as we can be by the too far removed. Closeness, even intimacy, does not guarantee recognition or responsibility; it can invite, conceivably, either blank resistance or, alternatively, incorporation. As Levinas (1981/1998) notes: "Proximity is to be described as extending the subject in its very subjectivity. . . . [Proximity,] the one-for-the-other . . . is not a configuration produced in the soul. It is an immediacy older than the abstractness of nature. Nor is it fusion; it is contact with the other. To be in contact is neither to invest the other and annul his alterity, nor to suppress myself in the other. In contact itself the touching and the touched separate, as though the touched moved off, was always already other, did not have anything in common with me" (86).

Levinas's notion of proximity preserves the separation of myself and the other, a separation that ensures the possibilities of both respect and responsibility for the other. It is a separation in which the notion of touch (elsewhere he writes of the caress) is central. For touch requires the sensitivity of, and to, distance in which there is recognition of the irreducible difference of the other as well as a sharing of identity with her or him. It is in this paradox of connection and separateness and in the ambiguities that we as individuals have to resolve in our relationships with the other that the creation of an ethical or moral life becomes, or does not become, possible.

I am proposing that the notion, but above all the achievement, of proper distance both sensitizes us to these ambiguities and provides the opportunity to surmount them. It recognizes that in our relationships to each other, in their flux and fluidity, we are confronted by a whole range of technological and discursive mediations that destabilize, in both directions, the proper distance that we must create and sustain if we are to act ethically. We have to determine, perhaps case by case, what that proper distance is or might be when we are confronted with both familiar and novel appearances or representations of the other. And we have to understand, of course, that in such cases there is no prix fixe, no singular, and

no permanent. Neither can proper distance, like everything else that is meaningful in social life, be taken for granted nor is it pregiven. It has to be worked for. It has to be produced.

Distance can be proper (correct, distinctive, and ethically appropriate) or it can be improper. If improper distance can be, and is, created both through the general waxing and waning of modernity, as well as more precisely in the mediations that electronic technologies provide for us, then it follows that we can use the notion of *proper* distance as a tool to measure and to repair our failures in our communication with the other and in our reporting of the world in such a way that our capacity to act is enabled and preserved (cf. Boltanski 1999). And it follows too that we can use it as a way of interrogating those arguments, most recently in the analysis of the Internet, that mistake connection for closeness and closeness for commitment and confuse reciprocity for responsibility. But before we do this in a more deliberative way, it is necessary to dig a little more deeply into the nature of that ethical relation and the conditions of its possibility.

Strangers and Neighbors

The media, that is the broadcast media, have always fulfilled the function of creating some sense of proper distance, or at least they have tried, or claimed to be able, to do so. The reporting of world events, the production of news, the fictional representation of the past, the critical interrogation of the private lives of public figures, the exploration of the ordinariness of everyday life—all involve, in one way or another, a negotiation between the familiar and the strange, as the media try, forlornly, to resolve the essential ambiguities and ambivalences of contemporary life. As I have argued on many occasions, their task is to create some kind of comfort and pleasure for those on the receiving end of such mediations, some comfort and pleasure in the appearance of the strange as not too strange and the familiar as not too familiar. Such mediations, however, also tend to produce, in practice, a kind of polarization in the determinations of such distance: that the unfamiliar is either pushed to a point beyond strangeness, beyond reach and beyond humanity, on the one hand (the Iraqi leadership both during the Gulf War and now), or drawn so close

as to be indistinguishable from ourselves on the other (the many representations of the everyday lives of citizens in other countries, as if the latter were in every respect just like us, really) (Silverstone 1999).

The new media, especially the Internet, in palpably challenging the one-to-many mediation of television, radio, and the press, and notwithstanding their evolutionary development from other forms of one-to-one electronic mediation, shift the terms of both the debate and the problem. They do so precisely insofar as they do enable that one-to-one-ness, or that many-to-many-ness, that e-mails and chatrooms and groupware offer. And it is this arguably transcendent characteristic, which involves, or might be called, the personalization of the other—that the person at the other end of the communication is a person rather than a thing, or an image or an event, and that I may be required to interact with that other, or she with me—is what I want now to evaluate. The Internet's claim is for interactivity, not uniquely perhaps, but centrally and essentially (Downes and McMillan 2000). But the notion of interactivity begs a number of questions, above all about its very nature and its capacity to connect interlocutors in new and significant ways. It also raises the question, though this has not been much discussed in the literature, of the moral status of those who communicate with each other and of the ethical status of the kind of communications that are generated online.

I want to suggest that this question of status requires, initially at least, a consideration of the difference between strangers and neighbors and that it requires, in a rather more focused way than I have yet attempted, a consideration of the difference between physical and social distance.

In premodern societies the differences between neighbors and strangers or aliens were rigidly enforced and accepted. Bauman (1993) suggests that for a large part of human history "an alien could enter the radius of physical proximity only in one of three capacities: either as an enemy to be fought and expelled, or as an admittedly temporary guest to be confined to special quarters and rendered harmless by strict observance of the isolating ritual, or as a neighbour-to-be, in which case he had to be made like [a] neighbour, that is to behave like the neighbours do" (150).

Modernity undermined the clarity, certainty, and defensibility of the boundary between strangers and neighbors. As Georg Simmel

(1908/1971) has famously noted, the stranger is "the wanderer who comes today *and stays tomorrow*" and is close to us "insofar as we feel between him and ourselves similarities of nationality or social position, of occupation or of general human nature. He is far from us insofar as these similarities extend beyond him and us, and connect us only because they connect a great many people" (147, emphasis added). What characterizes the stranger in modernity is precisely her ambiguity. We can neither avoid her, nor can we be sure of her status, and indeed of our own status as she might judge it (we are all strangers to each other now). In a world of both geographical and social mobility—what Bauman (2000) calls liquid modernity and John Urry (2000) calls the postsocietal—we are confronted, perhaps as never before, by a nomadic universe in which the cognitive, aesthetic, and moral boundaries between ourselves and others can neither be clearly identified nor consistently defended. We cannot be indifferent to, nor exclude, the stranger who can no longer be defined by her difference. Yet we cannot, because of that indefinable difference, completely include her either. The stranger *is* the neighbor, and we are all neighbors to one another now.

This is the problem of what I want to call *ambiguity 1,* the ambiguity that is inevitable when relationships with the other require the creation of manageable social *distance* under circumstances of otherwise determined physical *closeness.* And because both the cognitive and aesthetic spacing in our relationships to strangers is, in modern life, such a continuous problem, it produces ambivalence, a sense of moral and ethical indecisiveness in our relationships with the other. I want to go further to suggest, however, that in electronic space these positionings are reversed and that the problem of the stranger is, consequently, the obverse to what it is in physical space, though it is still a problem. In electronic space we are confronted with the situation of determined, and arguably uniform, physical *distance,* and the moral task is, somehow or another, to create manageable social *closeness.* This is the problem of what I want to call *ambiguity 2.* But I want to suggest that it is generated by, and generates, similar ambivalence, an ambivalence present therefore both in physical and cyberspace, an ambivalence that requires an equivalent, and an equivalently difficult, moral response. Are there any strangers in cyberspace? Are there any neighbors?

Roger Silverstone

478

This ambivalence comes not just from not knowing how to make sense of the other, but also from not knowing how to act in relation to the other: how to be, how to care, how to take responsibility. In the multiply converging worlds of technology, mediation, and social and geographical mobilities, it may be, as many have argued, that we are doomed to ambiguity and ambivalence, but this does not mean that we should avoid confronting it.

The Face

Back to Levinas. There are limits to reason. It is precisely because we cannot know, fully comprehend, the other that we have to accept our own limits and recognize that there will always be something that escapes us. For Levinas this escape is the source of humility, a necessary humility in the face of the other, and a necessary precondition for our capacity to care for the other.

Levinas's concept of the face is one of his most obscure but at the same time one of his most powerful. In trying to provide an account of it and its relevance to my own arguments I am fully aware of its difficulties (at least of some them) and my inadequacies (at least most of them). But the effort must be made, for I want to suggest that the notion of the face is of particular and unexpected relevance to an understanding of the morality of cyberspace: "The way in which the other presents himself, exceeding the idea of the other in me, we here name the face. . . . The face of the Other at each moment destroys and overflows the plastic image it leaves me, the idea existing to my own measure and to the measure of its *ideatum*—the adequate idea. . . . It is therefore to *receive*—from the Other beyond the capacity of the I, which means exactly: to have the idea of infinity. But this also means: to be thought. The relation with the Other, or Conversation, is a non-allergic relation, an ethical relation; but inasmuch as it is welcomed this conversation is a teaching" (Levinas 1969: 50–51).

The face, in Levinas's philosophy, is not a physical face. It does not depend on material presence. It is, literally, metaphysical. It exists as a commanding difference: different from me, but by virtue of that difference requiring a response from me. Levinas's concept of the face is a precondition for ethics, for a moral position, for it forces us to recognize the

responsibility we have for the other, whoever or whatever the other is. The Other (Levinas in this text instates the other as Other, as, perhaps, a proper subject) escapes our power, is different from us. We must recognize her presence, but also our own limitations in relation to her. The Other is a stranger, despite our capacity to identify with her: the pronoun "we," says Levinas, "is not a plural of the I. . . . He and I do not form a number" (38–39). Whereas the Other exists only in my recognition of her, the reverse is also the case, and indeed for Levinas, the Other precedes me—enables me, and requires me to take her into account, and to care.

This impossibly difficult discourse has to be understood as a struggle with language and with the dominant discourses of rationality that frame and characterize modernity and the Enlightenment. It also has to be understood as an attempt by Levinas to establish the primacy of the ethical in social life, "the primacy of the ethical, that is, the relationship of man to man—signification, teaching, justice—a primacy of an irreducible structure upon which other structures rest" (79). There is, in other words, something before being. And it is that something (he calls it responsibility) that is, I believe, a key notion in any viable struggling toward an ethics for cyberspace.

Perhaps the easiest way of approaching the distinctiveness of what is being said here is to return to the notion of proper distance. My responsibility for the other does not, if it is to have the moral force Levinas intends, require, or depend on, reciprocity. There is a necessary asymmetry in the moral position: an acknowledgment of the primacy of myself as the starting point, but no expectation that there will be feedback and that I will receive what I have given. The ethical stance, from this perspective, does not depend on identification with the other, as neighbor, but on a recognition that I have as much responsibility for the stranger, that other who is, either physically or metaphysically, far from me, as I do for my neighbor. This is, in many ways, quite crucial. It sees the possibility of a moral life's being grounded only in the asymmetry of social relations; that morality cannot emerge from the symmetry of the reciprocal; that it cannot be based on the expectation that my action will in some way require you to do the same for me. Nor can it be based on identification with the other, even though I am entirely dependent on her presence. My responsibility precedes me. I have no choice.

Roger Silverstone

In physical space, in the face to face, both neighbors and strangers are close at hand. The other's moral presence (or absence) is overdetermined (or undermined) by her physical presence. She is part of my neighborhood, even if I treat her as a stranger. In mediated space, both neighbors and strangers are far from reach. The other's moral absence (or presence) is overdetermined (or undermined) by her physical absence. She is somewhere else, even if I treat her as a neighbor. Yet for us to be moral beings we have to be able to take responsibility for the other in both situations.

The problem that mediated space creates for us as moral beings is that of the creation and defense of proper distance, that of making contact, ensuring proximity, and of establishing the moral duty of disinterested care. The mediated face is, in one sense, the metaphysical face as Levinas defines it. The Internet is, in some quite literal sense, metaphysical. Yet it is because the mediated face is not visible, even if we can see it, and because it is both escapable and exploitable that the implications of Levinas's critique become, in this context, both peculiarly relevant and urgent. The mediated face makes no demands on us, because we have the power to switch it off and to withdraw. But this is something we as moral beings cannot do. We cannot switch it off. "Responsibility is silenced once proximity is eroded; it may eventually be replaced with resentment once the fellow human subject is transformed into an [o]ther" (Bauman 1989: 184).

For Levinas (and for Bauman, who follows him closely in this) our capacity to be, and to act as, moral beings comes from a recognition that this capacity is in some quite fundamental way granted by the other, by her presence in our cognitive and aesthetic space. It precedes us. It humbles us. It forces us to acknowledge our limits and our own vulnerabilities. We cannot, therefore, put ourselves first or, indeed, last. "My responsibility," says Bauman (1989) "is unconditional" (182). It is the primary component of subjectivity. Distance threatens responsibility. So too does our belief in our omnipotence, our technologically enhanced omnipotence.

The mediated face comes to us in both broadcast and conversational modes (cf. Peters 1999). Each provides different opportunities and challenges for the moral self. It might be thought that the broadly conversational character of communication on the Internet would be more

conducive than that of television or radio in the creation of a moral life, especially given Levinas's own stress on the conversational mode, and this indeed is what many of its defenders argue. But there are dangers and misconceptions in both forms of technologically mediated discourse, and it is to this that I now want to turn.

Technology

There are, then, those who believe that the Internet offers a way of communicating that transcends the limitations that broadcast media impose by the absence in them of what might be called genuine interactivity. The distance that broadcast media place between sender, receiver, and object, a distance that creates a prima facie condition of moral distance (cf. Tester 1997), is overcome, it is suggested, once connection becomes interconnection and once communication, real communication, becomes possible between individuals and groups both in real time and in communicative spaces of their own choosing or creating.

In the terms in which I am now trying to set the debate it can be seen that broadcasting masks the face of the other by pretending to a proximity that is in fact false. The Internet, on the other hand, claims to reveal the face of the other by transcending distance and generating proximity that is, in effect, true. This latter claim, by implication a claim for the Internet's ability to reproduce natural communication or the authority and authenticity of face-to-face communication, both implicitly and explicitly, leads to a claim for moral superiority. Is that claim warranted or not?

There is one more step we need to take before addressing this question directly. It is answering the following question concerning technology: can technologies be moral? Bruno Latour (1992) seems to think they can. Technologies can act, and do act, as humans do. We delegate responsibility to them, and they in their turn impose their morality on us, as users and as mediating objects: "In spite of the constant weeping of moralists, no human is as relentlessly moral as a machine. . . . We have been able to delegate to nonhumans not only force as we have known it for centuries but also values, duties, and ethics. It is because of this morality that we, humans, behave so ethically, no matter how weak and wicked we feel we are" (232, quoted in Feenberg 1999: 102).

From the point of view of the arguments being offered here, this view is a profound mistake. The delegation of moral responsibility is a contradiction in terms. Whereas we can properly inquire into the embodied social values in technologies, and whereas we can see, for example, in Latour's deliberately trivial example of the door closer (a device that takes on the responsibility for automatically closing a door once we have passed through it) how such values and norms allow us to recognize a certain symmetry in our relationships to technology, it is precisely the absence of such symmetry that defines the core of the moral. The presumption that technologies can be moral, or that we can delegate our own ethical sense to technology, misreads the particular centrality of responsibility as a precondition for a moral life. Technologies don't care. Technologies can't care. Technologies can't be made to care.

Indeed the argument can be taken one step further. It is precisely in this delegation that some of the most profound acts of man's inhumanity to man have been released (Bauman 1989). Technologies, and the technologizing of the social, have in recent times both created and masked (and still do) the (improper) distance that has allowed responsibility for the other to be denied and for care for the other to be dissolved.

More specifically the morality that media and communications technologies enable is easily—and often—presumed to be a function of their capacity to connect. That is what they do. They bring us together. And that connection is sufficient, it is said, for us to relate to each other as human, moral beings. It is transcendent. It is all we need. It offers us unimaginable possibilities for controlling our lives and arguably, too, possibilities for our own personal fulfillment. But I am arguing that we need to go beyond connection, if we are to pursue a grounded ethics. The motivated irony in Levinas's position, and also in my own, is that it is precisely in the failure completely to connect, *and in the acknowledgment of the inevitability of that failure,* that technologically mediated communication might enable us ethically. This too is a question of determining proper distance.

Cyberspace

I hesitate. Perhaps there is no such thing as cyberspace. What exists, of course, and multiply, are claims for its existence: its separateness, its

transcendence, its difference, its liberatory potential. The claims are familiar, utopian, and easily challenged. The online world is very like, and still depends upon, the offline one, and we can observe its enclosure by the forces of capital and the World Wide Web (Silverstone 2001). Yet in these electronic networks, networks that are to all practical purposes infinite in their extent and their extension, there is a reality to be confronted: a new kind of communicative space that offers itself both to colonization and critique.

In this, the final section of the chapter, I want to address some of the claims that are made for cyberspace and to examine those claims—for community and identity (the terms that we use and that are required in our everyday concern with our relationship to the other)—against the measure of morality that I have derived from my discussion of Levinas. Once again, to restate, my aim is not to propose a specific code of ethics for cyberspace, but to provide a basis, at best, for doing so. It is also to propose a critical position from which to examine the failures of others to consider, or to read, the moral implications of their own arguments.

There is a paradox in many analyses of online behavior. It emerges from the observation that, on the one hand, identities are fluid and can easily be disguised, but that, on the other, such fluidity nevertheless results in things called communities, rarely defined but taken to mean more or less stable structures of sociability and conviviality. Identity and community are mutually intertwined in cyberspace as well as elsewhere. Identities come to be shaped through social interaction and participation. They are the product (and also the precondition) of our capacity to be in the world as active, one might say moral agents. Yet in cyberspace that crucial and interdependent relationship is both uncoupled and elided.

As Allucquère Rosanne Stone (1994) has famously noted in describing cyberspace as an "unexpected kind of 'field,'" it contains "incontrovertibly social spaces in which people still meet face-to-face, but under new definitions of both 'meet' and 'face.' These new spaces instantiate the collapse of the boundaries between the social and technological, biology and machine, natural and artificial that are part of the postmodern imaginary" (85). Tracing the origins of virtual communities in the idea of shareware, she defines the bid for sociality in both an expectation of reciprocity (88) and a desire for survival (111). Virtual communities offer

"the sense of unlimited power which the dis/embodied simulation produces, and the different ways in which socialization has led those always-embodied participants confronted with the sign of unlimited power to respond" (107). The irony here lies in the refusal of identity as a singular category but at the same time the insistence on the self as the focus of action and desire: the defining characteristics of our involvement in cyberspace are, for her, reciprocity, survival and potency, and all at a distance: no sense of the other.

More sophisticated analyses of online activity point to its relationship to, and continuing interdependence with, offline activity, but still insist on the viability of, and value in, the online. Nancy Baym (1995) points to a number of components of social action (new forms of expressive communication, the exploration of possible public identities, the creation of otherwise unlikely relationships, and the development of behavioral norms) both to signal the specificity of online sociality and also to relate it directly to forms of action and behavior in offline everyday life. This analysis recognizes the possibilities of group formation in cyberspace and the role of significant individuals as key cyberfigures in holding such spaces together, but it does not recognize how so-called online communities can create and sustain responsibility. Although it may be the case that "social realities are created through interaction as participants draw on language and the resources available to make messages that serve their purpose" (161), those social realities are defined according to a functional and solipsistic rationality that believes in the self before, and independent of, the other. And it is forced to recognize that online sociality is, necessarily and essentially, voluntaristic, and, arguably, ephemeral. The other poses no challenge. She can be avoided.

Barry Wellman and Milena Gulia (1999) take this position a step further. They argue that communities no longer exist as they once did (or were believed to have existed) and that modernity has already enabled communities that are neither as intense, nor as persistent, as those of old. Technologies and the dispersal and mobility of populations have changed and undermined the singularity of community and weakened it. Online communities are consequently as varied as offline ones, involving thin but also thick networks of relationships and providing the same kinds of network support that exist offline: "There is so little community life in most

neighborhoods in western cities that it is more useful to think of each person as having a personal community: an individual's social network of informal interpersonal ties, ranging from a half-dozen intimates to hundreds of weaker ties. Just as the Net supports neighbourhood-like group communities of densely knit ties, it also supports personal communities, wherever in social or geographical space these ties are located and however sparsely knit they may be" (187).

One of the tests of the viability of such community networks (is the notion of a community network a tautology or an oxymoron?), Wellman and Gulia suggest, lies in the degree of intimacy that can be generated online. At the same time they argue that computer-mediated communication offers people an enhanced ability to move among relationships. This is the problem of proper distance restated. But it is not addressed. Indeed the idea of the personal community is possibly the ultimate step: an appropriately postmodern narcissistic move in which community becomes conceptually and empirically, and without irony or reflexivity, both a projection and an extension of the self.

Conclusion

There are two distinct ironies of my own underlying the discussion presented herein. But they illuminate, albeit if only to a limited degree, the particular route I have followed in this chapter. The first irony revolves around the notion of the metaphysical. The Internet offers, at least in its apologists' eyes, a particular intensification of the kind of mediated communication with which we have become familiar in broadcast and telephone technologies, and that intensification (I have called it transcendent) is, by definition and in practice, metaphysical. It moves beyond, and no longer depends upon, the constraints of bodily communication and the limiting contiguities of the face to face. In the metaphysical spaces thus released, distance is no barrier to contact. The physical boundaries that separate the "social and technological, biology and machine, natural and artificial" (Stone 1994: 85) are transgressed, if not entirely dissolved. They are seen, at least, as no longer relevant.

The metaphysical character of the Internet licenses, I submit, its metaphysical interrogation. It is precisely through the claims and hopes

for the Internet as a liberatory force for human culture that its status as a moral entity both emerges and must be questioned. These claims involve a number of moves, not least the belief that technologies can themselves be moral and that they enable, even if they do not exactly determine, our capacity to act ethically. But as I have argued, moral responsibility cannot be delegated to the media machine, however sophisticated and human that media machine presents itself as being.

The second irony, more implicit than explicit thus far, involves not the metaphysical but the anthropological. Concern with the other has long been a preoccupation of those involved with the sociologically and culturally distant. Bringing anthropology back home, investigating its own otherness without exoticizing that otherness, has required some considerable soul-searching, both ethical and epistemological. Marc Augé's (1995, 1998) reflections on the characterization of the other neatly parallel, without in any way replicating or endorsing, some of the arguments that I have been attempting to pursue in this chapter. His *Sense for the Other* (1998) requires a double questioning, a questioning both of the meanings we make of the other and of the meaning of her presence among us, which he notes is being lost and at the same time becoming more acute in contemporary society, and of that other's own endless capacity to make meanings of her own. Anthropology is in these terms then always an anthropology of the other's anthropology (1998: xv–xvi).

But this anthropology is crucially both constructed in and from within space. It is spatial. It is grounded: for meanings, if they are to have significance, must be located and are so located. There is a necessary (if often nostalgic) interrelation among place, community, longing, belonging, and identity, an interrelationship that does not require singularity and does not presume consistency of position but that we can only think about, in some sense, as if these things were conjoined. Augé is keen to identify the increasing salience of what he calls nonplaces in contemporary society, to indicate both where and how the sense of self and the necessarily correlative sense of otherness becomes vulnerable, becomes dislocated, and where and how social ties that are "normally" inscribed in place are lost (1998: 108). Here too the Internet comes into question, as the virtual arguably struggles with or dissembles a sense of place. We need consequently to be wary of the Internet's claims for place, for its "placefulness."

If Levinas requires a focus on our new media spaces that has its origins in metaphysics, Augé's predisposition, as is anthropology's more generally, is to epistemology. His injunction to confront the other is a methodological one. Yet both are ethical. Both philosophy and anthropology require the creation of proper distance, which for the one, in this case, is principally a moral and for the other is a cognitive project. As Augé (1998) points out, "We ask of ethnology that it enable us to understand the other's culture, other cultures, both from within and without, that it be simultaneously participatory and distanced" (54).

The Internet's liberatory, if not libertarian, claims can then still be seen to involve the preservation of the centrality of identity and community as the dominant couplet for the analysis of life online. Neither, however, I believe, is any longer sufficient for the task, since both are losing, in their various postmodern reformulations, any capacity for critical interrogation. Identity is becoming fractured, community dissolved, and only shells and illusions remain. What seems to be replacing them analytically are (inevitably solipsistic and narcissistic) notions of performance and technologically enabled omnipotence (Abercrombie and Longhurst 1998). I suggest that this couplet should be complemented, if not replaced, by a different couplet, a couplet of quite a different kind: that of infinity and humility. For this couplet signals the requirement, always, to pause and to consider the limits, both technological and human, of our attempts to know and to control the world.

The first step in any move toward an ethics for the Internet, or for cyberspace, requires us to recognize and understand those limits and to see that they are not technology's but our own. The ambiguities that we confront in our dealings with each other, as neighbors and strangers, are irresolvable, and ambivalence is their necessary consequence. Insofar as our media technologies promise a resolution of these ambiguities and lead us to believe that they have the capacity so to do, they must be challenged. The Internet is no exception. An ethics for cyberspace must also be able to encompass distance as a crucial component of the moral life, and it must address the problem of how we can behave responsibly in our dealings with mediated others. This is the problem of proper distance as I have posed it. I hope that this chapter provides a contribution, albeit, as I am fully aware, an entirely limited one, to that critical project.

References

Abercrombie, N., and B. Longhurst (1998) *Audiences*. London: Sage.

Augé, M. (1995) *Non-places: Introduction to an Anthropology of Supermodernity*. London: Verso.

Augé, M. (1998) *A Sense for the Other: The Timeliness and Relevance of Anthropology*. Stanford: Stanford University Press.

Bauman, Z. (1989) *Modernity and the Holocaust*. Cambridge: Polity Press.

Bauman, Z. (1993) *Postmodern Ethics*. Oxford: Blackwell.

Bauman, Z. (2000) *Liquid Modernity*. Cambridge: Polity Press.

Baym, N. K. (1995) "The Emergence of Community in Computer-Mediated Communication." In Steven G. Jones (ed.), *Cybersociety: Computer-Mediated Communication and Community*. London: Sage, 138–163.

Boltanski, L. (1999) *Distant Suffering: Morality, Media, Politics*. Cambridge: Cambridge University Press.

Cairncross, F. (1997) *The Death of Distance: How the Communications Revolution Will Change Our Lives*. London: Orion Business Books.

de Sola Pool, I. (ed.) (1977) *The Social Impact of the Telephone*. Cambridge: MIT Press.

Descartes, R. (1940) "Meditations on First Philosophy." In T. V. Smith and M. Grene (eds.), *From Descartes to Locke*. Chicago: Chicago University Press, 49–113.

Downes, E. J., and S. McMillan (2000) "Defining Interactivity: A Qualitative Identification of Key Dimensions." *New Media and Society*, 2(2), 157–180.

Feenberg, A. (1999) *Questioning Technology.* London: Routledge.

Latour, B. (1992) "Where Are the Missing Masses? The Sociology of a Few Mundane Artifacts." In W. Bijker and J. Law (eds.), *Shaping Technology/Building Society: Studies in Sociotechnical Change.* Cambridge: MIT Press, 225–258.

Levinas, E. (1969) *Totality and Infinity: An Essay on Exteriority.* Pittsburgh: Dusquene University Press.

Levinas, E. (1981/1998) *Otherwise than Being: Or Beyond Essence.* Pittsburgh: Duquesne University Press.

Peters, J. D. (1999) *Speaking into the Air: A History of the Idea of Communication.* Chicago: Chicago University Press.

Silverstone, R. (1999) *Why Study the Media?* London: Sage.

Silverstone, R. (2001) "Finding a Voice: Minorities, Media and the Global Commons." *Emergences,* 11(1), 13–27.

Simmel, G. (1908/1971) "The Stranger." In D. E. Levine (ed.), *Georg Simmel: On Individuality and Social Forms.* Chicago: Chicago University Press, 143–149.

Stone, A. R. (1994) "Will the Real Body Stand Up? Boundary Stories about Virtual Cultures." In M. Benedikt (ed.), *Cyberspace: First Steps.* Cambridge: MIT Press, 81–118.

Tester, K. (1997) *Moral Culture.* London: Sage.

Urry, J. (2000) *Sociology beyond Societies: Mobilities for the Twenty-First Century.* London: Routledge.

Wellman, B., and M. Gulia (1999) "Virtual Communities: Net Surfers Don't Ride Alone." In M. A. Smith and P. Kollock (eds.), *Communities in Cyberspace.* London: Routledge, 167–194.

18

"Making Voices"

New Media Technologies, Disabilities, and Articulation

Ingunn Moser and John Law

Articulation: *n.* act or mode of jointing; joint; act of speaking; Articulate utterance, speech. [F, or f. L *articulation* (*articulare*) joint, as ARTICLE; see –ATE)]

This is a chapter on disabilities and new media technologies, but also on what it is to be a person, a competent person. In daily life we talk unproblematically of "people" or of "such and such a person," assuming this person or these people to be naturally abled. The habits of daily life also tend to find their way into social science. But (and no doubt this is also obvious) the ease of talk about "the person" conceals complexity, and it is this complexity that is our topic in this chapter. We are interested in how it is that "the competent and abled person" is constructed (or not) under specific circumstances and how it is that he or she is constructed (or not) in relation to new media technologies. Disability, then, is the site for our inquiry, both because we are concerned with assistive technologies for disabled people and because we are interested in this more general issue of what it is to be a person.

What are the disciplinary resources for such an inquiry? Sociology has a long tradition of exploring how the person is shaped by society.

Different kinds of people, it says, are produced by different societies and at different moments in history. Sometimes, but not always, these arguments are made on a large scale.[1] Symbolic interactionism, for instance, argues that the sense of self arises in the process of quite specific social interactions. This implies the need for small-scale and often intensive methodologies (for instance, ethnography) to explore how specific kinds of persons are produced in local circumstances. This is an approach that has been extended and explored in considerable depth in the contemporary sociologies of identity. As a part of this approach, how it is that some people are given (or refused) a voice in society has also been investigated.[2]

We come from the discipline of sociology and have learned much about the making and shaping of the person from these sociologies. In our work on new technologies, however, we have also encountered certain limits, two in particular. First, though there is much variation, sociology is often ambivalent about a crucially important issue: whether or not there is a more or less stable core to the self and, correspondingly, whether or not all aspects of the person are constructed in social relations.[3] This issue, the so-called question of theoretical humanism, is in part a metaphysical matter. For reasons that will become clear in this chapter, however, we prefer to experiment with the more radical option: that the person is constructed in relations, as it were, all the way through. Our assumption, then, is that there is no stable essence. Second, the extent to which sociologies deal with the body was also, at least until ten or fifteen years ago, very limited. But (or so we assume, and the point has particular force and poignancy in the context of disability) it is not possible to make sense of the construction of the person unless the body also forms part of the picture. Our thinking here has led us away from sociology to the interdisciplinary field of women's studies, in which there is indeed a large body of work both on the construction of gendered persons and on the relation of this to embodiment.[4]

But what, then, of technologies? Though there are exceptions, neither sociology nor women's studies is centrally preoccupied with technologies, at least as these relate to the construction of the person. Here we have turned to a third and interdisciplinary field of study: science, technology, and society (STS). This field, as its name suggests, explores the relationship between society, on the one hand, and science and technology,

on the other. During the last ten years within this field a considerable body of work has accumulated on the ways in which persons are produced in and through arrangements of heterogeneous materials: technologies (including, for instance, ICTs and new media), architectural arrangements, naturally occurring phenomena, texts and documents of all kinds, and (last but not least) other people. This body of work draws on various theoretical resources, but many of them are semiotic or poststructuralist in orientation. We cannot explore the full significance of semiotics here. For present purposes, however, the most important insight of STS is that of *relationality:* the claim that everything—people, subjectivities, actions, scientific facts, technological artifacts, texts, and symbols—achieves its form as a result of the network of relations in which it is located. This "material relationality" is at least implicit in the work of discourse analyst Michel Foucault, and it is an insight that has been developed at length in both actor-network theory (ANT) and the material semiotics of Donna Haraway (see, e.g., Foucault 1979; Law and Hassard 1999; and Haraway 1991a, 1991b, 1991c, 1991d, 1997). But how does this relate to the person? The answer has to do with the notion of "subjectivity." This is a term from structuralism and poststructuralism, and it refers to a location of consciousness and action, on the assumption that these are produced relationally, in the sense we have noted immediately above.[5] So it is such subjectivities and their production that we will explore in this chapter.

And this is where we start: with the person, and how it is that the person—or the subjectivities that make up the person—are articulated for people who are disabled. Our particular interest is in the significance of new communication technologies available to disabled people and in a specific technology that has been developed by a Norwegian firm called IGEL Kompaniet. This is an integrated computer system known as Rolltalk, comprising hardware and software for multiply disabled people. It commands a series of functions, for instance, allowing the user to express needs or wishes, to communicate feelings, to steer his or her electric wheelchair, or to control aspects of his or her living environment by way of remote control operation of doors, lights, the television set, etc. All functions can be operated with one switch and from the same system. The user needs no more than one controllable muscle to operate Rolltalk. This means that many severely disabled people who were formerly unable to

operate an electric wheelchair or to operate different writing and speaking devices for use in direct communication now have the ability to do so.[6]

In this chapter we tell short stories about disability and Rolltalk.[7] Alongside these empirical stories we offer theoretical commentary, that first explores the ways in which Rolltalk, through the kinds of voices and functions it offers, helps to constitute and articulate certain forms of subjectivity or personhood. Then, more briefly, we turn to the ways in which Rolltalk relates to other forms of subjectivity that in one way or another tend to escape it. Our thesis—and we would like it to be clear from the outset that this is not a criticism—is that Rolltalk (and doubtless other similar systems) tends to constitute some subjectivities in specific ways while allowing others to escape.

A brief word on the notion of articulation. In the title to the chapter we talk of "making voices" and we place these words within quotation marks. This reflects our desire both to index one of the most important tropes of feminism and radical sociology—the idea that voices are somehow taken from those who are powerless—and our simultaneous unease about the not infrequent essentialism of such moves. The radical argument is that it is important to find and to give voices to those from whom they have been taken, and this is a commitment that we share.[8] But it is also a move that needs to be recast. Our posthumanist suggestion, and it is hardly novel, is that "voices" do not exist in and of themselves. They do not reflect something that is given. Rather they are constituted or "articulated" into being in material arrangements that include social, technological, and corporeal relations. To say this is not to say that new voices or articulations cannot or should not be made (for instance, in the ways they are being made in or through Rolltalk).[9] Remaking and re-articulation are clearly important: "voices," like experiences, are cultural products and political constructions (see, e.g., Haraway 1991b and Law 2001). This explains our concern about the character of the voices and subjectivities granted to, or claimed by, those who are disabled. But the point is yet more complex, because to talk of giving "voices" is to take the risk of limiting articulation to that which is verbal, textual, or linguistic. But this, at least in the context of disability (though the point extends, or so we would suggest, much further), is to prejudice the result. Indeed it is to take the risk that "voices" that happen to be nonverbal are simply not

recognized or are disqualified. This is yet another reason why we prefer to talk of articulation.[10] We now illustrate this by presenting some scenarios of how Rolltalk is being used.

"Please Take the Money from My Bag"

IGEL adapts its Rolltalk system to each individual user, because it seeks to reflect the desires, concerns, needs, and abilities of each person in his or her menus and the options that these articulate. Figure 18.1 shows a Rolltalk. It is a computer system mounted on an electric wheelchair.[11] The box that holds the computer itself is on the back, behind the seat. In front, where the user can see it, there is a flat screen. It's a red box about the size of a sheet of paper and perhaps five centimeters deep. When the Rolltalk is powered up, three colored icons appear on the screen. This is the first level, so to speak, the "welcome" screen. In the upper left, we see the profile of a head with an open mouth and a series of semicircles

Figure 18.1
Rolltalk.

spreading out from the mouth. We understand straightaway that this has something to do with speech, with being heard, and with speaking. The second icon, in the upper right, shows various objects in the immediate environment (for instance, a door). We learn that this has to do with "environmental control," that is, the control of various aspects of the user's living environment. The third icon, in the lower right, shows a wheelchair. This has to do with moving and steering, that is, with mobility.

As we watch the Rolltalk continue to power up, we notice that each icon is highlighted in turn. A white box first frames the icon of the speaking head. Then after a few seconds it moves to the icon of the door. Then, a few seconds later, it shifts to the icon of the wheelchair before returning once again to the speaking head. This system we are looking at is being prepared for a boy. When the speaking head is framed, the person doing the demonstration clicks on a little button. Suddenly, the display changes. We are in a new menu, so to speak, down a level. Most of the icons now have to do with speaking, and there are many more of them. For instance, there is an exclamation mark that leads to another menu that has to do with the user and the ways he might present himself. There is a red heart; this has to do with the expression of feelings. There is an icon for food and another for drink. There is one for clothes. There is one that has to do with work. And then there is one to do with shopping. Our guide clicks his button again, and now we see the contents of the shopping menu: clothes, the greengrocery, the supermarket, and the record shop—each of these and more has its own icon. Another click and we find ourselves down a further level, in the record shop with its icons. Now we get, so to speak, to the action. For if we click on these, then we hear a man's voice. First click: "Do you have the most recent album by DiDerre?" Second click: "How much does it cost?" Third click: "Please take the money from my bag on the back of the wheelchair." Ingunn is smiling. She recognizes the regional dialect of the voice. It is her own dialect, from the west coast of Norway. Our guide explains (he scarcely needs to) that the boy who will use this Rolltalk likes music and lives in the fjord country.

Prosthetic Articulation

The Rolltalk system is a hierarchy, a tree.[12] The user enters the tree at the top, with the welcome screen, and moves down the branches of the

tree until he or she reaches the activity, the place, the function, that he or she wants (for instance, buying a record). Then we hear the words. The boy for whom this particular system is being made cannot speak: he cannot go into a record store and ask for the latest DiDerre CD with "his own voice." Instead, the Rolltalk "speaks for" him and articulates his wishes. An implication of this is that he has a clear idea of the nature of his own wishes. For instance he likes music, particular styles of Norwegian pop music, and his favorite group is DiDerre. For this reason we want to say quite straightforwardly that Rolltalk is a prosthesis, an extension. It enables the boy to articulate and fulfill his desires, his wishes. As is indeed certainly true in the present case, this also implies that those wishes are indeed clear and may be clearly articulated.[13] To use the language that we have said we would prefer to avoid, the boy is being given a voice. To use the language that we want to develop, his personhood or subjectivity is articulated by prosthetic means.

"Can I Have Two Apples, Please?"

In this demonstration the boy who will use Rolltalk asked for the latest CD by DiDerre. But he might have gone to the greengrocer instead of the record store. The designers have created a similar menu here. Apples, bananas, cherries, oranges, pineapples—all of these and more are included in the menu for the greengrocer. Pressing the demonstration button again has a similar effect. The voice says, "Can I have two apples, please?" And the interaction proceeds in the same way. There is a function that activates the voice to ask a question about how much they will cost. And then there is an instruction about where to look to find his money.

Articulating Discreteness

As with the record store, the idea or the notion of "giving a voice" works well here. But why?

We have already given part of an answer. First, there is indeed a voice. Words are heard. Second, the boy knows about fruit and has a clear idea about what he likes best. But something else is happening too, and this is a third point. It is fairly easy to frame definite, discrete, and well-ordered likes and dislikes of this kind in a way that is, indeed, definite,

discrete, and well-ordered. These are some of the conditions of possibility for the exercise of what we sometimes think of as "rational" discretion: options that are similar in kind but different in their specificities are arrayed alongside one another. Clear, yes, discrete contrasts that may for the time being be fixed and programmed into the machine or into the world are being framed.

This is our argument. Under such circumstances—for instance, those of going into (certain kinds of) shops with their array of discrete and distinguishable goods—it is relatively easy to articulate the conditions for discretionary subjectivity. No doubt shops demand this, and at the same time, produce it. Menus in restaurants work in a similar way. Those who read menus are confronted with discrete items and choices. The making of discrete classes presupposes and helps to produce a certain kind of person, namely, one who can distinguish instantaneously among possibilities. All of this is no doubt consistent with, indeed necessary for, the discretionary subject or what is sometimes called the modern subject.[14]

He Likes to Play His Music Very Loud

As mentioned, Rolltalk is adapted to its users' needs and contexts of use. Per, who has cerebral palsy and is 36, still lives with his parents in a specially adapted part of their house. Despite the fact that he has few voluntary movements, his Rolltalk has many functions. He works it with a head switch that he operates by shaking his head, one way or the other. With this movement, he can control his wheelchair. He can link it up with various pieces of kitchen equipment, for instance the electric mixer. He can play a range of computer games. He can switch the television on and off and choose among various channels and the video. He can play music on the CD player, selecting from among nine preloaded CDs and controlling its volume (in fact he likes to play his music very loud). He is also able to work a model electric railway and can use the telephone. His Rolltalk does not do absolutely everything that he would like. One day, or so he hopes, it will be linked to a robot arm that will allow him to maintain cars. Nevertheless, his Rolltalk has many, many functions. The point of the story is that all this multiplicity is arranged in an elaborate hierarchy of menus and options.

Centered Articulation

What is implied by a menu with its discrete and separated elements? We want to make three points. First, the argument that we draw from the studies of STS is that a menu or a table "draws things together" (Latour 1990), things that would otherwise have been distributed heterogeneously through time and space. So the argument (again from STS) is that structures like tables or Rolltalk displays create new relations by juxtaposing objects, bringing them together and arraying them at the same time and the same place. They operate, that is, by *making a center,* a mini-panopticon, a subject singularity from which all the various possibilities may be seen. And then, as a further performance of competence, this supports (or requires) the ability to distinguish among these possibilities. In the present instance Rolltalk thus turns Per into a center when he chooses among CDs, allowing him to command his music in a way that would not be possible if he were able to select only the CD that happened to be in his player—or indeed, if the CD options were spread across a series of different menus.

Second, since Rolltalk is also a hierarchy of menus and options, this means that its centering effect is multiplied many times over. For a user like Per, with a complicated system, the tree of possibilities is enormous, and its centering effects are startling. He is being positioned as a center with many, many possibilities. Again, a version of this argument has been made within the sociology of science. The idea is that centers are made not only in the form of single tables or menus, but also as *tiers* of simplifications and juxtapositions that combine to produce ever more powerful combinations (see Latour 1987, 1990). Something like that is happening here, though there are also important differences, because, unlike a laboratory scientist or a manager with his overview of bar charts or tables, Per has to move *down* through the tiers to the right location in the tree. In order to effect action, things are not simply being drawn together, but are also being *drawn apart* again. The simplification of the welcome menu precedes the reelaboration of moving down the tree. This means that for Per there is no view from nowhere. Per is always somewhere. He is centered, but he is also local.[15] The original point still stands, however, for, as he confronts the welcome menu, Per is indeed being strongly centered, articulated as a centered and discretionary subject by the Rolltalk hierarchy of menus.

Third, centered articulation also makes (or unmakes) that which falls off the edge that which is outside of what is possible within the given conditions of possibility. This happens in various ways. For instance we will talk of the difficulty of achieving fluidity below, but here we want to make two simpler points having to do with the fact that the *scope* of any menu is limited: (1) There is room for only nine CDs in Per's CD menu. This means that for the time being all the other CDs in the world disappear. (2) Any menu is restricted to functions that are closely related to one another. Others are indeed far removed, being located somewhere else in the tree. For instance, Per's CDs are distant from his vocal options for supporting the local football team. This means that moving from the CDs to the football team menu is a long process of moving up three or four levels in the hierarchy and then back down again, along another branch, though, to be sure, this is a journey that scarcely matters, since choosing CDs is not important when watching football. Both points, then, tell us that "giving a voice" also takes away other possible voices, or that in this technology (and no doubt others) locally centered subjectivities are articulated, but the scope of any particular subject position is restricted. That which is not for the moment within the field of vision disappears completely.

"Listening to Bjørn Eidsvåg"

Now we are in the flat of another user. He is sitting in his electric wheelchair and we are watching a demonstration of his Rolltalk. Like Per, this user (we'll call him Knut) has voluntary control only of his head and neck. To operate the Rolltalk he moves his head and presses a polystyrene ball attached to a joystick. He starts at the top of the hierarchy that we have already seen: speech, environmental control, and wheelchair. He knocks the switch with his head and the next menu pops up on the screen: television, CD player, doors, and lights. We watch as the Rolltalk moves from television to CD player, and again he knocks the switch. For a moment nothing happens. It turns out that the infrared signal from the Rolltalk to the CD player is not working. Someone gets up and rearranges a tablecloth. Now Knut knocks the switch with his head again. This time, after a moment, the CD starts to play. Like Per and the DiDerre fan we men-

tioned earlier, Knut likes Norwegian music. The familiar sound of Bjørn Eidsvåg fills the room. He relaxes.

But his mother wants us to see how the system works. She speaks to him: "Can you switch the television on now?" Knut considers her request for a moment, and then he turns his attention back to the Rolltalk. This is still moving through its slow cycle: television, CD player, doors, and lights. Finally it reaches the television icon again and he knocks the switch with his head. A new menu springs up. There are icons for three different television channels, one for video, and another for turning the television off. Knut knocks the switch with his head to select one of the channels, NRK1. The television turns itself on and we are watching the Winter Olympics—a little bit of Japan in Knut's living room.

Articulating Autonomy

Here we are witness to subjectivity in the form of discretionary choice. It is the kind of context in which Rolltalk works best. Do you want to listen to a CD? Do you want to watch the television? And if so, which channel do you want to look at? In his own flat, and equipped with Rolltalk and the environmental control, Knut has been "given a voice." He is able to articulate a desire to watch NRK1 and switch it on. This means that he has been turned for the moment into a relatively autonomous person able to make discretionary decisions. Here, though, the verbal trope, the talk of "giving a voice," is troubling, since what is most important is autonomous action rather than the use of words. Choosing to watch a television channel does not involve the literal use of a voice at all. This means that to talk of "giving a voice" is both correct and rather misleading. This explains why we would prefer to talk, more inclusively, of articulation—that is, the articulation of different forms of subjectivity.

"I Am Thirsty"

We are still with Knut and his Rolltalk. He is clicking on the communication silhouette in the welcome menu. A new menu pops up. Choosing the icon for drink, he opens a third menu. Here there are three choices: water, tea, and coffee. As it happens, Knut never drinks tea. He almost always drinks coffee. But when the drink menu appears, tea is framed

and highlighted first. We sit while the Rolltalk counts away its seconds. It moves to water. Again we wait. Finally, the frame jumps again and highlights the icon for coffee. He knocks the joystick with his head and a voice says, "I am thirsty. Could I have some coffee, please?"

Articulating Agency

There is a peculiarity about this scene, one that Knut has to live through a dozen times a day: although he usually drinks coffee, he has to sit each time and watch while the Rolltalk offers him the options of choosing tea and water. So what is going on? Why doesn't coffee come first? Or for that matter, why, since he never drinks tea, is this included in the menu at all?

The answer is that if he wants to ask for a drink Knut is being made to be active, and indeed more active than is strictly necessary. As his mother explains in an interview, though Knut usually drinks coffee, "we have put water and tea in first so that he has to get past their icons and choose coffee. In this way he gets to exercise the use of Rolltalk." She says this because she knows that Knut, who is also quite severely cognitively impaired, needs to practice with the Rolltalk every day if he is going to use it and its functions at all. Indeed, in the past she has watched Knut slide toward inactivity in other circumstances when he has not been challenged by the need to initiate activity. Some of Knut's caretakers also think that it is neither necessary nor worthwhile for him to deal with the complexities of Rolltalk: they wonder whether it should be taken away.

All of this tells us something more about Rolltalk and the forms of subjectivity and agency that it articulates. Competent subjects are (or are taken to be) centered, discretionary, and autonomous. But as a part of this they are also, and necessarily, *active agents*. To be passive is not, or so it seems, an acceptable option.

"On and Off"

Knut's Rolltalk is relatively slow, stopping at each of the icons in the menus for about five seconds, much longer than for some users. It is also relatively simple: many of the menus have relatively few options. For instance, in the wheelchair menu there is only one option: to move the

wheelchair forward, along the magnetic tape on the floor. Knut can neither reverse it, nor steer it round corners. Again, he has only a few environmental control functions: light, door control, CD player, and television. Within each submenu the range of options is similarly limited. For instance, in the case of the CD player it is only "on" and "off." This is quite different from Per's system with its choice of nine different CDs and its volume control. Knut is even further removed from some users who are able to use their Rolltalks to work a word processor.

In short, Knut's system is relatively simple—slow and simple. It has been designed as a prosthesis "matched" to his possible performance.

Pacing Articulation

The task for IGEL is to articulate Knut as far as possible and in specific circumstances into a centered, discretionary, and autonomous subject and agent. This is not easy because the extent to which he can handle complexity, and do so rapidly, is very limited. He finds it physically difficult to operate the switch for moving between functions. Even more difficult is the task of operating it at just the right moment, when the menu item that he wishes to choose is highlighted. Sometimes making a choice involves numerous and frustrating false starts and mistakes.

IGEL tackles this in the way we have described above. Compared with many users, Knut's available system options are few. Perhaps this sounds like a limitation, restricting Knut's capacity to operate as a discretionary and autonomous subject. Obviously there is one sense in which this view is correct. But to put it that way is too negative, because the restrictions also work the other way around, articulating Knut as an agent with independent capacity to choose, albeit within a limited range of options.

A similar argument applies to pacing. For both physical and cognitive reasons, Knut cannot "make decisions" rapidly. His Rolltalk, with its slow shuttle between the different menu options, thus enables him and works to increase his discretionary capabilities even if its stately pace leads to its own frustrations. To put this in a slightly different way, the textures of social life run at different paces, but they are almost all too fast for Knut. However, Rolltalk does display a flexibility about pacing that most social interactions do not. It is a trivial task to program the

speed of movement between the icons.[16] So at least in principle, it is a trivial task to slow that movement down to the point where Knut and the machine can interact successfully. In this way Rolltalk helps to order a set of relations between Knut and his faster-moving environment, translating between different streams of events and their different time. In its (re)pacing and its simplifications it thereby articulates him as a discretionary subject, one who can indeed turn his CD player on and off.[17]

"It Is Boring. It Is Difficult"

Thomas is twenty-two and lives in his own flat in a modern and uninstitutionalized home. He demonstrates Rolltalk and its capabilities. He has been doing this for some while when he suddenly starts to move through the menus of options and clicks on the icon for communication. Then he clicks again on the icon for "feelings and emotions." Now, at the third level, he clicks again on one of the faces that make up this menu, and a voice says "Det er kjedelig" (It is boring), a comment that is greeted with nervous laughter by Ingunn and John. But Thomas does not stop. He is busy again. He is clicking on another icon, another speaking face. This time the voice says "Det er vanskelig" (It is difficult). There is more laughter, but Thomas is certainly making his point. He would rather be doing something else.

Articulating Resistance

Rolltalk works to enact people with discretionary power and autonomy. It enables them to act, in specific circumstances, as independent subjects and agents. It follows that it may offer its users the possibility of expressing a dissenting voice that is, so to speak, a specific expression of autonomy. How this works for different users varies depending on what is programmed into the machine. Here, though, a specific voice of resistance for Thomas has been preconfigured. So this is a voice that has to do with resistance. Active resistance is being performed, and it is being performed via the machine and within its hierarchical series of options and choices. In some sense, then, this is resistance that is socially acceptable. It is preconfigured, it is anticipated, it is accepted. This is a feature of the exercise of autonomous and individual discretion: that centered subjects some-

times seek to resist the demands laid on them. Here is a telling comment from IGEL, the producers of Rolltalk: "People should be able to express their emotions forcibly. When one user got angry with his caretakers he didn't just want to say 'you stupid bitch.' He wanted to be able to say 'you fucking stupid bitch!' " (in Moser 1996, translated from Norwegian). It is obvious that this is a much stronger way of expressing dissent. Even so, since IGEL has programmed it in, there must be some sense, some discursive location, in which the expression "you fucking stupid bitch" is acceptable. Indeed, in interview with Ingunn, IGEL insisted that "there should be no taboos" in determining options. If a user wants to swear, he or she should be allowed to do so. So this is not simply a matter of the way in which autonomous subjectivity articulates itself through resistance, important though this may be. It is also, and more subtly, a matter of discretion, perhaps in part interdiscursive discretion—discretion that is about when it is appropriate to speak one way—for example, in obscenity—rather than another. Our suggestion is that competent subjectivity depends upon the proper discretionary articulation of different discourses, including the discourses of resistance. More or less obscene or violent expressions of resistance, such as the one mentioned above, have indeed to be used with discretion if the subject is to successfully articulate him- or herself as a competent and therefore responsible person. This is why IGEL insists that there should be no taboos.

"Do You Want Me to Answer for You?"

Birgit has severe cerebral palsy, and she likes her music. John is asking her about her favorite music. He is speaking in Norwegian, but his Norwegian is scant. He is looking at Birgit and she is looking at him, but she is not responding. Ingunn puts the question again, this time in proper Norwegian. Birgit looks at Ingunn, and for a moment it seems as if she will respond. She does not. Then Birgit's mother, who is sitting in front of her, makes eye contact with her, affectionately taps her on the knee, and repeats the question more simply. Finally Birgit responds. She is not very verbal, but it is clear to all of us that the question or at least the thought of music pleases her. She is smiling and the sound she is making is clearly one of pleasure. Her mother smiles back at her. She asks her,

"Do you want me to answer for you?" Birgit moves her eyes; the answer is "Yes." Then her mother turns to John and reels off the names of a series of Norwegian bands. She adds that, though her interest isn't limited to Norwegian music alone, Birgit particularly likes Norwegian groups because then she can follow the lyrics.

Articulating Fluidity

This story may be used to illustrate a number of points. One of these has to do with reciprocity. In one sense, Rolltalk is all about making agents and subjects who are able to interact in ways that are more symmetrical with those used by people who are not disabled. So the story points to a moment when Rolltalk was no longer able to fulfill that function and Birgit's mother spoke for her rather than a programmed voice. This should not be misread as a way of insisting on a necessary distinction between human and nonhuman. Our sense of what is important here is quite different. It is that "modern" subjectivity, in part at least, expresses itself as fluidity[18] and movement. So what does this mean?

Perhaps it is easiest to set this up by contrasting it with the relatively fixed options that we have already encountered in the Rolltalk menus. Thus it is relatively easy to program discrete sentiments or expressions of preferences between bands or kinds of fruit into the machine. But it is much more difficult, perhaps impossible, to articulate the displacements of subjectivity as these move not up and down a preprogrammed hierarchy and through its menus, but from one unprepared position to another.

The point is complex for two reasons. First, to emphasize the point we made above, it is not a point about technology per se. As we have noted, advanced Rolltalk users are able to use the machine to work a word processor. This may be slow and laborious, leading to the problems of pacing discussed above. On the other hand it is most certainly a textual process that may articulate movements in and between novel subject positions. Second, neither is it a point about fluidity per se. It is our assumption that all subjects, abled and disabled alike, are fluid often enough, constantly moving between different subject positions and articulating these moves in many different ways. Words form only a part of this. A competent subject is one who is able to articulate such movements in words as well. And (or so this story suggests) Rolltalk in its more limited

versions does not work to make such verbal displacements possible. This means that a crucial moment in competent subjectivity is missing.

"He Does Not Want to Sit in the Electric Wheelchair"

Thomas works in a protected workshop where he sews, knits, and makes candles and other craft products. When he gets home in the evening he is tired. Often, after he has eaten, he simply wants to sit in a manual wheelchair and watch television. He certainly doesn't want to sit in an electric wheelchair with its Rolltalk and face all the choices and decisions that follow from this.

There is a bit of a tussle among his caretakers about this. They know him well, for this is a rural home in which there is little staff turnover. Some of them like to go along with Thomas's wishes and simply put him in the manual wheelchair. Others aren't so sure. They think he is being too passive in his approach to life. They've known him since childhood and they think that this is too simple and undemanding. Some have suggested that the manual wheelchair should be taken away. This would reduce Thomas's options and force him to accept the challenge of mastering Rolltalk with its requirement of activity and decision.

Articulating Nonverbal Resistance

What is happening here? One view is that Thomas is going for the easy option rather than the one that is demanding. It is that at least in these circumstances he is being rendered passive. But what does this mean? Thomas's case is slightly unusual. Many Rolltalk users have an option within the feelings and emotions menu to say that they are tired or they do not want to be bothered—that indeed they do not want to do anything active. In Thomas's case these options are not available. Perhaps no one thought about it. Whatever the reason, he cannot say "I am tired. Leave me alone." Not in as many words. Not in his "own voice," at least if by this we mean verbal language. But here, if we are right, he is *indirectly* articulating the fact that he is tired when he indicates that he would prefer to sit in a manual wheelchair rather than in the electric wheelchair with its Rolltalk. He is, as it were, speaking without speaking. But he is (if we want to use the term at all) nonetheless "speaking," or communicating, performatively.

Let's return to Birgit and her music. John has asked her about her favorite band and he has received her answer. But why did John ask?

The answer is that John has been sitting for an hour in an interview with Birgit, Birgit's mother, and Ingunn. Almost all of the talking has been done by Ingunn and Birgit's mother, and it has all been in Norwegian. The result is that John has understood very little of what has gone on. But what he has noticed is that Birgit, equally detached from the proceedings for much of the time, not only has used her Rolltalk to put on her CD player, but has also, so far as he can tell, become completely absorbed in the music. Taken up by it, she as a result has detached herself from the current of interaction around her and the talk between Ingunn and her mother. From time to time, her mother has made it plain that she is not altogether happy with this. She has tried to draw Birgit back from her music and into the conversation by asking her questions, for instance, by redirecting and rephrasing Ingunn's queries and asking her, "Do you want me to answer this question for you?"

Articulating Withdrawal

Birgit uses the command structure of her Rolltalk to set her CD playing, constituting herself as an autonomous and discretionary subject. Once she has done this she moves away from that discretionary subjectivity. It is not very easy to tell (yes, to "tell") what is happening for her, but our guess, based on watching her as she listens to the music and on what her mother says about her musical tastes, is that music (music, not the CD player) is a prosthesis that enables her to articulate a fluid form of subjectivity, one that moves and displaces itself, carrying her along in a stream of tonality and words that transports her elsewhere with its desires, frustrations, hopes, and feelings.[19]

If this is right, then we guess further that it works for her without any reference to the "deficit" of disability. Birgit (or so we suggest) is not "disabled" when she listens to music. Disability is no longer a relevant category. Instead the process of listening to her music allows, indeed demands, her full participation in the romantic tropes of humanism,

which means that she is as "successful" or as "unsuccessful" as any other listening subject in a romantic world made of longing, losing, desire, and communion. This is a romanticism that is in many ways a form of resistance to the words and rational choices of decision making, but is to be sure, in its own way, just as contemporary as the hierarchical menus of Rolltalk.

We're suggesting, then, that Birgit has gone away. She has constituted herself (and been constituted as) a romantic and fluid subject. In her music she is a subject who flows between places that cannot be fully put into words. She has become Other not only to the rationalism of the Rolltalk, but also to the centered though more fluid displacements of conversational interaction. No doubt there is much going on here. It teaches us, for instance, that fluidity, romanticism, and indeed desire are not only Other to rationalism and its fixed points but are also entangled with it.[20] It reminds us that this not only is a fact of nineteenth-century European history but is also performed on a daily basis at the end of the twentieth century—and not, to be sure, simply by those who are normatively disabled. The particular lesson we want to take away from this example is that it appears—and this is what one would expect of romanticism in a world that tells of itself as a form of rationalism—to be another form of resistance. For by now we have seen an implicit resistance acted through the desire to be "lazy," to watch television. And we have seen resistance in an active form, built into Rolltalk in the form of words that say, "I am bored." But this fluid immersion in music counts, or so we take it, as a third form of resistance: resistance by absenting oneself.

Undoing Asymmetries

In this chapter we have explored some of the ways in which an assistive technology for multiply disabled people works to articulate subjectivities. Rolltalk works in the lives of scores of disabled people to offer them a degree of control over aspects of their environments that would otherwise not be available to them. Accordingly, it tends to undo some of the asymmetries between the disabled and those among whom they live and upon

whom they depend. In exploring the character of Rolltalk and the ways in which it is used we have highlighted five points:

1. Rolltalk tends to perform subjectivities in specific ways. This is in part because of the technical features of the system (for instance, its structure of menus) but also because certain (centered, autonomous, and discretionary) subjectivities are considered to be particularly important for disabled people, or for people *tout court.*

2. Rolltalk sets limits. For instance, in some of its simpler versions it cannot directly articulate certain kinds of subject positions and or movements between subject positions, such as relatively fluid displacements between unprepared but verbally articulated subject positions.

3. The relations between fixed subject positions or articulations, however, and those that are fluid are also more complex than Rolltalk suggests. This means that fixed and discrete subject positions do not necessarily exclude those that are more fluid and that the requirement of active agency built into the system does not necessarily preclude (indeed, it may help to create) contrasting and passive forms of agency and subjectivity.

4. The process of designing and adapting Rolltalk may be imagined as a double experiment. Each individual system is tested and adapted for particular users. But more generally over time, IGEL can also be seen as building a more general model of the disabled user together with assumptions about the nature of competent agency and subjectivity.

5. Finally, we have considered the issue of "giving voice." Rolltalk enables severely disabled people to speak or act for themselves in ways that would otherwise be impossible. But the term "giving voice" is not quite accurate. First, it implies that a person has a voice that is simply waiting to be expressed, which is not always the case. "Voices" or, as we would prefer to say, "articulations" are created in an emergent and cyborg-like logic. Second, to talk of "giving voice" also implies a troubling commitment to logocentrism. Talk is a mode of articulation, but only one. Our data suggest that there are many other ways of acting, signifying, articulating, or resisting.

The new information and communication technology of Rolltalk is a double experiment: an attempt to enable disabled people and an explora-

tion of the character of competence, personhood, and subjectivity. To enable disabled people is a good. But how to tell of the goods of Rolltalk? What are the narratives that press themselves upon us? The complexities of competence, personhood, and subjectivity revealed by the Rolltalk technology suggest that there are various simple stories that are best avoided. For instance, there is an excessively optimistic story that overemphasizes the power of Rolltalk to open up unknown possibilities, give voice, generate discretionary autonomy, and all the rest. There is also an overly pessimistic story that points to the inability of Rolltalk to meet the fluid demands of conversation or verbal expression. As we hope we have shown, however, the truth, if there is a single truth, lies somewhere in between. Or, better, the truth is that competent subjects are both centered, autonomous, and discretionary and decentered, dependent, and determined, and competent agents are, at different times, active and passive.

It is possible to talk about this in general terms. For instance, in an earlier draft of this chapter we argued that Rolltalk performs a "modern subject." No doubt this is partly right. Disabled users of technologies such as Rolltalk often find that they have to be more "modern," more centered, and more discretionary than those who inhabit enabled bodies.[21] But there is something else. First there is the desire of those who are abled to "normalize" those who are not. Second, there is a loop: the desire by many of those who are disabled to be counted as competent or "normal" because they embrace normatively approved features of modern subjectivities. The latter, the desire for competence, is one of the reasons why the rather humble voices and subject positions offered by Rolltalk are so important. This is why passivity is not an option. All of this suggests that stories about "modern subjectivities" are important but also far too simple. As we have seen, the modern autonomous discretionary subject is certainly a great deal more than a fable, but it is always performed alongside its dependent and fluid Others.

But what of those Others? Here there is an alternative grand narrative about the "romantic subject." Yet this is a trap, because it romanticizes that Other by telling stories that celebrate Otherness, difference, and passivity by telling of the desirability of silence, nature, immanence, and the feminine. The body and the emotions are lauded as against the cognitive, the rational, and the verbal, and in the context we are considering, this

comes to romanticize disability. So though the romantic trope catches something important, it is also a trap to be avoided. In large measure it is a nostalgic repetition of modernism with its own risks. These risks have to do with passivity, which in the forms associated in Euro-American societies with disability, but also with childhood and femininity, is often closely related to and produced within extreme asymmetries in power that may turn into forms of abuse. This is yet another reason why a new assistive technology such as Rolltalk may be so important if it operates, however modestly, to re-form the relations of power, that is, to reduce asymmetries.

These dualist but related categories of modernism and romanticism point to another grand narrative that also presses itself upon us: that of gendering. The attributes of the "modern subject" and its Other, the "romantic subject," map onto those of gender discourse in ways that are all too obvious. It is tempting, therefore, to say that Rolltalk, with its structure of centered control and command, is a gendered technology, and no doubt there are many ways in which this is correct. But once again the issue is more complex. The technology itself is used successfully by both men and women, in which case, if we stick with the notion that it is gendered, then we are pressed to the position that to the extent to which women pick it up and make use of it, women are performed, or being made to perform, more in terms of certain norms of masculinity. Perhaps this is true. It is certainly a possibility that deserves consideration. But then again, it is also a standard trope in STS that technologies do not rigidly determine their uses, as is the case here. If fluidity or verbal fluidities are attributes that are coded as feminine (and this is self-evidently already far too simple), then we need to remember that fluidity is included within and enabled by the rigidities of Rolltalk. Our conclusion is that a large story about gendering works no better than large stories about the modern subject and its romantic Other. This should not, however, be misunderstood as a way of saying that this technology is gender-indifferent or gender-neutral. There is no doubt that it interferes in and performs gendering, but it does so in ways that are complex and specific. This too suggests the need for careful inquiry into the modes by which feminine and masculine subjectivities and agencies are performed, or not performed, through specificities,

including the specificities of assistive and other new technologies (see, e.g., Hirschauer and Mol 1995).

A Double Challenge

New media and new technologies not only require critical analysis but may be treated as occasions for exploring and testing assumptions embedded in social science and everyday understandings of the world. In this chapter, in attending to a new assistive technology, we have sought to explore the character of the person—of subjectivity—that is built into both the efforts of the IGEL engineers and more generally into Norwegian society. Such an exploration, as we noted at the beginning of the chapter, depends on interdisciplinary tools; we have drawn on sociology, feminist theory, and in particular, STS. It is our suggestion that these tools, and in particular, those drawn from the semiotic and poststructuralist claim that people (that is, subjectivities) may be understood as specific relational effects, are important in the analysis of the challenges posed by new media and their technologies. It is also our suggestion that the tools developed in STS, with its particular interest in the practices and materialities of the world, are particularly important in resisting the logocentrism of the notion of "giving voice" that we earlier noted. Articulation, we have tried to show, is not simply about speaking or language. It is also about performances and expression in other media. Our conclusion, then, is that the new technologies may, as we have suggested above, be seen as large-scale experiments in the character of personhood, the character of the subject, and the character of articulation. Yet at the same time, they offer rich opportunities for understanding the construction and the reconstruction of the person. So there is a double challenge: to understand and to remake those technologies and the subjectivities that they carry and to create the interdisciplinary tools that are needed if we want to understand these more or less ubiquitous processes.

Notes

1. For instance, in the classic social theory of Max Weber we learn that modern acquisitive capitalism originated in certain personality types that were

produced by ascetic Protestantism. In Karl Marx's writings, social and economic interests that arise from the mode of production of a specific society are seen to shape people, their interests, and how they interpret the world (see, for instance, Marx and Engels 1970 and Weber 1930).

2. On symbolic interactionism see, for instance, Blumer 1969 and Star 1991 and 1992. The literature on identities is huge, but for a recent sample, see Hall and du Gay 1996.

3. See, for instance, the work of Erving Goffman (1971), in which he tends to distinguish between self, on the one hand, and presentation of self, on the other.

4. Again the literatures are large. But see, for instance, Butler 1970.

5. The term "subjectivity" has a wide currency and is used in many different ways in different discourses (for instance, in law, politics, and philosophy). In the present context, it is the semiotic or poststructuralist usage that we adopt.

6. There is a body of work in STS studying how users are configured in the development of new technologies (see, for instance, Woolgar 1991 and Akrich 1992).

7. To protect the confidentiality and anonymity of our disabled informants and their families all names are changed, and, where necessary, we have disguised fieldwork material in other ways.

8. For recent instances in STS, see Star 1991 and 1992 and Vehviläinen 1998.

9. Or in the more overtly political context of deafness and the desirability or otherwise of the cochlear implant. For discussion, see Blume and Yardley 1997 and Lane 1997.

10. The term "articulation" draws on and resonates with the work of both Haraway (1991a, 1991b, 1991c, 1991d, 1997) and Thomas Kuhn (1970).

11.　　Rolltalk's Web site ⟨http://www.rolltalk.com/index2.html⟩ has images and further descriptions.

12.　　For other discussion of related information technologies for disabled people and their treelike structures, see Moser and Law 1998a, 1998b, and 1999.

13.　　Prosthesis does not necessarily imply the extension of something that is already given. For discussion of emergent cyborg-like qualities of partial connection, see Haraway 1991a, 1991b, 1991c, 1991d, 1997.

14.　　Here we are no doubt all pupils of Michel Foucault. But the discretionary subject is particularly lauded within the individualist and certainly also gendered (masculinist) discourses of active and autonomous agency. See, for instance, the discussion in Law 1991, 1994, 2000, and 2001 and Law and Moser 1999, in which it is primarily linked to the ordering mode of "enterprise."

15.　　In feminist STS there has been much critical comment on the notion of "modest witness" and its fiction of a "view from nowhere." See, for instance, Haraway 1991a, 1991b, 1991c, 1991d, and 1997.

16.　　This can in principle be done by anyone who has participated in the "toolbox" courses IGEL runs for family members and other caretakers of Rolltalk users.

17.　　There are subtleties here that require much further consideration. These have to do with level of complexity. In what we have written we indicate that Knut is unable to cope with levels of complexity that can be handled by those who are not cognitively impaired. This is an argument that assumes that complexity is indeed something that varies. There is an alternative position that suggests that complexity never varies, that level of complexity is, so to speak, self-regulating. This appears in Callon and Latour 1981 in which, in talking about black-boxing, they suggest that it is no more difficult to send tanks into Kabul than to dial 911 and call for the emergency services. This is explored much more fully by Marilyn Strathern (1991) in her work on self-scaling. The deeper argument here is that scaling, size, and complexity are effects rather than facts of life. See also Law 1991, 1994, 2000, and 2001.

18. The notion of fluid continuity is developed by Annemarie Mol, John Law, and Marianne de Laet (see Mol and Law 1994, Law and Mol 2001 and de Laet and Mol 2000). The argument is topological and has to do with conditions for the continuity of objects or subjects within different topological systems. In this writing three dominant topologies have been explored: regional or Euclidean, network, and fluid topologies. Physical geographies (which are also implied or presupposed in much social theory) rest on the Euclidean presupposition that objects subsist, unchanged by virtue of their temporal and volumetric continuity, in Euclidean space. Semiotics, with its commitment to invariance based on a stable configuration of relations (as, for instance, in the actor-network notion of the immutable mobile), rests upon or presupposes a network topology. A fluid topology assumes that continuity is secured as a result of changes rather than stabilities in relations. Thus the bush pump (and indeed its "inventor") described by de Laet and Mol (2000) continually changes its form, and the boundaries between it and its environment are similarly mutable. The assumption in all of this work is that the world and its contents are topologically heterogeneous, an assumption that is mirrored in this chapter. The hierarchy of menus of Rolltalk and the centered subjectivities that it generates rests initially upon the performance of a network topology. The displacement that we are about to consider is topologically other and fluid in character.

19. The idea that practical technologies and their centered subjectivities allow escape into other forms of subjectivity and that activities such as listening to music—or writing—might be imagined as prostheses is discussed in Moser and Law 1998a, 1998b, and 1999 and explored in Moser 1996 and 2000.

20. This is a point that we have explored elsewhere (Moser and Law 1998a, 1998b, and 1999) and is developed in a somewhat different idiom by Émilie Gomart and Antoine Hennion (1999) and Michel Callon and Vololona Rabeharisoa (1999).

21. In Norway there was a suggestion that twelve-year-old disabled people should pursue their own cases in the court that deals with social security claims. The oddity is that no other twelve-year-old would pursue a case of any sort in court on his own and that no one—no parent or anyone else—would argue

that this counted as evidence of his excessive dependence. This is not, however, apparently the case for those who are disabled.

References

Akrich, M. (1992) "The De-scription of Technical Objects." In W. E. Bijker and J. Law (eds.), *Shaping Technology/Building Society: Studies in Sociotechnical Change*. Cambridge: MIT Press, 205–224.

Blume, S. (1997) "The Rhetoric and Counter-Rhetoric of a 'Bionic' Technology." *Science, Technology and Human Values, 22*, 31–56.

Blume, S., and L. Yardley (1997) "Advice and Consent: Parents Choosing for or against the Cochlear Implant." Paper presented at Science and Technology Dynamics Internal Progress Conference (University of Amsterdam).

Blumer, H. (ed.) (1969) *Symbolic Interactionism: Perspective and Method*. Englewood Cliffs, NJ: Prentice Hall.

Butler, J. (1990) "Gender Trouble: Feminism and the Subversion of Identity." In Linda J. Nicholson (ed.), *Thinking Gender*. New York: Routledge.

Callon, M., and B. Latour (1981) "Unscrewing the Big Leviathan: How Actors Macrostructure Reality and Sociologists Help Them to Do So." In K. D. Knorr-Cetina and A. V. Cicourel (eds.), *Advances in Social Theory and Methodology: Toward an Integration of Micro- and Macro-Sociologies*. Boston, Mass: Routledge and Kegan Paul, 277–303.

Callon, M., and V. Rabeharisoa (1999) "La leçon d'Humanité de Gino" ("Gino's Lesson on Humanity"). *Réseaux, 17*, 189–233.

de Laet, M., and A. Mol (2000) "The Zimbabwe Bush Pump: Mechanics of a Fluid Technology." *Social Studies of Science, 30*, 225–263.

Foucault, M. (1979) *Discipline and Punish: The Birth of the Prison*. Harmondsworth, UK: Penguin.

Goffman, E. (1971) *The Presentation of Self in Everyday Life.* Harmondsworth, UK: Penguin.

Gomart, E., and A. Hennion (1999) "A Sociology of Attachment: Music Amateurs and Drug Addicts." In J. Law and J. Hassard (eds.), *Actor Network Theory and After.* Oxford: Blackwell and the Sociological Review, 200–247.

Hall, S., and P. du Gay (eds.) (1996) *Questions of Cultural Identity.* London: Sage.

Haraway, D. (1991a) "A Cyborg Manifesto: Science, Technology and Socialist Feminism in the Late Twentieth Century." In D. Haraway (ed.), *Simians, Cyborgs and Women: The Reinvention of Nature.* London: Free Association Books, 149–181.

Haraway, D. (1991b) "Reading Buchi Emecheta: Contests for 'Women's Experience' in Women's Studies." In D. Haraway (ed.), *Simians, Cyborgs and Women: The Reinvention of Nature.* London: Free Association Books, 109–124.

Haraway, D. (1991c) *Simians, Cyborgs and Women: The Reinvention of Nature.* London: Free Association Books.

Haraway, D. (1991d) "Situated Knowledges: The Science Question in Feminism and the Privilege of Partial Perspective." In D. Haraway (ed.), *Simians, Cyborgs and Women: The Reinvention of Nature.* London: Free Association Books, 183–201.

Haraway, D. (1997) *Modest_Witness@Second_Millenium.Female_Man©_Meets_Oncomouse™: Feminism and Technoscience.* New York: Routledge.

Hirschauer, S., and A. Mol (1995). "Shifting Sexes, Moving Stories: Feminist/Constructivist Dialogues." *Science, Technology and Human Values,* 20, 368–385.

Kuhn, T. S. (1970) *The Structure of Scientific Revolutions.* Chicago: Chicago University Press.

Lane, H. (1997) "Constructions of Deafness." In L. J. Davis (ed.), *The Disability Studies Reader*. London and New York: Routledge, 153–171.

Latour, B. (1987) *Science in Action: How to Follow Scientists and Engineers through Society*. Milton Keynes, UK: Open University Press.

Latour, B. (1990) "Drawing Things Together." In M. Lynch and S. Woolgar (eds.), *Representation in Scientific Practice*. Cambridge: MIT Press, 19–68.

Law, J. (ed.) (1991) *A Sociology of Monsters: Essays on Power, Technology and Domination*. London: Routledge.

Law, J. (1994) *Organizing Modernity*. Oxford: Blackwell.

Law, J. (2000) "Transitivities." *Society and Space,* 18, 133–148.

Law, J. (2001) *Aircraft Stories: Decentering the Object in Technoscience*. Durham: Duke University Press.

Law, J., and Hassard (eds.) (1999) *Actor Network Theory and After*. Oxford: Blackwell and the Sociological Review.

Law, J., and A. Mol (2001) "Situating Technoscience: An Inquiry into Spatialities." *Society and Space,* 19, 609–621.

Law, J., and I. Moser (1999) "Managing, Subjectivities, and Desires." *Concepts and Transformation,* 4, 249–279.

Marx, K., and F. Engels (1970) *The German Ideology, Part 1*. London: Lawrence and Wishart.

Mol, A., and J. Law (1994) "Regions, Networks and Fluids: Anaemia and Social Topology." *Social Studies of Science,* 24, 641–671.

Moser, I. (1996) *Informasjonteknologi for Funksjonshemmede* (*Information Technology for the Disabled*). Oslo: TMV, Senter for Teknologi og Menneskelige Verdier, University of Oslo.

Moser, I. (2000) "Against Normalisation: Subverting Norms of Ability and Disability." *Science as Culture,* 9, 201–240.

Moser, I., and J. Law (1998a) "Materiality, Textuality, Subjectivity: Notes on Desire, Complexity and Inclusion." *Concepts and Transformation: International Journal of Action Research and Organizational Renewal,* 3, 207–227.

Moser, I., and J. Law (1998b) "Notes on Desire, Complexity, Inclusion." In B. Brenna, J. Law, and I. Moser (eds.), *Machines, Agency and Desire.* Oslo: TMV, University of Oslo, 181–197.

Moser, I., and J. Law (1999) "Good Passages, Bad Passages." In J. Law and J. Hassard (eds.), *Actor Network and After.* Oxford: Blackwell and the Sociological Review, 196–219.

Star, S. L. (1991) "Power, Technologies and the Phenomenology of Conventions: On Being Allergic to Onions." In J. Law (ed.), *A Sociology of Monsters? Essays on Power, Technology and Domination.* Sociological Review Monograph no. 38. London: Routledge, 26–56.

Star, S. L. (1992) "The Sociology of the Invisible: The Primacy of Work in the Writings of Anselm Strauss." In D. Maines (ed.), *Social Organization and Social Processes: Essays in Honor of Anselm Strauss.* New York: Aldine de Gruyter, 265–284.

Strathern, M. (1991) *Partial Connections.* Savage, MD: Rowman and Littlefield.

Vehviläinen, M. (1998) "Silence, Strangeness and Desire in Writing Technology." In B. Brenna, J. Law, and I. Moser (eds.), *Machines, Agency and Desire.* Oslo: TMV, University of Oslo.

Weber, M. (1930) *The Protestant Ethic and the Spirit of Capitalism.* London: Unwin.

Woolgar, S. (1991) "Configuring the User: The Case of Usability Trials." In J. Law (ed.), *A Sociology of Monsters: Essays on Power, Technology and Domination.* London: Routledge, 57–102.

The Good, the Bad, and the Virtual

Ethics in the Age of Information

Mark Poster

. . . for what is morality, if not the practice of liberty, the deliberate practice of liberty?
—Michel Foucault

The media have a complex relation with ethical practice. The introduction of each medium, from print to the Internet, has been greeted with howls of despair over the fate of morality. Critics complain that the new medium will undermine the ethical basis of society. As late as 1880 readers of novels were warned of the dire consequences of print media: "Millions of young girls and hundreds of thousands of young men," the journal *The Hour* shrieked, "are *novelized* into absolute idiocy. Novel-readers are like opium-smokers; the more they have of it the more they want of it, and the publishers . . . go on . . . making fortunes out of this corruption" (in Tebbel 1975: 171).[1] The same concerns are often voiced today about the Internet with the same imagined threat of addiction. Of course jeremiads like this one are commonplace and cannot be given too much importance. Yet they sound a note that is revealing: they register the force of the medium and its impact, as medium, on the ethical culture. The complaint in 1880 said nothing about the content of the novel. The same

story told orally presumably would not raise hackles. Media, to employ Gilles Deleuze's term, deterritorialize culture and in doing so unsettle ethical certainties. And the Internet urges a rethinking of ethics, an innovation in the theory of ethics.

Sergio Leone's film *The Good, the Bad and the Ugly* (1966), for instance, sets cinema in opposition to mainstream American values as it upsets the moral framework of the Western movie genre. Westerns, from the early days of cinema with Edwin Porter's *Great Train Robbery* of 1903 through the 1950s, reenacted the American myth of the frontier (Wright 1975), the struggle against the Indians, the violence of life in the West and, above all, the clear delineation of good and evil. The morality of liberal America is tested and performed in Western settings: the struggle for society based on law against the harsh natural ambience, against pagan "primitives" and Mexicans, against the lust, greed, and brutality of transplanted Europeans—instincts set loose in the wilderness. The other presents a simulacral replay of America's origin myth: the building of a New Jerusalem in a desolate world and its repeated rebuilding in the settling of the frontier. In the Western, the American movie audience was constructed as a moral agent with an unambiguous imperative. As an American, one knew right from wrong. To do good meant progress and well-being, at least for white males with guts, brains, and brawn.

Leone's movie plays with the panorama of American morality. The protagonists (Eli Wallach as Tuco, Lee Van Cleef as Angel Eyes, and Clint Eastwood as Blondy) are introduced in turn at the outset of the film as the Ugly (*il cattivo*), the Bad (*il brutto*), and the Good (*il buono*). In a long (almost three-hour) quest, the three men prove themselves morally bankrupt. Eastwood's "the Good" only marginally improves on the other two when near the end of the film he shows compassion for a dying soldier. In the main, however, the heroes pursue buried gold with no higher goal. As they romp and murder in the stark Western landscape, Leone places them amid the Civil War, one of America's deepest ethical events. Again the war appears without moral justification, only as senseless butchery, for instance, in a battle costly of human life over a bridge that is without value. A dying Union commander dreams of the destruction of the bridge since so many men are lost needlessly in quest of its prize. The Good and the Bad comply by blowing up the bridge, but not to redeem

the captain's moral wish, only to allow themselves to pass through the battlefield to arrive at a cemetery where the gold lays interred in a grave.

The Good, the Bad and the Ugly introduces into the binary good-bad a third term, ugly, which destabilizes the opposition into a nonlogical list. The ugly is taken from a binary that has no direct relation with good and bad, from an aesthetic binary. "The good" and "the bad" in the title both suggest the standard moral equation of the Western and deny it: all three characters are bad, in an obvious way. In this way the terms "good" and "bad" shift from their adjectival sense into nouns. The trio may be Tom, Dick, and Harry or the Good, the Bad, and the Ugly. And by deploying these terms, Leone also suggests that his movie is a medieval morality play with characters given the names of virtues. In this chapter, I use the terms "the good," "the bad," and "the virtual" in a different way. I do not hypostatize them into characters. Instead I use the terms to suggest that the virtual may not fit into existing definitions of the good and the bad. For Leone in the mid-1960s employing the medium of film, the genre of the Western afforded the undoing of American ethical aspirations. The Italian director made use of an American medium and American narratives to question the core of American beliefs. And Americans loved it, judging by both critical and popular responses.[2] As the media extend their influence and multiply their forms, what might be the fate of ethics in what has been called "the age of information"?

Ethics as a Problem

How are we to evaluate mediated cultural acts? Can we apply to acts that are distanced by information machines the same norms, value judgments, and moral and ethical criteria that we use in evaluating face-to-face speech acts?[3] Do the standards deployed in real life serve us well in the virtual domains of cyberspace, film, radio, television, telephone, telegraph, and print—in short, in the media? I shall explore the hypothesis that the emergence of an age of information may put into suspension established ethical principles. Perhaps there is a specificity to ethics that limits its range of applicability to what is now, after the vast dissemination of media, called real life. Perhaps the virtual imposes a species of cultural life that is, to use Friedrich Nietzsche's phrase, beyond good and evil. The problem then

would not be to determine a means to apply ethics to a recalcitrant and strange domain of the virtual, but to invent new systems of valuation that adhere effectively to mediated life.

Another question arises just as the first is posed: if new ethical rules are required for mediated culture, perhaps the earlier system of ethics was itself flawed. Perhaps ethics as we have known it is put into question when the virtual complicates the real. Perhaps certain problems with the ethical emerge when one attempts to extend its reach to mediated acts. As long as the media were contained to particular times and spaces, ethics was arguably not in question. To read a printed novel, newspaper, or treatise is a special act, easily delimited from real life and face-to-face relations by the very materiality of the printed page. It is simple to distinguish between talking to a person and reading a novel, even if the novel is more arresting than the conversant. The medium of film is similarly bounded by its reception and its form: films are shown in specific places at specific times; they are determined in time and place. After the credits have rolled, the audience leaves the theater and encounters other people, perhaps to discuss the film.

These familiar boundaries between relations among people and the media are now beginning to crumble. Walkmen and portable radios permit a person to listen to music regardless of location. The assignment of specific places for listening to music has become obsolete. Television with its continuous flow of programming disrupts the sense that mediated culture is a collection of finite works. Twenty-four hours a day, over one hundred channels continue to broadcast, punctuated more by commercials than by boundaries between shows. Cell phones enable connections between people regardless of location. Space is eliminated as an obstacle to conversation. The digital network of computers enables global connections that are interactive, like conversations. Teleconferencing adds voice and video to remote relations. Audio and video reproduction by the consumer undercuts the hegemony of network programming; time-shifting, as it is called, the enactment of cultural objects. Combinations of these technologies are further blurring the lines between real relations and virtual relations. The Internet incorporates malls, radio, film, television, fax, and other media. Cell phones include e-mailing and limited Web browsing. Cars and home appliances "speak to" the consumer, and the computer

"recognizes" the user's speech. It is possible that the domain of the ethical was context-specific to cultures that at one end of a time scale were secularized and at the other end had not yet been immersed in virtual media. I shall turn now to the premodern period to ask if ethics were possible before modernization.

The great ethical philosophers of the modern period presupposed an individual separated from webs of dependency that characterized premodern society in the West. There had first to exist a certain distance between individuals and political and religious authorities in order for the individual to raise the question of the nature of the good. When Immanuel Kant formulates his categorical imperative for ethics ("Act so that you may will that the principle of your action be universal"), he assumes a world in which individuals may choose how to act and that the consequences of their acts will in some significant sense not be determined by institutional authorities (Kant 1949). Neither the peasant, nor the priest, nor the aristocrat could be the ethical person; only the bourgeois, the commoner bound not by personal ties of allegiance and obedience but by the impersonal rules of the market, could, from this perspective, be ethical. When these market rules were universalized, along with it came the universalization of the ethical domain. Even then the process took ages to accomplish. Nonwhites, women, and the poor all were outside the ethical when Kant wrote in the late eighteenth century.

Religion, the cultural dominant of the premodern era, does not give ethics the pride of place it has in modern society. To be commanded by God is hardly to adopt an ethical criterion in an autonomous rational act. One might still have a narrow slice of choice between God and Satan, but this decision is theological, affecting the soul for eternity, not properly speaking ethical. Søren Kierkegaard put ethics in its proper theological place, well beneath the religious, spiritual domain in import for individuals. Although the spiritual is here separate from and above the ethical, some religious thinkers did address the question of ethics in relation to the media. Kierkegaard, for instance, in *The Present Age* understands the challenge the media present for ethics and for spiritual life in general (Dreyfus 1999). He regards the press as a danger to humanity because of the anonymity it introduces. For him "the powers of impersonality" of the press are nothing less than a "dreadful calamity." The medium of

print eviscerates responsibility on the reader's part, undermining the moral dimension of commitment characteristic of face-to-face relations. The press creates a phantom public realm in which everything is "reduced to the same level" (Dreyfus 1999: 16). Kierkegaard maintains his critique of the print media at the level of the ethical. His complaint about the virtuality of print (what he calls its phantom quality) might raise more difficulties for him if he placed it at the spiritual level, where God himself might be regarded as a virtual being.

It is true that in the twentieth century, religious thinkers such as Martin Buber and Gabriel Marcel introduced ethical dimensions into theology. Perhaps this tendency is best illustrated by Emmanuel Levinas, who regards the ethical relation to the Other as deeply religious or at least spiritual. His notion of the Other serves to decenter the self, taking up familiar poststructuralist themes in a critique of philosophies of consciousness and of individualism more generally. The Other for Levinas is the moral ground of the self, disrupting all forms of Cartesian egoism. For our concern, it is especially interesting to note that Levinas presents the Other as a "face." Although the face for him is surely metaphorical, its position as the foundation for ethics reminds us of the territorial assumptions of the ethical, even as late as 1963 when *Infinity and Otherness* appeared. One could still at this point presume the arena of the face to face as the horizon of human relations; one could still forget about the machinic mediation, the facelessness of relations that insist on the partiality and multiplicity of the self engaged in moral interactions (Levinas 1985).[4] One might well carry further my line of argument about ethics and information by considering the ethical qualities of machine-to-machine communications, as well as of those from human to machine (as opposed to human *and* machine).

The philosopher's quest for the summum bonum, with all its variations and inventions, is but one perspective from which to consider the ethical. Another is the simple observation that individuals in their daily lives continuously make judgments about good and bad. Humans evaluate. This indisputable fact of social life, taken as a starting point for developing an ethics, is Nietzsche's (1967) approach. He develops a genealogy of morals by demonstrating the historicity of value systems. He outlines the pagan

noble ethics of good and bad, contrasting it with the Judeo-Christian slave morality of good and evil. Nietzsche's genealogy defines ethics as a historical construction. True enough, he overlays this history with a transcendental criterion of life affirmation, evaluating each moral system in relation to what he regards as its ability to promote great health (*grosse gesundheit*). And he closes his narrative of moral history with a future utopian system of the transvaluation of all values, a Hegelian synthesis of earlier systems that combines the spontaneity of judgment in the master morality with the depth of the slave morality, adding to the new moral regime an aesthetic dimension of creativity by the free spirits, the overmen.

What is most pertinent to my argument concerning ethics in the age of information is that Nietzsche includes a sociological moment in the understanding of moral systems. The standpoint of the group is crucial to the type of morality it will create. The noble stands above other people, making valuations from a position of domination. Whatever the noble likes is the good, because there is no one to tell him otherwise. By contrast the slave, who is in a subordinate position, must have values that first refute those of the rulers. To regard themselves as good, the slaves must negate the rulers' judgment. So the priest among the slaves invents another world, a heaven, with a moral authority superior to that of the earthly rulers, and in this higher authority, the slaves are regarded as the good, the slaves, that is, who attend to the higher authority and his rules. But the mediation of the higher world requires the slave to disavow all earthly judgments by elevating himself above the world. Discarded is the morality of flesh and blood, of territory, that is controlled by the lash of the earthly rulers' whip. Nietzsche's genealogy of ethics then goes through the circuit of sociocultural position, of territorial space. Yet Nietzsche, writing in the 1870s and 1880s, attentive as he was to the typewriter (Kittler 1990), did not consider the role of the media, of information machines, in the problem of the ethical.

I shall then pick up from the place left off by Nietzsche and attempt to outline some directions for the genealogy of morals in an age populated not only by humans but also by information machines. I shall pay particular attention to the Internet, since the term "information age" has taken on new urgency since people have begun flocking to the Net.

Terrible Machines

The incursion of information machines into daily life elicits considerable worry about ethics.[5] On the Internet itself there are many discussion groups in Usenet devoted to the topic, and it is a constant issue in chatrooms across cyberspace. Until the Web was created in 1993, the culture of computer scientists and the ethos of the university community dominated the moral tone of communication on the Internet. A vague ethic of the sharing of information characterized exchanges on the Net. In fact the architecture of networked computing promotes just such rapid, decentralized information flows. One of the basic functions of the Net, file transfer protocol, has no other purpose. The design of the Net maximized openness among users as if participants lived in a harmonious community, one where no one need lock her door, surround her property with fences, or erect gates to keep out intruders. Civility was presumed and largely prevailed on the Net from 1969 to 1993. Users were for the most part convinced that a utopian communication device had been set in place that surpassed the moral tone of real-life meetings as well as encounters in other media. Howard Rheingold's (1993) discussion of The Well, a bulletin board or electronic cafe located in the San Francisco Bay Area, attests to the general goodwill and mutual aid of this period.

Yet even in this halcyon period of the Net, troubles emerged. Forms of conflict appeared that were possible just because of the technological design of the Net, forms of strife that had little parallel in real life. In particular, spamming (sending unwanted messages) and flaming (insulting an addressee, often with violent language) ruffled the equanimity of users (Spinello 1999). Spamming was promoted by the ease of sending messages in multiple copies to multiple addressees. Flaming was encouraged by the distance between sender and receiver and by the interface of the screen (Dery 1993). These flies in the ointment of open communication, users believed, could nevertheless be regulated by the Net itself. "Netiquette" was the term invented for proper Net communication, and protocols of civil communication spread quickly among users. New users were initiated into the mores of the Net by older users. But in 1993 Web browsers were invented, making the use of the Internet easier and more attractive as graphics and sound were integrated into computer communications pro-

grams. The population of users grew quickly from 20 million to 200 million by the end of the decade, overwhelming the Net culture of the earlier period. In the new conditions of mass usage, the practice of coaching newbies in the ways of netiquette could not keep up.

The problem of the ethics of the Net attracted the attention of other media—newsprint, radio, film, and television—in which the issue of intermedia rivalry must not be overlooked. These broadcast media (transmitting the same copy from the few to the many) presented the world of the Internet to society at large, to those who had never used the Net. The discussion of ethics on the Net escaped the confines of the Net itself and became news for everyone. If spamming and flaming besmirch the moral tone of conversation on the Net, newsprint and television arguably present even more degraded frames of communication. In those media, the capitalist profit motive encourages gross, sensationalist strategies of information conveyance. Selling newspapers or movie tickets and attracting viewers and listeners lower the discussion to a deplorable level. When the topic of ethics on the Net turns to its presentation in the broadcast media, the medium is so coarse that the message, in this case ethics, is difficult to discern. In newspaper and television reporting about Net ethics, it is impossible to separate motives of gain from evaluations of behavior in cyberspace. The ethics of broadcast media render absurd a discussion of ethics.

Acknowledging these problems, I shall discuss the treatment in the press of ethics on the Internet, focusing on issues of content, censorship, and anonymity. In this discussion it is important to keep in mind the question of the private and the public, for what seems to raise ethical concerns about the Internet is often the ease of access and global availability of what is posted there, just the features that the design of the medium promotes. In other words, what raises hackles for some is not that a particular act is committed or statement is made but that it is so out there, so blatantly in one's face, so terribly, unashamedly available, so public. In 1985, Joshua Meyrowitz raised the issue of the media's ability to blur boundaries between public and private, especially in the case of television. The televised shooting of Lee Harvey Oswald by Jack Ruby, news films from the front in the Vietnam War, the live broadcasts of the Gulf War and the O. J. Simpson trial, and so many other cases are self-evident

examples of the power of the media to change audiences by transporting what had previously been public actions right into the home. In the early 1990s, Lynn Spigel (1992) made a similar case for television's impact on the public/private distinction in regard to gender. Broadcast media undermine modern culture's ability, she argues, to maintain a private realm separate from the outside, and with this loss so disappears the ethical individual. In a mediatized culture, individuals lose their distance from the public sphere, lose a sense of separateness from objects and events outside themselves, and lose the cultural distance that is essential to autonomous, ethical judgment. The Internet continues this trend but amplifies it considerably because its content is always and everywhere available, not limited by the time/space controls of the broadcast corporations, and because it is interactive, fostering a deeper participation in the cultural event by the recipient of the message.

Take the example of a sex change operation performed for everyone to see on a Webcam. The *Los Angeles Times* reported the event as an ethical question. The headline read "Sex-Change Webcast Stirs E-thics Debate," underlining both the ethical and the media aspect of the event. The doctor performing the surgery was asked to defend himself on ethical grounds, not because he was doing a sex change operation but because he was Web-casting it. The ethics of transgender may be objectionable to many people, but as long as the event is sequestered behind the walls of an operating room, it does not seem to incite moral emotions. In the newspaper report, the operation rises to the ethical dimension solely because of its media existence, its availability. The important point is that acts that may be regarded as acceptable in certain contexts become moral issues because of their media proximity. The media (in this case the Internet) change the ethical environment. They do so by juxtaposing actions, images, sounds, and texts from diverse subcultures. The media mix together what in real life is held apart. They in short transform the cultural basis of ethics by erasing boundaries that subsist in time and space around local communities. The Internet demands that we acknowledge as morally acceptable things that we prefer to disavow. Thereby the Internet brings to its users a wider spectrum of humanity than before. It reveals to us that our comfortable distinction of public and private permits us to tolerate experiences that we regard as bad or even evil.

The report of the event in the newspaper further complicates the ethics of new media. It ensures that those who do not use the Net will know about the operation and the Web-cast. Those who are not familiar with new media and perhaps are somewhat anxious about them are confronted by information about an experience they judge without any actual sense of what happened. Newspaper readers are likely to make judgments not about the surgery as such, but about the propriety of its appearance on the Internet. A similar complication occurred two months earlier when the *Los Angeles Times* ran a story about FBI agents who pose as underage girls in chatrooms to entice would-be sex offenders. In this case the ethical question was not about sex with thirteen-year-olds but about the authorities' behavior. Since on the Internet no one knows you are a dog, no one knows you are an FBI agent either. Officers manipulated features of the medium to encourage pedophiles and then to arrest them. A representative of the Electronic Frontier Foundation told the *Times* reporter that "at least half the 13-year-old girls in chat rooms are probably policemen" (Miller 1999b: A21). The content of chatroom discussions is not in question in the newspaper report, only the ethics of police luring pedophiles.

If the ethics of the FBI become questionable when agents go online, print media find just as perplexing distinctions between the virtual and the real induced by the Net. It is well-known that a good deal of downloaded content on the Web is erotic, a fact that says as much about the state of sexuality in postmodern Puritan culture as it does about new media. And some of this material consists of images of children. But is it ethical to view or download child pornography? The *Los Angeles Times* wanted its readers to know that courts found computer images of naked children acceptable but photographs of those children illegal. A Circuit Court of Appeals judge explained to the reporter: "The 1st Amendment prohibits Congress from enacting a statute that makes criminal the generation of images of fictitious children engaged in imaginary but explicit sexual conduct" (Weinstein and Miller 1999: A1). The judiciary discovers that the Internet is the realm of the virtual, quite distinct from the real, where other laws apply. The newspaper disseminates information to all society that questions the ethics of a separate order of the virtual. The key is the criterion of the fictitious. If an erotic image of a child is digitized and some of the pixels are altered, the image is no longer that of an

"actual" child. How many pixels have to be changed for the image to enter the register of the virtual? Or is the mere digitization and uploading of the image itself a conversion into the virtual? The reporter did not clarify the precise aspect of the networked computing that alters the ethical quality of an image.

With new media, contents of actions and symbols no longer fall under ethical rules that apply in real life, and the print media disseminate a disturbance. Another example illustrates the difficulty more fully. Again the case involves FBI agents cum underage girls. This time the perpetrator raised the defense of virtuality: even though he showed up in real life for a meeting with the underage cybergirl, Patrick Naughton, the accused, argued in court that his actions "were grounded in an online fantasy world" and were not reprehensible morally and legally (Miller 1999a: C1). He won his case. The justice system accepted the distinction between real and virtual pedophilia.[6] And I rest mine that the media upset ethical certainties and alter the content of human experience, a condition that older media find troublesome.

Anonymity of Identity

In the early days of Internet messaging in the 1980s, the ethical problem of computer-mediated communication had already arisen. In such communication, the interface of the computer removes all traces of the embodied person: her voice, appearance, and gestures. The receiver of the message perceives only what is typed on the screen, and this is received from a user name that is often fictional. Many users assume the identity they are communicating with is a "real" individual, one whose e-mailed statements are equivalent to spoken words in proximate relations. Thus in an electronic community from the early 1980s, participants were dismayed to learn that their long-time friend whose online identity was "Joan" was a male psychologist named Alex. Many participants were troubled by what they regarded as an ethical transgression: a person willfully misled others about his gender (Van Gelder 1996). To swap genders and to carry on years of exchanges as if the "wrong" gender were the actual one was, for these users of electronic messaging, an ethical crime of identity fraud.

Networked computing is not the only medium in which such deceptions occur. It is possible to switch genders in written letters, in masquerades, and even in everyday life by cross-dressing, as the movie *Boys Don't Cry* (1999) demonstrates. Books may be published under a pseudonym; passports and identity papers may be forged or altered. Even before electronic and print media complicated personal relations, identity could be in question. The film *The Return of Martin Guerre* (1982) depicts identity confusion in a preindustrial village community. One cannot be absolutely certain then of the identity of one's interlocutor. While not unprecedented, the ethical issue of identity in online exchanges is new in its systematicity. The interface of the computer, coupled with the ease of communicating through the network, renders identity in question *in every case*. Messages sent through the Net *are always* suspect. What is the ethical value of this unrelenting suspicion?

One aspect of the question of online identity is the relation of responsibility to anonymity. Some observers argue that the easy anonymity of the Net promotes irresponsibility. On the Net, this position maintains, users may say or do what they like without suffering the consequences. If I insult someone I am "chatting" with, I may leave that "room," and I may even return under a different handle. In a widely publicized case of cyber-rape, a participant in an online community performed on the screen unmentionable acts upon other members of the electronic space. The offended parties, that is, the individuals behind the online identities, were deeply affected by the outrage and demanded that the operator of the system punish the offender, who, as far as anyone knows, committed no such infractions in real life (Dibbell 1993). It would appear from this case that Net anonymity contributes to ethically questionable behavior. To decide whether such a statement is accurate, one would, I suppose, have to compare the ethical quality of conversations on the Net with those in proximate relations. Perhaps such a study would need to include a vast quantity of dialogues. There would be difficulties for the analyst, such as the availability after the fact for study of online dialogues in archives compared with the need of the analyst to be present, or have a recording device present, during proximate conversations. In each case the analyst is in a different relation to the dialogue, a difference that some social scientists might find troublesome in terms of biasing the research results.

If the role of anonymity in the ethical quality of conversations online and proximate is undecidable, the anxiety Net dialogues elicit is revealing. Those who worry about the ethics of anonymous conversations impose two questionable assumptions. They presuppose the moral superiority of face-to-face relations, and they imply that online dialogues may be evaluated by the same criteria, are of the same order, as proximate relations. Each of these premises presents difficulties. The first leads to a contradiction: if people act morally, in part, because they are in certain physical relations, then the act, to the extent that its ethical value derives from the spatial arrangement, cannot be moral. If morality supposes choice, then territorial qualities of acts are not moral. They are conditions within which acts may or may not be moral. It is true that the decision to place oneself in proximity to a conversant, as opposed to communicating online, might be a moral choice. But once one is in that position of nearness, the nearness is not volitional, but a condition of the conversation.

The second premise—that real and virtual are equivalent—begs the question of the possible difference between the two. A good case can be made that proximate relations and virtual ones invoke different ethical choices and even different criteria. Kant's ethical imperative might apply and be appropriate for bourgeois society, one in which individuals have a great deal of choice (job, marriage, political affiliation, etc.) and considerable social distance from authority figures. Yet the Kantian ethical individual is in the real: he or she meets with others in face-to-face relations. The Other for this individual is someone known and experienced proximately. As one moves away from this configuration of ethical choice, say, toward the non-European Other, Kantian ethics works less well and seems harder to apply. Act so that you may will the principle of your action to be universal is difficult to consult when you know nothing about the subject of the universal and when you tend to regard the Other as the same as you (when Eurocentrism prevails). The Kantian principle governs the real, as choices are continuously negotiated by Others who are proximate.

In virtual space, the Other is a configuration of pixels on a screen. Proximity to the Other may be emotionally and aesthetically compelling—one may fall in love with one's interlocutor—but the relation is not with an embodied presence. In cyberspace one may dump the

Other with ease and little consequence. Simply turn off the machine, do not reply to e-mails, change one's handle, get a different Internet service provider or a different account and the ethical relation is ended. The ease of disappearance requires a different type of moral obligation: the virtual invokes the ethical duty to maintain one's identity. Continuity of subject position in the virtual is an ethical requirement that makes no sense in real life. In real life, even the hint that one is multiple evokes psychological diagnosis and legal action. In the real everything conspires to maintain the collective fantasy of the centered self. Only within that form of the self does the Kantian imperative come into play. The virtual realm shifts the register of the self's relation to itself. In cyberspace a practice emerges of continual self-definition. Ethics recedes into ontology. The Other has not vanished, and the practice of self-constitution is not that of liberal prescriptions about autonomous choices. In the virtual, the Other is just as exigent as in the real, only without physical embodiment. Self-constitution occurs in the virtual in language practices, just as in the real. The mechanisms of interpellation and misrecognition operate just as surely in the virtual as in the real. If one insists on ethical terms, it might be said that virtual ethics entails a different, perhaps deeper type of obligation. The moral imperative might be "act so that you will to continue to maintain the identities you have constructed in relations with others."

Overload and Censorship

There is a moral dimension to the political economy of information, one that has intensified dramatically with the spread of awareness about the Internet. People object to having not enough information, to a lack of access to information, to exclusion from sources of information, and to the unequal distribution of information. The assumption in this position is that information correlates directly with life chances. The more information one has, so the logic runs, the better one can live. Surprisingly this position is held both in corporate discourse and in that of its critics on the left. Business ideology has completely adopted the view that information access is the key to success: the more information one has at one's disposal, the more likely one can reap higher gains. Since the summum

bonum of the capitalist is the bottom line, in a perverse way, information *is* morally good. And the same applies to critics of capitalism: for them, the high-tech wired and wireless world of telecommunications is immoral in its exclusion of the poor, nonwhites, and women. This charge is made rather harshly against the Internet, although the same complaints are often raised against television despite its almost universal dissemination. Despite these disagreements, surely open access to information on the Internet is a moral good and a political necessity.

Contrariwise others bemoan the flood of information, bewail information overload, and protest being inundated by information. The discourse of the data flood, as we might call it, presumes a psycho-physiological model that is questionable: humans must have a limited ability to absorb external sensations, and the Internet is hogging too much brain space. Anyone who has ever set foot in the Library of Congress must realize that the treasure of knowledge has long ago surpassed the individual's ability to survey it. Perhaps the ease of access afforded by the Internet to massive stores of cultural objects disturbs those in this category of moral positioning.

Even astute cultural critics often succumb to one or the other of these hypotheses. Jean Baudrillard (1994), for instance, bemoans "the implosion of meaning in the media." He warns that "we live in a world where there is more and more information, and less and less meaning" (79). Baudrillard argues the interesting proposition not that we are drowning in information, but that an inverse relation exists between the quantity of information available and the quality of meaning in social life. The term "information" for him denotes electronic mass media (in short, television). Within this medium, information takes on the form of the simulation, the sign that is cut off from social exchange. Information, for Baudrillard, constitutes an opposition to the real, one that eventually supplants it. Meaning persists only at the moral level of social life and cannot survive the mediation of electronic circuitry. Hence the more we communicate or receive signals through electronic media—the more information we have—the less meaning we have. Baudrillard's dire judgment about information was offered in 1981 before the Internet was a glimmer in his eye. His writings since the mid-1990s, however, simply extend the analysis of televised information to the new media (Baudrillard 1995).

If the unprecedented quantity of cultural objects available in cyberspace has generated ethical discussions, so has the type of objects. Moral questions in the information age focus on what may be seen, read, and heard on the Internet. The censorship of what can be said and what material can be accessed on the Internet, as well as the sheer mass of available material, has stimulated debates over the moral quality of new media. Without question, one of the most lucrative Internet businesses is the provision of erotic materials. If the marketing success of videotape recorders depended on the demand for rentals of pornographic films, so the spread of the Internet has been motivated for many by access to erotica. In some cases such images concern children, and we have seen how difficult it is to apply laws designed for territorial space to cyberspace. Questions of free speech are also at stake. Obnoxious neo-Nazi home pages offend anyone with the faintest sense that racism is puerile and dangerous. Less controversial Web sites also raise moral questions. Parodic sites proliferate on the Web, often containing false information, deceptive images, and misleading pastiches of text, image, and sound. Since these sites are easy to construct and cheap to maintain, the Net allows cranks of all stripes to vent their peculiar feelings, sometimes in damaging forms. With this newfound ease of presenting disturbing materials accessible worldwide, perhaps a new level of moral restraint is required.

Discourse on Ethical Machines

Scholars have begun to discuss the question of ethics in the information age. The journal *Ethics and Information Technology* began in 1999, and a bibliography on the subject is available both in print and online (Tavani 1996). The first annual meeting of the Association for Internet Researchers was held in 2000 with attention to the question of ethics. The basic issue pursued by researchers on the ethics of the Internet is not what is the good or even what is the ground of ethics, but a more primordial concern: how can identity in cyberspace conform with identity in "real life"? The question of the nature of the good has become the question of the nature of the ethical subject. Computer-mediated communication places a thick interface between the phenomenological subject and the online subject, with the consequence that usual ethical issues

must be set aside and another question raised, that of identity. In Kant's ethics and even in Nietzsche's genealogy of morals there is, properly speaking, no question of the ethical subject. Researchers on the Internet have no such assurance. They must first ascertain the nature of the communicating subject and its connection with the "real" subject. The ethical question thus shifts to this relation: mediated and immediate identity.

Many scholars simply assume that it is good if the identity of the online subject conforms to that of the phenomenological subject. In her study of Usenet identity, Judith Donath (1999) asserts the "unity" of the subject in the real and argues that cyberspace raises the question of "deception" about identity because the body is not present at the point of enunciation and because technical means of changing identity are readily available, even built into the communication situation. The Internet then makes possible a new ethical concern: deception about identity. Donath thus registers the uniqueness of communications on the Internet but wants to impose upon it what she regards as the standard or norm of "the real world." She does not explore ethics from the point of view of the new speech situation to ask what new issues might emerge for the older assumptions on the basis of the new circumstance.

Confusions over identity occur routinely in mediated communications with far less complex interfaces than the Internet. One research team reports on a medical technology in which patients are given advice by a computer, "an intelligent interactive telephone system" known as telephone-linked care (Kaplan, Farzanfar, and Freeman 1999: 71). What surprised the scientists were the deep emotional reactions of patients to the computer. Patients formed "personal relationships" with the voice on the phone, even though they knew that it was machine generated. Strong ethical judgments were made by the patients about the machine. They loved and/or hated the machine (Kaplan, Farzanfar, and Freeman 1999). In this case, the identity of the machine was altered by the patient. It was "humanized" and brought into the sphere of the ethical. The study of telephone-linked care suggests that mediated identities are by no means stable, that "identity deception" is not an adequate conceptual vehicle for understanding ethics in the mode of information.

Habermas's "Discourse Ethics"

One theory of ethics that properly claims attention in relation to the question of the information age is Jürgen Habermas's notion of "discourse ethics." Habermas grounds ethics in communicative practices in which individuals reach consensus by recognizing the validity of claims of others in the group. By looking for a basis of ethics in communications, it would appear that Habermas comes close to the issue of an informational ethics. Discourse ethics, according to Habermas (1990), "stands or falls with two assumptions: (a) that normative claims to validity have cognitive meaning and can be treated *like* claims to truth and (b) that the justification of norms and commands requires that a real discourse be carried out and thus cannot occur in a strictly monological form" (68).

The first requirement for a discourse ethics—that moral claims be *like* claims to truth—takes the argument to Kant and the need to ground morality in reason, a claim that I have argued above pertains to a situation of autonomy that is no longer pertinent. Nevertheless the bulk of Habermas's effort aims to clarify this issue: to ground discourse ethics in a truth claim that aims at universality. Lacking this principle, Habermas maintains, the speaker falls into performative contradiction. But performative contradiction pertains to the individual as speaker, isolating once again the position of speech from the intersubjective context and the possible reliance on machine mediation. It also presumes a field of discourse that is subject to rational resolution. But contra Habermas, there may be no individual who is separate from a machinic interface, as in mediated communication. In the speech situation of networked computing, no unitary individual faces another. Instead, partial identities exchange cultural objects in a condition of paradox, that is, as if they were temporarily at least unitary subjects.

The second criterion sets ethics in relation to language and social interaction. Here we are closer to the problem at hand. Habermas (1990) specifies the communication situation again without reference to the media. Discourse ethics occurs for him in the "lifeworld": "The symbolic structures of every lifeworld are reproduced through three processes: cultural tradition, social integration, and socialization" (102). These

processes might be elaborated to include media, but Habermas does not venture in that direction. Without such an elaboration, the question of ethics in the age of information machines cannot even be posed. His promising move toward an ethical theory related to language ends in repeating the context of face-to-face speech.

Beyond Good and Evil

I have argued that a transcendental ethical principle is not possible, or at least that in the current conjuncture of mediated information society, its elaboration does not adequately constitute the conditions of ethics, does not illuminate the dynamics of good and bad in the various cultural contexts of cyberspace and broadcast and print media. Instead I urge a Nietzschean perspective that explores the good and the bad in the culture of the virtual. The moral positions of the master and of the slave, which Nietzsche analyzed so trenchantly, take as their communication context oral and print cultures. Moralities of good/bad and good/evil growing out of these contexts apply at best partially to information society. Even so, Nietzsche's critique of these moral postures is worth considering in relation to today's high-tech world. He proposed a "transvaluation of all values" with an eye to the enhancement of "life" (Nietzsche 1966). Although his project contains many difficulties, his method of cultural transformation may serve as a starting point for rethinking ethics in an information age.

Nietzsche advocated, paradoxically, an aesthetic process of moral creation. His "free spirit" or "superman" resembles nothing so much as an artist, a spiritual warrior, one who wrestles with her own limitations to move beyond them, to get to a place where new values are possible. "One must have chaos in one's soul to give birth to a dancing star," his Zarathustra urges (Nietzsche 1969: 11). The Nietzschean moral elite (for it is an elite) explores its own values, dissects them, rejects them, devalues them, and purposefully seeks the pain of being lost, uncertain, without direction. In Herculean struggle with herself, the free spirit experiments with "living dangerously," risking her beliefs, deliberately placing herself amid the unfamiliar and the strange. This interior battle is Nietzsche's

formula for cultural innovation. Only after such a self-reflective struggle is the individual in a position to find new values, new ways of valuing that he thinks are less self-destructive than both the noble and the democratic moral mechanisms. Having undergone a rigorous process of self-transformation, the free spirit is capable of expressing beautiful values, values that will attract others to join in their celebration of them. Nietzsche's moral elite *charismatically* and without force draws others within its moral circle, thereby enhancing the "life" or affirmation of life of all. This new will to power of the ethical requires for its appreciation the imagination of a constellation that has rarely if ever existed. In such a world the good and the beautiful are not opposites, the good, the bad, and the ugly do not constitute an oxymoron, and the elite and the *demos* are not in struggle against one another, so power and submission or acceptance are not achieved by brutal force.

Nietzsche's utopia beyond good and evil may be impossible or wrongheaded or undesirable. Its interest, however, lies in the mechanics of cultural transformation that it delineates. Is there some analogy or resemblance between the process of moral transformation in Nietzsche's elite of supermen and the conditions of moral judgment in the age of mediated information? Does our submersion in print, broadcast, and computer-networked media provide us with anything like the conditions of estrangement, disorientation, and critical uncertainty that Nietzsche outlined as the basis of cultural questioning, of bringing "chaos to one's soul"? Well, there is one enormous difference between them. Nietzsche spoke of an elite few capable of undergoing self-exploration, self-examination, and self-rejection. The media, by contrast, surround and solicit the many and involve multitudes in their web of remote cultural exchange. And the prospect is clearly that more and more will be so implicated, even to the extent of eventually enveloping a good deal of the world's population.

Contrariwise there are similarities. Networked, digitized information media cut across territorial boundaries of cultural groups. They juxtapose differences in a homogeneous medium. They bring together individuals with common interests but divergent nationalities and traditions. They shuffle us around, mixing and remixing the basic elements

of cultural coherence. They form new agglomerations that make no sense in relation to proximate practices and norms. They interrupt the smooth flow of naturalized, legitimized mechanisms of constituting subjects, reconstituting them with bits and pieces of dissociated culture. They require a constant travel back and forth from the face-to-face, print, broadcast, and networked information flows. They disrupt the narcissism of the familiar, the identifications with the same. In these ways they perform a reorganization of the ethical subject, bringing chaos to the souls of those online. The Internet enacts a massive deterritorialization of cultural values and by so doing links or reterritorializes the ethical and the political. One innovation, then, of the Internet is a call for a new theory of the political as a collective determination of the good in a context in which the ethical, the individual determination of the good, receives somewhat less prominence than in the modern or print age.

The disruption of ethics as usual introduced by the Internet is enabled by its deterritorialization of information exchange both in the literal sense of reducing the significance of space in communication and in the figurative, Deleuzian sense of unhinging preexisting patterns of culture. As a consequence, ethics takes on a political dimension, one that in some sense it perhaps has always had. The establishment of ethical norms, for instance, those of netiquette in cyberspace, occurs in the process of forming new relations of force, giving shape to the emergent zone of cyberspace. Ethics and politics appear mutually imbricated in networked computing. Whereas ethical issues in the information age include topics of censorship and overload, as these challenge existing norms and attitudes, the more serious issues point to the possibility of a transvaluation of values and the political aspects of forming subjects in the domain of the virtual. These last issues provide the occasion for a rethinking of the ethical in terms that no longer postulate a circle of the transcendental and the individual. Instead, ethics in virtual space might suggest multiple, relational patterns that at once invoke issues of power, the good, and the beautiful.

Acknowledgments

Anne Friedberg and Joan Scott gave me valuable comments on this essay.

Notes

1. I wish to thank Jon Wiener for calling my attention to this passage.

2. The U.S. gross receipts for the film were $6.1 million.

3. Face-to-face relations ought not be understood as unitary but as themselves differentiated in numerous rhetorics. Michael Taussig (1993), for example, provides one such analytics. The problem is that when one draws lines between different media, one inevitably gives the impression of the unity of each media. Such unity is of course by no means the case.

4. Raphael Sassower (1997) discusses Levinas's ethics in relation to technology and science.

5. For the classic statement of this problem by a philosopher, see Johnson (1994).

6. After a hung jury, Naughton was convicted on possession of child pornography, which was thrown out of court on appeal. Before the second trial, he reached an out-of-court settlement in which he pled guilty to a count of interstate travel with intent to have sex with a minor, agreeing as well to develop computer programs for the FBI to assist it in apprehending online pedophiles.

References

Baudrillard, J. (1994) *Simulacra and Simulation.* Ann Arbor: University of Michigan Press.

Baudrillard, J. (1995) *Le crime parfait* [The perfect crime]. Paris: Galilée.

Bernauer, J., and D. Rasmussen (eds.) (1988) *The Final Foucault.* Cambridge: MIT Press.

Dery, M. (ed.) (1993) *Flame Wars: The Discourse of Cyberculture.* Durham, NC: South Atlantic Quarterly.

Dibbell, J. (1993) "A Rape in Cyberspace." *Village Voice* (December 23), 36–42.

Donath, J. (1999) "Identity and Deception in the Virtual Community: Communities in Cyberspace." In M. Smith and P. Kollock (eds.), *Communities in Cyberspace.* New York: Routledge, 29–59.

Dreyfus, H. (1999) "Anonymity versus Commitment: The Dangers of Education on the Internet." *Ethics and Information Technology,* 1(1), 15–21.

Habermas, J. (1990) *Moral Consciousness and Communicative Action.* Cambridge: MIT Press.

Johnson, D. (1994) *Computer Ethics.* Englewood Cliffs, NJ: Prentice Hall.

Kant, I. (1949) *Fundamental Principles of the Metaphysic of Morals.* New York: Bobbs-Merrill.

Kaplan, B., R. Farzanfar, and R. Freeman. (1999) "Research and Ethical Issues Arising from Ethnographic Interviews of Patients' Reactions to an Intelligent Interactive Telephone Health Behavior Advisor." In O. Ngwenyama, L. Introna, M. Myers, and J. DeGross (eds.), *New Information Technologies in Organizational Processes.* Boston, Kluwer Academic, 67–78.

Kittler, F. A. (1990) *Discourse Networks: 1800/1900.* Stanford: Stanford University Press.

Levinas, E. (1985) *Ethics and Infinity: Conversations with Philippe Nemo.* Pittsburgh: Duquesne University Press.

Meyrowitz, J. (1985) *No Sense of Place: The Impact of Electronic Media on Social Behavior.* New York: Oxford University Press.

Miller, G. (1999a) "Former Internet Exec Says Online Pursuit of Girl Was Role-Playing." *Los Angeles Times* (December 10), pp. C1, C8.

Miller, G. (1999b) Online Chat Is Sting of Choice in Illicit-Sex Cases. *Los Angeles Times* (September 25), pp. A1, A20, A21.

Nietzsche, F. (1966) *Beyond Good and Evil.* New York: Vintage.

Nietzsche, F. (1967) *On the Genealogy of Morals.* New York: Vintage.

Nietzsche, F. (1969) *Thus Spoke Zarathustra.* London: Penguin.

Rheingold, H. (1993) *The Virtual Community: Homesteading on the Electronic Frontier.* New York: Addison-Wesley.

Sassower, R. (1997) *Technoscientific Angst: Ethics + Responsibility.* Minneapolis: University of Minnesota Press.

Spigel, L. (1992) *Make Room for TV: Television and the Family in Postwar America.* Chicago: University of Chicago Press.

Spinello, R. (1999) "Ethical Reflections on the Problem of Spam." *Ethics and Information Technology,* 1(3), 185–191.

Taussig, M. (1993) *Mimesis and Alterity: A Particular History of the Senses.* New York: Routledge.

Tavani, H. (1996) *Bibliography of Computing Ethics and Social Responsibility.* New York: CPSR Press.

Tebbel, J. (1975) *A History of Publishing.* New York: R. R. Bowker.

Van Gelder, L. (1996) "The strange case of an electronic lover." In R. Kling (ed.), *Computerization and Controversy: Value Conflicts and Social Choices.* New York: Academic Press, 533–546.

Weinstein, H., and G. Miller (1999) "'Virtual' Child Porn Is Legal, Court Rules." *Los Angeles Times* (December 18), pp. A1, A38, A39.

Wright, W. (1975) *Six Guns and Society: A Structural Study of the Western.* Berkeley and Los Angeles: University of California Press.

Illustrations

5.1 Reprinted with permission from Margaret Waller.

5.2 Pixelated extract from author's photograph of textile, Harare Polytechnic. Reprinted with permission.

5.3 Digitally modified image, original photograph in Marjorie Locke, *In the Dove's Footprints* (Harare: Baobab Books, 1994). Reprinted with permission.

5.4 Collage by Andrew Morrison. Images reprinted with permission from Margaret Waller and Jane Shepherd.

5.5 Image by Andrew Morrison.

5.6 Altered photograph, original by Margaret Waller. Reprinted with permission.

5.7 Digitally modified image, original photograph in Marjorie Locke, *In the Dove's Footprints* (Harare: Baobab Books, 1994). Reprinted with permission.

5.8 Reprinted with permission from Margaret Waller.

7.1–7.15 Reprinted with permission from the author.

7.16 Screenshot from *Final Fantasy VII*. Reprinted with permission. © 1997 Square Co., Ltd. All rights reserved. FINAL FANTASY, SQUARESOFT and the SQUARESOFT logo are registered trademarks of Square Co., Ltd. ILLUSTRATION/YOSHITAKA AMANO.

7.17 Courtesy of Henrik Garde.

7.19 Reprinted with permission from Microsoft Corp.

7.20–7.23 Reprinted with permission from the author.

9.1 Reprinted with permission from the author.

11.1, 11.3–11.6 Reprinted with permission from Verdens Gang (VG).

11.2 Reprinted with permission from CNN.

12.1–12.4, 12.7 Reprinted with permission from 3D Realms Entertainment.

12.6 Reprinted with permission from Photo RMN—Amaudet; J. Schormans.

12.8, 12.10 Reprinted with permission from Thames & Hudson Ltd.

12.9 Reprinted with permission from The National Gallery Company Limited, London.

12.11 Two drawings of scouts in the role of Saint George. By R. S. S. Baden-Powell, *Scouting for Boys* (World Scout Organization, 1908). Reprinted with permission from World Scout Organization.

13.1–13.10 Reprinted with permission from the author and the artists.

15.2 Screen shot reprinted with permission from Apple Computer, Inc.

18.1 Reprinted with permission from the authors.

Index

Aarseth, Espen, 318–321

Abelson, Robert P., 166

Adorno, Theodor, 21

Aesthetic judgment, 242–243, 270, 272

Aesthetics, 7, 239–241, 248, 264–265, 270–272, 281, 284

Agacinski, Sylviane, 93

Alberti, Leon Battista, 242, 244

Analysis, 390–392, 397, 406, 408, 411. *See also* Synthesis

ANT, 82–83, 85

ARPANET, 2, 422, 443–445, 447, 449, 452–453, 455–457, 460, 462

Art theory, 241, 264

Artaud, Antonin, 92–93

Articulation, 491, 501, 510, 513

Atkinson, Bill, 206

Augé, Marc, 487–488

Austin, J. L., 222

Automata, 6, 16, 183–185

Automaton, 184–185, 210

Autopoiesis, 445–446, 464

Badinter, Elizabeth, 348

Bakhtin, Mikhail, 40, 43, 47, 119, 136–137

Baklema, Annette W., 263–265, 275

Balzac, Honoré, 319

Baran, Paul, 450–452, 462

Barlow, John Perry, 23

Barnhurst, Kevin G., 302

Barthes, Roland, 19, 40, 43–44, 407–409

Bartle, Richard, 423

Baudrillard, Jean, 43, 536

Baudry, Jean Louise, 21

Bauman, Zygmunt, 472, 474–475, 477–478, 481

Baym, Nancy, 485

Benjamin, Walter, 273–276, 280–281

Bernstein, Mark, 404

Bochner, Mel, 265

Bolter, Jay David, 137, 281–282, 295, 298–305, 311, 313, 316–318, 321, 419, 437n.1

Bookchin, Natalie, 360, 362–363, 367–368, 378, 380

Bordwell, David, 22, 198
Bourdieu, Pierre, 120
Braidotti, Rosi, 367, 369
Bregman, Albert, 165
Breton, André, 374
Brown, George Spencer, 245
Buber, Martin, 526
Bush, Vannevar, 42
Butterworth, Dianne, 369

Caillois, Roger, 217–218, 231, 351, 398
Cairncross, Frances, 473
Carey, James C., 417
Censorship, 529, 537, 542
Cerf, Vint, 460
Christiansen, Anne Dorte, 255
Computer games, 15, 24, 320, 328, 352–354, 359–360, 369, 370, 378, 391, 393
 impact on players' dreams, 379
 study of, 433
 violence in, 368
 violent historical context, 374
Computer science, 16–17, 24, 86, 443
Conceptual art, 91
Conceptual convergence, 320
Convergence, 8, 35, 51, 130, 294, 295, 297
 corporate, 297
 network, 297
 service, 297
Counternarrative, 119, 126, 128
Crawford, Chris, 399–401, 425
Cyberculture, 359, 379
 as U.S. technoculture, 384
 women in, 383
Cyberfeminism, 360, 361
Cybernarrative, 134
Cyberplace, 116, 124
Cyberspace, 10, 24, 127
 ethics, 480

Dangarembgwa, Tsitsi, 128
Davies, Donald, 460

de Man, Paul, 18
Deleuze, Gilles, 43, 44, 267, 270, 522
Derrida, Jacques, 18–20, 29, 40, 43–44, 49–50, 55, 102–104, 107
Descartes, René, 446, 471
Design, 7
 art and, 240, 245, 247–248, 250
Developer's discourse, 8, 119, 396, 397, 404, 406
Digital learning environments, 66–67, 70–73, 75
Digital media, 415–419, 424, 426, 429, 436
Digital poetics, 240, 248
Digital revolution, 15, 417
Dinesen, Theis Barenkopf, 255
Disability, 491, 492, 494, 508, 512
Distributed communications, 450
Distributed society, 444, 462
Divergence, 8, 294
Donath, Judith, 538
Douglas, J. Yellowlees, 321
Duchamp, Marcel, 240–241, 246–247, 250, 253
Duguet, Anne-Marie, 253–254

Eco, Umberto, 77–78
Education, 24, 28, 44, 48, 66
 Bakhtinian approach to, 46–47
 business-orientated, 25
 "the rat-maze theory of," 42
 university, 40, 48
Electracies, 6, 120
Electracy, 5–6, 91, 94, 96, 102, 103, 120, 143
 categorical order of, 91
 identity in, 107
 sense of "voice" for, 100
 subject formation in, 109
Ellis, John, 317
Ellul, Jacques, 444
Embodiment, 492
Englebart, Douglas, 42

Epistemology, 271–274
Escobar, Arturo, 127, 130–131
Ethical, 521
 criteria, 523 (*see also* Kant, Immanuel)
 culture, 521
 judgment, 530
 practice, 521
Evreinoff, Nicolas, 218–220, 231

Felman, Shoshana, 228–229
Feminism, 21
Feminist theory, 10, 19
Finneman, Niels Ole, 416
Flaming, 528–529
Foucault, Michel, 277–278, 493
Frege, Gottlob, 405
Freud, Sigmund, 94–96, 108, 268,
 277, 370, 374, 405
Fry, Christopher, 207

Gadamer, Hans-Georg, 329, 353–354, 398
Game studies, 215, 231
Gameplay, 8, 397–404, 406, 434
Gaming culture, 8
Gender, 8, 23
Genette, Gerard, 319
Genre, 49, 168
 theory, 408
Gibson, William, 423
Gillespie, Thom, 361
Goethe, Johann, Wolfgang von, 390–
 391, 406
Graphic design, 17–18, 24, 30
Green, Maxine, 122
Greenberg, Clement, 278–280
Greimas, A. J., 394, 402, 404
Grossberger-Morales, Lucia, 360, 371–
 374, 375, 378, 380
Grusin, Richard, 281–282, 295, 298–305,
 311, 313, 316–317, 321, 419, 437n.1
Guattari, Félix, 43, 44
Gulia, Milena, 485–486

Habermas, Jürgen, 445, 448, 539–540
Haraway, Donna, 361, 381, 493
Harding, Sandra, 373
Hauben, Ronda, 461
Heidegger, Martin, 94–95, 100, 284, 472
Heim, Michael, 430
Hermeneutics, 217, 228, 254, 354
HIC, 16–17, 24
Hjarvard, Stig, 317
hooks, bell, 126
Horkheimer, Max, 21
Hove, Chenjerai, 128
Huizinga, Johan, 218, 231, 398
HyperCard, 206–207
Hyperland, 116, 122, 126, 140, 144n.2
Hypermedia, 19–20
Hypermediacy, 281–282, 298–299
 defined as, 303
Hypernarrative, 115–118, 120–122,
 124–129, 132, 137
 postcolonial, 126
Hyperpedagogy, 116, 128
Hypertext, 9, 19–20, 28, 35, 38, 40–43,
 50, 51, 118, 415, 418, 426, 432, 436
 critics, 20
 educational paradigm, 41
 ideology, 428–429
 paradigm, 44, 46, 57
 technology, 44
 theory, 5, 19, 43, 50, 55, 429
 topographical writing, 137

Ibsen, Henrik, 431
Iconographical analysis, 328
Iconological analysis, 328
Ideology, 30, 415, 426
 Althusserian sense, 418
 capitalist, 21, 25, 27
 and innovation, 435–436
 sexist, 21
Immediacy, 281, 298–299
 defined as, 303

Informatics, 66–67, 84
 literacy, 80
Innovation, 1–2, 7, 10, 35–37, 40, 58,
 269, 271–272, 276, 444
Interaction, 240, 248, 254–255, 400, 401
Interactivity, 9, 400, 415, 418, 424, 426,
 428, 436
 definitions of, 425
Intermedium, 421
Internet, 9, 455, 459, 462, 464–465
 architecture of, 23, 460
 design, 463
 ethics, 529, 537
 logic of, 444
 protocol, 453, 462
 search tools, 38
 social significance, 445
Interpretation, 254
 as play, 329 (see also Ludic interpretation)
Irigaray, Luce, 381

Jay, Martin, 27
Jennings, Pamela, 360, 375–377, 378, 380
Joyce, Michael, 119, 141–142, 321

Kahn, Robert, 460
Kant, Immanuel, 2, 7, 93, 242–244,
 272–273, 284, 397, 403, 404, 525,
 538–539
 ethical imperative, 534
Kavanagh, James, 418
Kierkegaard, Søren, 525–526
Kirschenbaum, Matt, 319
Kittler, Friedrich, 267–268, 283, 420–
 421
Kolko, Beth, 225
Krauss, Rosalind, 265, 275, 279–282, 284
Kress, Gunther, 249
Kristeva, Julia, 108–110

Lacan, Jacques, 101–102, 108, 370
Lai, Kum-Yew, 207

Landow, George, 19, 118–119, 125,
 127, 317, 320, 426
Language games, 8, 396, 397, 401
Latour, Bruno, 245
Laurel, Brenda, 239, 402
Leone, Sergio, 522–523
Levinas, Emmanuel, 9, 469–470, 472,
 475, 479–481, 484, 488, 526
Lévi-Strauss, Claude, 49
Lichtenstein, David, 51
Licklider, J. C. R., 443, 449, 457
Liestøl, Gunnar, 29, 119, 316
Lippman, Andy, 425
Literacy, 5–6, 91, 119, 143
 academic, 116
 electronic, 116
LMSs, 72–74, 79
Louw, Bill, 129
Ludic interpretation, 354. See also Inter-
 pretation as play
Ludology, 215
Luhmann, Niklas, 7, 9, 244, 445, 447–
 448, 451–453, 457–460, 462, 464–
 465
Lyotard, Jean-François, 277

Machover, Tod, 169
Malone, Thomas W., 207
Mangini, Mark, 165
Manovich, Lev, 318
Marcel, Gabriel, 526
Marcuse, Herbert, 444
Marvin, Carolyn, 417
McLuhan, Marshall, 18–19, 267, 298
Meaningware, 3, 389, 410
Media studies, 66, 78, 80, 84
Medium, 184, 210
Mentalware, 43
Metadata, 74, 161, 171–172, 174–175,
 177
Metz, Christian, 21
Meyrowitz, Joshua, 529

Model reader, 78, 88n.8

Monodrama, 220

MOOs, 23–24, 26–27

Morrison, Andrew, 51

MUDding, 216–218, 231

MUDs, 7, 23, 215–216, 218, 220, 222–223, 225–227, 320

Mulett, Kevin, 17

Multilinearity, 227

Multimedia, 28–29

Multisensory, 6, 161
 artifact, 166
 design, 163
 media, 162, 178
 reading, 158, 161
 semiotics, 162

Multivocality, 46–47, 48–49

Mulvey, Laura, 21

Mungoshi, Charles, 128

Murray, Janet, 317, 318, 419, 425

Mystory, 101

Myth, 99, 108

Narrative, 2
 folk, 101

Narratology, 392, 394

Negroponte, Nicholas, 417

Nelson, Ted, 42–43, 327, 349, 426–427

Nietzsche, Friedrich, 523, 526–527, 538, 540–541

Nin, Anaïs, 92–93

Noble, David, 22

Nyamfukudza, Stanley, 128

Object-activity, 401–403

Odin, Jaishree K., 51

Ong, Walter, 18

Oppenheim, Méret, 379

Optimal communication flow, 350

Packet switching, 445, 449–450, 452–453, 455–457, 460

Panofsky, Erwin, 328, 352

Pearce, Celia, 375

Pedagogy, 66–67, 71, 84

Peirce, Charles Sanders, 249

Performance, 215–217, 221–222

Performatives, 217, 222–223, 225, 231

Peters, John Durham, 446

Plant, Sadie, 361–362, 381

Poetics, 7, 239, 247

Pool, Ithiel de Sola, 474

Popular culture, 17, 360, 369

Postcolonial web, 53, 62n.10

Postcolonialism, 51

Postmodern ethics, 472

Poststructural theory, 19

Poststructuralism, 19, 21, 29–30

Pre-iconographic description, 328

Prigogine, Ilya, 246

Print technology, 37

Programming language, 185, 205

Projection, 240, 248, 250

Propp, Vladimir, 99

Prosthesis, 58, 102–103, 497, 503, 508

Proust, Marcel, 319

Remediation, 8, 282, 295, 298–300, 302–304
 concept of, 281

Rheingold, Howard, 430, 431, 528

Rhetoric, 271, 273, 281, 313–316, 407–408
 multilinear, 20
 of resistance, 25

Rhetorical operation, 407

Ricoeur, Paul, 217, 225–227

Rolltalk, 493–512

Rosenberg, Jim, 427

Ross, Andrew, 22

Sano, Darrell, 17

Sardar, Ziauddin, 127

Schank, Roger C., 166

Schema, 166, 167
Schelling, Friedrich, 95
Schiller, Friedrich von, 397, 403
Schjødt, Morten, 255
Schleiermacher, Friedrich, 254
Shannon, Claude, 446–447, 449
Shaw, Jeffrey, 252
Simmel, Georg, 477
Simon, Herbert, 161
Simulation, 69, 218
Slaa, P., 297
Snyder, Ilana, 119, 426
Spamming, 528–529
Spigel, Lynn, 530
Standage, Tom, 417
Stanislavski, Konstantin, 219
Stereotype, 24, 348
Stickgold, Robert, 379
Stone, Allucquère Rosanne, 484
Strain, Ellen, 29
Subject-activity, 401–403
Subjectivty, 10, 493–494, 498, 501, 508,
 510–511, 513–514n.5
 autonomous, 505
 competent, 507
 modern, 506
Svedjedal, Johan, 426
Sylvester, Christine, 130
Synthesis, 390–392, 397, 406, 408, 411.
 See also Analysis

Technological determinism, 81–82
Theatre of cruelty, 92. *See also* Artaud,
 Antonin
Theatricality, 7, 215–218, 220, 231
Thillemann, Peter, 255
Thompson, Ken, 423
Thompson, Kristin, 198
Tomlinson, Ray, 422
Tool, 184, 210
Topics, 269, 274
 as method, 409

Trubshaw, Roy, 423
Turkle, Sherry, 24, 379
Turner, Mark, 167

Ulmer, Gregory, 18, 118–119, 122–124,
 139, 273–274, 277
Urry, John, 478

Van Cuilenburg, J., 297
Van Dam, Andries, 42–43
Van Hoosier-Carey, Gregory, 29
Van Leuwen, Theo, 249
Vera, Yvonne, 128
Virtual, 429–431, 437
 body, 369
 body of women, 361
 characters, 369
 person, 96
 rooms, 72
 voice, 94
 worlds, 431, 432, 435
Virtuality, 9, 96, 415, 418, 430, 431,
 435, 436
Vogler, Christopher, 98–99

Walker, Jill, 321
Watanabe, Makoto Sei, 251
Weaver, Warren, 446
Web genres, 314
Weber, Max, 2
Wellman, Barry, 485–486
Wiener, Norbert, 429, 449–450
Williams, Raymond, 314–315, 317
Wittgenstein, Ludwig, 277, 405
Women's games, 360, 362, 370–371,
 373–374, 378–379
Women's gaming movement, 380

Yun, David, 51